2/04

The Maya and Teotihuacan

The Linda Schele Series in Maya and Pre-Columbian Studies

This series was made possible through the generosity of

William C. Nowlin, Jr., and Bettye H. Nowlin

The National Endowment for the Humanities and the following donors:

Elliot M. Abrams and AnnCorinne Freter
Anthony Alofsin
Joseph W. Ball and Jennifer T. Taschek
William A. Bartlett
Elizabeth P. Benson
Boeing Gift Matching Program
William W. Bottorff
Victoria Bricker
Robert S. Carlsen
Frank N. Carroll
Roger J. Cooper
Susan Glenn
John F. Harris
Peter D. Harrison
Joan A. Holladay
Marianne J. Huber
Jānis Indrikis
The Institute for Mesoamerican Studies
Anna Lee Kahn
Rex and Daniela Koontz
Christopher and Sally Lutz
Judith M. Maxwell
Joseph Orr
The Patterson Foundation
John M. D. Pohl
Mary Anna Prentice
Philip Ray
Louise L. Saxon
David M. and Linda R. Schele
Richard Shiff
Ralph E. Smith
Barbara L. Stark
Penny J. Steinbach
Carolyn Tate
Barbara and Dennis Tedlock
Nancy Troike
Donald W. Tuff
Javier Urcid
Barbara Voorhies
E. Michael Whittington
Sally F. Wiseley, M.D.
Judson Wood, Jr.

The Maya and Teotihuacan
Reinterpreting Early Classic Interaction

Geoffrey E. Braswell, *Editor*

UNIVERSITY OF TEXAS PRESS AUSTIN

First paperback printing, 2004

Requests for permission to reproduce material from this
work should be sent to Permissions, University of Texas Press,
Box 7819, Austin, TX 78713-7819.

∞ The paper used in this book meets the minimum requirements
of ANSI/NISO Z39.48-1992 (R1997) (Permanence of Paper).

LIBRARY OF CONGRESS CATALOGING-IN-PUBLICATION DATA
The Maya and Teotihuacan / reinterpreting early classic interaction /
Geoffrey E. Braswell, editor.— 1st ed.
 p. cm.
Includes bibliographical references and index.
ISBN 0-292-70587-6 (pbk.)
1. Mayas—Antiquities. 2. Teotihuacán Site (San Juan Teotihuacán,
Mexico) 3. Mexico—Antiquities. 4. Central America—Antiquities.
I. Braswell, Geoffrey E.
F1435 .M37 2003
972.5'2—dc21 2002008280

With the greatest affection and respect, we dedicate this book to

Edwin M. Shook

PIONEER OF PACIFIC COAST ARCHAEOLOGY

INVESTIGATOR OF KAMINALJUYU MOUND B

DIRECTOR OF THE UNIVERSITY OF PENNSYLVANIA TIKAL PROJECT

SURVEYOR OF COPÁN

EXPLORER OF OXKINTOK

Contents

Figure List

Foreword

Arthur A. Demarest

In all fields of scholarship, certain issues become prisms of theoretical and interpretive positions. In the small subfield of Mesoamerican archaeology, one of the most divisive issues (in a literal, "prismatic" sense) has been the debate over the role of external central Mexican influence in the ancient Maya civilization.

In the earliest days of stratigraphic excavation in Mesoamerican archaeology, Manuel Gamio and others made the shocking discovery of very early settled village cultures in the Valley of Mexico. This finding led to the so-called archaic hypothesis that these earliest farming societies had spread from central Mexico to the rest of Mesoamerica, including the Maya region (e.g., Spinden 1917). Mayanists reacted with disdain to the idea that their chosen brilliant and literate culture could have derived from such crude central Mexican roots. Some of them countered with a proposed Q-complex of ceramic traits from Upper Central America providing a unique "eastern" component to Mesoamerican culture and Classic Maya origins (e.g., Lothrop 1927; Merwin and Vaillant 1932; Vaillant 1930b). We now know that the dates and the data for both positions were terribly flawed. Yet the battle lines for the rest of the century were drawn. Mexicanists and Mayanists were ready to defend and promote their respective regional cultures.

As the database grew exponentially and culture history became more detailed and complex, regional chauvinism managed to continue unabated. In the 1940s and 1950s, Miguel Covarrubias and Matthew Stirling proposed that the Olmec civilization of Mexico was the "mother-culture" ancestral to later civilizations, including the Maya (Covarrubias 1946; Stirling 1943). J. Eric S. Thompson and other leading scholars working in eastern Mesoamerica dismissed this as anti-Maya heresy. When the early dating of the Olmec was demonstrated, some Mexicanist scholars overreacted by wholly embracing the genealogical metaphor of the "mother culture," deriving almost all aspects of later societies from the Olmec (e.g., Bernal 1969).

More recently, a new round of Mexicanist/Mayanist academic conflict

began with the regional archaeological projects of the 1960s and 1970s, which revealed the astonishing size, complexity, and sophistication of Teotihuacan. The Tikal Project recovered ample evidence in the Maya lowlands of Early Classic central Mexican contacts. Scholars working in the Valley of Mexico proclaimed a second central Mexican genesis, this time of state-level society that spread to other regions via Teotihuacan influence or even imperialism (e.g., Sanders and Price 1968; Wolf 1976). They applied from Andean studies the "horizon" concept of rapid interregional spread of traits as a framework for chronologies and interpretations. As described in Chapter 1 of this volume, many Mayanists reacted with a reassertion of the independent development and distinctiveness of their beloved lowland Maya states.

Obviously this century-old dialogue was only vaguely related to any events or processes in precolumbian prehistory. It had far more to do with the structure and territoriality of modern academics. The application of the horizon concept, World Systems Theory, or other frameworks to explain apparent intensified Early Classic contact only reified such territoriality. In fact, the horizon model envisioned regional cultural sequences as fairly isolated territorial developments only episodically penetrated by important periods of interregional influence during the proposed pan-Mesoamerican horizons.

In 1986, Don Rice organized a conference of prehistorians of the central Mexican, Maya, and Andean regions to reexamine the horizon concept and related models of interregional interaction in the precolumbian world (Rice 1993). At that conference, Antonia Foias and I presented a study of Mesoamerican horizons and the effects of interaction on the Maya (Demarest and Foias 1993). We believed it to be neither "externalist" nor "internalist" (i.e., Mexican diffusionist or Maya isolationist) in character. We argued for continuous, ongoing, and multidirectional interaction between eastern and western Mesoamerica, rather than the intense but only episodic and generally unidirectional structure of the horizon concept as often applied to central Mexico–Maya relations. We intended our position to be a rejection of the horizon concept itself. Indeed, we had hoped that we were writing its obituary.

> The horizon model may have outlived its utility. It has guided us to force periods of interaction into narrow chronological bands and interpret them in terms of Mexican dominance. As archaeologists continue to explore Mesoamerican interregional interaction, these errors can be avoided by adhering closely to the specific known dates and

by reconstructing the precise nature of individual interactions, contacts, or exchanges. . . . Generalizations and overarching models for Mesoamerican interaction can then be built upon the documentation of such contacts, rather than by forcing evidence into preconceived molds. . . . Only with an appreciation for the continuity, complexity, and diversity of the forms of interregional contact can we begin to reconstruct the rich tapestry of the ancient Mesoamerican world. (Demarest and Foias 1993:176)

The authors of this volume do not all concur with us regarding the uselessness of the horizon concept, and one or two may consider our position as listing too heavily in the direction of internalism. What I can assert is that this volume directly responds to our recommendations and, thus, addresses many of the issues that we raised. Most of the chapters in this volume have already successfully completed the more specific and precise documentation of Teotihuacan-Maya contact that we called for at the horizon conference. Remarkably, in little more than a decade, new decipherments of monumental texts, isotopic studies of bone, more precise iconographic studies, and archaeological discoveries together have allowed for more detailed reconstructions of multidirectional interactions between specific lowland Maya polities, Kaminaljuyu, Teotihuacan, and other regions of Mesoamerica.

Although many details remain unclear, this important volume truly marks a fundamental change in Mesoamerican studies of these issues. Scholars have begun to push aside the fruitless debate over broad interpretive frameworks for Classic-period cultural interaction and have begun to reconstruct specifically what happened, between whom, and when. In the past two decades an avalanche of new data from osteology, epigraphy, iconography, and archaeology has raised the discussion to a new level, rendering earlier broad schemes and debates obsolete. As we absorb the data and refine new historical reconstructions, we will also begin to form the structure of new, more appropriate global frameworks, models, and theoretical conclusions.

Healthy disagreements and debates abound in the chapters that follow, but I have a strong sense that this dialogue has now become focused on ambiguous aspects of the archaeological and historical record on the Maya and Mexican peoples and their interaction. That is, it rightly concentrates on those areas illuminated by current research and on those questions that still need to be answered. The debate now has matured beyond preconceived perspectives on internal development versus diffusion, and well beyond conscious or unconscious defense of our territories as scholars.

Within the current theoretical milieu, truth and objectivity have been questioned, although we can still aspire to a higher level of consistency and complexity to render our subjective reconstructions more elegant (and, perhaps, more self-revealing). Yet in reading the insightful analyses, interpretations, and debates in the chapters of this volume, I again become convinced of the unfashionable empiricist position that we are, in fact, beginning to more closely approximate an accurate reconstruction of what happened in the ancient past. In that respect, this volume may mark a watershed in Maya culture history and in the maturation of Mesoamerican studies. At the very least, these studies are certain to provoke a wide range of new and original reactions, responses, and researches on these great civilizations of precolumbian Mesoamerica and the relations between them.

The Maya and Teotihuacan

Introduction: Reinterpreting Early Classic Interaction

Geoffrey E. Braswell

Since the remarkable discovery in 1936 of foreign ceramics and *talud-tablero* architecture (platforms with façades consisting of inward-sloping basal elements stacked with rectangular bodies containing recessed insets) at Kaminaljuyu, Guatemala (Figure 1.1), the nature of interaction between the central Mexican culture of Teotihuacan and the Maya of southern Mexico and Central America has been a fundamental question of Mesoamerican archaeology. During the fifty years that followed, few scholars doubted that the presence of central Mexican–style artifacts and architecture in the Maya region represented an actual migration and colonization of southeastern Mesoamerica by population segments from the great city of Teotihuacan.[1] These "resident Teotihuacanos" formed enclaves in previously existing Maya sites—frequently depicted until the 1970s as empty ceremonial centers—and, in the most extreme models, were responsible for stimulating nearly all aspects of the Late Classic Maya florescence. Specifically, economic determinists argued that state-level political organization emerged in southern Mesoamerica as a direct result of Teotihuacan influence. To a great degree, this conclusion was based on the comparison of the monumentality of Teotihuacan with the less impressive architecture of Kaminaljuyu.

Although there were a few dissenting voices, the Teotihuacan-centric view maintained currency well into the 1980s. In part this was due to the strength of the voices supporting the preeminence of Teotihuacan—voices that not only dominated the North American academy, but also counted in their number some of the loudest, brashest, and truly extraordinary individuals in the colorful history of Mesoamerican archaeology. In the intervening years, many of these voices have fallen silent, have mellowed to a muted *basso profundo,* or have simply ceased to be relevant.

A second reason that Teotihuacan-dominance models retained precedence until recent years is that the 1960s saw unparalleled developments in our understanding of Teotihuacan and important Classic Maya sites where central Mexican–style art, artifacts, and architecture are found. Three large-

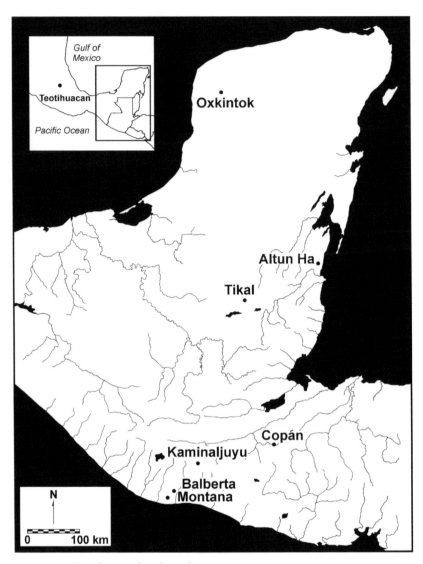

FIGURE 1.1. Sites discussed in this volume.

scale projects, which focused on regional survey, mapping, and extensive ex-
cavation, were conducted at and around the great city itself. The Teotihuacan
Valley Project (1960–1964) and its successor, the Basin of Mexico Settlement
Survey Project (1966–1975), gave dramatic new insight into 13,000 years of
ecological adaptation and human settlement in central Mexico (e.g., Blan-
ton 1972; Parsons 1971, 1974; Sanders 1965, 1970, 1981; Sanders and Price
1968; Sanders et al. 1979; Wolf 1976). Results of these projects were so im-

pressive that aspects of their methodology have served as models for most subsequent surveys in Mesoamerica.

Concurrent with William T. Sanders' survey and test pitting in the Teotihuacan Valley, Ignacio Bernal of Mexico's Instituto Nacional de Antropología e Historia excavated and restored most of the major structures along a 2 km stretch of the Street of the Dead, the north-south "avenue" that forms a principal axis of Teotihuacan (e.g., Acosta 1964; Bernal 1963; Sociedad Mexicana de Antropología 1966). At an intermediate scale, the Teotihuacan Mapping Project of René Millon, Bruce Drewitt, and George L. Cowgill created a detailed map of the 20 km² city, complementing survey with systematic surface sampling and small-scale excavations (e.g., Cowgill 1974; Drewitt 1966; Millon 1964, 1966, 1967, 1970, 1973, 1981). These three projects, as well as Laurette Séjourné's (1959, 1966a, 1966b) excavations in several apartment compounds during the years 1955–1964, transformed Teotihuacan from a poorly understood site to one of the best-studied cities in Mesoamerica.

At the same time, great strides were made in southern Mesoamerica. The Tikal Project (1956–1970), directed first by Edwin M. Shook and in later years by William R. Coe, conducted excavations, survey, and restoration on a scale never before seen in Central America. Many important discoveries, particularly of foreign-style ceramics in Burials 10 and 48 and in several so-called problematical deposits (see Chapter 6), and of central Mexican motifs on Stelae 31 and 32 (Chapter 8), pointed directly to a connection with Teotihuacan. Also of great importance was the ambitious Pennsylvania State University Kaminaljuyu Project (1968–1971), directed by William T. Sanders and Joseph W. Michels. Little or no evidence of interaction with Teotihuacan was found in most portions of the site, but additional *talud-tablero* structures and a few tripod cylinders were found during excavations in the Palangana (see Chapter 3; Cheek 1977a). Theoretical contributions by project members, although not representing a unified voice, provided the first anthropological perspectives on Teotihuacan influence at Kaminaljuyu (see Chapter 4; Sanders and Michels 1977). Additional projects conducted in the 1960s and 1970s at sites in the Maya area, including Altun Ha (Chapter 9), Becan (Ball 1974), and Dzibilchaltun (Andrews 1979, 1981:325–326), continued to find evidence—chiefly in the form of *talud-tablero* architecture, imported or copied central Mexican ceramics, Teotihuacan-inspired iconography, and green obsidian from the Pachuca, Hidalgo, source—of interaction with non-Maya societies in highland and Gulf Coast Mexico. Other projects adopted what David M. Pendergast (Chapter 9) calls "Teotihuacanomania,"

and reported a central Mexican presence at sites as widely separated as Chichén Itzá and Bilbao (Parsons 1967–1969). Still others designed ambitious projects to find Teotihuacan influence where comparatively little exists (e.g., Hellmuth 1972, 1986). Given that in 1970 Teotihuacan was by far the best-understood Classic-period site in the Mexican highlands, and that evidence for some sort of interaction with central Mexico was either found or perceived at many Maya sites, it is not at all surprising that Teotihuacan was widely viewed as *the* pristine state of Mesoamerica: a kind of "mother state" that inspired—or even mandated—the evolution of all other state-level political systems from Jalisco to Honduras.

As a result of this research, the 1960s and early 1970s saw the definition of a "Middle American Co-Tradition" (Parsons 1964), a "Middle Classic" period of A.D. 400 to 700 (Parsons 1967–1969; Pasztory 1978b), and a "Middle Horizon" of A.D. 200 to 750 (Wolf 1976). The last, proposed in an attempt to replace the traditional Preclassic/Classic/Postclassic chronological scheme of Mesoamerica with a horizon/intermediate periodization borrowed from Andean studies, was put forward by a small group that included no scholars from Latin America and only one Mayanist (Pasztory 1993:116). Fortunately, the horizon/intermediate scheme now has few adherents and has been scrapped as too cumbersome and inaccurate. Although the concept of a "Teotihuacan horizon style" may have some crude utility, it has been abandoned because it blurs regional distinctions, implies a long-outmoded culture-area concept of evolution, and generally is "out of step" with processual archaeology (Demarest and Foias 1993; Pasztory 1993; Rice 1993). Moreover, the term "Middle Horizon" is neither developmentally neutral nor purely chronological, as its proponents suggested. Finally, improved regional chronologies demonstrate that interaction with Teotihuacan dates to different times at different sites, in some cases was intermittent, and in others was so long in duration as to contradict the very definition of the horizon concept.

In addition to referring to a period of posited Teotihuacan hegemony throughout Mesoamerica, the term "Middle Classic" has also been used to discuss very different processes limited to the central Maya lowlands. During the sixth century, Tikal and other sites in its sphere of political influence ceased to produce carved monuments bearing Maya dates. The period from A.D. 534 to 593, therefore, has been called the Middle Classic Hiatus, and at Tikal itself the interruption seems to have lingered to the end of the seventh century. An interesting twist was put on Teotihuacan-influence models by Gordon R. Willey (1974), who proposed that this hiatus—once thought to

be characteristic of all lowland Maya sites—was caused by the withdrawal of Teotihuacan trade relations. In other words, he suggested that the Middle Classic Hiatus was the *antithesis* of a period of Teotihuacan domination. In Willey's view, the Middle Classic was the beginning of an intermediate period, not a horizon. Nonetheless, recent breakthroughs in the study of hieroglyphic inscriptions strongly indicate that events leading to the downturn in the political fortunes of Tikal during the Middle Classic Hiatus were linked to other Maya sites rather than to Teotihuacan.

Since "Middle Classic" has been used in three distinct ways—one that denotes a period of Teotihuacan influence, one that indicates a period after such interaction, and one that may have nothing at all to do with Teotihuacan—it seems best to avoid this confusing term. For this reason, we have opted in this volume to refer to the late fourth through sixth centuries as the late Early Classic.

Many of those who once considered the polities of the Early Classic Maya to be chiefdoms were archaeologists who worked at Teotihuacan or who used the central Mexican city as a measuring stick. They envisioned archaic states as polities dominated by one primate center, as the Basin of Mexico was during the Classic period. In contrast, Maya populations were more dispersed. Some leading Maya scholars of the day still supported the "empty ceremonial center" view of Maya sites, strengthening the Teotihuacan-centric argument. Because major lowland sites were not considered urban, scholars assumed that Early Classic Maya polities were not states. It is astonishing that today, after more than thirty years of demographic research, there are still some who deny that the Maya had true cities.

It should surprise no one that depictions of Early Classic Maya polities as chiefdoms that developed into states during the Middle Classic only because of the inspiration or military might of Teotihuacan did not sit well with some scholars. As a group, Mayanists were less sanguine about the passive, Teotihuacan-centric view than their counterparts working in highland Mexico. Without doubt, a few saw Teotihuacan-dominance models as unwanted attacks on the unique and brilliant innovations of Maya civilization, just as some of their predecessors had hoped to reject the temporal priority and cultural importance assigned to the Gulf Coast Olmec (see Foreword); it simply could not be that drab, repetitive, and seemingly illiterate Teotihuacan dominated or stimulated Maya genius. But the persuasive arguments against Teotihuacan-dominance models that eventually emerged were based on data rather than sentiment.

Beginning in the late 1970s, archaeologists and art historians turned their

gaze to the Preclassic period (c. 2000 B.C. to A.D. 200/425) in a concentrated effort to understand the genesis of Maya civilization. Early pottery found at Cuello, Belize, seemed to suggest that settled village life had developed in the tropical lowlands at a time much earlier than previously thought (e.g., Hammond 1977, 1985). Although subsequent reevaluation of chronometric data failed to support initial claims for the antiquity of settlement (Andrews and Hammond 1990), Cuello has been placed firmly on the map as one of a growing number of Maya sites occupied by 1000 B.C. In the northern Maya lowlands, significant Middle Preclassic occupations were discovered at Komchen and the nearby Mirador Group (e.g., Andrews 1981:315–320; Andrews et al. 1984). David Freidel's (1977, 1978, 1979; Freidel and Schele 1988a) research at Cerros provided critical evidence that the roots of Maya kingship—and hence, of state-level political organization—could be traced back well into the Late Preclassic period. That is, the transition from chiefdom to state in the Maya lowlands seemed to be the seamless result of continuous local processes.

Complementing Freidel's iconographic argument, new discoveries at El Mirador revealed that the largest monumental constructions ever built in the Maya region date to the Late Preclassic period (e.g., Dahlin 1984; Demarest and Fowler 1984; Hansen 1984; Matheny 1980). Subsequent research at Nakbe, located in the El Mirador Basin, indicated that truly monumental construction occurred c. 600 to 400 B.C., near the end of the Middle Preclassic period (e.g., Hansen 1991, 1993, 1994). It now seems likely that El Mirador, Nakbe, and Calakmul were complex polities hundreds of years *before* the emergence of Teotihuacan as a power in central Mexico. Iconography suggesting divine kingship, the erection of carved stelae, massive monumental construction, dramatic alterations of the landscape, large nucleated populations, and perhaps the emergence of truly urban places all support the notion that local processes led to the advent of the state in the central Maya lowlands long before significant contact with Teotihuacan. It may even be that early cities such as Zapotec Monte Albán[2] and Maya Nakbe and El Mirador were models for urbanism in the Basin of Mexico.

Debating Early Classic Interaction

By the mid-1980s, therefore, it was clear that the origin of state-level political organization in the Maya region—which, even by conservative estimates, occurred no later than the advent of the Early Classic period—could not have been a result of Teotihuacan influence. For the most part (but see Chapters 2 and 9), central Mexican–style artifacts, architecture, and symbolism found

at Maya sites date to a much later time, particularly the late fourth through sixth centuries A.D. (Figure 1.2).

The recognition that the emergence of states in the Maya lowlands cannot be attributed to central Mexican influence in no way minimizes the importance of interaction with Teotihuacan. Models that proposed Teotihuacan as the Mesoamerican *Urstaat* clearly are wrong. But the two cultures interacted, and evidence for that interaction is abundant. Moreover, iconographic motifs referring to a Teotihuacan-inspired ideology endured at Late Classic Maya sites long after the collapse of the great city (e.g., Fash and Fash 2000:450–456; Stone 1989; Stuart 2000a:490; Taube 2000a). There is no doubt that Teotihuacan impacted the consciousness of Late Classic Maya elites in ways that melded "the formidable power and memory of that foreign city with their own political symbolism and ideology" (Stuart 2000a:466). These Late Classic elites, then, were conscious actors who selectively adopted foreign imagery and ideas.

The nature and consequences of interaction with Teotihuacan are still very much a subject of debate. David Stuart (2000a:465–466) divides different perspectives into two broad camps: "internalist" and "externalist" models. Externalists, including those who advocated Teotihuacan as the cause of the development of "secondary" states in the Maya area, posit "an overt and disruptive Teotihuacan presence in the Maya lowlands during the late 4th century C.E., associated with military incursions if not political domination" (Stuart 2000a:465). In contrast, internalists propose "that Teotihuacan styles and material remains in the Maya area might better be seen as a local appropriation of prestigious or legitimating symbolism and its associated militaristic ideology. . . . In this latter view, the evidence of Teotihuacan influence in the Maya area says very little about what actual power relations might have existed between the Mexican highlands and the Maya lowlands" (Stuart 2000a:465).

It should be stressed that neither camp denies that interaction took place. Instead, the principal differences between the two perspectives may be described in terms of (1) the degree of impact that Teotihuacan had on the Maya; (2) the duration of political, social, and economic changes stimulated by interaction; and (3) the extent to which the Maya should be considered passive recipients or active participants in that interaction.

Externalist Perspectives

Most externalist narratives evolved out of research conducted both at Teotihuacan and within the Maya area during the late 1950s and 1960s. Many

FIGURE 1.2. Ceramic chronologies of sites discussed in this volume; complexes marked with an asterisk contain Teotihuacan-style ceramics (derived from Cassandra R. Bill, personal communication 2000; Bove et al. 2000; Cowgill 1997:Figure 1; Culbert 1993:Table 1; T. Kam Manahan, personal communication 2000; Parsons et al. 1996:Figure 1; Pendergast 1982; Popenoe de Hatch 1997:figura 5; Varela 1998:38–44; Viel 1999:figura 1).

Time scale (years): 1400 · 1200 · 1000 · 800 · 600 · 400 · 200 · BC/AD · 200

PERIOD	Balberta & Montana	Kaminaljuyu	Copán	Tikal	Altun Ha	Oxkintok	TEOTIHUACAN
LATE POST-CLASSIC	Ixtacapa	Chinautla	(abandoned)	Caban? (abandoned)	Uayeb	Tokay III	Teacalco / Chimalpa
EARLY POST-CLASSIC	Pantaleón	Ayampuc (abandoned)	Ejar			Tokay II	Zocango
TERMINAL CLASSIC		Pamplona	Late Coner / Middle Coner	Eznab	(abandoned)	Tokay I	
					Pax	Ukmul II	Atlatongo
LATE CLASSIC		Amatle	Early Coner	Imix	Muan	Ukmul I	Mazapan
			Late Acbi	Ik	Kankin / Mac	Noheb	Xometla
	San Jerónimo*	Esperanza*	Early Acbi*	Manik 3B	Ceh	Oxkintok Regional*	Oxtoticpac / Metepec
EARLY CLASSIC				Manik 3A*	Yax	Ichpá	Late Xolalpan
	Colojate*	Aurora	Bijac 2	Manik 2	Ch'en		Early Xolalpan
				Manik 1			L. Tlamimilolpa
		Santa Clara	Bijac 1	Cimi	Mol*		E. Tlamimilolpa
TERMINAL PRECLASSIC	Guacalate			Cauac			Miccaotli
		Arenal	Chabij		Yaxkin	But	Tzacualli
							Patlachique
LATE PRECLASSIC	Mascalate	Verbena	Sebito	Chuen	Xul		(Tezoyuca?) / Late Cuanalan

scholars proposed that Teotihuacan became interested in the Maya area, particularly the Pacific Coast and Guatemalan highlands, because of its rich resources, including cacao, obsidian, rubber, jadeite, and quetzal feathers (e.g., Brown 1977a, 1977b; Cheek 1977a, 1977b; Hellmuth 1975, 1978; Michels 1977; Parsons 1967–1969; Sanders 1977; Santley 1983, 1989).[3] These economic perspectives posit a process wherein occasional contacts with visiting merchants, similar to the Aztec *pochteca*, gradually led to a permanent presence of Teotihuacan colonists. Why such an incursion of colonists was favored—or even tolerated—by local elites is rarely addressed. Externalist perspectives, therefore, tend to view the Maya as passive recipients of Teotihuacan "influence" and not as actors engaged in interaction for their own benefit. In some narratives, colonization eventually led to conquest and consolidation as a province within a centralized Teotihuacan "empire" (e.g., Ohi 1994b; Sanders and Price 1968), incorporation in a more loosely organized "empire" (Bernal 1966), or the formation of an independent Teotihuacan-centric state (e.g., Sanders 1977). In a different model, local political independence was seen as necessary for the maintenance of stable economic relations (e.g., Brown 1977a, 1977b).

But commerce was not the only factor considered by externalists as motivating interaction. Stephan Borhegyi (1956) suggested that the spread of central Mexican influence to the Maya region was due to the universal appeal of a new Teotihuacan-sponsored religion focused on gods of natural forces instead of the deified ancestors of rulers. In his original formulation, Borhegyi (1951:171; 1956) implied that the mechanism by which these ideas gradually spread was diffusion, but his later writings (Borhegyi 1965, 1971) heavily favor invasions by small groups of powerful central Mexicans. As Charles Cheek (1977a:160) points out, Borhegyi (1965) at first did not postulate why these invasions took place. In a later article, however, he speculated not only that new economic riches and tribute possibilities must have been a motivating factor, but also that

> a simultaneous and perhaps originally peaceful propagation of a "Teotihuacan faith" combined with a missionizing zeal may well have been the initial vision of one single person, that of a "pacifist New World Alexander," the culture hero Quetzalcoatl, the legendary high priest of the God Tlaloc-Quetzalcoatl-Ehecatl. (Borhegyi 1971:84)

Thus, religious proselytizing may have been an important secondary motive that spurred central Mexican invasions of the Maya region.

In an influential contribution, the great Mexican archaeologist Ignacio Bernal (1966) proposed that Teotihuacan was, indeed, the center of an empire. Nonetheless, he pointed out that an empire need not be monolithic and occupy the territory over which it extends "like a wave covering all" (Bernal 1966:107). Instead, Bernal proposed that the Teotihuacan empire was dispersed, with troops and colonists occupying certain key locations. Intermediate territories were either independent or indirectly governed, but even those areas with resident Teotihuacanos were subject to "very superficial" control.

Bernal, therefore, speculated that although most sites were not occupied, "Teotihuacan established military bases in those regions where the local population, always more numerous, absorbed . . . the elements of Teotihuacan culture" (Bernal 1966:106). Within the Maya area, Bernal (1966:104–105) saw the strongest evidence for these imperial outposts in the Guatemalan highlands and upper Grijalva region (particularly Kaminaljuyu and Mirador, Chiapas; see Chapter 12), and evidence for indirect or occasional "contact" and "encounters" at Copán and other sites in Honduras.[4] Bernal's (1966:106) bridging argument linking the widespread distribution of objects from Teotihuacan with some form of political domination—and hence, empire—is the disputable assertion that Mesoamerican merchants and pilgrims did not stray far from those areas under the control of their home cities.

The pioneering Maya epigrapher Tatiana Proskouriakoff also contributed greatly to externalist models. In a masterly combination of epigraphic and iconographic analyses, she concluded that the death of the Tikal king "Great Paw" (whose name is now read as Chak Tok Ich'aak) on the Maya date 8.17.1.4.12 11 Eb' 15 Mak (January 16, A.D. 378) was related to the arrival of conquering strangers bearing central Mexican weapons (Proskouriakoff 1993:4–10). As we shall see, this argument has recently received significant support (Stuart 2000a). Clemency Coggins (1975, 1979), whose astute analyses of Early Classic tombs at Tikal led to the identification of the individuals buried within them, further postulated that "Curl Nose" (now called Yaax Nu'n Ahyiin), the successor to "Great Paw," was a foreigner from Teotihuacan-dominated Kaminaljuyu. Although she saw aspects of Tikal-Teotihuacan interaction as being mediated by Kaminaljuyu, Coggins suggested that delegations from Teotihuacan visited Tikal. A central Mexican-style vessel from Problematical Deposit 50 may even contain the cremated remains of an emissary or merchant from Teotihuacan (Coggins 1979:263; Green and Moholy-Nagy 1966; see also Chapters 6 and 13).

A good deal of the evidence marshaled by both Proskouriakoff (1993) and Coggins derives from Tikal Stela 31 and Uaxactun Stela 5 (Chapter 8). In

particular, figures on these monuments are dressed as warriors from central Mexico (Figures 8.3b and 8.4a,c). Richard E. W. Adams (1986, 1990, 1999) argued that Teotihuacan advisors or warriors helped a growing Tikal expand at the expense of its neighbors. He wrote that tripod cylinders (a common pottery form in the Gulf Coast region and at Teotihuacan) that appear as mortuary offerings in Tombs 19 and 23 of Río Azul, as well as the unusual stature of two interred individuals, indicate that the dead men were "important nobles from central Mexico" (Adams 1986:439). Adams' externalist interpretation is unique because he also considered the benefit of interaction from the perspective of Tikal. In his view, "[t]he reasons for Tikal's successful transition into the Classic period may have derived in part from an astute alliance, perhaps military as well as commercial, with Teotihuacán" (Adams 1986:434).

Internalist Perspectives

A common criticism of the culture historical approach is the old adage that "pots are not people." Neither are architectural or artistic styles. The art historian George Kubler (1973) provided the first significant volley against externalist models that argued for the colonization of Kaminaljuyu by Teotihuacanos. The presence of *talud-tablero* architecture in the Maya highlands has been interpreted by some scholars as particularly strong evidence for the existence of a Teotihuacan enclave (e.g., Cheek 1977a, 1977b; Sanders 1977). Their argument is not persuasive, but it is true that ceramic vessels are portable—and hence are subject to trade and copying by anyone who comes into contact with them—and architecture is not. Kubler (1973) quite reasonably challenged the notion that *talud-tablero* platforms should be equated with the ethnicity of the people who lived on or were buried within them. Moreover, he noted that the *talud-tablero* architecture of Kaminaljuyu differed in some key respects from that of Teotihuacan itself (see Chapter 4). In any event, we now know that the *talud-tablero* style developed not at Early Classic Teotihuacan, but within the Tlaxcala-Puebla region during the Preclassic period (e.g., Gendrop 1984; Giddens 1995). Given its great antiquity and appearance at Tikal long before any clear sign of interaction with Teotihuacan (Chapter 7), it is hard to know how or from where the *talud-tablero* was introduced to the Maya region.

The most influential scholar who saw the Maya as active manipulators of foreign symbols was the late Linda Schele. An unpublished but widely cited lecture presented at the symposium organized for *The Blood of Kings* exhibit proposed that central Mexican iconographic elements seen in late

Early Classic art were appropriated by Maya elites and transformed for use within the essentially Maya contexts of bloodletting, sacrifice, and astrologically synchronized warfare (Schele 1986). Her argument, therefore, presented a lowland Maya-centric view rather than a Teotihuacan-oriented perspective rooted in the monopolistic control of certain resources. Not only did she invert the traditional notion that interaction is best explained by understanding the motivations of the dynamic "core" (frequently thought to be Teotihuacan) rather than those of the passive "periphery" (to which the Maya had been banished), but she also gave priority to ideology over economy. This argument appealed to many art historians and archaeologists who were not enamored of the notion that political ideology and cosmology should be dismissed as epiphenomenal. But it contradicted notions of techno-environmental infrastructure and economic determinism championed by North American scholars who worked in the Basin of Mexico.

Schele's perspective was developed in *The Forest of Kings* (Schele and Freidel 1990), in which she and David Freidel built upon Peter Mathews' (1985) reevaluation of the 11 Eb' 15 Mak event discussed by Proskouriakoff (1993:4–10). Schele and Freidel argued that Tikal waged a new kind of war against neighboring Uaxactun on that date. The innovation of conquest was symbolized in art through the use of elements — including depictions of a foreign rain god (frequently equated with the Aztec Tlaloc), the Mexican year sign, owls, and the atlatl (spear thrower) — derived from central Mexico. Karl Taube (1992c) studied imagery from the Feathered Serpent Pyramid at Teotihuacan and concluded that the War Serpent of the Maya and a particular headdress are derived from this figure.[5] An important aspect of Teotihuacan-Maya interaction, therefore, was the propagation and transformation of a warrior cult throughout southern Mesoamerica.

Soon other arguments were put forward suggesting why Teotihuacan symbols were appropriated by Maya elite. Andrea Stone (1989), in a perceptive study of Late Classic Piedras Negras, proposed that Maya rulers adopted foreign imagery in order to create social distance from their subjects. This "disconnection of the elite" has many ethnographic parallels. Arthur Demarest and Antonia Foias (1993), in what can be described only as a *tour de force,* argued that interaction with Teotihuacan was stimulated by the need of Maya rulers to procure exotic goods and information from a world much broader than their own domains. The display of such items, participation in cults originating in foreign lands (but perhaps adapted to fit local ideological norms), and use of esoteric symbols all would "tend to enhance power, wealth, and status, by implying contact or even (largely symbolic) political

alliance with foreign realms" (Demarest and Foias 1993:172). Demarest and Foias rejected the notion of a Teotihuacan horizon by reemphasizing the fact that Teotihuacan goods and symbols are not the only ones found at Early Classic sites—a theme of many chapters in this volume—and by noting that the impact of interaction was seen not during a short and intense period, but over many centuries. They proposed instead that interaction should be viewed as complex, shifting, and dominated by no single site or culture. The theoretical perspective offered by Demarest and Foias is particularly sophisticated in that they moved beyond the simple externalist-internalist dichotomy. Although they saw internal factors as stimulating interaction between the Maya and their neighbors, they did not deny that such contacts could be transformative. Nevertheless, Demarest and Foias decisively rejected models relying on invasion, colonization, foreign domination, and the passive role played by the Maya in such processes.

Alternative Perspectives

Stuart (2000a) cautions that we should not adopt an "either-or" model of Teotihuacan-Maya interaction. In particular, he suggests that externalist models may best explain late Early Classic processes—the subject of this volume—while internalist models are best suited to Late Classic developments. In addition to a temporal dimension, a central point of our book is that interaction may have been manifested at different sites in distinct ways. The art historian Janet C. Berlo recognized this years ago. She proposed that central Mexican imagery on censers from Pacific and highland Guatemala pertain to a warrior cult that originated at Teotihuacan (Berlo 1983). To Berlo, the propagation of the cult served the needs of a resident colony of soldiers and merchants. But she conceded that at sites like Tikal, "where Teotihuacanos met sophisticated cultures on an equal footing, Teotihuacan artistic and cultural influence [was] absorbed into already living traditions" (Berlo 1984:215). Thus, we should not propose internalist or externalist models without specifying time and place.

Although I have adopted Stuart's framework in the previous discussion, alternative views—particularly ones that posit important results of interaction with Teotihuacan, yet also argue that the Maya were both conscious actors and the equals of their Teotihuacan counterparts—should also be considered. A critical aspect of Early Classic interaction that is not covered by the externalist-internalist dichotomy is the extent to which Teotihuacan was influenced by the Maya (see Chapter 11). That is, an interaction model of the "peer polity" (Renfrew 1986) sort might explain Early Classic elaboration

in both the Maya area and central Mexico. Moreover, the degree to which other cultures, particularly those of the Gulf Coast and Oaxaca, impacted or were influenced by the Maya has received far too little attention. An accurate depiction of the lattice of Early Classic interaction will emerge only when the fundamental reciprocity of exchange is acknowledged and when the roles of all participants are known.

The Pendulum of Interpretation

The dichotomy of externalist-internalist models also obscures several aspects of thought on interaction between Teotihuacan and the Maya. First, different perspectives have not coalesced through coincident dialogue; rather, they represent a gradual shift in opinion. Externalist narratives were predominant during the years immediately following research at Teotihuacan, Kaminal-juyu, and Tikal. Most of the readers of our book—like its editor—were born after the three momentous projects conducted at Teotihuacan were completed and after the great discoveries of the Tikal Project had been made. Just as some scholars of the 1960s and 1970s saw aspects of investigations conducted twenty years earlier as worthy of criticism, it is fitting that contemporary scholars should reevaluate theoretical constructs that emerged from research conducted forty years ago. The internalist paradigms that began to crystallize in the 1980s reflect a swing in the pendulum of thought, and it may even be that the pendulum has already reached its opposite apogee (e.g., Chapter 12; Stuart 2000a).

Second, the externalist-internalist dichotomy fails to reveal an important fact: the motion of the pendulum, for the most part, reflects a *latent* change in perspective. Relatively few internalists have openly refuted Teotihuacan-influence narratives. As work at Cerros began to be published in the late 1970s, Freidel (1978, 1979) emphasized that kingship coalesced simultaneously throughout the entire Maya lowlands and did not first occur in regions either particularly rich or lacking in specific resources.[6] He did not stress the chronological implication that the emergence of Maya states occurred without the influence of Teotihuacan. That Schele's (1986) presentation is still widely cited suggests that relatively few published works have followed it. The full impact of discoveries at El Mirador and Nakbe—that urbanism and the state may have developed in the El Mirador Basin at a time contemporary with similar developments in Oaxaca—only now are being explored. Although "this effectively demolished the idea that the lowland Maya evolved large, complex societies in response to the rise of the pristine state in Teotihuacan" (Fash and Fash 2000:439), it is an observation that

very few have articulated in print. With the exception of Demarest and Foias (1993), no one has *explicitly* challenged all aspects of Teotihuacan-dominance models. In 1996, when I began to plan this project, I was surprised by how many scholars had shifted to what Stuart now calls internalist positions, yet this important swing of the pendulum seemed to be largely subconscious. The priority of local processes and the realization that the Maya were conscious actors in Early Classic interaction form a metanarrative that permeates current thinking. Nonetheless, this metanarrative does not constitute a unified—or even well-defined—theoretical perspective.

Other than sentimental reasons, alluded to above, what caused the reversal of the pendulum from externalist to internalist positions? To a great degree, it was stimulated by broader developments in archaeological thought.

The Word *Influence* and Culture-Historical Approaches to Interaction

In a study of Postclassic interaction, Michael Smith and Cynthia Heath-Smith (1980) critically examine the Mixteca-Puebla concept. They particularly oppose use of the term *influence* because it is an outmoded notion derived from culture history. To them, the depiction of "waves of influence" emanating outward from a productive, dominant core to a stagnant, passive periphery does not adequately explain the complex nature of Mesoamerican interaction. Externalists of the 1960s and 1970s applied these same diffusionist concepts to Teotihuacan-Maya interaction of the Early Classic period. In retrospect, this seems surprising given the low regard in which many archaeologists of the period held culture history.

Interaction, as Demarest and Foias (1993) argue, is multidirectional and involves more participants than a single core and an inert periphery. The implication is that we should seek to explain interaction from both internal and external perspectives. Our models should include all sites and regions in an interaction network and consider agency-based approaches. Interaction is a two-way street, even when one participant is much more powerful than the other. In such cases, resistance often is an important factor in the dialectic of cultural interaction. Indeed, it may even be that cultural innovation occurs most rapidly in boundary or frontier zones where two or more cultures interact (Lightfoot and Martinez 1995).

Migration as an Explanatory Concept and Notions of Ethnicity

Several of the strongest Teotihuacan-centric models posit the existence of enclaves or colonies at certain Maya sites (e.g., Cheek 1977a, 1977b; Michels

1977; Sanders 1977; Santley 1983). The presence at these sites of central Mexican artifacts and locally produced goods with forms or motifs borrowed from Teotihuacan, therefore, was interpreted by some scholars as the result of migration rather than exchange. Migration studies are now reappearing in the forefront of North American archaeological research after a long absence (e.g., Anthony 1990, 1997; Cameron 1995; Snow 1995, 1996). As one leading scholar of this renaissance notes: "Migration was once a lazy person's explanation for culture change, used by archaeologists who could not or chose not to deploy more demanding models and theories" (Anthony 2000:554). The reason that migration was rejected as an explanatory paradigm by most New Archaeologists is that its theoretical foundations, inherited from culture history, were seen to be inadequate (Adams 1968; Adams et al. 1978).

That colonialist Teotihuacan narratives of the 1960s through early 1980s were put forward by members of the Basin of Mexico and Valley of Guatemala teams—all New Archaeologists—is particularly strange. These scholars struggled to force the culture-historical concept of "site-unit intrusion" into an explanatory, processual model. They were only partially successful in creating bridging arguments linking the presence of imported artifacts or copies to physical migration. For example, the *talud-tablero* was interpreted as the strongest evidence for colonization by a superior Teotihuacan force, in part because it was assumed that the Maya would not build such structures unless coerced (Cheek 1977a, 1977b).

Joseph W. Ball (1983) has sought a more rigorous way to distinguish between the archaeological correlates of migration and diffusion. His chapter in *Highland-Lowland Interaction in Mesoamerica: Interdisciplinary Approaches* (Miller 1983), the last major collection devoted to Maya-Teotihuacan interaction, is still current. His discussion ties ceramic "identities" (imported pottery) and "homologies" (locally produced copies of foreign pottery) to distinct interaction processes. Ball argues effectively that homologies indicate strong interaction, including the possibility of migration, between two regions. Unfortunately, for reasons explained by Stone (1989) and Demarest and Foias (1993), homologies may also be items commissioned by imitative native elites. Thus their presence does not necessarily demonstrate the arrival of foreign settlers. Nevertheless, Ball's perceptive discussion is valuable, and aspects of his bridging arguments are adopted by authors in this volume.

What sort of contextual evidence for either homologies or identities would support an actual migration by a population segment from Teotihuacan?

That is, how may scholars identify central Mexican ethnicity in the archaeological record? Ethnicity, like other forms of identity, is constructed, negotiated, fluid, and situational. It is similar in some respects to Ian Hodder's (1990) notion of style. Ethnicity may or may not have biological aspects. Mortuary customs often are assumed to be one of the most conservative realms of human behavior, but John M. O'Shea (1981) and others have documented that they can be highly variable. Moreover, it should be expected that the burials of elites—who participate in much broader nets of social interaction than commoners—will exhibit a particularly wide range of variability. That is, local elites may emulate the burial practices of their foreign counterparts. In addition, interpretation is complicated by the fact that when a population segment has migrated, its burial patterns are subject to change. "Cemeteries are cultural texts produced by the living for the dead as the living. Matters of social concern are communicated here, so in a changing world they will also be a locus of change" (Burmeister 2000:560).

One archaeological approach to identifying ethnicity (and hence, cases of migration) is based on in-group versus between-group displays of identity. Stefan Burmeister (2000) argues that the internal domain (aspects of the behavior of a migrating group that are generally hidden from members of the host society) is more likely to reflect ethnicity than the public or external domain. Heinrich Härke (2000) sees this suggestion as new, but it has been applied to questions of ethnicity and Teotihuacan enclaves for many years. Michael W. Spence (1992, 1996b) had the distinction of private and public domains of social behavior in mind when he excavated the Oaxaca Barrio at Teotihuacan. The local production of highly conservative, Oaxaca-style utilitarian ceramics and urns, as well as the presence of a jamb containing Zapotec hieroglyphs in the entrance to a tomb—items that normally would not be seen by ethnic Teotihuacanos—in a group that outwardly resembled a typical Teotihuacan apartment compound were factors that led to the identification of the enclave during the early 1960s. Similarly, because local-style utilitarian pottery continued to be produced and used at Kaminaljuyu throughout the Classic period, Alfred V. Kidder et al. (1946) proposed that the "warlike adventurers" from Teotihuacan who established themselves at Kaminaljuyu must have married native women. Kidder et al. (1946), therefore, based their argument on the observation that certain items pertaining to the internal domain of Kaminaljuyu households did *not* change with the arrival of foreigners. Sanders (1977) adopted this position and pointed to the lack of objects related to Teotihuacan ritual at Kaminaljuyu as evidence for marriage with local women. This is an interesting argument, but the lack of

expression of Teotihuacan ethnicity in the internal domain can also be explained by the absence from Kaminaljuyu of both Teotihuacan women *and* men (Chapter 4).

Although models that consider migration as a process with particular archaeological correlates are being developed, they represent a recent reversal of a long-standing bias. It is not surprising, therefore, that Teotihuacan-centric models proposing the existence of far-flung colonies were viewed with skepticism in the 1980s. Moreover, colonialist models adopted a rather old-fashioned and apparently biologically rooted notion of ethnicity. For example, the effects of separation from the homeland on the identity of colonists was not addressed. Migration often *entails* a change in identity. Elite Teotihuacan-born men who married local women, stopped practicing Teotihuacan household rituals, and raised children of mixed heritage surely would have been deeply transformed by the process of migration. It is not at all clear that their children and grandchildren would have considered themselves to be Teotihuacanos, and if they did, that their identity would have resembled that expressed in the ancestral highland city. Above all, then, colonialist models proposed for Teotihuacan-Maya interaction failed to consider migration as a *process* with latent results and long-term effects.

The Primacy of Data over Theory

In a characteristically humorous manner, George L. Cowgill (1999a) discusses what he calls "Godzilla theory"—theory that lets no data stand in its way—and the issue of Teotihuacan-Maya interaction. As a student in the mid-1980s, I once heard him describe a particular application of a statistical test to poor data as an example of "trying to pull a plough with a Mercedes." His point was that it was not only overkill—like Godzilla theory—but also an inappropriate tool that would fail to get the work done. Such overly elaborate theoretical constructs have often been applied to data regarding Early Classic interaction between the Maya and Teotihuacan. They tend to tip the balance of data and theory rather heavily in the latter direction. Moreover, some narratives are far too speculative and particularistic to have general explanatory value. Thus, I call them "narratives" and "scenarios" rather than "hypotheses."

Maya archaeology of the 1960s and 1970s has been chided for remaining data-driven and for being a bit parochial and isolationist (see Marcus 1983a). In contrast, Anglophone central Mexican scholarship of the same period often consisted of much theorization supported by few data. There are, of course, exceptions, and work in the Valley of Oaxaca provides a bril-

liant counterexample (e.g., Flannery and Marcus 1983). Nevertheless, during the 1970s the dialectic between data and theory that is central to scientific research stalled in some corners of Mesoamerican archaeology. New data were used to illustrate strongly held beliefs, but seldom led to the revision of theoretical perspectives. All students of Mesoamerican archaeology will recognize the feeling "I knew what Professor Fulano was going to say even before I read his latest article." As central Mexican–centric positions regarding Teotihuacan-Maya interaction crystallized, they ceased to develop in any meaningful way. Internalist perspectives emerged, in part, as a dynamic reaction against the stasis of externalism.

Over the course of the past thirty years, Mayanists have continued to study Early Classic interaction. Many (particularly since the dramatic epigraphic revolution began to expand and enlarge our field in the 1980s) have become "theory producers." Exciting research conducted during this time has led to the accumulation of a great deal of data. Several of the contributors to our volume adopt positions that give primacy to these new data over old theories. No author proposes or advocates a universal model for understanding the causes and effects of ancient interaction. Our approach, therefore, may seem both particularistic and atheoretical. But given the faults of "Godzilla theory," we have chosen to postpone "high-level" theoretical discussion until the significance of our new data is more clearly understood. Only by setting the horse before the cart can we begin again to develop new models of Teotihuacan-Maya interaction.

Contributions to This Volume

Our volume grew out of a session held in Chicago at the Sixty-fourth Annual Meeting of the Society for American Archaeology in March 1999. All contributions save one (Stuart 1999) appear here in expanded form. Chapter 6 was prepared especially for the volume.

The chapters that constitute our book are arranged in two general ways. First, the treatment is geographical. Chapters 2 through 5 focus on the Pacific Coast and the Maya highlands, together forming what is often called the Southern Maya Area. Chapters 6 through 8 discuss Tikal in the central Maya lowlands, and Chapter 9 considers Altun Ha in the lowlands of Belize. Chapter 10 takes us farther afield to Oxkintok, an important site in the northern Maya lowlands with a substantial Early Classic occupation. This generally south-to-north progression mirrors the second organizational aspect of the volume. Sites and regions where evidence for interregional interaction are strongest are considered first, and sites where the effects of that inter-

action are less evident are discussed last. Thus, we propose that strong interaction models are appropriate for central Escuintla; weaker ones should be applied to Kaminaljuyu, Copán, and Tikal; and the weakest of all should be considered for Altun Ha and Oxkintok. Chapter 11 reverses the question of Teotihuacan-Maya interaction by focusing on Teotihuacan. The last two chapters are broader in nature and develop contrasting historical and theoretical perspectives on Early Classic interaction.

Figure 1.2 presents ceramic chronologies for the sites discussed in the text. The intention is to provide a comparative tool to be used by readers of the volume. Unfortunately, the construction of the table entailed many decisions that have broader ramifications. In some cases, I had to choose between multiple chronologies for the same site. This was particularly true for Kaminaljuyu and Teotihuacan, but Copán and Oxkintok also have alternate (or even revisionist) ceramic chronologies. For the most part, I have chosen chronologies that the individual authors of this volume either have proposed or advocate. The ceramic phases and dates presented for Copán incorporate both the best published schema and the unpublished results of a decade of chronological refinement. A small injustice is done to the Teotihuacan chronology proposed by Cowgill (1996, 1997). He cogently suggests that dividing lines of the conventional sort emphasize the least-secure aspects of ceramic chronology: the transitions between one phase and the next. Such transitions may be vague, and phases that overlap may still be useful (Cowgill 1996). Nonetheless, the ceramic phases of Teotihuacan have "fine-scale" resolution compared to those of many Maya sites. Given both the size of Figure 1.2 and the less precise nature of the other ceramic chronologies, the use of horizontal phase-division lines for Teotihuacan seems only a minor misrepresentation.

In Chapter 2, Frederick J. Bove and Sonia Medrano Busto discuss the important and exciting results of two major projects conducted in Escuintla, Guatemala. Data suggesting interaction with central Mexico and the Gulf Coast are particularly strong for this portion of Pacific Guatemala. The authors have constructed what I believe is the best evidentiary argument for a long-term process of economic interaction leading to colonization ever put forward for southeastern Mesoamerica. An important aspect of their argument is that interaction began during the Terminal Preclassic–Early Classic transition, by A.D. 200 to 250 if not somewhat earlier. A "pulse" of interaction this early has been noted before only at Altun Ha (Chapter 9). Bove and Medrano's dramatic evidence from Balberta—consisting of cached vessels with effigy cacao beans and related finds of central Mexican Thin Orange ware and green obsidian from Pachuca, Hidalgo (the principal source of

prismatic blades used at Early Classic Teotihuacan)—may suggest the commemoration of a trade agreement. Their data also reveal links to the Gulf Coast region of Veracruz. Gulf Coast fine-paste ceramics and obsidian from Zaragoza, Puebla (the principal source used in the Gulf Coast region during the Classic period), were identified. Connections between the Maya area and Veracruz are often overlooked, but are particularly important at Kaminaljuyu, Tikal, and sites in the northern Maya lowlands.

At a somewhat later time, the nature of interaction changed in ways that suggest the establishment of a central Mexican enclave. A new site, Montana, replaced Balberta as the regional capital at about A.D. 400. At that time, Teotihuacan-style drinking cups, imitations of Thin Orange ware, "Tlaloc" tripod supports, *candeleros*, warrior "portrait" figurines, and even an elaborate censer were used at the site. These data are important for three reasons. First, all the objects are locally produced homologies and tend to support a strong interaction model. Second, specific artifact classes found at the site are associated with rituals that reflect the state-sponsored ideology of Teotihuacan. Third, the artifacts were found overwhelmingly in domestic contexts rather than in dedicatory caches indicative of public activities. That is, they represent behavior associated with the internal or private domain of the household. Together, the artifacts and their contexts strongly argue for migration, colonization, and the concomitant transformation of the religious, domestic, and economic fabric of central Escuintla. Nevertheless, neither central Mexican–style architecture nor evidence of Teotihuacan site planning were discovered, perhaps because these would have impinged too much upon the public or external realm. This suggests to me that the immigrants may not have completely dominated and overwhelmed their host community. Again, I note that many artifacts also point to the Gulf Coast, and it may be that central Mexican immigrants at Montana arrived via the process of "leapfrogging" (Lee 1966) through southern Veracruz. That is, the proximal source of central Mexican cultural traits in central Escuintla may have been an established colony in the Gulf Coast region.

The next two chapters, by the editor, focus on Kaminaljuyu, the highland Maya site where evidence for interaction between the Maya and Teotihuacan was first discovered. In Chapter 3, I summarize the contextual information related to central Mexican–style ceramics and architecture at the site, and note that the last three decades of intensive and extensive investigations have failed to uncover additional signs of interaction with Teotihuacan. I also emphasize chronometric data related to the finds, and stress that the temporal placement of the Esperanza ceramic complex and *talud-tablero*

architecture is not especially clear. The implication is that we cannot yet determine if Teotihuacan-Kaminaljuyu interaction occurred before, during, or after similar processes expressed at Tikal and Copán. It may be, as Coggins (1979) suggests, that Kaminaljuyu was responsible for mediating contact with Tikal. Alternatively, Tikal or some site in Veracruz may have served as an intermediary between central Mexico and the Maya highlands.[7] Temporal differences in the patterns of appearance of central Mexican–style artifacts and *talud-tablero* architecture are also discussed for the three sites. At Kaminaljuyu, both central Mexican ceramic imports and copies appeared before *talud-tablero* architecture. The opposite pattern has been noted at Tikal. At Copán, however, central Mexican–style architecture and ceramics co-occur. The reasons for these disparate patterns of adoption are not known, but they may indicate either very different interactive processes or the essential randomness of cultural emulation.

In Chapter 4, I examine various scenarios that have been proposed to explain the presence of central Mexican identities and homologies in the elite burials of Esperanza-phase Kaminaljuyu, as well as the use of *talud-tablero* architecture in mortuary structures and platforms that may have supported residences. In particular, I question narratives that posit colonization and conquest of the site. My approach is to consider the data for interaction with Teotihuacan (as well as with other central Mexican groups and Gulf Coast cultures) on differing levels of scale. In general, evidence of interaction is seen most strongly at intermediate scales and is much less evident at either micro or macro scales. For example, isotopic analyses of tooth enamel fail to point to a Teotihuacan origin for the individuals buried in Mounds A and B, and no aspects of site or group planning reflect central Mexican norms. That evidence for interaction is most clear at intermediate scales suggests that central Mexican elements were combined in ways and in contexts that are decidedly non-Teotihuacan in both overall plan and inner detail. This is inconsistent with the existence of an enclave. Emulation of foreign cultural traits for reasons of status reinforcement provides a partial answer for the presence of Teotihuacan-style artifacts, but it does not adequately explain why portable objects of central Mexican affinity are found in tombs rather than in contexts suggesting more frequent public manipulation. Instead, the semantic domain of foreign-style artifacts at Kaminaljuyu seems to imply participation in an elite warfare cult of foreign origin. Interaction had little or no impact on the internal domestic realm of both native rulers and commoners, and for unknown reasons was expressed most elaborately in elite mortuary rituals.

Robert J. Sharer, in Chapter 5, presents important new archaeological and epigraphic data regarding K'inich Yaax K'uk' Mo', the founder of the Copán dynasty. Images of the Founder dating to the Late Classic (i.e., several centuries after his death) depict him wearing a costume containing elements borrowed from Teotihuacan that pertain to warfare. Structures built during the fifth century A.D., including a single example with a *talud* and *tablero*, reveal familiarity with architectural styles from central Mexico, the Maya highlands, and the central Maya lowlands. Tombs thought to be those of K'inich Yaax K'uk' Mo' and his wife contain pottery imported from these areas as well as locally produced copies of foreign ceramics. Early hieroglyphic texts imply that the Founder was not a local, but "arrived" at Copán. Isotopic analyses of what are thought to be his remains support a foreign origin, but point away from Teotihuacan and toward the Petén. K'inich Yaax K'uk' Mo', then, was a successful warrior from the Maya lowlands who skillfully employed Teotihuacan imagery in an attempt to solidify his position in the new royal center he built at Copán. His son, in contrast, chose to de-emphasize the Founder's real or claimed central Mexican connections, and instead highlighted ties to the central Maya lowlands.

David Stuart's (1999) paper presented at our symposium (as well as a longer version published in a different volume [Stuart 2000a]) is particularly relevant to Chapter 5 and the three that follow it. Because it is so widely cited throughout our volume, a brief summary here is appropriate. In a brilliant series of decipherments and inferences, Stuart reexamines the "war" between Tikal and Uaxactun postulated by Mathews (1985) and described by Schele and Freidel (1990). He concludes that Proskouriakoff's (1993:4–10) initial interpretation of the events surrounding 8.17.1.4.12 11 Eb' 15 Mak is in close agreement with the epigraphic record. His externalist argument focuses on four individuals: Chak Tok Ich'aak, Siyaj K'ahk' ("Smoking Frog"), Yaax Nu'n Ahyiin, and an enigmatic figure nicknamed "Spear-Thrower Owl."

According to Stuart's reconstruction, "Spear-Thrower Owl," a foreigner whose name glyph closely resembles the common Teotihuacan "heraldic" emblem called the *lechuza y armas* (von Winning 1987), was inaugurated as a ruler of an unidentified but named place in A.D. 374. Less than four years later and a week after passing through the site of El Perú, Siyaj K'ahk' "arrived" in the Tikal-Uaxactun area on the pivotal day 11 Eb' 15 Mak. The reigning ruler of Tikal, Chak Tok Ich'aak, died on that day, perhaps in a battle with Siyaj K'ahk' (Proskouriakoff 1993:8). It should be stressed, however, that no mention of a battle or description of the king's demise has been found in the texts. Less than a year later, the young son of "Spear-Thrower

Owl" was inaugurated as king of Tikal in an event that somehow was over-
seen by Siyaj K'ahk'. The death of "Spear-Thrower Owl" is mentioned as
occurring in A.D. 439, during the reign of his grandson Siyaj Chan K'awiil at
Tikal. It also is important that at distant Copán, an individual named Siyaj
K'ahk' is associated with K'inich Yaax K'uk' Mo' in a text that may dedicate
the tomb of the Copán Founder (Chapter 5).

Stuart speculates that the *lechuza y armas* (owl and weapons) emblem so
common at Teotihuacan is the name of a great king of that city whose long
reign corresponds with most of the Early Xolalpan phase. If he is correct,
it is the first time that the name of an individual ruler has been identified
at Teotihuacan. The implication, therefore, is that Siyaj K'ahk' was a war
chief (perhaps Maya, perhaps not) who came from the "west," conquered
Tikal in A.D. 378, and imposed a Teotihuacan-centric rule by installing the
boy-king Yaax Nu'n Ahyiin. Nonetheless, contextual evidence at Teotihua-
can for the *lechuza y armas* emblem does not suggest that it is a name — at
least at that site (von Winning 1987, 1:90). Thus the degree to which "Spear-
Thrower Owl" is reified by the texts of Tikal remains unclear. He may have
been the biological father of Yaax Nu'n Ahyiin, as the texts indicate, or he
may have been an abstraction to which fatherhood was ascribed in order to
strengthen a new king's claim to leadership. Moreover, as Borowicz (Chap-
ter 8) points out, at least two cases cited as examples of the "Spear-Thrower
Owl" name at Tikal contain neither an owl nor an atlatl, and are derived
from a completely different Teotihuacan emblem (see also Paulinyi 2001:4).

Schele and Freidel (1990:156–157, 449–450) argued that "Spear-Thrower
Owl" is a central Mexican–derived war title. Both the "Spear-Thrower
Owl" compound and Siyaj K'ahk's name appear together with the *kalo'mte'*
title. Given that Yaax Nu'n Ahyiin was not of the established royal line, it
may have been necessary to create an illustrious past — by retroactively and
opaquely assigning the high title *kalo'mte'* to his father, a war captain of
Tikal — in order to justify his own right to rule. Thus, it is conceivable that
"Spear-Thrower Owl" (along with *ochk'in k'awiil* and *kalo'mte'*) was one of
the titles held by Siyaj K'ahk'. It is also possible that both Siyaj K'ahk' and
"Spear-Thrower Owl" were alternative names or portions of the full name
of the same individual. That Yaax Nu'n Ahyiin's son bore the name Siyaj is
consistent with the conjecture that Siyaj K'ahk' was his grandfather.

Nevertheless, it is much more likely that "Spear-Thrower Owl" and Siyaj
K'ahk' were distinct individuals and *kalo'mte'ob* of different sites, as Stuart
argues. According to his interpretation, the site from which Siyaj K'ahk'
came is not named. Stuart's (2000a:478) cautious reading of glyphs A7–

B8 of the Tikal marker can be summarized as: HUL-ye SIYAJ-K'AHK' KAL-ma-TE', or "he arrived, Siyaj K'ahk' [the] *kalo'mte'*." An important question is how the next and last two glyphs in these columns fit with the previous phrase. One reading of glyphs A9–B9 is: AJ-yo'-OTOOT'-NAL' MUT-CHAN-na-CH'E'N, which may be glossed as: "[he-]of-[the]-house Mut[u'l's]-upper cave/temple" (Marc Zender, personal communication 2001). Stuart (2000a) argues that the toponym at B9 is the object of the sentence, and hence the place of Siyaj K'ahk's arrival: Tikal. Alternatively, and more grammatically consistent, it may be that the place of "arrival" is not explicitly named. That is, the sentence may not have an object. If this is the case, B8–B9 form a title, and the entire phrase should be read: "he arrived, Siyaj K'ahk' [the] *kalo'mte'* of-[the]-house Mut-Chan-Ch'e'n." A similar but poorly preserved passage on Uaxactun Stela 5 might be glossed: "he arrived, Siyaj K'ahk' [of] Mutu'l's-'-'." In other words, Siyaj K'ahk' may be a lord *of* Mutu'l (Tikal), and not a "stranger" from a distant land. This reading supports Juan Pedro Laporte and Vilma Fialko's (1990) proposition that Siyaj K'ahk' was a lord from a Tikal lineage or great house rivaling that of Chak Tok Ich'aak. In this light, "arrival" may not mean the first appearance of a stranger, but may entail the *return* of Siyaj K'ahk' from a journey to a foreign place. We also cannot rule out the possibility that such a pilgrimage was spiritual rather than corporeal. Finally, "arrival" may have a more metaphorical meaning. In any of these alternative interpretations, the events of A.D. 378–379 signal the ascendancy of one *local* dynastic line over another.

A different passage in the Tikal marker discusses the accession of "Spear-Thrower Owl" (Stuart 2000a:483) on 8.16.17.9.0 11 Ajaw 3 Wayeb (glyphs E1–E5). It refers to him as a *kalo'mte'* and the fourth king of a place that possibly should be read as Ho' Noh Witz (Marc Zender, personal communication 2001). If the place/polity where "Spear-Thrower Owl" ruled was called a "place of reeds," an argument might be made that it was Teotihuacan. But even so, Ho' Noh Witz could equally be Kaminaljuyu (consistent with Coggins' [1979] position) or some other Maya site closer to Tikal. At present, it seems safest to consider Ho' Noh Witz as just another toponym/polity name that we have yet to identify archaeologically.[8] Alternatively, if "Spear-Thrower Owl" was more invented than real, Ho' Noh Witz might be an imaginary location.

An intriguing—and to me the most likely—scenario is raised by Peter D. Harrison (1999), who argues that *kalo'mte'* and *ajaw* were titles originally held by distinct individuals. He concludes that Siyaj K'ahk' became *kalo'mte'* of Tikal in A.D. 378, and that Yaax Nu'n Ahyiin became *ajaw* of the polity

in A.D. 379. After the death of Siyaj K'ahk' Yaax Nu'n Ahyiin received the more exalted title of *kalo'mte'*. Siyaj Chan K'awiil, in his turn, became *ajaw* in A.D. 411, while his living father was still *kalo'mte'*. Thus, rulership at Tikal may have been divided between two hierarchically ranked individuals, with the highest title passing to the *ajaw* after the death of the *kalo'mte'*. Such systems of divided rulership are known from the Maya highlands (e.g., Braswell 2001b). I suggest that Chak Tok Ich'aak died a natural death without an heir apparent at Tikal. The nearest kinsman able to inherit the title of *ajaw* of Tikal was Yaax Nu'n Ahyiin, the child of a close female relative of Chak Tok Ich'aak (Martin and Grube 2000). I speculate that this woman was sent years before to Ho' Noh Witz, a Maya site of less importance than Tikal, to marry "Spear-Thrower Owl." We know that royal Maya women often "married down" in this fashion (Marcus 1992b). Siyaj K'ahk', who probably came from Tikal and may have been another kinsman of the deceased ruler, was immediately given the title of *kalo'mte'* and served as both regent and "protector of the realm" well into Yaax Nu'n Ahyiin's adulthood.[9] This may have been necessary in order to guard the affairs of Tikal from interference by "Spear-Thrower Owl" and other relatives of Yaax Nu'n Ahyiin from Ho' Noh Witz. Upon Siyaj K'ahk's death, Yaax Nu'n Ahyiin adopted the title of *kalo'mte'*, which came to have real meaning and power because of its previous holder. In order to ensure that the accession of Siyaj Chan K'awiil occurred without incident, Yaax Nu'n Ahyiin installed his son as *ajaw* in A.D. 411, nine years before his own death.[10] In this scenario, "Spear-Thrower Owl," a less exalted ruler of a relatively minor Maya site, may have been called *kalo'mte'* by his son's propagandists in order to legitimate the weakest link in Yaax Nu'n Ahyiin's heritage. An example of this kind of equivocation is found at Pusilha. There, a Late Classic king who inherited his position from his mother assigned the *kalo'mte'* title to his less-than-illustrious paternal grandfather. The latter came from a minor Maya center, which, like Ho' Noh Witz, has not yet been identified as an archaeological site (Christian Prager, personal communication 2001).

In sum, Stuart's (2000a) interpretation of these difficult inscriptions is compelling, but alternative scenarios are consistent with the texts as we now understand them. Specifically, there is no epigraphic evidence that "Spear-Thrower Owl" was a ruler of Teotihuacan or that Siyaj K'ahk' came from anywhere other than Tikal. Like all significant and exciting research, Stuart's (2000a) discoveries answer some questions but raise even more. Was Yaax Nu'n Ahyiin foreign born or from Tikal? Does the appearance of Teotihuacan "influence" at Tikal during his reign have anything to do with the cir-

cumstances of his accession? If Teotihuacan actually did impose a foreign ruler (or even a locally born puppet) on Tikal in A.D. 379, what were the long-term effects of Teotihuacan-centric rule? Burial 10 has been identified as the interment of Yaax Nu'n Ahyiin, and oxygen isotope assay of his teeth will soon let us know if he was locally born and raised, was born and grew up in the highlands of Mexico, or spent time in both regions (Lori E. Wright, personal communication 2000). Unfortunately, such analysis may not resolve the question of the power behind the throne. Even if oxygen isotope assay supports a local origin for Yaax Nu'n Ahyiin, it still may be that he was a pawn imposed upon Tikal by some outside power. Chapters 6 through 8 examine the more complicated question of the impact of Teotihuacan on Tikal—whatever the origin of Yaax Nu'n Ahyiin is found to be.[11]

In Chapter 6, María Josefa Iglesias Ponce de León focuses on the economic ramifications of Teotihuacan-Tikal interaction through the study of central Mexican identities and homologies recovered from two kinds of contexts: burials and "problematical deposits." The latter are enormous concentrations of virtually every sort of artifact known from Tikal. They incorporate domestic refuse from elite households, human burials, ceramic offerings, jade, shell ornaments, and carved monuments. Because they contain a bit (or even a lot) of everything from garbage to precious stones, their interpretation is difficult. Many of the most spectacular of these enigmatic features date to the Manik 3A phase, which is thought to have begun with the installation of Yaax Nu'n Ahyiin. They contain some of the best contextual evidence for evaluating relations with central Mexico.

Iglesias concludes that the economic impact of Teotihuacan on Tikal has been profoundly overstated. Compared to the great quantity of locally produced objects, the number of imports from central Mexico is minimal. Moreover, the problematical deposits, which derive in part from domestic refuse, show that Teotihuacan had limited or no effect on the internal domain of elite households. A very small number of miniature vessels that resemble *candeleros* have been found, as well as two figurine heads that are somewhat similar to examples from Teotihuacan. But evidence that the state-sponsored religion of Teotihuacan was practiced at Tikal is negligible. Moreover, the appearance of identities and homologies is limited to a very short period of time. By the end of the fifth century A.D., trade with central Mexico had all but ceased and local copies were no longer produced in significant numbers. Iglesias does not rule out the possibility that, in A.D. 379, a foreign king was imposed on Tikal in the manner that Stuart (2000a) describes. But she does not see such a takeover as having a significant effect on local culture. She

notes that many kings (and even more queens) of Spain were foreigners. Foreign royalty were quickly *absorbed* into the cultural fabric of the country they ruled. The original identity of a king, therefore, is much less important than the ethnicity forced upon him.

In Chapter 7, Juan Pedro Laporte looks at architectural evidence from Tikal for interaction with central Mexico. He notes that the oldest examples of structures containing *tableros* date to the Terminal Preclassic Manik 1 phase, or the third century A.D. This is considerably earlier than a time when ceramics produced in Teotihuacan were brought to Tikal. During the next several centuries, specific elements of the *talud-tablero* form were used at Tikal in ways that suggest the development of a local style. Given that *talud-tablero* architecture was widespread before any clear evidence for connections with Teotihuacan, Laporte argues that it is a Mesoamerican form that developed in many areas and that its propagation should not be attributed to any single site. Instead, he sees *talud-tablero* architecture as evidence for the cosmopolitan nature of Tikal, a city that by A.D. 250 was already participating in a far-flung lattice of interaction.

The second half of his chapter turns to Group 6C-XVI, a complex of structures (some in *talud-tablero* style) built during the third through sixth centuries. Laporte argues that, contrary to one interpretation, it is not a local version of the Teotihuacan apartment compound. He stresses, in fact, that there is little reason to suspect that Group 6C-XVI was a residential group. Instead, he suggests that it served a function related to the ballgame. One object recovered during excavations is the so-called Tikal marker, which closely resembles examples from Kaminaljuyu and the La Ventilla A compound of Teotihuacan. The last is stylistically linked to the Gulf Coast. Laporte argues that we should interpret these sculptures as indicating complex and multidirectional interaction, rather than the overpowering "influence" of one site on another. He ends by returning to Teotihuacan in order to look for evidence of interaction with the Maya region, and notes that the Ciudadela is built according to the "E-group" plan developed in the central Maya lowlands during the Preclassic period. This argument recently has been accepted and discussed by two scholars of Teotihuacan archaeology. Important corollaries of Laporte's position are that interaction between central Mexico and Tikal began long before (and continued long after) the events of A.D. 378, and that we should not underestimate the effects of the Maya on the development of Teotihuacan.

In Chapter 8, James Borowicz examines the iconographic content and style of Early Classic stelae at Tikal. He argues that shifts in royal icono-

graphic programs reflect important changes in the nature of rulership. He notes that until the reign of Yaax Nu'n Ahyiin, Early Classic rulers were depicted in ceremonial, ritual, and military contexts that strongly echo earlier Preclassic traditions from the Pacific Coast of Guatemala, Kaminaljuyu, and even Monte Albán. Yaax Nu'n Ahyiin, in contrast, was shown as a Teotihuacan-style warrior. Borowicz suggests that by emphasizing both his martial attributes and powerful foreign connections, the king and founder of a new dynastic line was able to justify his rule and create social distance from potential rivals of the old order. Following Laporte and Fialko (1990), he speculates further that Yaax Nu'n Ahyiin and his supporters were rivals of the previous dynasty, and that they manipulated both the ballgame and associated Teotihuacan military symbols in a quest for power. Borowicz, then, implies that the events of A.D. 378–379 represent an internal struggle—perhaps aided by foreign allies or perhaps not—rather than the imposition of a ruler from distant Teotihuacan. His position is consistent with the facts that Chak Tok Ich'aak (the last ruler of the *ancien régime*) was accorded full burial honors and that Tikal does not seem to have suffered the physical indignities of a military defeat.[12]

Borowicz next turns to the reign of Siyaj Chan K'awiil, the son of Yaax Nu'n Ahyiin. Instead of continuing his father's iconographic program, Siyaj Chan K'awiil consciously returned to the program of earlier Tikal rulers. The portraits on the sides of Stela 31, which are famous for their Teotihuacan costumes, are rendered in Maya proportions and in a Maya style (Figure 8.4a,c). The front of Stela 31, Borowicz argues, is dominated by clear references to earlier rulers and their monuments, and only two small motifs that derive from Teotihuacan are shown. It seems, then, that Siyaj Chan K'awiil used foreign imagery only to identify his father, but very deliberately chose to associate himself with older Maya traditions.

This program was continued by the next ruler, K'an Ak, who commissioned the recently discovered Stela 40. This spectacular monument (Figure 8.5) is a clear imitation of Stela 31, but the side portraits are replaced by images of Siyaj Chan K'awiil dressed as a Maya king. At a later point in his reign, K'an Ak developed a third iconographic program that, although wholly Maya, portrayed the ruler engaged in rituals associated with calendrical cycles. This change in iconographic content from the ruler-as-warrior to the king-as-priest seems to suggest a transformation in the nature of rulership at Tikal.

In Chapter 9, David Pendergast focuses on the beginning of the Early Classic period at Altun Ha, Belize. He discusses an interment offering con-

sisting of Teotihuacanoid (but not from Teotihuacan) vessels and a large number of green obsidian artifacts from the Pachuca source. In many respects, the spectacular offering resembles a Miccaotli/Early Tlamimilolpa cache that (except for the ceramics) would not stick out as odd at Teotihuacan itself. Isotopic assay, however, reveals that the deceased was not from Teotihuacan and probably was of local origin. Pendergast reanalyzes the contextual implications of the cache and concludes—for some of the same reasons put forward by Ball (1983) in his discussion of ceramic identities and their lowland contexts—that it represents ties between Teotihuacanos and the individual buried in the tomb, and is not a reflection of community-to-community relations. Pendergast next asks what the impact of these early relations with Teotihuacan were on the development of Altun Ha, and he argues that since there is no evidence for later interaction, the cache is best interpreted as a single event with no long-term consequences.

In Chapter 10, Carmen Varela Torrecilla and I discuss developmental processes in the northern Maya lowlands. Our contribution focuses on Oxkintok, one of the few Puuc sites with a substantial Early Classic occupation. We view the sixth and early seventh centuries, a period of great cultural elaboration at Oxkintok, as a time of extensive interaction and innovation. Proto-Puuc architecture of the sixth century utilizes the *tablero* form, and the ceramic complex of the Oxkintok Regional phase contains tripod cylinders, but these forms are adapted and transformed in innovative ways. *Tableros* are combined with Maya apron moldings, and pottery vessels contain an iconographic program quite different from that of Teotihuacan. Although we see interaction with Teotihuacan and the Gulf Coast as important, we emphasize that stronger economic ties were forged with the Maya highlands and central lowlands. We interpret interaction with all these regions not in terms of hegemony or dominance, but as an indication of the emergence of political complexity in the Puuc zone. As power became more centralized, the elite of Oxkintok sought wider interaction networks so that they could obtain more prestige items. Varela and I, therefore, consider participation in pan-Mesoamerican networks as linked to the emergence of states in the northern lowlands. We do not consider the Puuc region to be unique in this regard, and we suspect that many of the great polities of the Late Classic developed in similar social and economic contexts.

Karl A. Taube takes an entirely different perspective in Chapter 11 and looks at evidence for Teotihuacan-Maya interaction found in the great highland city. He focuses on the mural iconography and ceramic artifacts of Tetitla, an important apartment compound located 600 m west of the Street

of the Dead. The Tetitla murals not only depict Maya supernaturals such as the Bearded Dragon (who sometimes appears as the Vision Serpent), the Pawahtun (an old creator god often shown in a shell), and the Tonsured Maize God, but also contain phonetic Mayan texts. In addition, the eclectic murals also show influence from other areas, particularly the Gulf Coast. Moreover, censers, plano-relief vessels, and other ceramic forms from Tetitla contain iconographic elements borrowed from Maya art.

Taube interprets these murals and artifacts as indicating that Tetitla was a kind of "International House" associated with upper-class merchants or diplomats. He notes that Maya-made objects found at Teotihuacan are limited to goods of the highest quality, suggesting that interaction was conducted at the elite palace level. Taube concludes that Teotihuacan, which often has been portrayed as a monolithic culture, borrowed freely from other societies, and that some of the most "typically Teotihuacan" works of art are among the most eclectic in the city. Finally, he demonstrates that just as the Maya were fascinated by elite goods and esoteric ideas from central Mexico, the uppermost stratum of Teotihuacan society was captivated by Maya notions of kingship and royal ancestor worship.

In Chapter 12, George Cowgill presents an important counterpoint to themes developed in several chapters of this volume. He begins with a discussion of new data from Teotihuacan. He describes the transition between the Early and Late Tlamimilolpa phases—now thought by Evelyn C. Rattray to be even earlier than shown in Figure 1.2—as one of the most important in the history of Teotihuacan. Importantly, many of the ceramic traits associated with Teotihuacan "influence" in the Maya area do not appear at the central Mexican city before this transition. Cowgill also presents other data suggesting that the Feathered Serpent Pyramid (which dates to a time before the Late Tlamimilolpa phase) should not be compared with structures in the Maya region, or even with other buildings at Teotihuacan. Moreover, he stresses that we know practically nothing about high-level elite burials at Teotihuacan during the Late Tlamimilolpa and subsequent phases: the interval of greatest relevance for comparison with the Maya region.

Cowgill then turns to other portions of Mesoamerica and focuses on the region between the Basin of Mexico, the Valley of Oaxaca, and the Maya area. His very useful summary stresses that evidence of Teotihuacan "influence" has been found throughout the Isthmian region. Thus, we should not use discontinuity as an argument against an important Teotihuacan presence in the Maya area.

In his last section, Cowgill presents a scenario that he sees as the most

likely explanation for the appearance of central Mexican traits in the Maya region during the late Early Classic period. His perspective is an example of Marcus' multistage model (Chapter 13), and may also represent a new reversal in the direction of the pendulum of thought. He entertains the possibility that, for a fleeting moment, Teotihuacan may have established a far-flung and unstable empire that included important Maya cities like Kaminaljuyu, Tikal, and Copán. His position shares much with previous scenarios (most notably Bernal [1966]), but seeks support from recent and impressive archaeological finds (from central Escuintla) and new hieroglyphic decipherments (discussed above). One important distinction between Cowgill's account and earlier strong externalist narratives is that he does not see any particular long-term effects of Teotihuacan's brief intervention in Maya political affairs. Nor does Cowgill consider that the contraction of Teotihuacan ushered in a decline in the Maya region. On the contrary, he suggests that it may have presented new opportunities for exchange among the flourishing new polities of the Epiclassic/Late Classic period.

Readers may question how convincing the evidence is for Teotihuacan winning "a stunning series of victories" outside the Basin of Mexico, and whether or not intervention in the Maya region represented "the farthest southeastern extent of military successes that already had a long history behind them." Certainly no physical remains indicating a military conflict with Teotihuacan have been found in the Maya area, although evidence of internecine warfare abounds (e.g., Demarest 1997). In fact, a central point to Stuart's (2000a) new interpretation of the 11 Eb' 15 Mak event is that there is *no* mention in the inscriptions of a battle.

As has been the case for several decades, the principal sources of data regarding interaction between the Maya and Teotihuacan are imported and foreign-inspired ceramics, a borrowed architectural form, central Mexican obsidian, and the incorporation of foreign motifs and elements of style into existing artistic programs. We may now add to this brief list the use of a foreign-looking name at Tikal and several accounts describing the "arrival" from unknown places of two elite individuals: K'inich Yaax K'uk' Mo' of Copán and Siyaj K'ahk' of Tikal. Both have Maya names, and the first seems to come from the Petén (Chapter 5). Cowgill sees this body of evidence, new information from Montana (Chapter 2), and additional data from non-Maya Chiapas as sufficiently strong to posit that interaction was "backed by force." Many of the contributors to this volume do not agree. We all share the hope that our readers will one day resolve this friendly difference of opinion.

In the final chapter, Joyce Marcus returns to comprehensive models of

interaction. She notes that no single model seems to account for all Maya sites and stresses that the nature of interaction also varied over time (as do our interpretations of Teotihuacan-Maya relations). Instead, she proposes four general models: single-event interaction, multistage interaction, simple dyadic interaction, and numerous partners or interactions mediated by multiple sites. The first is applicable to Altun Ha. The fourth and most complex of Marcus' models seems to be the most accurate and complete one for understanding Early Classic interaction at all the other sites discussed in this volume, although multistage interaction may explain some events in central Escuintla, Copán, and Tikal.

Most previous narratives of the sort that Stuart (2000a) calls externalist positions can be considered simple dyadic scenarios. There is a growing body of evidence that the Maya interacted with multiple partners as early as the Middle Preclassic period. Marcus emphasizes that many other important trade partners of the Early Classic Maya—including inhabitants of central and southern Veracruz, Tabasco, Oaxaca, Puebla, and Tlaxcala—have frequently been overlooked by scholars focused on Teotihuacan connections. In particular, many sites for which simple dyadic models have been developed, including Kaminaljuyu and Tikal, evince strong ties to the Gulf Coast. Narratives for these sites that attempt to explain local developments only in terms of Teotihuacan are incomplete.

Marcus argues that it is simplistic—and also wrong—to consider influence as unilateral. That is, an adequate model must account for and explain Maya impact on Teotihuacan of the sort that is documented by Taube. Moreover, local or internal processes must be taken into account, even in models that attribute significant importance to foreign interaction. The most important aspect of her view, one shared by all the authors of this volume, is that the Maya were conscious actors who manipulated foreign interaction and selectively adapted, modified, and transformed aspects of imported culture to suit their own needs. Just like their colonial and modern counterparts, the Maya of A.D. 350–550 should not be envisioned as the passive victims of foreign interference.

Characterizing Early Classic Interaction

The authors of this volume, with the notable exceptions of Cowgill, Bove, and Medrano, adopt perspectives on Teotihuacan-Maya interaction that lean heavily toward internalism.[13] Indeed, many chapters reject Teotihuacan-"influence" or -"dominance" models proposed in the 1960s to early 1980s. But our purpose and results, I hope, reflect a more complex view than is sug-

gested by the externalist-internalist dichotomy. Our varying perspectives can be summarized by several salient points.

Material and Temporal Patterns of Early Classic Interaction

Interaction between the Maya and Teotihuacan has left a large and disconcerting range of material correlates. At some Maya sites, interaction (be it direct or indirect) is manifested in *talud-tablero* architecture. Green obsidian from the Pachuca source is found at other locations. Still others have imported ceramics or other goods from central Mexico. Some sites evince interaction in stylistic or iconographic conventions. For the most part, there does not appear to be an ordered hierarchy of material traits that reflects the intensity or nature of interaction. That is, we cannot say that any particular material category, including the *talud-tablero,* indicates stronger or more lasting interaction than any other. As Cowgill points out (Chapter 12), we know little about what the different patterns of material traits may mean. In many cases, the random nature of the central Mexican traits adopted by the Maya seems to signify nothing more than the arbitrariness of elite emulation.

Nevertheless, we consider items used within the household realm, particularly those related to the practice of a Teotihuacan-centric religion (*candeleros,* censers, warrior "portrait" figurines, and perhaps *copas,* "cream pitchers," and *floreros*), to be better indicators of migration than are status-endowing elite items subject to exchange. With the apparent exception of Montana, the distribution of these items within the Maya region is extremely limited.

Two temporal patterns seem to be particularly important. First, over the course of the Classic period, greater numbers of Maya sites came to reflect some degree of interaction with or awareness of central Mexico. This pattern survived the fall of Teotihuacan itself; iconographic references to the city are more widespread in the Maya region during the Late Classic than they are in the Early Classic. Second, the ratio of imports to locally produced copies of central Mexican objects decreases over time. Thus, at second- and early third-century Altun Ha and Balberta, evidence of interaction with Teotihuacan is limited to the presence of actual imports from central Mexico. At fourth- and fifth-century Kaminaljuyu, Tikal, and Copán, there are many more copies of central Mexican goods than imports. Finally, there do not appear to be any actual imports from highland Mexico at fifth-and sixth-century Montana or sixth-century Oxkintok.

Following Ball (1983), we interpret this rise in the ratio of homologies (copies) to identities (imports) as indicating that interaction between the

northwestern and southeastern halves of Mesoamerica generally was more frequent and intense at the end of the Early Classic than it was during the Terminal Preclassic/Early Classic transition. In fact, we suspect that this trend continued during later periods. But this does not necessarily imply political or economic domination in the late Early Classic, let alone the existence of foreign colonies; such a colony seems extremely unlikely at Oxkintok, the latest of all the sites discussed in this volume. On the contrary, in many cases an increase in the frequency of homologies seems to indicate intensified elite emulation. To reiterate, the essential tool used to distinguish sites with a possible colony (such as Montana) from sites that almost certainly lacked a colonial presence (such as Oxkintok) is the frequent appearance of homologies in humble internal contexts.

Variation in the Nature and Effects of Interaction

Just as the material correlates of Teotihuacan interaction varied over time and place within the Maya region, so too did the nature and effects of that interaction.

At Altun Ha, a unique event—perhaps indicating the recognition of the death of one ruler by another—seems to have signaled the beginning and the end of Teotihuacan interaction. At Balberta, and perhaps at Nohmul and Becan, the public nature of caches containing goods from central or Gulf Coast Mexico more likely bespeaks the limited interaction of communities. Evidence for a central Mexican affiliation at Montana is abundant, particularly in the household domain. This is the strongest case for an actual central Mexican presence, but there is some ambiguity as to whether foreign colonists at the site came directly from Teotihuacan or from some intermediate site in the southern Gulf Coast area. At Kaminaljuyu, the nature of interaction is less clear, but probably involved multiple actions of inter-elite gift giving, the emulation of central Mexican culture by Maya elites, and perhaps both the adoption of a foreign religious cult and a low but important level of economic exchange. At Copán and Tikal, evidence for direct ties to Teotihuacan, either of a military, trade, or religious nature, is both less tangible and more evanescent. Finally, evidence at Oxkintok points to multiple trade connections with many areas, and perhaps only the most indirect of ties with Teotihuacan itself.

For reasons outlined above and in Chapters 12 and 13, we reject the possibility that the earliest states in the Maya region somehow were stimulated by Teotihuacan. Nevertheless, the late development of state-level organization in Pacific Guatemala may have been sparked by a Teotihuacan pres-

ence. Similarly, the emergence of states in the Puuc region at the very end of the Early Classic period may have been engendered (in the true sense of the word) by increased exchange with various regions of Mesoamerica, including central Mexico. At Tikal and Copán, the Early Classic effects of interaction appear to be transitory and are limited to a period of less than a century. Most important, they are closely tied to dynastic change. This may signal the imposition of foreign rulers or new native lines sponsored by Teotihuacan, or—as advocated by most of the authors of this volume—may indicate an attempt to legitimate the precarious claims of Maya sovereigns establishing new dynasties.

The Early "Pulse" of Interaction

Contact between central Mexico and the Classic Maya spanned several centuries. Within this longer period we have identified two important "pulses" of interaction. An early pulse, corresponding to the Terminal Preclassic/Early Classic transition, is seen clearly in Pacific Guatemala and at Altun Ha, and possibly at Kaminaljuyu and Tikal. At the last site, the adoption of and experimentation with certain aspects of the *talud-tablero* style suggest interaction not with Teotihuacanos, but with nearer neighbors from the Gulf Coast. Early cylindrical tripods from Kaminaljuyu also might reflect relations with that region. In central Escuintla and northern Belize, however, trade goods unambiguously demonstrate interaction with central Mexico, perhaps with Teotihuacan itself. Objects imported from central Mexico have been found in caches or offerings at both Balberta and Altun Ha. Nonetheless, these items could have reached southeastern Mesoamerica indirectly via the Gulf Coast. Interaction during this early pulse is best depicted as occurring between equal (or near equal) partners. There is no evidence for asymmetrical relations, let alone for economic or political hegemony. As mentioned, the Balberta caches suggest community-to-community relations, perhaps in the form of trade agreements, celebrated in the public arena. In contrast, the offering at Altun Ha appears to imply affiliations between individuals. It is the sole example in our volume that seems to fit the single-event model. The long-term impact of this early pulse was negligible in the Maya lowlands and is somewhat ambiguous in Pacific Guatemala.

The Late "Pulse" of Interaction

An important contribution of recent work in the Maya region and at Teotihuacan is the clarification of chronological evidence for interaction. It now

appears that the strongest data for direct Maya-Teotihuacan contacts are limited to the late fourth and early fifth centuries, contemporary with the Early Xolalpan phase of Teotihuacan (Figure 1.2). Evelyn C. Rattray (1989:111) has noted that the odd round structures of the Merchants' Barrio, built in a style reminiscent of the Gulf Coast, also date to this phase. Thus, at Teotihuacan itself, we expect to find most evidence for intense relations with the Gulf Coast and Maya regions in Early Xolalpan contexts. It now seems likely, for example, that the Tetitla murals discussed by Taube (Chapter 11) date either to the end of the Early Xolalpan phase or to the beginning of the ensuing Late Xolalpan phase. Dating the murals of Teotihuacan has proven to be a thorny problem, and Taube's work represents an important breakthrough.

Although Maya sites undoubtedly maintained contacts with Teotihuacan and other regions northwest of the Isthmus of Tehuantepec throughout the first half of the Early Classic period, interaction changed in several important respects during the late fourth and early fifth centuries. First, both imports and copies of central Mexican objects appeared in greater numbers and at more sites than in earlier periods. Second, most of these items are locally produced homologies, suggesting either elite emulation or—in at least one case—colonization. Third, ideological constructs, apparently absent during the early pulse, accompanied imported goods. *Candeleros,* warrior "portrait" figurines, and the elaborate "theater" censers found in central Escuintla reveal the practice of the Teotihuacan state-sponsored religion within domestic contexts. Many ceramic homologies also evince close ties with central Mexico. It seems likely, as Bove and Medrano argue, that a foreign colony was established during this period at Montana. Such a colony, however, may not have included many women from Teotihuacan (Chapter 12). At Tlailotlacan, the Zapotec barrio of Teotihuacan, locally made copies of common Oaxacan utilitarian wares are found. Such mundane and quotidian homologies are missing from the San Jerónimo complex, suggesting that potters of local origin made most of the everyday ceramics consumed at Montana.

In contrast, the elite of Kaminaljuyu probably adopted and transformed certain aspects of a Teotihuacan belief system, but there is no compelling evidence for the existence of an enclave. At Kaminaljuyu, the ideological impact of central Mexican interaction was limited to prominent elite males, who appear to have taken part in a pan-Mesoamerican warfare cult manifested most strongly in mortuary behavior. Participation in these rites, however, had little or no impact on either domestic rituals or household economy.

The late pulse seen at Oxkintok corresponds with the end of the Late

Xolalpan and the Metepec phases, or the last gasps of Teotihuacan as a major highland power. In this case, the impact of relations is so diffuse and rarefied that interaction with Teotihuacan seems more abstract than real. The physical manifestations of interaction are limited to the borrowing of stylistic elements that were reconfigured and transformed within local contexts. The purpose of interaction, to gain access to foreign esoteric goods and symbols associated with elite status, was primarily material. Exchange with central Mexico did not diminish after the decline of Teotihuacan. Instead, such trade seems to have increased at Oxkintok during the Late and Terminal Classic.

The "Arrival of Strangers"

An important aspect of the late pulse of interaction at both Copán and Tikal was the emergence of new dynastic lines that either had or claimed affiliation with Teotihuacan. Stuart's (1999, 2000a) important contribution raises many questions concerning the nature of this impact. Chief among these are: (1) Were the principal actors Maya or foreigners from Teotihuacan? and (2) Does the Teotihuacan-derived military symbolism seen in depictions of K'inich Yaax K'uk' Mo' and Yaax Nu'n Ahyiin indicate an alliance that enabled these men to rule, or does it reflect an attempt by dynastic founders and their successors to legitimate their reigns?[14]

Isotopic analysis has answered the first question for Copán, but has not yet been applied to Tikal. Nonetheless, several authors are inclined to favor a local—or at least Maya—origin for Yaax Nu'n Ahyiin. We also suspect that the Teotihuacan-derived imagery of Copán and Tikal reflects an ideological alignment more than a true military alliance. That is, the kings of both polities used a vigorous, new, elite mythology to legitimate their tenuous grasps on power. Because they were not members of existing dynasties, they could not call upon royal ancestor veneration, as had been the practice since kingship emerged in Preclassic times. I speculate—and it is no more than a conjecture—that Siyaj K'ahk', K'inich Yaax K'uk' Mo', and at least one of the principal figures in the Kaminaljuyu tombs may have made pilgrimages to Teotihuacan in order to strengthen their claims to a powerful foreign ideology. If one was not of the royal line, a trip to the metaphorical "Place of Reeds" might have been needed to cement one's rule. In contrast, the sons of the (new) dynastic founders at both Copán and Tikal quickly reverted to royal ancestor veneration as the principal tool of legitimization. By the middle of the fifth century, ties—either real or fabricated—to Teotihuacan were not as important as more traditional customs and alliances.

Multiple Contacts

Many of the authors see evidence for interaction between the Maya and multiple regions of Mesoamerica. At Kaminaljuyu and Tikal, there are some indications of exchange with Monte Albán. Particularly strong ties are seen between Maya sites and the Gulf Coast of Veracruz. In Pacific Guatemala, ceramics and Zaragoza obsidian indicate contact with that region. It may even be that the warrior "portrait" figurines of Montana, because of their large size, were inspired by figurines from southern Veracruz. At Kaminaljuyu, the iconographic content and style of a few ceramic vessels and a mosaic plaque, as well as the proportions of *talud-tablero* architecture, suggest contact with the Gulf Coast. Similar evidence for interaction with the Gulf Coast is found at Tikal, including the later appearance of the *atadura* (cinch) form of the *talud-tablero,* and the ceramics of the Altun Ha cache may come from the Gulf Coast region. Moreover, it is not clear that the tripod cylinder form was introduced to southern Mesoamerica from Teotihuacan. Tripod cylinders have been found in small quantities in Preclassic contexts at Kaminaljuyu, and the ceramic form appeared in the Gulf Coast region centuries before such vessels were produced in Teotihuacan (Rattray 1977). In some cases, it may even be that contact with Teotihuacan was mediated by inhabitants of the Gulf Coast who had forged exchange ties with Maya elites during the Late and Terminal Preclassic periods.

The Cosmopolitan Nature of Maya Cities

We are not surprised that the apparent strength of economic and ideological ties between central Mexico and the Maya region is related to the size and complexity of the sites involved. We do not see this as either a cause or a result of Teotihuacan intervention, but instead consider it to be a reflection of the cosmopolitan nature of local communities. Although not immense cities, Montana, Kaminaljuyu, and Copán were the largest and most complex population centers in their regions during the late Early Classic period. Tikal, in fact, already was a substantial city and power in the central lowlands. We consider it only natural that foreign trade — and perhaps even merchants, emissaries, or priests — would be drawn to these vibrant centers. We suspect that the largest and most dynamic Maya cities were multiethnic and international, as was Teotihuacan. We are surprised, in fact, at how difficult it has been to identify foreigners in the archaeological record of sites like Tikal. But the identification of such individuals, even those of high status, should not be construed on its own as indicating foreign dominance.

The Lattice of Interaction

Finally, we follow Demarest and Foias (1993) in understanding Teotihuacan and each of our sites or regions as nodes in a complex, multidirectional lattice of interaction. Teotihuacan was the largest and most powerful city of Early Classic Mesoamerica, and it is not surprising that the web of connections reflected its size and grandeur. Distance, too, played a role in the lattice, and closely spaced sites were more likely to be directly and strongly linked than more distant ones. Taube's contribution demonstrates the multidirectional flow of ideas and goods throughout the lattice. Because Teotihuacan was the single largest and most complex node, it should be expected that more evidence for interaction with foreign places would be found there than at the other sites. Foreign enclaves (containing people from the Gulf Coast and the Valley of Oaxaca) have long been proposed for the central Mexican city, and a Maya "presence" or "influence" of some sort now seems likely at Tetitla.

Our understanding of Early Classic interaction and its effects on local processes conforms in several ways to the "peer polity" model (Renfrew 1986), although the distances involved are greater and the intensity of interaction is somewhat less. Both external *and* internal factors played a role in local, regional, and pan-Mesoamerican processes. In some areas, such as central Escuintla, Teotihuacan appears to have had a momentous impact on political and economic development. In most parts of the Maya world, however, the results of relations with Teotihuacan are seen most strongly in the ideational domain of the elite and much less so in the broader political and economic realms. In some cases, such as Altun Ha, the long-term effects of such interaction were negligible.

We recognize that, as in Charlemagne's court, some peers were more important than others. As one of Mesoamerica's greatest cities, Teotihuacan surely was one of its most influential. But it is important to remember that the interaction lattice was an innovation neither of the Early Classic period nor of Teotihuacan. Agricultural, ceramic, and lithic technologies spread throughout Mesoamerica in a similar lattice at the beginning of the Early Preclassic period. Later in the Early Preclassic and during the Middle Preclassic, material goods, particular iconographic motifs, and aspects of a shared ideology circulated from west Mexico to El Salvador. The roots of Mesoamerican kingship evolved in a variety of locations during the late Middle Preclassic, and the first states and cities also appeared at that time. By the end of the Late Preclassic period, a number of new cities—including Teotihuacan, Tikal, and

Kaminaljuyu—emerged as important nodes in the shifting lattice of inter-action. Of course, interregional and long-distance interaction continued after the decline of Teotihuacan and the abandonment of the cities of the central and southern Maya lowlands.

To a great degree our definition of Mesoamerica as a culture area *implies* the long duration and importance of such a network. But it does not negate the significance of regional and local processes as sources of innovation, as some externalists would have it. Both central Mexico and the Maya area were regions of great experimentation, innovation, growth, and complexity during the Early Classic period. Interaction between the Maya and Teotihua-can reflects a mutual fascination no less strong than contemporary readers feel for each society. Neither simple core-periphery scenarios nor the most isolationist internalist models adequately describes the complex and recip-rocal nature of Mesoamerican interaction. As we begin to move from the site-specific data and interpretations presented in this volume toward more general and predictive theoretical constructs, we should seek explanatory frameworks that emphasize local innovation yet underscore the complexity of interaction.

Acknowledgments

I thank the American Council of Learned Societies for the fellowship during which this book was written and edited. Our initial symposium was generously sponsored by the United States Information Service of the Embassy of the United States of America in Guatemala. In particular, I wish to thank Dr. Michael Orlansky, former Cultural Affairs Officer, for his support of our endeavor. I am especially indebted to Jennifer Briggs Braswell and Joyce Marcus for their insightful comments and skillful editing of Chapters 1, 3, and 4. Marc Zender and Stephen Houston were generous with their time and expertise in answering some basic questions about the Tikal marker. With-out exception, the authors of the chapters in this volume have allowed me a free hand in editing each of their contributions. I gratefully acknowledge their cooperation in forging a book that, I hope, presents a wide variety of positions in a unified manner. I ask forgiveness of the authors who submitted manuscripts in Spanish; my transla-tions do not do justice to their work. Finally, a special thanks is due to Marc Zender for his crucial aid with the emerging orthographic conventions of Southern Classic Mayan. But the standardized use of these conventions, particularly duplication to in-dicate long vowels and the marking of internal glottal stops, throughout the volume does not necessarily imply that we all advocate them. We employ these new conven-tions for both calendrical terms and the names of Maya rulers. But we have chosen to use more familiar spellings for archaeological sites named by modern scholars and explorers. Spanish accents are not used with indigenous place-names.

Notes

1. The Carnegie scholars who excavated Kaminaljuyu, however, preferred to emphasize the chronological implications of their finds (Kidder et al. 1946). A critical breakthrough of the project was the establishment, for the first time, of Classic-period ceramic crossties between the Maya region and central Mexico (see Chapter 3).

2. A few years before these discoveries in the Maya lowlands, research conducted in the Valley of Oaxaca revealed that both urbanism and the Zapotec state emerged at Monte Albán during the fifth through third centuries B.C. (e.g., Blanton 1978; Flannery and Marcus 1983; Marcus and Flannery 1996). There, too, such developments could not have been stimulated by polities in the Basin of Mexico. Mesoamerica, then, witnessed the rise of the state in several areas long before a period of intense interaction with Teotihuacan.

3. Despite the fact that Kidder et al. (1946) argued for a Teotihuacan presence at Kaminaljuyu, I do not classify them as externalists because they were not concerned with colonization as a process. That is, they did not take a stance on the ultimate effects of Teotihuacan on the evolution of Maya culture. Indeed, they used the fact that Teotihuacan-style artifacts were found at Kaminaljuyu to argue that the Classic Maya and Teotihuacan were contemporaries, and hence, one could not have evolved from the other. These brilliant culture historians were externalists only in that they concluded that a common "root" for Middle American culture was to be found in the Preclassic period.

4. Although Bernal (1966) recognized Teotihuacan "influence" at Tikal and along the Pacific Coast, his discussion of these areas is both brief and ambiguous. In particular, it is not clear if he believed that there was a physical presence of Teotihuacanos at Tikal.

5. At Teotihuacan, the "Tlaloc" imagery on the Feathered Serpent Pyramid is a headdress resting on the tail of the serpent. In the Maya region, the only known example of this exact configuration is at Uxmal.

6. Freidel (1979), in fact, focused his discussion on the rejection of several models for the origin and evolution of lowland Maya civilization that he saw as based on the culture area concept. These models do not explicitly consider the role of Teotihuacan on the development of Maya culture and in fact are more concerned with cultural ecology (Rathje 1971, 1972, 1973; Sanders 1973) or population pressure and competition (Ball 1976; Webster 1977). Because they consider environmental factors limited to the Maya region, it is tempting to classify them as early internalist scenarios. But they do not truly satisfy Stuart's (2000a:465) definition of internalism. Moreover, the more ecologically focused models share with externalist scenarios the view that the Maya were passive: in this case, manipulated by their environment rather than by bellicose or entrepreneurial central Mexicans. It may be best to consider all these models as members of a third school of thought, one that is neither internalist nor externalist, and hence, of little relevance to this volume.

7. Montana also may be a candidate, but ceramic data supporting late Early Classic ties between Kaminaljuyu and that site are slim at best.

8. That "Spear-Thrower Owl's" name glyph is not lowland Maya in appearance may indicate: (a) nothing other than the unique characteristics of the individual; (b) that it is derived from a non-Mayan language; (c) that it is derived from a Mayan language very different from Southern Classic Mayan; or (d) that it is a pictorial "neologism" of a Mayan or non-Mayan name from a place that lacked hieroglyphic writ-

ing but claimed some connection with central Mexico. Given that there are no Early Classic texts in the Guatemalan highlands and that the elites of Kaminaljuyu tried to identify themselves with central Mexico, it seems to me that Kaminaljuyu—or some other powerful highland or Pacific Maya site—is at least as strong a candidate for Ho' Noh Witz as Teotihuacan.

9. That is, Siyaj K'ahk' was the paramount ruler of Tikal, but not its *ajaw*. For this reason, he is not included in the list of numbered *ajawob* of Tikal.

10. I am not wedded to this specific chronology. In particular, I am not sure that Yaax Nu'n Ahyiin lived beyond A.D. 404. Moreover, I am uncertain that the *kalo 'mte'* title is in any sense superior to the *ajaw* title. In truth, we know little about the meaning of the so-called directional world tree titles. The *k'alomte'* title, for example, may indicate only that its holder is a forebear of a living *ajaw* or designated heir. Thus, "Spear-Thrower Owl" may have been *kalo 'mte'* because his son was heir apparent to Chak Tok Ich'aak, and Siyaj K'ahk may have held the title because of a connection to Yaax Nu'n Ahyiin's mother. In turn, Yaax Nu'n Ahyiin may have claimed the title (in addition to *ajaw*) upon naming Siyaj Chan K'awiil as his own heir.

11. The remains of Siyaj K'ahk' have never been identified, nor is it certain that he was interred at Tikal. One candidate for his burial place is Problematical Deposit 22. This was found in front of Str. 5D-26, on the centerline and at the heart of the North Acropolis (Coe 1990, 2:324–327, Figures 9 and 85; see also Chapter 6). The deposit is in line both with Burial 48 (where Siyaj Chan K'awiil was laid to rest) and Burial 22 (another royal burial of the Manik 3 phase; see note 11). Although the rich deposit apparently did not contain "masses of undecorated pottery of purely Teotihuacan style" (Coggins 1975:182), it did include a fragment from a Tlaloc effigy jar (Culbert 1993:Figure 124l), a locally made cylindrical tripod with "coffee-bean" appliqués (Culbert 1993:Figure 124a), a *candelero,* and fifty-seven green obsidian artifacts (Coe 1990, 2:325). Most important, it also contained Stela 32, showing the central Mexican storm god (or possibly a human imitator) wearing a tasseled headdress and what may be the "profile-bird-with-shield-and-spear" emblem (see Chapter 8). The remains within Problematical Deposit 22 are partially cremated and appear to come from an elderly male (Coe 1990, 2:325). Teeth from this individual should be subject to isotopic analysis to determine his place of origin.

12. Coggins (1975:137–146) argues that Chak Tok Ich'aak's tomb is Burial 22 (Coe 1990, 2:307–311), located in what then was the focal point of the North Acropolis. In contrast, Laporte and Fialko (1990) speculate that Burial 22 was the interment of Siyaj K'ahk', whom they suggest was the immediate successor to Chak Tok Ich'aak.

13. Bove and Medrano note that sociopolitical elaboration in the Pacific Coast began long before interaction with Teotihuacan. Moreover, they see the inhabitants of central Escuintla as active participants in determining their own economic and political destiny. Bove and Medrano's position, then, considers both internal and external factors as relevant to regional development.

14. Only two probable portraits of K'inich Yaax K'uk' Mo' that may date to his lifetime are known: Stela 35 and the Motmot marker. It is important to stress that neither portrays him in the guise of a Teotihuacan warrior. His connections to central Mexico, whether real or invented, appear to have been much more important to the Late Classic rulers of Copán than to the Founder or his son.

Teotihuacan, Militarism, and Pacific Guatemala

Frederick J. Bove and Sonia Medrano Busto

The nature of interaction between Teotihuacan and distant regions has been ambiguous, and an understanding of its essential characteristics is important for several reasons. First, from the perspective of regions such as Pacific Guatemala (Figure 2.1), we need to know if local political and economic shifts reflect changes in the foreign relations of Teotihuacan. Such a determination would also help us understand Teotihuacan's own political and ideological development. Second, we need to develop explanatory models of local evolutionary trends against the background of Teotihuacan interaction. This can be achieved by determining the degree to which Teotihuacan affected the dynamics of local political institutions and controlled the economies of other complex societies. Conversely, we need to know the extent to which local elites legitimized their power through the manipulation of goods and ideology imported from Teotihuacan.

In this chapter, we first present a brief historical summary of the evidence for and speculations regarding interaction between Teotihuacan and the south coast of Guatemala. This provides the framework needed to better appreciate changing perceptions of Teotihuacan–Pacific Guatemala interaction. We then examine new findings from our regional projects conducted in Pacific Guatemala during the past two decades, and emphasize the contextual and chronological nature of central Mexican–style objects and symbols found during research. The findings are divided into two sections. The first covers the objectives and results of the Balberta Regional Project, which began in 1983 and 1984 and was followed by extensive excavations and controlled surveys over a wide area in 1986–1987. The next section focuses on the Montana Project of 1991–1992, which was followed by subsequent surveys and material analyses.[1] The Balberta Project concentrated on the Guacalate and Colojate phases (100 B.C. to A.D. 400), while the Montana Project focused on the Colojate and San Jerónimo phases (A.D. 100/200 to 650/700). These periods coincide with increasing and waning Teotihuacan

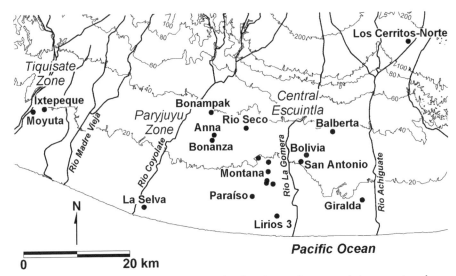

FIGURE 2.1. Central Escuintla, Guatemala, showing study area and sites mentioned in the text.

interests in the Pacific Coast. For both periods and regions, our data are linked with local social, political, and economic variables. These show that regional political and economic shifts reflect changes in the dynamics of re-lations with central Mexico. We argue that Teotihuacan ultimately achieved complete dominance of this section of the Pacific Coast, most likely through the dual processes of military victory and colonization.

Teotihuacan and Pacific Guatemala in Historical Perspective

In the 1940s and 1950s, the Carnegie archaeologist Edwin M. Shook con-ducted a program of salvage archaeology combined with broad survey within the Tiquisate region of western Escuintla, Guatemala. Shook (1965) observed that although remains demonstrated an intensive Early Classic occupation, a Teotihuacan presence in the region was of very short duration and was re-stricted to only a few sites. In the late 1960s, Lee Parsons (1964, 1967–1969) argued strongly for a Teotihuacan presence at the site of Bilbao, and more generally for a Middle Classic "Horizon."[2] He also maintained that Cotzu-malguapa art derived from the exceptionally intense influences of Teotihua-can during his proposed Middle Classic period, arguing for a two-stage horizon style. The first stage, from A.D. 400 to 550, involved a period of Teotihuacan expansion and domination. His second, or "Teotihuacanoid," stage lasted from A.D. 550 to 700.

As agricultural activity increased on the central Guatemala coast in the 1970s, large numbers of looted Teotihuacan-style *incensarios* (censers) and tripod cylinder vases from the coastal Escuintla region began to appear on the art market. Nicholas Hellmuth (1975, 1978) conducted an informal study of censers in private collections and observed that most contained Teotihuacan symbols and motifs, including war imagery. He concludes that a Teotihuacan military and ideological incursion occurred on the Escuintla coast with the goal of obtaining monopolistic control of cacao production and — through Kaminaljuyu — the obsidian source at El Chayal.

In a perceptive monograph, Janet Berlo (1984) argues convincingly that Teotihuacan had a major impact on the southern piedmont of Guatemala because of the high frequency of Teotihuacan-style censers found there. She believes that these were the principal cult icons of small groups of Teotihuacanos who wished to maintain their traditional religious beliefs. She also suggests that there was a strong link between the related themes of warfare and a martial butterfly deity, and that a new religious ethos based on militarism was adopted by traveling merchants and emissaries to foreign lands. With remarkable prescience, Berlo argues that the Escuintla region of the Pacific Coast was the strategic area from which Teotihuacan launched northward incursions into Kaminaljuyu and the Petén.

In contrast, Arthur Demarest and Antonia Foias (1993) cogently argue for a limited Teotihuacan presence in the Pacific Coast, Kaminaljuyu, and the Maya lowlands. They conclude, for example, that the individuals buried in Mounds A and B of Kaminaljuyu were local elites who drew on exotic symbols and objects for status reinforcement, and were not resident Teotihuacan chiefs or lords. Still others argued that Teotihuacan-style imagery marked astrologically sanctioned sacrifice and bloodletting rituals associated with "Venus warfare" or "Star Wars" (Carlson 1993; Schele 1986; Schele and Freidel 1990).

More complications are added to these divergent views of Teotihuacan foreign relations by George Cowgill, who focuses instead on the ideational realm. He observes that

> although the scale and significance of Teotihuacan commerce are highly contested, symbols related to Teotihuacan, often connected with warfare, are widespread in Mesoamerica. It therefore seems likely that the prestige and perceived sacred efficacy of Teotihuacan was so great that identification with the city could be an important symbolic resource in local political strategies. (Cowgill 1993:565)

Based on the results of intensive research conducted at Teotihuacan in the 1980s, particularly at the Feathered Serpent Pyramid of the Ciudadela, Saburo Sugiyama (1996, 1998b, 1998c) stresses the military aspects of Teotihuacan power. He suggests that by the late fourth century A.D., Teotihuacan had become an expansionist state that engaged in military campaigns in distant areas. The discovery of a major workshop in the Ciudadela that mass-produced composite "theater" censers leads Sugiyama to believe that by A.D. 350 a new state ideology had emerged. The manufacture of these censers, the vast majority of which contain military symbols, was controlled by the state. The censer complex gave strong military connotations to Teotihuacan until the violent end of the metropolis. An interesting development in assessing the nature and extent of militarism is the argument that Teotihuacan warfare was not limited to elites and that Teotihuacan society was meritocratic (Hassig 1992). This idea has interesting implications to which we will return.

The limited contextual evidence from the Pacific Coast of Guatemala combined with the obviously complex nature of Teotihuacan relations with it, Kaminaljuyu, and the Maya lowlands are the basis of a classic anthropological dilemma. To what extent was cultural change in the Maya area, including Pacific Guatemala, stimulated by interaction with Teotihuacan? Conversely, to what extent was it driven by local factors? We follow David Stuart (1998, 2000a) in reducing the myriad arguments to two theoretical camps: one that focuses on *external* factors (e.g., commercial networks, intervention, military conquest, and foreign ideology); and one that emphasizes *internal* processes (such as symbolic emulation). Complicating the issue is the changing nature of relations over the centuries of Teotihuacan-Maya interaction. The dilemma is analogous to the continuing debate regarding the status of the Olmec as a mother or a sister culture, and the related difficulty in modeling—much less quantifying—the complex processes of interaction (e.g., Clark 1997; Flannery and Marcus 2000; Grove 1993, 1997; Hammond 1989).

The Balberta Project

These issues related directly to our regional Balberta Project (Bove et al. 1993:Figure 2.2). Balberta was the largest completely exposed Early Classic regional center in the Pacific Coast of Guatemala. It presented an exceptional opportunity to study the massive changes that occurred in the region—and by extension, in southern Mesoamerica—during the Terminal Preclassic to Early Classic transition. We also wished to determine whether the develop-

ment of the Balberta polity was a result of pressures from intense interaction with Teotihuacan or its surrogates, or was instead primarily the result of local evolutionary forces. Several questions related to nonlocal intrusions were proposed by Joyce Marcus (1989) and proved difficult to test. Were actual Teotihuacanos attracted to the region? If so, was the interaction initially reciprocal—for example, involving some sort of exchange between "equals"? Was the interaction direct, or was it mediated by some other center, such as Kaminaljuyu? Were these Pacific Coast Guatemalans incorporated into some type of Teotihuacan "realm"? Were they actually conquered or just economically tied to central Mexico?

A related series of research questions concerning the origins of the state derived from Barbara Stark's then concurrent Mixtequilla Project in coastal Veracruz, Mexico. Stark was especially interested in political and economic change within an area containing a state, and how these processes related to developments at Teotihuacan. In specific, a goal of the Mixtequilla Project was to determine: (a) if Teotihuacan dominated the economy or political structure of La Mixtequilla; (b) if local centralization and political hierarchy increased because of the presence of a more powerful neighbor in the highlands; (c) if the local state became more centralized before the Teotihuacan epoch and maintained its autonomy, like Oaxaca; or (d) if local political power developed after the decline of Teotihuacan, suggesting that local elites obtained greater wealth and power in the vacuum left by the withdrawal of the great highland state from local affairs (Stark 1989, 1990).

The results of the Balberta Project are only briefly summarized here (see Arroyo 1990; Bove 1990; Bove et al. 1993; Carpio 1989; Chinchilla 1990a; Lou 1991; Medrano 1988). Our research indicates that Balberta originally was an important Guacalate-phase center, probably linked to San Antonio. The latter, a major Mascalate-to-Guacalate-phase regional center with sculpture, is 6 km west of Balberta. Through a series of monumental constructions and related demographic movements at the beginning of the Early Classic Colojate phase, Balberta was transformed into a fortified regional center with political dominion over a wide area. We originally thought that this process was the result of local political units losing their autonomy and becoming districts subordinate to a central government (Cohen 1978). This working hypothesis seemed reasonable at first because the process appeared to be the continuation of local Preclassic trends toward greater centralization, combined with increasing architectural rigidity and formality within the region that Balberta eventually dominated. Our views have since changed, and we now believe that warfare more likely is responsible for the

seemingly rapid change that occurred at about A.D. 200 to 250. Two col-
leagues echo our new view: "We do not believe that a chiefdom simply turns
into a state. We believe that states rise *when one member of a group of chief-
doms begins to take over its neighbors,* eventually turning them into subject
provinces of a much larger polity" (Marcus and Flannery 1996:157). More-
over, we suggest that this process was stimulated by early and ongoing con-
tacts with Teotihuacan.

We now turn to material objects imported directly from central Mexico
or the Gulf Coast that have been recovered from Balberta and sites in the
Tiquisate and Paryjuyu zones.

Pachuca Obsidian

We discovered the second highest frequency of green obsidian from the
Pachuca, Hidalgo, source (N=134) ever reported in Guatemala for this
period. Most of these artifacts were associated with ritual offerings of cached
vessels that contained ceramic effigies of cacao beans (Bove 1990; Bove et al.
1993). The quantity of Pachuca obsidian is exceeded only at Tikal and is
far greater than has been reported for Kaminaljuyu or other highland sites
such as Mejicanos, Frutal, and Solano (Brown 1977b; Mata 1964; Mata and
Rubio 1987). All of the green obsidian was found within the central Balberta
core, and the majority was sprinkled within the area containing the effigy
cacao offerings. Ten green obsidian projectile points were also recovered.
According to Michael Spence (personal communication 1987), they are in
pure Teotihuacan style. Five were recovered from the ritual area of Balberta
and the remainder from either residential or other ritual contexts within the
site core.

We later discovered several green obsidian artifacts at sites within the
Paryjuyu zone, located about 10 km west of Balberta between the Tiquisate
area and central Escuintla. Three green obsidian artifacts were recovered
from excavations at the Bonanza site, which was occupied in the Guaca-
late and Colojate phases. All are from Mound 1 at the southern end of the
site (Bove et al. 1993:Figure 8.12). One green obsidian artifact was recovered
from Anna, a large regional center during the Middle Preclassic (Bove et al.
1993:Figure 8.11). The artifact came from Mound 2, a 3 m high platform
that apparently supported an elite residence. Most associated ceramics are
late Middle Preclassic to Late Preclassic in date, but some sherds are older.
Six green obsidian artifacts were excavated from the platform-plaza at Los
Cerritos-Norte, a large Classic-period regional center located 17 km north

of Balberta. This site, along with Los Cerritos-Sur, has abundant Colojate-phase ceramics.

The green obsidian artifacts from Balberta and the Paryjuyu zone are, along with other artifact classes to be discussed, the earliest indications of contact with central Mexico. In fact, the juxtaposition of green obsidian with effigy cacao caches at Balberta probably indicates the beginnings of commercial ties between the Pacific Coast and Teotihuacan. It is interesting that these caches are roughly contemporaneous with an offering at Altun Ha (see Chapter 9).

Following Cowgill's (1996, 1997) revised chronology, the period of the Balberta caches, Paryjuyu finds, and the Altun Ha offering is about A.D. 150/175 to 250/275. At about this time, the Feathered Serpent Pyramid and the final stage of the Pyramid of the Moon were completed at Teotihuacan. David Pendergast and George Cowgill (Chapters 9 and 12) are both persuaded that there is no evidence that Teotihuacanos dominated Altun Ha, and Cowgill suspects that trade in highly valued perishable goods was the motive for gifting. Similarly, the Balberta caches of effigy cacao and associated green obsidian (perhaps a gift) may have been offered in celebration of a trade agreement concerning cacao, a highly valued and perishable good.

Thin Orange Ware

The Balberta Project excavations recovered a small quantity of Thin Orange ware sherds from the Puebla, Mexico, source (Rattray 1990; Rattray and Harbottle 1992). These were recognized through instrumental neutron activation analyses conducted by the continuing Ceramic Resources Project directed by Hector Neff of the Missouri University Research Reactor (MURR), and are the first ever to be chemically identified in Pacific Guatemala. Three of the Thin Orange sherds excavated at Balberta come from the cached offerings that contained green obsidian and effigy cacao. Two additional Thin Orange sherds were found at Bonanza in the Paryjuyu zone, in the same excavated unit as the green obsidian. Another sherd was recovered during surface collection of a residential mound between Bonampak and Bonanza. Yet another came from Moyuta, an Early Classic platform site in the Tiquisate zone (Bove 1989b:figura III.9). Two more specimens were identified in controlled surface collections from Ixtepeque, a huge platform complex that we believe was the capital of the Tiquisate zone (Bove 1989b:figura III.10). Finally, a Thin Orange sherd was found in surface collections from La Selva, a large, predominately Late Preclassic coastal site near the mouth of the Río

Coyolate. Six to ten Teotihuacan-style censers were looted from the site and now are in private collections. We believe that several of these censers are illustrated in a recently published brochure (Banco Industrial 1998).

During our analyses of ceramics from Balberta, we were struck by the similarities in form and surface treatment of several varieties of Esmeralda Flesh and Thin Orange ware. A sample of Esmeralda Flesh sherds was assayed at MURR, and three different production loci were tentatively identified as Coastal Flesh 1, 2, and 3. Production zones of Coastal Flesh 1 and 2 are located on the central Escuintla coast. We believe that they represent a determined effort by coastal pottery producers to copy the forms and surface appearance of Thin Orange ware. Coastal Flesh 3 sherds have high chromium concentrations that are very anomalous for Guatemalan pottery (Neff et al. 1994). It too appears to be a copy of Thin Orange ware, but it was produced in another location, most likely the Gulf Coast region, where central Mexican ceramics were copied. The most popular forms of Coastal Flesh, as for imported Thin Orange ware, are open bowls with annular bases.

Fine Paste Ware

Other evidence for early interaction, either directly with Teotihuacan or indirectly through related centers on the Gulf Coast, are sherds with a distinctive fine paste that we originally believed might be the precursor to Tiquisate ware. These were found in late Guacalate or early Colojate contexts at Bonanza in the Paryjuyu zone (Bove et al. 1993:Figure 8.12).

Six specimens were analyzed using instrumental neutron activation at MURR. All had extremely high chromium concentrations, which again are generally unknown in Guatemalan clays. According to Neff, the San Lorenzo–Matacapan area of the Gulf Coast of southern Veracruz is a likely candidate for the production zone. Such fine-paste ceramics have not been identified previously on the central Escuintla coast or anywhere else in Guatemala and are yet another indication of interaction with the Gulf Coast during the Terminal Preclassic to Early Classic transition. Two specimens were visually identified by Evelyn Rattray as El Tajín Marfil; she labeled three others as "Gulf Fine Paste" (Hector Neff, personal communication 2000).

Bonanza shows indications of an episodic change during the Guacalate to Colojate transition (c. A.D. 200), as do other sites in the Paryjuyu zone. The two Thin Orange sherds from the site were found with other Colojate-phase ceramic markers in intrusive deposits over 2 m deep. An extended burial, with a Gomera Black tripod cylinder vessel (Figure 2.8a) and several finely incised bones, was uncovered in San Jerónimo–phase contexts at the nearby

site of Bonampak, where several Teotihuacan-style censer fragments were also found.

At Balberta, gray obsidian projectile points were found with some frequency in a variety of contexts. Four of these points come from Mexican sources. Three are from the Zaragoza, Puebla, source area, and one from Otumba, Estado de México. These were found in the vicinity of the effigy cacao/green obsidian caches, and also within an elite residential area on top of the giant Balberta platform. The relatively high frequency of points may be related to increasing militarism within the region.

Balberta Project Summary

In spite of the presence of imported artifacts from Teotihuacan and sites in the Gulf Coast, the data available at the end of the Balberta Project suggested to us that the emergence of sociopolitical complexity was well under way within the region before the arrival of Teotihuacan merchants, warriors, or emissaries. There was, however, no question of some sort of contact with Teotihuacan by about A.D. 200 to 250, if not earlier. For reasons unknown to us, Balberta was abruptly abandoned by the end of the Colojate phase (c. A.D. 400). The latest radiocarbon dates from the site are 1620 ± 90 BP (Beta 25615), 1630 ± 80 BP (Beta 25612), and 1700 ± 60 BP (Beta 25614). The one-sigma calibrated ranges of these dates are A.D. 307–529, A.D. 306–516, and A.D. 260–398 (Stuiver and Kra 1986).

We concluded that the Teotihuacan presence, at least in the Balberta zone, was minimal. As a result, we became increasingly skeptical of claims of military conquest or colonization on the Pacific Coast. This view, it should be noted, was in sharp contrast to Frederick Bove's (1989a) earlier research that favored a conquest model. But the abrupt abandonment of Balberta was puzzling and could not be adequately explained (Bove et al. 1993).

The Montana Project

Our attention next shifted to the nearby monumental Montana complex. Here we continued our investigations of state evolution on the Pacific Coast, the possible role of Teotihuacan in these processes, and the nature of the relationship between Montana and Balberta. Montana was a sizable Early Classic center that was transformed into a massive regional capital by the beginning of the San Jerónimo phase. Occupation continued in the Late Classic Pantaleón phase, when the nearby major groups of Manantial, Loma Linda, and Paraíso were incorporated into the site complex. The architecture of Montana is completely different from that of the earlier Balberta, and its

a

b

FIGURE 2.2. The Montana complex, Escuintla: (a) aerial view from the north; (b) ground view of the great Montana pyramid and platform from the north.

monumental construction is truly impressive (Figure 2.2a). There is nothing comparable on the south coast. The central core of Montana consists of an 18 m high pyramid placed on top of a gigantic platform measuring 200 m by 220 m and standing more than 7 m high (Figures 2.2b and 2.3). Remnants of a west-facing staircase are still observable. Platforms and pyramids enclose a plaza at the north end of the site. This portion of Montana is con-

nected by a 300 m long platform-plaza structure to the immense two-level Los Chatos platform at the southern end of the site. Dimensions of the Los Chatos platform itself are 200 m by 330 m. Surrounding the nuclear core of Montana are thirteen large platform sites located within a 5 km radius. The Manantial site is 1,000 m north of Montana, and between the two are more than 200 mounds. These include elite residences, the domestic structures of commoners, and platforms measuring as large as 100 m to a side.

Excavations within the Montana nuclear zone were designed to: (a) obtain information about the occupational sequence of the site; (b) form a solid chronology based on stratigraphic, radiocarbon, and archaeomagnetic dating; and (c) reveal something about the nature and function of the monu-

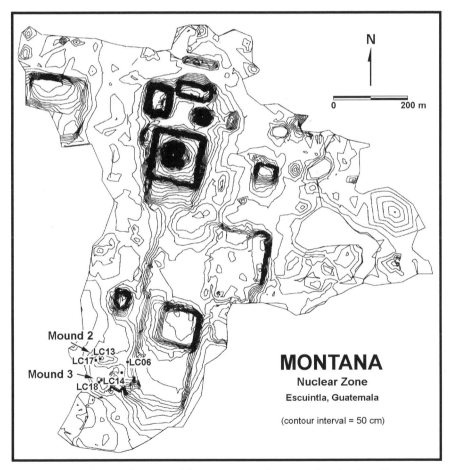

FIGURE 2.3. Topographic map of the Montana nuclear zone showing Los Chatos operations discussed in the text.

mental platform and pyramidal constructions, as well as more humble structures in the surrounding areas. Controlled surface survey was followed by an extensive program of test pitting in the densely occupied area between the Montana complex and the Manantial site. These excavations revealed abundant house floors, trash middens, burials, and special deposits. Surveys in areas to the east and south are still incomplete, and an ongoing project undoubtedly will add significantly to the total number of structures known from the zone.

Excavations within the Los Chatos platform itself revealed a continuous sequence of more than twenty-five well-prepared floors. Ceramic drain pipes were found within the Los Chatos and Montana platforms and as far as 500 m north of the core. Each section of pipe is about 1 m long and 15 to 20 cm in diameter. The pipes are part of a well-engineered drainage system that helped stabilize structures by preventing subsidence. Ceramic drain pipes are found at other San Jerónimo and later sites in Escuintla, and have been reported at major platform sites in the Tiquisate region, the Paryjuyu zone, and at El Castillo in the Cotzumalguapa area. They were also used in Oaxaca at roughly the same period (Javier Urcid, personal communication 2000). No evidence of *talud-tablero* architecture was found, but we conducted very few deep excavations within the central core of Montana.

When satellite centers such as Manantial, Paraíso, Loma Linda, Las Victorias, Las Hortencias, and La Fronda are considered together with district capitals, secondary centers, and myriad lesser sites, Montana represents an impressive regional polity. Ceramic analyses and archaeometric data demonstrate that an overwhelming portion of the monumental construction and occupation within the zone date to the San Jerónimo phase (Bove et al. 2000).

We now focus on central Mexican–style material objects—all locally produced copies—discovered at Montana during extensive excavations and survey.

Teotihuacan Censer

At Los Chatos we excavated the only complete Teotihuacan-style censer ever recovered from a controlled stratigraphic context on the Pacific Coast. All other censers that are known were looted, except for a fragmentary example that Shook uncovered in 1971 in a small mound at Río Seco, a San Jerónimo-phase site near Montana (Edwin M. Shook, personal communication 1986).

Context and date. The Los Chatos censer was found in LC13 (Figure 2.3), near the top of Mound 2, a 3 m high mound just west of the Los Chatos

platform. We conducted exploratory excavations around and below the censer, but found no burials or cache offerings associated with it. Fragments of Floor 1 were found 50–52 cm below the surface. The floor fragments were about 12 cm thick and consisted of *talpetate* and burned-clay lumps. Associated ceramics on top of the floor dated predominately to the San Jerónimo phase and included materials assigned to the Perdido, Recuerdo, Firpo, and Tiquisate ceramic groups (Bove et al. 2000). Floor 2 was encountered approximately 80 cm below the surface and was in better condition. It was penetrated by an intrusive pit directly over the area where the censer was located. The censer itself rested just above Floor 3, a well-constructed surface consisting of four compacted clay levels at about 90 cm below the surface. Below this was Floor 4, a virtually intact, hard-clay construction. Floor 4 was perforated by seven postholes forming a semicircle. Evidence of a burned area with residues of red pigment was found around one of the postholes. We obtained burned-clay samples from Floor 4 for archaeomagnetic dating. Even deeper was Floor 5, which was painted red in its entirety and contained two steps in front of an elevated area. Four postholes were found in Floor 5, the two largest of which were 45 cm in diameter. Most ceramics associated with Floors 4 and 5 date to the Colojate phase. Seven more floors were uncovered before reaching the water table at 406 cm below the surface. The burials of two children were found on top of sterile sands at this level. Associated sherds and a complete Garrucha Black vessel date to the Mascalate and Guacalate phases.

To summarize, the censer was placed in an intrusive pit dug in the center of the floor of the structure. The base of the censer was several centimeters above and almost resting on the earlier Floor 3. Below the censer and Floor 3 we exposed Floor 4, from which we obtained a burned-clay sample for archaeomagnetic dating. Because of peculiarities in the movement of the north magnetic pole in the Colojate and San Jerónimo phases, the possible date ranges for this sample (LC831) are A.D. 225–270, 520–540, and 545–565. A second burned-clay sample was obtained from Floor 5 and yielded an archaeomagnetic date of A.D. 45–75, 240–280, or 545–570.

We favor the date range of A.D. 225–270 for Floor 4 for several reasons. The first is that ceramics from above Floor 3, that is, with or above the censer, date predominately to the San Jerónimo phase. Second, nearby excavations in LC17 also uncovered a series of clay floors and domestic refuse deposits in association with San Jerónimo- and Colojate-phase pottery. Here, a total of six floors were discovered before reaching sterile soil at 245 cm below the surface. An archaeomagnetic date from Floor 2 in this unit is A.D. 65–

85, 255–285, 505–565, or 545–565 (LC834). A radiocarbon date of 1740 ± 60 BP (Beta 62517) was determined from a sample found below Floor 2. The one-sigma calibrated range of this date is A.D. 211–365. A second radiocarbon date of 1750 ± 80 BP (Beta 62518) was obtained from a sample recovered below Floor 4 of LC17. Its one-sigma calibrated range is A.D. 170–371. The radiocarbon dates favor the archaeomagnetic date of A.D. 255–285 for Floor 2 of operation LC17, consistent with the date of A.D. 225–270 for Floor 4 of LC13.

These excavations, as others in the vicinity, revealed that Mound 2 was first occupied at the end of the Mascalate phase. At that time a series of structures and floors, many of which were painted red and contained postholes, were built and occupied as domestic residences. This interpretation is based on the abundant domestic refuse and carbon deposits found during excavations. All but the last three or four floors are associated with trash deposits containing Colojate- and some Guacalate-phase pottery. Above these deposits and associated with the uppermost floors are the remains of San Jerónimo–phase occupations. During the San Jerónimo phase, when Montana was undergoing major construction episodes, the inhabitants deposited the censer within an intrusive pit and buried it. Thus, this startling piece of evidence for interaction with Teotihuacan dates to a time considerably later than the green obsidian, Thin Orange, and other imported pottery found at Balberta. Mound 2 apparently maintained a ritual aura throughout the San Jerónimo phase. According to looters who live on the adjacent Los Chatos platform, a large number of cache offerings and urn burials were discovered in Mound 2. Whole vessels and fragments offered to us for sale, as well as sherds salvaged from looters' pits in the mound, all date to the San Jerónimo phase.

These data overwhelmingly support a date for the censer of A.D. 350–400 or perhaps a bit later. Comparison with examples from Teotihuacan imply that it must date no earlier than Late Tlamimilolpa times, and probably to the Xolalpan phase (Cowgill 1997, 1999b; George L. Cowgill, personal communication 1998). According to Cowgill's (1997) revised Teotihuacan chronology, the Late Tlamimilolpa and Xolalpan phases date to about A.D. 300 to 530 (Figure 1.2). Our date for the censer also fits well within Berlo's (1984) stylistic chronology and agrees with the fourth-century date proposed by Sugiyama (1998b, 1998c) for the censer workshop at Teotihuacan.

Iconography. The censer was complete and was found in good condition (Figures 2.4 and 2.5).[3] It is well made and compares favorably with the finest examples we have observed in private collections. Earth surrounding the cen-

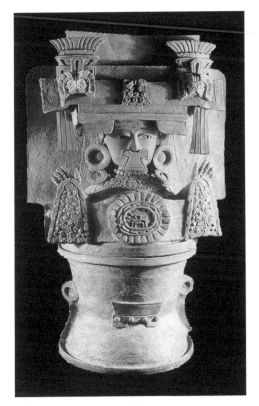

a

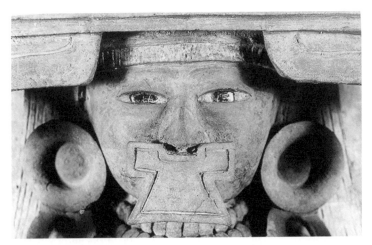

b

FIGURE 2.4. The Los Chatos censer: (a) cover and base; (b) detail of figure on cover.

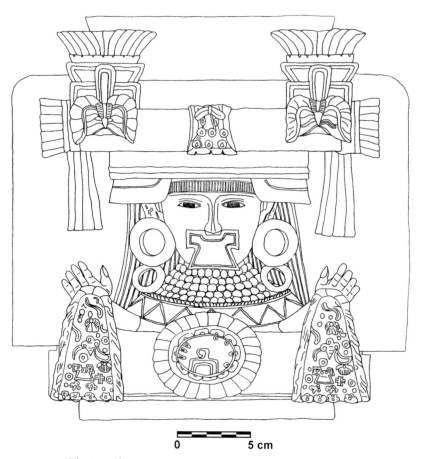

0 5 cm

FIGURE 2.5. The Los Chatos censer cover.

ser was burned, possibly during rituals performed for its interment. The cen-
ser was placed with its base inverted, perhaps to indicate that its useful life
had ended. Four very crude jade or jadelike beads, each 5 mm in diame-
ter, were found inside the base. At Balberta, a number of human burials
had small jade or other greenstone beads placed inside the deceased's mouth
(Arroyo 1990). It is possible that the green objects placed inside the censer
base were part of a symbolic burial ritual.

The hourglass base has two identical vertical side ornaments that may be
handles, and an unusual *talud-tablero* sign or emblem with four infixed dots
(Figure 2.4a). Both the base and the anthropomorphic cover are made of a
reddish brown paste with a lightly brushed surface that is finished with a
translucent white wash. The ceramic fabric and surface treatment are similar
to the local Nahualate ceramic group that was widely distributed during the

Colojate phase and continued into the early San Jerónimo phase. The elaborate lid has a chimney in the center with two large, flat, vertical flanges on its sides (Figure 2.5). Below each flange is a square handle. The face of the central figure is painted red and white with a horizontal yellow band that extends over the nose and cheeks to the ears (Figure 2.4b). This may represent a mask. The figure sports a butterfly nose ornament that is a clear military symbol (Berlo 1984). The unusual eye pupils are made of mica. The hair is painted yellow, hangs straight down on the sides, and is confined by what appears to be a fringed headband. The figure has two pairs of earplugs and a necklace formed of five strands of white beads. Attached to the bead necklace is a cord to which is fastened an element, perhaps a cloth scarf, consisting of alternating red and white triangles.

Resting on the figure's chest between its upraised hands is a reptile-eye glyph inside a plumed medallion. The glyph is flanked by three lines and four dots that may represent a date. The figure wears an elaborate headdress that differs somewhat from those typically found at Teotihuacan (see Langley 1992). The headdress is a lateral tablet with painted red and yellow bands. At the center is an unidentified element that has not been observed on other censers (James Langley, personal communication 1999). It could be a knotted bag with six infixed dots of unknown meaning. At both ends of the tablet are sign clusters that include an owl—another military symbol—surmounted by a manta compound (Langley 1992).

Apart from the butterfly and owl military symbolism on the censer, the central figure has what probably are local manifestations of the open "divine hands" typical of Teotihuacan mural paintings. At Teotihuacan, "divine hands" are associated with a central figure identified as representing the "Great" or "Mother" Goddess of the city (Berlo 1992; Pasztory 1988b, 1992). The Teotihuacan mural panels depict what seem to be flowing liquids containing offerings, divine petitions, or divinatory messages. In the case of the Los Chatos censer, these offerings are tentatively identified as nose pendants, flowers, shells, stemmed plants, crosses, cotton balls, and trefoils. These symbols may be related to agricultural abundance and, if our interpretation is correct, clearly were important to the local community. Two other censers reported from Pacific Guatemala contain some of the same elements. Both were looted, however, and their proveniences are uncertain (Banco Industrial 1998:foto 3; Berlo 1984, 1989; Hellmuth 1975:Plate 37, 1978:Figure 4). The iconography and style of the Los Chatos censer fall clearly into the provincial style, and although some elements are derived from Teotihuacan, the order and general appearance is different (Berlo 1984; Saburo Sugiyama, personal

communication 1998). We point out that a number of Teotihuacan-style censer fragments from various coastal sites were analyzed at MURR. All were made locally in Escuintla.

Sugiyama (1998b, 1998c) has stressed that at Teotihuacan, censers were related to militarism originating from the Feathered Serpent Pyramid. He links butterfly images and other martial elements on *adornos* to dead soldiers who sought symbolic association with the mass sacrificial burials found at the Feathered Serpent Pyramid. This symbolism diffused to residential compounds and abroad *after* the Feathered Serpent Pyramid was constructed (Sugiyama 1998c). Sugiyama also argues that in the fourth century A.D., the Ciudadela became a source of prestigious symbols related to militarism and authority—all intimately linked to a new state ideology. This was the period of Teotihuacan's strengthened presence in southern Guatemala.

Sugiyama conducted a comparative analysis of Teotihuacan and Pacific Guatemalan censers and noted several interesting similarities and differences. Censers with butterflies or owls, identified as abstract military symbols, are abundant both at Teotihuacan and in Escuintla. Censers with explicit warrior symbols such as spears, atlatl darts, and shields are frequent at Teotihuacan, but are significantly less common in Pacific Guatemala. He believes, however, that in both locations they communicated specific meanings in complex ways. An essential point is that both Teotihuacan censers and examples from Escuintla conveyed multiple meanings because no two censers combine identical elements.

Associating specific iconographic elements with function or meaning is almost impossible for Pacific Guatemala because all other censers were looted. We have observed that censers reputed to be from the Tiquisate region contain more overt militaristic symbols such as spears and shields than the few examples we have been able to assign to the Río Seco and Montana regions. It is entirely possible that the different regions emphasized distinct symbol sets determined by the interests of resident central Mexicans and by the messages that were meant to be transmitted to local elites. Another explanation is that Teotihuacan colonists fabricated the censers, but due to distance and the passage of time, their original meanings gradually changed or were lost. It also is possible that local elites were incorporated into a Teotihuacan-centered worldview. Although they did not understand the symbolism of the censers, they wished to perform rituals using foreign paraphernalia. This implies acceptance of alien ritual habits and beliefs. The censers deposited in Lake Amatitlan at the Mejicanos site probably represent this behavioral pattern. Many of these censers contain Teotihuacan-style symbols, including cacao

pods, owls, stars, reptile-eye glyphs, and Tlalocs (Mata and Rubio 1987), but they are incorporated into local forms and in ways that do not conform to Teotihuacan norms.

Candeleros

A number of twin-chambered rectangular *candeleros* were found at Montana (Figure 2.6), many in domestic refuse deposits adjacent to the Los Chatos platform. The latter apparently served as a large elite residential complex. Many of the *candeleros* have chambers that are darkened with soot.

Several exploratory excavations were placed in the area of Mound 3. One was located at a point approximately midway between the western side of the platform and Mound 3 (LC06; Figure 2.3). Two other test units were placed on top of Mound 3 and at its southern base (LC14 and LC18; Figure 2.3). Although no Teotihuacan-style compounds were clearly identified, we suspect that this structure was a local version of the apartment complex. Mound 3 is a San Jerónimo–phase multiroom residential compound. Our limited excavations in the structure uncovered a number of rooms separated by fired-clay walls approximately 60 cm thick. The refuse pits below the mound (LC06) contained high densities of San Jerónimo–phase domestic vessels, many burned, as well as cached offerings. It was here that the majority of the *candeleros* were discovered. It is possible that some refuse deposits in this area came from residential activity on top of the Los Chatos platform, because excavated floors in all units on or associated with the platform were clean.

LC18 was excavated at the southwestern base of Mound 3, and in it we encountered extraordinarily rich domestic refuse deposits. Two burials were found. In one, an adult female was placed in an extended position with her head to the west. Tiquisate ware sherds were inserted in her eye orbits. The other burial was disarticulated and placed inside two large Recuerdo ceramic urns placed lip to lip. Several offerings associated with these burials were found.

Other *candeleros* were found at nearby Manantial and Paraíso, always within domestic refuse contexts. At Manantial, we excavated a *candelero* from a sealed deposit under the first floor of a Pantaleón-phase I-shaped ballcourt. We believe that Manantial was a large village during most of the San Jerónimo phase. It was leveled at the end of the phase so that nucleated ceremonial and elite occupational structures could be constructed. The same refuse level underlies most of the site and contained many other *candeleros* and "portrait" figurines. A radiocarbon date of 1520 ± 80 BP (Beta

FIGURE 2.6. *Candeleros* from central Escuintla: (a) Montana; (b–c) Los Chatos; (d) Los Cerritos-Norte.

65713) was determined for a sample from the sealed deposit that contained the *candelero*. The one-sigma calibrated range of this date is A.D. 443–600.

An intact *candelero* was recently recovered from a newly excavated drainage ditch approximately 500 m north of the giant Montana pyramid-platform complex. The modern ditch cuts through the base of a low structure dating to the San Jerónimo phase. The *candelero* came from domestic refuse at this location.

Yet another *candelero* came from the Bonanza site where earlier Gulf Coast fine-paste ceramics, Thin Orange, and green obsidian have been found. One *candelero* was found in 1979 during surface survey and mapping of the large regional center of Los Cerritos-Norte. In 1995, Oswaldo Chinchilla made a single test excavation into the platform-plaza of the site during his dissertation research on the Cotzumalguapa archaeological culture (Chinchilla 1996a). The excavation and controlled surface survey revealed a large Colojate- and San Jerónimo–phase occupation underlying the later Pantaleón-phase structures. As mentioned, six green obsidian artifacts were recovered. We strongly suspect that Los Cerritos-Norte was part of the Montana polity because of the abundant San Jerónimo–phase ceramics at the site.

The *candeleros* were apparently locally produced, but they are very similar to those reported for Teotihuacan. Scholars who work at that site agree that *candeleros* are household ritual items because they are found in domestic middens rather than in burials or caches (Kolb 1988; Widmer and Storey 1993). Our examples all are rectangular and differ slightly from those reported by Laurette Séjourné (1966a). The *candeleros* found at Montana and nearby centers are most similar to Teotihuacan examples that date to the Late Tlamimilolpa to Late Xolalpan phases (c. A.D. 300–530; see Kolb 1988). *Candeleros* first appear at Teotihuacan after the largest pyramids and civic-ceremonial structures were built, corresponding to the time when many of the apartment compounds surrounding the nuclear zone were constructed (Cowgill 1999b). Twin-chambered Teotihuacan-style *candeleros* are rarely found at Maya sites, but they are not infrequent at Matacapan (Santley 1989). Alfred Kidder et al. (1946:216) commented that "two-holed candeleros are so abundant at Teotihuacan and so rare elsewhere that wherever found their presence may reasonably be attributed to influence from that site."

William T. Sanders (personal communication 1999) has commented that "ritual household activity is the strongest and best evidence for the existence of a foreign colony." The presence of the Montana *candeleros* contrasts sharply with the situation at Kaminaljuyu, where there is little evidence for household religious practices derived from Teotihuacan. To Sanders (1977),

this suggests that foreign colonists at Kaminaljuyu all were male (but see Chapter 4). We argue that Teotihuacan colonists in the Escuintla region included women because of the items related to domestic ritual that have been found. The presence of Chapulco ware jars and Polanco drinking cups in household contexts also supports this supposition (see below). Given the scarcity of *candeleros* at such major centers as Kaminaljuyu, Tikal, and Copán, the number found at Montana surely is a strong indication of a resident Teotihuacan colony dating to the San Jerónimo phase.

Warrior ("Portrait") Figurines

A startling finding was the discovery of large numbers of whole and fragmentary figurines of a type previously unreported not only for the Pacific Coast but also for southern Mesoamerica (Figure 2.7). The figures are unclothed, and the bodies are crudely made. The heads share generally uniform characteristics, the most notable being a slightly protruding upper lip or tooth similar to that of the Maya solar deity. The heads appear to be mold-made, as do the feet, which have an unusual curved feature that allows the figurines to stand upright. Their pose is remarkably similar to that of a large number of "portrait" figurines found in Teotihuacan (Pasztory 1988b, 1992).

Florencia Müller (1978) and Warren Barbour (1976) argue that Teotihuacan "portrait" figurines wore perishable clothing and carried miniature shields and spears. The "portrait" figurines are an important indication of increasing militarism at Teotihuacan (Cowgill 1997; Sugiyama 1998b), consistent with the military symbolism of the theater censers produced by the state. Cowgill (1999b) also points out that they may have been used to socialize young children in order to maintain a highly trained and motivated army. In an earlier article, he suggests that small objects such as *candeleros* and "portrait" figurines "reflect the penetration of Teotihuacan state-related ideology into household contexts" (Cowgill 1996:330). Neither *candeleros* nor "portrait" figurines were produced after the collapse of the Teotihuacan state.

Most warrior ("portrait") figurines from Los Chatos, Paraíso, Montana, and Manantial were found in household middens, many of which also contained *candeleros*. The figurines are relatively common, considering their rather unusual nature and apparent absence elsewhere within the Maya area. The position of the body, arms, and hands is virtually identical to those from Teotihuacan. Geoffrey E. Braswell (personal communication 2000) points out that, like other kinds of figurines found at Matacapan (Santley 1989:136), the "portrait" figurines of Pacific Guatemala are much larger than

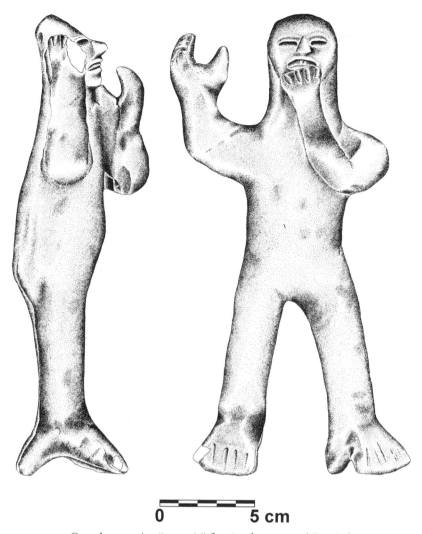

0 5 cm

FIGURE 2.7. Complete warrior "portrait" figurine from central Escuintla.

examples from Teotihuacan. Esther Pasztory (1988b, 1992, 1996) believes that the "portrait" figurines of Teotihuacan date to the Xolalpan phase, or about A.D. 350–530 in Cowgill's (1996, 1997) revised chronology. Nonetheless, several calibrated radiocarbon dates for contexts at Montana that contained figurines are slightly later than the revised Xolalpan chronology.

Drinking Cups and Chapulco Jars
Prominent in San Jerónimo–phase ceramic deposits is a vessel form that surely represents a direct copy of drinking cups found at Teotihuacan (Müller

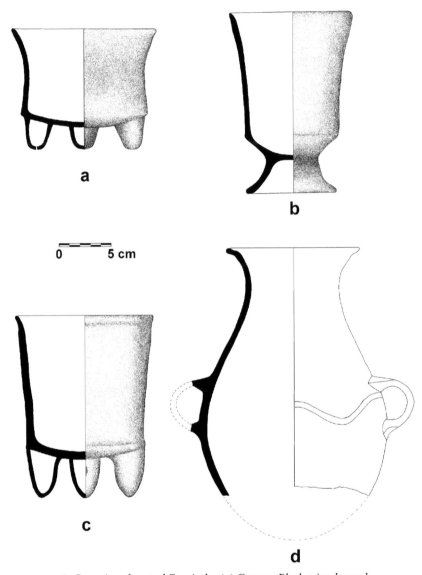

FIGURE 2.8. Ceramics of central Escuintla: (a) Gomera Black tripod vessel, Bonampak; (b) Polanco Black cylindrical vase, Los Chatos; (c) Polanco Black tripod cylindrical vase, Manantial; (d) Chapulco ware jar.

1978; Séjourné 1966a:figura 73). Those at Montana and related sites are included within the Polanco Black-Brown ceramic group. Forms are either vases with vertical sides and pedestal, annular, or tabular tripod supports, or open-sided bowls with annular supports (Figures 2.8b–c). Whole vessel examples are sufficiently plentiful to suggest their widespread use as con-

tainers for a liquid, perhaps a ritual beverage. Almost all examples are from household refuse deposits or domestic fill, including many contexts that also contained warrior "portrait" figurines or *candeleros*. Examples in storerooms at the Museo Popol Vuh (Guatemala City) are said to be from Pacific Guatemala, and most likely come from Escuintla. Other examples are on display at the Regional Museum in La Democracia, Escuintla. These are said to be from the vicinity of Río Seco, the same site where Shook excavated fragments of a Teotihuacan-style censer. More drinking cups in the collections of the Instituto de Antropología e Historia include several recovered during recent salvage excavations at a small San Jerónimo–phase site just north of Puerto San José in Escuintla (René Ugarte, personal communication 1997).

The Bilbao Project reported Black-Brown annular-based cups, but only four sherds were identified (Parsons 1967–1969). They appear similar to the Polanco Black-Brown drinking vessels from Montana, but are smaller. Parsons believed that the annular-based cups at Bilbao are Teotihuacan-related vessel forms, probably dating to the early Laguneta phase.

A second class of Teotihuacan-related ceramic vessel found during the Montana excavations is the Chapulco ware jar (Figure 2.8d). Many of these are extremely thin-walled and fragile and appear almost identical to jar forms reported by Séjourné (1966a) and Müller (1978) for Late Tlamimilolpa to Late Xolalpan Teotihuacan. The smaller varieties may have had a ritual function. Almost all known examples of Chapulco vessels are from domestic refuse contexts associated with either the Los Chatos platform or the Manantial residential zone just north of Montana. A few have also been identified within the Cotzumalguapa nuclear zone, and these, along with several fragments of locally produced warrior "portrait" figurines, may indicate a Teotihuacan presence.

Tlaloc Tripod Supports

Several examples of tripod cylinder supports with "Tlaloc" (storm god) imagery were recovered from looted pits in the Los Chatos platform middens (Figure 2.9a–c). A single Tlaloc support was found at the Ixtepeque complex during the Universidad de San Carlos de Guatemala field class in 1982 (Figure 2.9d; Bove 1989b:figura III.10). These are similar but not identical to several illustrated by Séjourné (1966a:figuras 72 and 82).

Tiquisate Ware

A strong argument can be made that abrupt and sweeping ceramic changes took place throughout Pacific Guatemala during the transition between the

FIGURE 2.9. Tlaloc tripod supports: (a–c) Los Chatos; (d) Ixtepeque.

Colojate and San Jerónimo phases. Our colleague Hector Neff is convinced that of all the ceramic changes he has examined across the entire south coast and through all time periods, none is more striking than this transition. Neff has analyzed ceramics from Teotihuacan and the Gulf Coast in addition to directing our ongoing Ceramic Resources Project. In his opinion, Tiquisate ware of the San Jerónimo phase shows striking similarities in paste, texture, surface treatment, form, and decoration with Gulf Coast ceramics found at Teotihuacan. He further believes that Guatemalan producers of the distinctive Tiquisate White ware looked for specific raw materials in order to build vessels that are nearly identical in paste and color to examples from the Gulf Coast. The specific source of Tiquisate White ware, a residual clay developed on rhyolitic ash at the upper edge of the coastal plain near Tiquisate, was not

utilized prior to the San Jerónimo phase (Bove and Neff 2000; Neff 1995; Neff and Bove 1999). This clay fires to a very dense, light buff- or cream-colored fabric that is very similar to that of the Marfil pottery found at Teotihuacan and presumed to come from the Gulf Coast.

We have also observed remarkable similarities in surface treatment, decoration, and form among Caulote (a distinctive early San Jerónimo–phase red-painted Tiquisate ware), Perdido Red-on-buff (a widespread ware of Pacific Guatemala), and ceramics illustrated by Séjourné (1966a:figuras 158 and 159). These similarities, especially with Perdido ware, were also pointed out by Hellmuth (1993a, 1993b) in his perceptive analysis of Tiquisate ware and Teotihuacan cylinder vases from the Pacific Coast. The critical point is that Caulote and Perdido Red-on-buff appear intrusive in the context of earlier pottery from Pacific Guatemala.

Chronological Comparisons

The archaeomagnetic and corrected radiocarbon dates from a variety of contexts within the Montana complex range from A.D. 260 to 685, or the Colojate and San Jerónimo phases. These dates contrast sharply with those from Balberta, which range from 19 B.C. to A.D. 427, or the Guacalate and Colojate phases. San Jerónimo–phase contexts in which *candeleros,* warrior "portrait" figurines, and several Teotihuacan-style censer fragments were found have dates that average to A.D. 563.

Only two pieces of green obsidian were found in a total collection of more than 6,500 obsidian artifacts from the Montana zone. One is from a near-surface context at Site 470501-14, a low residential mound just north of the Paraíso complex. Pottery from this lot dates to the Colojate, San Jerónimo, and Pantaleón phases. The second Pachuca artifact was identified in a controlled surface collection from a domestic mound in the Montana-Manantial residential area (MAL7-6-03-07). Twelve of the thirteen sherds associated with the obsidian artifact date to the San Jerónimo phase, and a single Ixtacapa phase (i.e., Late Postclassic) sherd was also recovered.

No Thin Orange ware was identified in the Montana zone. The paucity of green obsidian and the lack of imported Thin Orange and fine-paste ceramics surely reflect a later and different form of interaction with Teotihuacan than Balberta enjoyed. At Guacalate- and Colojate-phase Balberta, central Mexican–style objects are *imports* presumably brought to the region by Teotihuacan emissaries or traders. In contrast, all Teotihuacan-related objects—such as censers, *candeleros,* warrior "portrait" figurines, drinking

cups, Chapulco ware, Tlaloc tripod supports, and probably Caulote, Tiquisate, and Perdido ware—found at San Jerónimo–phase Montana are *copies* rather than imports.

Teotihuacan and the South Coast

How do ideas of external and internal causation fit the Pacific Coast data? Stuart (1998, 1999, 2000a) emphasizes the shifting nature of Teotihuacan-Maya relations and suggests that both external and internal causation models can be valuable when applied to different periods in the long and complex history of interaction. Do political developments in Pacific Guatemala reflect changes in the dynamics of Teotihuacan foreign relations? Several Teotihuacan scholars have speculated that following an early period of autocratic rule, a shift occurred to collective, group-oriented leadership (Cabrera Castro et al. 1991; Cowgill 1983, 1992, 1997; R. Millon 1988; Pasztory 1992, 1997; Sugiyama 1993, 1996, 1998c). At the same time, a new state-dominated ideology emerged. Cowgill (1997) recently stated that the novelty and monumentality of the Ciudadela suggest a distinct and intentional break with an earlier ideology whose central focus was the Pyramid of the Sun. He also proposes a model consistent with a trend toward increasingly visible militarism.

We now answer the research questions posed at the beginning of this chapter using our new data and interpretations. Following a model proposed by Charles Cheek (1977a, 1977b) and William Sanders (1977), the data from Balberta suggest that a period of occasional, economically motivated contact led to more-frequent and periodic visits by trading expeditions from Teotihuacan. This process accounts for the sporadic finds of green obsidian, Thin Orange, and imported fine-paste ceramics at Balberta and within both the Paryjuyu and Tiquisate zones during the Guacalate and Colojate phases. Succeeding stages of military conquest and colonization by both men and women from Teotihuacan fit the Colojate-to-San Jerónimo–phase data from Montana.

Were actual Teotihuacanos attracted to the region? Yes, the data from Balberta and Montana fully suggest that Teotihuacanos, rather than middlemen or surrogates from other regions, were not only interested in the rich natural resources of Pacific Guatemala but also migrated there.

If so, was the interaction initially reciprocal—for example, involving some type of exchange between "equals"? The answer again is yes. The evidence for initial interaction seems to involve exchange between equals because there is no evidence for overt political domination at sites where the earliest Teoti-

huacan imports are found. At Balberta, the juxtaposition of exotic Pachuca obsidian with offerings of effigy cacao may ritually celebrate some sort of commercial agreement.

Was the interaction direct, or was it mediated by some other center such as Kaminaljuyu? There is no evidence from Balberta, Montana, or any other site in Escuintla that gives the slightest indication of a mediated contact or series of contacts. Although objects from Kaminaljuyu and the adjacent highlands are found at Late to Terminal Preclassic coastal sites, their frequency declines dramatically in Colojate- and San Jerónimo–phase contexts. We now concur with Berlo (1984) that Teotihuacan solidified gains in this strategic area before making northward excursions into Kaminaljuyu and the Petén and eastward forays into El Salvador and Copán.

Were these Pacific Coast Guatemalans incorporated into some sort of Teotihuacan "realm"? Were they actually conquered or just economically tied to central Mexico? We believe that the local population was incorporated into a Teotihuacan-centered polity most likely through an overt military incursion and conquest. Various models may explain the specific mechanisms involved. The most likely scenario, in our opinion, is that "Teotihuacan established colonies in distant lands to exercise direct military power; these entered into local alliances, multiplying their own power by that of local allies" (Hassig 1992:59).

We are also convinced that the "new" Montana, dominated by Teotihuacan colonists and their local allies, was responsible for a war of expansion that led to the collapse and abandonment of Balberta in the early part of the San Jerónimo phase. Massive construction episodes and a reordering of the local site hierarchy occurred throughout central Escuintla at this time, and it stretches credulity to believe that the enormous depth of transformation over a very wide area was caused by some vague and unidentified economic factor.

Did Teotihuacan dominate the economy or political structure of central Escuintla? The region would have been particularly attractive to Teotihuacan colonists for several reasons. Some of the richest soils in all of Mesoamerica are found in Pacific Guatemala. Valuable local products include cacao, quetzal feathers, cotton, rubber, shells, and salt. Moreover, the favored location of the region with respect to major communication routes into the central Guatemalan highlands provides a strong geopolitical advantage to a colony in central Escuintla.

A model proposed by Joseph Ball (1983) provides particularly useful contextual perspectives on interaction between Teotihuacan and the Pacific

Coast. Although Ball emphasizes ceramics, his models can easily accommodate other artifact classes. During the earlier Colojate-phase stages of contact between the two regions, a genuine flow of goods—that is, the actual movement of central Mexican pottery and obsidian—occurred. Ceramic "identities" include Thin Orange ware from Puebla and fine-paste pottery from the Gulf Coast. Interaction most likely combined both commercial and socioceremonial concerns. Later on in the San Jerónimo phase, ceramic "homologies" (local copies) from Montana seem to indicate movements of population segments, including military forces, colonists, merchants, and possibly administrators. Evidence for this model is quite strong and is linked to Ball's concept of "ideational diffusion" manifested in ceramics that resemble, approximate, or even duplicate each other, but may differ in technology. We believe the evidence for this model is exceptionally persuasive. During the San Jerónimo phase, Teotihuacan censers, warrior "portrait" figurines, *candeleros,* Coastal Flesh wares, Tiquisate ware, the Caulote and Perdido ceramic groups, as well as Chapulco jars and Polanco drinking cups all attest to the *local* production of ceramic homologies. The case for a form of economic domination therefore seems clear.

We believe that political domination is evident in the abrupt and massive transformation of Montana into a dominant regional capital. Teotihuacan political interests were transported by the colonists and are manifested in the locally produced Teotihuacan-style censers, warrior "portrait" figurines, and *candeleros.* At Teotihuacan, all three artifact classes are clearly identified with the ideology of the state. Another point, perhaps not emphasized sufficiently in this chapter, is the dramatic demographic transformation of a large region concurrent with the construction of Montana. Because of the significant agglomeration that developed within the Montana core area, the spatial distribution of centers within its domain approximates a primate distribution. In contrast, earlier Colojate-phase distributions are closer to log-normal, and Middle to Late Preclassic settlements display a convex pattern (Bove 1989a). Thus, during the San Jerónimo phase, settlement within the territory dominated by Montana began to replicate in miniature the demographic patterns of the Teotihuacan state. This area was administered by a hierarchical system of large platform sites spaced regularly across the landscape. All such sites share similar architecture and ceramics.

Did local centralization and political hierarchy increase because of the presence of a more powerful neighbor in the highlands? The trend toward increasing local centralization and hierarchical organization was under way during late Mascalate and Guacalate times, well before the arrival of Teotihuacan

emissaries or traders. The possible influence of Kaminaljuyu in the adjacent highlands on this process is unknown and even more difficult to quantify. There appear to have been reciprocal economic relations with a number of highland sites, including Kaminaljuyu, during the Late and Terminal Pre-classic, but we see no evidence that Kaminaljuyu dominated any site on the Pacific Coast. We now believe that the even more rapid centralization seen at Balberta at the end of the Guacalate phase was caused by increases in the Teotihuacan presence on the lower coast. This view contrasts with our earlier thinking that emphasized local developmental trends.

Did the local state become more centralized before the Teotihuacan epoch and maintain its autonomy like Oaxaca? The question is partially answered above. Balberta became an early state or statelike polity in the Colojate phase, but it is difficult to divide contributing factors into purely internal and external causes. Oaxaca, a powerful state long before the emergence of Teotihuacan hegemony in the Basin of Mexico, had diplomatic relations with Teotihuacan and clearly retained its autonomy. The central Escuintla case is not comparable with Oaxaca.

Did local political power develop after the decline of Teotihuacan, suggesting that local elites obtained greater wealth and power in the vacuum left by the withdrawal of the great highland state from local affairs? The answer to this question is somewhat complicated by the rise of the Cotzumalguapa state during the Pantaleón phase. It appears that by or shortly after the collapse of Teotihuacan, there was a disruption of the centralized Montana political system, and its core zone became more diffuse. The region formerly united during the San Jerónimo phase disintegrated into small competitive polities. The proliferation of *palangana*-style sunken ballcourts at relatively small acropolis-type sites such as Bolivia, Lirios 3, and Pantaleón-phase Manantial exemplify this process of political fragmentation. At Montana itself, an open court was constructed at the northwest corner of the gigantic platform during Pantaleón times. It is during this phase that Cotzumalguapa became the dominant political and economic power center on the upper Guatemala coast (Chinchilla 1996a, 1996b). Results of the Ceramic Resources Project clearly show that economic relations between Manantial and the Cotzumalguapa region were maintained during the Pantaleón phase, but it is difficult to prove that the lower coastal polities were either economically or politically dominated by the Cotzumalguapa state (Bove and Neff 2000; Neff and Bove 1999). The process outlined here, however, may very well be a direct outcome of the withdrawal of Teotihuacan from Pacific Guatemala and the eventual absorption of former colonists into the local population.

Conclusions

The large numbers of warrior "portrait" figurines, twin-chambered Teotihuacan-style *candeleros,* and other artifact classes that have been found in a variety of nonritual contexts argue persuasively that a substantial Teotihuacan colony was established at the Montana complex by the early San Jerónimo phase, if not a bit earlier. We are now convinced that Teotihuacanos arrived on the south coast in significant numbers and brought with them a powerful new ideology and sufficient military prowess—perhaps combined in the notion of sacred war—to interact intensively with the local elites of central Escuintla. An actual military conquest has yet to be proven, and more research is required, but we now suspect that such an event did take place and resulted in the establishment of Teotihuacan colonies at Montana and other nearby sites, including Ixtepeque in the Tiquisate zone.

The colonists could have been disaffected groups or adventurers from Teotihuacan (Kidder et al. 1946), and if so, this might provide some support for Ross Hassig's (1992) meritocracy hypothesis. Such groups might have become disaffected as a result of the apparent changes in rulership that occurred at Teotihuacan during the fourth century A.D.

It may also be that the Balberta regional polity was conquered during the Colojate-to-San-Jerónimo transition. We posit that the arrival of colonizing Teotihuacanos was followed by a lengthy period when local elites appropriated Teotihuacan styles and associated military ideology. At Montana and in the Tiquisate region, this process may have transformed the superstructure of local polities in ways that resulted in new and strengthened political organization. An ideological focus on warfare may have led to expansion at the detriment of polities to the north and east. In any event, Montana and the Tiquisate region maintained a Teotihuacan worldview and remained Teotihuacan-centered polities.

The impact of Teotihuacan on the Pacific Coast of Guatemala was not limited to the military takeover and colonization of a major site complex in central Escuintla. Concurrent with the involvement of Teotihuacan in this region, the political and ideological landscape of a large portion of Pacific Guatemala, southern Chiapas, and western El Salvador was changing. The massive desanctification of the "potbelly" and stela cults at the end of the Preclassic period resulted in the virtual absence of monumental art during the Early Classic, and signified an enormous change in the nature of rulership that must have been related to changes in the sociopolitical structure.

Prior to the Early Classic period there was a lengthy tradition of erecting stone monuments at many coastal and piedmont sites. The Preclassic inven-

tory includes plain stelae and altars, Olmecoid relief carvings, "potbellies," and stelae with Long Count dates (Miles 1965; Parsons 1986; Rodas 1993; Shook 1971). The last were undoubtedly intrusive from the adjacent highlands. It has been suggested that the absence of stone monuments on the lower coast is due to an absence of naturally occurring stone. Nevertheless, we have found large "potbelly" sculptures at sites on the lower coast, including Giralda, which is only 6 km from the Pacific Ocean. Clearly the elites of Late and Terminal Preclassic complex societies exercised sufficient power over local populations to transport raw or finished materials a considerable distance.

Why did the coastal region stop producing monumental art at the end of the Terminal Preclassic period? We submit that the reason lies in a new cognitive orientation spread by Teotihuacan-oriented cultures. An interesting contribution by David Grove provides an answer:

> The dominant theme in Olmec monumental art was rulership. . . . The rulership theme in monumental art continued over another 2,000 years of Mesoamerican prehistory and essentially distinguishes western Mesoamerica (where it is virtually lacking) from southern/eastern (Maya) Mesoamerica (where it was very important). With few exceptions, the importance or non-importance of identified rulership within the political ideology generally accounts for the presence or near absence of stone monumental art at major Mesoamerican centers until the Postclassic period. During the Classic period, monumental art carrying a rulership theme was prevalent throughout the Maya realm but was unimportant at the great central Mexican centers such as Teotihuacan, Cholula, and Monte Alban. . . . [S]cholars . . . realize that the difference is plainly the reflection of two extremely different Classic period ideological systems. . . . In the Gulf Coast sociopolitical and ideological system, as with the Maya a millennium later, rulership was personalized and reified through monumental art, while the ideological structure of societies in western Mesoamerica had different foci—foci in which monumental portraits of rulers were unimportant because rulership was structured quite differently. That regional dichotomy continued essentially unchanged throughout the Classic period. (Grove 1993:92–93)

New structures from Teotihuacan replaced the older political and ideological system so that virtually all monumental art ceased on the lower

coast. Instead, the new state ideology seems to have been expressed principally through monumental construction projects combined with the use of Teotihuacan-style censers and both *candeleros* and warrior "portrait" figurines at the household level.

The virtual absence of monumental art on the coast continued until the collapse or withdrawal of Teotihuacan-oriented systems and the *subsequent* development of new social and political structures. This included a return to personalized rulership, as glorified in the Pantaleón-phase monuments of Late to Terminal Classic Cotzumalguapa (Chinchilla 1996a, 1996b; Parsons 1967–1969; Popenoe de Hatch 1989).

There is a tendency to think of Teotihuacan as a monolithic, unchanging, and all-powerful polity. This perspective is at least partly due to its enormity, monumentality, and powerful political and economic effects on much of Mesoamerica. But without question Teotihuacan was also dynamic, cosmopolitan, and heterogeneous, all of which were potential causes of conflict within the society. Although there is a propensity to view the Pacific Coast of Guatemala through Teotihuacan eyes, we believe, as Marcus (1989:xv–xvii) stated, "that we need to understand it in its own terms, rather than simply as a reflection of its neighbors." Only in this manner can we develop explanatory models of local evolutionary trends against the background of Teotihuacan interaction. Nevertheless, it now seems to us that momentous changes in relations with Teotihuacan played a critical role in determining the course of sociopolitical process in Pacific Guatemala.

Acknowledgments

We gratefully acknowledge the invaluable assistance of the National Science Foundation, National Geographic Society, National Endowment for the Humanities, University of California-Santa Barbara, Arizona State University, Missouri University Research Reactor Facility, Foundation for the Advancement of Mesoamerican Studies, Inc., and the Asociación Tikal. Deep appreciation is also due to the Instituto de Antropología e Historia, the Museo Nacional de Arqueología y Etnología in Guatemala City, and to all the archaeologists and students who worked so diligently over the years on our various projects. We are also indebted to James Langley and Karl Taube, whose comments on the Los Chatos censer have influenced our interpretations. A special note of thanks to Geoffrey Braswell, Hector Neff, and Oswaldo Chinchilla for their useful suggestions on earlier drafts. We are particularly grateful for the inspiration of the late Daniel Wolfman, who introduced us to the mysteries of archaeomagnetism.

Notes

1. The Montana Project was formerly known as the Los Chatos–Manantial Project and appears as such in various papers presented during the 1990s. The earlier designation reflects an attempt to include most of the area encompassed by the two site groups of Los Chatos and Manantial, which are located at the extreme ends of the core zone studied by the project. We have decided to use Montana as the project designation to avoid the confusion generated by the names of various site groups within the study area. The great Montana pyramid, platform, adjoining platform-plaza, and related large structures are located on Finca Montana. The Los Chatos platform and associated structures are found in the bordering Parcelamiento Los Chatos, located at the south end of the Montana core. When we speak of the Montana Project or the Montana Complex, we normally include Los Chatos. Nonetheless, the excavations conducted at the Los Chatos group all carry Los Chatos terminology (see Figure 2.3). The same holds for the Manantial core located 1,000 m north of the Montana platform. Other sites such as Paraíso, Loma Linda, and Las Victorias are discussed individually.

2. Editor's note: See Marion Popenoe de Hatch (1995:104–105), who argues that although Teotihuacan-style cylindrical tripods are found in the Tiquisate region and elsewhere in Escuintla, they are not found at Bilbao or El Baúl in the Cotzumalguapa zone.

3. Rodolfo Yaquian of the Museo Nacional de Antropología e Historia, Guatemala City, magnificently and painstakingly reconstructed the censer. We wish to acknowledge his contributions, including the restoration of the vessels that made up the Balberta effigy-cacao caches, to our various projects.

Dating Early Classic Interaction between Kaminaljuyu and Central Mexico

Geoffrey E. Braswell

In 1925, the polymath Walter Lehmann identified central Mexican ceramics in private collections from Kaminaljuyu (Bove 2000). But the presence of Teotihuacan-style pottery at the site remained generally unknown until 1936, when Alfred V. Kidder, Oliver G. Ricketson, and Robert Wauchope of the Carnegie Institution of Washington began excavating Mound A (Figure 3.1; Mound F-VI-1) at the behest of José Antonio Villacorta Calderón, the Guatemalan Minister of Public Education (Kidder et al. 1946:1). Excavation of this rather unimpressive earthen mound—measuring a mere 20 m across and 6 m high—was concluded in 1937 by Jesse D. and Jane C. Jennings, while Kidder commenced excavation of its larger companion, Mound B (Mound F-VI-2). In 1942, Edwin M. Shook completed the investigation of this second structure. What began as a simple three-week project with a budget of $150 took three field seasons to finish because each mound consisted of multiple superimposed structures, the last of which were built in a local variant of the *talud-tablero* style. The mounds contained a total of twelve richly furnished tombs, eight minor burials, and two pit burials (Kidder et al. 1946:42–85).

The discovery of a large quantity of central Mexican–style ceramics—side by side with Maya vessels—in the tombs of Mounds A and B led to one of the most important breakthroughs in the history of Mesoamerican archaeology. These materials provided for the first time a way to tie directly the Classic-period ceramic sequence of the Maya region to that of the distant city of Teotihuacan, and hence, resolved a long-standing chronological puzzle.[1] A temporal overlap of Classic Maya and Teotihuacan cultures had been considered for several years (e.g., Joyce et al. 1927:311; Linné 1934:100, 220; Thompson 1939:225; Vaillant 1932:94), but was uncertain before the excavation of Mounds A and B. Coupled with the discovery of Preclassic, then called "Archaic" or "Middle Culture" (Vaillant 1930a, 1930b), pottery and figurines by Manuel Gamio (1926, 1927a, 1927b, 1927c) in the Finca Miraflores section of Kaminaljuyu, the Carnegie excavations demonstrated the long and essentially contemporaneous development of Maya and central Mexican

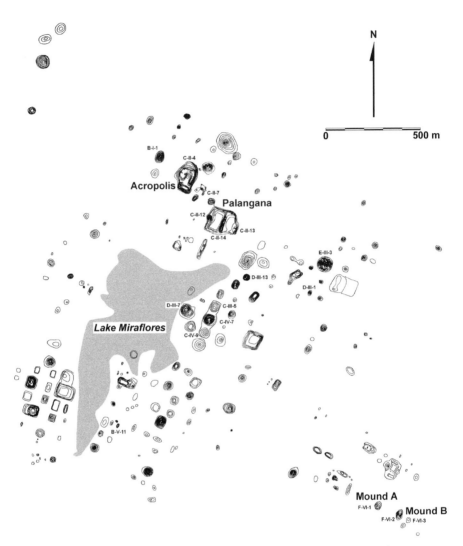

FIGURE 3.1. Kaminaljuyu, Guatemala (based on a survey by T. R. Johnson and E. M. Shook and on a plan by G. Espinoza).

societies. This had a profound effect on the diffusionist models of culture historians searching for a single Mesoamerican *cultura madre*. As Kidder et al. (1946:4) noted: "We should not think of Maya culture as the trunk of the Mesoamerican tree but merely as its most luxuriously blooming branch." Since the Maya "Old Empire" and Classic Teotihuacan were contemporaries, neither could have been the sole stimulus of Classic civilization in Middle America.

The discovery of central Mexican–style ceramics and architectural fea-

tures in Mounds A and B also led to a seemingly contradictory conclusion: that Teotihuacan had an extraordinary impact on the developmental trajectory of Kaminaljuyu. The quantity and quality of central Mexican–style artifacts found in the tombs of Mounds A and B were so impressive as to suggest that the individuals interred in the tombs were "a small group of warlike adventurers whose leaders became overlords of an already resident population" (Kidder et al. 1946:255). The Carnegie investigators argued that the invaders came from Teotihuacan and married local women who continued to produce utilitarian pottery belonging to a local tradition. Nonetheless, Kaminaljuyu was not considered to be representative of other Classic Maya sites. In fact, the influence of Teotihuacan at Kaminaljuyu was viewed as remarkable in part because it was thought to be unique. For this reason, the Carnegie investigators did not conclude that Teotihuacan caused the rise of the Classic Maya. Only in more recent years have archaeologists proposed that the emergence of state-level society in the Maya region was stimulated by interaction with Teotihuacan (e.g., Becker 1983; Sanders and Michels 1977; Sanders and Price 1968; Sanders et al. 1979).

In this chapter, I summarize the history of archaeological research at Kaminaljuyu, concentrating on the few projects that have found evidence for Early Classic interaction with central Mexico. The goal of this chapter is to place the evidence—chiefly the appearance of nonlocal architectural traits, imported or foreign-inspired ceramics, and green obsidian from the Pachuca source—within a chronological framework. In Chapter 4, I outline several theories that have been proposed to account for the presence of these materials in the Maya highlands. I then reexamine evidence at Kaminaljuyu for interaction with Teotihuacan and other sites in northwestern Mesoamerica. I conclude that foreign cultural traits tend to be superficial in character and are visible only on certain scales of analysis. These two factors suggest to me that central Mexican artifacts and symbol sets were manipulated in native cultural contexts by local people who were either unfamiliar with, or chose not to emulate, the details of Teotihuacan technology, style, and ritual. Neither conclusion supports the hypothesis that Teotihuacanos lived in a barrio at Kaminaljuyu, let alone controlled key aspects of the economy or political system of the site. Finally, I turn to other possible explanations for the appearance of central Mexican cultural traits in the Guatemalan highlands.

Archaeological Research at Kaminaljuyu

Few sites in the Maya area, and none in the Maya highlands save Copán, have a history of investigation that is as long and complicated as that

of Kaminaljuyu. Since the late 1950s, at least five multiyear projects and dozens of small-scale salvage operations have been conducted at the site. With the exception of the Pennsylvania State University Kaminaljuyu Project of 1968–1971, little of this work is well known outside of Guatemala. Until recently, this could be attributed to the fact that few projects adequately reported their results. Most of what we know about Gustavo Espinoza's five years of excavations in the Acropolis (Group C-II-4), for example, is due to Charles Cheek's (1977a:98–126) careful and indispensable analysis of architectural features left uncovered in the group. The Pennsylvania State University Project published an important annotated bibliography of Kaminaljuyu archaeology (Kirsch 1973), which includes many of the one- or two-page items that describe all that is known of some earlier excavations at the site. A recent bibliography, compiled by Shione Shibata (1994b:figura I.G.-III-4), contains references to many—but by no means all—projects conducted before 1994. Two short pieces summarize the history of archaeology at Kaminaljuyu and our understanding of the development of the site (Ericastilla and Shibata 1991; Popenoe de Hatch 1991).

Small-scale archaeological projects conducted at Kaminaljuyu in the past fifteen years are, in general, more adequately published than their predecessors. To a great degree this is due to the annual Simposio de Arqueología Guatemalteca, which since its inception has published nineteen volumes of papers delivered between 1987 and 1999. The Guatemalan directors of most salvage and investigatory operations conducted during this period have contributed to the series. Moreover, three large-scale projects—the Proyecto Kaminaljuyú/San Jorge (Popenoe de Hatch 1997), the Proyecto Arqueológico en el Centro y Sur de Guatemala (Ohi 1991, 1994c), and the Proyecto Arqueológico Miraflores II (e.g., Martínez et al. 1996; Popenoe de Hatch et al. 1996; Valdés et al. 1996; Valdés, Urquizú, and Castellanos 1996)—all have published monographs or filed multiple reports describing their field and laboratory research. Finally, a short but important monograph discusses the Culebra, one of the largest Preclassic constructions in Mesoamerica (Navarrete and Luján 1986).

Kaminaljuyu Chronology

For many Mesoamericanists, two continuing sources of confusion are the ceramic sequence of Kaminaljuyu and the absolute chronology of the site. As their work continued, the Carnegie investigators revised and published many ceramic chronologies, often proposing new phases, new orders of phases, and new names for existing phases (e.g., Berlin 1952; Borhegyi 1965; Kidder

1961; Shook 1952). The confusion generated by these conflicting chronologies is ably summarized by Shibata (1994b), who charts the development of temporal studies at Kaminaljuyu. Unfortunately, the Carnegie ceramicists never released a final report, so it often is less than obvious which ceramic taxa they considered as forming the complexes of different phases. Nonetheless, copious illustrations provided by Kidder et al. (1946), Shook and Kidder (1952), and by the authors of numerous shorter reports (e.g., Berlin 1952) document certain key periods in the sequence.

The Pennsylvania State University Project did not resolve problems with the ceramic chronology of Kaminaljuyu. Principal goals of that project were the investigation of settlement patterns and residential architecture subject to destruction by the uncontrolled expansion of Guatemala City. A report on the archaeological ceramics was published (Wetherington 1978b), but it is not a major achievement of the project. The chronological placement of types and wares in the report is especially inaccurate, and many temporally bound taxa (e.g., Esmeralda [elsewhere called Esperanza] Flesh Color, Amatle Hard Paste, and the Usulután ceramics) are assigned to all phases from the Middle Preclassic to Late Classic periods (Wetherington 1978a:Tables 3 and 4). A large part of this confusion must be attributed to the obsidian hydration dates that were used to determine the absolute chronology of certain contexts (see Michels 1973). As Edwin M. Shook (personal communication 1990) once noted: "Nothing has messed up our understanding of Kaminaljuyu chronology more than those obsidian dates; they set us back twenty years."

Fortunately, many problems with the ceramic sequence of Kaminaljuyu have been solved by Marion Popenoe de Hatch (1997) in her San Jorge report, perhaps the most important contribution to Kaminaljuyu archaeology since the publication of the Carnegie investigations of Mounds A, B, and E-III-3 (Kidder et al. 1946; Shook and Kidder 1952). Chapters in the recent volume devoted to the Late Preclassic and Early Classic pottery of the site describe in detail the wares characteristic of each phase and place a new emphasis on ceramic discontinuities first noted by Carnegie investigators.[2] As they wrote, "none of the characteristic Miraflores [Late Preclassic] types continued to be made in Esperanza [late Early Classic] times" (Kidder et al. 1946:246). A revised ceramic chronology for Kaminaljuyu that incorporates Popenoe de Hatch's work is presented in Figure 1.2.

The phases that constitute the ceramic chronology are dated by ceramic cross-ties with other sites and by chronometric data from Kaminaljuyu. Fifteen carbon samples collected from Carnegie and other early excavations at Kaminaljuyu were among some of the first to be assayed from the Maya re-

gion (see Michels 1973:Table 3). None of these dates are directly relevant to the appearance of central Mexican cultural traits at Kaminaljuyu, but four, discussed below, help fix a lower bound. The Pennsylvania State University Kaminaljuyu Project ran another nineteen radiocarbon dates (Michels 1973:Table 2), principally as a calibration check for a much more extensive program of obsidian hydration dating. Problems with the ceramic typology and chronology of the project, as well as the lack of descriptions of materials recovered from radiocarbon-dated contexts, limit the utility of the dates. Daniel Wolfman (1973:177–252; 1990:Table 15.1; see also Cheek 1977a:Table 2) determined a total of sixteen archaeomagnetic dates from Pennsylvania State University and Instituto de Antropología e Historia excavations, some of which date the occupation of *talud-tablero* structures.[3] More recently, the Proyecto Arqueológico en el Centro y Sur de Guatemala assayed fifteen carbon samples from their excavations in Mounds B-I-1 and D-III-1 and experimented with archaeomagnetic dating (Sakai et al. 1994). The ceramic analysis conducted by members of that project is described in only four pages (Ohi et al. 1994:505–508), and there is no tabulation of the ceramic types found associated with the assayed carbon.

Excavations of *Talud-Tablero* Architecture and Esperanza-Phase Ceramics at Kaminaljuyu

The six decades of archaeological research since the Carnegie Institution concluded its investigations at Mounds A and B have revealed significant quantities of central Mexican–style artifacts in just one other portion of the site: the Palangana (Mounds C-II-12, -13, and -14). *Talud-tablero* architecture has been found in this group and in the neighboring Acropolis (Group C-II-4). Components of the style have also been discovered at a few more mounds dating to the Classic period, such as the Mound C-II-7 ballcourt (Borhegyi 1965:21–22; Shook and Smith 1942), Mound F-VI-3 (see Cheek 1977a:128), a nearby nonmound structure (Shook and Smith 1942), and possibly Mound D-III-1 (Miles 1963; Murcia 1994; Ohi 1994a; Rivera and Schávelzon 1984; Shibata 1994a, 1994c) and Mound D-III-13 (Berlin 1952).[4] With the exception of the last two, all are found in just two portions of the site: Finca Esperanza and the Acropolis-Palangana complex, located respectively in the southeastern and northern peripheries of Kaminaljuyu (Figure 3.1). *Talud-tablero* architecture and central Mexican–style pottery, then, have a very limited distribution.

Mounds A and B. Before turning to more recent excavations, a few points must be made about Mounds A and B in order to correctly place them within

the Esperanza phase. Cheek (1977a:154–155) astutely observes that Tombs A-I and A-II contained central Mexican–style ceramics such as Thin Orange ware, "cream pitchers," and cylindrical tripod vessels, but date to a period *before* the first appearance of the *talud-tablero* style and construction techniques that may be derived from central Mexico. In contrast, the opposite temporal pattern has been identified at Tikal, where a local variant of *talud-tablero* architecture developed long before the first central Mexican–style vessels were placed in tombs and problematical deposits (see Chapter 7). The buildings with which the earliest Esperanza tombs were associated, Structures A-1, A-2, A-3, and B-1, were built in a local style and were constructed using local techniques. They were simple shrines or altars, for the most part made of earth, that were erected over burials (Figure 3.2a–c; Kidder et al. 1946:12–15, 28–30). Since the earliest known Esperanza ceramics appear to date to a period devoid of foreign architectural influence, we should place all examples of the *talud-tablero* style at Kaminaljuyu somewhat later than the beginning of the Esperanza phase. Cheek (1977a:Figure 62) calls this initial period of interaction the Contact phase.

Kidder et al. (1946:15–20, 30–34) noted a second architectural pattern in the three structures that succeeded Structure A-3 and the two that followed Structure B-1. These five platforms consisted of a single, large *talud*. Structures A-4, A-5, A-6, and B-3 also contained a vertical cornice, a smaller summit platform that (at least in some cases) supported a superstructure, and offset stairs with balustrades (Figure 3.2d–f). Although certain elements of the *talud-tablero* style were present, others—notably finial blocks (called *remates*) and a true *tablero*—were missing. Moreover, all five structures were earthen constructions. Because of the presence of some foreign features combined with local elements and building techniques, Cheek (1977a:Figure 62) refers to this as the Integration phase.

The final two versions of both Mound A and B were built of what the Carnegie excavators called "pumice pudding" and coated with an exterior layer of *piedrín*, a concrete made of lime and bits of black volcanic ejecta (Kidder et al. 1946:20). This material is similar to the concrete used to cover buildings at Teotihuacan. Flat slabs of stone were tenoned into the buildings and, at least in Structure B-4 (Kidder et al. 1946:36), these supported *tableros*. The facing was gone from Structure A-7, and Structures A-8 and B-5 were encountered in a highly destroyed state, so the *tableros* shown in Figure 3.2g–h are hypothetical—though highly probable—reconstructions. The presence of all these elements, particularly the true *tablero* and the use of *piedrín*, signals the fullest manifestation of the *talud-tablero* style at Kami-

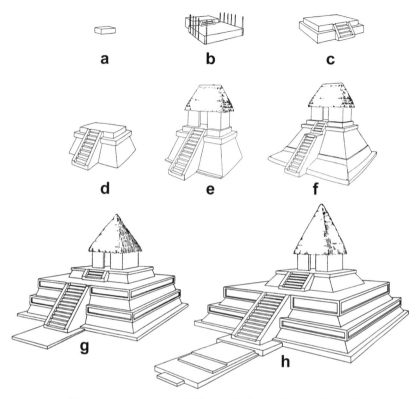

FIGURE 3.2. Construction sequence of Mound A, Kaminaljuyu: (a) A-1; (b) A-2; (c) A-3; (d) A-4; (e) A-5; (f) A-6; (g) A-7; (h) A-8 (Kidder et al. 1946:Figures 106–108; redrawn from Kidder et al. 1946:Figure 109, using information in their text).

naljuyu. For this reason, Cheek (1977a:Figure 62) calls this the Teotihuacan phase. Nevertheless, as is discussed in the next chapter, these structures differ in important ways from most of the *talud-tablero* buildings in the great central Mexican city.

Other than four unreliable obsidian hydration measurements (Cheek 1977a:146), no chronometric dates are available for the sequence of structures and tombs excavated at Mounds A and B. Because little change was observed in the ceramic contents of the tombs, Kidder et al. (1946:258) wrote: "We believe that Mounds A and B served as a place of sepulchre for not over a century and perhaps for a considerably shorter time." But they stressed that as a ceramic temporal unit, the Esperanza phase probably lasted longer. In particular, they noted that A. Ledyard Smith's (Shook and Smith 1942) excavations in the Acropolis produced sherds that were similar to the ceramics of Mounds A and B, but also found additional types not known from

Finca Esperanza. Moreover, certain types from Mounds A and B were not recovered from Smith's excavations (Kidder et al. 1946:258).

Acropolis. Excavations in the Acropolis were conducted by A. Ledyard Smith in 1941 and 1942 as part of his study of highland ballcourts (Shook and Smith 1942; Smith 1961). Two tenoned markers were discovered in association with an Amatle- or Pamplona-phase ballcourt built on top of earlier Late Classic terraces. What is now called Structure E, built in the *talud-tablero* style, was found below the terraces. Arenal- or Verbena-phase pottery was found deeper still.

After a lapse of fifteen years, Gustavo Espinoza continued Smith's work in the ballcourt and expanded excavations to the north (Borhegyi 1956). During the five years of his project, he uncovered as many as twenty Early and Late Classic structures, labeled A through S and M[1] by Tatiana Proskouriakoff and Charles Cheek (1977a). Structures A, D, E, F, G, J, and K contain elements of the *talud-tablero* architectural style (Figure 3.3). What little we know about these excavations is due to the work of Proskouriakoff, who in 1962 drew plans and sections of some of the structures, and of Cheek (1977a:98–126), who analyzed the exposed architecture ten years later.

Correlating the construction of these *talud-tablero* buildings with the ceramic chronology of Kaminaljuyu is problematic. Only rudimentary provenience information was recorded by Espinoza, and notes explaining his recording system were lost. Cheek (1977a:101), however, did examine ceramic collections from the excavations and concludes that many are either pure Aurora- or Amatle-phase lots. It is significant that he does not mention central Mexican–style ceramics belonging to the Esperanza complex. This underscores two points. First, the Esperanza complex, as originally identified from the ceramics recovered from Mounds A and B, differs from the preceding Aurora complex chiefly in that it includes high-status mortuary ceramics of an exotic style. That is, the Esperanza complex of Mounds A and B was as much a result of context as chronology. The Acropolis excavations apparently did not discover elite tombs, so it is not surprising that Cheek (1977a) does not mention Teotihuacan-style vessels. Fortunately, Popenoe de Hatch (personal communication 1996) has identified morphological changes in utilitarian wares that may be used to identify Esperanza-phase contexts lacking elite mortuary ceramics. Heinrich Berlin (1952) also mentioned several attributes that can be used to distinguish Aurora pottery from local-style Esperanza ceramics.

The second point is that the disappearance of central Mexican–style pottery from the ceramic inventory of Kaminaljuyu may not have coincided

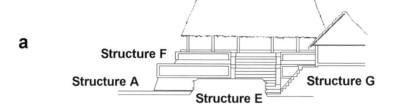

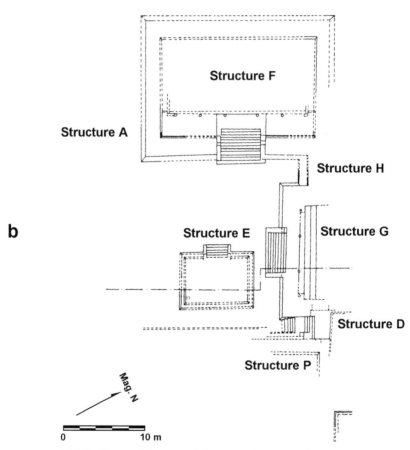

FIGURE 3.3. *Talud-tablero* architecture of the Acropolis, Kaminaljuyu: (a) section; (b) plan (redrawn from Cheek 1977a:Figures 53 and 57).

precisely with the abandonment of architectural traits adopted from Teotihuacan, if indeed that was the source of inspiration at Kaminaljuyu. The *talud-tablero* architecture of the Acropolis, therefore, need not date to the Esperanza ceramic phase, but may be associated with the succeeding Amatle phase. At Tikal, for example, the *talud-tablero* style endured after central Mexican–style vessels ceased to appear in tombs and problematical deposits (see Chapters 6 and 7). The opposite pattern has been noted for Copán (see Chapter 5). The appearance and disappearance of central Mexican ceramic and architectural traits from the archaeological record do not necessarily coincide.

There are no radiocarbon dates from the Acropolis. In 1971 and 1972, Wolfman (1973, 1990) collected five samples from Structures A, D, and L for archaeomagnetic dating. Structure L was constructed at a time after *talud-tablero* architecture ceased to be built in the Acropolis. The two dates from Structure L, therefore, provide an upper limit for the architectural style. Sample 775 dated to A.D. 595–615, and Sample 586 to either A.D. 745–795 or A.D. 825–875 (Wolfman 1990:Table 15.1). It is likely, therefore, that the *talud-tablero* architecture of the Acropolis was built and occupied before A.D. 615.[5] Structure A has a *talud-tablero* façade, contains a stair with balustrades that are capped with finial blocks, and is covered with *piedrín*. It belongs to Cheek's (1977a:Figure 62) Teotihuacan phase, roughly contemporary with or later than Structures A-7, A-8, B-4, and B-5. Two archaeomagnetic samples were taken from Structure A and were dated to A.D. 490–525 (Sample 584) and A.D. 500–520 (Sample 772; Wolfman 1990:Table 15.1). Structure A, therefore, probably was constructed no later than A.D. 520. Structure D, which was built in the same general construction stage as Structure A, is covered with *piedrín*, contains a *talud*, and has a stair with a balustrade. Somewhat later, the structure was modified and steps covered with *pumidrín* (a substance containing pumice that was used later in the Early Classic than *piedrín*) were built (Cheek 1977a:108). Wolfman (1990:Table 15.1) collected Sample 585 from a baked *piedrín* floor in Structure D, which he dated to A.D. 585–610. Thus Structure D of the Acropolis probably was built before A.D. 610.

Although we have no chronometric data from the Acropolis that place a lower limit on the construction dates of *talud-tablero* architecture, it seems likely that all structures of that style were built before A.D. 615. Moreover, structures belonging to the Teotihuacan phase, which exhibit the most developed form of the style, were used heavily during the sixth century.

Palangana. Additional information on the chronology of both Esper-

anza ceramics and *talud-tablero* architecture comes from Sean Cárdenas and Cheek's (1977a:7–98) excavations in the Palangana (Structures C-II-12, -13, and -14), located 200 m southwest of the Acropolis. Samuel Lothrop (1926) found several sculptures in this area and excavated one between Mounds C-II-12 and -14. Carnegie investigators who gave the group its name once thought that the space where Lothrop worked was a giant ballcourt. In fact, Smith (1961) and all later researchers in the central highlands refer to many *palangana*-style ballcourts dating to the Late Classic period. Lee A. Parsons (1967–1969), on the other hand, suggested that it served as a monument plaza. Cheek (1977a) refers to the area as the Lower Plaza.

Excavations in the center of the Lower Plaza exposed a structure built in five major construction stages (Cheek 1977a:37–70). The first three of these, called Stages E1, E2, and E3, date to the late Early Classic period. Cheek subdivides Stage E2 and Stage E3 into four substages each, but the distinction will not be used here. Stage E1 was a small platform built with the shape of a sloping *talud*. There is some evidence that it contained a stair with a balustrade. The sloping platform supported a superstructure. If the reconstruction is correct, the superstructure had three walls that were flush with the edges of the platform (Cheek 1977a:37–42). The corners of the superstructure apparently were vertical columns offset out from the corners of the platform. Thus, the superstructure formed a *tablero* framed on the sides and perhaps on top (Figure 3.4a). The entire Stage E1 structure was coated with *piedrín*. Both the *tablero* and the use of *piedrín* are defining traits of Cheek's Teotihuacan phase (Cheek 1977a:Figure 62). That is, the Stage E1 structure appears to be roughly contemporary with the last two versions of Mounds A and B and with the *talud-tablero* structures of the Acropolis.

The Stage E1 structure was built above a disturbed tomb called Burial 1 (Cheek 1977a:42, 169–175). One ceramic vessel was found within the tomb, but it is neither described nor illustrated and cannot be assigned to any ceramic phase. The sole radiocarbon date from this portion of the Palangana comes from the tomb. It is 1505 ± 90 BP (I-6608), which has a one-sigma calibrated range of A.D. 444–615 and a two-sigma range of A.D. 343–669 (Michels 1973:Table 2; Stuiver and Kra 1986:805–1030). If the carbon sample was not introduced at a later time, we can assert at the 84.1 percent confidence level that the E1 structure above the burial was built no earlier than A.D. 444. Since the Palangana structure was constructed in the same architectural style as the *talud-tablero* structures of the Acropolis and the last two versions of Mounds A and B, the mid–fifth century may be considered an approximate lower limit for the construction dates of these structures.

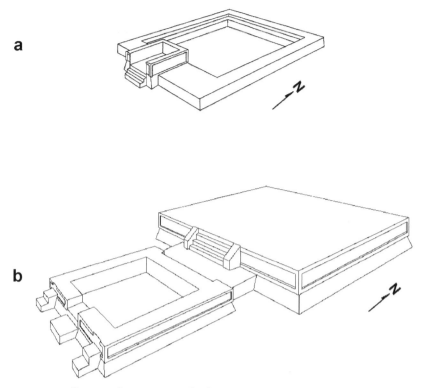

FIGURE 3.4. Construction sequence of Palangana structure, Kaminaljuyu: (a) Stage E2-a with Stage E1 visible in center of south side; (b) Stage E3-c (redrawn from Cheek 1977a:Figures 13, 14, and 22).

The Stage E1 platform was incorporated into the Stage E2 structure, a peculiar *piedrín*-coated building that Cheek (1977a:42–50) calls an enclosure. It was a rectangular sunken area completely surrounded by a parapet (Figure 3.4a). The function of the building is not known, but it contained no central Mexican architectural features other than those left exposed on the Stage E1 structure. Burial 2 was cut into the last substage of the Stage E2 structure, probably when the Stage E3 structure was built. Grave goods from the tomb include stone and limonite plaques and other items similar to those found in the Mound A and B tombs. Moreover, the deceased may have been seated in the cross-legged "tailor position" shared by the principal occupants of many of those burials. The ceramic inventory consists of four bowls, a "napkin ring," and a possible censer (Cheek 1977a:175–177). Brief descriptions of the vessels suggest that they belong to the Esperanza complex.

Unlike its predecessor, the Stage E3 structure was built in the *talud-tablero*

style. It consisted of an enclosure, accessible in later substages by a southern stair, a small platform or step that Cheek (1977a:51) calls an atrium, and a large platform that supported a superstructure (Figure 3.4b). In its earliest substage, the *talud-tablero* on the large platform of the Stage E3 structure did not pass completely around the building. Instead, the north façade (rear of the platform) and the northern half of the sides were built in two terraces, the lower of which resembled a bench (Cheek 1977a:53). This partial *talud-tablero* is stylistically similar to some examples at Tikal (see Chapter 7). In the following substage, a partial *talud-tablero* was added to the enclosure. An archaeomagnetic date of A.D. 525–545 was determined for a sample taken from the third version of the atrium (Wolfman 1990:Table 15.1, Sample 474). The fourth version of the Stage E3 structure was coated with *pumidrín*, suggesting that it was built after the last versions of Mounds A and B and near the end of the sequence of *talud-tablero*-style architecture.

Burial 3, which was roughly contemporary with Burial 2 and the construction of the first version of the Stage E3 structure, was found within the fill of E3. Its contents are quite similar to those of Burial 2 and the tombs of Mounds A and B. Burial 3 contained seven ceramic vessels, two of which are tripod cylinders (Cheek 1977a:Figure 66). Two limonite laminated plaques were found, including one on the lap of the sitting skeleton. A dog was also interred with the deceased.

Wolfman (1990:Table 15.1) and Cheek (1977a:Table 2) mention two other archaeomagnetic dates that are relevant to the chronology of *talud-tablero* architecture in the Lower Plaza. These are A.D. 535–555 (Sample 470) and A.D. 515–530 or A.D. 550–565 (Sample 477). A reference and two brief contextual descriptions suggest that the samples came from the Stage E3 structure (Cheek 1977a:94, Table 2; Wolfman 1990:Table 15.1). These two dates, then, suggest that the Stage E3 structure was used during the sixth century.

Cheek (1977a:76–92) also conducted excavations in Mound C-II-14. The long construction sequence of this mound included several versions that were coated with *piedrín* or *pumidrín,* and at least one version contained a stair with offset balustrades. No *talud-tableros* were found, but Cheek (1977a:84) postulates their existence. A total of eleven archaeomagnetic samples were collected, and all yielded very early dates. Wolfman (1990:275, 301) attributes these erroneous dates to a possible lightning strike. A radiocarbon date of 1175 ± 90 BP (I-6611), which has a one-sigma calibrated range of A.D. 740–945 and a two-sigma range of A.D. 667–1010 (Stuiver and Kra 1986:805–1030), was determined from a sample collected from Mound

C-II-14 (Michels 1973:Table 2). The radiocarbon assay suggests that the feature dates to the Amatle or Pamplona phase.

Archaeomagnetic Sample 483, which produced a date of A.D. 525–545 or A.D. 550–570, was collected from the floor of a largely unexplored platform in the Upper Plaza (Wolfman 1990:Table 15.1). Two caches near the platform contained a number of cylindrical tripods, suggesting that the platform might date to the Esperanza phase (Cheek 1977a:94–95).

Mound D-III-13. Excavations in this large mound were conducted by Heinrich Berlin (1952), Joel S. Canby, and Gustavo Espinoza. In addition to the highly eroded final version (called Structure N), at least three substructures (Structures K, L, and M) were revealed. It was first thought that all construction dated to the Esperanza phase, but the ceramics recovered during excavations differed from those of Mounds A and B enough for Berlin (1952:17) to propose a new phase, which he called Aurora. The Aurora complex lacks the central Mexican–style vessels of the Esperanza phase. Because locally produced stuccoed tetrapod vessels and flanged tetrapod bowls were found in Mound D-III-13, but were limited to the earliest contexts from Mounds A and B, the Aurora phase was proposed as an Early Classic precursor to the Esperanza phase.

The Mound D-III-13 excavations are relevant for two reasons. First, Structure N, the last version of the platform, may date to the transition between local and central Mexican–inspired architectural styles. Structure N had a stair built of pumice blocks that may have been flanked by a balustrade (Berlin 1952:9), two features that Cheek (1977a:131–132) ascribes to central Mexican influence. Second, since earlier versions of Mound D-III-13 were older than Mounds A and B, four radiocarbon dates from the excavations may be used to define a lower limit for both the Esperanza complex and the appearance of *talud-tablero* architecture at Kaminaljuyu.

The four radiocarbon dates determined from the Mound D-III-13 excavations are 1560 ± 70 (Y-629), 1660 ± 60 (Y-405), 1785 ± 60 (Y-378), and 1860 ± 60 (Y-396) (Michels 1973:Table 3). The one-sigma ranges for the calibrated dates are A.D. 422–568 (Y-629), A.D. 285–450 (Y-405), A.D. 153–320 (Y-378), and A.D. 84–220 (Y-396) (Stuiver and Kra 1986:805–1030). If these dates all represent the Aurora phase, we may combine them in order to find an interval that probably lies within the phase. The one-sigma range for a combined calibrated date is A.D. 260–352, and the two-sigma range is A.D. 233–390. These fit rather well within the span proposed by Popenoe de Hatch (1997) for the Aurora phase (Figure 1.2).

The contexts from which the carbon samples originated are somewhat problematic. Y-629 and Y-378 were associated with Burial 1, which was in front of, rather than below, Structures K, L, and M. This suggests that it dated to a late period in the architectural sequence. A plaza floor and first step of a stair were discovered over Burial 1 (Berlin 1952:figura 1). It appears that these features pertained to a version of Mound D-III-13 built after Structure M and possibly should be associated with Structure N.[6] The earlier of the two dates associated with Burial 1 came from the interment itself, and the later date was determined from a sample recovered from below the burial (see Michels 1973:Table 3). The two dates do not overlap in their one-sigma ranges, but do in their two-sigma ranges (A.D. 326–385). Perhaps old charcoal was introduced into Burial 1.

The samples that yielded dates Y-405 and Y-396 were associated with various versions of Mound D-III-13. Sample Y-405 predates Structure K, and Sample Y-396 came from a posthole that was more recent than Structure M but earlier than Structure N (Michels 1973:Table 3). As with the other two dates, there is an apparent stratigraphic reversal. Y-396 and Y-405 do not overlap in their one-sigma range, but do in their two-sigma ranges (A.D. 240–315). One explanation for the apparent reversal is that Sample Y-396 could have come from an old post that was reused in a later structure.

Y-405, the later of the two dates from the core of Mound D-III-13, suggests at the 84.1 percent confidence level that the Aurora phase continued until at least A.D. 285. The sample that yielded this date came from a post within the fill of a "structure below Structure K" (Michels 1973:Table 3). That is, this unnamed structure; Structures K, L, and M; at least two major construction stages after M (represented by Floors 3, 3a, 4, and the three predecessors to Floor 4); and Structure N all were probably built after A.D. 285 (see Berlin 1952:figura 1). It does not seem likely that this long construction and occupation sequence could represent a period of less than fifty years. In sum, the Aurora phase probably continued well into the fourth century.

Other relevant excavations. Several additional projects exposed *talud-tablero* architecture or recovered ceramics belonging to the Esperanza complex. These include Smith's and Stephan de Borhegyi's brief explorations of the Mound C-II-7 ballcourt (Borhegyi 1965), Espinoza's excavation of an exposed area south of the Palangana, Ismael Tercero and Vivian Browman Morales' exploration of Mound F-VI-3, and Smith's (Shook and Smith 1942) investigation of an unnamed structure east of Mound B. Detailed descriptions of these excavations have not been published.

Dating *Talud-Tablero* Architecture and Central Mexican–style Ceramics at Kaminaljuyu

The previous section summarizes all that is known about the distribution of Esperanza pottery and *talud-tablero* architecture at the site. What is perhaps most notable is that no project conducted during the past thirty years has recovered more than a handful of central Mexican–style sherds or exposed additional examples of *talud-tablero* architecture. The reason seems to be that their distribution at Kaminaljuyu is quite limited, appearing in only the Acropolis-Palangana complex and the Mounds A and B area of the former Finca Esperanza. Locally produced Esperanza ceramics also seem to have a limited distribution. Compared to the Late Preclassic and Late Classic periods of florescence at Kaminaljuyu, the late Early Classic was one of diminished activity. I have placed special emphasis on the few chronometric dates that allow us to fix the occurrence of central Mexican–style ceramics and architecture in time, and I summarize the data in this section. Of course, any or even all of the dates may be in error. Moreover, there are always problems when different kinds of chronometric dates—in this case, radiocarbon assays and archaeomagnetic measurements—are combined.

To begin with, it is important not to equate the appearance of *talud-tablero* architecture with either the Esperanza phase or the period when central Mexican–style pottery was used at Kaminaljuyu. Central Mexican–style ceramics, which in part define the Esperanza complex, are found in tombs that predate the first appearance of *talud-tablero* architecture. Moreover, the Esperanza complex contains both central Mexican–style funerary vessels and locally produced ceramics derived from the older Aurora complex. It is possible that the presence of central Mexican–style vessels may be limited to a temporal facet within a longer Esperanza phase.

We have few dates that allow us to fix a lower bound for either the beginning of the Esperanza phase or the first appearance of central Mexican ceramics at Kaminaljuyu. The four radiocarbon dates from Mound D-III-13 suggest that much or all of the fourth century should be subsumed within the Early Classic Aurora phase. Only one radiocarbon date (Y-629, calibrated to A.D. 422–568) from excavations at Mound D-III-13 suggests that the Aurora phase might last until sometime later than A.D. 400, but the stratigraphic relationship of the sample with the mound is not clear. Moreover, Cheek (1977a:131–132) proposes that the last construction phase of Mound D-III-13, with which the burial may be associated, might date not only to the Esperanza phase but also to a period when certain features of the *talud-*

tablero style were used at Kaminaljuyu. In sum, the dates from Mound D-III-13 make it unlikely that either the Esperanza phase or the consumption of central Mexican–style ceramics began earlier than the middle of the fourth century.

An upper bound for the beginning of the Esperanza phase and the appearance of foreign-style pottery may be extrapolated from archaeomagnetic and radiocarbon dates from the Acropolis and the Palangana. An archaeomagnetic date (Sample 772) suggests that Structure A of the Acropolis was constructed before A.D. 520. Structure A is stylistically similar to, and hence roughly contemporary with or later than, the last two versions of Mounds A and B. If we assign at least fifty years for the construction and use of the first six versions of Mound A and the first three of Mound B—which were built in two earlier architectural styles—we may reasonably date the beginning of the Mounds A and B sequence to before A.D. 470. Since both foreign-style and locally produced Esperanza ceramics were found in the earliest tombs of Mounds A and B, a reasonable upper bound for the beginning of the Esperanza phase is the middle of the fifth century.

The end of the Esperanza phase is not clearly defined either. A radiocarbon date (I-6608) from Tomb 1 and as many as three archaeomagnetic dates (Samples 470, 474, and 477) from the Palangana sequence "sandwich" Burials 1–3 within the century A.D. 444–545. Burial 3 contains both foreign- and local-style Esperanza-phase ceramics, and both Burials 2 and 3 are similar in many respects to the tombs of Mounds A and B. It is reasonable to propose, therefore, that central Mexican–style and local Esperanza pottery continued to be used until at least the end of the fifth century. Wolfman (1990:Table 15.1) determined five archaeomagnetic dates (Samples 469, 479, 583, 586, and 775) from contexts that are said to date to the Amatle phase. One of these, Sample 775 (A.D. 595–615) comes from Structure L of the Acropolis, constructed in a post-*talud-tablero* style. Since ceramics from the Acropolis were not studied in detail, the assignment of Structure L to the Amatle phase seems to be based entirely on the assumption that the end of *talud-tablero*-style architecture at Kaminaljuyu coincided with the end of the Esperanza ceramic phase. The least upper bound of the other four archaeomagnetic dates is A.D. 735. Five radiocarbon dates (I-6611, -6743, -6270, -6246, and -6251) determined by the Pennsylvania State University Project pertain to the Amatle phase (Michels 1973:Table 2). The earliest of these is 1430 ± 90 (I-6251), which has a one-sigma calibrated range of A.D. 503–672 (Stuiver and Kra 1986:805–1030). The sample was collected from the excavated superstructure of Mound B-V-11 (Webster 1973).[7] Recent excavations

indicate that the ceramics associated with the end of the Mound B-V-ii sequence date to the Late Classic Amatle phase (Martínez et al. 1996). Thus, we can be reasonably confident that both the Esperanza phase and the use of foreign-style mortuary ceramics ended no later than the middle of the seventh century, and perhaps one hundred or more years before that date. In sum, the Esperanza ceramic phase appears to have begun during the late fourth century or early fifth century, and certainly was over by the middle of the seventh century. The use of central Mexican–style ceramics might have been limited to a facet within the phase, but both the earliest (Tombs A-I and A-II) and the latest (Tombs B-IV, -V, and -VI, and perhaps Burials 2 and 3 of the Palangana) contexts from which Esperanza-phase ceramics have been recovered contained both foreign-style and local wares.

The earliest examples of Kaminaljuyu architecture containing elements of the *talud-tablero* style are Structures A-4, A-5, A-6, B-2, and B-3 of Mounds A and B. These were *talud*-and-cornice structures that were not coated with *piedrín*. They were not directly dated, but must be older than the *piedrín*- and *pumidrín*-covered structures containing *tableros* that were excavated in the Acropolis and Palangana. The least upper bound for the construction of this second group of structures is A.D. 520. Since we must allow a certain amount of time for the A-4 to A-6 sequence, it appears quite likely that the earliest of these was constructed before A.D. 500. But these structures could be a century or more older without breaking the lower limit set for the Esperanza phase.

We are on somewhat firmer footing when dating the end of the *talud-tablero* style at Kaminaljuyu. It seems likely that Structure D, a *piedrín*-covered structure with a stair and balustrade, was occupied at least until A.D. 585 (archaeomagnetic Sample 585). Structure L, a post-*talud-tablero*-style structure, appears to have been built no later than A.D. 615 (archaeomagnetic Sample 775). Thus it seems quite likely that the earliest manifestations of the *talud-tablero* style at Kaminaljuyu date to before A.D. 500 (and perhaps a century or more before that date), and that the style ceased to be used around A.D. 600.

Implications of the Dates for Central Mexican–Style Ceramics and Architecture at Kaminaljuyu

I have discussed the chronology of both the Esperanza phase (c. A.D. 350/450–500/650) and *talud-tablero* architecture (c. A.D. 370/500–600) for several reasons. First, the earliest indications of Classic Maya/central Mexi-

can interaction—found at sites in the Pacific plains of Guatemala (Chapter 2), at Tikal (Moholy-Nagy and Nelson 1990), at a few sites in Belize such as Altun Ha (Chapter 9) and Nohmul (Hammond et al. 1985:193; Hammond, Donaghey et al. 1987:280; Hammond, Rose et al. 1987:106), and perhaps also at Becan (e.g., Ball 1979:271–272)—date to a time well before the inception of the Esperanza phase and the first appearance of *talud-tablero* architecture at Kaminaljuyu. Although Pacific Guatemala and the eastern Maya lowlands attracted the attention of Teotihuacan during the Miccaotli or Early Tlamimilolpa phases, Kaminaljuyu did not participate in this "Early Pulse" of central Mexican–Maya interaction. This may seem surprising given the proximity of Kaminaljuyu to the Pacific piedmont and the location of the site at the upper end of a major communication route connecting the south coast to the central Maya highlands. But the century surrounding the Terminal Preclassic to Early Classic transition at Kaminaljuyu was a period of great disruption: population levels dropped, construction decreased, literacy and a carved-stone sculptural tradition disappeared,[8] one ceramic tradition was replaced by another, and lithic technology changed (e.g., Braswell and Amador 1999; Popenoe de Hatch 1997, 1998). Given these upheavals, which probably represent the near abandonment of the site by its Preclassic inhabitants and an influx of new settlers from the western Guatemalan highlands, it is not surprising that connections with the Pacific Coast, and hence indirectly with central Mexico, were quite weak during the period A.D. 150–250.

The beginning of the Esperanza phase, and probably also the first appearance of *talud-tablero* architecture at Kaminaljuyu, is contemporary with the Early Xolalpan phase of Teotihuacan. Nonetheless, several different "Late Pulse" assignments for the period of intense central Mexican–Kaminaljuyu interaction are consistent with the available evidence. Chronological data for Kaminaljuyu are sufficiently blurry that we can rule out neither Cheek's (1977b:443) late model nor the early models of Clemency C. Coggins (1979:259) and René Millon (1988:122). There has been much discussion regarding the transmission of central Mexican traits to the Maya highlands and lowlands, and whether or not Kaminaljuyu was responsible for introducing central Mexican–style iconography and pottery to Tikal. Specifically, it has been suggested that Yaax Nu'n Ahyiin ("Curl Nose"), who became king of Tikal in A.D. 379, was a foreigner from Kaminaljuyu (Coggins 1979). Evidence for interaction between central Mexico and Tikal that can be dated to his reign include Stela 4 (erected in A.D. 379) and the materials in Burial 10, which is thought to be his tomb.[9] Many of the Manik 3A problematical deposits discussed by María Josefa Iglesias Ponce de León (Chapter 6) also

date to either the reign of Yaax Nu'n Ahyiin or to that of his son. Coggins' (1979) hypothesis has been questioned on the grounds that central Mexican-style pottery appeared for the first time at Kaminaljuyu *later* than it did at Tikal. But chronological evidence for the beginning of the Esperanza phase and the earliest foreign-style pottery in Mound A is insufficient for determining if Tombs A-I and A-II precede, are contemporary with, or postdate the life of Yaax Nu'n Ahyiin. These early Esperanza tombs and their central Mexican–style pottery could date to either the late fourth century or to the early fifth century. Thus, we do not know if central Mexican–style ceramics appeared first at Tikal or earlier at Kaminaljuyu.

Tikal Burial 48 (Coe 1990, 1:118–123; Shook and Kidder II 1961), which was dedicated and sealed in A.D. 457/458,[10] is thought to be the tomb of Siyaj Chan K'awiil ("Stormy Sky"; Coggins 1975:193–201). In several respects, most notably the bundled and seated position of Skeleton A, Burial 48 more closely resembles the later tombs in the Mounds A and B sequence than it does the earlier tombs. In contrast, Tikal Burial 10 shares more similarities with the earliest tombs in Mounds A and B than it does with the later burials. Tombs A-I and A-II, therefore, might date to a time close to—but before, during, or after—A.D. 420. Moreover, it may be that the later tombs in the Mounds A and B sequence span the mid–fifth century.

Similarly, it is not clear if the first appearance of central Mexican ceramics at Copán precedes or postdates the beginning of the Esperanza phase. The earliest dated examples of central Mexican ceramics at Copán are from the Hunal tomb, thought to be the burial of the dynastic founder K'inich Yaax K'uk' Mo', who died in A.D. 437 (Chapter 5). This is close to the upper limit for the beginning of the Esperanza phase, but well within it. The fact that the individual in the Hunal tomb was buried in an extended position may be taken as weak corroboratory evidence that Tombs A-I and A-II of Kaminaljuyu are roughly contemporary. Thus, although we have ample evidence for interaction between Kaminaljuyu, Tikal, and Copán during the late Early Classic, temporal data do not allow us to propose any one of these sites as the point of origin from which central Mexican–style pottery spread throughout the Maya region.

The pattern of the end of the use of central Mexican–style mortuary ceramics is clearer. The end of the Manik 3A phase of Tikal, to which most foreign-style vessels are assigned, was approximately A.D. 480. In fact, only one of the vessels from Tikal Burial 48 is of a foreign style (see Chapter 6). The end of the practice of using central Mexican–style vessels at Copán is roughly contemporary with Tikal Burial 48. The last known central Mexi-

can imports and copies at Copán come from the Margarita tomb, dated to c. A.D. 445–460 (Chapter 5).[11] In contrast, it seems likely that the Esperanza phase continued until at least A.D. 500, and perhaps until the early seventh century.

It is clear that *talud-tablero* architecture appeared at an earlier date at Tikal than at either Kaminaljuyu or Copán (see Chapter 7). But Hunal—the only *talud-tablero*-style structure discovered so far at Early Classic Copán—was built, used, and abandoned between A.D. 427 and 437, a time that could have been before or after the first appearance of the style at Kaminaljuyu. At Copán, the end of the *talud-tablero* style, or more properly its Early Classic manifestation, dates to the death of K'inich Yaax K'uk' Mo'. In contrast, *talud-tablero* structures were built and used in Tikal throughout the fifth century. The last expressions of the full *talud-tablero* form at Tikal are three platforms dating to the second half of the sixth century (see Chapter 7). These are roughly contemporary with the last *talud-tablero* structures of the Acropolis of Kaminaljuyu.

The chronological placement of central Mexican–style ceramics and architecture at Kaminaljuyu is relevant to the timing of important events at Teotihuacan. At that site, there is little evidence for the local production of cylindrical tripods before A.D. 300 or after A.D. 600 (Chapter 12). All of the central Mexican–style vessels found at Kaminaljuyu date to a period after A.D. 300,[12] but a date later than A.D. 600 cannot be completely ruled out for the sixteen cylindrical tripods found in Tombs B-IV, -V, and -VI. It is not known if these vessels were imported or locally produced, but the shape and decoration of most do not suggest a central Mexican origin (Foias 1987). The oldest examples of the *talud-tablero* architectural style at Kaminaljuyu almost certainly date to a time after the middle of the fourth century, long after the style first appeared at Teotihuacan. In particular, Mounds A and B, which are similar in some respects to the Feathered Serpent Pyramid, clearly date to a time after that structure was built. These three structures are discussed in detail in the next chapter.

Most interestingly, strong manifestations of foreign stylistic influence at Kaminaljuyu seem to date to about A.D. 500, a time later than central Mexican–style ceramics appear at either Tikal or Copán, but roughly contemporaneous with the first use of tripod cylinders and the *tablero* form in the northern Maya lowlands (Chapter 10). Although there still is considerable discussion concerning the chronology of Classic-period Teotihuacan, the early sixth century appears to be rather late in its history, falling at the end of the Late Xolalpan phase or early in Metepec times. A signifi-

cant number of radiocarbon dates suggest that the Epiclassic Oxtoticpac (early Coyotlatelco) phase dates to the seventh century (Figure 1.2), and that the burning of the civic-ceremonial epicenter of Teotihuacan probably occurred c. A.D. 600–650 (Cowgill 1997). It is quite conceivable, therefore, that Kaminaljuyu and Teotihuacan continued to interact until the beginning of Metepec times or even until the collapse of the Teotihuacan state and the burning of the city.

Wolfman (1990:295–301) collected eight archaeomagnetic samples from features fired by the burning of civic-ceremonial structures in central Teotihuacan. Because of a crossover point in the polar curve, these dates could cluster at either approximately A.D. 270–330 or A.D. 450–505. The first range is far too early for the event, but the later range—though early—is somewhat more probable. Still, it does not seem to be consistent with the chronometric data, including other archaeomagnetic dates, from Kaminaljuyu. If future chronological investigations at Teotihuacan support Wolfman's early burning hypothesis, either new dates for the Esperanza phase or a different central Mexican partner will need to be proposed for Kaminaljuyu.

Notes

1. It is more accurate to state that the Carnegie excavations at Kaminaljuyu solved several temporal enigmas. By tying central Mexican–ceramic chronologies to that of Kaminaljuyu, which in turn could be linked to the sequences of lowland Maya sites containing hieroglyphic monuments, Kidder et al. (1946) provided the first reliable calendar dates—albeit subject to the correlation controversy—for Teotihuacan. It should be remembered that not long before, Teotihuacan was generally believed to be either the ethnohistorical Tollan or some other important Toltec city (Krickeberg 1937; Vaillant 1935, 1938). Given that the central Mexican–style vessels from Kaminaljuyu were most similar to Teotihuacan ceramics dating to long after the construction of the Pyramids of the Sun and the Moon, Kidder et al. (1946:252) proposed that those two massive structures were built during the Formative period. As they noted, this was a somewhat startling idea. In a rather casual comment, they corrected both Pedro Armillas (1944:132) and Sigvald Linné (1942), who suggested that the Xolalpan complex was older than the Tlamimilolpa complex. Finally, Kidder et al. (1946:254) were the first to propose Xolalpan as a phase name for Teotihuacan.

2. Popenoe de Hatch (1997) uses the ware system rather than the familiar type:variety-mode system. The former is a nonhierarchical approach to ceramic analysis, while the analytical language of the latter contains terms for larger units of integration. It should be stressed that the two systems of analysis use the term *ware* in very different ways.

3. Another eleven samples, all from Mound C-II-14, yielded unsatisfactory dates (Wolfman 1990).

4. Mound D-III-1 contains at least six superimposed versions that appear to span the Late Preclassic to Late Classic periods (Shibata 1994a). Substructure 1, known as

the Edificio Chay, is an earthen structure with a stepped balustrade consisting of three staggered *tablero*-like elements (see Rivera and Schávelzon 1984). These are framed by moldings on all sides but the bottom, and hence, resemble Cheek's (1977a:41, Figure 13) reconstruction of the *tablero* superstructure on the Palangana Stage E1 platform. The dating of Mound D-III-1 Substructure 1 is somewhat uncertain. Earthen masks on the façades of both Substructures 1 and 2 suggest an Early Classic date, but Shibata (1994a:420) argues that both were constructed during the Late Classic period.

5. An archaeomagnetic date indicates an episode of intense heating associated with either the use or abandonment (often because of fire) of an earthen feature. The earlier of the two burning episodes on Structure L probably was no later than A.D. 615; hence, Structure L was probably built before that date.

6. Alternatively, the floor and step may have formed part of an altar, apron, or projecting platform in front of any of the structures in the Mound D-III-13 sequence.

7. An archaeomagnetic date of A.D. 670–695 or A.D. 880–900 was determined for the burning of the superstructure (Wolfman 1990:Table 15.1). The older range is in general accord with the radiocarbon date.

8. Fahsen (2000) recently has identified central Mexican weaponry in a monument fragment. For this reason, he assigns it to the Esperanza phase. There are no other stone monuments at Kaminaljuyu that have been dated to the Early Classic period (see Parsons 1986).

9. Burial 10 is the only context at Tikal containing central Mexican–style ceramics that can be assigned securely to the reign of Yaax Nu'n Ahyiin. A text at a vassal site suggests that the Tikal ruler died in A.D. 420, which is rather late in the range of possible dates for the beginning of the Esperanza phase.

10. Stela 40 records 9.1.0.8.15 12 Men 8 Pax as the death of Siyaj Chan K'awiil, but notes that his tomb was sealed on 9.1.2.17.17 4 Kab'an 15 Xul (Valdés et al. 1997:45). A date inscribed on the wall of the tomb is 9.1.1.10.10, which falls between the dates on Stela 40. Thus, it seems probable that Siyaj Chan K'awiil died in A.D. 456, that his tomb was dedicated in A.D. 457, and that it was sealed in A.D. 458.

11. The tomb of Copán Ruler 2, which should date to A.D. 472, has not been located. It could contain central Mexican–style pottery, but given K'inich Popol Hol's propensity to de-emphasize his father's foreign connections, this seems unlikely (see Chapter 5). The cylindrical tripod form continues at Copán into Late Acbi times, but appears on types belonging to a southeastern Maya tradition (Cassandra Bill, personal communication 2000).

12. A few Late or Terminal Preclassic tripods have been found at Kaminaljuyu, which raises the possibility that the general form was known well before A.D. 300 (see Foias 1987). If these early vessels reflect foreign influence, it cannot be from Teotihuacan.

Understanding Early Classic Interaction between Kaminaljuyu and Central Mexico

Geoffrey E. Braswell

Numerous explications have been proposed for the appearance of central Mexican ceramics and obsidian, as well as for locally manufactured architecture in a foreign style, at Kaminaljuyu. Nearly all published scenarios, including that put forward by the Carnegie investigators of Mounds A and B, imply that foreigners from the great city of Teotihuacan resided at Kaminaljuyu.[1] Most suggest that these resident foreigners dominated the economy or political system of the site. It is incorrect to call many of the reconstructions "models" or even "falsifiable hypotheses." Few have predictive value, and because of their highly inductive and interpretive nature, even fewer have been rigorously tested. Instead, many are speculative narratives that seem to be consistent with the meager information available to their proponents. Several, too, are legacies of a time when "theorization" was given priority over data, and these seem to push interpretation far beyond a point supported by evidence.

Priests, *Pochteca*, Pirates, and Politicians

Many narratives of central Mexican/highland Maya interaction posit that a small band of Teotihuacanos moved to Kaminaljuyu, married local women, and—either operating alone or on behalf of their home city—conquered the site (e.g., Borhegyi 1965:24; Cheek 1977a, 1977b; Kidder et al. 1946:245, 255; Sanders 1977; Sanders and Price 1968). The most extreme version proposed that the conquerors incorporated Kaminaljuyu into an expansionist Teotihuacan empire (Sanders and Price 1968:167). But this scenario was retracted by one of its proponents on the grounds that it was difficult to see how Teotihuacan could have controlled such a far-flung empire when there was little evidence for the political control of territory between the highlands of Mexico and Guatemala (Sanders 1977:404–405; cf. Bernal 1966; see also Chapter 12). Nonetheless, the imperial conquest scenario has been resurrected by Kuniaki Ohi (1994b:752), who argues that Teotihuacan was responsible for a massive fire at Kaminaljuyu at about A.D. 200. According

to his narrative, this destruction ushered in a 350-year period of political and economic domination by the great central Mexican empire, which ended in another conflagration at Kaminaljuyu. Ohi (1994b) is alone in positing such an early Teotihuacan conquest and in rejecting the Aurora phase as a valid temporal-ceramic unit (see Figure 1.2). His evidence for a great fire at the beginning of the Early Classic is consistent with Marion Popenoe de Hatch's (1997, 1998) proposal of a site-unit intrusion near the end of the Santa Clara phase, although she does not associate this disruption with Teotihuacan.

In a series of articles, Stephan de Borhegyi (1951, 1956, 1965, 1971) suggested that religion played a role in the expansion of Teotihuacan material culture throughout Mesoamerica. In particular, he suggested that "missionizing zeal" (Borhegyi 1971:84) may have been one factor leading to the appearance of Teotihuacan "influence" in Kaminaljuyu. Nevertheless, economic motivation is usually put forward as the principal reason Teotihuacanos moved so far from home. Charles D. Cheek (1977a, 1977b), for example, sees the Teotihuacan presence at Kaminaljuyu as developing from trade. At first, the elite of Kaminaljuyu controlled exchange in the Valley of Guatemala. Because of their interaction with Teotihuacanos, local rulers became aware of certain aspects of central Mexican culture and traded for the prestige goods that were interred with them when they died. The earliest tombs and versions of Mounds A and B date to this Contact phase (Figure 3.2a–c). Somewhat later in time, burial patterns changed, tomb furnishings became richer in exotic goods, and certain elements of the *talud-tablero* style were adopted. Structures A-4, A-5, A-6, B-2, and B-3 were built during this Integration phase (Figure 3.2d–f). Eventually, however, Teotihuacan influence became so strong at Kaminaljuyu that it cannot be explained "on the basis of a non-coercive contact model" (Cheek 1977b:450). This is Cheek's (1977a:Figure 62) Teotihuacan phase, during which the last two versions of Mounds A and B, as well as the *talud-tablero* architecture of the Acropolis-Palangana complex, were built (Figures 3.2g–h, 3.3, 3.4, and 4.1).

The data used to support an eventual conquest are the adoption of the full *talud-tablero* form, the local production of cylindrical tripods, and the use of the seated "tailor position" for the central occupants of the tombs (Cheek 1977a:Figure 62). The last feature, however, was introduced during the earlier Integration phase and cannot be attributed to Teotihuacan influence. Although kneeling or seated burials are common at Teotihuacan, the tailor position is not (Spence 1996b; see also Manzanilla and Serrano 1999; Rattray 1992, 1997). Moreover, Alfred V. Kidder et al. (1946) and Antonia Foias (1987) suggest that some of the tripod cylinders from the *earliest* Esper-

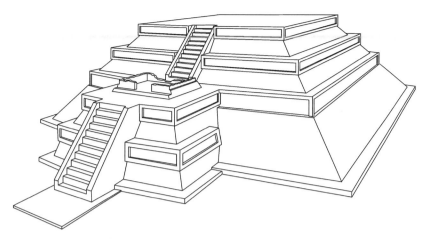

FIGURE 4.1. Kaminaljuyu Structure B-4 (redrawn from Kidder et al. 1946:Figure 113).

anza tombs at Kaminaljuyu were copies (e.g., Tomb A-I, Vessel 1). The copying of a style—be it in ceramics or architecture—seems to be rather weak evidence for the use of coercive force. William T. Sanders (1977:406) also equates the appearance of the full *talud-tablero* style at Kaminaljuyu with the physical presence of Teotihuacanos who "were able to obtain access to sufficient local labor to construct substantial temples." One way to obtain access to such labor is coercion. But it also is reasonable to suggest that the local elite had gained enough wealth to sponsor foreign (or foreign-trained) architects who built structures in the full *talud-tablero* style (see Brainerd 1954:23). Finally, although the phases that Cheek (1977a, 1977b) identifies have chronological merit, the distinctions between them do not suggest—at least to me—anything particularly dramatic about the transition from the Integration to the Teotihuacan phase. Instead, the latter seems to be the culmination of the gradual adoption and transformation of foreign styles and goods into a local substrate. In particular, I do not understand why the addition of the *tablero* and *piedrín* to the *talud*-and-cornice architecture of the Integration phase indicates force. A bridging argument more persuasive than Sanders' is needed to link the *tablero* and *piedrín* to a military takeover.

If one assumes that the rulers of Kaminaljuyu were buried in the tombs of Mounds A and B, an important implication of Cheek's model is that the principal occupants of the earliest tombs dating to the Teotihuacan phase (i.e., Tombs A-V, A-VI, B-I, and B-II) might have been born in Teotihuacan. This is discussed below in further detail.

Sanders' (1977) narrative differs from Cheek's (1977b) in that Sanders does not argue for a period when the Teotihuacan state directly con-

trolled Kaminaljuyu. Instead, he suggests that professional traders similar to the Aztec *pochteca* visited the site and traded with the local elite during Cheek's Contact phase. When interaction increased in frequency and intensity, Teotihuacano merchants settled at Kaminaljuyu and married local women. Sanders (1977:407) argues that as the power of Teotihuacan declined, relations between the great city and the *pochteca* waned. At this point, the merchants living in Kaminaljuyu, like the whites of Ian Smith's Rhodesia, acted on their own and seized power. He writes that "ultimately the taking over of the Kaminaljuyu community by this foreign merchant colony was a private political venture" (Sanders 1977:407). The *pochteca*, then, became pirates and politicians.

Data supporting intense trade relations between Teotihuacan and Kaminaljuyu can be mustered, and the hypothesis that professional merchants from the great central Mexican city lived in Kaminaljuyu is arguable, although not demonstrated. But intermarriage is pure speculation and the final scene of Sanders' reconstruction is conjecture, supported by little more than the observation that the contents of the last tombs of Mounds A and B suggest declining contact with Teotihuacan.

The Port-of-Trade Model and the Kaminaljuyu Chiefdom

One of the more interesting contributions made by the Pennsylvania State University Project is Kenneth L. Brown's (1977b) analysis of sites located in the natural communication route linking the highlands to the Pacific piedmont. He argues that merchants from four regions of Mesoamerica (central Mexico, the southern Maya lowlands, the northwestern Maya highlands, and the northern Maya highlands) all used the Valley of Guatemala as a politically neutral port-of-trade (Brown 1977a:428–431; 1977b:304–352). In his reconstruction, control of the valley was split between two paramount sites, Kaminaljuyu and San Antonio Frutal, which maintained their political independence. According to Brown (1977b:364), the rulers of these sites regulated exchange conducted in the port-of-trade. Teotihuacan merchants lived in a barrio at Kaminaljuyu, but Maya traders from the southern lowlands and other parts of the highlands maintained a presence at San Antonio Frutal. Brown (1977b:291–295) stresses that there is no evidence for a conquest of the Valley of Guatemala by Teotihuacanos. There are no garrisons, site location was not determined by defensive concerns, there are no signs of widespread destruction, there is no reason to think that populations were

relocated, and there is no evidence for a disruption of native artifact traditions. Instead, Brown (1977b:317–322) argues that a political takeover would have been counterproductive because the maintenance of neutral and weak polities was necessary for the port-of-trade to function.

Brown ventures that potential conflict between resident foreigners and the local elite was abated by integrating the former into the native political and economic system. Nonetheless, he speculates that "at the point that inequitable control was assumed by the Teotihuacan traders over the port operations, the port of trade as such came to a halt" (Brown 1977a:364). In other words, the eventual economic dominance of Teotihuacan led to the collapse of the system and the abandonment of the region by foreign traders.

There are notable aspects of Brown's scenario, particularly the sober evaluation of data relevant to conquest scenarios and the observation that material goods from other regions of the Maya area appear in the Valley of Guatemala. But evidence for Brown's political reconstruction and the existence of a port-of-trade seems somewhat scanty. Moreover, chronological data for San Antonio Frutal, Solano, and Esperanza-phase Kaminaljuyu are insufficient for demonstrating anything more than general contemporaneity. For example, it is not at all clear that the lowland Maya and Pacific piedmont ceramics found at San Antonio Frutal date to precisely the same period as Teotihuacan "influence" at Kaminaljuyu. Finally, as with most other scenarios, one must question whether the data are sufficient to support the existence of a Teotihuacan barrio at Kaminaljuyu.

Joseph W. Michels (1977, 1979) provides a fourth perspective from the Pennsylvania State University Project. Agreeing with Brown, he considers Kaminaljuyu to have been part of a port-of-trade and argues that the site neither lost its political hegemony nor shared power with resident Teotihuacanos. In fact, he views the establishment of the "Teotihuacan enclave" as

> a brilliant set of moves that the leadership of Kaminaljuyu made . . . to protect and preserve the chiefdom's political autonomy in the face of the awesome prestige and economic power of the imperial state of Teotihuacan, while at the same time maintaining correct protocol so as to avoid any slighting of Teotihuacan's political sensibilities. (Michels 1977:464)

The argument supporting this position is singularly opaque, relying on a complex set of assumptions regarding the "precinct," "subchiefdom," "inter-

mediate lineage," "moiety," and "conical clan" structure of the Valley of Guatemala. Most scholars have neither adopted nor challenged Michels' (1977, 1979) "Kaminaljuyu chiefdom" narrative, and it never has been the subject of constructive discourse.

Economic Imperialism and Elite Gift Giving: Two Perspectives Derived from Obsidian Studies

Building on Brown's port-of-trade scenario, Robert S. Santley (1983) proposed an influential hypothesis regarding strategies of economic imperialism. According to Santley (1983:107), the emergence of Teotihuacan as a power was related to its natural environment. The city was located in an agriculturally precarious zone that happened to be near important obsidian sources. In order to increase the resilience of the economy, agricultural surpluses were used to foster diversified strategies of energy acquisition. In particular, by developing a specialization in lithic production and distribution, Teotihuacan used the capital gained through exchange to purchase staples needed during times of agricultural stress (Santley 1983:108).

But nearby Otumba and Malpaís are not the only obsidian sources in Mesoamerica. In order to protect its growing monopoly, Teotihuacan expanded the zone of its direct control to include the Paredón, Pachuca, and Tulancingo (Pizzarín) source areas. Other source areas, such as Zaragoza (Puebla) and El Chayal (Guatemala), were too distant for Teotihuacan to incorporate into its territory. Instead, "a cartel of power centers, all under the control or influence of Teotihuacan, attempted to dominate the distribution of exotic resources to the most densely settled parts of Middle Classic Mesoamerica" (Santley 1989:133). Kaminaljuyu, which Santley (1983) calls a "Teotihuacan enclave," was one of these sites.

Santley notes that the Teotihuacan "barrio" was located far from the center of Kaminaljuyu, away from the zone of "factory workshops" (see Hay 1978). He writes:

> Consequently it does not appear that Teotihuacan dominated craft production. The implication is that Teotihuacan controlled some other aspect of the economy, and that aspect I believe involved long distance bulk trafficking of obsidian and probably other goods as well. (Santley 1983:101)

An analogous argument is that the distance between the Oaxaca Barrio and the principal lithic production areas of Teotihuacan suggests Zapotec con-

trol of the exchange of Pachuca obsidian. This notion, of course, has no advocates.

Santley (1983, 1989) proposes that in areas where Teotihuacan could not exert direct political control, highly organized Teotihuacan merchants— again thought to be similar to the Aztec *pochteca*—transported greater quantities of goods more efficiently than their Maya counterparts. Merchants living in enclaves such as Kaminaljuyu, therefore, maintained the Teotihuacan monopoly of the obsidian trade by filling an important niche in regional and local economies.

The *pochteca* argument—whether Santley's (1983, 1989), Sanders' (1977), or Brown's (1977a, 1977b) version—has lost favor in recent years because the temporal gap between Late Postclassic Tenochtitlan and Early Classic Teotihuacan is too great to support a direct historical analogy. Moreover, as Santley (1989:144) himself notes, the argument that caravans of Teotihuacan merchants moved obsidian from Kaminaljuyu to the Petén is contradicted by the relatively small quantities of volcanic glass found in the Maya lowlands. A highly organized obsidian transportation system was not needed because local chert was plentiful.

Another problem is that there is little evidence that Kaminaljuyu controlled the widely dispersed El Chayal obsidian deposits. Classic-period settlement in the area is not dense, and there are no features suggesting an attempt to restrict access (see Mejía and Suyuc 1999). If access to El Chayal obsidian was not controlled by Kaminaljuyu, it seems unlikely that foreign obsidian merchants would establish themselves at the site. In fact, there are few sources that appear to have been directly controlled by Classic polities, and most are located in interstitial areas or buffer zones *between* major polities (e.g., Braswell 1996, 2002b; Cruz 1994; Cruz and Pastrana 1994; Daneels 1997; Healan 1997). An important exception is the Zaragoza source, located only 6 km from the immense city of Cantona (Ferriz 1985; García and Merino 1998). Most Classic and Epiclassic obsidian artifacts from the Gulf Coast and Isthmian regions came from the Zaragoza source (see Braswell 2002b). Recent archaeological research at Cantona has not suggested the presence of a Teotihuacan enclave, so it does not seem likely that Teotihuacan merchants supplied most of the obsidian consumed in the Gulf Coast or Isthmus of Tehuantepec. Thus, the area thought to have been subject to Teotihuacan mercantile control has shrunk dramatically since Santley (1983, 1989) first proposed his hypothesis. If indeed there was a barrio of Teotihuacan merchants at Kaminaljuyu, there is little reason to suppose that its residents were deeply involved in the obsidian trade.

In a recent contextual analysis of green obsidian from the Pachuca source, Michael W. Spence (1996a) suggests that obsidian artifacts made in Teotihuacan as commodities were transformed by acts of gift giving into expressions of relationships between elite Maya and Teotihuacanos. When found in primary contexts in the Maya lowlands, most imported central Mexican ceramics are associated with tombs rather than with dedicatory caches in public buildings. Joseph W. Ball (1983:138–143) argues from the contexts of imported ceramics that they were private expressions of individual relations, rather than public affirmations of community affiliations. Spence (1996a) notes the same general context for green obsidian and suggests that artifacts made of Pachuca obsidian were given as gifts to Maya elite by their Teotihuacan counterparts (see Chapter 9). But the gift-giving hypothesis does not explain why copies of central Mexican ceramics often appear in the same contexts as Pachuca obsidian and imported ceramics. Presumably, Teotihuacanos were not giving lowland "knock off" vessels to their Maya peers. Moreover, once exotics entered the system, Maya leaders could have given them to each other. In that case, the presence of green obsidian or foreign-style ceramics in tombs would reflect ties between Maya elites.

Spence (1996a:33) also proposes that under certain circumstances, green obsidian served the same utilitarian purposes as tools made of Guatemalan obsidian (see Moholy-Nagy 1999a). Moreover, other items lost all symbolic reference to Teotihuacan and were used in purely Maya ritual contexts. Finally, in some cases the symbolic reference to Teotihuacan was transformed and objects were used in contexts that were "largely Maya" (Spence 1996a:33). Here, Spence refers specifically to the Late Classic use of Teotihuacan symbols within the context of ritual warfare (see Stone 1989). One may speculate that such a transformation need not have occurred at a time *after* the collapse of Teotihuacan, but could also have happened during the late Early Classic.

The logical implication of the gift-giving hypothesis is that the Teotihuacan obsidian and imported ceramics found in the tombs of Mounds A and B were gifts to local elites. Yet Spence concludes: "The individuals buried in the mounds A and B tombs of Kaminaljuyú were probably Teotihuacán emissaries" (1996a:33). Two other works reach the same conclusion (Spence 1993, 1996b), but a recent article presents an evolving and more complex interpretation of the identity of the human remains from Mounds A and B (White et al. 2000).

Status Reinforcement

Arthur A. Demarest and Antonia E. Foias (1993) are among a small group of scholars who have questioned all aspects of the "Middle Classic Horizon" concept (Parsons 1967–1969; Pasztory 1978b; Wolf 1976) as it has been applied in the Maya region. They argue that the appearance of central Mexican imports and homologies (local copies; see Ball 1983) suggests that the Maya elite manipulated exotic goods and symbol sets in ways that reinforced their status. Some of these materials were imports from Teotihuacan and other sites in central Mexico and indeed indicate contact with Teotihuacanos or other foreigners. But many copies of central Mexican–style ceramics, mirrors, and other artifacts were made within the Maya region. Since such homologies are more common than identities (imports), it follows that the *appearance* of foreign relations was at least as important as actual connections between individual rulers and their central Mexican counterparts. In other words, although gift giving of the sort discussed by Spence (1996a) took place, Maya leaders commonly created the impression of foreign personal ties in order to enhance their status.

In an undergraduate thesis, Foias (1987) examines the ceramics of Kaminaljuyu Mounds A and B. She argues that the quantity of ceramic identities found in the tombs has been exaggerated. Only 16 of the approximately 337 vessels are Thin Orange ware imported from central Mexico. Although Thin Orange ware is common at Teotihuacan and may have been circulated in Mesoamerica by Teotihuacan traders, it is now known to have been manufactured in the Río Carnero region of Puebla (Rattray 1990; Rattray and Harbottle 1992). Moreover, of the sixty-seven cylindrical tripods excavated from Mounds A and B, just eight are similar enough in shape and decoration to be central Mexican imports. The low number of ceramic identities and the comparatively high number of homologies suggest that the occupants of the tombs were not Teotihuacanos (Demarest and Foias 1993:158). Demarest and Foias also reemphasize that Teotihuacanoid ceramics were not the only foreign-style artifacts found in the tombs. Gulf Coast pottery, lowland Maya Tzakol-phase vessels, and even Oaxaca-style ceramics also were recovered (Kidder et al. 1946).

Thus, the elite of Kaminaljuyu imported and copied a wide variety of foreign goods and symbol sets in order to reinforce their status. Although the quantity of central Mexican–style goods in the tombs suggests relatively frequent interaction with foreigners, "[i]t does *not* necessarily follow from this that these contacts reflect any intense economic connection or control from

Teotihuacan" (Demarest and Foias 1993:158). Demarest and Foias (1993), therefore, are the only scholars discussed here who have challenged not only the assumption that some of the principal occupants of the Mounds A and B tombs were Teotihuacanos, but also the notion that Teotihuacan controlled the economy and political system of Kaminaljuyu.

Teotihuacan Identity and the Existence of a Foreign "Barrio"

Archaeologists who have argued for a late Early Classic foreign "enclave" or "barrio" at Kaminaljuyu have not explicitly described what they mean by "resident Teotihuacanos," but they seem to imply males who were born and raised in the central Mexican city. Ethnicity, like other forms of social identity, is constructed. If foreign-born warrior-priests or merchants married women from Kaminaljuyu, as suggested by Kidder et al. (1946) and Sanders (1977), the children born of those unions could have had a shifting range of contextually defined identities. First-generation male settlers might have been from Teotihuacan, but their children might not have expressed their own identities in the same way. Just as the pharaohs of Ptolemaic Egypt were Greek, Egyptian, and neither, the offspring of Teotihuacan settlers at Kaminaljuyu would have had complex identities.

Ethnic identity also is instrumental. Even if the principal occupants of the tombs of Mounds A and B were locally born elites without biological connections to central Mexican populations, as is suggested by Demarest and Foias (1993), they may have claimed a Teotihuacan identity. Elsewhere, I have argued that the Postclassic nobles of the Guatemalan highlands constructed a hybridized "Toltec"-K'iche'an identity (Braswell 2001a, 2002a). This allowed the creation of social distance between classes within the framework of a social system that, although stratified, was understood according to the metaphor of kinship. Ethnogenesis, therefore, served to "disconnect" the elite (Stone 1989). Similarly, the manipulation of central Mexican symbols, objects, styles, and ideology by the elite of Kaminaljuyu may have supported social stratification by creating a new Teotihuacan–highland Maya identity that could not have been imitated by commoners.

Despite the lack of anthropological discussion regarding what Teotihuacan identity meant in the context of the Maya highlands, it is reasonably clear that most scholars consider the "resident Teotihuacanos" of Kaminaljuyu to have been, at least in the first generation, members of a central Mexican population born at or near the great city of Teotihuacan. These scholars

also suggest that for however many generations an enclave was maintained at Kaminaljuyu, the descendants of Teotihuacan colonists maintained an ethnic identity that was, in whole or in part, defined by actual rather than invented connections to the central Mexican city. Using this narrow definition of Teotihuacan identity, the remainder of this chapter is devoted to examining the possibility that Kaminaljuyu contained a "barrio" or "enclave" of resident central Mexicans.

I do not consider the presence of *talud-tablero*-style architecture to be sufficient evidence on its own for positing the existence of a politically dominant resident foreign population. There are numerous alternative scenarios that account for the presence of this style at Kaminaljuyu. *Talud-tablero* architecture, even its most central Mexican form, could have been brought from Teotihuacan to the Guatemalan highlands without a migration. I have suggested already that architects and builders from Kaminaljuyu could have been sent to train in central Mexico, and that Teotihuacanos could have been brought to the Maya highlands in order to construct *talud-tablero* buildings. Alternatively, a more complex chain of intermediaries, perhaps from the Pacific piedmont or the Gulf Coast, might have been involved. There are, in fact, reasons to suppose that the proximal source of architectural inspiration was not Teotihuacan itself, but some site in the latter region.

What, then, would constitute significant evidence for a resident population of Teotihuacanos (*sensu stricto*) in Kaminaljuyu? The strongest line of argument would be the demonstration, through the study of genetic material, that a subpopulation living in late Early Classic Kaminaljuyu shared traits unique to central Mexicans. The identification of such traits through morphological studies of human bones would also be reasonably strong evidence. Another line of data derived directly from human remains is stable isotope evidence of residence in central Mexico. Both strontium- and oxygen-isotope assays may be used for this purpose. Such data, however, cannot distinguish local Maya from ethnic Teotihuacanos who were born, raised, and lived their lives in Kaminaljuyu. That is, stable isotope analysis may be used to identify first-generation immigrants, but not their offspring.

If direct evidence from human remains is lacking, data suggesting that central Mexican–style artifacts and symbol sets were manipulated in ways and in contextual settings similar to those of Teotihuacan would support the existence of resident foreigners. The strength of such an argument would be proportional to the breadth of the behavioral domain for which such similar artifacts and contexts were found. Moreover, for analogous behav-

iors, complete symbol and artifact sets would provide greater evidence for an actual Teotihuacan presence than partial sets. Thus, the presence of central Mexican–style ceramics in a burial is weak evidence, unless the vessels are similar in kind, number, and arrangement to those used in burials at Teotihuacan. Moreover, the full array of grave goods should be similar, as well as the position of the body and mode of its interment. The *talud-tablero* does not strongly suggest a Teotihuacan presence unless all components of the style appear and are built in the same relative proportions as those of the city, are constructed using the same techniques and analogous materials, are combined to form structures similar in both appearance and use to those of the homeland, and are arranged in groups that reflect a similar sense of site planning as that of Teotihuacan.

Sanders (1977:403–404) points out that if intermarriage was practiced, certain aspects of Teotihuacan culture would be lost, abandoned, or transformed in the diaspora. In particular, some items pertaining to Teotihuacan residential technology and household religion would be absent. Moreover, if resident Teotihuacanos did not belong to the upper stratum of Kaminaljuyu society, but instead lived as equals or even pariahs within the community, additional facets of central Mexican culture would be masked and other classes of artifacts would be missing. Still, there should be evidence for certain aspects of Teotihuacan culture replicated in whole for a particular realm of behavior (e.g., burial customs, architectural canons, or even dietary habits). In addition, if military leaders, merchants, or even slaves from Teotihuacan lived in an enclave at the site, their presence would be replicated at different physical scales. This would be particularly true if foreigners occupied a position of political or economic dominance. But there should also be some replication if Teotihuacanos lived as autonomous equals or even as inferiors in Kaminaljuyu. The absence of replication at different scales, in contrast, would suggest that central Mexican artifacts and symbol sets were manipulated in native cultural contexts by local people.

My evaluation of the evidence for the existence of a Teotihuacan barrio at Kaminaljuyu proceeds from the largest units of scale to the smallest, in which I include analyses of the isotopic composition of teeth. Along the way, I evaluate the two potential expressions of identity for which there is significant evidence: architecture and interment practices. I conclude that they do not replicate Teotihuacan behavior. Moreover, a foreign presence tends to be visible only at certain intermediate scales of analysis and is often manifested in a superficial manner.

Macroscale Analysis

The last two versions of Mounds A and B, as well as several structures in the Acropolis-Palangana complex, are built in the *talud-tablero* style (Figures 3.2–3.4, and 4.1). At a larger scale of analysis, however, the plans and orientations of the groups in which these structures are found do not resemble anything at Teotihuacan. Mounds A and B, like several other Classic-period groups at Kaminaljuyu, face each other, and are oriented northwest to southeast across an open plaza (Figure 4.2a). The Acropolis-Palangana complex is also oriented on a northwest-to-southeast axis (Figure 4.2b).[2] It illustrates a second type of architectural plan at Kaminaljuyu, which consists of mounds arranged on top of earthen barriers or large platforms that completely enclose patios. Similar arrangements of closed, mounded groups are quite common in the Maya highlands west of Kaminaljuyu. Investigation of these sites, however, has produced little or no evidence of contact with central Mexico. One such site is El Perén, located in the *municipio* of San Martín Jilotepeque, which replicates the basic architectural plan of the Acropolis-Palangana complex of Kaminaljuyu but is aligned with the natural landscape (Figure 4.2c). The north group of El Perén also contains two opposing mounds like Mounds A and B. Access to each group is restricted by large earthen constructions resembling walls, upon some of which higher mounds were raised. El Perén is a single-component Early Classic site, and radiocarbon dates suggest that it was constructed during the fifth century (Braswell 1996:281). A similar site is La Merced (Figure 4.2d), also in San Martín Jilotepeque, which was occupied throughout the Classic period (Braswell 1996:921–928). Most importantly, no indications of foreign connections — in the form of central Mexican–style ceramics, architecture, and imported obsidian — have been found at El Perén, La Merced, or other similar sites west of Kaminaljuyu. The northwest-to-southeast orientation of late Early Classic groups at Kaminaljuyu is quite different from the Cartesian grid of Teotihuacan. Moreover, the two basic plans of late Early Classic groups at Kaminaljuyu are seen at both contemporary and slightly earlier sites in the Maya highlands that lack central Mexican–influenced artifacts and architecture. Furthermore, neither of the two highland Maya layouts are found at Teotihuacan. Finally, the typical Teotihuacan apartment compound (Figure 11.4) is completely lacking at Kaminaljuyu. Thus, although certain late Early Classic structures at Kaminaljuyu were built in the *talud-tablero* style, they were not combined in ways that suggest central Mexican influence. At the scales of the site map (Figure 3.1) and the group plan (Figure 4.2a–b), late Early Classic Kaminaljuyu was built according to high-

FIGURE 4.2. Examples of Classic-period highland Maya group plans: (a) Mounds A and B, Kaminaljuyu; (b) Kaminaljuyu Acropolis-Palangana complex; (c) El Perén; (d) La Merced (redrawn from Braswell 1996:Figures B.16, B.21–B.22, and survey data collected by T. R. Johnson and E. M. Shook).

land Maya canons of site planning, and no Teotihuacan influence may be seen. Since *talud-tablero* structures were not arranged in ways reminiscent of highland Mexico, one should wonder if they were designed by or for Teotihuacanos.

Intermediate Scales of Analysis

Evidence for interaction with central Mexico is most evident at Kaminaljuyu at intermediate scales, particularly the levels of the entire structure and

the complete artifact. Nonetheless, even at these scales deviations from typical Teotihuacan architecture and craftsmanship are visible. Saburo Sugiyama (2000:128–129) and George L. Cowgill (1997; cf. Chapter 12) have noted similarities between the Feathered Serpent Pyramid and Mounds A and B. Moreover, as Juan Pedro Laporte (Chapter 7) and Vilma Fialko (1988b) have argued, the plan of the Ciudadela, in which the Feathered Serpent Pyramid is located, may be modeled after the Maya "E-group" (see also Cabrera 2000; Morante 1996). For these reasons, it is worth comparing in some detail the Feathered Serpent Pyramid with Mounds A and B. Nevertheless, as Cowgill (Chapter 12) warns, there are three reasons why the importance of such a comparison should not be overemphasized. First, the Feathered Serpent Pyramid and the Kaminaljuyu mounds are not contemporary: the former was built no later than the third century, and the construction history of the latter did not begin before the middle of the fourth century A.D. Second, the Feathered Serpent Pyramid is unique not only at Teotihuacan, but also in Mesoamerica. Kaminaljuyu Mounds A and B, although much more humble in size, also are unique. Third, no high-level elite burials have been discovered in the Feathered Serpent Pyramid, although pits looted in antiquity provide some clues that they may have once contained interred rulers (Chapter 12). Thus, comparison of the burials—if conducted at all—should be limited to the sacrificed retainers found in each structure.

At the structural level, similarities between the Feathered Serpent Pyramid and Mounds A and B are indeed impressive (Figure 4.3). The alignments of the Feathered Serpent Pyramid and Mound B are similar, and Mound A mirrors that orientation. Subrectangular burial pits are located not only under the center of the mounds, but also on their central axes. In particular, the buildings all may share a pattern of burials found under and in front of the stair. At Kaminaljuyu, these were major tombs. Unfortunately, a large pit just west of the stair of the Feathered Serpent Pyramid was looted in antiquity in an event that may have been related to the building of the Adosado, so it cannot be compared with the rich tombs found under the aprons and projecting platforms of Mounds A and B. Other potential elite tombs beneath the body of the pyramid were also looted. The suggestion that these were the tombs of rulers or other elite members of Teotihuacan society is based not only on what remains of their contents but also on an analogy with Mounds A and B (Sugiyama 2000). Moreover, the presence of burials directly under the stair of the Feathered Serpent Pyramid has been inferred rather than tested (Cabrera 2000:208–209; Sugiyama 2000:Note 4). On a more detailed level of analysis, however, the two Finca Esperanza mounds

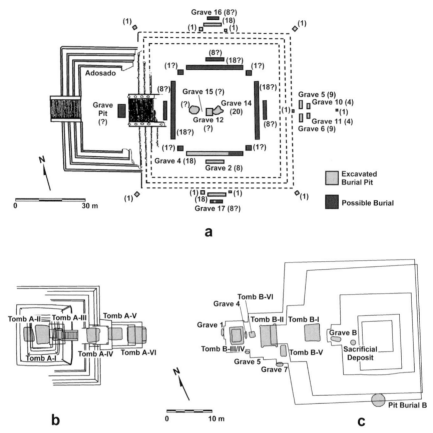

FIGURE 4.3. Comparison of structures at Teotihuacan and Kaminaljuyu:
(a) Feathered Serpent Pyramid (parenthetical notations indicate the number of
interred bodies); (b) Mound A; (c) Mound B (redrawn from Cabrera
2000:Figure 7.11c, Kidder et al. 1946:Figures 103 and 110; Sugiyama 2000:Figure 3.10).

and the Feathered Serpent Pyramid differ greatly in important architectural
features, construction histories, burial configurations, positions of the dead,
mortuary furnishings, and proposed functions.

Architecture and construction history. On a scale below the individual
building level, the *talud-tablero* architecture of Kaminaljuyu is distinctly dif-
ferent from most structures of that style that are known from Teotihuacan.
As at Tikal (Chapter 7), the earliest buildings that incorporated aspects of the
talud-tablero style contained certain traits (the *talud* and the balustrade) but
lacked others (a concrete surface, finial blocks, and the *tablero*) that were im-
portant, but by no means universal, at Teotihuacan. These Integration-phase
structures also contained certain elements that appear to have been locally

derived, particularly the cornice and the apron (appearing in a rudimentary form on Structure B-3). That is, certain elements of the style could *not* have come from Teotihuacan. Thus, it would be surprising indeed if they were designed by or for Teotihuacanos. Moreover, these early structures were made of earth and were built using techniques developed at Kaminaljuyu during the Las Charcas phase. Unlike the earliest *talud-tablero* structures of Tikal, Integration-phase architecture is accompanied by central Mexican–style artifacts. For this reason, no one has suggested that the full, later expression of the style at Kaminaljuyu emerged as a result of local experimentation with a pan-Mesoamerican style.

The Teotihuacan-phase platforms of Kaminaljuyu are among the most foreign and exotic appearing structures in the Maya area (Figures 3.2g–h and 4.1). Even so, they do not conform to the architectural norms of any particular site in central Mexico, and they contain several unique and locally derived elements. One commonly discussed feature of *talud-tablero* architecture is the relative height of each element. Santley (1987) has noted that the ratio of *talud* to *tablero* height at Teotihuacan is approximately 1:1.6 to 1:2.5. At Tepeapulco, *tableros* are proportionally even larger, with a ratio of 1:3 (Rivera 1984). In contrast, the relative proportions of the *talud-tableros* of Kaminaljuyu are approximately 1:1 (Cheek 1977a:133), a value very similar to that of Mound 2 at Matacapan (Valenzuela 1945:94–96) and the most common proportion used at Tikal (Chapter 7; Laporte and Fialko 1990). In other words, at least one aspect of the *talud-tablero* style of Kaminaljuyu seems to conform more closely to the norms of Gulf Coast architecture than to the most common variants of the style at Teotihuacan. Still, as Cowgill (Chapter 12) suggests, it may be that archaeologists have overemphasized the significance of *talud-tablero* proportions, and that the range of variation seen at Teotihuacan and Kaminaljuyu has been incorrectly reported. To these concerns, I add that the size of a *tablero* may have been constrained by the instability of the fill and the lack of sufficient mass to cantilever it. Structures that are built primarily out of earth cannot support *tableros* as large as structures built of heavy fill, large stones, and concrete.

It may be that certain elements of the *talud-tablero* style diffused slowly from the Gulf Coast to Kaminaljuyu, perhaps through Tikal (see Laporte and Fialko 1990). The partial *tableros* of the Stage E3-b structure of the Palangana (Cheek 1977a:53, 57) also are reminiscent of Tikal architecture. It should be stressed that very few buildings of this style are known from Teotihuacan.

At least five of the *talud-tablero* structures at Kaminaljuyu had balustrades capped with finial blocks (Structure A-7 of Mound A, and Structures A,

E, F, and G of the Acropolis), but other contemporary structures at Kaminaljuyu lacked this feature (Cheek 1977a:133). As at Tikal (Chapter 7), the finial block was an optional feature of the local variant of the *talud-tablero* style. In contrast, it can be seen much more frequently in the architecture of Teotihuacan.

The incomplete molding of the Stage E1 superstructure *tablero* (Cheek 1977a:41, Figure 13) and of the *tablero*-like balustrade on Mound D-III-1 (Rivera and Schávelzon 1984) also differs from nearly all examples at Teotihuacan, but is somewhat similar to the *tablero* panels of Oaxaca. Many—but by no means most—*tableros* at Teotihuacan, including those of the Feathered Serpent Pyramid, were either painted or adorned with sculpture. In contrast, the *talud-tablero* architecture of Kaminaljuyu appears to have been bereft of such decoration.[3]

Two important features of local origin are found on structures dating to the Integration and later phases. These are the apron or frontal platform (a projection from the front of the stair that often contains two or more platforms; see Figures 3.2g–h) and the enclosure-atrium-platform configuration (Figure 3.4b). Neither is found at Teotihuacan, but the large projecting shrine platform of Structure B-4 does have parallels at the central Mexican city (Figure 4.1; Cheek 1977a:133–134). The enclosure-atrium-platform composition of the Palangana Stage E3 structure is unique in Mesoamerica, although Cheek (1977a:136–137) sees slight similarities with other sunken patios and courtyards at Kaminaljuyu, Teotihuacan, and Bilbao. It seems unlikely that Teotihuacanos governing Kaminaljuyu would mandate the construction of buildings containing local Maya features, including an example with a configuration unique to Kaminaljuyu.

Cheek (1977a:130–132) considers the construction techniques and materials of both Kaminaljuyu and Teotihuacan and points to many important similarities. Although the *piedrín* coating, certain aspects of the fill, and the use of cantilevered flat stones to support *tableros* have close parallels at Teotihuacan, the *talud-tablero* structures of Kaminaljuyu were often built with more earth and faced with less—and more coarsely shaped—masonry. For example, the fill of Structures B-4 and B-5 was almost completely clay, and even the facing immediately below their *piedrín* surfaces contained few pumice stones (Kidder et al. 1946:45). Thus, these two structures differed from their Preclassic predecessors principally in *superficial* attributes (i.e., *piedrín* and the *talud-tablero*). Moreover, as Cheek (1977a:132) points out, "the honeycomb pattern of the matrix of the Temple of Quetzalcoatl and the use of vertical tree trunks to redistribute the weight and transmit the force di-

rectly to the ground" do not appear at Kaminaljuyu, suggesting that different methods of stabilizing fill were used at the two sites.[4] Cheek proposes, however, that the small Kaminaljuyu structures may not have required a more intricate stabilization technique. Nonetheless, he concludes that the architects who built the Kaminaljuyu structures may have been "familiar only with the form of the talud and tablero and not with the details of its construction" (Cheek 1977a:132). Elsewhere, when discussing the Stage E1 structure, he writes: "the builders knew what the Teotihuacan building [*adoratorio*] looked like, but did not know how it was built" (Cheek 1977a:134).

Turning more specifically to the comparison of the Feathered Serpent Pyramid and Mounds A and B, the construction histories of the buildings are quite different. Mounds A and B each contained superimposed structures, most of which appear to have been constructed when a new tomb was built. None was used for any length of time (Kidder et al. 1946:42). In contrast, the Feathered Serpent Pyramid appears to have been built in one enormous construction phase that occurred c. A.D. 150–250 (Cabrera 2000:208). With the exception of Graves 12 and 15, which were first used before the construction of the Feathered Serpent Pyramid, the burials so far excavated in and around the pyramid all are related to a single, large-scale sacrificial event (Sugiyama 1989, 1996).

Burials and mortuary furnishings. The placement of burials, the arrangement of the dead, and the accompanying artifacts of Kaminaljuyu Mounds A and B are quite dissimilar from those of the Feathered Serpent Pyramid on several analytical scales. Rubén Cabrera (2000:208–209) has noted a symmetrical pattern to the burials within the Feathered Serpent Pyramid that he sees as a reflection of cosmological and calendrical beliefs expressed by the Fejérváry-Mayer cruciform-quincunx. Burials in and around the structure fall on two principal orthogonal axes (north-south and east-west), two secondary intermediate axes, and in the center of the pyramid (Figure 4.3a; Cabrera 2000:Figure 7.11c). Twenty bodies were found in the epicenter of the structure where the axes intersect. This is seen as a representation of the earth or center of the Mesoamerican cosmos. The principal axes of the pyramid correspond to the four cardinal directions. Interments along them occur in arrangements of two, four, eight, nine, thirteen, eighteen, and twenty individuals: all numbers of calendrical importance (Cabrera 2000:208; Sugiyama 1996, 2000:127). Finally, the minor axes represent the intermediate directions. Cabrera (2000:208) writes: "The symmetrical distribution of these burials and the quantity of skeletons found so far suggest that 260 people must have been buried at this building, a number corresponding to the

amount of days in the ritual calendar." On a larger scale, the Ciudadela and Great Compound, which together were the political and cultural nexus of Tlamimilolpa-phase Teotihuacan, also formed the geographical center of the city at the intersection of the Street of the Dead and the East and West Avenues. The burials within the Feathered Serpent Pyramid and even the great plan of the Tlamimilolpa city itself, therefore, were cosmograms (Cabrera 2000:209).

No such cosmological or calendrical pattern has been detected in the arrangement of the tombs and in the number of skeletons and disarticulated bones found in Mounds A and B. Instead, these structures appear to have functioned as mortuary temples that grew by accretion as new tombs were added (Kidder et al. 1946:13). Moreover, they did not occupy a central position in either Kaminaljuyu or the group in which they are located (Figure 3.1). Instead, Mounds A and B were quite peripheral. They do not seem to have symbolized the physical nexus of either the community or the world.

Both Cabrera's numerical reconstruction and a simpler argument based on symmetry suggest that the empty burial pit west of the stair of the Feathered Serpent Pyramid contained eight individuals arranged in a manner similar to that of Graves 10 and 11.[5] Nevertheless, the pit clearly is unique in form and preparation. Unlike the other graves, which are irregular and shallow trenches, it was well dug, spacious, and deep. It may very well be that it once contained the body of a ruler (Cowgill 1997; Sugiyama 2000:128–129) or even a ruler and a sufficient number of victims to preserve Cabrera's symmetry. Moreover, sherds from relatively fine vessels, including White-on-red vases (compare with Berrin and Pasztory 1993:Figure 111; Séjourné 1966a:figura 197), were found in looters' back dirt from Grave 13, beneath the pyramid (George L. Cowgill, personal communication 2001). This, too, is consistent with the argument that the Feathered Serpent Pyramid once contained elite burials. Although I find it less likely, it could be that these apparently elaborate "graves" held richer and more special offerings without containing the bodies of rulers. Since they were looted in antiquity, we will never know for sure who or what they contained.

Even though the Feathered Serpent Pyramid may once have contained elite burials, the calendrical-cosmological significance of the sacrificed individuals (Cabrera 2000), their placement as part of a massive dedicatory event related to the construction of the platform (Sugiyama 1989, 1996, 2000), and the different construction histories of the structures all demonstrate that the Feathered Serpent Pyramid not only is quite different from Kami-

naljuyu Mounds A and B, but also is unlike any other structure known in Mesoamerica.

On a more detailed level of analysis, the arrangement of the bodies within Mounds A and B and many aspects of the tomb furnishings do not resemble burial patterns known from Teotihuacan. Tomb A-I, the earliest in the Mound A sequence, was opened and reused on several occasions. Similarly, Tomb A-II contained two sequential burials. Tomb B-IV, which intrudes into the earlier and larger Tomb B-III, may also represent a variant of this practice. The only tombs at Teotihuacan that are known to have been periodically reopened, added to, and resealed are located in Tlailotlacan, the Oaxaca Barrio (Spence 1992).[6] But the occupants of these tombs are thought to have been Zapotecs, so tomb reuse does not seem to have been an indigenous practice at Teotihuacan.

The later tombs of Mounds A and B, as well as those excavated in the Palangana, shared a very distinct pattern of arrangement and burial furnishings (Cheek 1977a:141-153). Principal figures were seated with crossed legs in the tailor position. They faced south, regardless of the orientation of the structure. Many of the Mounds A and B tombs were deliberately filled, but ornaments as well as bones were found spread over an appreciable area. Kidder et al. (1946:88-89) accounted for this by arguing that the principal figures had been wrapped in voluminous bundles that, as they decayed, left space for bones and furnishings to settle. Moreover, fragments of wood that did not come from the roof beams of the tomb were found scattered symmetrically about the principal occupant of Tomb A-III, and similar marks were found on the floor of Tomb B-I (Kidder et al. 1946:55, 74, 89, Figure 31). Kidder et al. interpreted this as evidence that the principal figures of these tombs were seated in some sort of wooden box or crib.

Seated burials are common at Teotihuacan and have been found at Tikal (Coe 1990, 1:118-123; Shook and Kidder II 1961), Copán (Chapter 5; Fash and Fash 2000), Mirador (Agrinier 1970, 1975), and in the Ixil region (Becquelin 1969; Smith and Kidder 1951). Nonetheless, the orientation of the bodies, the tailor position, and the use of a mummy bundle with a wooden box have no antecedents beyond Kaminaljuyu. Citing an ethnohistorical account provided by J. Eric S. Thompson (1939:283-284), Kidder et al. (1946:89) argued that the closest parallel is with sixteenth-century burial customs of Alta Verapaz.

If the principal figures in Kaminaljuyu Mounds A and B were Teotihuacanos, why were they interred in a manner that is completely unknown from Teotihuacan? As Cowgill (Chapter 12) points out, no high-level elite buri-

als dating to the Xolalpan phase have been discovered at Teotihuacan in all the years of extensive excavation in the city. He lists several possible reasons why this may be the case, but only three seem tenable to me: (1) elites did not receive special mortuary treatment; (2) they were cremated (Headrick 1999); or (3) they were disposed of in some other way that leaves no obvious archaeological correlates. All three possibilities distinguish Teotihuacan from Kaminaljuyu and all other Maya sites where Teotihuacan "influence" has been found. If any of the high-level elites interred in Maya tombs *were* Teotihuacanos, they were buried according to local customs, not those of their home city.

Many of the items that constituted the mortuary furnishings of the Esperanza-phase tombs either were imported from northwestern Mesoamerica or were inspired by central Mexican material culture. For this reason, at the analytical scale of the artifact, the offerings evince interaction with Teotihuacan, the Gulf Coast, and other regions northwest of the Isthmus of Tehuantepec. But on the level of the entire funerary assemblage, the types of foreign-style goods, their placement, and their roles were transformed for use in a highland Maya context. That is, although certain items from the Mexican highlands were found within the tombs, they were combined and manipulated in ways that reflect neither central Mexican behavior nor the Teotihuacan belief system.

Numerous ceramic vessels were found within the Mounds A and B tombs. Kidder et al. (1946:92–93) noted that certain kinds of vessels, particularly cylindrical tripods, appeared in all of the tombs. In most cases, these were found in nearly identical pairs. Pairing was common with other sorts of vessels, including some of local style. Other ceramics that served a mortuary function are "cream pitchers," found in all but Tomb B-VI, and "ash bowls," used as containers for incense burned in other vessels. Some ash bowls were found on floors, but most were placed within the lower levels of the earth used to fill the tombs (Kidder et al. 1946:93). Cheek (1977a:144–145, 147–152) discusses typological and morphological patterns in more detail and identifies chronological changes within the funerary complex.

Other items found in all of the tombs include mosaic plaques, jade, and shell. With the exception of Tomb B-VI, the poorest and last in the sequence, all contained grinding stones and either secondary individuals or a disarticulated skull.[7] At Teotihuacan, grinding stones are associated with female burials, but not with males like the principal figures of the Esperanza tombs. One to three mosaic plaques, which probably were mirrors worn on the chest, were found on the lap or just south of each principal individual (Cheek

1977a:144; Kidder et al. 1946:Table 1). Two individuals from Tomb B-I had composite mirrors placed in the small of their back (Kidder et al. 1946:74). Mirrors of both sorts are depicted commonly at Teotihuacan and often were combined with flares and other items made of jade (Taube 1992a:175–177). Kidder et al. (1946:127, Figures 53c, 143b) reconstructed one mirror with jade flares and also found a jade spool on a pyrite mirror. According to Karl A. Taube (1992a:198), mirrors were imbued with many meanings at Teotihuacan and were used as a means to see into the supernatural world. At Teotihuacan and later sites, individuals wearing mirrors are often depicted in military garb and carrying weapons. Two of the composite mirrors from Mounds A and B have backs that are richly decorated in a Teotihuacan style (Kidder et al. 1946:Figure 175a–b). It seems very likely, then, that the mirrors found within the Esperanza tombs were important cult items related to warfare and divination, and that some of them may have come from Teotihuacan. Nonetheless, the back of a mirror from Tomb B-I is carved in the Classic Veracruz style of El Tajín (Kidder et al. 1946:Figure 156). Since the use of composite pyrite mirrors was quite widespread during the Classic period, it may be that the principal figures of the Kaminaljuyu tombs participated in a pan-Mesoamerican cult focused on warfare and divination.

A cache of obsidian blades, presumably for letting blood, was placed near each of the principal figures of the Esperanza tombs, and the location of the cache seems to be chronologically meaningful (Cheek 1977a:92). Peripheral bodies that were accompanied by fewer or no adornments and offerings were found in most burials, but some of the less elaborate tombs contained isolated skulls. These secondary individuals were interpreted by Kidder et al. (1946:89–90) as sacrificed slaves, and the isolated skulls as either trophies of war or victims of sacrifice. The secondary individuals, including the skulls, most often were adolescents, young females, or children (Kidder et al. 1946:90). One reasonable conjecture is that the grinding stones found in all the tombs save the last, which also lacked an isolated skull or secondary skeleton, were included as items to be used by the companions to prepare food for the principal figures.

Returning to the comparison with the Feathered Serpent Pyramid perhaps is flogging a dead horse. The repeated pattern of mortuary goods found in the Esperanza-phase tombs is quite different from that of the burials unearthed in the Teotihuacan structure or any other burials known from the great city. Ceramic offerings were quite uncommon in the Feathered Serpent Pyramid (Sugiyama 1996), but this may be a result of the looting of the pits that might have contained elite individuals. The form most represented in the

few ceramic offerings associated with the Feathered Serpent Pyramid is the "Tlaloc" jar (Cowgill 1997:142; Sugiyama 1996), two of which were found in the mass grave and offering at the center of the pyramid (Cabrera et al. 1991:86). Esther Pasztory (1992:297) associates these with household religion and notes that they frequently are found in burials at Teotihuacan. In contrast, Tomb A-II is the only burial at Kaminaljuyu where the form has been found. A paired set, which probably was made locally, was recovered from that tomb (Kidder et al. 1946:Figure 200). Paired cylindrical tripods and cream pitchers of the sort so common at Kaminaljuyu are not known from the Feathered Serpent Pyramid burials.[8]

The closest parallel in mortuary furnishings is the use of mirrors, which were found associated with many of the individuals interred in the Feathered Serpent Pyramid (Sugiyama 1989:97, 1992:210, 1996; 2000:126). All are interpreted as either warriors, priest-warriors, or warrior impersonators who were sacrificed when the pyramid was constructed. Since they were sacrificial victims, they are more analogous to the companions than they are to the principal figures of the Kaminaljuyu tombs. But only a few of the companions wore pyrite mirrors as items of personal adornment. In fact, few ornaments were in clear association with the companion skeletons.[9] Moreover, the gender and age profiles of the warriors of the Feathered Serpent differ considerably from those of the Kaminaljuyu companions. The former overwhelmingly are adult males. Thus, although both the warriors of the Feathered Serpent Pyramid and the secondary companions of the Esperanza tombs appear to have been sacrificial victims, the analogy ends there.

It is tempting to argue that the presence of Teotihuacan-related objects in the Esperanza tombs implies the maintenance of a central Mexican ethnic identity. But the artifacts, their pattern of disposition, and the arrangement and orientation of principal figures do not reflect what is known about burial patterns at Teotihuacan. Most dramatically, the fact that we have *identified* elite burials at Kaminaljuyu (as well as at other sites) suggests that they do not contain Teotihuacanos who practiced the funeral rites of the Xolalpan phase. If there was indeed an enclave at Kaminaljuyu, than we must expect that elite foreigners either were interred in simpler burials or were cremated. In either case, it seems that the principal occupants of the Esperanza tombs were Maya.

The general lack of "Tlaloc" jars—found not only in the Temple of the Feathered Serpent but also in other graves at Teotihuacan—suggests that the individuals buried in Mounds A and B and in the Palangana did not prac-

tice the same rituals as their counterparts at Teotihuacan. In light of recent discoveries at Montana (Chapter 2), it is also worth noting that warrior "portrait" figurines are not known from Kaminaljuyu, and only one *candelero* was recovered during the Carnegie excavations of Finca Esperanza.[10] Moreover, as Kidder et al. noted:

> We found nothing to indicate that the elaborate "built up" incense burners of Teotihuacan and Atzcapotzalco were made at Kaminaljuyu; had they been, it is incredible that some of the little moldmade *adornos* so lavishly applied to them should not have turned up in our excavations. (Kidder et al. 1946:214).

Thus, there is little reason to suspect that the inhabitants of Kaminaljuyu practiced the religion sponsored by the Teotihuacan state. Instead, they seem to have borrowed certain elements of central Mexican ritual and to have used them in novel social and cultural contexts.

The combination and manipulation of Teotihuacan objects and other foreign-style items in a manner that is very different from central Mexican behavioral patterns does not imply a Teotihuacan origin. Sanders' (1977) suggestion that the household rituals and burial practices of Teotihuacanos and their ethnically mixed offspring at Kaminaljuyu differed from those of Teotihuacanos living in central Mexico is reasonable, but the lack of Teotihuacan burial practices at Kaminaljuyu should not be construed as supporting the presence of Teotihuacanos. After all, most—if not all—sites in the Maya area lack clear evidence for Teotihuacan burial practices. Since virtually all foreign-style portable artifacts found at Kaminaljuyu come from funerary contexts that do not resemble central Mexican burials, the most notable behavioral realm in which Teotihuacan interaction is manifested seems to be locally derived.

Microscale Analysis

I do not doubt that the Thin Orange vessels from the Esperanza tombs of Kaminaljuyu come from central Mexico, although they probably were not manufactured at Teotihuacan itself and may have been brought to Kaminaljuyu by traders from other less distant sites. Moreover, Foias' (1987) identification of eight cylindrical tripods as ceramic identities seems accurate. Nonetheless, at the microscale level of modal analysis, most of the central Mexican–style vessels from Mounds A and B do not conform to the artistic

canons of Teotihuacan. They are homologies that were made outside of central Mexico by potters who either did not know or who chose to violate the norms of Teotihuacan proportions (Foias 1987).

Other artifacts from the Kaminaljuyu tombs, when viewed at a microscale level of analysis, appear to be homologies rather than identities. Not counting three lots of obsidian pebbles, a total of 204 obsidian artifacts were recovered from the tombs of Mounds A and B. Eighty-five pieces are of green obsidian from the Pachuca, Hidalgo, source, which provided most of the material used to make prismatic blades and blade-derived artifacts at Teotihuacan. Sixty-one of the Pachuca artifacts are small sequins found in close association in Tombs A-II and A-IV. These probably were appliqués sewn onto a cloth backing. Those from Tomb A-IV were found with what may have been a stuccoed and painted mask or headdress. The remaining 24 pieces of green obsidian occur in a variety of forms: a finely made handheld knife (from Tomb A-I), 15 finely made projectile points (from Tombs A-V and B-I), and 8 prismatic blade fragments (from Tombs A-I and A-II). The remaining 119 obsidian artifacts, as well as approximately 575 pebbles that probably were used in turtle-shell rattles, all are of gray obsidian. It is highly likely that the gray prismatic blades (N=104) are made of material from the nearby El Chayal source. Although gray obsidian artifacts, generally assumed to be from the Otumba source area, are common at Teotihuacan, most are bifaces rather than prismatic blades. Fourteen gray projectile points were recovered from the Kaminaljuyu tombs (in sets of 5 from Tombs A-VI and B-II, as well as a set of 3 from B-IV and a fragment from B-I). All but the fragment are illustrated (Kidder et al. 1946:Figure 157b, d, and g). The illustrated projectile points made of gray obsidian are crudely worked and do not exhibit the patterned flaking that is typical of Teotihuacan manufacture. Although Spence (1996a:26) notes that these gray projectile points differ in form from Teotihuacan examples, the 10 pieces from Tombs A-VI and B-II share a general—albeit crude—resemblance to the set of 7 green projectile points from Tomb A-V. Moreover, they differ in certain aspects from highland Maya forms typical of the Classic period. I suspect, therefore, that these gray obsidian projectile points are crude homologies made of local obsidian.

Human remains can be examined on at least three microscale levels of analysis. First, traits that are manifested in bone morphology and are thought to be genetic may be studied. Such "biological distance" studies have become less common in recent years, in part because many of the traits subject to analysis have unknown expression and inheritance patterns (Buikstra et al. 1990). In any event, the remains from the Esperanza tombs, except for the

teeth, are in exceptionally poor condition and prohibit such studies (Lori E. Wright, personal communication 2000). Second, direct comparative genetic studies may be undertaken. This approach is quite new to Mesoamerica (see Chapter 6), and the data so far collected are not sufficient to distinguish between central Mexican and highland Maya populations. Third, chemical assay may be employed to study paleodiet and to determine geographical origin (e.g., Buikstra et al. 2000; White et al. 1998; Wright and Schwarcz 1998). Because both dietary practices and geographical residence may indirectly reflect ethnic identity, these analyses are of particular relevance to Teotihuacan-Maya relations.

The most promising new research to be conducted on materials from the Mounds A and B tombs is the determination of the isotopic composition of teeth. Unlike bone, which continues to be remodeled throughout the life of an individual, the composition of tooth enamel does not change after it is mineralized. The mineralization of the first molar occurs between birth and three years, and the enamel of the third molar is formed between ages nine and twelve (White et al. 2000). Changes in diet during these periods may be studied by comparing the isotopic composition of the enamel of these teeth. Lori E. Wright and Henry P. Schwarcz (1998, 1999; see also Wright 1999, 2000), for example, have used stable isotope analyses of bone, tooth enamel, and dentine to study weaning practices and the diets of both children and adults at Kaminaljuyu. In particular, they have compared the diets of the principal and attending figures in the tombs of Mounds A and B, as well as those of individuals from other contexts. Although differences in weaning patterns were noted (Wright 2000; Wright and Schwarcz 1999), diets were fairly uniform at Kaminaljuyu and differed from those of lowland sites in that proportionally less protein was obtained from terrestrial animals (Wright and Schwarcz 1998). Important differences between individuals were noted in the values of $\delta^{18}O_c$, the oxygen-isotope ratio of enamel carbonate (Wright 2000; Wright and Schwarcz 1999). These results are supported by independent assays of oxygen-isotope ratios of enamel phosphate ($\delta^{18}O_p$) from the same teeth (White et al. 2000).

The oxygen-isotope composition of bone and enamel is largely dependent on the oxygen-isotope composition of ingested water, which in turn is determined by local temperature, distance from the sea, latitude, elevation, and humidity (Yurtsever and Gat 1981, cited in White et al. 2000). After evaporation from the ocean, the first rain to fall from a cloud contains higher levels of ^{18}O than later precipitation. As that cloud moves farther inland and rain falls at higher altitudes, the oxygen-isotope ratio of rainwater

decreases (Wright 2000). The $\delta^{18}O$ values from either enamel phosphate or carbonate provide paleoclimatological data regarding the region in which a child lived. If the $\delta^{18}O$ values from the first and third molars of an individual differ significantly, a change in climate or location during childhood is indicated. Moreover, if the $\delta^{18}O$ value of a tooth from an individual differs from that of a local baseline value, it suggests that he or she moved to the area after that enamel mineralized. Such studies, then, can be of great importance to understanding residence patterns and, indirectly, identity. It must be stressed that locally born people who maintain a foreign identity share the same $\delta^{18}O$ ratios as their neighbors. Thus, both Teotihuacanos and the Teotihuacan-born-and-raised inhabitants of the Oaxaca Barrio had similar $\delta^{18}O$ ratios (White et al. 1998).[11]

Christine D. White et al. (2000) determined the $\delta^{18}O_p$ values for forty-one teeth from thirty-one individuals excavated at Kaminaljuyu and Beleh, another site in the Valley of Guatemala. The teeth came from burials dating to the Middle Preclassic to Postclassic periods, including sixteen individuals from the tombs of Mounds A and B. A total of twenty-one first and third molars from principal figures (N=4), companion skeletons and isolated skulls (N=10), and remains of ambiguous classification (N=2) were analyzed.[12] The $\delta^{18}O_p$ values from these teeth were compared to a local baseline value of 16.9 ± 0.8 ‰ (one-sigma) determined for Preclassic burials at Kaminaljuyu (White et al. 2000), as well as with baseline values of 14.7 ± 0.3 ‰ determined for Teotihuacan, 13.0 ± 0.6 ‰ for Monte Albán (White et al. 1998), and 19.9 ± 0.7 ‰ for Río Azul (White and Longstaffe 2000).

Results indicate that of the sixteen individuals from the tombs who were studied, four exhibit $\delta^{18}O_p$ ratios significantly outside the range of trophic variation characteristic of Kaminaljuyu. These include a probable companion skeleton from Tomb A-I (Skeleton 8), a principal figure and companion from Tomb A-V (Skeleton 1 and Skull 3), and an ambiguous figure from Tomb B-IV (Skeleton 2). Three of these four individuals exhibit $\delta^{18}O_p$ values of 18.7 to 20.3 ‰, which are considerably higher than those typical of Kaminaljuyu (White et al. 2000:Table 1). These values may suggest a lowland Maya origin, as White et al. (2000) propose, or may be consistent with the Pacific Coast and piedmont, an area for which no information currently is available. Due to the proximity of the latter to the ocean, $\delta^{18}O_p$ values from the Pacific Coast and piedmont should be considerably higher than those of Kaminaljuyu. Most notably, only one individual, Skeleton 1 of Tomb A-V, has a $\delta^{18}O_p$ value (14.8 ‰) that falls within the range noted for Teotihuacan (White et al. 2000:Table 1). This was determined from the upper left third molar of the

individual. Assay of the lower left first molar, however, yielded a corrected $\delta^{18}O_p$ value of 17.3 ‰,[13] consistent with the Kaminaljuyu baseline. Based on these data, White et al. (2000) suggest that the principal figure of Tomb A-V was born and died in Kaminaljuyu, but spent a portion of his childhood at Teotihuacan.

Wright (2000), who first noted a low oxygen-isotope value for this tooth in her study of enamel carbonate, cautiously suggests that this conclusion may be premature. Tomb A-V was the most disturbed of all the Esperanza tombs, and few remains of Skeleton 1 were found (Kidder et al. 1946:62–63). It is conceivable, therefore, that the sample was somehow contaminated. Moreover, oxygen-isotope assay provides data on a single variable. The baseline level determined for Teotihuacan may reflect conditions at a wide variety of sites across the highlands of Mesoamerica. Until more data are available, such as the results of an independent strontium assay, it seems best to consider the conclusion that this individual spent part of his childhood at Teotihuacan as preliminary.

For the most part, the results of Wright's (2000) analyses strongly concur with those of White et al. (2000). Wright (2000), however, notes that Skeleton 2 of Tomb B-IV, which exhibited the highest $\delta^{18}O$ values seen in the Kaminaljuyu sample, also had very high $\delta^{15}N_c$ values. This suggests that the individual—or more likely his nursing mother—consumed a lot of marine fish. Wright proposes, therefore, that he was born not in the Petén, but in Pacific Guatemala or some other coastal region. Wright also notes that $\delta^{18}O_c$ values from the three sampled skulls of Tomb A-III (all independently assayed by White et al.) indicate a lowland pattern. Thus, the $\delta^{18}O_c$ results are in good accord with the $\delta^{18}O_p$ assays for thirteen of sixteen individuals, but do not concur on Skulls 1–3 of Tomb A-III.[14]

White et al. (2000) and Wright (2000) both determined $\delta^{18}O$ values for other burials at Kaminaljuyu. White et al. (2000) consider the individuals in Burial 2 of Mound B-V-5 and in Burial 4 of Mound B-VI-2, both Amatle-phase interments, as displaying $\delta^{18}O_p$ values consistent with the Teotihuacan signature. The lower right first molar from the first of these two Late Classic burials yielded an adjusted $\delta^{18}O_p$ of 15.6 ‰, and a value of 15.7 ‰ was determined for the lower left third molar of the second individual (White et al. 2000:Table 1). Although these values fall below the baseline range for Kaminaljuyu, they are considerably higher (at least three standard deviations) above the mean for Teotihuacan. Thus, these data are best interpreted as indicating that the two individuals spent at least a portion of their childhood at some still unidentified place, but not at Teotihuacan.

Three aspects of the oxygen-isotope data are highly suggestive and relevant to the issue of a foreign presence at Kaminaljuyu. First, there is no evidence that any of the sixteen analyzed individuals from the tombs of Mounds A and B were born and spent their early childhood at Teotihuacan. Only one individual, the principal figure from Tomb A-V, may have spent time in central Mexico during his childhood. This tomb, associated with the construction of Structure A-7 (Figure 3.2g), is the earliest one dating to Cheek's (1977a:Figure 62) Teotihuacan phase. According to Cheek's model, if any individual in the Esperanza tombs was born in Teotihuacan, it should be the principal figure of this tomb. Apparently, however, he was born in or near Kaminaljuyu.

Second, a strong foreign presence, from one or more sites typified by higher $\delta^{18}O$ values, is represented in the tombs of Mounds A and B. These individuals (three according to the enamel phosphate analyses; six according to the enamel carbonate assays) may have come from the Petén, but a Pacific piedmont or coastal origin also is possible. White et al. (2000) suggest that the presence of individuals from these regions is more in accord with Brown's (1977a, 1977b) port-of-trade hypothesis than with any of the Teotihuacan-dominance models.

Third, none of the foreigners represented in the Esperanza tombs are clear principal figures. Kidder et al. (1946), in fact, interpreted all six of these individuals as sacrificed attendants, as offerings of some sort, or as trophy heads. The only foreign-born individual that possibly is a principal figure is the ambiguously classified Skeleton 2 of Tomb B-IV (the marine fish eater). No third molar from this individual was analyzed, but he may have spent most of his life at Kaminaljuyu. Given that nearly all foreign oxygen-isotope signatures were determined from companion figures or isolated skulls, the port-of-trade hypothesis is not strongly supported. Instead, it is more plausible to speculate that these children and juveniles were sacrificed captives or slaves from either the Pacific Coast or the Maya lowlands.

The Nature of Relations with Central Escuintla and the Proximal Source of Teotihuacan "Influence" at Kaminaljuyu

If the foreigners interred as attendants or sacrificial victims in the Mounds A and B tombs did indeed come from central Escuintla, we may wonder if relations between Kaminaljuyu and that region were friendly. Compared to earlier times, few coastal ceramics are found at Kaminaljuyu and few highland wares are present in central Escuintla during the Early Classic period. Moreover, there are strong data suggesting that obsidian cores from the

El Chayal source (near Kaminaljuyu) were not traded to certain sites in Escuintla. Instead, finished prismatic blades made of El Chayal obsidian apparently trickled into the region from some unknown site or sites. A decrease in ceramic exchange, an apparent restriction of the trade of polyhedral cores, and the possibility that Kaminaljuyu captured and sacrificed young women and children from Pacific Guatemala all suggest that relations between the two centers of Montana and Kaminaljuyu were not cordial. Moreover, it is important to remember that *talud-tablero* architecture, Thin Orange ware, and obsidian from the Pachuca source have been found at both Kaminaljuyu and Solano, but are either unknown or extremely rare at Montana. Conversely, the warrior "portrait" figurines, *candeleros,* theater censers, and certain ceramic types that suggest a foreign presence at Montana are either unknown or exceedingly rare at Kaminaljuyu. It is peculiar, as well, that sites in the Guatemalan highlands with significant quantities of Pacific Coast and piedmont ceramics, such as Frutal (Brown 1977b:270–271), lack *talud-tablero* architecture and green obsidian. Apparently, highland communities that traded with the Escuintla region did not receive central Mexican–style artifacts or ideas from their partners in Pacific Guatemala. It is significant that the only evidence for a Teotihuacan "connection" at Frutal is a small quantity of Thin Orange sherds. As Brown (1977b:266) rightly concludes, this suggests contact with Kaminaljuyu, and not with contemporary sites in central Escuintla, where Thin Orange ware is unknown (see Chapter 2).

Together, all these data argue that the sources of "Teotihuacan influence" at Montana and Kaminaljuyu were not the same, and that the two sites did not engage in intense economic interaction. Although it is tempting to envision Pacific Guatemala as the staging ground for "Teotihuacan incursions" into the Maya highlands (e.g., Berlo 1984), to do so requires that we ignore the nature and context of nearly all the evidence from both regions concerning contact with central Mexico.

From where, then, did Kaminaljuyu receive central Mexican goods and ideas? Both the kinds of materials found at Kaminaljuyu and their contexts suggest a relationship with Tikal and Copán. At all three sites, imported tripod cylinders are limited to elite burials and a few other peculiar contexts, most notably the problematical deposits of Tikal. Teotihuacan "influence" is not seen in any meaningful way in household contexts at these three Maya sites. In particular, items suggesting participation in the state-sponsored religion of Teotihuacan are missing from Kaminaljuyu, Tikal, and Copán. At all three cities, Thin Orange ware and green obsidian (including sequins)—materials that are unknown or exceedingly rare in late-fourth- to

fifth-century contexts in southern Guatemala—have been found. At these three sites, *talud-tablero* platforms were built, but to date no evidence for that architectural style has been found in central Escuintla. Although chronological data are insufficient to determine the direction in which ideas and materials spread (Chapter 3), interaction among Kaminaljuyu, Copán, and Tikal seems to have been an important mechanism in their dispersal throughout the Maya highlands and lowlands. Conversely, Montana does not seem to have played an important role, despite the likely presence of a foreign colony at that site.

Conclusions and an Alternative Narrative

Data supporting the existence of a Teotihuacan enclave or barrio at Kaminaljuyu are extremely weak. To date, no bioanthropological evidence supporting a central Mexican origin for any individual at Kaminaljuyu has been mustered. Oxygen-isotope analyses of both enamel phosphate and carbonate from a single tooth may suggest that the principal figure of Tomb A-V spent part of his childhood at the central Mexican city. Alternatively, the sample may have been contaminated somehow, or may indicate a sojourn at some yet unknown place that happens to have an oxygen-isotope signature similar to that of Teotihuacan. Given the infancy of this type of research and the fact that oxygen-isotope assay yields only one dimension of data, it seems quite possible that such a region someday will be identified. In addition, it is worth repeating that oxygen-isotope analyses conducted on tooth enamel indicate place of birth and development rather than ethnicity. Some of the individuals exhibiting the Kaminaljuyu signature could have been considered Teotihuacanos. Likewise, a hypothetical individual with a value typical of Teotihuacan could have been a Maya raised in highland Mexico.

Central Mexican–related material culture is present in only very limited and spatially isolated contexts at Kaminaljuyu. Moreover, evidence of interaction with Teotihuacan is manifested in only two aspects of material culture: architecture and mortuary furnishings. The *talud-tablero* architecture of Kaminaljuyu, like that of other Maya sites, differs in important ways from most examples at Teotihuacan. Construction techniques were different, certain elements of the style that were common at Teotihuacan were optional at Kaminaljuyu, the basic proportions of the elements appear to have been different, and local features that are not seen at Teotihuacan were incorporated into structures at Kaminaljuyu. In addition, at least one kind of *talud-tablero* structure, the enclosure-atrium-platforms of the Palangana (Figure 3.4), has no known analogue in central Mexico. Finally, the *talud-tablero* structures

of Kaminaljuyu were not arranged in larger patterns that suggest Teotihuacan influence. At the macroscale level of the group and site plan, late Early Classic–period Kaminaljuyu was wholly highland Maya in appearance.

Interaction with Teotihuacan can also be seen in burial practices. In particular, both central Mexican homologies and identities are found in the ceramics and obsidian artifacts that accompanied the principal figures of the Esperanza tombs. Mirrors and certain shell ornaments also indicate interaction with central Mexico and the Gulf Coast. Nonetheless, if typical highland Maya goods were substituted for these items, all central Mexican aspects of the tombs would disappear. That is to say, there are no broader patterns of burial placement, body position, and complexes of material goods that replicate the mortuary practices of Teotihuacan. Moreover, the kinds of central Mexican goods found in the Esperanza-phase tombs are not the same as those most frequently found in Teotihuacan burials. An important exception is the use of back and chest mirrors, which were used not only at Teotihuacan but also in much of Classic-period Mesoamerica. Most striking is the arrangement of principal figures. Their seated cross-legged position, voluminous mummy bundles, and placement in wooden boxes appear to be unique to the Guatemalan highlands. The reuse of the earliest tombs of Mound A also are not consistent with Teotihuacan practices. Most important, the use of tombs for high-level elite burials is *completely unknown* from Xolalpan-phase Teotihuacan. Above the analytical level of the individual artifact, there are few affinities with central Mexican burial patterns.

Evidence for interaction with central Mexico, then, is limited to intermediate levels of analytical scale, particularly the artifact and elements of the structure. Moreover, such affinities tend to be superficial, that is, limited to the visible surface rather than the hidden interior. I attribute this to the manipulation of central Mexican symbols and artifacts in cultural contexts that are decidedly highland Maya in both their inner details and larger patterns. Together, superficiality and only limited replication at different scales indicate that evidence for a barrio or enclave of Teotihuacanos at Kaminaljuyu is insubstantial.

Nearly all of the narratives discussed here argue for the existence of a resident group of politically or economically dominant Teotihuacanos. Kidder et al. (1946) wisely chose to emphasize other aspects of the data, particularly their chronological implications. But others have piled additional speculation—regarding marriage patterns, *coups d'état,* economic structure, and even political intrigue—upon this rather shaky supposition. The imaginative narratives proposed by many researchers seem too complicated to be

warranted by a few dozen pots, composite mirrors, a couple of handfuls of obsidian, and several structures built in an eclectic, partially foreign style. If one accepts that evidence for a permanent and dominant Teotihuacan presence is rather weak, other explanations that do not require the existence of such a population should be sought.

One possibility is the gift-giving hypothesis proposed by Spence (1996a). It may be, therefore, that the foreign goods buried with the principal figures of the Esperanza tombs represent direct and personal relations with Teotihuacanos. Oxygen-isotope data from Skeleton 1 of Tomb A-V, in fact, support the notion that such direct contacts existed. But the gift-giving hypothesis on its own does not explain why locally produced "knock offs" are found in greater number in the tombs than actual central Mexican goods. Such homologies, and perhaps some of the central Mexican identities from the tombs, may reflect ties with the elite of other Maya and non-Maya sites closer to home. Two possibilities are Tikal and Copán, but it may also be that Kaminaljuyu was a source of "Teotihuacan influence" at those cities.

Demarest and Foias (1993) present a compelling argument for the presence of both identities and homologies. Their perspective does not contradict Spence's (1996a) hypothesis; indeed, it complements his. Nonetheless, the elite-emulation hypothesis has two points of weakness. First, it is unclear how Teotihuacan-style goods were manipulated in ways that reinforced status. Second, nearly all foreign-style portable artifacts at Kaminaljuyu were found in private contexts with restricted access. The manipulation of status-endowing objects presumably would have been conducted frequently and in very public arenas; large stelae are much better suited for this purpose than prismatic blade fragments and other small items. But Teotihuacan identities and homologies (with the exception of *talud-tablero* architecture) come overwhelmingly from only one sort of behavioral context: elite tombs. There is no reason to think that foreign-style vessels were brandished about in public as status symbols. Moreover, they do not appear in association with elite residential architecture. They were not luxury goods consumed in the homes of the elite. Instead, they seem to be objects whose transformative power lies in their hidden, mysterious, and perhaps religious attributes.

Linda Schele, Mary E. Miller, and David A. Freidel all have argued that expressions of late Early Classic interaction between Teotihuacan and the lowland Maya were related to ritual warfare, particularly the type that has been called the "Star war," "Venus war," or "Tlaloc-Venus war" (Schele 1986; Schele and Freidel 1990; Schele and Miller 1986). Janet C. Berlo (1983), Karl A. Taube (1992c), and Saburo Sugiyama (1992, 1996) have discussed the

importance of warfare and sacrifice in the imagery of the Feathered Serpent Pyramid and other contexts at Teotihuacan. What ties the burials of Mounds A and B most securely to Teotihuacan is not the presence of central Mexican identities and homologies within the tombs. Instead, it is the fact that the principal figures, and perhaps several attendants, were accompanied with the accouterments of both war and sacrifice. In particular, the composite pyrite mirrors worn on the chests and, in some cases, backs of the dead of Mounds A and B have parallels throughout Mesoamerica (see Taube 1992a).

Borhegyi (1971) once suggested that religion was an important motivator for interaction between Teotihuacan and the Maya region. Although I do not believe that the individuals in the Esperanza tombs were evangelizing priests from Teotihuacan, the foreign-style portable objects of Kaminaljuyu were found in—quite literally—occult contexts. Their hidden nature, therefore, seems to suggest something beyond public-status reinforcement and the expression of interpersonal relationships. One more conjecture that may be added to the long list of narratives concerning Teotihuacan-Kaminaljuyu interaction is that the principal figures in the Esperanza-phase tombs—regardless of their ethnic identity—participated in a pan-Mesoamerican cult. A similar mechanism has been proposed by William M. Ringle et al. (1998) to explain cultural similarities across Mesoamerica during the Epiclassic/Terminal Classic period. Local manifestations of such a cult could have differed from site to site. At Kaminaljuyu, it was expressed most dramatically and elaborately in syncretistic mortuary rites that employed objects and symbols from central Mexico within the context of highland Maya funerary practices.

At many sites, this proposed cult focused on warfare, Venus, the Bearded Dragon/War Serpent, and the goggle-eyed storm god. Perhaps the Late and Terminal Classic Maya Vision Serpent, which sometimes was conjured from a mirror, is related to the War Serpent imagery of both Early Classic Teotihuacan and many lowland Maya sites (see Schele and Mathews 1998:222; Taube 2000b). Both the storm god K'awiil and his Postclassic highland avatar Tojil were tied to rulership. One may hazard, therefore, that the conjectural Early Classic cult imbued its warrior priests with the *mana* of rulership. The Epiclassic/Terminal Classic cult of Quetzalcoatl posited by Ringle et al. (1998) may have been a revival of this earlier cult.

Stepping further into the realm of speculation, participation in a world cult may have entailed occasional pilgrimages to or training in Teotihuacan, which perhaps was its most powerful and important center. The oxygen-isotope analysis of the principal figure of Tomb A-V may indicate such a trip.

Alternatively, in special circumstances, local rulers might have traveled to the great central Mexican metropolis for rites of legitimization. European kings and emperors sometimes were coronated by the pope in Rome and Mixtec lords underwent such journeys to have their noses pierced. Sugiyama (2000:128) discusses similarities between greenstone nose pendants found in the Feathered Serpent Pyramid and those depicted in the art of lowland sites (e.g., Laporte and Fialko 1990:53; Schele and Grube 1994a:91). Somewhat similar jade nose pendants were found in Tomb B-I and the fill of Structure B-3 at Kaminaljuyu (Kidder et al. 1946:115, Figure 146k–l). It also may be that the "arrivals" mentioned in hieroglyphic texts associated with both K'inich Yaax K'uk' Mo' of Copán and Siyaj K'ahk' of Tikal describe *returns* from such pilgrimages of legitimization (see Chapter 5; Stuart 2000a).[15] The authority of Teotihuacan, just as that of some unknown place (Cholula?) in the Mixtec example and of Rome in the European case, would have been symbolic and religious rather than actual and political.

Why is this scenario any better than the speculative narratives of researchers who suffer from "Teotihuacanomania" (Chapter 9)? For one thing, it is a minimalist hypothesis. That is, it narrowly accounts for the data we have for Teotihuacan "influence" without presupposing a much broader and intense sort of interaction for which we have little evidence. It is consistent with the cultural contexts in which central Mexican–inspired goods are found (at Kaminaljuyu, these contexts are elite tombs and the façades of a small number of buildings), and does not force us to account for the numerous realms of material culture in which there are *no* manifestations of Teotihuacan "influence." It also is compatible with the eclectic mixture of both local and imported stylistic elements in architecture and ceramics. In contrast, narratives that posit the existence of a Teotihuacan enclave containing elites who dominated Kaminaljuyu require us to explain why *no* household contexts contain green obsidian, pottery, figurines, or *candeleros* from or inspired by Teotihuacan. Such narratives also must account for the fact that mortuary patterns seen in the tombs of "Teotihuacanos" abroad never have been observed in contemporary Teotihuacan. Although migrations frequently lead to changes in burial practices (Chapter 1), the adoption of so many aspects of Maya funerary rituals would indeed be surprising. Finally, a world-cult hypothesis affords insight into *why* foreign traits were not only tolerated but also embraced by local elite. It considers the Maya as actors, rather than as passive victims.

I have argued that evidence is insufficient to conclude that a resident popu-

lation from central Mexico lived at and dominated the site of Kaminaljuyu. But the elite members of highland Maya society who sponsored the construction of *talud-tablero*-style architecture and who were buried in the tombs of Mounds A and B may have been, in some sense, Teotihuacanos. Participation in a pan-Mesoamerican cult limited to the elite would have created social distance between local rulers and their subjects, particularly if cult members were seen as divine warriors of a foreign god. At late Early Classic Kaminaljuyu, which apparently lacked writing and all but lacked a tradition of carved-stone monuments, social distance was created by erecting foreign-style public architecture (Mounds A and B) and more private buildings (in the Acropolis and Palangana). A hybridized Teotihuacan–highland Maya ethnicity could have been fabricated to create even greater social distance. It is possible, too, that the need for social distinctions led to the early evolution of the myth of foreign origin so common to Postclassic Mesoamerica. Through ethnogenesis, the Maya rulers of Kaminaljuyu may indeed have become Teotihuacanos.

Acknowledgments

I am particularly grateful to Marion Popenoe de Hatch for the many conversations we had regarding Kaminaljuyu while I taught at the Universidad del Valle de Guatemala under the Fulbright Scholars Program. The conclusions to this chapter specifically reflect those conversations. Nevertheless, I take all blame for extending speculation further than may be warranted. I also thank her and Juan Antonio Valdés for inviting me to participate in the Proyecto Arqueológico Miraflores II. Christine D. White and Lori E. Wright both were generous and collegial in sharing their unpublished manuscripts with me. George L. Cowgill's cogent criticisms in both his symposium paper (Cowgill 1999a) and an earlier version of Chapter 12 clarified both the direction and content of this chapter. Finally, I wish to express my appreciation for the friendship of Edwin M. Shook, who for ten years graciously treated me to his cordial hospitality and seriously entertained any question—no matter how inane—I had about Kaminaljuyu and Middle American archaeology.

Notes

1. Marion Popenoe de Hatch (personal communication 2001) correctly notes that Guatemalan scholars actively engaged in research at Kaminaljuyu no longer consider such scenarios. Nevertheless, they still dominate the published literature on Kaminaljuyu-Teotihuacan interaction.

2. Both Early and Late Classic structures at Kaminaljuyu tend to be oriented in this fashion. This represents an important shift from the Preclassic pattern of large, open plaza groups oriented northeast to southwest (see Figure 3.1).

3. Structures A-4 and A-5, built in the *talud*-and-cornice style of the Integration phase, contained painted cornices and summit platforms (Kidder et al. 1946:18, 43, Figure 7).

4. George L. Cowgill (personal communication 2001; see Chapter 12:Note 1), however, notes that the method used to stabilize the core of the Feathered Serpent Pyramid was not used in the Moon Pyramid. It may be another feature that makes the Feathered Serpent Pyramid unique at Teotihuacan.

5. This suggestion is based on the distance of the pit to the base of the pyramid, and not to the bottom of the stair. Alternatively, the pit might have been analogous to Graves 5 and 6, which each contained nine individuals.

6. Grave 12 of the Feathered Serpent Pyramid may have been reused when the structure was built, but only after being emptied and modified. That is, Grave 12 does not reflect a pattern of reuse and accretion.

7. Tomb A-I contained a *metate* but no *mano*.

8. In fact, at the time the Feathered Serpent Pyramid was built, cylindrical tripods apparently were not made at Teotihuacan (Chapter 12).

9. This observation is somewhat tautological. Companions often were identified not only by their peripheral positions within the tombs, but also by the lack of accompanying items. Nonetheless, Kidder et al. (1946:74) argue that Skeletons 2 and 3 of Tomb B-I were secondary individuals, and each was accompanied with a pyrite plaque, including the spectacular Veracruz-style example (Kidder et al. 1946:Figure 156). The identification of certain figures, including these two, as sacrificed servitors or companion figures is problematic.

10. The *candelero* was recovered from the fill of Structure B-4 and may have been associated with a destroyed tomb or structure (Kidder et al. 1946:71, 216). A peculiar figurine was found in Tomb A-III (Kidder et al. 1946:214, Figure 168a). It does not resemble examples known from Teotihuacan.

11. White et al. (1998) conducted their study on bone, rather than on enamel phosphate or carbonate.

12. These are Tomb A-I, Skeleton 4 and Tomb B-IV, Skeleton 2. The first is an isolated skull, but because Tomb A-I was opened and reused, we cannot rule out the possibility that this individual once occupied a more central position in the tomb. The fact that he was an adult of middle years at the time of his death suggests that he may have been a principal figure (Wright 2000). Kidder et al. (1946:80) propose that Skeleton 2 from Tomb B-IV is a sacrificed victim, but acknowledge that the accompanying items are more generous than for any other companion figure. The young age of the individual supports their tentative identification. As for Skeletons 2 and 3 of Tomb B-I, the role played by Skeleton 2 in Tomb B-IV is unclear (see Note 9).

13. $\delta^{18}O_p$ values from first molars must be adjusted by -0.7 ‰ in order to correct for the weaning effect (Wright and Schwarcz 1998, 1999).

14. Lori Wright (personal communication 2000) suggests that this apparent difference is overstated. The phosphate values of these individuals are at the very top of the Kaminaljuyu range as defined by other analyzed samples. Given the small overall sample size, these three values may distort the definition of that range.

15. On the Tikal marker, Siyaj K'ahk' is described as a *kalo'mte'* (perhaps of Tikal), a high title used by the rulers of only a few sites. I speculate that he might have received this title because of a pilgrimage.

Founding Events and Teotihuacan Connections at Copán, Honduras

Robert J. Sharer

The archaeological site of Copán is situated in a fertile upland valley in western Honduras. Copán has long been recognized as an important political and religious center that was settled during the late Early Preclassic (c. 1000 B.C.; Fash 1991), but reached its apogee during the late Early Classic and Late Classic periods (c. A.D. 400–800). This chapter surveys the archaeological evidence for connections between Copán and central Mexico—including Teotihuacan—during the era of the dynastic Founder K'inich Yaax K'uk' Mo' and his son and successor, K'inich Popol Hol (Fash 1997; Schele and Grube 1994b; Sharer 1997c; Stuart and Schele 1986). Their reigns correspond to the mid–fifth century in our calendar (A.D. 426/427–472), in the middle of the Early Classic period (A.D. 250–600), and are contemporary with those of the great Siyaj Chan K'awiil of Tikal and his son K'an Ak (see Chapter 8). This chapter sets the scene with a synopsis of the architectural history of the Copán Acropolis during this period. It then isolates some of the most important components of this development, as seen in architecture, burial practices, and artifacts, as indicators of interaction with other major Mesoamerican sites. The goal of this study is a better understanding of interaction with Teotihuacan at the time of the founding of the Copán dynasty. It must be pointed out, however, that this is a preliminary study. Our research is ongoing, and new data and analyses could necessitate a revision of the conclusions described here.

The archaeological evidence discussed here has been collected by a consortium of programs investigating the Copán Acropolis, originally organized by William Fash as the Proyecto Arqueológico Acrópolis Copán (PAAC). Since 1989, I have directed one of these PAAC programs, the Early Copán Acropolis Project (ECAP) of the University of Pennsylvania Museum. ECAP has excavated some 3 km of tunnels, starting from the famous cross section, or *corte*, exposed by the Río Copán along the eastern edge of the Acropolis (Sharer et al. 1992). ECAP tunnels join with others excavated in programs directed by Ricardo Agurcia beneath Str. 10L-16 (Agurcia 1996) and

by William Fash within Str. 10L-26 (Fash et al. 1992). Together, the three PAAC programs have excavated the most extensive system of tunnels ever dug at a Maya site, covering the eastern two-thirds of the Acropolis. As a result, a stratified sequence of the palaces, temples, and administrative buildings used by the rulers of Copán over a four-hundred-year period has been revealed, mapped, and consolidated (Sharer, Fash et al. 1999; Sharer, Traxler et al. 1999).

One of our major research goals is to correlate archaeological evidence with historical information provided by texts recorded by the Maya both during and after the founding events (Fash and Sharer 1991). Both archaeological and historical sources are fragmentary, but in combination they proffer a far more complete picture than either can by itself. The extant historical record of Copán has been enhanced by seven newly discovered texts. These are historical inscriptions found directly associated with Early Classic architecture in the tunnels beneath the Acropolis. These new texts provide crucial information about the individuals and events of the Early Classic era of Copán, and they allow us to test the validity of later retrospective accounts. They also allow us to directly correlate and evaluate Early Classic archaeological evidence with historical information dating from the same era (Sharer, Traxler et al. 1999).

The Dynastic Founder

The best known of the retrospective histories of Copán is Altar Q, famous both for its text and for its portraits of sixteen Copán rulers around its four sides (Schele 1992). These begin with the Founder, K'inich Yaax K'uk' Mo', and end with the sponsor of the monument, the sixteenth ruler, Yaax Pasaj Chan Yopaat, who dedicated this stone 350 years after the dynasty was established (Figure 5.1). The text of Altar Q records that in September of A.D. 426, K'uk' Mo' Ajaw took the royal scepter, and three days later he was given the Founder's title, K'inich Yaax K'uk' Mo', as he arrived at the royal lineage house (Schele 1989; Stuart 1992; Stuart and Schele 1986). There is no indication as to the location of the royal lineage house. A third and final event occurred 152 days later, when, as "Lord of the West" (Schele and Grube 1992), K'inich Yaax K'uk' Mo' arrived at Ox Witik (Three Mountain Place). This is assumed to be Copán, implying that the actual arrival and founding event at Copán was in A.D. 427 rather than 426. The reference to the arrival at Ox Witik and the association of K'inich Yaax K'uk' Mo' with the "Lord of the West" title also could mean that the two earlier episodes were not at Copán, but at a place located a 152-days' journey away. Although this

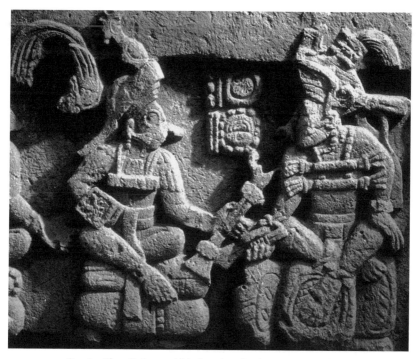

FIGURE 5.1. Copán Altar Q (west side) showing the dynastic Founder K'inich Yaax K'uk' Mo' (left) and his Teotihuacan-style warrior gear (goggles and War Serpent shield on his right forearm).

might reflect the location of the royal lineage house, several scholars suggest that Teotihuacan was the location of K'inich Yaax K'uk' Mo's inauguration events (Martin and Grube 2000; Stuart 2000b).

In his Altar Q portrait, K'inich Yaax K'uk' Mo' is shown as a Maya ruler seated on the *ajaw* glyph. But he also is wearing warrior gear linked with Teotihuacan: goggles over his eyes and a War Serpent shield on his right arm. Other Late Classic references to the Founder associate him with Teotihuacan (Fash 1998), as in the goggle-eyed ceramic image associated with the Scribe's Tomb (most likely that of Ruler 12, K'ahk' Ti' Ha' K'awiil) beneath Str. 10L-26 (Fash 1991, 1997), and in a carved stone figure originally associated with Str. 10L-16 (Fash 1992). The textual evidence indicates that K'inich Yaax K'uk' Mo' ruled from A.D. 426/427 to 437 (Sharer, Traxler et al. 1999). His son and successor, K'inich Popol Hol, appears to have reigned for some thirty-five years thereafter until A.D. 472 (Grube et al. 1995). The sum of the extant epigraphic and iconographic evidence tells us that K'inich Yaax K'uk' Mo' probably was foreign to Copán, and that he was a warrior king

who may have come to power by conquest. If indeed K'inich Yaax K'uk' Mo' came from outside of Copán, one possibility for his homeland is the Petén, but in any event it seems that he arrived at Copán with strong Teotihuacan associations (Sharer 1997c, 1999b).

The Acropolis in the Founding Era

The evidence for external interaction with Teotihuacan and other Early Classic centers comes from the architecture, burials, and artifacts discovered in the lowest Acropolis tunnel levels. These levels are dated to the dynastic founding era (c. A.D. 400–450) by associated texts, ceramics, and radiocarbon assays (Sharer, Traxler et al. 1999). The earliest monumental buildings beneath the Acropolis actually comprise three separate architectural complexes: the Southern Group, the Northeast Group, and the Northern Group (Sharer 1997a). Today these early complexes respectively lie deep beneath Str. 10L-16, the Acropolis East Court, and Str. 10L-26. These complexes represent the first known monumental constructions in this locus, and they contain examples of both earth or adobe structures and masonry buildings (Sharer, Fash et al. 1999). Expansion episodes connected all three groups, and later they were integrated into a single elevated architectural complex, the Early Acropolis (Sharer 1996).

In the Southern Group, ECAP excavations supervised by David Sedat have documented what appears to have been the core of the Founder's royal center, a series of monumental buildings situated on a small platform directly beneath Str. 10L-16 and about 100 m west of the Río Copán (Sedat 1996). In the Northeast Group, ECAP excavations supervised by Loa Traxler and Julia Miller have revealed several large residential-type structures arranged around central courts that probably served as the royal palace during the Early Classic period (Traxler 1996, 1998). The Northern Group excavations of William Fash's program have uncovered an early sequence of temples and the initial ballcourt that together probably served in public rituals dedicated to the royal dynasty and the Copán state (Fash 1998; Fash et al. 1992). In the summary that follows, I trace the major landmarks in the evolution of the Southern and Northern Groups, both of which contain recently discovered monuments with Early Classic texts. For the simultaneous development of the intermediate Northeastern Group, the reader is referred to other published accounts (Sharer, Fash et al. 1999; Traxler 1996, 2001).

Excavation has revealed remnants of demolished buildings that predate these three complexes, but these earlier structures apparently were relatively

small earthen and cobble constructions (Sharer, Fash et al. 1999; Traxler 2001). The only preexisting large-scale construction in the area seems to have been beneath the monumental complex known as Platform 10L-1, still visible (and largely unexcavated) in the northwest quadrant of the Main Group. It has long been hypothesized that the bulk of the construction of Platform 10L-1 dates to the Bijac phase (A.D. 1/100–400/425), and that it could have been part of the royal center used by the rulers of Copán prior to the arrival of K'inich Yaax K'uk' Mo' (Fash and Sharer 1991). In fact, the only monument standing in front of this complex, Stela E, may include a textual reference to the ruler in power at the time of the arrival of K'inich Yaax K'uk' Mo' (Schele et al. 1993:3).

It seems, therefore, that the three monumental complexes dating to the time of the founding of the dynasty represent a new royal center constructed by K'inich Yaax K'uk' Mo' south of what may have been an older royal complex (Sharer 1996; Traxler 2001). This new royal center included the earliest known masonry constructions at Copán. The largest component of the new royal center was the Southern Group, with structures of both masonry and non-masonry materials built over earlier small-scale constructions. The Southern Group was situated on a low earthen platform, provisionally named Yune, located on slightly higher ground in the midst of swampy terrain adjacent to the Río Copán (Sedat 1997a).

Three Early Buildings Associated with the Founder: Hunal, Yax, and Motmot

One of the buildings on the Yune platform, Hunal (Sedat 1997b; Sedat and Sharer 1997), stands out because of its uniqueness. It is a low masonry platform with a façade in the central Mexican–*talud-tablero* style (Figure 5.2). Several stages of the summit building of Hunal were demolished by later construction, but enough of the final stage survives to determine that it had a north-facing doorway centered on an outset stairway, and two rooms separated by an east-west interior wall that was broken by a doorway offset to the east and equipped with curtain holders. Debris indicates that its interior walls probably were decorated originally with brilliantly painted murals. Hunal was surrounded by several other constructions, including a monumental masonry structure to the south (field-named Wilin) and a sequence of earthen temple-type structures to the northwest that culminated in a monumental terraced substructure named Maravilla (Sedat 1997a; Sharer, Fash et al. 1999). We interpret Hunal and the other buildings on the Yune plat-

FIGURE 5.2. Hunal structure (north side): (a) hypothetical elevation; (b) detail of *talud-tablero* façade.

form as the royal residence and administrative center constructed for K'inich Yaax K'uk' Mo' (Sedat 1997a; Sharer 1997c; Traxler 2001).

Some 75 m directly north of Hunal, another masonry building, given the field name Yax, was also constructed at the time of the Founder (Fash et al. 1992; Williamson 1996). It was part of the Northern Group, which anchored

the new dynasty in Maya time, because associated with its earliest build-ings are two retrospective texts that commemorate the auspicious 9.0.0.0.0 (A.D. 435) period ending that occurred late in the reign of K'inich Yaax K'uk' Mo'. These texts link the new *bak'tun* to the newly established dynasty and seem to proclaim its destiny to rule during the ensuing four-hundred-year period (Sharer 1997a).

The Yax structure soon was demolished and succeeded by a larger masonry substructure named Motmot, built either at the time of the period-ending ceremonies or soon thereafter (Fash 1998). The façade of Motmot was decorated by four modeled-stucco sky-band motifs. Its western stair was served by an extensive plaster floor on its western and southern sides; the floor, in turn, is associated with the earliest-known ballcourt (Fash 1998; Williamson 1996). A round tomb chamber west of Motmot contained the remains of an adult female and offerings that included three male skulls, pre-sumably trophies. The similarities between the circular Motmot tomb and burials at Teotihuacan have been discussed by Fash (1995, 1998). The identity of the buried woman remains an enigma, but strontium isotope analysis sug-gests that she was not native to Copán (Buikstra 1997; Buikstra et al. 2000).

The burial may have been placed in the Motmot tomb as part of the 9.0.0.0.0 period-ending ceremonies. In any case, there is evidence that the tomb was reopened and additional offerings were placed inside before being resealed by a disk-shaped limestone monument known as the Mot-mot marker (Fash 1995, 1998). The Motmot marker was dedicated by K'inich Popol Hol to commemorate the auspicious 9.0.0.0.0 period ending that he celebrated with his father. It has a double-column text flanked by portraits of K'inich Yaax K'uk' Mo' and his son and successor, K'inich Popol Hol (Schele, Fahsen, and Grube 1994). The dedication date of the monument has been difficult to determine. It first was suggested that distance numbers reading either 9.0.7.10.5 (A.D. 443) or 9.0.10.7.5 (A.D. 446) date the place-ment of the Motmot marker. Recently, David Stuart (personal communica-tion 2000) has proposed that the dedication of the monument corresponds to the 9.0.0.0.0 period-ending date, placing the Motmot marker within the reign of K'inich Yaax K'uk' Mo', some two years before his death (which may have occurred in A.D. 437 for reasons described below).

The apparent death date of the Founder in A.D. 437 makes it likely that his successor, K'inich Popol Hol, came to power in the same year. A host of new and larger buildings were constructed during the reign of K'inich Popol Hol, together forming the first Copán Acropolis (Sharer 1996; Sharer, Trax-ler et al. 1999). The success of K'inich Popol Hol's efforts can be seen in the

message of prestige and continuity of power proclaimed by the sequence of temples built over Yax and Motmot, culminating in the Late Classic with Str. 10L-26 and its hieroglyphic stair (Fash et al. 1992). The same message is proclaimed by an even longer sequence of at least seven temples built directly over Hunal in the Southern Group (Agurcia 1996; Agurcia and Stone 1991). The final temple in the southern sequence, Str. 10L-16, together with Altar Q explicitly commemorate K'inich Yaax K'uk' Mo' and the establishment of the dynasty (Taube 2000a).

The Hunal Tomb

At the base of the sequence of temples in the Southern Group was a vaulted tomb placed under the floor of Hunal (Sedat 1996; Sedat and Sharer 1997). The Hunal tomb contains offerings and the bones of a robust male who stood a little over 5′6″ tall, and who died between the ages of fifty-five and seventy years (Buikstra 1997). The burial goods reflect external ties with several important areas of Mesoamerica. More specifically, the Hunal offering vessels have close parallels to vessels from Early Classic burials at Teotihuacan, the Esperanza-phase tombs at Kaminaljuyu, and Tikal Burial 10 (Culbert 1993). Neutron activation analyses have been completed on samples from nineteen Hunal tomb vessels (Bell and Reents-Budet 2000). Results indicate that three of these vessels were manufactured in central Mexico. These imports consist of two Thin Orange ring-based bowls and a stuccoed vessel with Teotihuacan-style motifs (Figure 5.3). The neutron activation results also indicate that two vessels from the Hunal tomb are from the central Petén, and nine vessels are local products from the Copán region. A large deer-effigy vessel similar to effigy vessels from Esperanza-phase Kaminaljuyu (Kidder et al. 1946) and Tikal Burial 10 (Culbert 1993:Figures 14 and 18) was sourced to the southern Maya area.

Another possible association with Teotihuacan is seen in two composite objects made from cut shell "spangles." One was found adjacent to the cranium, the other on the tomb floor. These appear to be headdresses similar to those shown on Teotihuacan warrior figures such as those on the sides of Tikal Stela 31 (Stone 1989). There also is a Maya-style mosaic rendered on a collar-shaped shell pendant of an Early Classic type associated with both Teotihuacan and Kaminaljuyu (Kidder et al. 1946:149). It is manufactured from *Patella mexicana*, a species from the Pacific Coast of Mesoamerica (Ekholm 1961). Most of the other offerings in the tomb appear to be of Maya origin, including both locally made objects and goods that probably reflect ties to the Maya highlands of Guatemala.

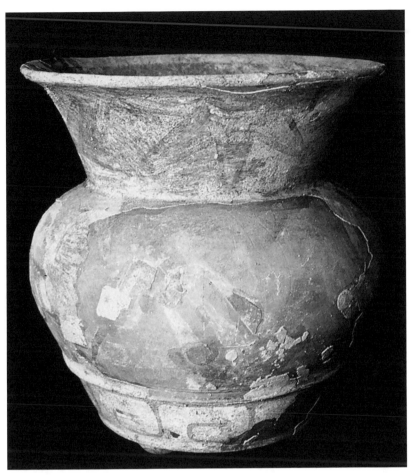

FIGURE 5.3. Teotihuacan-style painted vessel from the Hunal tomb.

Although all the evidence cannot be reviewed here, consistent clues indicate that these are the bones of K'inich Yaax K'uk' Mo' (Sharer 1997b). The strategic position of the tomb and the vessels within it are associated both spatially and temporally with the death of the Founder. Several tomb offerings have probable direct links to K'inich Yaax K'uk' Mo', including a carved jade with the mat design, a Maya symbol of rulership, and a large jade bar pectoral very similar to that depicted on the Founder's portrait on Altar Q. In addition, the aforementioned collar-shaped shell pendant is "name-tagged" with a *wi te* title that probably refers to K'inich Yaax K'uk' Mo' (David Stuart, personal communication 1999). The individual in the Hunal tomb suffered a severe parry fracture of the right forearm, consistent with the depiction of K'inich Yaax K'uk' Mo's warrior portrait on Altar Q, in which

he is shown holding a small shield protecting his right forearm (Figure 5.1). Also consistent with the text on Altar Q, the strontium isotope analysis of remains from the Hunal tomb show that the individual was not native to Copán, but spent his early childhood and young adult years in the Petén before becoming a resident of the Copán region in the final years before his death (Buikstra et al. 2000).

We may never be certain that the Hunal tomb holds the remains of K'inich Yaax K'uk' Mo', but the evidence for the way this location was used over the remainder of the Classic period provides compelling support for its identification with the Founder. Excavation reveals that Hunal and its tomb established a symbolic center of the Acropolis that was maintained by the Founder's successors during the remainder of the dynastic history of Copán (Sharer 1997a). The structures that succeeded Hunal appear to have been funerary temples, and several refer to K'inich Yaax K'uk' Mo' (Sharer 1996). The second temple built over Hunal, called Margarita, presents the Founder's name on its western façade. In addition, K'inich Yaax K'uk' Mo' is prominently mentioned in the text of the Xukpi stone, an Early Classic monument found in Margarita (see below). Both the extraordinarily preserved Rosalila temple, dedicated by Ruler 10 in A.D. 571 according to the eroded text on its stair, and the final temple in the sequence, Str. 10L-16, built by Yaax Pasaj Chan Yopaat, were decorated with carved portraits of K'inich Yaax K'uk' Mo' and iconographic references to the Founder (Agurcia and Stone 1991; Taube 2000a).

Yehnal and Margarita: Successive Temples
Dedicated to the Founder

K'inich Popol Hol's efforts expanded all three architectural groups founded by his father (Sharer 1996; Sharer, Traxler et al. 1999), but the major focus of this building program was in the Southern Group (Sedat and Sharer 1997). After the burial beneath the Hunal structure was sealed, the first two successors to Hunal were constructed within a span of about a decade, as were the beginnings of a larger Acropolis platform that replaced most of the buildings erected by K'inich Yaax K'uk' Mo' (Sedat 1996).

The first structure that succeeded Hunal, Yehnal (c. A.D. 437–445), established a new westward orientation adopted by all later temples built at this location. Yehnal was decorated with painted stucco-relief panels of K'inich Ajaw, the Maya sun god, flanking its western stair. These images may refer to the *k'inich* title held by the departed Founder, or even to his celestial status. A masonry stair led from inside the temple on Yehnal to a new vaulted

tomb chamber that was constructed several meters below its floor (Sedat and Sharer 1997).

But before the tomb was occupied, Yehnal was replaced by a larger temple, given the field name Margarita, that is dated to c. A.D. 445–460. The still empty tomb (dubbed the Margarita tomb) remained accessible by an extended stair under the floor of the new summit temple. It seems likely, then, that the intended occupant of the tomb incorporated into Yehnal survived the usefulness of that building and lived to see the construction of Margarita. The elaborate western façade of Margarita displays polychrome full-figure emblems of the Founder's name, identifying it as the second of K'inich Yaax K'uk' Mo's funerary temples built at this location (Sharer 1996).

The Margarita substructure was successively buried by flanking platforms, which to the west encased the burial of an apparently sacrificed male wrapped in a bundle and accompanied by Teotihuacan warrior paraphernalia, including shell goggles and atlatl darts (Figure 5.4). Strontium isotope analysis indicates that the warrior was native neither to Copán nor to Teotihuacan, but may have come from the northern Maya lowlands (Buikstra 1997; Buikstra et al. 2000). Eventually, Margarita was buried and replaced by the Chilan structure, the third temple to occupy this locus directly above Hunal and its tomb (Sedat and Sharer 1997).

The event that seems to have triggered the replacement of Margarita by Chilan was the interment of a very important royal lady in the tomb chamber beneath its summit floor (Sedat and Sharer 1997). This interment was accompanied by the demolition of Margarita's summit temple. But in the construction of the succeeding Chilan substructure, access to the Margarita tomb was maintained by a new vaulted passageway that was connected to the stair of the tomb. This passageway also led to a new vaulted offering chamber constructed above the burial chamber. Although no texts identify her, the position and elaborateness of her tomb, together with the huge quantity of jade and other materials left as her offering, suggest that this royal lady was the widowed queen of K'inich Yaax K'uk' Mo' and the mother of K'inich Popol Hol (Sedat and Sharer 1997). Her body was covered with jade and shell ornaments and placed on a stone slab in the burial chamber. The chamber floor was covered with pottery and other offerings. More offerings were placed in the chamber above the burial crypt. Although the vessels recovered from the burial chamber floor have yet to be tested, neutron activation analyses of twelve vessels from the upper offering chamber are available. These results indicate that one of the vessels is of local manufacture, seven appear to be imports, and four are unidentified (Bell and Reents-Budet 2000). The

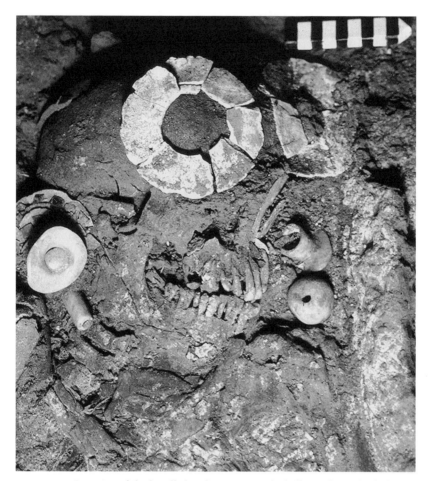

FIGURE 5.4. Remains of the bundled male warrior with shell goggles and atlatl darts *in situ*, buried in the platform west of the Margarita structure.

imports include five vessels from central Mexico and two basal-flanged poly-chromes from the Maya area. One of these is from the central Petén and is similar to a vessel from Tikal Burial 177 (Culbert 1993:Figure 37). The other, from the southern Maya area, is similar in form and decoration to vessels from Tomb A-VI of Kaminaljuyu (Kidder et al. 1946:Figure 207).

Neutron activation analysis suggests that an unidentified site in central Mexico is the source of the most extraordinary vessel found in the upper offering chamber of the Margarita tomb, a lidded painted-stucco polychrome cylindrical tripod (Sedat 1997c). The painted scene on this vessel depicts a building with a *talud-tablero* substructure that may in fact represent the Hu-nal structure (Figure 5.5). According to Dorie Reents-Budet (personal com-

munication 2000), the proportions of this vessel are like those of cylindri-
cal tripods from Kaminaljuyu and Teotihuacan, but its open-work supports
are similar to contemporaneous vessels from Petén sites such as Tikal and
Uaxactun. Her examination reveals that the building depicted on the vessel
is actually Maya in style and that an iconic rendition of K'inich Yaax K'uk'
Mo's name is painted on the side of the building. Reents-Budet concludes
that the potter who made the vessel mixed forms from Teotihuacan, Kami-

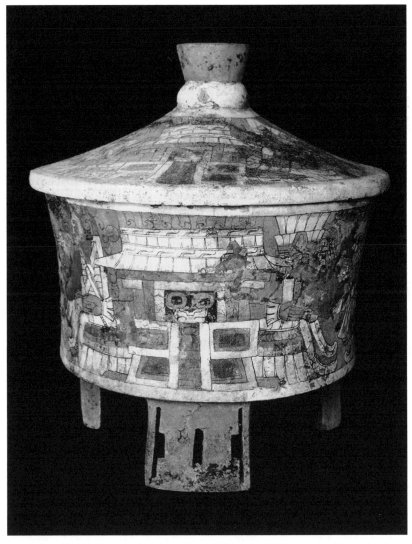

FIGURE 5.5. Teotihuacan-style painted vessel from the Margarita tomb.

naljuyu, and the central Petén, and that the artist who decorated the vessel used Maya pictorial and glyphic conventions.

A carved bench known as the Xukpi stone was reset into the south wall of the upper chamber of Margarita (Sedat and Sharer 1994). Its text records the dedication of a tomb or funerary temple by K'inich Popol Hol on 9.0.2.0.0 13 Ajaw (November 30, A.D. 437; Schele, Grube, and Fahsen 1994), probably a reference to the underlying Hunal tomb and, by implication, to the death of K'inich Yaax K'uk' Mo' (Sharer, Traxler et al. 1999). The text closes with the name of the Founder followed by a possible title or relationship glyph and another name read as Siyaj K'ahk' ("Fire Is Born," nicknamed "Smoking Frog"). Given the importance of a similar name in the early dynastic events of Tikal (Fahsen et al. 1995; Stuart 1997), and more recent evidence that may link Siyaj K'ahk' with Teotihuacan (Stuart 2000a, 2000b), the further study of the Xukpi stone text may provide crucial new evidence about the origins of K'inich Yaax K'uk' Mo' and the establishment of the ruling dynasty of Co-pán. Because the Xukpi stone is reset, we cannot be sure of its initial prove-nience, but it is plausible that its original context was Yehnal, an association strengthened by the dedication reference.

The Building and Monument Programs of Ruler 2, K'inich Popol Hol

After his death, K'inich Yaax K'uk' Mo' was promoted as the dynastic Founder of Copán by the efforts of his son and heir, who sponsored a vast building program and the carving of texts on stone monuments in honor of his father. K'inich Popol Hol expanded the royal center established by his father, beginning the process that would integrate the three original archi-tectural groups into a single Acropolis (Sharer 1996). The architecture of this expanding royal center seems increasingly to have emphasized lowland Maya architectural canons. The best-known indication of this is the already men-tioned replacement of Hunal, with its *talud-tablero* substructure, by Yehnal and Margarita, two funerary temples constructed with lowland Maya apron moldings on their façades.

Lowland Maya traditions were also promoted by the dedication during K'inich Popol Hol's reign of at least two monuments with hieroglyphic texts. One of his monuments, the Xukpi stone (A.D. 437), has already been dis-cussed. The other, Stela 63, comes from the final years of K'inich Popol Hol's reign, probably c. A.D. 465 (Stuart et al. 1989). It was found buried inside the Papagayo structure, the building that succeeded Motmot in the long se-quence that culminated in Str. 10L-26 (Fash et al. 1992). Stela 63 refers back

to the 9.0.0.0.0 event and explicitly names K'inich Popol Hol as the son of K'inich Yaax K'uk' Mo' (Stuart et al. 1989).

The combined archaeological and textual evidence from the Early Classic levels of the Acropolis have greatly amplified our understanding of the founding era, specifically the reigns of K'inich Yaax K'uk' Mo' and his son. We know now that K'inich Yaax K'uk' Mo' was not a mythical Founder but an actual ruler who apparently dedicated one monument during his reign (the Motmot marker) and was referred to by his son and successor on two other newly discovered monuments. It now appears that the establishment of the Copán dynasty in A.D. 426/427 was marked by the construction of a new royal center in a previously marginal location, a "place of reeds" (Stuart 2000b), given its river-bottomland setting. This new royal center included buildings of both masonry and adobe that were clustered in three groups. The Hunal structure may have been built during the reign of K'inich Yaax K'uk' Mo', and the tomb beneath it may hold his mortal remains. It also appears that K'inich Yaax K'uk' Mo' ruled at Copán for a relatively short time, a little more than a decade (A.D. 426/427–437), but he held the throne at an especially significant time that included the auspicious 9.0.0.0.0 period ending. He marked this profound event by sponsoring a long-remembered ceremony conducted with his son and heir. The death of K'inich Yaax K'uk' Mo' and the succession of his son as Ruler 2, both apparently occurring late in the year A.D. 437, initiated a new reign of some thirty-five years during which K'inich Popol Hol established his father's legacy as dynastic Founder and sponsored the expansion of the new royal center that eventually would grow into the Acropolis we see today.

External Connections during the Founding Era

With this architectural synopsis in mind, we turn to the external links seen in the archaeological record from the founding era of the Acropolis. The focus of the issue is the association of K'inich Yaax K'uk' Mo' with areas outside of Copán, and most specifically, with Teotihuacan. Of course, these external connections are critical to understanding where K'inich Yaax K'uk' Mo' came from and how he came to power.

There are several retrospective references to the rulers of Copán before the reign of K'inich Yaax K'uk' Mo', including a "Mak'ina Leaf Ajaw" who was in power at 8.6.0.0.0 (A.D. 159) and is named on Stela 4 and Stela I (Schele 1987; Stuart 1986), and a "First Ruler" cited on Stela 24 (Stuart 1989). The Stela E text may name the ruler of Copán at the time of the founding event in A.D. 426/427 (Schele et al. 1993). Thus, it seems that a break oc-

curred between the old royal line and a new line established by K'inich Yaax K'uk' Mo'. This leads to the obvious question of how the Founder managed to supplant the established royal lineage of Copán.

There is some evidence that military conquest was the immediate means used by K'inich Yaax K'uk' Mo' to gain power. Assuming that the bones in the Hunal tomb are those of the Founder, several combat-type injuries, all of which healed before his death, testify to his warrior status (Buikstra 1997; Buikstra et al. 2000). Thus, the depiction of K'inich Yaax K'uk' Mo' in warrior garb on Altar Q (Figure 5.1) may be an accurate representation of his avocation during life. Possible historical support for the conquest of Copán comes from the text on Stela E that mentions K'inich Yaax K'uk' Mo' and from phrases interpreted by Linda Schele et al. (1993) as referring to a conflict between K'inich Yaax K'uk' Mo' and the established Copán ruler that led to the victory of the former and the founding of a new dynasty. Finally, in the Motmot text, K'inich Yaax K'uk' Mo's name is followed by a title or event glyph that depicts a burning Copán temple (Fahsen et al. 1995). This could be a conquest reference presented according to the canons of a general Mesoamerican tradition.

In addition, it is reasonable to expect that the Founder used kin ties to justify his claim and that of his descendants to the throne of Copán. The most common means for doing this is royal marriage (Marcus 1992b:223–259). We may speculate, then, that K'inich Yaax K'uk' Mo' married a woman from the old royal family of Copán in order to strengthen his legitimacy and establish his patriline as the new royal dynasty. As we have seen, judging from its elaborate architecture and rich offerings, the Margarita tomb could be the burial place of this high-status woman from the old royal lineage who became K'inich Yaax K'uk' Mo's wife, thereby reinforcing—or at least making more palatable—his right to rule at Copán (Sharer 1996). Although she remains unidentified in the inscriptions, support for this hypothesis comes from strontium isotope analysis that indicates that this important royal lady was a native of the Copán region (Buikstra 1997; Buikstra et al. 2000).

These considerations lead to the issue of K'inich Yaax K'uk' Mo's origins and, more specifically, of whether or not the external ties seen in the Early Classic levels of the Acropolis are reflections of his actual homeland. Of course, a great deal hinges on the identification of the remains in the Hunal tomb as being those of K'inich Yaax K'uk' Mo', since the strontium isotope analyses of the Hunal bones show that this man was not native to

Copán. Thus, accepting Hunal as the Founder's tomb means that the strontium isotope results are consistent with the account of his "arrival" at Copán a decade or so before his death. It is possible that further analyses of bones from other sites may allow us to pinpoint his place of origin, but at present the evidence suggests a homeland in the Petén.

Architectural Evidence

Recovered archaeological evidence indicates that three major architectural traditions are represented within the earliest Acropolis (Sharer 1997c). The first is an earthen architecture that predates the Founder and is part of a Maya highland tradition (Smith 1965) or, more specifically, comes from the southeast Maya area. Substructures consist of dense clay fill and are painted red, and their superstructures are built of red-painted adobe. This tradition at Copán has ties to the great highland center of Kaminaljuyu (Kidder et al. 1946) and the southeastern center of Chalchuapa (Sharer 1978), especially in the monumental constructions of the Maravilla sequence of early royal temples in the Southern Group (Sharer, Fash et al. 1999) and in the residential complexes of the Northeastern Group (Traxler 1996, 2001).

The second is a masonry tradition that was linked closely to the Early Classic architecture of the central Petén (Pollock 1965), particularly Tikal (Coe 1990). Substructures often are painted red and have apron moldings, inset corners, and polychrome stucco masks or panels. Both vaulted and unvaulted buildings are found on the summits of these substructures. The earliest examples at Copán all are temple-type buildings. During the first few decades after the founding of the dynasty, masonry became more prevalent and replaced most earthen constructions, including the palace-type structures of the Northeastern Group (Traxler 1996, 2001).

The third tradition is represented by the Hunal structure, the unique example of central Mexican–style *talud-tablero* architecture that was part of the initial royal center beneath the Acropolis (Sharer, Traxler et al. 1999). Hunal has a north-facing outset stair and a single-terraced substructure with a *talud-tablero* ratio of about 1:2.7 (Figure 5.2). In comparison, the ratios at Kaminaljuyu and Matacapan are 1:1 (Cheek 1977a), and those at Tikal vary between 1:1 and 1:2, with one example of 2:1 (Chapter 7; Laporte 1989). The 1:3 ratios at Teotihuacan given by Cheek (1977a) seem closest to those of Hunal (see also Marquina 1964:figura 3). The *talud-tablero* form is often associated with outset stairs containing balustrades (Chapter 7; Cheek 1977a; Laporte 1989; Marquina 1964), but the stair of Hunal is too demolished to

know if it had balustrades. The *tableros* of Teotihuacan and Tikal are usually decorated with painted or sculpted designs (see Chapter 7). In contrast, those at Kaminaljuyu and in Hunal appear undecorated. Hunal appears unique among all examples in its absence of a superstructure platform; the north wall of its summit structure springs directly from the upper surface of the *tablero*. But it should be noted that the *talud-tablero* buildings of Kaminal-juyu also have at least one unique feature: frontal platforms not found else-where (Kidder et al. 1946). As Juan Pedro Laporte (Chapter 7) proposes, Early Classic architects throughout Mesoamerica adapted the *talud-tablero* form in different ways to fit local architectural norms and needs. From a perspective based in western Honduras, the architectural style of Hunal pro-claims its affiliation with structures in central Mexico. Nonetheless, if it were found at Teotihuacan, Hunal would be equally notable for its clear violations of Teotihuacan architectural norms.

Perhaps the most distinguishing factor of Hunal is its apparent unique-ness for its time at Copán. Unlike *talud-tablero* architecture at Teotihuacan, Kaminaljuyu, Tikal, and many other Mesoamerican sites where the form is found in entire complexes of buildings and where it underwent long periods of evolution (Gendrop 1985; Giddens 1995), Hunal is without known local predecessors. During the 1999 Copán field season, an apparent *talud-tablero* substructure was discovered in later Acropolis levels to the east of Hunal, but the immediate successors to the structure were not rendered in a central Mexican style. In fact, Hunal had a relatively brief life span before being re-placed by a sequence of Petén-style structures (Sharer 1996). We place the construction of Hunal between A.D. 420 and 430, consistent with dates for *talud-tablero* architecture at both Teotihuacan (R. Millon 1973:54–56) and Tikal (Chapter 7; Laporte 1989), but somewhat earlier than examples from Kaminaljuyu, which Charles Cheek (1977a) dates to c. A.D. 450–550 (also see Chapter 3).

In sum, the architecture of the initial royal center beneath the Copán Acropolis reflects ties to some of the greatest Early Classic cities in Meso-america, yet no single connection dominates (Sharer 1997a). Nonetheless, the likely connection between K'inich Yaax K'uk' Mo' and the *talud-tablero* style of Hunal offers a clear symbolic expression of power and prestige, in all likelihood associating the dynastic Founder of Copán with Teotihuacan, the outstanding power in Mesoamerica during the Early Classic. But we cannot rule out the possibility that this architectural association reflects ties to other centers with *talud-tablero* architecture such as Kaminaljuyu and Tikal. At the time of the reign of K'inich Yaax K'uk' Mo', Hunal seems to have been the

only *visible* architectural link to central Mexico at Copán—the other buildings of the initial royal center were rendered in local, highland Maya, or even Petén styles.

The Evidence from Burials and Grave Goods

At the time of K'inich Yaax K'uk' Mo's reign, other evidence linking him with Teotihuacan was rendered in military paraphernalia or in motifs displayed on vessels and other artifacts. It seems that these personal and far less public symbols of Teotihuacan association were usually removed from circulation when they became sequestered in burials and tombs in the years immediately following the founding of the dynasty. Some of this evidence has emerged from the excavation of Early Classic funerary offerings. The earliest levels of the Acropolis furnish two royal tombs, Hunal and Margarita, that are within the lowland Maya tradition (Krejci and Culbert 1995), and a third, Motmot, that is not. Both the Hunal and Margarita tombs are vaulted chambers with single supine interments on stone slabs elevated by stone pedestals. Motmot is the only round masonry tomb chamber at Copán. This and the seated burial position of its occupant provide a connection to Teotihuacan (Fash 1995, 1998). On the other hand, unlike the solitary interments of the Hunal and Margarita tombs, the woman in Motmot was accompanied by trophy skulls and animal remains, recalling similar Early Classic grave goods from both Kaminaljuyu and Tikal (Coggins 1975; Kidder et al. 1946:93).

The number of pottery vessels in the Hunal and Margarita tombs are about the same, many more than were placed in the limited space of the Motmot tomb. But both the Hunal and Motmot tombs have far fewer offerings of jade and other materials than were interred with the Margarita lady. The two composite shell headdresses and the shell pectoral in the Hunal tomb reflect ties to central Mexico and Teotihuacan. Although most of the pottery in the Motmot tomb is apparently of local origin, the numerous vessels in the Hunal and Margarita tombs signal more diverse connections. Both inventories include several lowland Maya–style polychrome bowls with basal flanges. Several vessels in the Hunal tomb appear closely connected to Kaminaljuyu and the southeast Maya area. Neutron activation analysis reveals that at least three Hunal vessels appear to be imports from central Mexico, and two more apparently come from the central Petén. Neutron activation results from a more limited sample of Margarita tomb vessels show that five likely are imports from central Mexico, and one other is from the central Petén. Although the source of the spectacular Margarita painted vessel (Figure 5.5) also seems

to be central Mexico, in its form and painted style, it reflects a synthesis of both Maya and Teotihuacan traditions.

In addition to these three Early Classic tombs, two others have been excavated from beneath Str. 10L-26, one of which contained a Teotihuacan-style cylindrical tripod (Fash 1991:Figure 47). There are also several non-chambered burials dating to the founding era, all apparently representing sacrifices. At least three of these seem to be placed in special locations in the Early Acropolis, perhaps to offer supernatural protection (Sharer 1997c). The most elaborate was directly west of the Hunal and Margarita tombs. It consists of a single adult male "warrior" who was wrapped in matting and was adorned with mosaic jade-and-hematite earflares, shells, and jade, including the already mentioned items with explicit ties to Teotihuacan (cut shell "goggles" and a bundle of atlatl darts; see Figure 5.4). To reiterate, strontium analysis indicates that this individual was not native to either Copán or Teotihuacan, but may have been from the northern Maya lowlands (Buikstra et al. 2000). The other simple burials in the Early Acropolis are far less elaborate and without offerings reflecting external ties. Two examples were buried in seated positions (presumably bundled) to the north of the royal tombs. Another was found within an earthen substructure west of Hunal (Sedat 1996). A final possible example of a sacrificed seated burial, accompanied by shell goggles, was excavated by the PAC I project on the northern perimeter of Str. 10L-26 (Viel and Cheek 1983:604–605).

Once again, multiple external ties are reflected in the founding-era tombs and burials, and no connection with a single foreign site dominates (Sharer 1997c). Although clear external ties exist for some grave goods—such as the central Mexican vessels in both the Margarita and Hunal tombs, and the shell goggles and atlatl darts found in the bundled "warrior" burial—there are contrasts with burial practices and goods found at Teotihuacan and most Maya sites that seem just as striking. For example, in the total inventory of hundreds of burials found over the years at Copán, only one was found in a circular chamber linked to Teotihuacan (Fash 1995). In comparison with tombs from the Maya lowlands, the Early Classic Copán tombs are without painted texts or motifs. Of course, the poor preservation of plastered tomb walls at Copán could explain this contrast. More securely, no mosaic masks have been found in the tombs of the Copán Early Acropolis. These objects are well known from Early Classic tombs at Tikal, Calakmul, and several other lowland sites (e.g., Coggins 1975; Folan et al. 1995). This absence is particularly striking because of the relative proximity of Copán to the middle Motagua jade source.

Conclusions

A series of propositions are offered to summarize our current understanding of the role of Teotihuacan at the time of the founding of the Copán dynasty. These propositions certainly require further testing, and, since the ECAP research is not complete, all are subject to revision as new data and analyses become available.

Proposition 1. The dynastic founder, K'inich Yaax K'uk' Mo', was not a native of Copán or Teotihuacan. Although his specific homeland remains unknown, he was a successful warrior from the central Petén who based much of his authority and success on his associations with Teotihuacan military traditions.

Proposition 2. The recorded "arrival" of K'inich Yaax K'uk' Mo' at Copán in A.D. 426/427 resulted in the overthrow of the established ruler and the taking of the throne by K'inich Yaax K'uk' Mo'.

Proposition 3. The measures used by K'inich Yaax K'uk' Mo' to consolidate his rule at Copán included the construction of a new royal center, a postulated marriage to a royal woman from the old ruling family, and both the public and private use of symbols of political and supernatural power derived from Teotihuacan. These are seen in architecture, warrior paraphernalia, insignia, and motifs on artifacts.

Proposition 4. After K'inich Yaax K'uk' Mo's death and the succession of his son, K'inich Popol Hol, in A.D. 437, the latter reinforced his own authority and promoted K'inich Yaax K'uk' Mo' as the founder of a new Copán dynasty by dedicating monuments and expanding the royal center built by his father.

Proposition 5. Rather than emphasize his father's ties to Teotihuacan, K'inich Popol Hol accentuated lowland Maya connections in his architecture, monuments, and even specific textual references.

Taken together, these preliminary propositions paint a picture of a foreigner who used his powerful though indirect Teotihuacan associations to seize and consolidate power at Copán, and who was succeeded by a son who used his father's prestige and success to promote a new dynasty and to reinforce his own authority. K'inich Popol Hol did this by synthesizing central Mexican and orthodox lowland Maya traditions. The apparent parallels to the scenario reconstructed for Tikal rulers Yaax Nu'n Ahyiin ("Curl Nose") and his son, Siyaj Chan K'awiil ("Stormy Sky"), are as obvious as they are intriguing.

The founding events at Copán and their apparent Teotihuacan associations have important implications for understanding the evolution of com-

plex societies in Mesoamerica. More specifically, these events may signify the arrival of a new and more complex political order at Copán—in other words, this could represent a case of secondary state formation. Thus, the events surrounding the founding of the Copán dynasty in A.D. 426/427 could represent the establishment of a state organization at Copán inspired—directly or indirectly—by Teotihuacan. A somewhat less likely possibility would see these events as a conquest and takeover of an established polity that already possessed the essential components of state-level organization. This latter perspective is suggested by textual references to a line of rulers at Copán that date to before A.D. 426. We should also recognize the possibility that important political changes may have been put in place at Copán several decades later by the Founder's son, K'inich Popol Hol.

Apart from identifying possible shifts in political organization and development, the importance of the founding events at Copán also lies in what they tell us about the institution of Maya rulership—how individual rulers gained and lost power, how they reinforced their authority, and how royal authority was maintained over time. The Copán events of A.D. 426/427 give us a glimpse of how a sitting ruler lost power, and how a new king used his foreign associations to bolster newly won authority. Thereafter, the Founder's son and successor appears to have taken a different tack, returning to more traditional lowland Maya associations to reinforce his power, at least in his public monuments.

With the passage of time, successful continuity of dynastic succession became a source of power unto itself. Certainly by the Late Classic period, the buildings and monuments sponsored by the kings of Copán continued to proclaim the authority of K'inich Yaax K'uk' Mo' and his dynasty through references to the time and place of the founding itself. A related means used by later rulers to reinforce their power was a revival of highly visible architectural links to Teotihuacan (Fash 1998), examples of which can be seen on Str. 10L-22 (with its *talud-tablero* substructure platform) and Str. 10L-16 (which has Tlaloc masks). What is interesting about this "Teotihuacan revival" at Copán is that the power associations implied by these Late Classic architectural symbols had changed since the time of the dynastic Founder. In the Early Classic, we infer that K'inich Yaax K'uk' Mo' used Teotihuacan symbols, including one known example of *talud-tablero* architecture, to reinforce his authority by associating himself with the greatest political and military power of his time. The Late Classic rulers of Copán apparently used Teotihuacan symbols to associate themselves with the glorious past, since by that time Teotihuacan was all but abandoned and had become transformed

into the great mythical city of Mesoamerica. Of course, with the benefit of hindsight, we can see the irony in this. The efforts of the final Copán kings to bolster their declining authority by associating themselves with the fallen city of Teotihuacan did not prevent the demise of the dynasty established by K'inich Yaax K'uk' Mo' and the ensuing abandonment of their own great capital.

Acknowledgments

I am especially grateful to William L. Fash, Jr., Director of the Proyecto Arqueológico Acrópolis Copán, for his invitation to come to Copán and direct ECAP's research. I am also very grateful to all my PAAC colleagues, especially Ricardo Agurcia, Will Andrews, Barbara Fash, Rudy Larios, and Fernando López, who have been essential to all aspects of our research. Since 1989, ECAP's research has been conducted by a dedicated team of archaeologists and other specialists. It is not possible to mention all of these people here, but I do wish to give credit where it is due, beginning with my Field Director, David Sedat, who has also supervised most of the tunneling in the early levels of the Acropolis Southern Group. I am also very grateful to Loa Traxler for her many contributions, including supervision of the excavations in the early palaces in the Acropolis Northeastern Group and the critical mapping of all areas of Early Classic Acropolis architecture. A number of ECAP staff members have also made major contributions to our research: Ellen Bell, for excavating and registering the objects from the Hunal and Margarita tombs and other burials; Christine Carrelli, for cataloging all the Early Classic Acropolis architecture and recording construction techniques; and Eleanor Coates, for photographing the Early Classic buildings in our tunnels and the artifacts we have recovered. Other members of our field staff also deserve credit for their many contributions to ECAP's research: Edward Barnhart, Marcello-Andrea Canuto, Charles Golden, Julia Miller, Alfonso Morales, Christopher Powell, and Christian Wells. As is apparent from the results reported here, the ongoing bioanthropological analyses conducted by Jane Buikstra and her colleagues are yielding invaluable insights about the human remains in the Acropolis burials and tombs. The critical and successful conservation of the artifacts from these tombs, burials, and other ECAP excavations has been expertly handled by Lynn Grant and Harriet Beaubien, ably assisted by Rufino Membraño. A very special member of our research team is no longer with us, but the late Linda Schele is missed profoundly by all her Copán colleagues for her many brilliant insights and critical contributions to our research.

The research of the Early Copán Acropolis Program has been sponsored by the Instituto Hondureño de Antropología e Historia and the University of Pennsylvania Museum. My sincere gratitude is expressed to all the people associated with these organizations who have made ECAP's investigations possible. Since ECAP's inception in 1989, support for its research has come from the University of Pennsylvania Museum (Boyer and Shoemaker Chair Research Funds), the University of Pennsylvania Research Foundation, the National Science Foundation, the National Geographic Society, the Foundation for the Advancement of Mesoamerican Studies, the Maya Workshop Foundation, the Kislak Foundation, the Selz Foundation, the Holt Family Foundation, and a number of private donors.

Problematical Deposits and the Problem of Interaction: The Material Culture of Tikal during the Early Classic Period

María Josefa Iglesias Ponce de León

Twenty years have passed since the Dumbarton Oaks conference that resulted in the volume *Highland-Lowland Interaction in Mesoamerica: Interdisciplinary Approaches* (Miller 1983). The contributors to that work formulated the basis of what continues to be the majority opinion regarding the influence of central Mexican culture in various parts of the Maya region during the epoch of the maximum splendor of Teotihuacan. As a result of a series of archaeological discoveries, some investigators involved in the problem came to think that Teotihuacan influence was a factor essential to the development of state-level polities in both the Maya lowlands and highlands (e.g., Becker 1983; Sanders and Michels 1977; Sanders and Price 1968; Sanders et al. 1979). According to these scholars, centers such as Kaminaljuyu and Tikal were the capitals of emerging secondary states. In these places, the transition from chiefdom- to state-level social organization is thought to have been stimulated by the presence of enclaves of people from Teotihuacan, which, without doubt, already had a more complex sociopolitical system. These secondary states, in turn, are assumed to have influenced local development in other regions. That is to say, these thinkers view Teotihuacan as the motivating force behind the emergence of complex society throughout the Maya area.

A diametrically opposed position has been formulated by a second group of scholars. We think that an undue emphasis on the presence in the Maya area of certain central Mexican goods has resulted in interaction models that exaggerate the importance of Teotihuacan to the development of Classic Maya complexity. In reality, as I will show in this chapter, the quantity of imported material goods is small, their identification as "Teotihuacan" or "Teotihuacanoid" often is problematic, and their chronological placement— from the first through the eighth centuries—is not limited to the period of Teotihuacan grandeur.[1]

During the last two decades, archaeological excavations have been carried out at numerous Maya sites. The discovery of remains (including artifacts, iconographic elements, and epigraphic symbols) apparently alien to Maya culture and supposedly of central Mexican affinity has been seen by some scholars as evidence supporting models of the crucial importance of Teotihuacan to Maya cultural development. It is true that the word *influence* has been rejected because it is perceived as "politically incorrect." But conclusions regarding interaction between the Maya and Teotihuacan—often described in terms of core-periphery relations and "waves" of cultural change—remain fundamentally unaltered.

There is some variation in the importance assigned to the material characteristics seen as diagnostic of Teotihuacan influence. For decades, paramount importance was given to the *talud-tablero:* where there was a *talud-tablero*, a Teotihuacan presence was assumed. After this architectural characteristic, green obsidian, tripod cylinders, and Thin Orange ware were viewed as most representative of Teotihuacan influence. *Candeleros*, figurines, and images of Tlaloc were less frequently encountered, and perhaps for this reason, were given less importance. A stimulating hypothesis posited the existence of different ways that Teotihuacan exerted control over its Mesoamerican contemporaries (Santley 1983). According to this model, the exact manifestation of Teotihuacan influence could be determined mathematically from the number and type of central Mexican characteristic features found at a given site. Depending on the quantity of such features observed in the archaeological record, a site was interpreted as a "Teotihuacan enclave," an "interactive node," or a "receiver node."

Later archaeological contributions have questioned the validity of various aspects of Robert S. Santley's (1983) model. The assumption that features such as the *talud-tablero* and the cylindrical tripod vessel are rightly ascribed to Teotihuacan influence is widely doubted. Builders of the great Maya city of Tikal, for example, constructed *talud-tablero* architecture before the era of important contact with Teotihuacan (Chapter 7; Laporte 1987, 1989, 1999b). In addition, cylindrical tripod vessels—but lacking slab feet—have been found at Tikal and other sites in the Maya lowlands in contexts that predate the Manik 3A phase (Hermes 1993:figura 19.1a,b; Laporte and Fialko 1987:142, 155, figuras 6 and 7). The ultimate place of origin for this form, in any event, appears to be the Gulf Coast and not Teotihuacan (Rattray 1977). If these "characteristic" features are eliminated from consideration, it is difficult to construe the few handfuls of green obsidian, the small number of *candeleros*, and a couple of figurines recovered from controlled

excavations as evidence that Tikal either contained a Teotihuacan enclave or was an important interactive node.

In the same line as Santley (1983), but from a perspective more firmly rooted in anthropology, Michael W. Spence (1996b) has conducted a comparative analysis of ethnic enclaves in Classic-period Mesoamerica. His analysis considers not only the foreign barrios identified within Teotihuacan but also possible enclaves composed of Teotihuacanos living far from their home city. In his discussion of the latter category, he considers the most recent discoveries made at Tikal.

Joseph W. Ball's (1983) contribution on ceramic identities and homologies is of particular relevance to all studies of interaction between Teotihuacan and the Maya area because of the wide spectrum of possible inferences that he considers. I concur with his opinion:

> Distinct material culture classes enter into human behavioral situations to differing extents and in different ways. Consequently, no one class can be expected to reflect accurately complex social events or processes such as interregional interaction mechanisms. Attempts to infer general cultural processes or historical situations from single material categories consequently are foredoomed to failure. (Ball 1983:142)

The advances in epigraphic research made in recent years have also afforded new information on relations between the Maya and central Mexico. The hieroglyphic inscriptions of Tikal, Uaxactun, and Copán describe the presence of nonlocals, thought by some to be Teotihuacanos, among the elite. The introduction during the Early Classic period of these foreigners into local dynastic sequences currently is interpreted as an interruption of autochthonous control (e.g., Stuart 2000a). I am certain that the field of epigraphy can help us clarify certain problems, and I am receptive to the perspective that it gives us, but hieroglyphic inscriptions are not sources of objective truth. They are texts that were consciously manipulated by the people who produced them. They transmit to us not only real events but also information that is less objective and more difficult to interpret.

The truth is that foreign objects and attributes found at Maya sites dating to the end of the Early Classic period are so dissimilar in form and appearance that it is difficult to compare them. They include dedicatory offerings and *talud-tableros*, sets of complete ceramic vessels recovered from burials and handfuls of sherds from problematical deposits, green obsidian and

iconographic elements—all of which appear in different places, contexts, quantities, and qualities. It is perhaps best to consider these very diverse phenomena as the results of discrete events of pure commercial exchange conducted among and limited to the elites of certain cities. These events acquired their greatest importance at Tikal and Copán, where the implication of the "arrival" of foreigners from outside the political boundaries of these polities is a subject of discussion (Sedat and López 1999; Sharer 1999a, 1999b; Stuart 2000a).

Many years ago, Gordon Willey and Philip Phillips (1958) described Mesoamerica as a great interaction sphere—a truth doubted by no one. It is obvious that interregional and long-distance contacts of diverse kinds existed since very early times. But what was the importance of these contacts? How were they manifested? How long did they last? What kinds of people and how many individuals were involved in long-distance interaction? How are different kinds of interaction observed in the archaeological record? Most importantly, what impact did these relations have on the different cultures that lived in Mesoamerica? We have few answers to these many questions. And it may be that we have more questions and even fewer answers than we thought.

In this chapter, I analyze data generated by excavations at Tikal that were conducted by the University of Pennsylvania Tikal Project and by the Guatemalan Proyecto Nacional Tikal. I will consider—from both qualitative and quantitative perspectives—important items of material culture (ceramics, lithics, bone, and shell) that date to the end of the Early Classic period. The analysis of the artifacts of Tikal complements other contributions to this volume that focus on architecture and site planning (Chapter 7) and the iconographic content of carved monuments (Chapter 8).

The artifacts that I discuss come from unusual contexts that are called "problematical deposits" by members of both the Tikal Project and the Proyecto Nacional Tikal. These, as we shall see, possess characteristics that allow them to be distinguished from other kinds of contexts—such as middens, offerings, and burials—that result from better-understood depositional behavior. The eclectic problematical deposits are particularly useful when studying interaction, even though their formation processes are not completely understood. Problematical deposits are very well dated and, above all, contain a great quantity and variety of ceramic, lithic, and bone artifacts representing an extremely wide range of behavior. It is my contention, therefore, that the problematical deposits closely reflect the complete assem-

blage of material culture used by elites who lived in the epicenter of Tikal. In contrast, household middens, caches, and burials are more limited contexts. These give us a vision of the moment of deposition and allow us to understand a single function: the discard of useless objects or the placement of an offering associated with a building or a cadaver. Because of the wide variety of objects found in problematical deposits, they provide the broadest representation of the material goods and of the people who used them: the elites of Tikal who may have interacted with people from central Mexico.

My analysis of the large collection of artifacts from the problematical deposits—contexts that contain a considerable portion of both the ordinary and extraordinary objects used by the elite—does not support the conclusion that Tikal had strong economic ties with Teotihuacan. At the very least, it suggests that these relations had special characteristics, which are not understood, that greatly limited the quantity of artifacts imported from central Mexico.

Problematical Deposits

In recent years, several of us *tikaleños* have studied and worked with the important and interesting concentrations of archaeological materials that are known as problematical deposits (Iglesias 1987, 1988, 1989, 1996; Laporte 1988, 1989; Laporte and Fialko 1987, 1993; Laporte and Gómez 1998; Moholy-Nagy 1986, 1999a).[2] In order to understand the nature of these material deposits, we have concentrated on three fundamental variables: spatial location, internal structure, and material content. We have defined problematical deposits as various concentrations of materials—chiefly ceramics, stone, shell, and bones—that were placed in intentionally dug cavities beneath the floors of rooms and plazas. These cavities were carefully sealed, and for this reason we can be sure that they contain chronologically "pure" deposits, with only a minimum amount of cultural material resulting from subsequent activity (Ball 1977a:4; Coe 1959:94–95; Lowe et al. 1960:55).

Problematical deposits, though occasionally identified at other cities, appear to be uniquely common at Tikal. It may be that at other sites, similar deposits—particularly those pertaining to later periods—have been identified as middens. Middens, however, contain materials of domestic use, and should not include objects of purely ritual function or artifacts that can be classified as sumptuary goods. The problematical deposits of Tikal contain not only the household refuse of the elite but also many items pertaining to specialized, restricted, and nondomestic behavior.

In this section, I briefly review the problematical deposits excavated by the Proyecto Nacional Tikal, with the goal of fully describing this cultural feature that first appeared at Tikal during the Early Preclassic and continued to evolve through the Late Classic period. I also discuss, but in a more abbreviated manner, the problematical deposits investigated by the Tikal Project, which also date to all periods in the chronological sequence of the site.[3] Early Classic problematical deposits are the focus of other sections of this chapter.

Preclassic

Two Early Preclassic (Early Eb phase, dating to before 700 B.C.) problematical deposits (PNT-6 and -12) were discovered during excavations in the Mundo Perdido complex. Each of these contained more than 10,000 sherds, mostly from domestic wares, and also a few complete vessels, figurines, ceramic disks, pendants, and polishers. Lithic and bone artifacts, as well as unmodified animal bone, were also recovered. The Middle Preclassic Late Eb phase (700–600 B.C.) is represented by a third concentration (PNT-13) that also contains broken pottery, figurines, pomaceous seashells, lithic materials, and animal bones (Laporte and Fialko 1993, 1995). Various concentrations dating to the Late Preclassic period have also been found. For the Tzec phase (600–400 B.C.), there are four deposits (PNT-8, -11, -16, and -17), and two examples dating to the Chuen phase (400–200 B.C.) have been excavated. These contain materials similar to those dating to the Eb phase, but are smaller deposits. PNT-2 was found beneath the West Plaza of the Mundo Perdido complex (Laporte 1995). It dates to the transition between the Cauac (200 B.C.–A.D. 200) and Manik 1 (A.D. 200–300) phases, and contains more than 4,000 sherds, most from domestic vessels. Two plates with mammiform tetrapod supports, one of which is decorated with Usulután designs, and cervid bones were also recovered.

Preclassic problematical deposits were also excavated by the Tikal Project. These include examples dating to the Eb (TP-1A and -1B), Tzec (TP-108), Cauac (TP-114 and -125), and Cimi-Manik (TP-97) phases. With the exception of the last problematical deposit, which was discovered in the North Acropolis (Hattula Moholy-Nagy, personal communication 1998), all were associated with habitational structures outside of the site epicenter.

Early Classic

During the Early Classic period (A.D. 200–550), the ritual activities that resulted in the problematical deposits became more elaborate and common. As a result, our knowledge for this period is greater. The structure and content

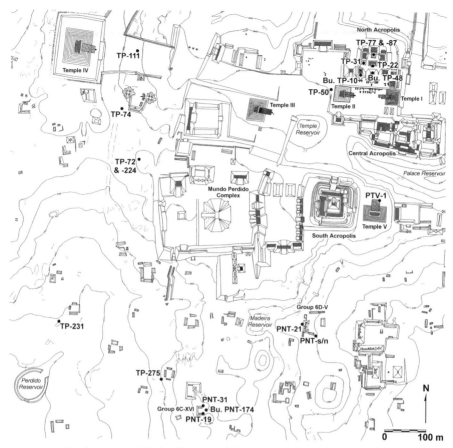

FIGURE 6.1. Location of Early Classic problematical deposits and burials at Tikal (Burial PNT-212, located in the North Zone, is not shown; redrawn from Carr and Hazard 1961).

of Early Classic problematical deposits are basically the same as those dating to the Preclassic period, but the deposits are considerably larger. Moreover, they include human bones that, in some cases, were fashioned into tools or other instruments. PNT-19, an important concentration from Group 6C-XVI (Figure 6.1), dates to the Manik 2 phase (A.D. 300–378). Its content is quite varied and includes pottery fragments (some 36,000 sherds); stone and bone tools; ornaments of bone, shell, and greenstone; unmodified human and animal bones; charcoal; and even a few sheets of mica.

The end of the Early Classic, due to its complexity and because of well-documented ceramic changes, has been divided into two phases: Manik 3A (A.D. 378–480) and Manik 3B (A.D. 480–550; Laporte and Iglesias 1992; Laporte et al. 1992). Both phases are represented by multiple problematical

deposits. Three concentrations date to Manik 3A. The first (PNT-31), located in Group 6C-XVI, includes almost 8,000 sherds, bone and stone artifacts, shell ornaments, numerous human and animal remains, and also a fragment of a solid figurine. The second deposit is PNT-21, found in Group 6D-V. It contains the single greatest concentration of materials known from Tikal: 167,000 pottery sherds, 800 ceramic objects, 7,000 lithic tools and fragments, 600 bone tools, and 900 pieces of worked shell. In addition to these artifacts, numerous animal bones, two primary burials, three cranial offerings, and the secondary remains of at least 20 individuals were also recovered from PNT-21. The analysis that I present below focuses on this problematical deposit. The third example that dates to Manik 3A, PNT-s/n, also was found in Group 6D-V. This deposit, of unknown size, was sampled rather than completely excavated, and it consists of materials very similar to those that make up PNT-21 (Iglesias 1987).

We have two additional deposits (PNT-22 and -23) from Group 6C-XVI that provide data for Manik 3B. Although both were sampled rather than fully excavated, their contents are the same as those dating to Manik 3A. Numerous sherds were found, as well as a great variety of tools and ornaments made of stone, bone, shell, and human bones.

Recent excavations carried out in Temple V (Gómez 1998, 1999) contribute two more examples to our sample of Early Classic problematical deposits. The earlier of the two, PTV-1, was encountered inside a small structure located below the northeast corner of the stairs. The deposit is a concentration of ceramics, human and animal bones, ash, charcoal, prismatic blades of green and gray obsidian, bifacial artifacts made of chert and obsidian, shell artifacts, and a jade bead. PTV-28, which dates to the Early to Late Classic transition, contains a good quantity of ceramics, chert and obsidian artifacts, human and animal bones, shell objects, and carbon (Laporte and Gómez 1998).

PNT-10, found in Str. 5C-47 of the Mundo Perdido complex, dates to the transition between the Manik 3B and Ik phases (c. A.D. 550). Its material content is extraordinarily similar to that of the previous examples, having typical ceramic, shell, stone, and bone artifacts associated with the secondary and direct remains of twelve individuals (Laporte 1989, 1999b).

The Tikal Project located and excavated a total of seventeen problematical deposits dating to the Manik phase, most of which were found in the epicenter of Tikal (Moholy-Nagy 1999a, personal communication 1998). As we shall see, the form and content of those dated to Manik 3A are virtually identical to the deposits studied by the Proyecto Nacional Tikal.

Late and Terminal Classic

Just two problematical deposits dating to the Ik phase (A.D. 550–700) and the Ik-Imix transition have been discovered. One of these is PNT-4, an important concentration located in Str. 5C-46. This deposit contains, in addition to the typical objects of bone (needles, awls, and spatulas), shell, and stone, an unusual concentration of intentionally destroyed polychrome vessels (Laporte and Fialko 1995). Juan Pedro Laporte and Oswaldo Gómez (1998) indicate that these form an excellent diagnostic sample for the seventh century. The second example is PNT-5, found beneath the East Plaza of Mundo Perdido, near Temple 5C-49 and the palace compound formed by Strs. 5C-45, -46, and -47. PNT-5 contains a large amount of ceramics (6,995 sherds), including polychromes. The Tikal Project excavated a single example of this cultural feature (TP-158) that dates to some time in the Late Classic period (Hattula Moholy-Nagy, personal communication 1998).

We have few examples to illustrate the end of the Classic period, in part because problematical deposits can be confused with middens. In addition, since later deposits are found closer to the surface than earlier ones, late Imix and Eznab problematical deposits may have been subject to more erosion or to destruction caused by the great architectural expansion of the city that occurred during the Late Classic period. Finally, although I do not have personal knowledge of its characteristics, TP-54, located in the North Acropolis, may date to this late period (Hattula Moholy-Nagy, personal communication 1998).

Problematical Deposits of the Early Classic: Their Validity as Samples Diagnostic of Chronology and Status

Given that the period of greatest interest to us is Manik 3A (A.D. 378–480), I shall refer principally to problematical deposits dating to that phase. Nonetheless, many of the inferences that are drawn for that century may be extrapolated to other periods in the long history of Tikal. The excavations carried out by the Proyecto Nacional Tikal and by the Tikal Project have provided excellent and abundant cultural material, which, though in greater or smaller measure for each category (ceramics, lithics, bones, and shells), reflects the cultural universe of the Maya. I shall concentrate more on ceramics than the other materials because sherds occur in the greatest frequency in the archaeological record. Moreover, ceramics as a class are more sensitive to cultural change than lithic, bone, or shell artifacts. Numerous studies of materials have provided information essential for developing a chrono-

logical framework for Tikal, as well as critical data on social structure (Culbert 1979, 1993; Emery 1997; Hermes 1983, 1984, 1985, 1991; Iglesias 1987; Laporte 1989, 1999a; Laporte and Iglesias 1992; Laporte et al. 1992; Moholy-Nagy 1989, 1991, 1994, 1998, 1999b; Moholy-Nagy et al. 1984; Ruiz 1986, 1989, 1990; Spence 1996a).

In any conventional excavation, not only artifacts but also their contexts provide a great deal of information. But what happens if we encounter a context that does not seem to fit the conventional, previously established categories? This is the case with the problematical deposits, because they cannot be described adequately using the parameters established for burials, middens, offerings, and other better-understood contexts. Instead, they display a marked eclectic character. They may be considered middens because of the massive quantities of domestic trash found in them. They may be considered the location of ceremonial activities because many of the objects found in problematical deposits are associated in other contexts with rituals. They may be considered funerary features because many contain primary or secondary burials, as well as the assemblage of materials typically resulting from interment behavior. At present, we cannot conclusively exclude any one of these interpretations. In this contribution, I will not try to resolve the problem of the function of the deposits. Instead, it is more important to demonstrate that the artifacts under discussion are valid and representative samples of the material universe of Tikal during the Manik 3A phase.

First, the problematical deposits were sealed beneath plaster floors and were not subject to disturbance. Second, regardless of their location, the problematical deposits comprise a variety of materials that in no case are surpassed by middens, offerings, or burial deposits. Third, the artifacts in the problematical deposits range from the purely domestic—with the possibility that they were used by any social class that lived in Tikal, from the most humble household to the inhabitants of palaces—to those artifacts exclusively used in ritual environments or typically found in elite burials.

I shall refer only tangentially to the spatial pattern of Early Classic problematical deposits within the city of Tikal because I think that the importance of these data is somewhat limited. For the Manik 3A phase, the Tikal Project located seven problematical deposits in the site epicenter and five more in the surrounding residential zone.[4] The Proyecto Nacional Tikal excavated three more Manik 3A problematical deposits in the latter area (Figure 6.1).[5] PTV-1, from Temple V, appears to be contemporaneous with these other concentrations. Although all these problematical deposits are located within

300 m of the site center, their specific architectural context—monumental architecture or residential structures—does not seem to be important.

There do not appear to be significant differences in the contents of the Manik 3A problematical deposits, except in the quantities of material that were recovered. In fact, certain kinds of artifacts present in these deposits, including those found outside of the site epicenter, form part of the funeral assemblages not only of elite burials (e.g., Burials TP-10 and -48) located in the North Acropolis (Coggins 1979), but also of less elaborate interments in the residential zone (e.g., Burials PNT-141 and -174 of Group 6C-XVI; Laporte 1989:168–180, figuras 69–83, apéndices 3–5).

Since elites and their dependents had access to the full range of material culture, whereas the lower classes had restricted access to the most exclusive items, I propose that the goods present in the problematical deposits are highly representative of both the daily and the extraordinary lives of the upper classes of Tikal during the Early Classic.

Problematical Deposit PNT-21: The Bull in the China Shop as a Site Formation Process

My analysis focuses on the enormous concentration of artifacts that make up PNT-21, which was discovered in Group 6D-V, a residential group located near the Madeira Reservoir and south of the Plaza of the Seven Temples and the South Acropolis (Figure 6.1). In its last years of occupation during the Late to Terminal Classic, Group 6D-V consisted of nine structures arranged around a rectangular plaza. The most important of these buildings is Str. 6D-20, a small palace containing six vaulted chambers. PNT-21, which was situated behind the small palace, is the largest and most complex problematical deposit found at Tikal, and hence, provides the most information. Even though it was not located in the site epicenter, its structure and content are perfectly representative of other deposits dating to the Manik 3A phase.

Only rarely does the possibility of analyzing such a considerable volume of materials from a single context present itself to the archaeologist. The title of this section says it all: at first glance, the quantity and variety of artifacts recovered from PNT-21 seem to suggest that we are looking at the smashed remains of one of those marvelous little shops that in Central America are called *abarroterías*, in which there literally is a little bit of everything. Of all the artifact classes known from Tikal, only incised obsidian, stelae,[6] and perhaps the bones of certain nonlocal animal species are absent from PNT-21. The zooarchaeological materials from PNT-21, however, were not analyzed in depth.

PETEN LUSTROUS WARE

Aguila Ceramic Group		78,843
Aguila Orange:	Aguila	76,942
	Matte-Red[1]	
Dos Arroyos Orange:	Dos Arroyos	1,203
Pita Incised:	Pita	312
San Clemente Gouged-Incised:	San Clemente	83
Undesignated (scratched orange)		65
Undesignated (applied orange)		59
San Blas Red-on-orange:	San Blas	55
Mataha Fluted:	Mataha	46
Susana Composite:	Susana	32
Japón Resist:	Japon	22
Boleto Black-on-orange:	Boleto	11
Diego Orange-striated:	Diego	8
Undesignated (orange with stucco)		3
Nipon Resist:	Nipon	2

Balanza Ceramic Group		24,158
Balanza Black:	Balanza	19,771
Lucha Incised:	Lucha	2,509
Urita Gouged-incised:	Urita	968
Undesignated (black with applique)		305
Paradero Fluted:	Paradero	300
Undesignated (thin walled black)		150
Delirio Plano-relief:	Delirio	100
Undesignated (black with stucco)		40
Maroma Impressed:	Maroma	12
Undesignated (scratched black)		3

Undesignated Ceramic Group		682
Caldero Buff Polychrome:	Caldero	634
Moc Orange Polychrome:	Moc	21
Yaloche Orange Polychrome:	Yaloche	20
Dos Aguadas Gray Polychrome:	Dos Aguadas	5
San Bartolo Red-on-buff:	San Bartolo	2

Pucte Ceramic Group		148
Pucte Brown:	Pucte	95
Santa Teresa Incised:	Santa Teresa	33
Chorro Fluted:	Chorro	10
Undesignated (gouged-incised)		9
Undesignated (plano-relief)		1

UAXACTUN UNSLIPPED WARE

Triunfo Ceramic Group		56,105
Triunfo Striated:	Triunfo	38,346
Quintal Unslipped:	Quintal	16,057
Incense Burners (five types)		1,670
Candelaria Appliquéd:	Candelaria	16
Cubierta Impressed:	Cubierta	16

UNSPECIFIED WARE

Unspecified Ceramic Group	7,323
Maaz Red-striated	7,323

UNDESIGNATED WARE

Undetermined Group(s)	75
Undetermined (white)	38
Undetermined (specular hematite)	37

THIN ORANGE WARE

Ratones Ceramic Group		4
Ratones Orange:	Ratones	4

[1]Included in tally for Aguila Orange:Aguila.

FIGURE 6.2. Classification of ceramics from Problematical Deposit PNT-21 (N=167,338).

Ceramics

The ceramic industry is represented by 167,338 sherds (Figure 6.2) classified in five wares, eight groups, and forty-two types.[7] Many of these are utilitarian wares for cooking, serving, and storing food. These include the types Quintal Unslipped, Triunfo Striated, and Maaz Red-striated, as well as specific forms of the types Aguila Orange and Balanza Black, and simply decorated examples of other types in the Aguila and Balanza ceramic groups. Together, utilitarian wares account for 90–95 percent of all sherds in PNT-21. These utilitarian wares all are common in domestic middens at Tikal, but

also are found in high-status tombs, albeit in lower frequencies than in either Early Classic middens or problematical deposits (Culbert 1993; Laporte et al. 1992:tabla 2). Also present in PNT-21 is a relatively small quantity of fine ceramics, less frequent than the utilitarian wares but surely used in the daily life of the elite. These include black pitchers, bowls with simple designs, and modest polychrome plates. As expected, the variety of ceramic forms represented in PNT-21 includes practically all those known from Early Classic Tikal (Iglesias 1987:205–265, figuras 89–107).

Types and forms typically found in elite funerary contexts also are present in PNT-21, though in much smaller quantities. These are characterized either by technological complexity (e.g., Japón Resist) or by elaborate designs (executed as incisions, gouges, plano-relief images, complex paintings, or stuccoed or otherwise applied images) that surpassed the abilities of simple potters (Figure 6.3). A review of the decorated pottery recovered from contemporary elite burials (Burials TP-10, -22, and -48; Burials PNT-141 and -174) and other problematical deposits confirms that the examples from PNT-21 are equivalent in complexity to these ceramics (Culbert 1993:Figures 14–31; Laporte 1989:figuras 69–83). This in turn reflects an access to the highest-quality elite goods, despite the location of PNT-21 outside of the

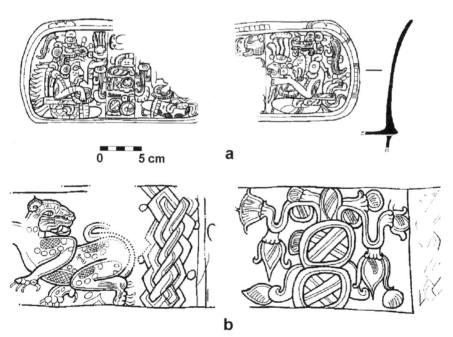

FIGURE 6.3. Decorated funerary ceramics from Problematical Deposit PNT-21.

site epicenter. The iconographic and epigraphic content of funerary ceramics from PNT-21 provides additional information (García Campillo et al. 1990; Iglesias and Sanz 1999), because certain fragments possess elements that appear in other contexts, such as on Stela 31 and the Tikal marker of Group 6C-XVI (Fialko 1987; Laporte 1989; Stuart 2000a). Nonetheless, it is important to remember that contexts such as PNT-21 are secondary depositions of material used elsewhere. Fragile artifacts and decorative motifs—particularly those found on stuccoed funerary vessels—are poorly preserved. Thus, although we have evidence of their existence, we cannot compare designs on stuccoed and painted vessels with those recovered from important Early Classic burials.

Among the immense quantity and variety of Maya pottery recovered from PNT-21, only one ceramic type has been identified with certainty as coming from central Mexico: Ratones Orange:Ratones. A variety of Thin Orange ware, it is represented by four sherds from two distinct vessels. Thin Orange also is represented in Burial TP-10 and Burial PNT-174, as well as in two other problematical deposits, but it is virtually the only central Mexican ware found in Early Classic contexts at Tikal. Two unidentified ceramic groups represented in PNT-21 clearly were not made in the Tikal region: a white ceramic (appearing as a cylinder with an incised lid) and another with a specular hematite slip. They are of unknown origin, and we have no other examples from Tikal with which to compare them.

Those who argue for a Teotihuacan presence at Tikal will be surprised at how few imported sherds are present in PNT-21. Arriving foreigners are expected to bring with them some detectable changes in material culture. Thus, the presence of Teotihuacanos at Tikal should be marked by the appearance of pottery produced in the Mexican highlands (ceramic identities) and by the local manufacture of copies of these vessels (ceramic homologies). Both imported pottery and imitations of foreign ceramics reflect—at least to a certain degree—different patterns of interaction (Ball 1983). If those interactions are particularly strong, they may result in the palpable influence of one culture on another.

The incense burners recovered from PNT-21 also deserve mention. A total of five types were identified (Iglesias 1987:258–263), all of which belong to a local Maya tradition. These were used in diverse funerary, dedicatory, and propitiatory rituals.

Ceramic Artifacts

Fully 817 fragmentary or complete ceramic objects were recovered from PNT-21. These have been classified in seven primary and eight secondary types (Hermes 1983, 1991; Iglesias 1987:266–279). Among these are annular ornaments (Figure 6.4a–f), interesting artifacts that are distributed amply throughout all of Mesoamerica, though nowhere in as dense a concentration as at Tikal.[8] PNT-21 contains 94 examples, 82 of which have incised designs, and 18 more were found in TP-74. This kind of artifact is common in Early Classic burials in the Pacific Coast of Guatemala (Arroyo et al. 1993; Bárbara Arroyo and Frederick Bove, personal communications 1999, 2000), but has no special association with artifacts thought to come from Teotihuacan. At Tikal, annular ornaments cannot be associated with any specific context except the problematical deposits.

The presence of figurines—which appear only infrequently at Early Classic Maya sites—in PNT-21 is of great interest. In all, only twelve such figurine fragments have been recovered during excavations at Tikal, five of which come from PNT-21 (Figure 6.4g–j). Their presence, then, attests to the great diversity of material in this problematical deposit. At least two of these figurines have characteristics associated with Classic-period Teotihuacan (Figure 6.4g–h). Kim Goldsmith (personal communication 1999) concurs that they show some affiliation with Teotihuacan examples, but notes that "portrait" figurines from the central Mexican city lack ears (Figure 6.4g; Noguera 1962:129). The baldness of this figurine is its only feature that is reminiscent of the famous Cache 69-2 of Becan (Figure 13.4; Ball 1977a), one of the most frequently cited examples in the polemic concerning Teotihuacan-Maya interaction. The other figurine (Figure 6.4h) is either a half-conical or throne type, but its fragmentary state impedes its definitive classification (Barbour 1998). The chronological placement of PNT-21 is consistent with half-conical figurines known from Teotihuacan. In both cases, only paste analysis will determine if the figurines should be considered identities or homologies.

The heads of two other figurines (Figure 6.4i–j) lack eyes, an absence that does not seem to be the result of loss or deterioration. The ovoid faces, banded headdresses, and earflares are similar to many other representations in Maya art, but are found throughout Mesoamerica. The fifth example (not shown) is not really a figurine. It is a finely decorated canid or feline head that was mounted on a handle and carried (Iglesias 1987:lámina XXXVIIIm).

A final primary type, a single double-chambered *candelero*, is of particu-

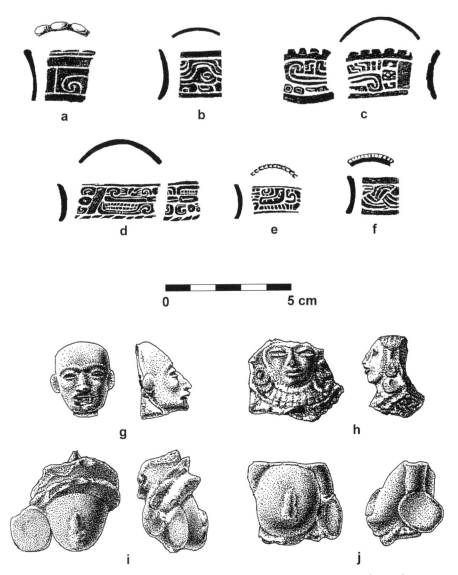

FIGURE 6.4. Ceramic artifacts from Problematical Deposit PNT-21: (a–f) annular ornaments; (g–j) figurine fragments.

lar interest. *Candeleros* frequently are found at Teotihuacan, where they are associated with household rituals.

The ceramic artifacts classified as secondary types present a problem of interpretation. The majority (602) are retouched sherds in a variety of forms—but mostly disks—and sizes (Iglesias 1987:273–278). Their functions are unknown, but they probably were used in domestic contexts.

Chipped and Ground Stone

Approximately 7,000 stone artifacts—almost all fragmentary and made either of chert or obsidian—were classified in thirty types, nineteen pertaining to knapping and eleven to grinding/polishing industries (Iglesias 1987:266–302). Tools and debitage from domestic or craft contexts predominate and include these categories: cores, blades, flakes, hand axes, knives, perforators, scrapers, *manos* and *metates,* hammer stones, and polishers. In the realm of ornaments are beads, earflares, disks, and pendants—all artifacts that commonly appear in ceremonial and funerary contexts.

In addition to the great variety of lithic artifacts—which mirrors a similar diversity in the ceramic content of the deposit—a further characteristic of PNT-21 and many other problematical deposits is worthy of note. The Petén is a karst zone. Sources of chert are common, but all obsidian in the region was imported from the volcanic highlands. Nonetheless, obsidian is much more common in PNT-21 than chert: 77.4 percent of the lithic material is obsidian (of which 92.4% is gray and 7.6% is green), but only 19.1 percent is chert.[9] In contrast, María Elena Ruiz (1986), in her study of lithic materials recovered from the surface of the Mundo Perdido group, noted that 77.3 percent of those artifacts were made of chert and only 18.4 percent were obsidian. Similarly, in his analysis of chipped stone from Groups 4F-I and 4F-II, William A. Haviland (1985:168) reports that 75 percent of the artifacts were chert and only 24 percent were obsidian. In other words, the ratio of obsidian to chert in PNT-21 is the inverse of that found in other kinds of contexts at Tikal. This difference principally is caused by the great number (N=5,206) of prismatic blade fragments. These account for nearly 73.1 percent of all the lithic material in the deposit.

Although no chemical analyses have been conducted yet on the obsidian from PNT-21, data from materials excavated by the Tikal Project strongly suggest that a good portion of the gray material comes from three sources in the Guatemalan highlands: El Chayal, San Martín Jilotepeque, and Ixtepeque (Moholy-Nagy and Nelson 1990; Moholy-Nagy et al. 1984). All the green obsidian, in contrast, comes from highland Mexican sources, particularly Pachuca (Figure 6.5e–h). Michael Spence (personal communication 1998), after seeing illustrations of the fifty gray projectile points from PNT-21 (Figure 6.5a–d), suggests on morphological grounds that many may come from Teotihuacan. Most authors agree that the economic role played by Mexican obsidian in the Maya lowlands was relatively minor and not necessarily part of the same dynamic that resulted in the importation of other goods from central Mexico (e.g., Ball 1983; Spence 1996a).

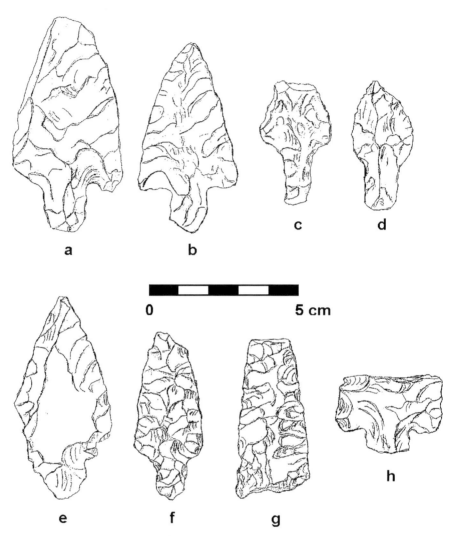

FIGURE 6.5. Projectile points from Problematical Deposit PNT-21: (a–d) gray obsidian; (e–h) green obsidian.

Shell and Marine Materials

A total of 896 artifacts from PNT-21 pertain to the malacological industry. These have been classified in nine types, most of which are ornamental (Iglesias 1987:303–317). Four tubular coral beads and two fragmentary pearls also were recovered. The collection is strongly dominated by 577 examples from the Marginellidae family, possibly placed together as an offering. Still, many other species, including gastropods, pelecypods, and scaphopods, are

represented. A variety of techniques were used to manufacture the artifacts, resulting in diverse kinds of pendants. Some were modified only by drilling, but others are so changed from their original form that it is difficult to identify their species. The same can be said for perforated beads, a variety of geometric shapes used as inlays, and circular seals with incised or negative designs. Only a few utilitarian artifacts, such as spatulate or extended polishers, were recovered. This suggests that molluscan material, for the most part imported from the coast, was used almost exclusively for making items of personal adornment. In contrast, other local materials were used more commonly for domestic and production activities.

Worked Bone

Approximately 600 objects—many fragmentary—of modified bone were found in PNT-21. These have been classified in ten types, and 78.9 percent of the artifacts seem to have served utilitarian functions (Emery 1997; Iglesias 1987). Plain or incised bone beads and pointy canines used as ornaments commonly are encountered in the archaeological record, particularly in funerary contexts. But the quantity of objects (N=467) from PNT-21 that pertain to craft production or domestic use—such as polishers, awls, needles, and spatulas—is notable, especially because polishers were the only kind of bone artifact recovered from general excavations in Group 6D-V. The disparity between actual and expected content, as predicted by other materials recovered near the concentration, is a common occurrence with Manik 3A problematical deposits at Tikal.

A sizable proportion (N=80, 13.5%) of the bone artifacts were classified as having an unknown function. These include a wide variety of artifacts such as carefully polished turtle-shell disks, incised bones that we speculate are numerical record-keeping devices, and bones with unequivocal butchering marks. The last commonly are found in domestic middens and problematical deposits. It also is worth noting that many human bones in PNT-21 showed traces of use, not only long bones that were modified to serve as polishers or perforators, but also cranial fragments with wear marks caused by rubbing—a trait that is not unusual in Mesoamerica (Iglesias 1987:318–326). In sum, the quantity and variety of bone artifacts demonstrate the importance of this material that often is treated by archaeologists as inconsequential. The use of bone as a raw material has great temporal depth, which demonstrates its significance to the technological development of the cultural environment (Laporte 1999a).

Human Remains

A brief reference to the presence of numerous human remains, for the most part appearing in PNT-21 as secondary depositions, is needed. A preliminary analysis reported the bones of at least twenty individuals, mostly adults, dispersed throughout the deposit (Iglesias 1987:329). Such secondary burials are common in all the Early Classic problematical deposits of Tikal, which typically contain the fragmentary remains of more than one individual. In several problematical deposits (TP-22, -50, -72, -74, -77, and PNT-21), human remains were partially cremated. Most human long bones in PNT-21 were used as polishers. In addition to these secondarily deposited remains, two primary burials (Burials PNT-155 and -178) and three offerings of crania were found at the edges of the deposit.

Studies of the human osteological collections from Tikal conducted during the last few years have been very productive (e.g., Wright 1996; Wright et al. 2000). Moreover, recent advances in molecular biology have prompted us to begin to study the mitochondrial DNA of the ancient inhabitants of Tikal, and several samples from PNT-21 have been analyzed (Iglesias 2000; Iglesias et al. 2000). If these results continue to bear fruit, such studies ultimately may have much to say regarding the possible presence of foreigners at Tikal.

Zooarchaeological Material

The faunal collection from PNT-21 contains the bones of many different species, including deer, peccary, turtles, rodents, and birds. All the species represented in the collection, however, are local. One may presume that they were hunted in the immediate environs and formed part of the diet of the elite of Tikal. They appear most frequently in domestic middens, but faunal remains also are found in most of the problematical deposits.

A Brief Synopsis of Other Early Classic Contexts at Tikal that May Contain Ceramics from Central Mexico

This section presents a summary review of other problematical deposits and burials at Tikal that contain pottery and ceramic objects that have been called "Teotihuacan" or "Teotihuacanoid." Eight of sixteen known Manik 3A problematical deposits did not contain foreign ceramics. These are TP-72, -77, -111, -224, -271, and -275, as well as PNT-s/n and PTV-1. In the course of both the Tikal Project and the Proyecto Nacional Tikal, numerous burials pertaining to the Manik 3 phase were excavated. The domestic

and sumptuary ceramics in most of these (e.g., Burials TP-22, -107, -160, -169, -170, -274; Burials PNT-141, -177, and -212) all are of local origin (Culbert 1993:Figures 27a1–4, 36a8–9, 37a2, 37b5, 37c; Iglesias 1987:175–178; Laporte 1989:168–172). Decorated vessels include bowls and plates that are incised, gouged, or painted, as well as cylindrical tripod vessels with incised, gouged, or fluted designs. The last form appears with a wide variety of feet, including slab supports, that do not necessarily indicate affiliation with or influence from Teotihuacan. It should be made clear that, with one exception, only those contexts that appear to contain foreign ceramics are discussed in this section.

Burials

Burial TP-10. This tomb is located in the North Acropolis and dates to about A.D. 420 (Coe 1990, 2:479–487). The funerary assemblage of the individual, thought to be the king and possible foreigner Yaax Nu'n Ahyiin ("Curl Nose"; Coggins 1975:137–148), consists of thirty vessels and an isolated lid, jade, shell, bone, chipped stone, and various perishable materials. A total of three bowls and two lids are similar to Thin Orange ware, but Anna Shepard (who conducted a paste analysis) and T. Patrick Culbert (1993:Figure 15c) are careful not to state that the vessels come from Teotihuacan. These are stuccoed and decorated with eclectic images that clearly show some—but not pure—affiliation with highland iconography. Other complete pieces include an anthropomorphic effigy vessel, a peculiar zoomorphic effigy vessel with a paste that resembles that of the possible Thin Orange vessels (Culbert 1993:Figure 18b), domestic forms of the Aguila ceramic group, polychrome plates, nine unslipped and flat-bottomed cylinders with lids, and various slab-footed tripod cylinders with lids that have anthropomorphic handles. These last are assigned to the Aguila and Balanza ceramic groups and undoubtedly were produced in the Maya region, if not at Tikal itself. Two additional covers and one vessel appear to be made of Tiquisate ware, imported from the Pacific Coast of Guatemala. Some of the pieces are decorated with painted stucco, others with gouged-incised designs, and one piece has resist designs (Culbert 1993:14–21).

Burial TP-48. Dated to A.D. 456/458,[10] this tomb is located at the southern edge of the North Acropolis, in bedrock below Platform 5D-4 and the later Str. 5D-33-1st (Coe 1990, 1:118–123). Coggins (1975:193–201) has identified its occupant as "Stormy Sky," now known as Siyaj Chan K'awiil, the son and successor to Yaax Nu'n Ahyiin. The burial offering consists of twenty-seven vessels, stone artifacts, shell, and traces of perishable materials. Most

of the pottery is clearly Maya: simple, annular, and round-sided tripod bowls of the type Aguila Orange; bowls and slab-footed tripod cylinders with lids that are assigned to the type Urita Gouged-incised; and other tripod cylinders with round or cylindrical supports that belong to the type Balanza Black (Culbert 1979:28–32). The sole exception in this sea of Maya pottery is a black tripod cylinder that is stuccoed and painted with Teotihuacan imagery (Coggins 1975:194; Culbert 1993:Figure 30b). The lid that accompanies the vessel also is stuccoed and painted but is more eclectic, having central Mexican butterfly imagery and a typical Maya anthropomorphic handle. This suggests that the vessel and its cover may have different origins, and that the lid may have been locally created in order to match a foreign piece (Culbert 1993:Figure 30b).

Burial PNT-174. This interment was placed in a cut through the floor in Complex Sub-85/87 of Group 6C-XVI. The burial, a primary though disturbed context, contained a very abundant offering. It consists of marine shell ornaments, ground stone—mostly green—and numerous ceramic pieces. Twenty-one vessels and four lids belong to the autochthonous Aguila and Balanza ceramic groups and are assigned to the types Lucha Incised, Japón Resist, and Caldero Buff Polychrome. Two effigy vessels, one zoomorphic (assigned to the Aguila ceramic group) and one anthropomorphic (of the type Lucha Incised), also were found. Nonetheless, several pieces stand out from the rest: two *floreros,* an annular-based *olla* that may pertain to the Ratones ceramic group, and six vessels and three lids of the Aguila and Balanza groups. The last have secondary decorations painted on stucco. The designs of these vessels and lids contain Teotihuacanoid images and symbols (Laporte 1989:173–180, figuras 69–76, 79–81).

Burial PNT-212. The only Early Classic burial discovered in the North Zone of Tikal is Burial PNT-212. It was located in a room in a buried structure below Str. 3D-43 (Laporte 2000). PNT-212 contained two individuals and a very rich offering, all mixed with abundant red pigment and blocks of copal incense. The funerary assemblage is composed of a wide variety of objects, including pyrite plaques, shell and greenstone mosaics, shell necklaces and plaques, pearls, mother-of-pearl plaques, shell earrings, and stingray spines. In addition to being used in mosaics, greenstone also appears as beads, appliqués, earrings, and pendants. Oddly, items of chert and obsidian are almost totally absent. The ceramics are quite fragmentary, and may have been smashed when a vault collapsed. We do know that twenty-one vessels were present. These include five pots, seven bowls with pedestal or annular bases, two cylinders and a bowl with supports, and five plates

with basal flanges and annular bases. All belong to lowland ceramic groups and are decorated according to Maya tradition. They do not display foreign attributes.

I include Burial PNT-212 in this section because of the information, again negative, that is provided by the most spectacular and well-known object from the burial: the sculpture called the Hombre de Tikal or Ximba. It is a representation of a corpulent man seated with his legs crossed and his hands resting on his knees. An incomplete hieroglyphic text covers all of the figure's back, and glyphic cartouches are found on each of his arms. The texts were carved at different times, which complicates their interpretation (Chinchilla 1990b; Fahsen 1988).

Epigraphers agree that a name shown in one of the cartouches is Chak Tok Ich'aak ("Jaguar Claw"), and that the other—although very damaged—contains the name (or title) Taj-al Chaak, or "Torch God of the Rain" (Martin 1998). These identify the Hombre de Tikal as a portrait of Chak Tok Ich'aak I, who governed Tikal between A.D. 317 and 378.[11] The text inscribed on the back of the figure is a subsequent modification, written during the epoch of Yaax Nu'n Ahyiin (A.D. 379 to c. 420). The ceramic offerings, however, indicate that the burial dates to the end of the fifth century, some seventy years after the second inscription was added. Specifically, the ceramics date to the end of the reign of K'an Ak ("Kan Boar"; A.D. 458 to c. 488) or to the early years of Chak Tok Ich'aak II (c. A.D. 488 to c. 497/508). Without doubt, the individuals in Burial PNT-212 were of very high status and had privileged access to imported objects. Curiously, no cultural intrusion originating from central Mexico, which would lend support to the Teotihuacan-dominance model, has been detected in any of the grave goods (Laporte 2000).

Problematical Deposits

Problematical Deposit TP-22. This was located in the North Acropolis, to the south but on the centerline of Str. 5D-26-1st (Coe 1990, 2:324–327). The fragmentary Stela 32, which may not be a stela and seems to portray a Teotihuacan war deity (Pasztory 1974), was found in the deposit. Also present were numerous objects of stone (including fifty-seven pieces of green obsidian), bone, and shell. Although Coggins (1975:182) writes that "masses of undecorated pottery of purely Teotihuacan style" were present in TP-22, evidence published by Culbert (1993:Figure 123) suggests otherwise. In fact, the only example that most likely was imported is a small fragment of a Tlaloc effigy jar. A single-chambered *candelero* also might be an import from central Mexico. A cylinder tripod classified as Urita Gouged-incised has "coffee

bean" appliqués, a trait common at Teotihuacan (Culbert 1993:Figure 124). Nevertheless, the vessel is classified as a lowland Maya type. These are among a vast quantity of numerous broken vessels and sherds, including simple bowls, polychrome plates, tripod cylinders, and pitchers, that all are of local origin (Culbert 1993:Figures 123–126; Moholy-Nagy 1986).

Problematical Deposit TP-31. Found beneath Room 2 of Str. 5D-25-1st in the North Acropolis, TP-31 contained relatively few artifacts (Coe 1990, 2:443–444). Among this material, however, is a complete single-chambered *candelero* (Moholy-Nagy 1986).

Problematical Deposit TP-50. Located southwest of the North Acropolis behind Temple II, TP-50 is securely identified as a secondary burial of an elite individual (Coggins 1975:177–181; Culbert 1993:Figures 128–130). The ceramic content is eclectic, consisting of a high proportion of Maya vessels and four cylinders of foreign affiliation. The first of these is a well-known black vessel with an incised scene depicting three temple pyramids (Figure 13.1; Culbert 1993:Figure 128a; Green and Moholy-Nagy 1966:432–434). The central pyramid is built in Maya style (Culbert 1993:Figure 128a1), but the flanking two contain *talud-tableros* (Culbert 1993:Figure 128a2–3). The fact that the three temples are joined to each other by a low platform belies the suggestion that they are at different sites (Conides 2000). A group of individuals (Culbert 1993:Figure 128aE–J), some wearing Teotihuacan-style headdresses and bearing cylindrical tripods, proceeds from the leftmost to the rightmost temple by passing around the vessel. The second cylindrical tripod vessel has an incised design of intertwined serpents against a floral background (Culbert 1993:Figure 128b). Although the elements of this eclectic cylinder look central Mexican, it is stylistically very different from the first vessel and also displays a typically Maya sense of *horror vacui*. Two more tripod cylinders are much more simple in design but have nonlocal pastes. TP-50 also contained lithics, shell, and bone (Moholy-Nagy 1986).

Problematical Deposit TP-74. This problematical deposit was found in Twin Pyramid Group 5C-1. TP-74 contained a great deal of ceramic, lithic, bone, and shell artifacts. In addition to numerous fragments of local ceramics (polychromes; domestic vessels; incense burners; and incised, gouged, and fluted cylindrical tripods), four figurine fragments—of unknown stylistic affinity—and a piece of what may be a *candelero* with a perforated wall were discovered (Moholy-Nagy 1986). Perhaps the content of this concentration is most similar to that of PNT-21.

Problematical Deposit TP-87. The concentration was discovered beneath Str. 5D-22-4th in the North Acropolis (Coe 1990, 2:345–346). The ceramic

content of TP-87 is partially dated to the Cimi phase (A.D. 150–250) because of the presence of many early vessels, some with mammiform feet. Lithic artifacts, shell, and osteological materials were also recovered. The only object of relevance to the question of interaction with central Mexico is a fragment of a miniature vessel that may be a *candelero.*

Problematical Deposit TP-231. The deposit was found in Chultun 6C-11 of Group 6C-V. It probably represents materials redeposited from an elite tomb. Along with typical objects of stone, shell, and bone, cylindrical tripod vessels, bowls, jars, and other local types are reported (Culbert 1993:Figures 153f and 154). A small ceramic object, either a miniature cup or a thin-walled *candelero,* was recovered (Culbert 1993:Figure 153f4).

Problematical Deposit PNT-19. This concentration was found in structure Sub-7 of Group 6C-XVI. Just like the preceding examples, it consists of domestic and ceremonial ceramics, stone artifacts and ornaments, shell, and bone. In addition to the abundant and varied local pottery, three featureless Thin Orange body sherds of the type Ratones Orange have been reported (Laporte 1989). PNT-19 is dated to the Manik 2 phase (A.D. 300–378).

Problematical Deposit PNT-21. To recapitulate data presented in the previous section, PNT-21 contained the fragments of two figurines of central Mexican affiliation, a double-chambered *candelero,* and four Thin Orange sherds of the type Ratones Orange. Also present are more than 168,000 sherds and ceramic artifacts of local manufacture.

Problematical Deposit PNT-31. This concentration of artifacts was found in structure Sub-75 of Group 6C-XVI. Found among the diverse and varied materials of this problematical deposit were a fragmentary solid figurine and three rim sherds from an out-flaring-walled bowl. The last are Thin Orange ware, belonging to the type Competencia Incised (Laporte 1989).

Methodological and Cultural Analogies

In archaeology, as in all life, it is difficult to swim against the current. It is not my intention to contradict all of what has been written previously regarding relations between Tikal and Teotihuacan. As I stated at the opening of this chapter, I do not question the existence of very fluid and dynamic relations among the diverse cultures of ancient Mesoamerica. Nor do I reject the possibility of the physical presence of Teotihuacanos in certain Maya cities. But I am against interpretations that overvalue certain classes of data and ignore others.

We have before us a great puzzle, and we have neither all the pieces nor a complete idea of what the image should look like. As always happens, some

of the pieces we possess are very distinctive and appear easy to place. But the great majority of the pieces pertain to the immense and exasperating sky, sea, or forested background, and contain only the faintest details to guide us in our task. Most strategies of puzzle working involve forming groups of distinctive pieces that nonetheless share something in common. The great non-differentiable mass is left for last. But the rules of the game do not allow us to reject any particular piece as being unimportant to the completed image.

I sometimes feel that the scientific discourse on Mesoamerican interaction contains overvalued pieces, pieces of consistently underestimated and marginalized importance, and pieces that have been incorrectly placed. In addition, we reject *a priori* those pieces that have no place in our cherished vision of what the final image should look like.

From my perspective, the pieces that have been placed badly are those features that some unquestioningly classify as "Teotihuacan" or "Teotihuacanoid." These include the *talud-tablero* and the cylindrical tripod vessel. Despite evidence against these interpretations, some puzzle solvers deceitfully ignore new data because they stand in the way of an old pet theory. As a result, newly discovered pieces are positioned directly next to those that have already been misplaced, compounding previous errors of interpretation.

The overvalued pieces are glaringly obvious and can be counted on one hand: isolated discoveries such as Cache 69-2 of Becan (Ball 1974, 1977a) and Tomb F-8/1 of Altun Ha (Pendergast 1971), the presence of green obsidian from the Pachuca source, and, to a certain extent, hieroglyphic interpretations and iconographic analyses.[12]

The pieces that are undervalued or ignored are the data that make up the greatest portion of the image: the autochthonous substrate of Maya cultural development represented in funerary and problematical contexts, as well as in materials recovered from general excavations. It is on this substrate that we should concentrate. In order to begin to understand Tikal during the fourth and fifth centuries, we must be able to detect the presence of intrusive traits in material culture. To do this, we must first identify and quantify those objects of local origin. My analysis is based on archaeological data—the materials excavated from PNT-21 and other deposits at Tikal—that provide a view of what the city was like during the Early Classic. These quantified data are derived from the objects that were imagined, fabricated, used, and discarded by people living in a precise place and moment. My goal in this contribution is to convince the reader that these pieces belong to the puzzle and should be valued in measure to their rate of occurrence. The data derived

from the problematical deposits and burials reflect the dominant culture of the elites of Tikal during the late Early Classic period, a material culture that is overwhelmingly of local origin. In contrast, the presence of foreign elements is extremely minimal.

But what should we do when material evidence does not support—or even contradicts—interpretations of hieroglyphic texts? A recent reading of texts from Tikal and Uaxactun suggests that a strongly disruptive event played an important role in the sociopolitical development of the central Maya lowlands, and even names the individuals whose arrival promulgated these changes (Stuart 2000a). This interpretation raises a multitude of questions. Why did foreigners "arrive" at Tikal? What happened in Tikal that allowed an interruption of its dynastic line? Did the same or a similar series of events occur at Copán? Did Calakmul stay out of this intrusion, or has its involvement so far escaped detection? How does Kaminaljuyu fit into these events? Why was it necessary for rulers of a variety of sites in the Maya region to seek legitimization or sanction from Teotihuacan and other distant sites?

When cultures interact, specific processes that are mediated by numerous factors come into operation. A strong determinant in these relations is the nature of the contact. Was it peaceful or violent? Was the authority or coercive power of Teotihuacan so strong that it was capable of imposing rulers in a variety of places more than 1,500 km from its center? From my perspective, a control by force is assumable only if we believe that a Teotihuacan presence at Tikal was somehow similar to the Spanish Conquest. The essential actors in that later drama were the thousands of indigenous people—allied by conviction or subjugation—without whom the imposition of sociopolitical control would have been impossible. Did something equivalent occur in the event of 8.17.1.4.12 11 Eb' 15 Mak (Stuart 2000a), January 16, A.D. 378? Who were the Maya allies that made the imposition of a foreign-born ruler possible? What were the economic circumstances behind this arrival—a struggle to control the obsidian trade? Few scholars now think that Teotihuacan played any role in the distribution of obsidian within the Maya region. Could it have been an overwhelming need to exchange Thin Orange ware? Even if Teotihuacan controlled production of this ceramic, which seems unlikely, the total number of whole vessels (perhaps as many as five and two lids) and sherds (ten total, representing another four to six vessels) found in primary contexts at Tikal is negligible. They may represent one load carried to Tikal by a single person. In any case, the exchange of this pottery over such distances cannot be explained in economic terms. What, then, happened?

As a Spaniard and a European, I belong to a culture in which marriages of state between elites of different nations have been practiced for centuries. The idea that a person of mixed descent—the product of the union of local and foreign elites—can come to control a territory and be accepted by the local populace is understandable to me. An example from Spanish history seems quite analogous to the situation in Mesoamerica. King Charles I of Spain (Charles V of the Holy Roman Empire; A.D. 1500–1558), son of the Spanish Doña Joanna the Mad and the Flemish Philip the Fair, was born and educated far from the Iberian Peninsula. He came to Spain without speaking a word of Spanish, but he died completely Hispanicized and immersed in a culture that absorbed him. The Austrian Hapsburg dynasty was maintained for more than two hundred years before other foreigners, from the House of Bourbon, intervened. The first king in that line, the French-born Philip V, greatly increased the appreciation of French and Italian fashion among the Spanish elite, but had little effect on the common people. Eventually, members of the Houses of Bonaparte and Saboya also interceded. Key to understanding the acceptance of this intricate network of interrelated dynastic lines that crosscut ethnic and national identities is the notion of divine kingship, a concept shared with some Mesoamerican cultures.

During all the centuries of intermarriage, Spanish culture did not remain static. Nonetheless, changes fundamentally were due to internal dynamics and to the fluidity of European relations, and, of course, to the economic and cultural influences of the Americas. Throughout this long period, Spain remained undeniably Spanish. This is perfectly equivalent and analogous to the development of Mesoamerican civilization.

Conclusions

Where do the data from the problematical deposits leave us? Fundamentally, they suggest that the mountain of evidence regarding the importance of economic interaction between Tikal and Teotihuacan is no more than a molehill. Archaeological data supporting the notion that Tikal contained a Teotihuacan "enclave" or was an important "interactive node" in a large-scale, Teotihuacan-focused network have been greatly exaggerated. Assuming that inter-elite contacts existed, their effects on both sociopolitical and cultural development at Tikal were quite literally immaterial. Only the most minimal quantity of material goods—green obsidian, figurines, *candeleros,* and Thin Orange ware—may possibly be "identities," transported objects that could have formed part of the personal goods of displaced Teotihuacanos,

people who in the following one or two generations were completely accul-turated. Moreover, many—or even most—of these artifacts may have been manufactured at sites other than Teotihuacan. And of course, exchange with intermediaries who were not from Teotihuacan may account for the presence of the very few central Mexican imports at Tikal.

What is lacking at Tikal is evidence that Teotihuacan had any lasting im-pact on material culture. If Teotihuacan "made a difference" (Chapter 9), we should expect a continuation of central Mexican stylistic influences, in-corporated at different levels with Maya features, during later periods. The reality is that after Manik 3A, the material culture of Tikal regained its purely Maya character. Not even the faintest traces of cultural syncretism can be found in the later artifacts of Tikal. The ceramics of the Manik 3B and Ik phases (A.D. 480–700) have no characteristics that are reminiscent of pottery from Teotihuacan. The only two possible exceptions to this rule date to the Late Classic Imix phase (A.D. 700–850), long after the demise of Teotihuacan as an international power. A Zacatel Cream Polychrome bowl with variants of the Mexican year sign forms part of the extraordinary burial furnishings of Burial TP-116 of Temple I, the tomb of Jasaw Chan K'awiil (Culbert 1993:Figure 64c2). The second counterexample is a Pal-mar Orange Polychrome vase that bears a representation of Tlaloc and four glyphic medallions that are central Mexican in character. This vessel was re-covered in Burial PNT-84 of Group 6C-XII (Laporte and Iglesias 1999:figura 13). It is not at all clear if the design elements on these two vessels should be attributed to a lingering Teotihuacan "influence" or to interaction with some later Epiclassic group.

What we see in the archaeological record of the Early Classic is dynamic development, without strong interruptions, characterized by innovation and an interesting variability in specific cultural features, particularly ceramics and funerary customs. In comparison, these same features display a standard-ized and formal homogeneity in later periods.

Almost thirty years ago, John Paddock (1972:223) wrote: "I believe I have more doubts than data." Echoing his words, I suggested in the intro-duction that this chapter would provide few answers and would raise more doubts and questions. We live in a world of specialization, to which archae-ologists are not immune. Each archaeological specialist defends his or her portion of Mesoamerica with tooth and nail. Thus, when the evidence sug-gests interaction among ancient peoples, we enter a competitive discourse focused on systematically reaffirming the importance, independence, superi-

ority, and originality of "our" archaeological culture. On numerous occasions, I have been plagued by the thought that it is impossible to withdraw ourselves from the cultural realities that constrain and filter our perceptions and explanations. Do our positions reflect the modern dialectic of imperialism versus nationalism (European/North American/Mexican: Guatemalan :: Teotihuacano:Maya)? Have we lost sight of the fact that Mesoamerican polities were not nations, at least as we conceive them? Why has there been so much desire to treat as transformative and extraordinary a relationship that in reality had little demonstrable effect on the cultural development of the elite class of Tikal that was directly involved with these interactions, let alone on the Maya in general? Has our intransigence in accepting other propositions been due in part to the impossibility of purely objective interpretation? Is this why we have so many questions and so few answers?

For years, archaeologists have considered Mesoamerica to be a culture area. This concept implies that the unfolding of historical processes in various regions of Mesoamerica was not a series of unique and isolated events, and that economic or ideological interaction played an important role in cultural development. Yet we often privilege violent and traumatic scenarios of acculturation and devalue more realistic models that might be described as "Interaction Lite." Moreover, many scholars speak of a Teotihuacan presence in the Maya area as though Martians—extraterrestrials from a cultural substrate as different as it was sophisticated—landed and permanently changed the face of Maya history. They do not consider Teotihuacan-Maya relations in terms of the interaction of peoples that already shared in common many ideas, technologies, items of material culture, and visions of the world.

Many years ago, in the first study of Maya-Teotihuacan interaction, attention was called to the risk of assigning excessive importance to interregional relations: "Also tending to minimize the apparent significance of local developments has been the present woeful lack of knowledge of Guatemala highland archaeology" (Kidder et al. 1946:256). At the time, this observation could have been extended to any site in the Maya area, including Tikal. Likewise Paddock warned us of the dangers of this obsession:

> At times one has the impression that everyone denies the possibility of the invention of the smallest characteristic here, in the place that we are exploring and describing; all has to come from some other place. . . . [W]e should tread with much caution among the Teoti-

huacan objects, local imitations, vestiges of traces of reflections of the Teotihuacan style, and the clear misconceptions that occasionally arise because of the intensity with which connections were sought. (Paddock 1972:224)

Why have we not heeded these and other calls of attention? Is it so difficult to expand our perspective? Will we, the archaeologists, become as immobile as the great pyramids that so attract us?

As the contributions to this volume show, there are a myriad of perspectives on Teotihuacan-Maya interaction, each determined by the frame of reference from which we view the problem. Perhaps the importance of these new contributions, written in the last gasps of the twentieth century, lies in the fact that new voices have been called together to resuscitate an old problem that we hope will be solved in the next century.

Notes

1. Despite the extraordinary length of time for which evidence of contact with central Mexico is manifest, the period of significant interaction with Teotihuacan was limited to the fourth through fifth centuries.

2. In order to avoid confusion, features—such as burials and problematical deposits (called "burial-like problematical deposits" by Moholy-Nagy [1999a:308])— excavated by each project are assigned the prefix TP (Tikal Project) or PNT (Proyecto Nacional Tikal).

3. These data were kindly supplied to me by Hattula Moholy-Nagy, with whom I have maintained a strong and fruitful "scientific interaction" for years.

4. In the North Acropolis, these are TP-22, -31, -77, and -87; near Temple II, TP-50; and near Temple IV, TP-74 and -111. Problematical deposits found by the Tikal Project outside of the epicenter include TP-72 and -224 located in Chultun 5C-8 near Str. 5C-56, TP-231 located in Chultun 6C-11 north of the Perdido Reservoir, TP-271 in the southwest corner of the Madeira Reservoir, and TP-275 in Group 6C-I (Moholy-Nagy 1986, personal communication 1998).

5. These are PNT-31 in Group 6C-XVI, and PNT-21 and -s/n in Group 6D-V. PNT-19, also in Group 6C-XVI, is relevant to discussions of Teotihuacan-Maya interaction but dates to the Manik 2 phase.

6. Stela 32, a portion of Stela 33, and fragments of other monuments were discovered in TP-22, another problematical deposit.

7. The type:variety ceramic typology used here is based on the previous work of T. Patrick Culbert (1979) and Bernard Hermes (1984), respectively the ceramicists of the Tikal Project and the Proyecto Nacional Tikal. More recently, Laporte and Gómez (1998) have reexamined the problematical deposits excavated by our project with the goal of refining the ceramic chronology of Tikal.

8. These objects are commonly classified as earflares because they resemble similar pieces executed in stone. But at Tikal, none have been found in pairs or in contexts

that clearly indicate their use. For this reason, a functionally neutral term has been chosen.

9. Additional materials include greenstone (0.6%), quartz (0.9%), slate (0.2%), and other stones and minerals (1.8%; Iglesias 1987:299–301).

10. See Chapter 3, note 10.

11. Stela 31 mentions that Chak Tok Ich'aak celebrated the ending of both *k'atun* 8.14.0.0.0 (A.D. 317) and 8.17.0.0.0 (A.D. 376). It is possible, as Jones (1991) suggests, that two fourth-century kings of Tikal had this name.

12. In many cases, investigators who make these discoveries are more cautious in their interpretations than others who use the data (see Chapter 9).

Architectural Aspects of Interaction between Tikal and Teotihuacan during the Early Classic Period

Juan Pedro Laporte

The development and nature of interaction between Tikal and Teotihuacan are controversial subjects. Many perspectives have emerged in the attempt to understand the relationship between these two Early Classic Mesoamerican cities. Each line of argument is supported by studies of architecture, hieroglyphic inscriptions, sculpture, stone tools, or ceramics. The archaeological record of Tikal is particularly rich in data that can be applied to the problem. In fact, the cosmopolitan character of Early Classic Tikal has fostered extreme positions regarding the role played by Teotihuacan in the development of the city and, consequently, of a considerable part of the Maya lowlands.

A clear and complete understanding of this interaction does not exist at this time. In this contribution, I aim to clarify the context and temporal position of various elements that are treated as diagnostic of foreign "influence" at Tikal. I will consider a single category of related features: architecture, site planning, and their chronology. Other elements thought to be diagnostic of interaction—such as imported lithics, ceramics, and iconographic motifs—are more widely dispersed in the Maya area and are treated in this volume by investigators who work at other sites.

The presence of the *talud-tablero* form in several buildings in the central area of Tikal is well known. It also is found farther away from the center of the Classic city, in structures located in groups thought to be "apartment compounds." Structures that make up these groups are considered to be houses, even though they are very diverse in form and size. They include platforms, pyramidal substructures, and palaces that supported simple or vaulted roofs.

Both elements—the *talud-tablero* and the specialized groups in which it is found—have been construed as evidence demonstrating Teotihuacan influence at Tikal because they are assumed to be central Mexican in origin.

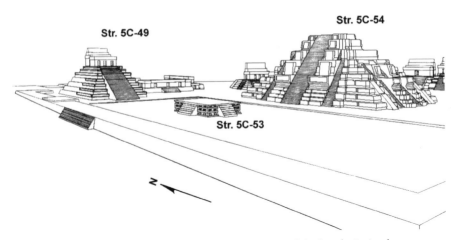

FIGURE 7.1. The Mundo Perdido complex as it appeared during the Imix phase (A.D. 700–800).

Such arguments do not consider other critical aspects that affected the development of architectural and settlement patterns throughout Mesoamerica, particularly the movement and mutual exchange of goods and ideas through interaction. In order to understand why multilateral interaction is a better explanation for the appearance of these elements at Tikal, it is necessary to understand in detail how and when they appear in the cultural framework of the city.

The *Talud-Tablero* as an Architectural Style at Tikal

I begin with the feature that is most evident and controversial in the debate concerning relations between Tikal and Teotihuacan: the *talud-tablero*. At Teotihuacan, the complete form that emerged during the Early Classic period consists of pairs of *taludes* and framed *tableros* that pass completely around a platform, and stairs flanked by balustrades that are capped with finial blocks (called *remates*). I am well aware of the stylistic variation that exists at Teotihuacan (Chapter 12). Nonetheless, the majority of *talud-tablero* structures at the central Mexican city conform to these norms. At other sites, including Tikal, different versions of the architectural style developed, and other canons were established.

During the second half of the third century A.D., the first *tableros* appear in the Mundo Perdido complex as details on each of the four sides of the fifth version of Str. 5C-54, the Great Pyramid (Figure 7.1). This is the central and principal structure of one of the oldest architectural groups at Tikal,

and it has a developmental sequence spanning one thousand years before the version containing the *tableros*. The long history and central location of the structure indicate its importance to Early Classic Tikal.

The fifth construction episode corresponds to the Manik 1 ceramic phase, now considered part of the Terminal Preclassic. Also built at that time was the first version of Str. 5C-49, one of the most important temples of Mundo Perdido. Str. 5C-49 has a vertical *tablero* that lacks a frame and was painted black. The stair is flanked by balustrades that lack upper finial blocks (Figure 7.2). Although these two third-century structures contain *tableros*, they diverge from the stylistic norms established at about this time at Teotihuacan.

In the fourth century, during the Manik 2 phase, the second version of Str. 5C-49 was built in a variation of the *talud-tablero* style. It has framed *tableros* on its three levels. The *tableros* are placed on the front of the building and project toward the sides, where they merge with the inclined mass of the pyramid. Only the uppermost level has a *tablero* on all four sides. Again, this use of the *talud-tablero* differs from contemporary examples at Teotihuacan. The third version of Str. 5C-49 also contains this variation of the *talud-tablero*. Moreover, the Stage E3-a structure of the Palangana at Kaminaljuyu seems to employ this variant (Cheek 1977a:51–53; see Chapter 3).

Other structures (Strs. 5C-51, 5C-52, and 6C-24) of the Mundo Perdido complex exhibit the *talud-tablero* form during the fifth century, corresponding to the Manik 3 phase. These buildings mark the western and southern

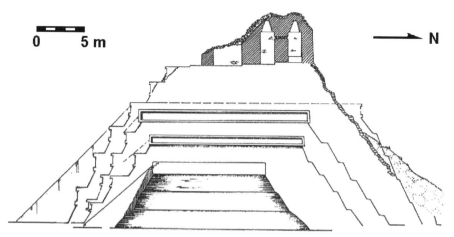

FIGURE 7.2. Construction stages of Structure 5C-49, Mundo Perdido.

limits of the group. Another example is the base of the East Platform of Mundo Perdido, which was remodeled by adding a *talud-tablero* of great dimensions.

The widespread use of the *talud-tablero* form in Mundo Perdido during the fifth century coincides with the adoption of iconographic elements shared by both Tikal and Teotihuacan. It is important to stress that this occurred at least two centuries after the first examples of what eventually developed into Tikal's version of the Early Classic *talud-tablero* appeared at the site. The chronological gap between the adoption of these architectural and iconographic norms also should exist at Teotihuacan. An independent appreciation of each universe would clarify aspects of the bilateral relations between the two cities during the four centuries of the Early Classic period.

The *Talud-Tablero* in Group 6C-XVI

Use of the *talud-tablero* and its variants at Tikal is not limited to Mundo Perdido. It first appears in Group 6C-XVI at the end of the fourth century, when four distinct platforms employing the architectural style were constructed. This group is located 350 m south of the Mundo Perdido complex (Figure 6.1; Carr and Hazard 1961; Laporte 1989).

The initial construction stage of Sub-4, a particularly complex platform, dates to the first half of the fourth century (i.e., during the Manik 2 phase). Sub-4 contains a *talud-tablero* on one section of the sides of the platform, as well as an apron molding and stairs without balustrades. A series of stucco figures decorated the inset portion of the *tablero,* and the front side of the platform had masks representing a deity. A fragment of one mask made of stone and stucco survives, and traces of red and black paint can be observed. The iconographic content of these fragments suggests that the mask consisted of a face framed by a headdress. The lower section of the mask is well preserved, beginning with the zoomorph generally shown as a chin rest. Three round elements appear below this, forming a version of what often is called the *ajaw* bone (Sanz 1998). To the sides of the mask are what appear to be two large blocks of feathers, possibly frontal depictions of plumes instead of the more common profile representations. The incomplete state of the mask does not allow the identity of the individual to be determined.

A second structure, Sub-17, has a *talud-tablero* in the front and also on a portion of the sides of the platform, where it merges with the apron molding. The stairs do not have balustrades. A third example is Sub-26, which has a *talud-tablero* on all four sides of the building, and a stair with balustrades that end in finial blocks. This is the only example at Tikal that is known to

contain all the stylistic elements of the complete architectural form that developed at Teotihuacan. Finally, Sub-48, a small platform-altar situated at the center of the North Patio of the group, also contains a *talud-tablero*.

Other later examples of the *talud-tablero* in Group 6C-XVI correspond to the fifth century (i.e., the Manik 3 phase). The *tablero* of platform Sub-57 contains a painted, low-relief architectural sculpture. The remains of the scene show three people seated cross-legged on small thrones covered with jaguar skins (Sanz 1998). All three wear knee-length skirts, aprons, belts, and loincloths knotted in back. The central figure appears to be surrounded by the remains of a cartouche. Although little can be interpreted from this scene, the number of figures and their seated positions are peculiar for the Early Classic. It also is surprising that the central figure looks to the right, a posture usually reserved for deities.

Given that known Early Classic examples of the *talud-tablero* style are concentrated in Mundo Perdido and Group 6C-XVI—two unrelated architectural groups—it is likely that their discovery is a product of the sampling strategy used to choose groups for excavation. It is probable, therefore, that other Early Classic plaza groups in the city have structures built in the *talud-tablero* style.

Late Classic Use of Central Mexican Elements in the Architecture of Tikal

There are no other Early Classic examples of the *talud-tablero* known at Tikal, but isolated elements of the architectural style have been reported. These include the balustrades flanking the stairs of Str. 5D-22-1 of the North Acropolis, Temple V, and Str. 4H-43. The first of these structures dates to the Early Classic, the second to the beginning of the Late Classic (Gómez 1998), and the third to the Late Classic period (Haviland 1985).

Those who believe that Teotihuacan is responsible for conveying the *talud-tablero* form to Tikal must explain why architects of the Maya city continued to emulate the old style after the demise of Teotihuacan. During the Late Classic, other platforms incorporating the *talud-tablero* were built.

The debate concerning architectural relations between Tikal and Teotihuacan began not with the examples from Mundo Perdido and Group 6C-XVI described above, but with three conspicuous structures that may have functioned as plaza altars. These are Str. 5D-43 in the East Plaza, Str. 5C-53 in Mundo Perdido (Figure 7.1), and Str. 6E-144 in a minor group southeast of the site epicenter. Str. 5D-43 is the only one of these that supported a superstructure; the others are rectangular or radial platforms. They were

constructed c. A.D. 550–650 at the beginning of the Late Classic Ik phase. The three platforms have distinctive features. They consist of three sections: a *talud*, a framed *tablero* containing iconographic elements, and a projecting or flaring cornice that mirrors the *talud* (Coe 1972; Coggins 1975; Dahlin 1976; Puleston 1979; Rodríguez and Rosal 1987). The resulting form, called an *atadura* (cinch), is particularly common in Veracruz and Oaxaca, and also appears in the moldings of Puuc structures. But only one structure at Teotihuacan is known to contain the *atadura* form (Pasztory 1978a:109). Explorations of the three Tikal platforms indicate that their earliest versions did not contain the flaring cornices. These were added at the end of the Ik phase.

Another important construction project dating to the beginning of the Late Classic period was the renovation of Str. 5C-49 in Mundo Perdido (Laporte 1998). In this remodeling episode, the stairs were expanded by covering earlier projecting balustrades. But the original façade of the fourth version and its *taludes* and *tableros* were retained. In addition, the upper level of the platform was raised 4.6 m by adding two more levels built in *talud-tablero* style (Figures 7.1–7.2). Thus, the selective refurbishing of Str. 5C-49 conserved a façade decorated in a style that may have been outmoded by the Late Classic period. The augmented platform supported a vaulted temple with three rooms. Today, even without its roof comb, the complete structure is more than 22 m high. The construction episode resulting in this version of Str. 5C-49 was either slightly before or contemporary with the erection of Temple V, the first of the great temples of Tikal.

Two distinct interpretations account for the peculiar and unusual way that Str. 5C-49 was renovated. First, the *talud-tablero* form of the fourth version may have been retained as a conscious remembrance of a significant cosmopolitan and international style. A more realistic if less attractive interpretation is that it was impossible to cover the entire fourth version of the platform because a change in the level of the adjoining West Plaza had greatly reduced the available space.

The *Talud-Tablero* as a Common Mesoamerican Form

The tangible and overwhelming evidence for the use of the *talud-tablero* at Tikal has led many archaeologists to claim that Teotihuacan was the focus or core from which the style emanated. Nevertheless, clearer and more precise dates of the feature, as well as a better understanding of its evolution at Tikal, exclude from consideration the possibility of just one source of influence. The architects of Tikal were experimenting with and modifying the style two centuries before there is other evidence of contact with central Mexico. Thus,

it is more plausible that multiple areas participated in the exchange of ideas and styles across Mesoamerica during the Early Classic period.

Elements associated with the *talud-tablero* style have been found at other sites in the Maya lowlands that have not been explored as intensely as Tikal. These include Becan, Dzibilchaltun, Oxkintok (Chapter 10), Río Azul, Copán (Chapter 5), and Cerro Palenque. Recent reports indicate that these elements are also found at Ixtinto and La Naya in the northwest Petén (Vilma Fialko, personal communication 1998). Other examples are found at Kaminaljuyu and a few additional sites in the Guatemalan highlands (Cheek 1976, 1977a; Kidder et al. 1946; Shook and Smith 1942). Are all these examples contemporaneous? Do all the elements that constitute Teotihuacan's version of the *talud-tablero* form appear at these sites, or are only certain features present, as is generally the case at Tikal?

The diverse variations of the *talud-tablero* found at Tikal indicate nothing more than the eclectic manner in which the form was used. At that site, the preferred proportion of the *talud-tablero* was 1:1, and it was placed on the front and a portion of the sides of a building. Balustrades, finial blocks, and frames were optional. Other fourth-century sites in Mesoamerica, including some in the Mexican highlands, display a similarly eclectic pattern. At Tepeapulco, Hidalgo, the *talud-tablero* has a size ratio of 1:3 and was used on the fronts and a portion of the sides of structures (Rivera 1984). Similar examples exist at Teotihuacan itself, in buildings on the north, east, and south platforms of the Ciudadela (i.e., Str. 1-R, 1-Q, and 1-P of Platform 1-G). These are formed of two levels of *taludes* and *tableros* that unite on the sides of the structure with a *talud* running to the top (Jarquín 1987; Jarquín and Martínez 1982). Here, the *talud-tablero* has a proportion of 1:1.5, rather close to the most common ratio at Tikal. These were constructed at approximately A.D. 300 within a compound that was built somewhat earlier in time (Cowgill 1979:53–54).

A different pattern, in which the *talud-tablero* was used on all four sides of a building, was preferred at Matacapan, Veracruz (Valenzuela 1945). This pattern also appears in some examples at Kaminaljuyu. At both sites, the *talud-tablero* appears in 1:1 proportions.

These data, in combination with evidence for the local development of the *talud-tablero* in Tikal beginning in the third century, suggest that the form was amply distributed throughout Mesoamerica during the Terminal Preclassic period. The *talud-tablero* came to be used to a greater or lesser degree in different regions, and it was modified to fit the local architectural requirements of each site.

The process of adoption and modification should be observable at Teotihuacan as well. But the Preclassic architecture of the city is not well known, so we know little about the early use of the form at that site. Once local canons for the use of the *talud-tablero* were established in Teotihuacan during the early Early Classic period, the particular expression of the style associated with the city was carried to other regions that form the political or cultural zone of influence of Teotihuacan.

Given the diverse and complex ways in which the style is manifested at Tikal, the argument that the *talud-tablero* was brought directly to that Maya site by groups of Teotihuacanos—instead of being an expression of the long-established cosmopolitan nature of the city—paradoxically reduces the importance of a foreign presence. Following the Teotihuacan-dominance model proposed by some for the Early Classic, an architectural style representative of that city should appear in a subordinate center precisely as it does in the core, and not in a fragmentary manner wherein certain aspects of the form are eliminated and its proportions are altered. Changing the semiotic code that underlies a specific style such as the *talud-tablero* diminishes the importance of the message brought by foreign elites.

An alternative mechanism, therefore, must explain the manipulation of the architectural style at Tikal, one that does not undervalue the importance of foreign and multiethnic groups to the city. This mechanism is rooted in the interaction and movement of iconographic systems, as well as architectural and ceramic styles, that characterize Mesoamerica beginning in the Middle Preclassic period.

This brief review of the use of the *talud-tablero* at Tikal should lead us to question if it is still valid to consider that all examples of the style in Early Classic Mesoamerica are modeled after the version developed at Teotihuacan. More generally, it is unlikely that the aesthetic advances of the Classic period—including experimentation with and adoption of the *talud-tablero* form—were derived from a single intellectual center. It is clear that the Petén was not permanently divorced from the rest of Mesoamerica (Coe 1972). But was interaction unilateral, as some propose? Or did Maya elements form part of this intellectual exchange?

An Early Classic Residential Compound at Tikal

Studies of Maya settlement often are subject to a bias created by the destruction or covering of Early Classic remains by Late Classic structures. The best-preserved example of an Early Classic specialized residential group at Tikal is Group 6C-XVI, which, in its last form, consists of insignificant

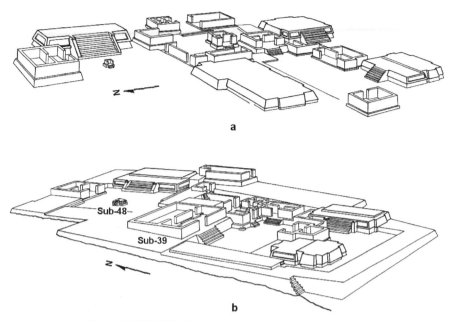

FIGURE 7.3. Group 6C-XVI, Tikal: (a) Construction Stage 3; (b) Construction Stage 8.

habitation platforms (Strs. 6C-51, -52, and -53) dating to the Late Classic. Beneath this occupation is a complex of Early Classic structures that were built and then gradually covered during the third to sixth centuries. Grouped around five patios were numerous small pyramidal platforms as well as larger platforms and palaces containing porticoes, passageways, and vaulted rooms (Figure 7.3).

This type of residential compound should be present at other centers with a strong Early Classic component. At Tikal itself, there should be other areas where specialized architectural groups dating to the Early Classic remain hidden. In order to discover them, the contours and levels of the original surface must be known (Coe 1972:268). But it still seems surprising that Group 6C-XVI was encountered under a flat surface supporting only a few late architectural features. Another important residential complex dating to the Early Classic is Group 6D-V (Iglesias 1987). Despite the proximity of a monumental Preclassic ritual complex such as Mundo Perdido, a lack of evidence for earlier occupation suggests that these Early Classic residential groups occupied new areas around the perimeter of the site.

Why has Group 6C-XVI been associated with Teotihuacan? Once again, the justification lies in superficial resemblances with architectural and artis-

tic features known from that city: Group 6C-XVI consists of multiple inter-communicating patios, the *talud-tablero* form is present in a few of its more than ninety structures, and a controversial sculpture—the Tikal marker—was found in the group.

The simple but functional idea of the residential compound cannot be ascribed to the influence of a single Mesoamerican center. It is true that Early Classic apartment compounds were identified at Teotihuacan a century before superficially similar groups were found at Tikal. But the historical precedence of archaeological discovery does not imply that elaborate residential compounds developed first at the central Mexican city. Apartment compounds were identified at Teotihuacan earlier than at other sites in part because of local topography, in part because the city was not subject to extensive modification after the Early Classic period, and in part because of historical events in the development of Mesoamerican archaeology.

Most of the apartment compounds of Teotihuacan developed between the second and fifth centuries A.D., and there are no known Preclassic examples. Thus, the apartment compounds of Teotihuacan are roughly contemporaneous with the examples from Tikal and from two other sites in the lowlands: Chiapa de Corzo (Lowe et al. 1960) and Piedras Negras (Houston et al. 1999). Similar platform structures and truncated palaces have been found at both of these centers, but their arrangements are open and accessible in comparison to those groups known from Early Classic Tikal and Teotihuacan.

Despite the apparent similarities between the residential compounds of Teotihuacan and Tikal, notable differences exist in their social organization, planning, and, above all, function.

Social Aspects of the Early Classic Residential Compound at Tikal

The concept of the barrio as a level of organization or as a unit of cognatic descent cannot be applied to Tikal as it has been to Teotihuacan (Millon 1981). Nor can significant differences in the status of the occupants of a compound be deduced from variations in building size, construction techniques, or the presence of exotic and local artifacts. Such an argument for internal status differentiation has been made for the Merchants' Barrio of Teotihuacan (Rattray 1987a, 1987b).

Planning of the Early Classic Residential Compound at Tikal

The apartment compounds of Teotihuacan were planned, laid out, and completely built in a single operation. If rebuilt, later layouts seem to replicate earlier ones with relatively minor modifications (Millon 1981:203). The

apartment compounds of Teotihuacan were surrounded and enclosed by high walls. In contrast, the internal evolution of Group 6C-XVI was character-ized by the multiple remodeling and mutilation of nearly all its structures, and by great changes in its overall dimensions (cf. Figures 7.3 and 11.4). The group was occupied continuously for approximately three centuries, during which it was remodeled in at least twenty-two major construction episodes (Laporte 1989).

During the first ten construction phases, structures were grouped around four principal patios, but the original plan was lost as the group continued to expand (Figure 7.3a). Eventually, construction spread to both the east and west (Figure 7.3b). The group as a whole expanded horizontally through a process of accretion and was not confined to a sharply delimited area. Al-though Group 6C-XVI consists of various patios, only one has at its center a small structure that served as an altar. In contrast, this feature is found in most of the large patios at Teotihuacan, which are thought to have served as places where activities organized by the political-religious authorities were conducted (Angulo 1987).

At every stage in its development, Group 6C-XVI contained alternate ac-cess routes with multiple stairs connecting patios and structures, allowing a greater freedom of movement and constituting a more ambiguous access hierarchy than is typical of strictly residential compounds (Hopkins 1987). Moreover, Group 6C-XVI does not contain a central patio like those of Zacuala and the Palace of the Jaguars at Teotihuacan, suggesting that it was not planned around a central space and that it increased around various focal points.

Functional Aspects of the Early Classic
Residential Compound at Tikal

The most important difference from its Teotihuacan counterparts is that Group 6C-XVI does not display the apartment character of the residential compounds of Teotihuacan. Despite the fact that the group was extensively excavated, remains indicative of a densely occupied apartment compound—numerous hearths, middens, and burials—were not discovered. In Teotihua-can, multiple burials are present in residential groups (Millon 1981). In con-trast, there are only a few Early Classic burials in Group 6C-XVI. These are intrusive tombs dating to the Manik 3A and 3B phases (A.D. 378–550), whose offerings indicate the high status of their occupants. In the Late Clas-sic period, burials were more common, but unrelated to the earlier occupa-tion or function of the group.

FIGURE 7.4. Group 6C-XVI Sub-21 mural depicting the ballgame (after Laporte and Fialko 1990:Figure 3.18; courtesy of the University of New Mexico Press).

In addition to the platforms that were present in all the construction stages of Group 6C-XVI, palace structures developed in the group and became more complex with the passage of time. The palaces of the initial occupational stages (Manik 2 phase) have one or two rooms with wide doorways. Buildings that date to the later Manik 3 phase tend to be larger and have three doorways opening into one, two, or three rooms.

Because there are no elements within the compound that indicate aspects of residence, kinship, or production, it is necessary to identify other attributes that define the function of the group, at least for some moment in its long history before it became hidden not only to us but also to the Late Classic inhabitants of Tikal. Those attributes are related to the ballgame, most probably to preparation and initiation rituals, training in the particularities of the game, and other events that were not for public view. The severe and austere qualities of the group suggest that it may have been a kind of Spartan academy for ballplayers.

A ballcourt was not found in Group 6C-XVI, but other elements link the group to the game. One such feature is a mural that decorates the front of a palace platform built early in the second construction phase of the group at about A.D. 370 (Figure 7.4). The upper portion of the mural is damaged, but remaining fragments display a player in action facing a black ball that contains a hieroglyph (possibly *muwan*) that could be related to death or the underworld (Schele and Miller 1986).

Later in the fourth century, a palace platform built in the seventh con-

struction stage was painted with a mural consisting of two sections separated by a stair (Figure 7.5a). The steps, five in total, have three vertical panels painted in red and black. The images on the risers are geometric and hieroglyphic elements that possibly are associated with some blood ritual.

The west section of the mural displays a sequence of three individuals shown in profile, their bearing conveys movement, and they wear or carry items that generally are ascribed to ballplayers. These include skirts with trilobe elements, kneepads, face masks, and bloodletters (Figure 7.5b).

The east section of the mural is badly preserved, but the lower legs of five individuals are still visible (Figure 7.5c). Compared to the west section, the most notable differences are the smaller size of the individuals and the colors with which they are portrayed. Individual 2 (second from west end of the fragment) is the only one that has legs painted in black. The lower section of his skirt and a kneepad on his left leg bear the *ajaw* glyph. An additional element on Individual 3 (third from west) can be identified as a medallion worn on the back of the belt. This element is present on other figures at Kaminaljuyu, Monte Albán, Teotihuacan, and El Tajín (Clancy 1979:15). At those sites, individuals wearing the medallion are interpreted as priests rather than ballplayers (Pasztory 1976:12).

This combination of figures in a single mural is baffling and seems to be a syncretistic representation of Maya ballplayers and other individuals who may be foreigners. Could the individuals of smaller stature be ballplayers rather than priests or merchants? The answer is unknown.

In addition to these two murals and a few more on other structures, another object associates the group with the ballgame. Before covering the North Patio of Group 6C-XVI during the twelfth construction stage (dated to A.D. 450–460), a dedicatory offering was placed inside altar Sub-48. It consists of a *Spondylus* shell, an anthropomorphic head modeled in stucco —apparently removed from a wall destroyed during construction—and a carved monument (Figure 7.6). Before deposition, the last may have been mounted above the upper platform in the North Patio as a dynastic monument. This sculpture is known as the Tikal marker and has been described in detail in other publications (Fialko 1988a; Laporte and Fialko 1990).

The marker, measuring 1 m in length, was carved from compact limestone. It has a composite silhouette: the upper part forms an oval, the middle section consists of a subspherical portion and a truncated cone, and the lower portion is cylindrical in form. Both sides of the upper section are carved with feather motifs. The center of Side A consists of a medallion or oval, which contains a glyphic expression that is a stylized representation of Tlaloc. In

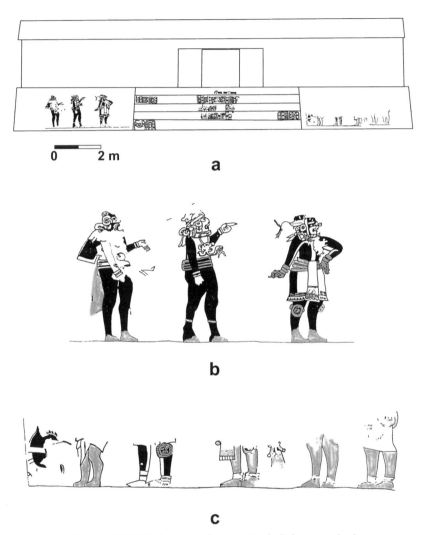

FIGURE 7.5. Group 6C-XVI Sub-39 mural portraying ballplayers and other individuals: (a) position of mural on platform and stair; (b) west fragment; (c) east fragment.

the center of Side B is a bird shown in profile (Figure 7.6b). It has a trilobe-shaped eye. Superimposed over the profile of the bird is a left hand holding an atlatl.[1] In the middle section, the subspherical portion contains four ovals. Side B shows in deeper relief the faces of two individuals with foreign headdresses. They are united by an earflare and sport butterfly nosepieces. Below the pair is a sign consisting of a double trapezoid sign and a bundle (Figure 7.6b). It probably is a variant of the Mexican year sign. Both sides

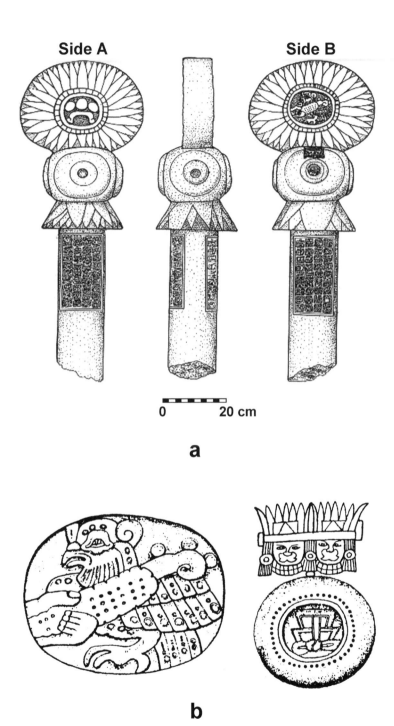

FIGURE 7.6. The Tikal marker, recovered from Group 6C-XVI: (a) three views of marker; (b) details of elements on Side B.

of the lower section include an integrated panel of thirty-six hieroglyphs divided into four columns of nine blocks. The inscription of the marker contains various dates, including A.D. 416 (the date of erection) and the critical date of 11 Eb' 15 Mak (A.D. 378), mentioned in various monuments of Tikal and Uaxactun.

Both the peculiar form and some of the designs on the upper sections of the piece have been subjects of multiple interpretations. But the Tikal marker clearly is related to two other monuments from Teotihuacan and Kaminaljuyu. The distribution of this otherwise unique form suggests a trilateral relationship among the sites.[2] Without considering when and how each of the three sculptures was discovered, we should ask: Which was the first site to design a marker of this type? Unfortunately, the Tikal marker is the only one that is well dated, not only because of its hieroglyphic inscription, but also because of the type of excavation that was carried out in Group 6C-XVI.

Conclusions

Although the origin of the triangular relationship between Tikal, Teotihuacan, and Kaminaljuyu is unknown, it is clear that the old concept of unidirectional "influence" is inoperative. We are left with the much better notion of multidirectional interaction—mutual relationships among people, objects, or phenomena—manifested in the sculptural and architectural styles, iconographic elements, and artifacts that were exchanged in various directions. This is a feature characteristic of Early Classic Mesoamerica (Santley 1983; see Chapter 10).

It is the objects rather than the ideas subject to mutual exchange that are most evident to the archaeologist. Compared to the frantic growth that characterized Tikal during the Late and Terminal Preclassic, the controversial Early Classic was a period of architectural splendor and innovation and also a time of magnificence and wealth expressed in the acquisition of prestige artifacts. Although this activity appears to be closely tied to the elite of the site epicenter, the truth is that we know little about life in peripheral areas, except for the few elaborate groups that have been excavated (e.g., Groups 6C-XVI and 6D-V). It is evident that many of the inhabitants of these groups had access to what we consider to be luxury goods (Chapter 6).

As is true for many other sites dating to before, during, or after the Early Classic, objects from Teotihuacan are present in the material assemblage of Tikal. In addition, people who came from the Mexican highlands could have lived in cosmopolitan cities like Tikal. A mutual interaction model suggests that the same should be true for Teotihuacan. Nonetheless, despite the fact

that a Maya stylistic presence has been widely noted in the art and ceramics of Teotihuacan, indications of the physical presence of Maya in the city are both ambiguous and tenuous (Chapter 11; Linné 1934; C. Millon 1973; Rattray 1987a, 1987b).

For a number of years—but without hearing a single echo—I have maintained that the ideological impact of cultural interaction may be seen in at least one facet of this complex relationship. The Ciudadela is an architectural group situated at the epicenter of Teotihuacan. The heart of the complex consists of two structural and functional elements: a western pyramid (the Feathered Serpent Pyramid) and an eastern platform that supports three structures. These components form what in the Maya region is called an E-group (Chase and Chase 1995; Rathje et al. 1978; Ruppert 1940), an astronomical observatory (Aveni and Hartung 1989), a public ritual complex (Cohodas 1985; Laporte 1996), or an astronomical commemoration complex (Fialko 1988b).[3] This characteristically Maya architectural pattern first appeared in the lowlands during the Middle Preclassic period and is represented at El Mirador, Nakbe, Uaxactun, Tikal, and many other sites. Because the architectural and ritual form is so widely spread in the lowlands of the Petén and Belize, we cannot conclude that its appearance in the Mexican highlands is a result of a direct and exclusive relationship with Tikal. Nevertheless, the form of the Ciudadela does demonstrate the multidirectional nature of interaction between Teotihuacan and the Maya.

I am aware of the evolutionary complexity of the Ciudadela, but my intention is to do no more than draw attention to the presence of a foreign pattern at the center of Teotihuacan, in a group that is often considered to have been a political or religious nexus of the city during a specific period in its long history. Although there may be undiscovered versions of some of the structures that form the Ciudadela, for now the earliest construction episode is dated to c. A.D. 200–250 (Cabrera 1998a, 2000; Cowgill 1983, 1998; Sugiyama 1996, 1998a), considerably later than the development of this type of complex in the Maya area, but coincident with the appearance of the first examples of the *talud-tablero* at Tikal.

It is interesting to return to the cultural triangle that also includes Kaminaljuyu. This center shares all the aspects of interaction described here but one: the architectural plan of Mundo Perdido that I consider also to be present in the Ciudadela. Although recent destruction of Kaminaljuyu impedes the discovery and direct investigation of such a group, plans of the ancient city depict a series of mounds (C-III-5, C-IV-7, C-IV-9, and D-III-7) in the section called Quinta Samayoa that may have formed an E-group.

During the Early Classic period, people from different parts of Meso-america exchanged ideas and goods to their mutual benefit, retaining at the same time their distinct regional identities (Parsons 1967–1969). This inter-action promoted a high degree of architectural and artistic innovation and led to the development of eclectic styles and iconographic syncretism (Pasz-tory 1978a). What is important to know now is when this process began and why certain ideas that entered the lowlands during the Early Classic period continued to be part of the Maya cultural tradition following the decline of Teotihuacan.

Notes

1. This enigmatic figure may be an example of the *lechuza y armas* symbol from Teotihuacan. Hasso von Winning (1987, 1:90) interprets it as representing a military association or as some sort of heraldic sign. Linda Schele and David A. Freidel (1990:156–157, 449–450) and Nikolai Grube and Linda Schele (1994) interpret the symbol as a title linked to Tlaloc-Venus warfare. The complementary pairing of the owl-atlatl with the glyphic image of Tlaloc on the Tikal marker seems to support both of these identifications. Alternatively, David Stuart (2000a:481–487) proposes that the *lechuza y armas* at Teotihuacan and the owl-atlatl combination at Tikal are name glyphs for a powerful ruler of Teotihuacan.

2. The Teotihuacan example also evinces ties to the Gulf Coast, perhaps indicating a fourth partner in this relationship.

3. Editor's note: As this book came into production, explicit reference to and ac-ceptance of the identification of the Ciudadela as an E-group was made by Rubén Cabrera (2000). See also Rubén B. Morante (1996), who interprets the radial plat-form Str. 1C, located in front and west of the Feathered Serpent Pyramid, as the ob-servation locus of the group.

Images of Power and the Power of Images: Early Classic Iconographic Programs of the Carved Monuments of Tikal

James Borowicz

A t the dawn of the Early Classic period, inhabitants of the Maya lowlands began to carve and erect stelae.[1] For some of these sites, the appearance of carved monuments corresponded with the establishment of dynastic rule, a new political order that required innovative forms of public propaganda. Carved stelae answered this need.

The most basic function of these monuments was to glorify individual rulers. Stelae were public proclamations of the importance of the ruler to the community. Clothing themselves in costumes reflecting wealth and prestige, and manipulating symbols of military and sacred power, rulers depicted themselves in service to the polity (Laporte and Fialko 1990:33; Schele and Miller 1986:66). These monuments also were a means of documenting bloodlines and venerating ancestors (McAnany 1995:40).

The iconographic programs developed for these early stelae appropriated elements not only from earlier lowland Maya architectural sculpture (Freidel and Schele 1988b:62) but also from the carved monument traditions of the Maya highlands and Pacific Coast. This foreign imagery was modified for use in a lowland idiom in ways that met the specialized needs of local rulers. At the same time, autochthonous elements of the program continued to evolve.

Once an iconographic program was established as a means of disseminating propaganda, the consistent use of its symbols and images maximized its effectiveness. The clarity of the message relied on its images being constant and unambiguous. Changing an iconographic program risked losing established meanings and jeopardized the communicative power of the stela image.

But changes to iconographic programs did occur at several Early Classic lowland sites. These changes were responses to sociopolitical develop-

ments that earlier iconographic programs were ill equipped to handle. New or altered iconographic elements were developed by rulers as their roles were redefined in changing sociopolitical climates. We gain insight into the dynamics of lowland Maya political systems by examining the changing iconographic programs of carved monuments.

Tikal as a Case Study

The wealth of data generated by extensive excavations at Tikal and by analyses of the substantial corpus of carved monuments from the site make it an ideal case study. During the Preclassic, structures with stuccoed and painted façades were built around large plazas in both the North Acropolis and the Mundo Perdido complex, indicating that both were well-developed ceremonial/ritual precincts with distinct functions (Coe 1990; Jones 1991; Laporte and Fialko 1990, 1995). The stucco images on these structures are related to those from other lowland sites and may indicate the crystallization of a lowland religious phenomenon mediated by the growing elite (Freidel and Schele 1988a; Mathews 1985). The great quantity of stucco sculpture at Preclassic Tikal provided Early Classic monument carvers with an abundant source of symbols and images.

The idea of individual rulership within a dynastic framework coalesced at Tikal during the second century A.D. (Freidel 1990; Schele and Freidel 1990:140). The right to hold the highest office may have been reserved for an individual from a specific lineage that achieved dominance through its control of rituals associated with specific ceremonial precincts (Haviland 1992; Laporte and Fialko 1990:35; Pohl and Pohl 1994).

The appearance of individual rule required new forms of public imagery because existing methods of displaying iconographic programs in architectural contexts were too impersonal, largely anonymous, and limited in many ways. Therefore, Early Classic rulers drew upon the preexisting stone-carving tradition of Preclassic Tikal and combined it with elements of the highland Maya and Pacific Coast traditions, yielding the first iconographic program employed on Early Classic stelae.

The stela format was ideal for public propaganda because it was more flexible, personal, communicative, and mobile. Like façade sculpture, stelae could be associated with architectural space, connecting rulers to specific monumental structures or ceremonial plazas. The portable nature of stelae allowed them to be set and reset in a variety of locales, conveying different messages. Moreover, unlike architectural sculpture, stelae could survive numerous construction episodes. The appearance of text in association with

imagery also allowed for more complex concepts to be conveyed in a rather economical fashion.

Through costume elements and texts, the individual ruler emerged from anonymity. He could depict himself in elaborate raiment displaying exotic wealth obtained through resource control (Hendon 1991). In addition, his communal importance could be shown by displaying the performance of social, political, or cosmological roles in service to the polity (Fash and Fash 1996:135). These advantages led to stelae becoming one of the most effective means for lowland rulers to convey public propaganda.

Stela 29 and the First Iconographic Program (A.D. 292–378)

Stela 29, the earliest surviving stela at Tikal, represents an already mature iconographic program (Figure 8.1a). Fragments of carved stone found in Preclassic contexts indicate that a sculptural tradition was established at Tikal prior to Stela 29 (Coe 1990, 3:789). Painted figures from tomb walls of Burial 166 and on the exterior of Str. 5D-Sub. 10-1st demonstrate that a figural tradition also predated Stela 29 (Coe 1990, 2:229, 237–238, Figures 32 and 34–35). Yet neither the sculptural nor the painting tradition led directly to the mature iconographic program of this monument.

To make use of stelae, the elite had to develop an iconographic program that conveyed their propaganda efficiently in a format smaller than that provided by architectural sculpture. The symbols employed in the monuments had to be understood by the audience in their new context. One natural source of imagery was the iconographic program designed for earlier architectural sculpture. These large-format mask images were appropriated and translated into elements of apparel and paraphernalia worn and held by the ruler (Schele and Miller 1986:27).

The trilobe form of the Jester God appearing on the headdress of the protagonist of Stela 29 and associated with Preclassic and Early Classic rulership is found in architectural contexts throughout the lowlands and at Tikal on the greenstone mask from Burial 85 (Coe 1990, 2:219). The influence of architectural sculpture on the earflare assemblage of Stela 29 is apparent as well. This is yet another example of the process of adopting elements—including the bicephalic serpent bar and masks (Freidel and Schele 1988b)—from architectural contexts for use in stela iconography.

Much of the imagery on Stelae 29 and 39 (Figure 8.1b) was adopted from the carved monument traditions of regions outside the lowlands, particularly the highlands and Pacific Coast of Guatemala. The floating figure (which

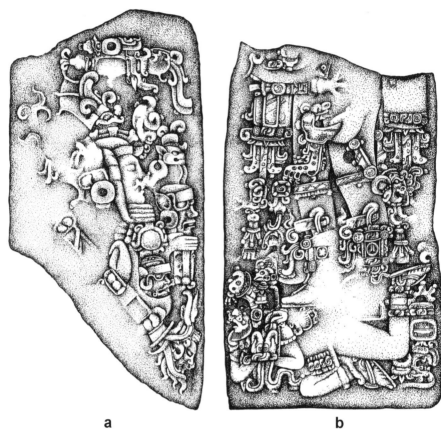

FIGURE 8.1. The first iconographic program: (a) Tikal Stela 29; (b) Tikal Stela 39 (illustration by the author).

gazes down from heaven upon the principal figure) and the bicephalic serpent bar on Stela 29, and the belt with head and pendants on both monuments, appear in the iconographic programs of a number of sites outside the Maya lowlands. The translation of these elements into a Maya symbol system was aided by the fact that they were costume elements worn while participating in public ceremonies. Their symbolic value thus was reinforced by use in public performance contexts.

The nature of the floating figures that appear on Abaj Takalik Stela 2, El Baúl Stela 1, Izapa Stela 4, and Kaminaljuyu Stela 11 (Figure 8.2) cannot be determined with confidence, yet their relationship to the "floater" on Stela 29 is undeniable. At Tikal this image was adapted to serve a crucial role in the first iconographic program. With dynastic rule came the need to legitimize oneself through celebrating ancestry. The floating head of a previously

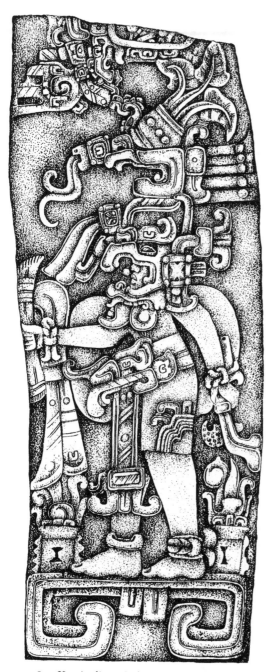

FIGURE 8.2. Kaminaljuyu Stela 11 (illustration by the author).

deceased ruler thus acknowledges his successor and at the same time is venerated by him. On Stela 29, the name of this ancestor appears in his headdress and is very similar to that of the later protagonist of Stela 39, suggesting that repeated use of a royal ancestral name was another way to emphasize legitimacy.

The ruler depicted on Stela 29 performs a ritual while wearing a headdress that connects him to rulership through the Jester God symbol and a reference to the Young Maize God (Freidel 1990:71; Schele and Mathews 1998:78; Taube 1985). He is personified as the god K'awiil by having a smoking celt in his forehead. He holds and wears images of God III of the Palenque Triad, the Bearded Jaguar God of the Night Sun (Schele and Miller 1986:50), and interacts with a deified ancestor floating above him. The arsenal of deities invoked in Stela 29 is essential in defining the public imagery of the first iconographic program at Tikal. Another critical element of the first program—military dominance expressed by a subdued and bound captive—is found on Stela 39, but is not preserved in the upper portion of Stela 29.

The imagery of the first iconographic program places the ruler within a ritual or ceremonial context that extended throughout much of Mesoamerica over a long period of time. The elite of Tikal employed symbols common to the highland Maya and Pacific Coast cultures, as well as others that appeared as far away as Monte Albán. The manipulation of symbols and their associated ideology may have been an important factor in the increased control gained by the elite over the population at large (Joyce and Winter 1996), and the rulers of Tikal probably used their stelae to that end.

Stela 4 and the Second Iconographic Program (A.D. 378–445)

When an existing iconographic program was insufficient or ineffective, the flexibility of the stela medium allowed rulers to alter the image in order to present different information. Such iconographic changes were driven not by aesthetic concerns but by political, social, and religious motivations (Nagao 1989). For this reason, stelae convey information that provides insight into the dynamics of sociopolitical change.

The first change of iconographic program at Tikal was initiated by Yaax Nu'n Ahyiin ("Curl Nose") with the erection of Stela 4 in A.D. 379 (Figure 8.3a). The iconographic program of this stela was markedly different from that of earlier monuments and carvings from Tikal, including Stelae 29, 36, 39, and possibly the Leyden Plaque.

The frontal treatment of the face and the proportions of the body are un-

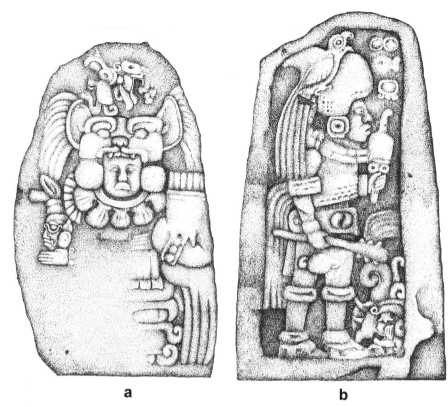

a **b**

FIGURE 8.3. The second iconographic program: (a) Tikal Stela 4; (b) Uaxactun Stela 5 (illustration by the author).

usual in the stelae of Tikal. The only other examples with this frontal posture are Stela 18 and 32, which also conform to the canons of the second iconographic program.[2] The dominant feature of the image is the feline headdress that takes up nearly one-third of the area of Stela 4. This headdress is unlike anything that previously appeared at Tikal. A similar headdress is found at Monte Albán on the Estela Lisa and appears in later mural images at Teotihuacan, sometimes in conjunction with *Pecten* shell necklaces (Kubler 1967:Figures 18, 20, 27, and 45). Felines with panaches emanating from their ears are found not only in the Stela 4 headdress but also in Teotihuacan murals beginning in the Tlamimilolpa phase (c. A.D. 230–370). Much of this imagery at Teotihuacan has military connotations.

The tail bundles of Stela 4 also appear on Uaxactun Stela 5 (Figure 8.3b) and on the sides of Tikal Stela 31 (Figure 8.4a,c). In both cases, the individuals clearly are warriors. Despite Flora S. Clancy's (1999:69) interpretation that Yaax Nu'n Ahyiin does not proclaim himself a warrior in Stela 4, he

prominently displays the apparel that constitutes the uniform of a Teotihuacan warrior.

The floating figure above Yaax Nu'n Ahyiin in Stela 4 cannot be identified as a human ancestor. With the smoking celt of the god K'awiil in its forehead, this long-lipped deity looking down from above shares features with the headdress of the floating figure in Abaj Takalik Stela 2. The use of a supernatural being suggests that Yaax Nu'n Ahyiin's intentions differ from those of the Stelae 29 and 31 protagonists.

Other components of Stela 4 that are from the first iconographic program are limited to the small head held in Yaax Nu'n Ahyiin's outstretched hand and one aspect of his posture. The handheld God III head relates the image to ceremonial behavior depicted in Stelae 29 and 36. The seated posture also is seen in Stela 36. These are the only concessions to the earlier program.

In Stela 4, Yaax Nu'n Ahyiin chooses to depict himself in the uniform of a foreign warrior, a uniform that appears predominantly in association with individuals surmised to be from Teotihuacan. He eschews martial elements from the first iconographic program at Tikal, including the bound captives and weapons seen on Stela 39. These traditional martial elements could not transmit the necessary information Yaax Nu'n Ahyiin sought to convey in order to legitimize his reign.

The use of foreign motifs, in this case a Teotihuacan-style military uniform, may be seen as a means of emulation—a form of visual name-dropping (Nagao 1989). By linking himself to a powerful foreign entity and "disconnecting" himself from his peers (Stone 1989), Yaax Nu'n Ahyiin may have been able to overcome the fact that he was outside the traditional line of succession. But this does not necessarily imply that he was a foreigner, which David Stuart (2000a) and others have argued from hieroglyphic texts.

Whatever the exact nature of the change in the political fabric, it was heralded by this second iconographic program not only at Tikal, but also at probable vassal sites such as Uaxactun, El Zapote, and Río Azul (Adams 1999:15; Culbert 1991:130; Schele and Freidel 1990:140). The expansionist tendencies of Tikal at this time may indicate an increased importance accorded to military factions within the polity.

Group 6C-XVI figured prominently in the events of this period and may have been the locale of one such military faction. Connected by the Tikal marker text and by murals (Chapter 7) to foreign individuals and military events, its occupants played a role in defining the political reality of the fourth–fifth centuries. The group was also associated with initiation rituals and training for the ballgame (Chapter 7; Laporte and Fialko 1990:57). The

expansion of Group 6C-XVI and its military and ballgame associations indicate the growing importance of the people housed there, as well as the arrival of the ballgame at Tikal. The construction of a ballcourt in the Great Plaza at this time marks the new importance of the game in the central ceremonial landscape (Coe 1990, 2:650; Jones 1991:111).

Evidence of interaction with Teotihuacan appears in a variety of contexts and locations at Tikal. The North Acropolis problematical deposits and burials have material related to Teotihuacan (Coe 1990, 2:324–327; Coggins 1975:146; Culbert 1993), but connections with that central Mexican city are also found in Groups 6D-V and 6C-XVI (Chapters 6 and 7; Iglesias 1987). The military and ballgame connotations of Teotihuacan artifacts and imagery at Tikal seem consistent with some sort of a Teotihuacan impact on Group 6C-XVI. Curiously, as María Josefa Iglesias and Juan Pedro Laporte (Chapters 6 and 7, respectively) point out, the actual quantity of imported or copied central Mexican goods is quite limited. We can say with confidence that the inhabitants of Group 6C-XVI were inspired by their counterparts at Teotihuacan, but little more.

Like Tikal, sites such as Copán, El Tajín, Monte Albán, and possibly Kaminaljuyu expressed a connection with Teotihuacan that coincides with a florescence of the ballgame (Fash et al. 1992:108; Miller 1995; Parsons 1991:195; Taube 1986:54; Wilkerson 1991).[3] At Monte Albán, the ballgame may have been linked to the growth of specialized military institutions formed in the context of expanding regional states (Kowalewski et al. 1991:42). The same process may have occurred at Tikal. A military faction associated with Group 6C-XVI and the ballgame could have assumed greater importance as a result of expansionist policies. The exploitation of Teotihuacan elements—including weapons, clothing, tactics, and deities—by such a faction may have led to the adoption of a foreign ideology as well as new iconography (Cowgill 1997:146).

To speculate further, the faction housed in Group 6C-XVI might have competed with the group described by Juan Pedro Laporte and Vilma Fialko (1990:35) as the Jaguar Paw lineage of Mundo Perdido. Aided by the expansionist policies of late-fourth-century Tikal, Yaax Nu'n Ahyiin, who was not a member of the Jaguar Paw group, came to power in part because of the rising importance of the Teotihuacan-affiliated military/ballgame cult. Association with this cult shaped the public propaganda of Yaax Nu'n Ahyiin and led to his abandonment of the first iconographic program. Like his predecessors, Yaax Nu'n Ahyiin made extensive use of foreign imagery in his new iconographic program. But the dominant donor of imagery to the sec-

ond program was Teotihuacan rather than the cultures of the Maya highlands and Pacific lowlands of Guatemala. In making this change of one foreign influence for another, Yaax Nu'n Ahyiin rejected the traditional package of deities linked to the cyclical passage of time, agriculture, and the sun in favor of nonlocal military imagery.

Stela 31 and the Return to the First Iconographic Program (A.D. 445–456)

Some time after Siyaj Chan K'awiil ("Stormy Sky") became ruler in A.D. 426, he abandoned the iconographic program of his father and returned to the first stela tradition of Tikal. The abandoned program of Yaax Nu'n Ahyiin was never revived to any great extent.

The front image of Stela 31 (Figure 8.4b) and the other stelae associated with Siyaj Chan K'awiil (Stelae 1, 2, and possibly 28) consistently follow the old canons. The floating figure on Stela 31 wears the name glyph of Yaax Nu'n Ahyiin in his headdress. He is an individual, rather than the floating abstraction depicted on Stela 4. Moreover, the floating image of Yaax Nu'n Ahyiin on Stela 31 is rendered nearly identically to that of the floating figure of Abaj Takalik Stela 2, reestablishing old connections with the same foreign traditions seen in the first program.

Siyaj Chan K'awiil wears a close-fitting cap with a crest of bones similar to that worn by the protagonist of Stela 29, carved more than 125 years earlier. Above Siyaj Chan K'awiil's cap is his name glyph, with appended jaguar and maize god imagery common in the first, but de-emphasized in the second, iconographic program. The back of his headdress carries a reference to the possible founder of the Tikal dynasty, Yaax Ehb' Xook. At the front of the headdress is a reference to the Jester God. Everything about his headdress connects Siyaj Chan K'awiil to his ancestors, the old Tikal dynasty, and traditional deities that legitimize rulership. The artist's attention to costume details such as the pectoral collar and the belt with head and celt assemblage leaves no doubt that the viewer is to recall the image of the great leader of the past depicted on Stela 29. The head in the crook of Siyaj Chan K'awiil's arm, though more elaborate, serves the same function as the heads proffered in outstretched hands on Stelae 29 and 4.

A key difference between Stela 31 and Stela 29 is the replacement of the serpent bar by an upraised headdress. Here Siyaj Chan K'awiil tells us that the theme of his image has a military nature. The upraised headdress shares many characteristics with that worn by the warrior protagonist of Kaminaljuyu Stela 11 (Figure 8.2). Mounted on the Kaminaljuyu-style headdress is

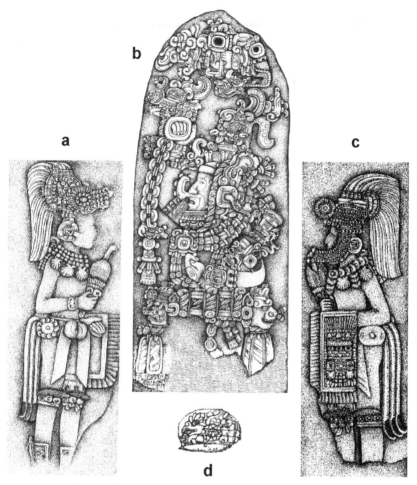

FIGURE 8.4. The reestablishment of the first iconographic program with Tikal Stela 31: (a) right side; (b) central image; (c) left side; (d) detail of medallion in the Kaminaljuyu-style headdress held by Siyaj Chan K'awiil (illustration by the author).

a Teotihuacan war emblem (Figure 8.4d; C. Millon 1988), one of only two small references to Teotihuacan on the front of Stela 31.[4] With the prominent display of a military headdress, Siyaj Chan K'awiil emphasizes his martial role as war leader of the Tikal polity. Another interpretation of this emblem is that it is a variant of the name of the mysterious individual nicknamed "Spear-Thrower Owl." In his interpretation of the events of A.D. 378–379, Stuart (2000a:481–487) posits that "Spear-Thrower Owl" was the father of Yaax Nu'n Ahyiin (and grandfather of Siyaj Chan K'awiil) and the ruler of Teotihuacan during the years A.D. 374–439. Nevertheless, it is important to point out that the bird shown in profile in the headdress emblem is *not* an

owl (perhaps it is an eagle [von Winning 1987, 1:89]), and that it bears a round shield and a spear rather than an atlatl. This second motif appears frequently in the mural art of Teotihuacan, where it is completely distinct from the *lechuza y armas* (owl-and-weapons) emblem (Pasztory 1988c; see also Miller 1973:Figures 361 and 363; von Winning 1987, 1:90). For this reason, it seems highly unlikely to me that the "profile-bird-with-shield-and-spear" emblem on the Stela 31 headdress is a variant of "Spear-Thrower Owl," be it a name (Stuart 2000a), a title (Schele and Freidel 1990), or a general reference to foreigners (Proskouriakoff 1993). A second fragmentary example of the "profile-bird-with-shield-and-spear" motif may appear on Tikal Stela 32, and an unprovenienced Maya earspool also bears the emblem (Stuart 2000a:Figure 15.14f).

The image on the front of Stela 31 recalls that of Stela 29 and is dominated by intricate and detailed pieces of apparel carrying imagery that was part of the first iconographic tradition of Tikal. The borrowed highland Maya and Pacific Coast imagery also has precedents in the first program. Perhaps the most remarkable characteristic of this image is its almost total lack of reference to the Teotihuacan iconographic tradition. Although the two attendant figures on the sides of Stela 31 (Figure 8.4a,c) are dressed in the uniform of Teotihuacan warriors, they are rendered in a Maya style, have Maya proportions, and stand in Maya postures. Their inclusion in this image reinforces the relationship between Yaax Nu'n Ahyiin and Siyaj Chan K'awiil, but in a way that emphasizes the importance of the son and—quite literally—marginalizes the father and his foreign associations.

Siyaj Chan K'awiil made a conscious effort to avoid the use of Teotihuacan imagery on Stela 31 and his other monuments. The revival of the first program reflects an attempt to return to an ideological and political world predating the Teotihuacan references that defined Yaax Nu'n Ahyiin's propaganda.

Stela 40 and the Continued Revival of the Initial Program (A.D. 468)

K'an Ak ("Kan Boar"), the son of Siyaj Chan K'awiil, began his reign in A.D. 458. His first monument was the recently discovered Stela 40 (Figure 8.5), erected on 9.1.13.0.0 6 Ajaw 8 Sotz', June 20, A.D. 468 (Valdés et al. 1997:4). Stela 40 is consciously modeled after Stela 31. K'an Ak, then, continued the tradition revived by his father.

Evidence from Tikal of continuing interaction with Teotihuacan during K'an Ak's reign is minimal. There is little in the way of Teotihuacan im-

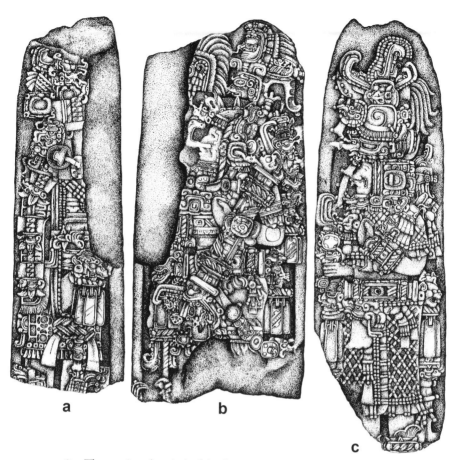

FIGURE 8.5. The continued revival of the first iconographic program with Tikal Stela 40: (a) right side; (b) central image; (c) left side (illustration by the author).

ports, and the ceramics of this period (the Manik 3A/3B transition) are markedly lacking in foreign motifs (Clancy 1980). In addition, the once expansive Group 6C-XVI, with its *talud-tablero* structures and foreign imagery, was decommissioned at about this time (Iglesias 1987).

The public sculpture of K'an Ak is nearly devoid of central Mexican references. Stela 40 shows him in a posture identical to that of Siyaj Chan K'awiil on Stela 31 (Figure 8.5b). Like Stela 31, the central image of Stela 40 is accompanied by attendant figures on the sides of the monuments (Figure 8.5a,c), but Stela 40 lacks a floating ancestral figure. Another important difference is that a serpent bar, rather than a God III head, is held in the crook of K'an Ak's left arm. By displaying a serpent bar, K'an Ak adds an element of the first iconographic program that is absent from Stela 31. The God III head

is not missing from Stela 40, but has been moved to the mouth of the serpent bar. Although the upraised headdress held in K'an Ak's right hand does not survive in its entirety, it clearly is not the headdress held by Siyaj Chan K'awiil on Stela 31. Instead, it is a feline mosaic headdress with a feather panache, possibly the only reference to central Mexican imagery on the front of Stela 40. The damaged headdress on Stela 40 may be an allusion to Yaax Nu'n Ahyiin. It closely resembles those worn by the earlier ruler on the right side of Stela 31 and on Stela 4. Thus, if Stuart (2000a) is correct in his interpretation of the emblem on the upheld headdress of Stela 31, the holding of a grandfather's headdress is another parallel in the iconography of Stelae 31 and 40 (Geoffrey Braswell, personal communication 2000).

The side figures differ from those of Stela 31 in that they are not dressed in the garb of Teotihuacan warriors, and military imagery in general is lacking. The figure on the right side of the stela is labeled as Siyaj Chan K'awiil by an image of the god K'awiil in his headdress (Figure 8.5a; Valdés et al. 1997:37). The figure to the left also appears to be Siyaj Chan K'awiil (Figure 8.5c). The belt worn by this individual is identical to that worn by Siyaj Chan K'awiil on Stela 31. The net skirt is worn by Siyaj Chan K'awiil on Stela 1. The headdress is that worn by the protagonist of Stela 2, which also is attributed to Siyaj Chan K'awiil. Thus, the figure on the left side of Stela 40 wears a composite of the costumes worn by Siyaj Chan K'awiil on his monuments. Stela 40, then, mimics the format of Stela 31 by portraying a ruler flanked on both sides by images of his father.[5]

Stela 9 and the Third Iconographic Program (A.D. 475–517)

Seven years after the erection of Stela 40, K'an Ak abandoned the iconographic program he inherited from his father and adopted a radically different program. Stela 9 (Figure 8.6a), the first dated monument to employ this third iconographic program, was erected on 9.2.0.0.0 4 Ajaw 13 Wo (A.D. 475). Along with Stela 13 (Figure 8.6b), also associated with K'an Ak, Stela 9 focuses on a set of behaviors performed in conjunction with the marking of cyclical periods of time. K'an Ak erected stelae to commemorate his participation in rituals associated with *k'atun* endings and half *k'atun* observances.

The image is restricted to the front of the stela in the third iconographic program. Brief texts replace the side images found on Stelae 31 and 40, as well as other earlier monuments. The stelae of this period tend to be smaller and have shorter texts than their predecessors, but they maintain some con-

a **b**

FIGURE 8.6. The third iconographic program: (a) Tikal Stela 9; (b) Tikal Stela 13 (illustration by the author).

tinuity in iconography. By employing costume elements from earlier stelae, K'an Ak adapted some of the older iconographic elements for use in a new context.

The headdress of Stela 9 is related to that worn by the figure on the left side of Stela 40, as is the collar and pectoral head. The cape and skirt are variations on a theme from the right side of Stela 40. The mat element above

the head and celt assemblage of Stela 9 appears below the same assemblage on the right side of Stela 40, and the apron is related to that of Stela 1. The costume elements of Stela 9 serve as a transition from the previous program to all the later "staff" stelae.

The staff and the pouch that appear in Stela 13 distinguish this series of monuments from all previous stelae at Tikal. Eight Early Classic monuments at the site depict a figure with a vertically held staff, and at least four of these also have handheld pouches. Not one of the images makes use of the floating ancestral figure, and none displays a bound prisoner. Similarly, the Jester God, K'awiil, the handheld image of God III, and the serpent bar are all absent. In several cases, the head with three pendant celts is removed from the rear of the belt and placed on an elaborate backrack. Just as Siyaj Chan K'awiil distanced his public propaganda from that of Yaax Nu'n Ahyiin, K'an Ak consciously established a new program that eliminated many of the key elements of the iconographic program revived by his father.

The new staff-holding images that appear at Tikal at this time are related to the earlier El Zapote Stela 4 (Clancy 1999:Figure 24) and distantly to images from both Monte Albán and Teotihuacan. The earlier influences of the highland Maya and Pacific Coast traditions on the public monuments of Tikal all but disappear after A.D. 475. Nevertheless, the elements of the third program seem to be derived from a broader Mesoamerican iconographic tradition.

This broader tradition provided K'an Ak with a set of motifs from which he constructed an iconographic program focusing on period-ending observances. Elements of previous traditions made their way into this imagery, but the new program was defined by elements never before depicted in the public art of Tikal: the vertically held staff and pouch. By prominently displaying this equipment, K'an Ak redefined his role in the community.

Conclusions

The importance of the stela as a form of public propaganda is evident at all stages of its use. The placement of stelae in public ritual space suggests that they remained active participants in the ritual life of the polity throughout their long existence. The ritual interment, destruction, and defacement of monuments indicate that these images were embodiments of power that survived beyond the life spans of the rulers who sponsored them. These were images of power that truly demonstrate the power of images.

Stelae successfully conveyed propaganda to the people. It is unlikely that a system that optimally disseminated information to an audience would be

altered by a ruler unless he was compelled by necessity. Since stelae were carved and erected with the express purpose of reinforcing the importance of rulership, the most likely forces of change would be sociopolitical in nature.

The first shift of iconographic programs at Tikal accompanied a change in the political landscape that is indicated by epigraphic evidence outlined by a number of scholars (Proskouriakoff 1993:8; Schele and Freidel 1990:147; Schele and Mathews 1998:66; Stuart 2000a). Yaax Nu'n Ahyiin's motivation to alter the traditional program came from a variety of sources. Texts indicate that he was outside the expected line of succession. His right to rule rested not in his descent, but in acts and attributes associated with him and his adult supporters. Iconographic reminders of these acts placed before the public in the form of stelae iconography served to reinforce their importance. New association with a vibrant and militaristic foreign polity served to strengthen Yaax Nu'n Ahyiin's political position. The military costume worn by Yaax Nu'n Ahyiin in Stela 4 and various hieroglyphic texts tied him to events that altered the political relationship between Tikal, Uaxactun, and Río Azul.

Replacement of the first iconographic program of Tikal indicates that it no longer functioned efficiently. Revision of the image of the ruler was necessary in order to maintain appropriate and effective public propaganda in the changing political climate. The impetus for using foreign military motifs was embedded in the policies of the state and was consistent with the practice of using nonlocal imagery established centuries before in the first program.

The subsequent return to the initial program seems to indicate the fleeting nature of interaction with Teotihuacan during Yaax Nu'n Ahyiin's reign. The third iconographic program, established by K'an Ak, also reflects the inability of the previous programs to meet the needs of a ruler in a new political environment. During his reign, military imagery and ancestor veneration were suppressed in favor of depictions of rituals related to the passage of time.

Barbara W. Fash's (1992:101) work on the architectural sculpture of Late Classic Copán suggests that rulers of that polity instituted similar solutions to the problems of communicating public propaganda. She interprets the iconographic themes depicted in façade sculpture during the reigns of Waxaklajuun Ub'aah K'awiil and his successor as stressing fertility and cosmological concerns. These subjects were replaced by militaristic themes during the reigns of the last two kings of Copán, possibly for political reasons.

Like the architectural sculpture of Copán, the stela iconography of Tikal was sensitive to changes in the political climate. The iconography of carved

monuments reflects the need of the ruler to reinvent his public image. Adherence to a traditional program, though advantageous during eras of stability, proved debilitating in times when rulership was redefined. For these reasons, the iconographic programs of periods of change are the most informative and their study the most fruitful.

Notes

1. In recent years, Preclassic monuments have been discovered at sites like El Mirador and Nakbe. Although their general form and manner of erection are similar to those of later Classic-period stelae, their content is not.

2. The fragmentary Stela 18 displays Yaax Nu'n Ahyiin in a seated position very similar to that of Stela 4. It is assumed that the head, which is missing, also faced forward.

3. There is some controversy surrounding the possible presence of late Early Classic ballcourts at Kaminaljuyu. Members of the Pennsylvania State University Kaminaljuyu Project argue for their existence, but most investigators of both prior and later projects concur that the first *palangana*-style ballcourts of the central Maya highlands date to the Late Classic Amatle phase. The difference of opinion centers on the utility of Ronald K. Wetherington's (1978a) ceramic chronology and the validity of Penn State's obsidian hydration dates.

4. The other is a small badge with a depiction of a quail that is worn on Siyaj Chan K'awiil's left wrist (Barthel 1963; Coggins 1979:266)

5. Juan Antonio Valdés et al. (1997:36) argue that the image on the left side of Stela 40 is Yaax Nu'n Ahyiin. More recently, they have suggested that the individual is the mother of K'an Ak (Federico Fahsen, personal communication 1997). Both identifications are based principally on *glyphic* readings of the small head portrayed in a trilobed cartouche in the headdress, and the net skirt is seen as confirmation that the individual is female. A better *iconographic* interpretation of the small head and its paraphernalia is that it is the Jester God of the Saak Hu'nal headband and complements a representation of K'awiil on the other side of the monument. The two gods often are paired and indicate that the individual is an *ajaw*. The jade pendants hanging from the belt (again, a belt worn by Siyaj Chan K'awiil on Stela 31) also indicate that the wearer is an *ajaw* and not a consort. Finally, the jade skirt and the maize foliage prominently displayed in the headdress are commonly worn by Maya kings and associates them with the young maize god. The skirt does not identify the gender of the wearer as female.

Teotihuacan at Altun Ha: Did It Make a Difference?

David M. Pendergast

For a number of Mesoamericanists, including some Mayanists, the core-periphery view of the ancient world offers notable attractions. In such reconstructions of the past, it is necessary only that one identify the central, productive core in order to commence discussion of the movement of goods, gods, and ideas outward to peripheral recipients. Once one has carried out this exercise, answers to all manner of questions that might otherwise seem unanswerable will begin to emerge before one's eyes. If simplicity is a virtue, it is made into a positive wonder tool by adoption of the navel-of-the-universe perspective. This perspective has engendered and sustained Egyptomania throughout the Western world from the eighteenth century to the present, and the very same view has also played a significant role in the Teotihuacanomania that has gripped a good many Mesoamericanists. The question is, however, quite clearly not whether Teotihuacan was truly central to much of what transpired in Classic-period Mesoamerica, but rather how much power and influence throughout the region the geopolitical position of the city actually underpinned. One part of the answer to that question is provided by examination of archaeological data from what was once seen as the remotest periphery of the southern Maya lowlands, the Caribbean-shore zone that today constitutes the country of Belize.

Artifacts of central Mexican green obsidian occur in small numbers and limited variety in late Early Classic–period contexts at a number of sites in the Maya world (Spence 1996a: Table 1), but the largest assemblages of Teotihuacan obsidian known in this period come from Kaminaljuyu and Tikal (Spence 1996a:25–27). From earlier times only six sites, Nohmul (Hammond, Clark et al. 1985:193; Hammond, Donaghey et al. 1987:280; Hammond, Rose et al. 1987:106), Tikal (Spence 1996a:27), three sites in Pacific Guatemala (Chapter 2), and Altun Ha (Pendergast 1971, 1990:266–270) have yielded artifacts of Pachuca green obsidian, and only Altun Ha has produced a body of material that sheds significant light on the relationship between Teotihuacan and the eastern edge of the southern Maya lowlands.

Part of the difficulty in assessing the significance of the Altun Ha evidence lay, in the years that followed the first reporting of the material (Pendergast 1971), in confusion regarding the relationship between the Teotihuacan material and Maya artifacts in the royal interment that produced the objects (Pendergast 1990:263, 274–275; Pring 1977). The principal problem thirty years ago rested, however, on the view that to adduce evidence of a Teotihuacan connection was, given the unquestionably pivotal role of the great metropolis in every aspect of Mesoamerican life, to provide all the developmental answers for Maya civilization that was required (John Sorensen, personal communication 1972). What I propose here is that one can indeed understand something of the link between Teotihuacan and the southern Maya lowlands through an examination of the Altun Ha evidence, but the understanding does not take us very far at all as regards the developmental dynamics of ancient Maya society.

The Evidence

Structure F-8

Set in rather splendid semi-isolation some 700 m south of the Central Precinct of Altun Ha, Structure F-8 dominates a zone in which there is more open space than nearby construction, and the buildings are both smaller and generally later than the 17 m high temple (Pendergast 1979:Map 2; 1982:Figure 110). The zone flanks the principal reservoir of the site, but F-8 looks out on a broad expanse of floor and turns its side toward that body of water. On all grounds of settlement patterning, the structure would seem not to have been of particular importance in the history of the community. Yet F-8's location belies its significance. In the middle phase of its three-stage development, probably not later than A.D. 250, the temple became the resting place for a body of material that solidly documents a link that spanned the 1,150 km distance between mighty Teotihuacan and this comparatively small center at the Caribbean edge of the Maya world. The fact of that link is beyond dispute; it is its meaning, in the context of Altun Ha and in the Maya lowlands as a whole, that remains somewhat difficult to grasp.

Probably preceded by smaller structures of which no traces other than associated floors were encountered, the first phase of the temple rose at the F-8 locus some time in the second century A.D. (Pendergast 1982:260–262, Figures 114–115). More than 16 m high at this juncture, the structure unquestionably made a strong ceremonial statement in an area that seemingly embodied no such message in earlier centuries. The initial temple re-

sembled no other at Altun Ha; with a two-element stair composed of tiny steps that produced very considerable run dimensions, and with stairside outsets composed of strongly vertical elements that resemble attached colonettes, it seems to have emerged full-blown from the mind of an architect devoted to innovation. Given the extreme eclecticism of the architects of Altun Ha, it would be surprising if the form of the building could be linked to later developments at the site. More important for present purposes, nothing about the squat, round-cornered assemblage of three platforms suggests a view northward to the Mexican highlands. If Teotihuacan figured in the minds of the citizens of Altun Ha, the thoughts clearly were not represented in major architecture.

The first modification of F-8 altered the front of the building in many ways significant to the architectural history of Altun Ha (Pendergast 1982:262–263, Figure 117), but it brought the building no closer to a visible link with Teotihuacan. Within the core of the structure, however, lay a far stronger statement of such a link than one could reasonably expect to encounter at the easternmost edge of the Maya mainland. The earliest royal tomb of Altun Ha, set at the summit of the new structure, contained nothing within its crypt identifiable with Teotihuacan, but was accompanied by a closure or post-interment offering for which the link northward is beyond question, and the composition of the assemblage highly instructive.

Tomb F-8/1

The lone royal tomb in Structure F-8 was cut into the uppermost platform of the initial structure during construction of the building's successor. The crypt was lined with a mixture of stones, as were later tombs at the site, and was roofed with perishable materials (Pendergast 1990:263). Within the crypt lay the remains of a mature adult or older male, accompanied by a necklace of jade and shell, a pair of jade earflares, two elaborate shell disks, a pair of pearls, five pottery vessels, and fifty-nine valves of the Pacific *Spondylus calcifer* Carpenter (Pendergast 1990:264–266, Figures 119d–i, 120a–c). Not one item in the assemblage reflects central Mexican influence; a series of six small bib-head beads in the necklace speaks more of the south than the north, and with one possible exception, both the fabric and the form of the ceramics fit well into the Altun Ha inventory. It was not in the tomb itself but above its roof that those who buried their ruler paid homage to Teotihuacan—or much more probably homage in the opposite direction.

In a pattern never fully repeated in later Altun Ha tombs but known at other southern Maya lowland sites, the tomb builders capped the burial

chamber with a mass of chert debitage that ran to more than 8,100 pieces, with an additional 163 formal chert tools thrown in for good measure. Added to the mix were 890 artifacts that included 83 jade beads of various forms plus a single jade pendant and 172 fragments of beads and carved pendants; 18 Caribbean *Spondylus* valves; 5 puma and 2 dog teeth; nearly 300 slate laminae; and a great variety of shell objects that represent a considerable number of species. The quantity of objects is sufficient in itself to demonstrate the status of the occupant of the tomb; the statement is made far more forcefully, however, by the *pièces de résistance* among the assemblage (Figures 9.1 and 9.2), more than 248 Pachuca green obsidian objects that constitute all the elements of a Teotihuacan offering of the Miccaotli or Early Tlamimilolpa phase (c. A.D. 150–250; Spence 1996a:30), together with 23 jars, bowls, and dishes that clearly are not of Altun Ha origin and are certainly from a Teotihuacan-related source, but possibly not from the great center itself (Figure 9.3; Pendergast 1990:266–272, Figures 120d–v, x, y, 121a–j, 122, 123a–o; Evelyn Rattray, personal communication 1972; Spence 1996a:29).

The Meanings of the Artifacts

The significance of the obsidian artifacts lies not just in their unmistakable Teotihuacan source but in the fact that they constitute an essentially complete Miccaotli- or Early Tlamimilolpa–phase offering (Spence 1996a:29–30). If the assemblage included only a few of the forms that one would find at Teotihuacan, it would be easy to conclude that random bits of material produced in Miccaotli or Early Tlamimilolpa times somehow had made their way the 1,150 km southward to Altun Ha, probably hand to hand and perhaps over a fair span of time. There can be no question, however, that the material reached Altun Ha as it had left Teotihuacan, its components and its symbolic significance intact. Three obvious conclusions can be drawn from this fact. The first is that the obsidian objects, almost certainly accompanied by the pottery vessels, traveled the distance from source to receiving end in a single journey and possibly in a single person's or group's hands. The second is that the journey is most likely to have taken place while Miccaotli/Early Tlamimilolpa–phase offering symbolism was still dominant at Teotihuacan. Third, and most important, the motivation for the journey must have lain in recognition at Teotihuacan of some very considerable importance that attached to the distant site of Altun Ha or to its leader in the third century A.D.

In the circumstances represented by Tomb F-8/1 there are obviously two primary options, with many secondary alternatives for each, as regards assessment of the significance of the Teotihuacan material: (1) either the offer-

FIGURE 9.1. Miccaotli/Early Tlamimilolpa-phase human (upper) and humanoid (lower) figures made on Pachuca green prismatic blades from the Altun Ha Tomb F-8/1 post-interment offering.

ing and vessels speak specifically about the place of the deceased ruler himself in the eyes of the leaders of Teotihuacan, or (2) they denote an aura of importance that surrounded the community as a whole (see Ball 1983). There are plausible, and indeed compelling, arguments for each of these options, and they warrant some examination because the answer to the question has much to do with the significance of the F-8 event in the history of both Altun Ha and the southern Maya lowlands.

If the intent behind the sending from Teotihuacan of an important statement of linkage with the great center was to underscore ties with a single

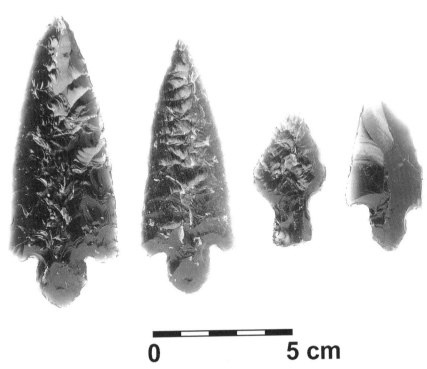

FIGURE 9.2. Bifacial stemmed blades, probably projectile points, of Pachuca green obsidian from the Altun Ha Tomb F-8/1 post-interment offering.

ruler, we might be safe in assuming that the assemblage of obsidian and ceramics arrived at Altun Ha long before the individual's death, perhaps as a gift at the time of his accession to power. If that had been so, however, inclusion of the material as part of the crypt contents on grounds of its close personal link to the ruler would seem to have been the most logical step—albeit in our frame of logic and not necessarily that of the ancient Maya. Unfortunately, neither the context nor the nature of the Teotihuacan material bespeaks any particular history, significance, or use prior to the final one, hence the nature of the link with the sovereign cannot be extracted directly from the data. The only thing of which we can be sure is that many of the artifacts in the post-interment offering are highly unlikely to have had any direct links with the ruler, and this makes the scattering among them of an important assemblage of the ruler's personal accouterments seem an improbable act. Let us turn, then, to the alternative view of the time of arrival at Altun Ha of the material from Teotihuacan, which is that it occurred after the ruler's death.

The likelihood of a postmortem arrival of the material seems on first

examination to be reduced to some extent by the exigencies of death in the Maya lowlands. Evidence from later times at Altun Ha indicates that a temple construction phase intended to house a ruler's remains was begun when the individual acceded to power, brought as close to the finishing point as possible, and held until the ruler died. At that point, interment was carried out, together with any post-interment offering activity that circumstances might dictate, and the uppermost floor surface of the structure was completed. If we assume that interment and the subsequent deposition activity occurred as a single short sequence, we must focus on the time that might have elapsed between death and burial as the determinant of whether the Teotihuacan material could have been sent as a funerary offering.

In the tropical heat, the ceremonies that attended a ruler's demise, elaborate as they clearly were, had to take place soon after death unless exten-

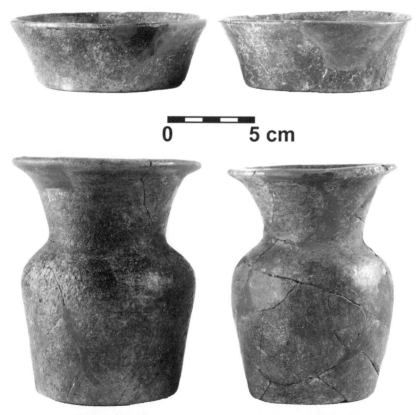

FIGURE 9.3. Teotihuacan-related out-curving side, brown-slipped dishes (upper) and brown-slipped jars (lower) from the Altun Ha Tomb F-8/1 post-interment offering.

sive decay of the corpse was a permitted part of the ceremonies. There were, of course, means of slowing, or at least encapsulating, the decay process, such as encasement of the body in tight and thick wrappings or in a mass of slack lime, that would have allowed the passage of some amount of time before interment became imperative. What is clear from the skeletal evidence is that the body was not allowed to decompose to such a state that its burial in articulated form was rendered impossible. The condition of the remains, both as regards articulation and as regards bone preservation, rules out long-term encasement in lime but tells us nothing about other methods that might have been employed to preserve the body in something that approximated its original form. It is clear, though, that even careful wrapping is not very likely to have served as a sufficient preventer of dissolution of the body to have retained natural relationships among major skeletal elements for a protracted period.

The condition of the skeletal remains surely indicates the passage of no more than a moderate time between the individual's death and his burial. This in turn indicates a fairly short span between the death and the arrival of the Teotihuacan assemblage — unless signs of the ruler's impending demise permitted earlier transmission of the news northward from Altun Ha, or the laying of the body in the crypt and the construction of the wooden chamber roof preceded the deposition of the post-interment material by some time.

Of course, we can never know the circumstances that preceded the ruler's death, and hence cannot assess the possibility of an early warning to the leaders of Teotihuacan that their counterpart at Altun Ha was soon to shuffle off this mortal coil. On the other front, unhappily there is nothing in the archaeological evidence that allows us to choose between the identification of the entire royal burial assemblage as the product of a single activity and the segmentation of the activity into two stages that could have been separated by a considerable time. In either scenario, however, there is no doubt that the delay between the ruler's death and his emplacement in the tomb would have made possible the transmission of news of the event from Altun Ha to Teotihuacan.

If we take the first view, it would be useful indeed if we could judge whether or not the time would have been sufficient for the transport of the obsidian and ceramic assemblage southward as a funerary gift. Such a judgment is, unfortunately, an impossible task for two reasons. First, we cannot know if the objects in the offering were readily available at Teotihuacan or had to be manufactured and assembled to order when the need arose. Second, we have no real basis for calculating the amount of time that would have

been taken in moving the material to Altun Ha, because we cannot know whether the journey was attended by ceremonies en route or was as rapid as possible, and we also have no solid information on the distance that could have been covered in a day's travel. Adoption of the second view, on the other hand, erases all difficulties regarding transport time; if sealing of the crypt marked the end of the first stage of the burial ceremonies, emplacement of the post-interment offering could easily have been delayed until the material arrived from Teotihuacan.

No matter what the mechanics of the arrival of the Teotihuacan assemblage at Altun Ha may have been, there remains the overriding question of why any tie at all should have existed between the royalty of two centers so widely separated and so disparate in size and power. In this sphere, the Teotihuacanocentric temptation becomes very strong, for it fits very logically into one scenario of political domination: the Altun Ha ruler was a native of Teotihuacan sent out to preside over an enclave that would serve as a center for a Teotihuacan political presence on the Caribbean Coast. Michael W. Spence (1996a:33) alludes to this possibility, with commendable reserve, but isotopic analysis of the Tomb F-8/1 skeletal remains (White et al. 2001) has now expunged it from the list. Of course, we could keep the game going at this point by suggesting that the ruler was linked by marriage to Teotihuacan, but unless we free ourselves of all restraints by moving into such a data void, we are left with the virtual certainty that Teotihuacan's recognition of the ruler of Altun Ha was actuated by the importance of the recipient rather than the strength of a biological link with the donor.

If we turn from the personalized view to the alternative assessment of the Teotihuacan material, that it arrived at Altun Ha as a reflection of the importance of the polity in central Mexican eyes rather than as homage paid to a single ruler, we obviously reduce or remove the concerns with timing vis-à-vis the ruler's burial, but we still face problems. Now we must look not to the charismatic qualities of a single leader, or to the untestable possibility of his affinal ties to Teotihuacan, but to the significance of Altun Ha itself. Here the arguments seem initially to founder on a simple fact: apart from the Tomb F-8/1 assemblage, Altun Ha boasts virtually nothing that identifies the site with Teotihuacan. Even given the remarkable catholicity of architectural taste at Altun Ha, there is no more in Classic settings than there is in Structure F-8 to bespeak the influence of Teotihuacan. Furthermore, with a single exception of rather equivocal nature, the statement made by the buildings of Altun Ha is repeated in its material-culture inventory.

Excavations beyond Structure F-8 yielded only one stemmed bifacial blade

of Pachuca green obsidian, from a post-abandonment offering in the small Late to Terminal Classic Structure D-2, at the edge of the site's Central Precinct (Pendergast 1990:13, Figure 3c). Although the blade has the form, size, and manufacturing characteristics of the F-8 specimens, evidence recently recovered at central Mexican sites indicates that it could have been manufactured long after the decline of Teotihuacan, as the Early Postclassic or later date of the context suggests. Alternatively, the blade may have been recovered from some earlier context and reused, but the severance between the offering and the construction history of Structure D-2 does not permit us to be sure that the object came from an Altun Ha Classic-period cache. Despite the central Mexican source of the blade, its presence really tells us nothing about Teotihuacan–Altun Ha ties.

A search of Classic-period elite contexts at Altun Ha is very revealing, but in a negative sense, as regards Teotihuacan contact with the community. Tomb A-1/1, the only Early Classic royal burial that falls within the period in which Pachuca green obsidian is relatively widespread in Maya contexts (Spence 1996a), contains nothing at all indicative of Teotihuacan (Pendergast 1979:61–81, Figures 16–23). The same absence of a discernible Teotihuacan quality marks the earlier Classic-period Burials 2 and 3 in Structure A-1 (Pendergast 1979:48–54, Figures 9–13), as well as all of the Early Classic burials and offerings encountered in the other Central Precinct buildings of Altun Ha (Pendergast 1979:102–106, 147–151, 166–168; 1982:46–47), even though in one case there is clear evidence of importation of an offering item from a source at least 1,750 km away by land or by sea (Pendergast 1970:118; 1979:151).

Surely, any sentient scholar would argue, if the Altun Ha polity as a whole was the focus of Teotihuacan interest, one would expect to find evidence of this attention in more than a single, very early royal tomb. The reasons for such an expectation lie at the recipient, rather than the source, end of the connection. Whatever importance Altun Ha may have achieved during the Preclassic, the community was clearly much farther from its Classic apogee when Tomb F-8/1 was built than it was 100 to 150 years later, when Teotihuacan's general strength in southern Mesoamerica and its specific influence in the Maya world were demonstrably at their peak. On grounds of logic, therefore, one might anticipate more evidence of Teotihuacan contact during Altun Ha's Early Classic than in preceding years—but the absence of such contact is documented by all the excavation data from the period.

If Teotihuacan's focus was on the Altun Ha polity rather than its third-

century leader, we are even less likely to be able to discern why the offering made its way southward than we are in the case of focus on the individual. It is not unreasonable to speculate, however, almost wholly on the basis of the offering, that some form of the small center's Classic importance, which is so forcefully represented by the wealth of jade in tombs and caches, was already strongly established by the mid–third century A.D. In later contexts, the importance seems to have rested at least partly on sun-connected symbolism, perhaps a reflection of the location of the site; there is nothing specific that demonstrates such a basis in the case of the F-8 tomb, but the assumption of continuity over the centuries is as reasonable a view as any. The assumption carries with it, however, an insoluble conundrum: if early development of the religious importance of the site is the explanation for the Tomb F-8/1 material, why does the material from Early Classic ceremonial contexts not convey the same message?

Beyond the putative sun symbolism of Altun Ha and the possibility that the site had gained fame so widespread as to have reached into the consciousness of Miccaotli/Early Tlamimilolpa Teotihuacan, might trade in the opening century of the Early Classic have aided in forging the link between the two communities? The burgeoning of trade between Maya-area coastal sites, as well as between such sites and non-Maya source areas, is now quite well documented (Graham 1987; Graham and Pendergast 1993; McKillop and Healy 1989) and represents an intensity of activity that remained unmatched until the Early and Middle Postclassic. If, as appears probable, A.D. 100–350 was a period of expansive contact between urban centers throughout Mesoamerica, the contact conceivably could have brought Altun Ha to the special attention of Teotihuacan's Miccaotli or Early Tlamimilolpa rulers, though I am at a loss to suggest how. Would such trade-generated attention in itself have resulted in the transmission of an important offering to Altun Ha? I think not.

Conclusions

Extensive rumination on a matter that cannot be resolved by the available data may seem an exercise in futility, and indeed, in some respects it is. We must, however, develop a view of the F-8 material as solidly based as circumstances will allow if we are to assess the meaning of the offering in the history of both Altun Ha and the southern Maya lowlands. Over the years, I have wavered between the two alternative interpretations, individual versus polity honor, and to some extent the wavering has reflected trend shifts in

Mayanists' frame of mind regarding the past they study. The writing of this chapter has given me the opportunity to weigh the evidence more fully than ever before, and I have found myself returning to the view that I held at the time of Tomb F-8/1's excavation, which is that it was the person entombed whom Teotihuacan's leaders sought to honor, not the polity over which he had held sway. It would be comforting if that view led us to a complete picture of the matter, but as the foregoing discussion makes clear, it most certainly does not.

At a broader level, the questions that arise from the tomb offering are two: what lasting impact did the Teotihuacan–Altun Ha link have at the site, and what conclusions can we draw from the material regarding the importance of Teotihuacan in early southern Maya lowlands development? The answer to each question is, in my view, the same: none.

As far as we are able to determine, the arrival of the Teotihuacan material at Altun Ha did not signal the beginning of a period of the great center's hegemony over the Maya community; it did not mark the commencement of an influx of central Mexican goods to Altun Ha or of any identifiable trade between the two; it did not even open the Caribbean coastal community's door a crack to central Mexican architectural canons or to northern styles in other areas of material culture. The fact that the very extensive, though by no means exhaustive, excavation of the site produced just one additional piece of central Mexican material, in a context far later than the fall of Teotihuacan, indicates fairly strongly that the tie between the two polities was a one-time thing. Once the F-8 ruler's tomb was capped and sealed, Teotihuacan presence at Altun Ha sank beneath the Caribbean waves without so much as a ripple.

I cannot profess to understand how so powerful a statement from Teotihuacan could have been made in the third century A.D. at Altun Ha and yet not have given rise to anything in subsequent years—but the evidence tells us that just such a thing is almost surely what happened. What I can say is that, given the evidence, it is foolish to suggest, as some have done, that the presence of the Teotihuacan offering at Altun Ha sheds great light on central Mexican influence over the shape that life assumed in the southern Maya lowlands during the Classic period. The offering does not tell us anything about developmental forces, but it does imply that a connection with Teotihuacan was evanescent. I wish, as all Teotihuacan scholars also must do, that the material could speak to us more eloquently about the reasons for the connection as well as the reasons for its severance. I cannot deny the possibility

that clarity may someday be brought to this matter, but at this point, more than three decades after Tomb F-8/1 came to light, I am left—as we so often are—with answers that give rise to further questions for which thus far I see no firm answers. Did Teotihuacan make a difference at Altun Ha, and perhaps in a larger part of the southern Maya lowlands, as the Classic period opened? Only, it seems, for a moment.

Teotihuacan and Oxkintok: New Perspectives from Yucatán

Carmen Varela Torrecilla and Geoffrey E. Braswell

Since the early twentieth century, questions of interaction and the spread of Teotihuacan-related features in the Maya area have generated many studies that use a variety of methodologies and adopt very different points of view (e.g., Berlo 1984, 1989; Coggins 1975; Hellmuth 1975; Kidder et al. 1946; Laporte 1989; Linné 1942; Miller 1983; Parsons 1967–1969; Pasztory 1978b; Sanders and Michels 1977; Sanders and Price 1968; Santley 1989; Seler 1976[1915]; von Winning 1987). Analysis of these works reveals several problems that are as much epistemological as they are empirical (Varela Torrecilla 1998:13–25).

In the case of the northern Maya lowlands, a chronological and cultural gap can be added to these problems. The cultural sequences of this region until recently have included very little information about the periods before the Late Classic and the Puuc phenomenon (Andrews 1965; Andrews 1986; Andrews and Andrews 1980; Ball 1978; Brainerd 1958; Pollock 1980; Smith 1971). Excavations of the Misión Arqueológica de España en México (MAEM) at Oxkintok (Figure 1.1), one of the major sites of northwest Yucatán, have generated data (derived from ceramics, architecture, burials, and other materials and contexts) that clarify the chronology of the Proto-Puuc architectural style and allow the definition of the Oxkintok Regional ceramic phase (Figure 1.2), both of which date to the sixth century A.D.

To date, no satisfactory explanation has been proposed for interaction between the Maya and Teotihuacan. In this chapter, we widen the discussion with an evaluation of both the epistemological framework and the empirical data from the northern lowlands. Looking at the archaeological record we have from Oxkintok and northwest Yucatán, one can find no evidence of either political/economic domination or colonization by Teotihuacan. Instead, the data suggest that the *in situ* transition to a more complex society was associated with processes of cultural adoption, adaptation, and innovation. Although it still is difficult to identify the degree to which interaction and transformation took place, we suggest that these processes were related

to participation in a pan-Mesoamerican interaction network and to changes in the sociopolitical and commercial relationship between the southern and northern Maya areas (Ball 1977b:182–183).

Epistemological Framework: Teotihuacan, the Maya, and the "Middle Classic Horizon"

Several explanations of interaction between the Maya lowlands and central Mexico are deeply rooted in the hypothesis of a Teotihuacan "empire" whose cultural traits spread because of: (1) economic processes, including the long-distance exchange of both basic subsistence and exotic goods; or (2) the political and military ambitions of priestly soldiers or militant *pochteca*. In our opinion, the supposedly dominant role played by Teotihuacan in Meso-america has served as a starting point for scenarios that assume that these cultural traits were "exported" from Teotihuacan. Such narratives do not take into account weaknesses in Teotihuacan's relative chronology and its dependence on temporal data and sequences from Maya sites (Millon 1967, 1968:111–112; cf. R. Millon 1973:61). Moreover, they do not attempt to date precisely the appearance of each central Mexican trait in the Maya area. In order to understand the origin and chronology of each feature, its exact temporal occurrence and context both at Teotihuacan and in other parts of Mesoamerica must be known. Recent results and closer readings of empirical evidence show that scant archaeological data all too often have been uncritically accommodated to diffusionist hypotheses (Clark 1986; Kidder et al. 1946:246).

It should also be noted that the "Middle Classic Horizon," whose underlying hypothesis is the development and expansion of a Teotihuacan "empire" throughout Mesoamerica, now is generally discredited. Nonetheless, this concept served for a time as a reference model (e.g., Pasztory 1978b; Wolf 1976). As Arthur A. Demarest and Antonia Foias (1993) point out, the lack of chronological alignment of "central Mexican" traits at different sites is the most disturbing aspect of evidence for interaction with Teotihuacan. "Without such an alignment, what meaning does the 'horizon' concept have?" (Demarest and Foias 1993:170).

One of us has addressed this question before (Varela Torrecilla 1998), and we stress again that there is confusion regarding the chronological and cultural meaning of the term *horizon*. The same "Middle Classic Horizon" markers (e.g., green obsidian, Thin Orange ware, and specific iconographic and architectural elements) are commonly used both for *defining* and for *dating* interaction. For example, green obsidian found at Maya sites has often

been taken as evidence for interaction with Teotihuacan, and hence is dated to the "Middle Classic." Nevertheless, Hattula Moholy-Nagy (1999a) and others have demonstrated that green obsidian was consumed during the Preclassic, Classic, and Postclassic periods. Moreover, comparatively few scholars have attempted to assess changes in the characteristics of these markers through time. Although the Maya built *talud-tablero* structures from the Terminal Preclassic through the Late Classic period, the style did not remain static (see Chapter 7). The earliest examples at Tikal employ framed *tableros* that pass only part way around a structure. Framed *tableros* became more common during the Early Classic period, as did the combination of *tableros* with typically Maya apron moldings. Late Classic *talud-tablero* structures sometimes were built with the *atadura* (cinch) form from Veracruz.

Thus, the common view of the "Middle Classic Horizon" presupposes a diffusion or migration mechanism that: (1) ignores the internal dynamic of change and evolution within the Maya area; and (2) gives a predominant role to central Mexican cultures as "creators" of features and undervalues the innovative capacity of the Maya. The second aspect of this view unconsciously reflects many confluent factors in current politics, including Mexican nationalism and North American/European imperialism.

For these reasons, the role of Teotihuacan in the development of Mesoamerica has been overestimated, and a satisfactory explanation for the relationship between that city and the Maya has not been proposed. Moreover, the concept of a "Middle Classic" period is especially problematic not only because of the way it has been defined, but also because of its application as a theoretical tool. In contrast, we prefer to describe the late fourth to sixth centuries as a period characterized by extensive interaction and a high degree of innovation *throughout* Mesoamerica.

Any historical interpretation of Teotihuacan-Maya interaction requires that each trait subject to exchange be placed in a concrete context. We need to determine the point or region of origin of each trait, and if we find actual imports in the Maya area, we need to understand the processes that brought them there. These may include colonization, extensive commerce, isolated contacts, elite alliances, and other possible mechanisms. We should determine which segments of local societies were most affected by interaction. This would allow us to determine when direct contact occurred, and when indirect contact—in which traits were reelaborated within the exchange network through which they were transmitted—was prevalent. In the latter case, we must strive to ascertain the specific cultural meanings assigned to traits at each node in the interaction lattice.

During the late Early Classic, probably as a result of increased commercial interaction, foreign contacts led to the reinterpretation of local traditions from a more cosmopolitan point of view. This could have stimulated not only the development of economic and sociopolitical organization but also local experimentation with foreign ideas. Such experimentation would have involved the processes of adoption, invention, and innovation as described by Robin Torrence and Sander E. van der Leeuw (1989): *adoption* is defined as behaviors and actions developed as much in their acceptance as in the use of that which has been adopted; *innovation* represents the complete process that begins with the conception or invention of a new idea and also includes its acceptance and development; and *invention* means any original conception of a new idea, behavior, or thing.

In the Maya area, one of the clearest examples of innovation is the use of the *talud-tablero* style in the architecture of Oxkintok. At that site, a framed *tablero* of the Tlaxcala-Teotihuacan tradition was incorporated above a typical Maya apron molding. Eclectic art styles that exhibit influences from two or three regions in a single work also are cases of innovation (e.g., Clancy 1979; Coggins 1983; Parsons 1967–1969). Through the study of such styles, we can identify the degree to which local people were receptive to new ideas. Eclecticism is especially evident when motifs from different regions are not only juxtaposed but also synthesized, as in the iconography of Tikal Stela 31 (see Chapter 8). In contrast, the simpler process of adoption can be seen in the architecture of Kaminaljuyu, Tikal, and Dzibilchaltun, where typical Tlaxcala-Teotihuacan *tableros* were used without being combined with the indigenous apron molding (see Chapters 3 and 7).

Not all regions of Mesoamerica participated equally in this interaction, nor did all material goods and cultural traits have the same distribution. For example, there was greater interaction between Monte Albán and Teotihuacan than between either of those sites and the Maya area. If one takes into account both imports and locally produced copies, Matacapan also appears to have had closer or greater ties with Teotihuacan than did most Maya sites (Santley 1983, 1989), although we hesitate to assert that it contained a Teotihuacan enclave. It is important to remember that the Maya interacted with foreign peoples from sites other than Teotihuacan. As Flora S. Clancy (1979) has shown, some shared iconographic motifs and even more complex features, including calendrical and writing systems, link the Petén to Oaxaca. Parsons (1978) describes an additional series of traits distributed along the Peripheral Coastal Lowlands of Mesoamerica—including both Gulf Coast Veracruz and Pacific Guatemala—that are seldom seen in other regions.

It is necessary, therefore, to determine the meaning, intensity, and distribution of each shared feature. Such a task is made more difficult by the lack of precise and detailed historical sequences in many regions. Nonetheless, there are four clusters of features that are frequently identified with Teotihuacan and that may have reached their maximum geographical distribution during the late fourth to sixth centuries: (1) green obsidian from the Pachuca, Hidalgo, source; (2) a ceramic complex characterized by cylindrical tripod vessels with slab feet, "coffee" (probably cacao) bean appliqués, applied faces, *candeleros,* and Thin Orange ware; (3) *talud-tablero* architecture; and (4) iconographic elements associated with the central Mexican storm god and Teotihuacan notions of warfare (e.g., the atlatl, tasseled headdresses, owls, and butterflies). It is not clear, however, that the appearance of these traits throughout much of Mesoamerica was a result of direct interaction with Teotihuacan. In the specific case of Tikal, many foreign elements and imports may have come from Monte Albán or the Gulf Coast rather than directly from the great highland city (Clancy 1979; Coggins 1983; Iglesias 1987; Laporte 1989).

The late Early Classic period is characterized by an interregionalism manifested in architecture, artistic styles, iconographic language, and ceramic modes that are associated with power and prestige. Evidence for a possible ideological transformation may be discerned throughout Mesoamerica in the eclectic styles and iconography of architectural and artistic traditions. This eclecticism differentiates the fourth to sixth centuries—the late Early Classic or "Middle Classic"—from the preceding period during which, despite the existence of long-distance commercial contacts, each region of Mesoamerica was immersed in its own relatively isolated sociopolitical and economic system. The degree of interaction during the late Early Classic is related to the volume, intensity, and frequency of economic relations, as well as to the power of the polities involved and the distances separating them. Different ideological responses to commercial interaction and political influence are manifested in the particular kinds of material evidence that we find at distinct sites and in different regions. The presence of imported goods, or "identities" (Ball 1983), does not on its own indicate a high level of ideological transformation and participation in the pan-Mesoamerican system. But when innovations or adaptations of foreign traits appear in locally produced architecture, monumental art, and ceramics, it may be supposed that native elites chose to associate themselves with ideas or symbols considered prestigious due to their distant origins, rarity, or power (Ball 1983). Interaction of this sort not only influences the later trajectory of local sociopoliti-

cal development but also generates detectable changes in the archaeological record.

Tikal provides a good example of this process. During the Manik 3 phase, a lineage or house associated with a particular title appropriated a series of foreign features in order to consolidate its prestige and install a new governing dynasty (Laporte 1989:319–320; Laporte and Fialko 1990). Some of the features of this period were incorporated into the Maya cultural substrate and, in modified form, continued to be used during later periods. The *talud-tablero* structures of the Ik phase are one example. Other features, including the cylindrical tripod vessel and applied "coffee" bean decorations, disappeared. During the ensuing Late Classic period, characteristically Maya polychrome pottery achieved some of its finest expressions.

Because the political and economic strengths that many Mesoamerican centers exhibited during the Late Classic may be due to the nature and dynamics of this earlier period of interregionalism and innovation, it is necessary to isolate and define—in a completely new sense—a "Middle Classic." Nevertheless, it will be possible to address concepts like political or economic control, acculturation, influence, and syncretism only when detailed and accurate historical sequences have been defined for each cultural region where shared traits are found. As Joseph W. Ball (1983:126) notes: "Acceptable, defensible reconstructions of general cultural historical events or interpretations of cultural processes must be based upon conjunctive considerations of multiple data sets and compatible syntheses of their support."

Empirical Framework: Archaeological Data from Northwest Yucatán

In the northern Maya lowlands, evidence for significant interaction with Teotihuacan dates to the last part of the Early Classic period, considerably later than similar data from the central and southern lowlands, and comparable to the latest manifestations in the highlands and Pacific Coast (Figure 1.2). Early Classic interaction between central Mexico and the northern lowlands has received relatively little attention from scholars because the focus of most research has been later periods, because relevant data are scarce, and because central Mexico has rightly been considered a less important source of late Early Classic influence than the Petén and the Maya highlands. In part, this view reflects a common perception that the northern lowlands were somehow peripheral to the central Petén "core." Moreover, the appearance of central Mexican traits in the north could not be tied closely to the expansion and contraction of Teotihuacan that was described

by Gordon Willey (1974) for the fourth to sixth centuries. The temporal lag between the central and northern lowlands suggests that Teotihuacan "influence" reached northwestern Yucatán during the "Middle Classic Hiatus," a time when Teotihuacan was thought to have *withdrawn* from the Maya region.

Evidence from Oxkintok demonstrates that the Oxkintok Regional phase (A.D. 500/550–600/630) was a period of great architectural activity. The most elaborate burials with the richest mortuary furnishings date to this phase, as do dramatic changes in ceramic forms and decorative techniques. Moreover, it is during the Oxkintok Regional phase that Teotihuacan-related features are seen most clearly in the material record. These characteristics make Oxkintok an ideal site for: (1) evaluating alternative hypotheses of Teotihuacan "influence"; (2) defining the features that characterize interaction at both local and regional levels; and (3) studying change in order to develop processual hypotheses concerning the transition from the Early to Late Classic.

The *talud-tablero* architectural style, specific exotic symbols, and certain characteristics of the ceramic complex appeared during the Oxkintok Regional phase but were not derived from local antecedents. The participation of Oxkintok in a Mesoamerican international system during the sixth century allows the definition of this phase, and by extension, a new and more accurate conceptualization of the "Middle Classic." The necessity of defining anew the Middle Classic period derives from the fact that during the late fourth to sixth centuries, many sites demonstrated for the first time participation in the broader, pan-Mesoamerican network of interaction. Participation in this international system also entailed the introduction of new ideas that may have strengthened and stimulated political development. If we include the fourth to sixth centuries within the Early Classic, we fail to call attention to the political, economic, and ideological changes that made possible the developments of the Late Classic. In the case of Oxkintok, we also create an artificial and qualitative leap from a simpler state to a more complex one, without emphasizing the transitional processes that eventually led to the florescence of Puuc society.

Investigations at Oxkintok

The city of Oxkintok is located some 50 km southwest of Mérida at the northwest extreme of the Puuc zone. In this region the study of the Early to Late Classic transition is particularly important because the processes leading to the great sociopolitical, economic, and artistic achievements of

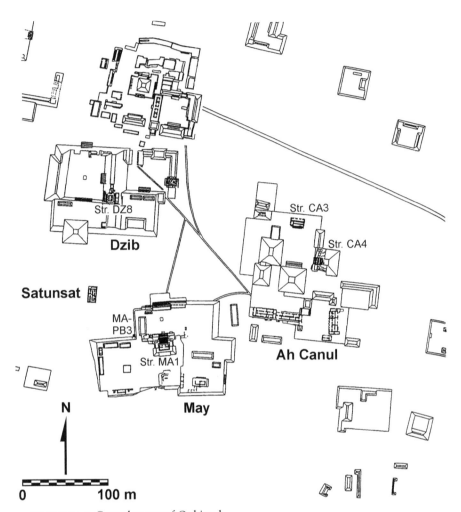

FIGURE 10.1. Central sector of Oxkintok.

the Late to Terminal Classic Puuc florescence are practically unknown. Ox-kintok is notable for the antiquity of its hieroglyphic inscriptions; Lintel 1 contains a date of 9.2.0.0.0 (A.D. 475), the earliest-known Long Count date in northern Yucatán (Shook 1940). MAEM's Proyecto Oxkintok was carried out by a multidisciplinary team between 1986 and 1991 and was designed specifically to investigate the period leading up to the Puuc florescence (Rivera Dorado 1988, 1989, 1990, 1992). At the center of the site, we conducted extensive and intensive excavations in the May, Ah Canul, and Dzib architectural groups, and also investigated and consolidated the labyrinthine structure called the Satunsat (Figure 10.1).

Our excavations revealed that Oxkintok grew to be a large Rank I site by or during the fourth century A.D. Most examples of the Early Oxkintok architectural style (Pollock 1980:584) are known from the city, and two subphases of the following Proto-Puuc style have been identified as a result of our research (Muñoz Cosme 1990). Several structures built during the Proto-Puuc A subphase (A.D. 500/550–600) contain the *talud-tablero* form. The only possible candidate for an earlier example of this form in the Puuc region was found recently at Chac II. There, an eclectic platform containing a "*talud-tablero*-like architectural profile" and a possible balustrade have been exposed (Smyth 2000).

Polychrome pottery characteristic of the Early Classic lowlands is associated with architecture of the Early Oxkintok style. But ceramics of the Oxkintok Regional complex, first identified by George W. Brainerd (1958), are associated with structures built in the Proto-Puuc A style. Pottery belonging to this second complex manifests what Brainerd called "Teotihuacan influences" in form and decoration. The contextual association of *talud-tablero* architecture, foreign ceramic forms, exotic decorative modes, and pottery belonging to a new local tradition all suggest that an important change in the nature of interaction occurred during the Oxkintok Regional phase.

In the following sections we discuss tombs, an offering, and a midden that date to the Oxkintok Regional phase. We also present a contextual analysis of ceramics, architecture, stone tools, and other artifacts with the goals of (1) describing changes in the cultural tradition of Oxkintok; (2) identifying changes in interregional and long-distance exchange; and (3) demonstrating the development of political complexity that distinguishes the Oxkintok Regional phase from earlier periods.

Primary Contexts Dating to the Oxkintok Regional Phase

A total of eleven tombs were excavated by the Proyecto Oxkintok. Five of these date to the Oxkintok Regional phase and contain the richest furnishings yet found at the site. Variations among the five tombs—defined in terms of spatial position; ceramic offerings; and tomb size, form, and shape—suggest that there were distinct social ranks among high-level elites. This implies that a much higher degree of social complexity existed at the site than in earlier times.

Tomb 1, located in the Satunsat, contained the richest offerings. Its placement in an existing and unique structure may indicate an important shift in the symbolism and function of the building. Chemical analyses of soils in the burial chamber did not reveal the presence of phosphates derived from the

decomposition of organic material (Ortiz and Barba 1992). This implies that the individual was moved after decomposition was complete and reinterred in the Satunsat. Secondary deposition, the limited care with which bones were deposited, and the lack of many important bones are all important characteristics of burials dating to the Oxkintok Regional phase. At the moment, however, the meaning of this burial pattern is not known.

Tombs 2–4 were found in Structure MA1 beneath the floor of the superstructure. The three tombs were aligned with each other and placed perpendicular to the central axis of the building. The individual in Tomb 4, the central of the three interments, was accompanied by the richest offerings. A similar triadic pattern also existed with Tomb 5, found in Structure CA3. Evidence was found of two additional tombs flanking Tomb 5 that were looted in antiquity.

Bodies in the tombs were found in an east-west orientation also seen at Dzibilchaltun, Uaxactun, and Río Azul. Some graves, crypts, or chambers, however, were oriented north-south. Two important differences between burials found in the northern and southern lowlands are that those in the south usually are primary and often have much richer offerings.

The only offering dating to the Oxkintok Regional phase (Offering 8) contained a female figurine carved from a manatee bone. A similar figurine was found in Tikal Burial 22, which dates to the Manik 3A phase (Hattula Moholy-Nagy, personal communication 1996). A somewhat similar example, with a different hand and arm position and four perforations in the breast, was found in Tomb 23 of Río Azul (Adams 1987:24). Thus, the female figurine from Oxkintok Offering 8 suggests connections to the central Petén.

The Ceramics of Oxkintok and Teotihuacan "Influence"

The complex of material traits that characterize the Oxkintok Regional phase is manifested most clearly in pottery. Substantial changes in the conception and manufacture of ceramics date to this phase. Locally produced polychrome ceramics are absent from the complex. With the exception of rare polychromes imported chiefly from the Chenes and Río Bec regions, the Late and Terminal Classic ceramics of the Puuc are monochromes. During the Oxkintok Regional phase, therefore, the ceramics of the Puuc region began to diverge from the traditions of the southern and central Maya lowlands. Equally important was the introduction of improved firing techniques that ultimately led to the development of Slate ware. Pottery belonging to the Early Classic Ichpá complex exhibits a high degree of formal variation. In contrast, large-scale manufacturing of highly standardized ceramics during

the Oxkintok Regional phase suggests the emergence of a centralized power that controlled production.

Seven forms and one ceramic ware are frequently discussed as evidence of interaction with Teotihuacan. These are: (1) cylindrical tripod vases; (2) *candeleros;* (3) *copas;* (4) *floreros;* (5) "cream pitchers"; (6) Teotihuacan-style figurines; (7) Teotihuacan-style incense burners; and (8) Thin Orange ware. Thin Orange ware—produced in Puebla and not at Teotihuacan itself (Rattray 1990; Rattray and Harbottle 1992)—is unknown at Oxkintok. Moreover, only two of the forms, the cylindrical tripod vase and the *candelero,* have been found at the site. The latter is represented by a solitary example recently discovered in a burial excavated by Ricardo Velázquez Valadez. These exotic forms are even rarer elsewhere in the Puuc. Michael Smyth (2000) has reported a burial at Chac II that contained a second *candelero* as well as a cylindrical vase "similar to *florero* vessel forms from Teotihuacan," but no other examples of these two forms are known from northwest Yucatán.

The tripod cylinders of Oxkintok and other sites in northwest Yucatán often have open-work supports (Figure 10.2b) or an otherwise unique decorative form: modeled supports representing bats (Figure 10.2a). Moreover, compared to similar vessels from elsewhere in the Maya area, the tripod cylinders of northwest Yucatán are characterized by a greater simplicity. Plano-relief, gouged-incised, and stucco decorations all are absent. Most frequently, the body walls of vessels lack decoration. If decoration is present, it appears in the form of fluting or, more rarely, as appliqué faces around the base of the vessel.

In contrast, fluted cylindrical tripods are completely unknown at Teotihuacan, as are modeled supports depicting bats. Nor are there any known examples with appliqué faces, as have been found on tripod cylinders from both the northern lowlands and the Petén (Iglesias 1987:lámina XXIXp; Varela Torrecilla 1998:figura 4.16). In addition to the distinctive iconographic program (bat supports and small appliqué faces), the occasional presence of pre-slip fluting, and the lack of painted stucco, tripod cylinders from northwest Yucatán also differ in their proportions. They are relatively taller and narrower than similar vessels from Teotihuacan.

Evelyn Rattray (1977, 1983) argues that the tripod cylinder vase originated in the Gulf Coast region and not at Teotihuacan. Furthermore, the basic form—without the modal characteristics of Teotihuacan—was used in Preclassic Kaminaljuyu. Thus the tripod cylinder of Oxkintok represents a local adoption of this form, but it is unclear if the source of inspiration was Teotihuacan, Veracruz, or elsewhere in the Maya region. Moreover, aspects

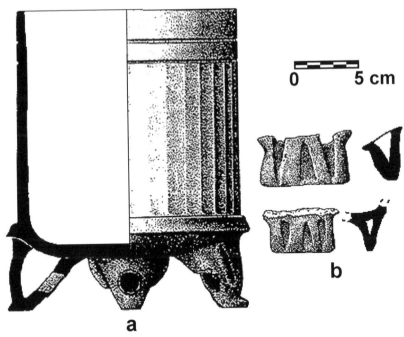

FIGURE 10.2. Tripod cylinders from Oxkintok: (a) Peba Composite:Peba vessel from Tomb 1 (note bat-effigy supports); (b) Kochol Black:Kochol open-work supports (redrawn from Varela Torrecilla 1998:figuras 3.29b,c and 3.104).

of the decorative techniques and iconographic program of examples from northwest Yucatán are innovations unique to that region. As argued by Foias (1987), the tripod cylinder appears to be a pan-Mesoamerican form that developed distinct local variants.

Much closer ties can be seen between the Oxkintok Regional complex and the ceramics of the Maya highlands and central lowlands. Two types belonging to the Oxkintok Regional complex (Chactún Crema Delgado and Chactún Crema Gubiado), particularly those examples with gouged decorations, closely resemble Ivory ware from Kaminaljuyu. The pastes of the Oxkintok types, however, are completely different, suggesting that they are local imitations. Another possible connection with Kaminaljuyu and other sites in the highlands of Guatemala is the use of bat iconography. Bats appear on pottery at Kaminaljuyu beginning in the Late Preclassic, and bat iconography dating to the middle of the Classic period seems to be restricted largely to the Guatemalan highlands, Copán, and northwest Yucatán.

Connections with the central Maya lowlands can also be seen in the Oxkintok Regional complex. Two groups of imported ceramics, Mudanza and

Balanza, come from this region. There also are parallels between the Hunab-chén and Kochol groups of Oxkintok and the Aguila Red-Orange and Pucté groups of the central lowlands. Finally, the lid of a tripod cylinder from Oxkintok Tomb 4 has a handle in the form of a water bird. Very similar depictions are known from Tikal, Uaxactun, and Kaminaljuyu (Varela Torrecilla 1998:193, figura 3.113b).

The *Talud-Tablero* Form in the Architecture of Oxkintok

Ceramics of the Oxkintok Regional complex were found associated with pyramidal structures decorated with *taludes* and *tableros*. These include Structures MA1 (Figure 10.3), DZ8-sub, and CA4. More recently, Ricardo Velázquez Valadez has identified other structures containing the form. The presence of *talud-tablero* architecture links Oxkintok to other large sites in the Maya highlands and lowlands, and also to the complex pan-Mesoamerican interaction network of the late fourth to sixth centuries. At Oxkintok, *taludes* and *tableros* are found on structures built in the Proto-Puuc A style. On a regional level, the style is concentrated in the south to west Puuc zone, with additional examples found at Uayalceh, Yaxcopoil, Acanceh, Ti-ho, Dzibilchaltun, and Ixil—all located in the plains north of Oxkintok.

In the Maya area, the regions that contain the greatest concentration of *talud-tablero* architecture are the central highlands and central Petén of Guatemala. According to Paul Gendrop (1984:16), "provincial modalities" of the form developed in the southern zone and appear to have radiated to the northern lowlands. In the latter region, examples are found on pyramidal, palace, temple, and altar platforms. They are characterized by the combination of a framed *tablero* with an apron molding and plinth, but Structure 612 of Dzibilchaltun is built in a more typically Teotihuacan fashion (Andrews 1981:325–326) and some *tableros* are not framed.

The apron molding originated in the Maya area. It appeared for the first time around 100 B.C. and is found at a wide variety of Late Preclassic sites, including Uaxactun, Tikal, Chiapa de Corzo, and Acanceh. In contrast, the framed *tableros* of Oxkintok and other northern sites appear to derive ultimately from the Tlaxcala-Teotihuacan tradition. Similar framed *tableros* are found at Kaminaljuyu, Tikal, Copán, Tazumal, and Becan in the Maya highlands and central lowlands. As discussed by Laporte (Chapter 7), the earliest Maya structures containing framed *tableros* date to the late third century A.D., but most were built during the late fourth to sixth centuries (Chapters 3 and 5). During the Late Classic at Tikal, additional *talud-tablero* structures

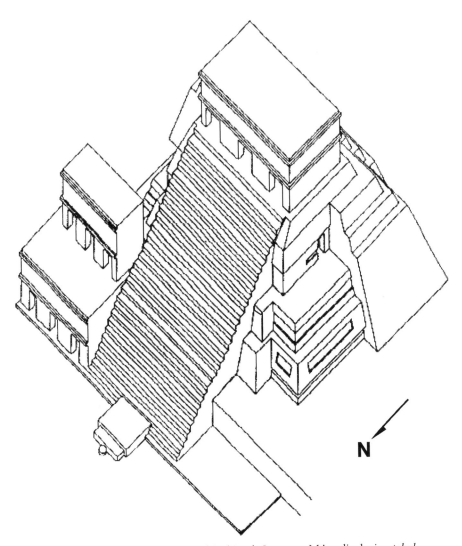

N

FIGURE 10.3. Ideal reconstruction of Oxkintok Structure MA1, displaying *talud-tablero* style of Structure MA1-sub (redrawn from an illustration by Alfonso Muñoz).

were built or modified by adding a cornice in order to produce the *atadura* (cinch) profile typical of Veracruz (Chapter 7; Kubler 1984:81). In northwest Yucatán, however, structures containing the *talud-tablero* form were typically abandoned or covered with Late Classic architecture of the Proto-Puuc B and Early Puuc styles.

Many early examples of the *tablero* at Tikal do not pass completely around a structure (Chapter 7; Laporte 1989:135–136). Instead, the form is limited to

the front or the front and sides, where it merges into the mass of the platform. Partial *tableros* are also found at Oxkintok and Dzibilchaltun, strengthening the suggestion that their appearance in the northern lowlands should be attributed to interaction with the Petén.

The relative heights of *talud-tableros* vary from site to site and sometimes within a particular site. At Matacapan and Kaminaljuyu, proportions of 1:1 apparently are the rule. Early *talud-tableros* at Tikal share this proportion, but later versions were built with a 1:2 ratio. At Oxkintok and Dzibilchaltun, the relative proportions range from 1:2 to 1:2.5. Like Tikal, Teotihuacan experimented with different proportions, with examples ranging from 1:1.3 to 1:2.6 (Chapters 4 and 12; Santley 1987). Thus, the *talud-tableros* of the northern lowlands have proportions that are more similar to those of later structures in the Petén and some examples from central Mexico than they are to those of the Gulf Coast and the Maya highlands.

In sum, the *talud-tablero* structures of Oxkintok and other sites in northwest Yucatán suggest that (1) the local manifestation of the form is a "provincial modality" in the sense used by Gendrop (1984); and (2) the form probably diffused northward from the Petén, where the apron molding developed during the Late Preclassic period,[1] and where framed *tableros* were used at an early date to decorate the fronts and sides of platforms.

We do not know why the *talud-tablero* and tripod cylinder appeared later in northwest Yucatán than they did in the central lowlands and the Maya highlands. It is conceivable that our absolute chronologies for the relevant architectural styles and ceramics of Oxkintok are in error. Late dates for the Early Oxkintok architectural style and associated Early Classic polychrome ceramics derive from the carved lintels of Oxkintok, none of which were found in their original contexts. They may have been set originally in structures built in the Proto-Puuc A style, and hence precisely date the construction of *talud-tablero* buildings. Some tenuous support for this position comes from Hieroglyphic Stair 1, which provides access to the Dzib group. The date of 6 Kawak "completion of" Yaaxk'in on the stair is consistent with a Long Count date of 9.5.3.2.19 (A.D. 537; García Campillo 1994:712). Moreover, José Miguel García Campillo (personal communication 1993) suggests that the calligraphic style of the stair is contemporary with or slightly later than that of the Early Classic lintels. The Dzib group contains a *talud-tablero* structure that is roughly contemporaneous with Hieroglyphic Stair 1, so it is possible that the *talud-tablero* form was already in use at Oxkintok at the beginning of the sixth century. A radiocarbon sample and a hieroglyphic inscription from Dzibilchaltun Structure 1-sub date that *talud-tablero* building

to the beginning of the sixth century. Thus, although no radiocarbon dates have been determined for Oxkintok, it is reasonable to date the appearance of the *talud-tablero* form in northwest Yucatán and the beginning of the Oxkintok Regional phase to about A.D. 500.

Other Artifacts

Obsidian. A total of ten obsidian artifacts were found in Tombs 1, 4, and 5 (the three richest tombs) and the two looted tombs of Structure CA3. No obsidian was found in Tombs 2 or 3 (those that flank Tomb 4) or in Offering 8. All ten pieces are gray in color, and a comparative analysis indicates that the primary source of the material probably is El Chayal, Guatemala. Although the obsidian from the tombs should be sourced, green obsidian—frequently cited as indicating interaction with Teotihuacan—is notably absent from these primary contexts.

Fifty-three additional obsidian artifacts were recovered from a midden deposit called MA-PB3 (May Group, Basal Platform, Pit 3). This deposit, which dates to a time late in the Oxkintok Regional phase, was discovered by extending Brainerd's original trench. All of the obsidian artifacts in this context are gray. We have analyzed fifty-two of the fifty-three artifacts, and have identified them as coming from El Chayal (N=42, 81%), San Martín Jilotepeque (N=8, 15%), and Ixtepeque (N=1, 2%)—all sources located in the highlands of Guatemala. A single piece (2%) closely resembles material from the Zaragoza, Puebla, source area, but should be chemically sourced. Zaragoza is near the important city of Cantona, and material from the source was traded extensively down the Gulf Coast during both Classic and Epiclassic times. The presence of this blade fragment, therefore, probably should not be attributed to Teotihuacan. Instead, it may reflect the participation of Oxkintok in a Gulf Coast trade network spreading from central Veracruz to northwest Yucatán.

We have analyzed an additional 487 obsidian artifacts excavated by our project. Although 58 percent of this material comes from six central Mexican sources, both contextual and technological data support a Terminal Classic to Early Postclassic date for the exotic obsidian. Of the 170 blade fragments made of Pachuca green obsidian, 39 are proximal fragments. An additional 63 proximal fragments come from the Ucareo, Zaragoza, Paredón, and Otumba sources, also located in highland Mexico. All 102 proximal blade fragments of exotic Mexican obsidian have pecked-and-ground platforms, a technological innovation that appeared in both central Mexico and the Maya region at about A.D. 800. In contrast, obsidian blades produced at

Classic-period Teotihuacan have simple facet platforms. Such platforms—also seen on late Early Classic Pachuca obsidian found at Kaminaljuyu and Copán—are *not* found on central Mexican obsidian blades in the Oxkintok collection. This may be taken as very strong technological evidence that exotic obsidian blades—with the exception of the possible Zaragoza artifact in the midden—date to a time *after* both the Oxkintok Regional phase and the decline of Teotihuacan. The suite of Mexican sources in the collection and their relative frequencies also strongly support a Terminal Classic to Early Postclassic date.

Green obsidian was first used at other sites in the Maya lowlands by the Late Preclassic and occurs in all periods through the Terminal Classic (Chapter 9; Moholy-Nagy 1999a; Moholy-Nagy and Nelson 1990; Moholy-Nagy et al. 1984). Pachuca obsidian is rare (usually no more than 2% of an assemblage) before the Terminal Classic and is typically found in elite ritual and ceremonial contexts, particularly burials (Spence 1996a). Some green obsidian, however, has been found in domestic contexts. Given the wide if sparse distribution of Pachuca obsidian in contexts dating to before, during, and after the period for which we have other material evidence of interaction with Teotihuacan, it should not be assumed that all green obsidian found at Maya sites implies contact with the great highland city. In any event, no green obsidian has been found in Oxkintok Regional–phase contexts.

Chert. Only four chert artifacts come from primary contexts dating to the Oxkintok Regional phase. Two of these are projectile points from Tomb 2 and a second context (PP-10/III). Additionally, two primary decortification flakes were found in the MA-PB3 midden. Chert is locally abundant and found in the form of nodules embedded in limestone. The earliest chert artifacts found so far at the site date to the Early Classic, and use was common through the Terminal Classic period. Curiously, the projectile point from Tomb 2 is the only one in any of the eleven tombs excavated by the Proyecto Oxkintok.

Jadeite. Jade can be considered an indicator of wealth and is found in elite ritual and ceremonial contexts. The jade used at Oxkintok almost certainly was imported from a source near San Cristóbal Acasaguastlán in the Motagua Valley of Guatemala. The importation and use of this material at Oxkintok began during the Early Classic period (Offering 4), but elaborate mosaic masks of jade were made only during the Oxkintok Regional phase. Such masks were recovered from Tombs 1 and 5. At other Maya sites—including Tikal, Abaj Takalik, Palenque, Río Azul, and especially Calakmul—mosaic jade masks were interred in elite burials dating from the Early to Ter-

minal Classic. The presence of such masks at Oxkintok ties the site to the central and southern lowlands and also to the Pacific piedmont of Guatemala. They also suggest that the Oxkintok Regional phase was a particularly prosperous period in the history of the city.

Other jade artifacts were recovered from Tombs 1, 3–5, and one of the looted tombs in Structure CA3. They include beads of various forms, anthropomorphic pendants, zoomorphic plaques, celts, disks, and earspools. All of the forms and decorative motifs are characteristically Maya. A zoomorphic plaque from Tomb 1 somewhat resembles a pendant that was found at the head of Skeleton 1 from Kaminaljuyu Tomb B-I (Kidder et al. 1946:Figure 149b).

Throughout the Maya region, the distributional range and quantity of jade found in tombs increased considerably during the fifth and sixth centuries A.D. This can be interpreted as an indicator of expanding trade, a sign of the increased wealth of members of the elite class, or an indication of growing political complexity.

Cinnabar. The Maya frequently used cinnabar (the mineral mercuric sulfide, also called vermilion) in funeral ceremonies and rituals of regeneration, almost certainly because the red color of the mineral suggests blood and life. It is particularly common in royal burials, but quantitative data of the sort needed to determine if its use increased over time have not been assembled. The closest known source of cinnabar is in the highlands of Quetzaltenango, but it is probable that other deposits exist in the Guatemalan highlands (Lou 1994:117). Other sources are found in the mountains of Honduras, and the distribution of "poison bottles," a rare ceramic form in which traces of mercury have been found, is concentrated in the southeastern Maya region. These vessels probably were receptacles for cinnabar.

Cinnabar was found in two of the tombs dating to the Oxkintok Regional phase. In Tomb 4, the mineral was found embedded in the zoomorphic handle of the cover to a tripod cylinder. In Tomb 5, it was found on an intentionally broken mosaic jade mask. The use of cinnabar at Oxkintok implies interaction with the Maya highlands of Guatemala or inhabitants of western Honduras. Smyth (2000) reports five "poison bottles" associated with burials at the Puuc site Chac II. Descriptions of these vessels indicate that they are very different from the "poison bottles" of Honduras and southeast Guatemala, but their general shape and context suggest that they may have served a similar function.

Shell. Marine shell was used at Oxkintok throughout the occupation of the site to make ornaments. In a recent review of malacological data from

Oxkintok, Rafael Cobos (2001) has identified a total of eleven species, all but two from the nearby coast of northern Campeche. But only two species, *Spondylus americanus* and *Oliva reticularis,* have been identified in contexts dating to the Oxkintok Regional phase. A total of 351 artifacts manufactured of *S. americanus* were found in each of the five numbered tombs, the two looted tombs, and the offering. All are beads, pendants, or other perforated adornments. The greatest quantity from any one context is a collection of 273 small beads from one of the looted tombs in Structure CA3. Two small pendants of *O. reticularis* were recovered from the other looted tomb. Finally, two unmodified fragments of *S. americanus* were recovered from the midden MA-PB3.

S. *americanus* was traded to Oxkintok from the north coast of Yucatán. Artifacts made of *S. americanus* are commonly found in Late Classic sites throughout the northern lowlands, the Petén, Belize, and western Honduras (Moholy-Nagy 1963). It is curious that, with the exception of the two ornaments made of *O. reticularis,* species native to the nearby Campeche coast were not used during the Oxkintok Regional phase. Moholy-Nagy (1963) notes a more dramatic shift in procurement patterns at Tikal. During the Early Classic period, most species in the shell assemblage came from the Pacific. In contrast, Atlantic (including the coasts of Campeche, Yucatán, and the Caribbean) species were used more commonly during the Late Classic period.

Interaction and Problems of Evidence

An appraisal of the artifacts recovered from contexts dating to the Oxkintok Regional phase reveals that interregional commerce was oriented toward the Maya highlands. Goods like jade, cinnabar, and obsidian came from this region; two ceramic types appear to be copies of Ivory ware from Kaminaljuyu; and the use of bat iconography suggests ties with the Maya highlands of Guatemala and Honduras. Also important were connections with the central Maya lowlands. Pottery belonging to the Mudanza and Balanza groups was imported from that region, and two locally produced ceramic groups exhibit close parallels with groups from the central lowlands.

Nonetheless, an important change of the Oxkintok Regional phase was that potters of Oxkintok ceased making polychrome pottery in the Petén tradition. The absence of polychromes is one of the important hallmarks of the ceramic complexes of later periods in northwest Yucatán. Thus, it seems likely that interaction between the Puuc and the central lowlands began to decline at the end of the Early Classic period.

Participation in an interaction network extending to other parts of Mesoamerica may be seen in the adoption of the framed *tablero,* the cylindrical tripod vessel, plain slab ceramic supports, and the "coffee" bean and face appliqués found on some pottery. With the exception of the framed *tablero* of the Tlaxcalan-Teotihuacan tradition and perhaps the tripod cylinder (cf. Foias 1987), the ultimate origin of each of these material traits is unknown. Nor is the immediate source from which Oxkintok received these ideas known, but some data suggest that it was the central Maya lowlands and highlands. Most important, the mechanisms of interaction that brought these material traits to the northwest Petén are not understood. Direct and sustained interaction with Teotihuacan seems quite unlikely because no items—such as green obsidian from the Pachuca source or Thin Orange ware from Puebla—have been found in Oxkintok Regional–phase contexts. We can say, however, that manifestations of foreign traits were limited to public displays of rank and power, particularly the construction of monumental architecture and the burial rituals of elites. Moreover, each trait was subject to the processes of adoption, adaptation, and innovation. What we see is not a "site-unit intrusion" where foreign styles, technologies, fashions, and motifs replaced local ones. Instead, evidence from Oxkintok suggests that exotic concepts were incorporated with local ideas in new ways.

Burial patterns of the Oxkintok Regional phase exhibit important innovations. Although our sample is too small to assert that the pattern is typical of the period, the triadic form—elite tombs flanked symmetrically to east and west by interments with less elaborate grave goods—seems to be unique to Oxkintok. It also is important that the mortuary furnishings of this period are, in general, more elaborate than in earlier times. T. Patrick Culbert (1994) has observed that fourth- and fifth-century burials in the southern and central lowlands became richer in the quantity of vessels, shell, and jade that accompanied the deceased. This observation can be extended to Oxkintok during the Oxkintok Regional phase.

Analysis of the distribution of Proto-Puuc A architecture in northwest Yucatán and its association with ceramics of the Oxkintok Regional complex has revealed two problems. First, there may be a mismatch in the proposed chronologies of the Puuc region and the northern plains of Yucatán (Varela Torrecilla 1998:221–225). In particular, it appears that architecture at Dzibilchaltun dated to the Copo I phase (defined as A.D. 600–800) is contemporary with Proto-Puuc A and B architecture at Oxkintok (A.D. 500/550–700). Perhaps dates given to buildings of this style at one or both sites are incorrect. Alternatively, the style may have diffused slowly from the

Puuc region to the northern plains.[2] A much greater problem is that there are no published ceramic sequences for other sites where Proto-Puuc architecture is found. Most have seen little investigation. It should be noted that twelve sites with Proto-Puuc architecture are located in a band to the south of Oxkintok, near the natural corridor of the Campeche coast. Sites in this region that particularly require investigation are Bakna, Kanki, Xkaxtun, Cacabxnuc, and Chelemi. Elsewhere, Xkukican and the North Acropolis of Uxmal should be studied. An understanding of the transition from the Early Oxkintok to Proto-Puuc style at these sites would allow us to study with greater precision the processes of change that occurred throughout the region during the sixth century.

Conclusions

The historical problem at the root of the "Middle Classic" is the transition to state-level polities. It now is widely recognized that complex states emerged in the central and southern Maya lowlands long before the fourth to sixth centuries, and the notion that such developments should be attributed to the intervention of Teotihuacan in the political affairs of the Petén is thoroughly discredited (Chapter 1). Nonetheless, the first states of northwest Yucatán emerged at a relatively late date. It still is valid to ask if Teotihuacan played a role in political development in this region.

Excavations at Oxkintok have revealed that during the sixth century A.D., this already large site became much more prosperous. A great increase in wealth is evident in the scale of monumental architecture constructed at that time, in sculpture, and particularly in the grave goods found in elite tombs. It seems quite likely that during the Oxkintok Regional phase, an elite class of rulers consolidated power and wealth within their realm and transformed the political system of the region into a centralized and hierarchically organized state.

Throughout Mesoamerica the accumulation of wealth and social prestige began in the Early Preclassic period. Even in early times, certain important sites in distinct regions—such as the Basin of Mexico, Oaxaca, central Veracruz, the Petén, the northern lowlands, and the Maya highlands—engaged in intermittent contact. Over time, some of these interactions became more regular, direct, and intense. The autonomous political groups that engaged in this interaction can be called "peer polities" in the sense used by Colin Renfrew (1986).

The widespread distribution of specific goods, architecture, and iconographic motifs associated with power during the fourth–sixth centuries A.D.

may be the result of a long-term process that began first at centers where centralized power was already established: Teotihuacan, Monte Albán, Tikal, Copán, and Kaminaljuyu. Over the course of time, other sites in regions with simpler political systems began to participate in this interaction network. They too emerged as new and vital states. We see sixth-century Oxkintok as an example of this second set of sites. There is sufficient evidence to propose that at this time, local social and political systems became elaborate enough to stimulate the genesis and development of the Puuc region. At Oxkintok, it is likely that participation in the international system—which included not only Teotihuacan but also polities in the central lowlands and Maya highlands—resulted in the introduction of new ideas that were used by local elites to reformulate existing political, social, and economic systems. This began a process of strengthening centralized power that culminated during the eighth-century reign of the Oxkintok king Walas.

Ceramics are one of the most sensitive indicators of this process. Three important changes—the cessation of the manufacture of polychromes, the development of hard-paste ceramics, and the standardization of production—date to this phase. The production of large quantities of highly standardized pottery was an important economic change that most likely reflects the establishment of a centralized power controlling ceramic production at Oxkintok (Varela Torrecilla and Montero 1994).

It should be stressed that participation in the pan-Mesoamerican exchange system increased over time, reaching its peak at Oxkintok long after the decline of Teotihuacan. Most of the obsidian consumed in the city during the Terminal Classic/Early Postclassic was imported from central Mexican sources. Sculpture carved during this late period exhibits eclectic iconographic motifs, but the carved monuments of the Oxkintok Regional phase do not. Thus, the sixth century should be viewed as the beginning of Oxkintok's participation in a far-flung interaction network. As first Teotihuacan and then cities in the central lowland waned, sites like Oxkintok began to interact with new, emerging partners in other regions.

Participation in this international system was not uniform across the Maya region. Many more ceramic imports from other parts of Mesoamerica have been found at Early Classic sites in the Guatemalan Pacific Coast, highlands, and central lowlands. Moreover, there is greater evidence for the development during the fourth to sixth centuries of an eclectic iconography in these regions than in northwest Yucatán. Why these differences existed is one of the key questions still to be answered.

Acknowledgment

We thank our friend Clifford Brown for his expert help in translating from Spanish a portion of a previous version of this chapter.

Notes

1. The Pyramid at Acanceh, which dates to the Late Preclassic period, also contains apron moldings. It might be, therefore, that the architects who built the *talud-tablero* structures of northwest Yucatán were already familiar with local antecedents of the apron molding.

2. A similar temporal discrepancy has been noted by E. Wyllys Andrews V (1981:332, Figure 11–1) for the appearance of later Puuc-style architecture at Dzibil-chaltun. Rather than arguing for contemporaneity of the style in both regions, he interprets the time lag as real.

Tetitla and the Maya Presence at Teotihuacan

Karl A. Taube

The great metropolis of Teotihuacan by no means stood alone in aloof isolation. Rather, it participated in direct and sustained contact with many regions of Early Classic Mesoamerica. Other chapters in this volume focus on Teotihuacan interaction with the Maya area, but Teotihuacan influence also is evident among Classic cultures of the Gulf Coast, Oaxaca, Michoacán, Guerrero, and Colima (see Marcus 1983b; McBride 1969; Noguera 1944; Ortiz and Santley 1998; Winter 1998). Evidence of this contact is not limited to portable objects, such as ceramics, but can also be discerned in architecture, monumental art, and even Teotihuacan texts that are found far from the Basin of Mexico (see Taube 2000a). But aside from its extensive web of influence, Teotihuacan truly was a cosmopolitan and multiethnic city, containing people from the Gulf Coast, Oaxaca, and both Michoacán and Guanajuato in western Mexico (Cabrera 1998b; Gómez C. 1999; Rattray 1987a; Spence 1992). Despite the keen interest in Teotihuacan influence in the Maya region, there has been relatively little discussion of a Maya presence at Teotihuacan, a topic that directly bears upon our understanding of the political and cultural relations shared between Teotihuacan and the Classic Maya. As a point of departure, this study focuses upon one particular apartment compound at Teotihuacan, Tetitla, located near the Great Compound some 600 m west of the Street of the Dead. Although I do not argue that Tetitla was a Maya "barrio," murals, portable objects, and even phonetic Maya texts from the compound point to a strong Maya presence.

Previous Documentation of Maya Material at Teotihuacan

Locally manufactured and imported objects in a Maya style have been documented at Teotihuacan since the first systematic study of archaeological finds at the site. In his 1904 study of Teotihuacan, Eduard Seler (1990–1998, 6:195, 197) described a pair of ceramic *almenas* covering infant burials. Although Seler noted that one *almena* is in pure Teotihuacan style, he was at a

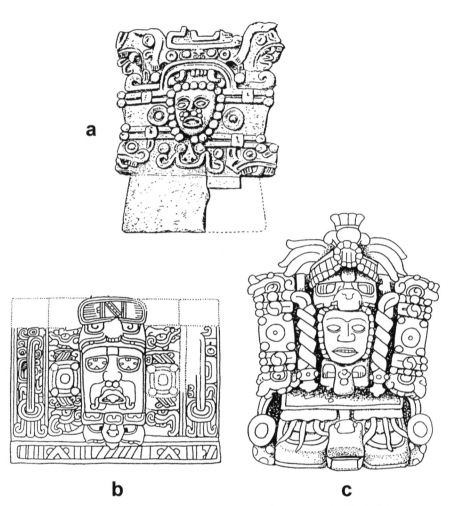

FIGURE 11.1. Comparison of Teotihuacan ceramic *almena* to Early Classic Maya art: (a) ceramic *almena* plaque discovered near the Pyramid of the Sun (from Seler 1990–1998, 6:198); (b) stucco façade from Kohunlich, Quintana Roo (from Taube 1998b:Figure 14b); (c) ceramic censer with royal ancestor atop zoomorphic mountain (after Hellmuth 1987:Figure 639).

loss to identify the other piece (Figure 11.1a). Thanks to more recent discoveries of ceramic vessels and architectural façades in the lowland Maya area, it is now readily apparent that this second *almena* is Early Classic Maya in style; it features a frontally facing Maya lord wearing an elaborate headdress complete with a zoomorphic chin strap and elaborate earspool assemblages (cf. Figure 11.1b–c). Because this image was fashioned on a Teotihuacan-type object, an *almena* plaque, it is likely that the piece was made locally at

Teotihuacan (for a discussion of Teotihuacan ceramic *almenas*, see Cook de Leonard 1985; Gendrop 1985).[1]

Other Maya-style pieces at Teotihuacan are clearly imports from the Maya region. In his monumental work *La población del Valle de Teotihuacán*, Manuel Gamio (1922, 1:lámina 132a) illustrated a magnificent Late Classic jade plaque of a *"deidad maya"* reportedly found at Teotihuacan and now in the British Museum collection. As Adrian Digby (1972:30) notes, this style of plaque corresponds to the Nebaj region of highland Guatemala. Given the plaque's relatively late date and vague attribution, it is by no means certain that the British Museum jade was discovered at Teotihuacan. Nonetheless, other imported Maya artifacts have been recovered from clear archaeological contexts at the site. During his 1932 excavations at Xolalpan, in the eastern side of the city, Sigvald Linné (1934:Figures 127–130) discovered Early Classic pottery sherds that he identified as Maya in style. One of the more intact specimens, a fragmentary bowl, portrays a human head emerging from the open mouth of a serpent (Figure 11.2a). In view of the woven headband and flower diadem, it is quite likely that this being is the youthful Maya wind god, appearing as patron of the month Mak, and the personified form of the number 3 and the day name Ik' (Figure 11.2b; see Taube 1992b:59–60). On another fragment, a probable Maya sun god holds an object with an attached pendant in his outstretched hand, a common convention in Early Classic Petén-style art (Figure 11.2c–e). In his subsequent excavations at the nearby Tlamimilolpa compound, Linné (1942:178) reported sherds from four Maya polychrome vessels, identified as Early Classic Petén ware by George Vaillant. Two of the vessels are basal-flange bowls, a common form of Early Classic Petén-style ceramics (Linné 1942:Figures 331–332, Plate 2).

Immediately south of the Tlamimilolpa compound lies the Merchants' Barrio, in the areas known as Mezquititla and Xocotitla in the contemporary community of San Francisco Mazapan (Rattray 1987a, 1989). The Merchants' Barrio is perhaps best known for its round structures, and although such buildings are in striking contrast to the typical domestic architecture of Teotihuacan, they are well documented for the Gulf Coast region. Evelyn Rattray (1987a:261) notes that the Merchants' Barrio contains the highest concentration of foreign pottery known for Teotihuacan, the majority of which derives from the Gulf Coast. Ceramics from the lowland Maya region are also found in significant quantities. According to Rattray (1987a:266), the southern portion of Xocotitla contains four times more Gulf Coast pottery than Maya sherds. Among the lowland Maya ceramics are Petén Gloss ware and basal-flange bowls of Dos Arroyos Orange Polychrome (Rattray

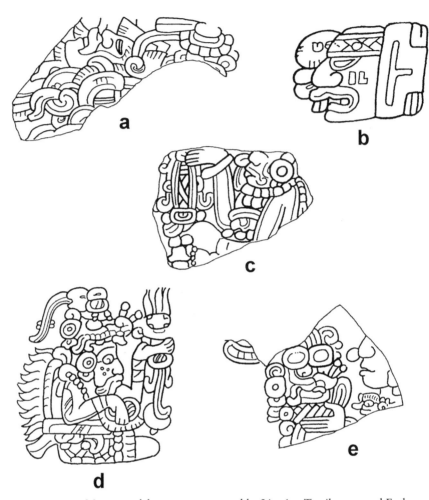

FIGURE 11.2. Maya vessel fragments excavated by Linné at Teotihuacan and Early Classic Maya imagery from Tikal: (a) bowl sherd with youthful god in maw of Bearded Dragon (after Linné 1934:Figure 130a); (b) portrait glyph of wind god with large flower on brow, Tikal Stela 31; (c) vessel sherd with probable sun god presenting offering (after Linné 1934:Figure 129); (d) Maya deity presenting offering, detail of fragmentary vessel from PNT-21 (after Laporte and Fialko 1995:figura 53); (e) fragmentary sculpture of figure presenting offering, Miscellaneous Stone 109, Tikal (after Jones and Satterthwaite 1982:Figure 66s).

1989:123). As in the case of the Oaxaca Barrio, where Zapotec-style pottery was fashioned from local Teotihuacan clay, many of the foreign-style vessels found in the Merchants' Barrio are copies of foreign ones. Many of these, including a magnificent Early Classic Maya vessel recently discovered by local residents in the general area of the Merchants' Barrio, are of very fine quality

(e.g., Figure 11.10g). The Merchants' Barrio also has notably high concentrations of jadeite and chert, the latter possibly deriving from Belize. The jadeite almost surely came from the Motagua Valley of Guatemala, the only documented source of this stone in Mesoamerica (Harlow 1993). The amount of chert and jade found in the Merchants' Barrio surpasses the total amount previously documented at Teotihuacan (Rattray 1989:124).

According to Rattray (1989:111), the strongest foreign influence in the Merchants' Barrio occurred during the Early Xolalpan phase (c. A.D. 400–550), the period contemporaneous with the round structures. During Late Xolalpan times (c. A.D. 550–650), these buildings were overlaid with quadrangular constructions typical of Teotihuacan.[2] Rattray (1989:125) correlates this phase with the well-known compound excavated by Linné at Tlamimilolpa. She also notes a still earlier phase in the Merchants' Barrio, corresponding to the first documented occupation of the area (Rattray 1987a:261). The ceramics of this initial phase are not of a local style, but are related to Late and Terminal Preclassic Maya types. This is not the only example of early Maya pottery at Teotihuacan. Excavations in the Pyramid of the Sun revealed lowland Maya Chicanel-phase sherds (Smith 1987:67). According to George Cowgill (personal communication 1999), these sherds can be contextually dated to the first century A.D.

Although the occurrence of imported vessels and other exotic goods may result from indirect contact, foreign-style architecture and local copies of exotic vessels indicate more direct interaction, including the likely presence of foreigners at Teotihuacan. The same can be said for foreign texts and art appearing on nonportable objects such as stone monuments and, especially, mural painting. An excellent example is the Zapotec date appearing on the stone tomb jamb from the Oaxaca Barrio (Berrin and Pasztory 1993:Catalog Number 175). In addition, a mural from Room 4 of the North Patio at Atetelco depicts pairs of turbaned individuals seated on mats with drinking vessels, recalling Classic Zapotec scenes of marriage (see Cabrera 1995:Plates 61–69). At Teotihuacan, the La Ventilla ballcourt marker and numerous murals display the interlace scroll designs of Classic Gulf Coast art (Aveleyra Arroyo de Anda 1963; de la Fuente 1996).[3]

In addition to Zapotec and Veracruz traits, Maya influence can also be detected in murals at Teotihuacan. Arthur Miller called attention to a looted mural formerly in the Sáenz collection:

> Although the Saenz mural is unmistakably Teotihuacan in such fundamental aspects as pictorial composition, style, and painting tech-

nique, it is blatantly non-Teotihuacan in the forms of the costumes and hats and in its possibly Maya subject matter. (1978:69)

In view of the seed-marked conical head and cranial foliation on one of the two figures appearing in this mural, it can be identified as an Early Classic form of the Maya maize god (Figure 11.3a). The wildly gesticulating, dancing pose of this figure recalls a series of winged maize gods appearing on an Early Classic Maya ceramic bowl (Figure 11.3b). The arms of the figure display green "god markings," a Classic Maya convention showing greenstone celts placed against the body (see Taube 1996:50). The limbs are bordered by thin, parallel lines. Although this convention is often noted for El Tajín bas-relief carving, it is also common in Early Classic Maya art (Figures 11.2c–d, 11.3b–c). Both of the figures on the Sáenz mural wear jaguar-pelt kilts, a common costume element of both gods and kings among the Classic Maya.

Although rare at Teotihuacan, the jaguar-skin kilt is worn by a diving avian figure portrayed in murals from the Palace of the Sun in Zone 5-A (Figure 11.3d). Displaying a combination of two birds, this anthropomorphic being has a macaw headdress with a green quetzal crest and tail. Moreover, the series of red macaw heads appearing on the wings, ankles, and tail are tipped with green, the color of the quetzal. This conflation of quetzal and macaw immediately recalls the founder of the Copán dynasty, K'inich Yaax K'uk' Mo', whose name can be glossed as "sun-faced green, or 'first,' quetzal macaw." David Stuart (2000a) notes the decidedly foreign nature of this ruler at Copán, and suggests that he may have come from distant Teotihuacan. The text of Copán Altar Q, which chronicles the arrival of K'inich Yaax K'uk' Mo' at Copán in A.D. 426, also mentions that several days before his arrival, he was known simply as K'uk' Mo' Ajaw, or "quetzal macaw king." As with other name glyphs of the Founder, the sign is an organic conflation of quetzal and macaw, being composed of a macaw head with a quetzal crest (Figure 11.3e). Although the ultimate origins of K'inich Yaax K'uk' Mo' are still a source of debate (see Chapter 5), he is consistently identified with Teotihuacan in the writing, art, and architecture of Copán. The earliest phases of the Copán ballcourt, roughly contemporary with the reign of K'inich Yaax K'uk' Mo', contain stone markers in the form of macaw heads with feather crests, quite like the quetzal-macaw name glyph appearing on Altar Q (cf. Figure 11.3e–f). William and Barbara Fash (1996:132) note that a series of stucco façades from these early phases of the Copán ballcourt probably refer to both the Founder and Teotihuacan. The façades portray a supernatural macaw with the head of the Teotihuacan quetzal-plumed

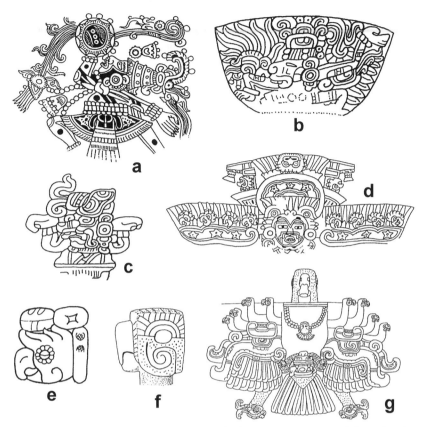

FIGURE 11.3. Teotihuacan mural imagery and Classic Maya iconography: (a) detail of Teotihuacan mural with probable dancing Maya maize god (after Miller 1973:Figures 357–359); (b) dancing avian maize god, detail of Early Classic Maya bowl (after Hellmuth 1987:Figure 577); (c) K'awiil deity with inner arms outlined with parallel lines, Tikal Stela 31 (after Jones and Satterthwaite 1982:Figure 51c); (d) diving quetzal-macaw figure with jaguar-pelt skirt, Palace of the Sun, Zone 5-A, Teotihuacan (after Miller 1973:Figures 107–109); (e) name glyph K'uk' Mo' Ajaw, top of Copán Altar Q; (f) Early Classic Copán ballcourt marker displaying probable conflation of macaw and crested quetzal (drawing by author); (g) stucco façade from Early Classic ballcourt, Copán (drawing by Barbara Fash, from Fash and Fash 1996:Figure 3).

serpent placed in the lower abdomen, thereby conflating macaw, quetzal, and serpent (Figure 11.3g). Although very common at Teotihuacan, the Quetzalcoatl rattlesnake with quetzal plumes covering its entire body is surprisingly rare in Classic Maya art (Nicholson 1987:174, 180). The Copán bird has multiple macaw heads on its wings and ankles, strikingly similar to the Zone 5-A figure at Teotihuacan (Figure 11.3d). Wearing the jaguar-skin kilt

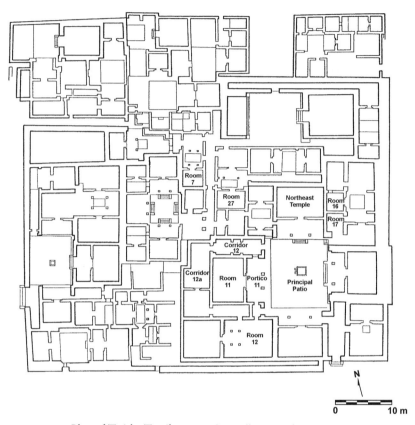

FIGURE 11.4. Plan of Tetitla, Teotihuacan (after Miller 1973:Plan VIII).

of Maya gods and rulers, the avian figure from Zone 5-A may well allude to the Quetzal Macaw lord, K'inich Yaax K'uk' Mo'.

The Murals of Tetitla

By far the highest-known concentration of murals displaying Maya influence occurs in the apartment compound of Tetitla, situated some 600 m west of the Street of the Dead (Figure 11.4). Initial excavations at Tetitla were performed by Carlos Margaín in 1944 and Pedro Armillas (1950:55) in 1945, with Frank Moore (1966) subsequently discovering a burial and other features in 1951. The following year, Agustín Villagra (1954) encountered a fragmentary but extremely important corpus of murals, often referred to as the Realistic Paintings. The remaining portions of Tetitla were excavated in 1963 and 1964 by Laurette Séjourné (1966a, 1966b), who discovered rich burials and many murals of unusual quality and complexity.

Many of the Tetitla murals allude to distant lands and precious materials.

Two of the more famous murals feature youths diving in waves for marine shells. These scenes obviously refer to a foreign place, as the nearest shore is some 220 km distant (see Miller 1973:Figures 274–277). Arthur Miller (1973:31–32; 1978:68–99) notes that a number of the Tetitla murals suggest influence from the Maya region. One such example appears in Room 7 and features a series of old men wearing large bivalves. They are oriented toward a central, frontally facing figure on the south wall (see Miller 1973:268–273). According to Miller, the yellow-red pigment used in the Room 7 murals is more consistent with Late Classic Maya pottery than with the typical color scheme of Teotihuacan murals. In addition, Miller notes that the theme of an old man in a shell appears in Maya iconography. The aged Maya deity known as God N, or Pawahtun, frequently emerges from a shell, although typically from a conch rather than a clam. Miller (1978:69) notes that another Tetitla mural portrays a man seated in a cross-legged pose typical of Classic Maya art (Figure 11.5a). The object worn over his chest probably is a version of the "vomit bib" appearing in Classic Maya scenes of feasting and intoxication (see de Smet 1985:59–60). A different Tetitla mural portrays another figure wearing the same bib while in a drunken state (Figure 11.5b).

The Realistic Paintings of Tetitla

During excavations in 1952, Agustín Villagra (1954) discovered a remarkable body of fragmentary murals in the chambers surrounding Room 11, situated on the west side of the Principal Patio at Tetitla (Figure 11.4). Known as the "Pinturas Realistas," or Realistic Paintings, these fragments were discovered in Corridors 12 and 12a, at the north and west sides of Room 11 (Villagra 1954:figura 1). Their badly fragmentary condition results from the fact that they were on the upper, partially destroyed walls, above the well-known *talud* murals depicting a Net Jaguar before a temple (see Figure 11.15a). Villagra copied some 250 fragments of the Realistic Paintings, but the originals were subsequently lost for many years (Foncerrada de Molina 1980:189). Recently a major corpus of the original murals was discovered in storage at Teotihuacan (Ruiz 1999). Villagra (1954:70) noted that some fragments bore elements comparable to Maya glyphs, and other researchers have noted similarities with Classic Maya writing and iconography (Foncerrada de Molina 1980:189–191; Hall 1962:82–85; Millon 1972:11–12, 1973:288–289; Rattray 1987a:264, 266). There has been little discussion, however, of specific Maya iconographic motifs and glyphs in the Realistic Paintings. In part, this surely is because specialists in Maya writing and art have paid surprisingly little attention to this fascinating body of material. In view of recent break-

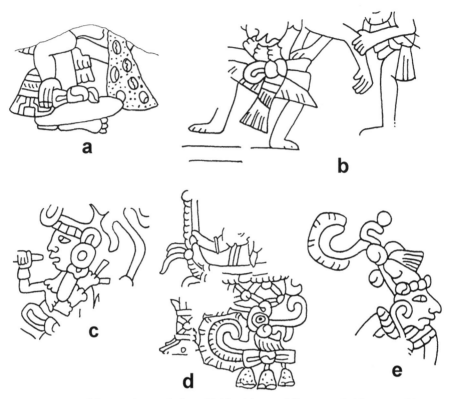

FIGURE 11.5. Maya-style murals from Tetitla: (a) seated figure, probably engaged in vomiting, Room 27 (after Miller 1973:Figures 278–279 and on-site observations by the author); (b–e) figures from Realistic Painting fragments (after Foncerrada de Molina 1980:figuras 16, 20, 21, and 32).

throughs in Maya epigraphic and iconographic research, a reappraisal of the Realistic Paintings is in order.

Many of the human figures appearing in the Realistic Paintings are entirely consistent with Early Classic Maya stylistic and iconographic conventions. In her doctoral dissertation, Clara Millon (Hall 1962:82) noted that the eyes of the figures are pointed in one corner, a common trait in Early Classic Maya art (Figures 11.5c, e, 11.6b–d, 11.7a, d–f, 11.9a, 11.10c, 11.11i, 11.13a, 11.16g–h). Millon also mentioned that a number of the earspools depicted in the Realistic Paintings resemble Maya examples. Many of the figures display a three-part earspool assemblage formed of a capping spiral, the central earspool, and an inverted *ajaw* glyph resembling a *T* in outline (Figures 11.5c). Such assemblages are common in Early Classic Maya art (e.g., Figures 11.2e, 11.3b–c, 11.10g, 11.14e). In addition to the treatment of the eyes and earspools, Millon (Hall 1962:83) noted that many of the figures in

the Realistic Paintings lack upper garments, a trait shared with the afore-mentioned seated figure from Tetitla Room 27 (Figure 11.5a–c, e). Male torsos typically are portrayed fully clothed in the cool and temperate region of Teotihuacan, but men are often portrayed bare-chested in Maya art (e.g., Figures 11.2c–d, 11.6b–d, 11.16g–h).

A remarkable, fragmentary plano-relief vessel in the Museo de la Cultura Teotihuacana portrays a series of seated men wearing Maya-style dress, including hip cloths and large necklaces on their bare upper bodies (Figure 11.6a). Their cross-legged seated pose, with one hand turned sharply back, is wholly Maya (Figure 11.6b–d). Two of the figures appear to be presenting decorated cloth, and another emits a large speech scroll while gesturing with his extended index finger. From the Late Preclassic to Late Postclassic periods, this hand gesture denotes speech in Maya art (Figure 11.6b, d). The Offering Scene mural from the Temple of Agriculture, which shares a number of thematic traits with the vessel scene, also portrays two figures using the same hand gesture (see Miller 1973:Figures 68, 69, and 71), as well as other individuals seated in cross-legged position. Although this early Teotihuacan mural does contain Maya conventions, it also clearly displays Teotihuacan-style elements, including the flanking pair of burning mortuary bundles or effigy censers and the scalloped water band at the base of the scene. The same can be said for the fragmentary plano-relief vessel. Although the seated basal figures do display Maya-style costume and poses, they also retain articles of Teotihuacan dress, including back mirrors and shell goggles on their brows (Figure 11.6a). Both these figures and the Offering Scene mural reflect a cosmopolitan synthesis of foreign and local traits.

I have mentioned that the seated male in Tetitla Room 27 wears the Classic Maya "vomit bib," a probable form of floral bouquet donned for drinking and feasting events. A Late Classic vessel from Burial 196 at Tikal depicts an anthropomorphized hummingbird seated before a basket containing such a bouquet (see Culbert 1993:Figure 84). One Realistic Painting fragment illustrates a man assisting his staggering companion, who wears the floral bib (Figure 11.5b). As Clara Millon (1973:Figure 4, legend) notes, this second figure is clearly drunk. Markedly similar scenes occur in Late Classic Maya representations of feasting and drinking (see Taube 1998a:42). Another mural fragment illustrates a figure with the same floral bib, in this case holding something before his mouth (Figure 11.5c). Although this object may be a wind instrument, such as a flute or a trumpet, a cigar is another likely possibility. These commonly are smoked in Classic Maya scenes of feasting and drinking (Barrera and Taube 1987:Figure 18; Taube 1998a). The theme of

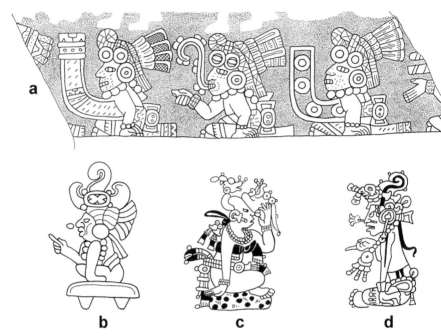

FIGURE 11.6. Maya-style poses and gestures appearing on a fragmentary vessel excavated at Teotihuacan: (a) lower portion of Teotihuacan plano-relief vessel (drawing by author); (b) Late Preclassic Maya lord, Kaminaljuyu Monument 65 (after Parsons 1986:Figure 149); (c) enthroned deity, detail of Early Classic vessel, Uaxactun (after Smith 1955:Figure 1b); (d) Late Postclassic portrayal of Maya wind deity, God H, Dresden Codex p. 12b (after Taube 1992b:Figure 12c).

festive celebration occurs on another fragment, which depicts a Maya hunchback holding a possible rattle (Figure 11.9a). He wears a heavy necklace of jade beads, indicating special status. In Classic Maya courtly life, dwarves and hunchbacks served important roles as dancers and other entertainers.

In addition to scenes of celebration, the Realistic Paintings also portray Maya supernaturals. One fragment depicts an individual seated in the feathered coils of a serpent found in Classic Maya iconography and known as the Bearded Dragon (Figure 11.5d). The beaded skirt worn by the seated figure commonly appears in Classic Maya art, including an Early Classic carved vessel from Tikal (Figure 11.2d). Another fragment portrays a figure with a sharply sloping head marked with a tuft of hair capped with Maya-style maize foliation (Figure 11.5e). In previous research, I identified this being as an Early Classic form of the Maya Tonsured Maize God (Taube 1985:173).

The Realistic Painting Texts

In a ground-breaking study devoted to Teotihuacan writing and iconography, Clara Millon (1973:298–299) tentatively identified a number of the Realistic Painting fragments as examples of Maya writing. Although no direct comparisons were made, three of the illustrated signs can be identified as specific Maya glyphs that also appear on Tikal Stela 31, a monument celebrating the Long Count period ending of 9.0.10.0.0 (A.D. 445; Figure 11.7a–c). One glyph fragment on the Realistic Paintings portrays the four-lobed, solar *k'in* glyph. Another appears to be the sign for *witz*, or "mountain," which often resembles a *kawak* glyph with a convoluted outline (Figure 11.7a–b). This mountain glyph strongly suggests that toponymic references are present in this Maya text (for a discussion of place-names in Maya hieroglyphs, see Stuart and Houston 1994). The third fragment corresponds to the mouth region of the phonetic *ba* rodent sign, with its open mouth, incisors, and cheek hair clearly indicated (Figure 11.7c; see also Figure 11.8a–c, e–f). The Tetitla sign, however, is unusual in one regard—its orientation is reversed. This is a common trait of the identifiable Maya glyphs in the Realistic Paintings (e.g., Figure 11.7d, 11.8a). Stephen Houston (1998:342–343) notes that such reversed texts often occur in Classic Maya architecture, allowing the glyphs to face out from both sides of a doorway. A clear example is the superstructure of Copán Structure 11, which has such pairs of texts on all four of its doorways. Quite probably, the Realistic Painting texts were from the north wall of Corridor 12, that is, to the right as one enters the chamber from the main patio.

In addition to these individual glyphs, two linear Maya texts occur in the Realistic Paintings. One fragment, composed of two glyphic compounds, appears to mark the beginning of a text. To the right is an elaborate border and immediately above is a foot and fragmentary speech scroll. These indicate that a human figure, rather than an earlier portion of the text, is located above the surviving glyphs (Figure 11.7d). When the first compound is reversed, a *yaax* sign prefix can be discerned, with the other Maya signs tentatively identified as a phonetic *nu* superfix, a possible *te* sign, and still further below, a glyph resembling a bird wing (Figure 11.7c). The bird wing has the phonetic value of *ch'i* in the Classic Maya script (see Houston et al. 1989). The *yaax* sign, meaning "green" or "first" in Mayan, appears in a rather distinctive form. At Tikal, this spoked shell-like *yaax* variant occurs on stelae with Long Count dates ranging from 9.2.13.0.0 on Stela 3 to a probable date of 9.7.0.0.0 on Stela 17, a temporal span of A.D. 488–573 (Figure 11.7f).

FIGURE 11.7. Comparison of Maya writing from Realistic Paintings and Early Classic Tikal glyphs (Realistic Painting fragments in a–c from C. Millon 1973:Figure 4; Tikal Stela 31 glyphs in a–c from Jones and Satterthwaite 1982:Figure 52b): (a) *witz* signs from the Realistic Paintings (left) and Tikal Stela 31 (right); (b) *k'in* signs from the Realistic Paintings (left) and Tikal Stela 31 (right); (c) *ba* gopher-head signs from the Realistic Paintings (left) and Tikal Stela 31 (right); (d) fragmentary text, Realistic Paintings (after Foncerrada de Molina 1980:figura 18); (e) compound of preceding fragmentary reversed (note *yaax* sign prefix); (f) calendrical compound denoting 13 Yaaxk'in, Tikal Stela 12 (after Jones and Satterthwaite 1982:Figure 18b).

Two vessels with *yaax* signs of this form were discovered in Tikal Burial 195, which also contained a carved wooden box with a reconstructed Long Count date of 9.8.0.0.0 (A.D. 593; Culbert 1993:Figures 50–51). In contrast, the type of *yaax* signs appearing on the earlier Hombre de Tikal and Stela 31, dating to the first half of the fifth century, are not of the spoked form. Thus, the *yaax* sign at Tetitla suggests that the Realistic Paintings roughly correspond to the mid-fifth and sixth centuries A.D. The upper portion of the following compound appears to be an aged human face with deer ears and antlers (Figure 11.7d, far left). It is possible that this sign is the logograph for the Maya god Sip, a hunting god frequently portrayed with aged features and deer ears and antlers (e.g., Figure 11.8e).

The second linear text fragment, again composed of two glyph blocks, can be read with far more success (Figure 11.8a). When the orientation of the fragment is reversed (Figure 11.8b), the text resembles an early form of a glyphic phrase concerning deity impersonation that has been deciphered by Houston and Stuart (1995, 1998). The Late Classic form of the phrase usually is *ubahil*(i) *anum* followed by the name of the impersonated deity, which can be glossed roughly as "(it is) the image of the famous 'god'" (Houston and Stuart 1995:299). Among the impersonated deities mentioned in such texts are the spotted hero twin Hunahpu, Ek' Sip, and the maize god

(Figure 11.8d–f). Although missing the term *anum,* designating "famous," the Tetitla fragment has the phonetic *ba* gopher sign followed by the portrait head of a youthful deity, probably the maize god. As noted above, an image of the Maya corn god appears in the Realistic Painting corpus (Figure 11.5a). My initial interpretation of the Tetitla text was soon confirmed by Stephen Houston (personal communication 1998), who notes the presence of an early form of the *li* syllable below the *ba* sign, a common feature in the deity impersonation statement (Figure 11.8d–f). This mural fragment reveals that the Realistic Paintings contain texts written phonetically in Mayan. I conclude, therefore, that the painter of this text and certain readers at Tetitla were both knowledgeable about Maya glyphs and conversant in Mayan.

FIGURE 11.8. Fragmentary Maya text from Realistic Paintings denoting deity impersonation: (a) Maya text from Realistic Paintings (after Foncerrada de Molina 1980:figura 18); (b) fragmentary text reversed; (c) Early Classic deity impersonation phrase, Hombre de Tikal monument (after Fahsen 1988:Figure 4); (d) Hunahpu deity impersonation phrase, Copán Stela 63 (detail of drawing by Barbara Fash, from Fash 1991:Figure 37); (e) Ek' Sip deity impersonation phrase, Dos Pilas Hieroglyphic Stairway 4 (after Houston 1993:Figure 4-11); (f) maize god impersonation phrase, Yaxchilan Hieroglyphic Stairway 3 (after Graham 1982:Figure 171).

The Serpent Borders

A number of Realistic Painting fragments provide important clues regarding the mural border and its relation to the Net Jaguar scene below (Figure 11.9). The aforementioned hunchback appears on a piece that also contains a border motif of a youthful Maya ancestor or god in the jaws of a snake (Figure 11.9a). This is a common Maya convention (cf. Figures 11.2a, 11.13a). The trefoil brow often appears with Early Classic Maya portrayals of serpents. Its feathered edge is very similar to a serpent headdress appearing on a carved Tikal vessel illustrating contact between Teotihuacan and the Early Classic Maya (see Figure 13, Individual D; Culbert 1993:Figure 128a, Individual D). In addition, the small, parallel lines on the teeth of the lower jaw are a common trait of serpent fangs in Early Classic Maya art. The feather-fringed body and tail of this serpent occurs on three *in situ* mural fragments flanking the interior doorway of Corridor 12. The largest of these, Mural 1 of Corridor 12, occurs on the interior jamb on the north side of the doorway (Figure 11.9d).[4] The tail of another can be discerned in Mural 8 on the corresponding south side (Figure 11.9c). Another, higher portion of Mural 8 appears on the second outer jamb of the doorway. It seems to depict the feathered tip of a serpent tail (Figure 11.9b). The lower part of this piece contains a portion of a mat-and-jade-disk band and feathered "pompon" elements. Below these is part of a temple roof. This border and temple roof are from the series of *talud* murals illustrating the Net Jaguar before a temple or shrine (Figure 11.15a, upper right). The fragment with the hunchback (Figure 11.9a), therefore, reveals that the Realistic Paintings were directly above the Net Jaguar scene. The jade-marked mat and feathered "pompons" are an integral part of the Net Jaguar murals, serving not only as the framing border but also as elements on the accompanying structure (Figure 11.15a). A vertical portion of the same border appears with the aforementioned serpent in Mural 1 of Corridor 12 (Figure 11.9d), indicating that these Maya serpents framed the sides as well as the top of the Net Jaguar scenes.

Although probably from different portions of the mural, two of the serpent fragments provide a general conception of the border motif (Figure 11.10a). The serpent twines around a central pole, portions of which are visible in both the upper and lower fragments. Tikal Stela 1, which dates to the Early Classic period, portrays a serpent similarly embracing—or, perhaps more accurately, climbing—a polelike form (Figure 11.10b). Other Early Classic Maya scenes portray piscine snakes intertwined on horizontal bands (Figure 11.10c–d). This convention represents swimming in water, which

FIGURE 11.9. Border fragments from Corridor 12, Tetitla (black denotes red outline and background); (a) border fragment with Realistic Paintings (after Soustelle and Bernal 1958:Plate 3); (b) border fragment with serpent tail, jade-marked mat, and portion of shrine or temple roof (after Miller 1973:Figure 322); (c–d) serpent borders flanking interior doorway of Corridor 12 (left, from field drawing by author; right, after Miller 1973:Figure 323).

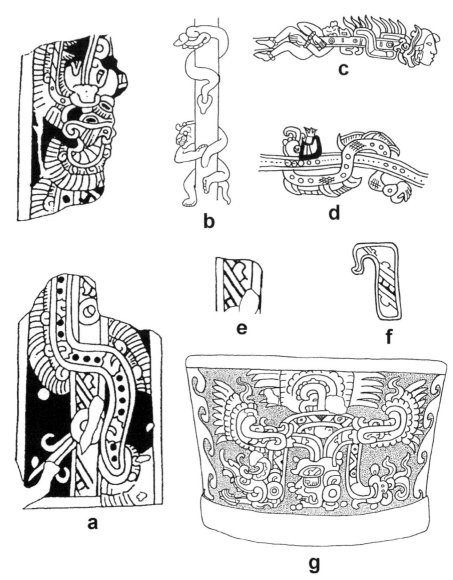

FIGURE 11.10. Reconstructed serpent border from Corridor 12 and Early Classic imagery pertaining to serpents and trees: (a) reconstructed image of plumed Bearded Dragon entwined on sprouting tree (see Figures 11.9a,d); (b) feline and rattlesnake climbing serpent pole, detail of Tikal Stela 1 (after Jones and Satterthwaite 1982:Figure 1a); (c) human figure in water band with plumed, fish-tailed serpent, detail of mold-made vessel (after Schele and Miller 1986:Plate 106a); (d) piscine water serpent entwined in water band, detail of ceramic vessel, Uaxactun (after Smith 1955:Figure 11f); (e) detail of wood markings on Corridor 12 tree (see Figure 11.10a); (f) schematic tree branch with wood markings, detail of carved vessel, Tikal (after Culbert 1993:Figure 31a); (g) Mayoid vessel on display in the Museo de la Cultura Teotihuacana (drawing by author).

may be thought of as a horizontal form of climbing. Thus, one vessel scene depicts a reclining human figure in climbing position on the band of water (Figure 11.10c). In contrast, the Tikal Stela 1 "pole" is the body of a large descending serpent passing through an earspool near the base of the monument (see Jones and Satterthwaite 1982:Figure 1). The Tetitla poles are budding or sprouting, thereby identifying them as trees (Figures 11.9c–d, 11.10a). In fact, the diagonal elements on these trees are Early Classic Maya *te* markings, designating wood and trees (Figure 11.10e). A very similar *te* sign occurs on a schematic tree sign from an Early Classic Tikal vessel (Figure 11.10f). The same markings can be discerned on the vessel discovered near the Merchants' Barrio (Figure 11.10g). Here both the branches and the sun god head constituting the trunk of a supernatural tree display *te* signs. As in the case of the Tetitla Corridor 12 serpents, the snake intertwined in the branches is a tree climber.

The arboreal serpents appearing on the carved vessel and the Corridor 12 murals are the same being, a creature commonly known as the Bearded Dragon in Classic Maya iconographic studies. Along with the frequent feather "beard," other common traits of the Bearded Dragon are a burning or smoking tail and tufts of long feathers on the sides of its body (see Figures 11.5d, 11.10g, 11.11f, 11.13a–b). The lines of dots on the Tetitla serpents probably denote water, and they also appear on Classic Maya water bands and piscine serpents (Figure 11.10c–d). The dots alternate with another water-related motif, a serrated spiral form probably representing a conch (Figure 11.11a). This motif is very similar to conchs appearing in the water bands of Structure A at Cacaxtla (Figure 11.11b). Karl Lorenzen (personal communication 1998) has called my attention to Classic Zapotec shell pendants of similar form (Figure 11.11c).

Rather than referring primarily to water, the cross-sectioned conch is a wind symbol, and as the *ehecailcozcatl,* it served as the pectoral of the Aztec god of wind, Ehecatl Quetzalcoatl. A similar concept was clearly present among the ancient Maya. Zoomorph P at Late Classic Quiriguá portrays the earth crocodile breathing out a pair of water-bearing Chaaks from the corners of its mouth (Figure 11.11g). Each breath volute is spoked, denoting a cross-sectioned conch. Beginning in the Late Preclassic period, Maya crocodilians appear with conch snouts that indicate their wind-creating breath (Figure 11.11h–i). At both Xochicalco and Tula, the cross-sectioned conch appears on the bodies of plumed serpents, personifications of rain-bringing wind (Figure 11.11d–e). The serpents from the Pyramid of the Plumed Serpent at Xochicalco exhale quetzal plumes as their breath, indicating the

FIGURE 11.11. Conch volutes in ancient Mesoamerica: (a) conch element on bodies of Tetitla serpents (see Figure 10a); (b) conch appearing in water band, Building A, Cacaxtla (drawing by the author); (c) cut-shell pendant, Classic Zapotec (after González 1990:figura 49); (d) conch on body of feathered serpent, Pyramid of the Plumed Serpents, Xochicalco (drawing by the author); (e) conch band on body of plumed serpent column, Tula (drawing by the author); (f) plumed Bearded Dragon with conch against side of body, detail of Late Classic Maya vase (after Reents-Budet 1994:Figure 5.60); (g) Chaak with water jar flying in conch-breath volute of earth crocodilian, Zoomorph P, Quiriguá (after Maudslay 1889–1902, 2:Plate 64); (h) Late Preclassic crocodile with conch snout, Izapa Stela 25 (after Norman 1973:Plate 41); (i) Early Classic Maya crocodile with conch snout (after Hellmuth 1987:Figure 598).

wind essence of these feathered beings (see Smith 2000:Figures 4.1–4.2). Similarly, long quetzal plumes commonly appear in Classic Maya portrayals of breath (e.g., Kerr 1997:826, 837). One Late Classic Maya vessel portrays a plumed Bearded Dragon with a spoked conch against its body (Figure 11.11f). At present, however, the Maya Bearded Dragon at Tetitla is the earliest-known example of a plumed serpent with cross-sectioned conchs on its body.

The *Talud* Borders

I have argued that the Tetitla serpents flank the Net Jaguar murals appearing on the lower *talud* walls of Corridor 12 (Figure 11.15a). These *talud* murals have one very unusual detail. The upper horizontal border projects sharply outward from the sloping wall below, creating a pronounced shelf some 10 cm deep on its upper surface (Figure 11.12a). This architectural convention is absent from all other *talud* murals at Tetitla, including the immediately adjacent "Jade Tlaloc" paintings of Portico 11. Displaying a jade-marked mat and pendant "pompon" elements, the projecting portion strongly resembles a horizontal throne with hanging tassels, such as commonly appear in Classic Maya art (Figure 11.12b–c).[5]

Although sloping *talud* murals capped with projecting elements are notably rare at Teotihuacan, a clear example occurs in the well-known feathered serpent and flowering tree murals from Techinantitla (see Pasztory 1988a). In these murals, the projecting upper portion is occupied by a gently undulating, quetzal-plumed serpent showering water upon the glyphically marked plants below. In view of the probable toponymic nature of the plants, I recently suggested that this scene is political in nature and represents a Teotihuacan metaphor of governance as cultivation, "with the polity watering and thereby sustaining smaller, subsidiary districts or communities" (Taube 2000c:26). The relation of the Techinantitla murals to rulership goes much further. Noting that the lower, plant-bearing portion is unusually narrow, Esther Pasztory (1988a:147) and René Millon initially suspected that the Techinantitla murals are early forms of the banquette thrones of Early Postclassic Tula and Chichén Itzá. The projections, however, are narrow shelves, making it unlikely that the Techinantitla murals ornamented functioning banquettes (Pasztory 1988a:147, 154). Nonetheless, in light of the Corridor 12 and Room 12 murals of Tetitla, it is likely that the Techinantitla examples are symbolic portrayals of banquette thrones. In fact, the carved banquettes of Tula and Chichén Itzá have outwardly projecting upper friezes of undulating plumed serpents, corresponding precisely, in both location and theme, to the plumed serpents appearing in the Techinantitla murals (see de la Fuente et al. 1988:figuras 78–82; Morris et al. 1931:Plate 125).

The jade-marked mat in the Tetitla murals is entirely consistent with Mesoamerican concepts of rulership. In both central Mexico and the Maya area, the woven mat was a basic symbol of rulership. As early as the Late Preclassic, mats were portrayed at Kaminaljuyu as lining the edges of Maya thrones (Kaplan 1995:Figures 10–12, and 15). Mat signs ornamented with jade beads or plaques commonly appear in Classic Maya art, including on

FIGURE 11.12. Mat and throne imagery in ancient Mesoamerica: (a) projecting upper portion of Mural 8, Room 12, Tetitla, with outer edge painted with mat, jade, and pendant tassel motifs (drawing by the author); (b) Late Classic Maya throne with pendant tassels, detail of carved column from region of Champotón, Campeche (after Miller 1988:Figure 11.8); (c) portion of Late Classic Maya throne with pendant tassels, detail of Piedras Negras Panel 3 (drawing by the author); (d) mat with jade element, detail of Early Classic stucco façade on display in the Sala Maya of the Museo Nacional de Antropología, Mexico City (drawing by the author); (e) throne with jade elements attached to mat, detail of Naranjo Stela 22 (after Graham and von Euw 1975:55); (f) Teotihuacan glyph of plumed serpent with crown of jade and quetzal plumes atop mat, Techinantitla (after C. Millon 1988:Figure V.5).

royal thrones (Figure 11.12d-e). In addition to being precious, jade was a symbol of kingship in ancient Mesoamerica. Aztec speeches of royal accession refer to the ruler as jade, other precious jewels, and quetzal plumes (Sahagún 1950–1982, 6:47). The same comparison appears in Aztec metaphors for authority recorded by Andrés de Olmos:

A lord is as priceless as:
turquoise, precious stones,
jewels, rich plumage.
He embodies the town.
He is the mat, the throne.
(Maxwell and Hanson 1992:170)

The text subsequently describes the king as an overarching being iridescent in feathers, a probable reference to the plumed serpent, Quetzalcoatl, a basic central Mexican symbol of kingship (Taube 2000c:26). From Early Classic Teotihuacan to the time of the Aztecs, the plumed serpent appeared on the mat throne. The Cerro de Malinche Aztec relief at Tula portrays Ce Acatl Topiltzin Quetzalcoatl standing atop such a mat (see Pasztory 1983:Plate 68). A Teotihuacan glyph from Techinantitla is particularly illuminating. There, the feathered serpent is not only on the mat, but also has a crown of jade beads and quetzal plumes—precisely the concepts mentioned in Aztec metaphors of kingship (Figure 11.12f).

Quetzalcoatl and the Bearded Dragon

In the borders of the Realistic Paintings, the Maya Bearded Dragon is portrayed as a form of the Teotihuacan feathered serpent against the precious mat throne of rulership. In Late Postclassic central Mexican thought, Quetzalcoatl is identified with the east, the realm of the Maya. In passages of the Borgia Group of codices that describe the world directions, east is consistently portrayed by jade and the quetzal, precious materials deriving from the Maya region (Taube 1994b:225). In addition, the warm summer winds that bring the rains derive from the east (Vivó 1964:192, Figure 4). According to the Aztecs, the plumed serpent is the source of this life-giving rain: "The wind that is called Quetzalcoatl, we say, sweeps the road for the Tlalocs" (Sahagún 1997:156). The Pyramid of the Plumed Serpents at Xochicalco portrays seated Maya lords floating in the coils of plumed serpents. Similarities between the sectioned conchs on the serpent bodies at Xochicalco and those of the Tetitla border motif already have been noted. In Build-

ing A at Cacaxtla, the Maya eagle warrior stands on the plumed serpent, directly opposite the central Mexican jaguar warrior atop a jaguar serpent (see Foncerrada de Molina 1980:figuras 1–2).[6] The jaguar serpent represents the night sky and the west, whereas the plumed serpent alludes to the blue diurnal sky and the east, the region of the Maya (Taube 1994a:665–666). The Tetitla border motif is an Early Classic precursor to the Epiclassic identification of the plumed serpent with the Maya.

In comparison with the Quetzalcoatl serpent of central Mexico, the Bearded Dragon remains a little-studied and far less understood entity. A number of researchers (Coe 1978:29; Nicholson 1987:186; Seler 1976 [1915]:28; Thompson 1939:158) have considered the Bearded Dragon to be a form of the fire serpent, analogous to Xiuhcoatl of Late Postclassic central Mexico. The Bearded Dragon frequently has a burning tail and commonly exhales flames out of its mouth. Moreover, as the Vision Serpent, it commonly rears out of burning offering bowls (Figure 11.13a; see Schele and Miller 1986). Like Quetzalcoatl, however, the Bearded Dragon is a being of breath and wind. Bearded Dragons often exhale the Maya tau-shaped *ik'* wind glyph, and serpent faces can appear as personifications of breath (Figures 11.13b, 11.20d–e). Moreover, zoomorphic *witz* mountains exhale pairs of these serpents out of the corners of their mouths (Figure 11.13c). The placement of these serpents recalls not only the conch breath volutes on Quiriguá Zoomorph P, but also a Teotihuacan portrayal of Tlaloc with a pair of plumed serpents emerging from his mouth (Figure 11.13d). In the latter example, these creatures personify the breath emanation of the rain god. In addition, the Teotihuacan plumed serpent commonly spews water or carries Tlaloc in its mouth, indicating its role as rain-bringing wind (see von Winning 1987, 1:capítulo 6, figura 6b; capítulo 10, figuras 1 and 3). Structure A at Cacaxtla and the Lower Temple of the Jaguars at Chichén Itzá portray conflations of Quetzalcoatl and the Bearded Dragon. In both cases, bearded plumed serpents breathe fire volutes. Although the combination of wind and fire seems to contrast with the strongly aquatic nature of the central Mexican Quetzalcoatl, it is entirely consistent with a striking natural phenomenon: powerful convection currents created by rising heat, as in the case of "roaring" fires. Maya Bearded Dragons ascending out of censers amidst swirls of fire and smoke are graphic portrayals of this rising air or wind (Figure 11.13a). Convection currents also play a major role in the development of rain clouds.

I have mentioned the youthful face in the mouth of the Tetitla Bearded Dragon (Figure 11.9a), which suggests that it is an image of a Vision Serpent.

FIGURE 11.13. The Classic Maya Bearded Dragon: (a) Bearded Dragon rising out of burning offering, Yaxchilan Lintel 15 (after Graham and von Euw 1977:39); (b) Bearded Dragon with *ik'* wind sign in mouth, detail of Late Classic bowl (after Hellmuth 1987:Figure 323); (c) pair of Bearded Dragons exhaled out of mouth of zoomorphic *witz* mountain, detail of Tonina Monument 106 (reconstructed by the author, after Becquelin and Baudez 1982:Figure 175); (d) Teotihuacan Tlaloc with plumed serpents in corners of mouth (after Séjourné 1959:figura 127a).

According to Linda Schele and Mary Miller (1986:177), the Vision Serpent of Maya bloodletting and fire offerings was a conduit to the supernatural realm of gods and ancestors. The doorway of Corridor 12a is framed not by Bearded Dragons but by a border of human faces in circular cartouches shown next to the jade mat (Figure 11.14a). The mouths of these faces are covered by large horizontal knots, a convention found with a Classic Maya *way* spirit glyphically referred to as *mok chi*, or "knot-mouth" (Figure 11.14c; see Grube and Stuart 1987:10). This character often appears lifeless or with death attributes, and the facial knot is a costume element from elite funerary ritual. Early Classic stucco façades from Structure D-32 at Seibal and Rosalila at Copán portray royal ancestral faces with the same buccal knot (Figure 11.14d–e). In the case of Rosalila, the face and censerlike cartouche may well refer to K'inich Yaax K'uk' Mo' in his tomb deep below the structure (Chapter 5; Taube 2000a). On the Early Classic Copán Motmot marker, K'inich Yaax K'uk' Mo' has this knotted element before his face, probably indicating that he is dead (Figure 11.14f). A carved cache vessel portrays another dead ruler with a name glyph in his headdress, evidently K'an Ak ("Kan Boar") of Early Classic Tikal (Figure 11.14g). The Bearded Dragon borders

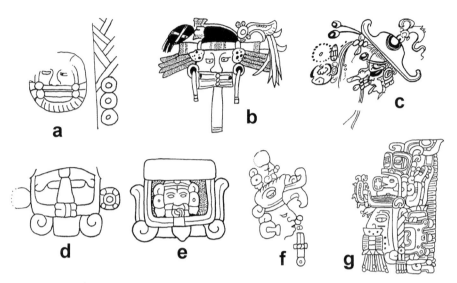

FIGURE 11.14. The facial knot in Classic Maya elite funerary costume: (a) cartouche containing face with knotted element over mouth, Corridor 12a, Tetitla (after de la Fuente 1995:Plate 70); (b) supernatural executioner with facial knot, detail of Late Classic Maya polychrome (after Hellmuth 1987:Figure 55); (c) bee *way* known as *mok chi*, with facial knot and other death attributes, detail drawn from photograph by Justin Kerr (after Grube and Stuart 1987:Figure 14b); (d) stucco ancestor cartouche with knot over mouth, Structure D-32, Seibal (after Smith 1982:Figure 178); (e) probable portrayal of K'inich Yaax K'uk' Mo' with knot over mouth, detail of Rosalila façade, Copán (after Agurcia Fasquelle 1997:Figure 7); (f) K'inich Yaax K'uk' Mo' with facial knot, detail of Motmot marker, Copán (after Fash and Fash 1996:Figure 2); (g) probable image of K'an Ak with death marking on cheek and facial knot (after Robicsek 1969:Figure 262c).

and ancestor cartouches from Tetitla Corridors 12 and 12a, therefore, are Maya symbols pertaining to elite ancestor worship.

The Net Jaguar and Foreign Traits at Tetitla

The Net Jaguars shown in the lower portion of the Corridor 12 and 12a murals also appear in Room 12 (Figure 11.4). In fact, the best preserved of the Net Jaguar paintings is Mural 8 of Room 12, in the collection of Dumbarton Oaks in Washington, D.C. (see Lothrop et al. 1957:Plates 25–26). Murals 7 and 8 of Room 12 flank a doorway similar in form to that of Corridor 12. Instead of a Bearded Dragon serpent frame, the Room 12 doorway has a netlike motif of knotted cords surrounding jade jewels of both simple and complex form (Figure 11.15d). Drafted in parallel lines, the complex knotted motif is comparable to designs appearing in the interlace scroll style of Veracruz, including examples from the site of El Tajín (Figure 11.15e). It is noteworthy

that according to the diagram of Agustín Villagra (1954:figura 1), no fragments of the Maya-style Realistic Paintings were discovered in Room 12. Clara Millon called attention to the complex combination of cultures appearing in the Tetitla chambers surrounding Room 11: "Whether it is archaeological accident or the distinctive function of the structure, the evidence on the walls of Tetitla gives it almost the character of an 'International House'" (Millon 1972:11). Thus Corridors 12 and 12a pertain to the Maya, whereas the Room 12 doorway evokes the artistic style of Veracruz.

The Net Jaguars on the lower *talud* walls of Corridors 12 and 12a and Room 12 constitute a unifying theme in the spaces surrounding Room 11. Together with the central room, this group of chambers and corridors is referred to as the Room 11 Complex in this study. Agustín Villagra (1954:70, figura 7) notes that Net Jaguars also appeared in the upper portion of the murals at the pivotal portico entrance to Room 11, above the so-called Jade Tlalocs. In the portico mural, a series of Net Jaguars was shown in rhomboids created by a net motif made of complex knots. Although pivotal to our understanding of the Tetitla murals, the Net Jaguar remains poorly understood. A substitutional pattern suggests that the Net Jaguar may have marked a certain office or title (Taube 2000c:28–29). Tetitla Room 11 contains a series of emblematic glyphs composed of a hill-like element with hands and a diagonal band topped with a version of the tasseled headdress, a probable marker of a particular military office (see C. Millon 1988). The Palace of the Jaguars from Zone 2 of Teotihuacan contains a similar emblematic glyph, although there the Net Jaguar substitutes for the tasseled headdress. The tasseled throne motif surrounding the Tetitla Net Jaguars is consistent with the concept of a public position of high rank. But the exact nature of this public office or title is unknown.

According to Esther Pasztory, the Net Jaguar mural in the collection of Dumbarton Oaks "is one of the most complex and quintessentially 'Teotihuacan' murals at the site" (1997:183). The mural is uniquely Teotihuacano, and there is no other place in the Mesoamerican world where one would expect to find such a scene. Nonetheless, it and the other examples from the Room 11 Complex also contain a complex amalgam of foreign themes and motifs. The presence of foreign traits by no means contradicts Pasztory's observation. Some of the most complex and arresting images at Teotihuacan, as at Cacaxtla and Xochicalco, derive from a cosmopolitan synthesis of foreign and local themes and styles.

The jade and quetzal plumes appearing in the borders of the murals and on the shrine or temple are materials that could come only from the Maya

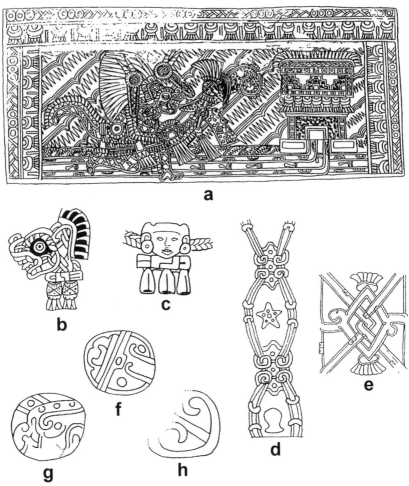

FIGURE 11.15. The Net Jaguar murals from Tetitla: (a) Net Jaguar before shrine or temple, Mural 7, Room 12 (from Villagra 1971:figura 13); (b) detail of Tetitla Net Jaguar with shell-and-knot pectoral (after de la Fuente 1995:Plate 65); (c) Zapotec-style pectoral with horizontal knot and pendant shells, detail of urn from Tomb 104, Monte Albán (after Caso and Bernal 1952:figura 168); (d) detail of interlace scroll design from interior doorway of Room 12 (after de la Fuente 1995:figura 19.39); (e) detail of interlace scroll design, El Tajín (after Brueggemann et al. 1992:figura 118); (f–h) Tetitla rattle gourds ornamented with Veracruz scroll motifs (note profile macaw face on example g; after de la Fuente 1995:láminas 58, 61, and 65).

region. The Net Jaguars appearing in these scenes also are richly bedecked in quetzal plumage, have nude upper torsos, and wear bracelets of large jade beads on their wrists (Figure 11.15a). More jades float in the song scrolls and cascade in streams from their outstretched limbs. The Net Jaguars of the Room 11 Complex are ethnically mixed and bear costume elements and regalia from the Maya region, Oaxaca, and the Gulf Coast. On close inspection, it can be seen that they sport the short jaguar-pelt skirt worn by Classic Maya gods and kings (Figure 11.15a; see also de la Fuente 1995:Plates 72–73). Another costume element is a pectoral with *Conus* shell tinklers suspended from a horizontal knot (Figure 11.15a–b). Although neither a Teotihuacan nor Classic Maya article of dress, it is commonly worn by Classic Zapotec figures (Figure 11.15c). The Net Jaguars hold a circular shield in one hand and a richly ornamented rattle upraised in the other. As in the murals of the Room 12 doorway, the rattles are decorated with curving parallel lines diagnostic of the Gulf Coast style (Figure 11.15f–h).

In a discussion of Teotihuacan mural painting, Clara Millon noted that the physique and relative body dimensions of the Net Jaguars of the Tetitla *talud* scenes are unique at Teotihuacan: "The long-limbed body violates all the canons of proportion observed in earlier and later paintings" (1972:10). The dynamic but rather unnatural kneeling stance is rare in Teotihuacan art. A fragmentary vessel excavated by Séjourné (1966a:figura 41) at Tetitla portrays a figure of very similar proportions and pose. Although the man is somewhat Maya in appearance, the vessel is probably Lustrous ware, a finely made Gulf Coast pottery known for elaborate carved decoration (Foncerrada 1980:figura 10; Rattray 1977). In fact, the one-legged kneeling stance is extremely common in Classic Gulf Coast art and can readily be traced to the Middle Formative Olmec style (Figure 11.16d). This stance appears frequently in scenes on mold-made bowls from central Veracruz, and it also occurs on nine vessels published in a recent corpus of Río Blanco material (von Winning and Gutiérrez 1996:figuras III.3–5, III.8–11, IV.9, and V.6a). On three of the vessels, a man holds a rattle in his upraised arm, precisely the stance appearing in the Tetitla scenes (Figure 11.16a–c). According to Hasso von Winning (1987, 1:102, 105), the complex of interlaced cords appearing on the Net Jaguar body indicates that this Teotihuacan being originates in part from Veracruz. The upwardly held rattle and kneeling pose of the jaguar figures in the Tetitla murals also point directly to the Gulf Coast.

In the Classic style of Veracruz, kneeling on one leg often indicates deference and respect and frequently relates to the presentation of offerings, including feather bundles, other precious materials, prayer, and song. Simi-

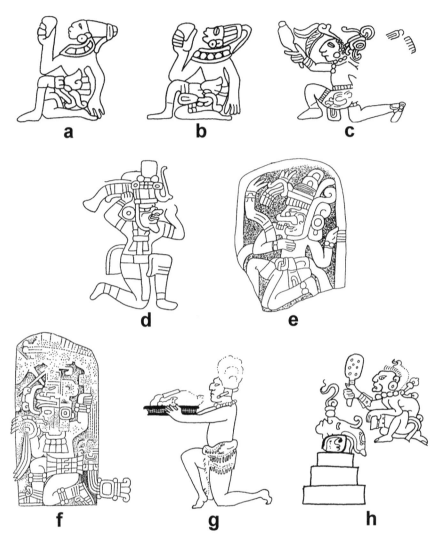

FIGURE 11.16. The one-legged kneeling stance in southeastern Mesoamerica: (a–c) figures holding rattles while kneeling on one leg, details from Río Blanco vessel scenes (after von Winning and Gutiérrez Solana 1996:figura 3:4, 5, and 11); (d) Olmec-style figure, Abaj Takalik (from Taube 1996:Figure 26a); (e) possible Protoclassic Isthmian form of maize god (from Taube 1996:Figure 19a); (f) figure kneeling on one leg, Cerro de las Mesas Stela 9 (from Stirling 1943:Figure 11a); (g) court official presenting valuables to ruler, detail of Late Classic Tikal vase (after Culbert 1993:Figure 68a); (h) figure with drum and rattle playing before altar shrine, detail from Dresden Codex, p. 34a.

larly, in Late Preclassic and Classic Maya art, secondary figures adopt this courtly posture before enthroned lords (Figure 11.16g). The kneeling stance has direct bearing on the interpretation of the Tetitla Net Jaguar murals. Although it may be tempting to view the Net Jaguars as running to a distant place of quetzal plumes and jade, they probably are making supplicatory offerings in the form of music and ritual hand scatterings to the freestanding structure. Page 34a of the Late Postclassic Maya Dresden Codex depicts a similar scene, with musicians playing before a stepped shrine. One of the Dresden musicians leans on one knee and shakes an upraised rattle (Figure 11.16h), a pose that is similar to that of the Tetitla Net Jaguars and the Río Blanco figures. Rather than portraying a foreign place, the building that appears in the Tetitla murals could well be the *talud-tablero* temple shrine in the main patio, some 20 m to the east. This structure faces Room 11 and its surrounding chambers (Figure 11.4; see Miller 1973:Figure 286). The net murals are filled with references to water, including a background of wave motifs and a "water road" formed by an eyeball-marked stream. Similar waves with marine shells appear in murals from Tetitla Rooms 16 and 17, at the northeastern corner of the main patio (see Miller 1973:Figures 296–299). Bounded by adjoining platforms on all four sides, the main patio at Tetitla could readily have held shallow amounts of water, which would have surrounded the central altar as a "sea" of standing water during particular ritual events. In sum, the Net Jaguar murals may pertain to rituals performed in the immediate vicinity of Room 11, the principal structure of the main patio at Tetitla.

Foreign Influence and the Ceramics of Tetitla

Censers
During her excavations at Tetitla, Séjourné (1966a) encountered a wide variety of ceramic material, including examples indicating foreign influence. In addition to the probable Lustrous ware sherd, an import deriving from the vicinity of El Tajín, Séjourné also illustrated a rim sherd from a locally made coarseware censer ornamented with an intricate appliqué decoration (Figure 11.17a). Although the details are somewhat obscured in the published drawing, the motif clearly is identical to a mold-made design appearing on other censers from various areas of Teotihuacan, including La Ventilla and the "Old City" region west of the Pyramid of the Moon (Figure 11.17b–c). The design, quite possibly fashioned from the same mold, features an Early Classic Maya serpent head in profile. The smoking *ajaw* brow and probable

FIGURE 11.17. Maya-style serpent appliqué on Teotihuacan coarseware censers: (a) rim sherd excavated at Tetitla (from Séjourné 1966a:figura 4); (b) appliqué on censer sherd excavated at La Ventilla, Teotihuacan (after Cabrera 1998b:figura 5); (c) appliqué sherd from "Old City" region of Teotihuacan, Site 121:N6W3 (drawing and provenience courtesy of Evelyn Rattray).

beard identify this supernatural being as the Bearded Dragon, the same creature that appears in Tetitla Corridor 12. In the most intact example of this motif, the serpent appears to be atop the coefficient four (Figure 11.17b). As in the Realistic Painting texts, this numeral with the serpent may allude to spoken Mayan. In Mayan languages, the terms for "four," "snake," and "sky" are generally homophonous, and glyphs pertaining to these three concepts frequently substitute for each other in the ancient Mayan script (Houston 1984). Thus the number four with a snake head supports the reading of this motif as *chan* or *kan* in Mayan languages.

The appearance of the Bearded Dragon on Teotihuacan censers is extremely apt, because this being commonly rises out of fire offerings in Clas-

sic Maya iconography (Figure 11.13a). It is very curious, however, that these censers were found in domestic contexts at Teotihuacan. In the lowland Maya area, the Bearded Dragon appears exclusively with fire rituals devoted to elite ancestor worship. Other Teotihuacan coarseware censers have their rims ornamented with different Maya-derived motifs. Although a number of rim sherds excavated at Oztoyahualco appear to be in Early Classic Maya style, the motifs are too fragmentary to be readily identified (Manzanilla 1993:figura 145). An intact example of a similar courseware censer, complete with a rim ornamented with rope and crenelations, was discovered in the Great Compound (Cabrera 1998b:figura 3). The anthropomorphic figure on the side of this vessel has been compared to Classic Zapotec imagery (Cabrera 1998b), but the prominent beads in the nostrils are a Classic Maya trait (see Figures 11.1a–b, 11.2b–c, e, 11.6c, 11.10c, g, 11.11i, 11.14f, 11.20d–e). This figure also displays butterfly attributes. At Teotihuacan, the butterfly is an important component of funerary ritual and symbolism, but it is notably rare in Classic Maya art and appears only in Teotihuacan-related contexts. As with the later Epiclassic murals of Cacaxtla and façade sculpture of Xochicalco, this censer exhibits a synthesis of central Mexican and lowland Maya traditions.

Plano-Relief Vessels

Several richly furnished burials were discovered in the patio and platform of the Northeast Temple at Tetitla, north of the Room 11 Complex and the Principal Patio (Figure 11.4). One of the graves, Burial 2, contained a plano-relief vessel bearing a complex design (Figure 11.18a–b). The vessel portrays a pair of Maya-style serpent heads—quite probably the Bearded Dragon—within circular medallions. A sherd displaying the same Maya serpent head in profile was also excavated by Séjourné (1966a:figura 86) at Tetitla. Although the serpent heads on the intact Burial 2 vessel are in Early Classic Maya style, the accompanying decoration of crossed bands and cartouches is not. This composition of three registers of crossed bands between serpent medallions is unknown in the corpus of Early Classic Maya ceramics, but it appears commonly at Teotihuacan on vessels of this form. A plano-relief vase in the Museo Nacional de Antropología in Mexico City displays a very similar design, although in this case the vessel has slab-shaped feet (Figure 11.18c). Virginia Fields (personal communication 1998) called my attention to yet another example in the collection of the Los Angeles County Museum of Art (Figure 11.18d). The design appearing in the three registers between the serpent medallions is virtually identical to that of the Museo

FIGURE 11.18. Mayoid pottery from Teotihuacan containing serpent cartouches with three registers: (a) vase from Tetitla Burial 2 (Sempowski 1992:Figure 10); (b) roll-out design on Tetitla Burial 2 vase (from Séjourné 1966a:figura 36); (c) Mayoid vase in the collection of the Museo Nacional de Antropología, Mexico City (after Manrique 1982:121); (d) Mayoid vase in the collection of the Los Angeles County Museum of Art (after photograph courtesy of Virginia Fields); (e) sherd with triple register and portion of cartouche, Zacuala Palace, Teotihuacan (after Séjourné 1959:figura 126d); (f) sherd with portion of serpent cartouche and upper edge of triple register, Oztoyahualco, Teotihuacan (after Manzanilla 1993:figura 175).

Nacional vessel. Although the vases from the Museo Nacional and the Los Angeles County Museum of Art lack precise provenience, vessel sherds of this type have been excavated in Teotihuacan at both Zacuala and Oztoyahualco (Figure 11.18e–f).

In a pioneering study of Maya-style pottery at Teotihuacan, Jacinto Quirarte (1973) called attention to another plano-relief vessel in the collection of the Museo Nacional de Antropología (Figure 11.19a). Although the form of the serpent face and the circular basal elements are comparable to those appearing on the Tetitla Burial 2 vessel, the serpent head is not shown in a circular frame with three horizontal registers of crossed bands and other elements. Instead, a pair of vertical bands containing schematic *ajaw* signs, a comblike series of short lines, and other elements bracket the head. A very

similar vessel in the collection of the University Museum at the University of Pennsylvania is also attributed to Teotihuacan (Figure 11.19b). The vertical borders appearing on these two vessels recall Early Classic stucco façades from Copán, which also feature schematic *ajaw* signs and comblike lines (Figure 11.19c–d).

Quirarte (1973) also noted that a pair of lidded vases excavated by Linné in Burial 2 at Xolalpan display the same Maya serpent head motif (Figure 11.20a–b). According to Quirarte (1973:19), the Xolalpan serpent motifs derive from Chiapas or highland Guatemala, and the vessels have proportions very similar to vases from Kaminaljuyu. Evelyn Rattray (2001:259), however, considers the Xolalpan vases and the other plano-relief serpent vessels under discussion to be locally made at Teotihuacan. It should be noted

FIGURE 11.19. Mayoid profile serpent head flanked by ornamented bands: (a) tripod vessel in the Museo Nacional de Antropología, Mexico City (after Quirarte 1973:Plate 10); (b) tripod vessel on display at the University Museum, University of Pennsylvania (drawing by the author); (c) Early Classic stucco relief from the southern corner of the Motmot platform, Copán (after Williamson 1996:Figure 1); (d) lower portion of Early Classic stucco cartouche (after Sharer et al. 1999:Figure 12).

that the Xolalpan examples have the same glyphlike basal register seen on other Maya-style plano-relief vases (Figures 11.18c–d, 11.19a–b, 11.20a–b). It is quite likely that this sign is a form of "pseudoglyph" alluding to but not accurately replicating Maya hieroglyphic writing.[7] Furthermore, the Xolalpan vessels are supported by slab feet in the form of stylized rattlesnake tails (Figure 11.20a–b). Rattlesnake-tail images are common at Teotihuacan but are very rare in Classic Maya art. Although still unknown in the Maya region, similarly ornamented tripod feet were excavated by Séjourné (1966a:figura 83) at Tetitla. In addition, a number of such supports were discovered with other Teotihuacan-style sherds in recent excavations of the North Platform at Monte Albán (see Martínez 1994:figuras 5–7).

Along with the rattlesnake-tail feet, the Xolalpan vessels have crested quetzals capping the conical lids (Figure 11.20a–b). Given their strongly Maya style, it is entirely appropriate that these vessels are graced with quetzals, the preeminent precious bird of the Maya realm. But their presence may have additional meaning. The quetzal handles and rattle feet may allude to a well-known combination at Teotihuacan, the quetzal-plumed rattlesnake. It has been noted that as the Bearded Dragon, the Maya serpent shares many traits with Quetzalcoatl. In fact, the short lines edging the faces of the Maya-style serpents often are quite similar to the facial feathers appearing in Teotihuacan plano-relief portrayals of plumed serpents (Figure 11.13d). A pair of serpent heads on the lid of one of the Xolalpan vessels underlines the identification of the Maya-style serpent with breath and wind (Figure 11.20a, c). The elements curling from the back of their faces are very similar to depictions of serpent breath appearing in Early Classic Maya art (Figure 11.20d–e). The Xolalpan serpents are especially similar to the serpent-breath motif appearing on El Zapote Stela 5, which bears a Long Count date of 9.0.0.0.0 (A.D. 435; Figure 11.20d).

Ceramic Palettes

In addition to the plano-relief Maya-style vessel, Tetitla Burial 2 also contained a pair of curious ceramic palettes (Séjourné 1966b:Plate 28). At Teotihuacan, these strange objects are known only from Burials 2, 3, 10, and 11 in the Northeast Temple area of Tetitla (Sempowski 1994:68, 70, 154). The palettes were fashioned from moist clay and then were fired. They do not appear to have been recarved from fired sherds. Some 15 cm in length, they are plain on both sides, have gently rounded corners, and tend to be rectangular. One example, from Burial 3, resembles a petaloid celt or Maya stela in outline (Sempowski 1994:Plate 20). The ceramic palettes tend to appear in

FIGURE 11.20. Pair of Mayoid vases from Xolalpan Grave 2 and Early Classic Maya serpent imagery: (a–b) Xolalpan vessels with quetzal lids and rattlesnake-tail feet (from Linné 1934:Figures 28–29); (c) detail of serpent head on lid of example a (after Linné 1934:Figure 28); (d) Maya serpent-breath element, El Zapote Stela 5 (after Easby and Scott 1970:Catalog Number 170); (e) serpent-breath element, detail of ceramic vessel from Mundo Perdido, Tikal (after Laporte and Fialko 1995:Figure 36).

pairs. Burials 2, 3, and 11 each contained two palettes, and Burial 10 had four examples (Sempowski 1994:68, 70). It is very intriguing that pairs of these palettes are also known from Early Classic Maya elite burials, including the richly provisioned Burial A22 of Uaxactun (Kidder 1947:69). In that case, however, the two palettes were recarved from large vessel sherds. In both size and shape, this pair is quite similar to the celtiform example from Tetitla Burial 3. Although locally made, many of the Tzakol vessels of Uaxactun Burial A-22 display clear Teotihuacan affiliation, and some are slab-footed tripod cylinders. Another pair of ceramic palettes was discovered in Tomb II of Mound 2 at Early Classic Nebaj, a site that also displays Teotihuacan influence. In fact, a Teotihuacan-style shell-platelet helmet was found in Tomb I of the same structure (Smith and Kidder 1951:Figure 42 and 69d). As in the case of the Tetitla palettes, the examples from Nebaj were fashioned from moist clay (Smith and Kidder 1951:Figure 87c–d, legend). One Nebaj palette has a rim marked by an incised line similar to that appearing on a palette from Tetitla Burial 10 (see Sempowski 1994:Plate 15).

The function of the ceramic palettes at Tetitla and in the Maya area remains poorly known, and indeed these rather small and nondescript items frequently have been ignored. A possible depiction of a ceramic palette appears on a Late Classic Jaina figurine in the collection of Dumbarton Oaks (Lothrop et al. 1957:Plate LXXIV). The wizened man holds out a palettelike object, much as if he is presenting it to be seen or read. Although Martha L. Sempowski (1994:154) acknowledges that the use of these objects is unknown, they are nonetheless described as "palettes"—hand-held objects that could be flat surfaces used for scribal practice. Alternatively, they may have been used for tallying and calculation. Despite the obvious importance of computations to calendrics, tribute, and trade, there is little evidence for mundane record keeping among the ancient Maya or at Teotihuacan. This surely is because such texts either were written on perishable materials or were erased. The palettes may well have supplied surfaces on which writing could have been composed and subsequently removed. Although charcoal could have been used, a layer of wax is another possibility. In ancient Rome, shorthand notes and computations were inscribed on surfaces of wax held in shallow, plaquelike boxes. The possible use of the ceramic tablets for tallying and mathematics is consistent with the stelalike form of several examples. The Long Count dates appearing on Maya stelae, after all, result from an especially grand and developed form of computation. William Haviland (1962) reported a "miniature stela" from Late Classic Tikal in the form of a ceramic plaque or palette with a human image incised on one side. The

incised line around the edge clearly denotes the raised rim of the stela and recalls the incision on one of the Nebaj examples. As in the case of the Early Classic examples, the blank side of the Tikal example could have been used for tallying or other scribal activities.

Conclusions

The abundant Maya-style writing and art found at Tetitla make it one of the most unusual apartment compounds at Teotihuacan. In addition, Tetitla has some of the most elaborate murals at the site, and according to Rattray (1992:78), constitutes "one of the finest compounds known in the city." It is noteworthy that many Tetitla murals actually are Teotihuacan-style texts that appear as massive emblematic glyphs (Taube 2000c). The abundance of writing at Tetitla is even seen in utilitarian bowls bearing incised Teotihuacan glyphs, including numerical coefficients (see Séjourné 1966b:figuras 136 and 138). The eclectic murals suggest that Tetitla truly was an "International House," and many scholars have suggested that foreigners indeed lived in this compound. According to Michael Spence (1994:402), "some of the murals raise the possibility that part of Tetitla may have been inhabited by foreigners." Charles Kolb (1987:124) argues that Tetitla possibly housed "Maya merchants and/or shell procurers." Nonetheless, although the texts of the Realistic Paintings strongly suggest that literate Maya visited Tetitla, it was by no means a Maya "barrio." The architectural configuration of the compound is wholly Teotihuacan. Moreover, three of the four burials containing the ceramic palettes were cremations, a common practice at Teotihuacan but notably rare among the Classic Maya (Sempowski 1994:68, 70). Rather than being a hostel for distant travelers, Tetitla may have been a residence and training area for a particular Teotihuacan occupation or office concerning contact with foreigners, such as merchants or courtly diplomats.

The Aztec *pochteca* model has been commonly used to explain longdistance contact and exchange in Mesoamerica, but it is highly unlikely that communication was limited to the level of upwardly mobile, middle-class merchants. The presence of phonetic Maya texts at Tetitla indicates elite interaction, because it is likely that only the highest echelon of Maya society was literate (see Houston 1994). Similarly, the presence of a monumental text, funerary urns, and subfloor masonry tombs in the Oaxaca Barrio is typical of Zapotec palaces rather than lower- or middle-class households (see Winter 1974:985). The foreign Maya imports appearing at Teotihuacan often are of exceptionally fine quality. For example, the vase discovered near the Merchants' Barrio (Figure 11.10g) would be an outstanding object even in

the richest royal graves of Tikal or Copán. Thus, it is likely that trade with the Maya was conducted at the palace level. Evidence that long-distance exchange was the purview of the elite can also be found in the Maya area. For example, the Classic Maya merchant god, God L, frequently is portrayed as a Maya king enthroned in his palace (Taube 1992b:88, Figure 39). In his account of the fifteenth-century revolt at Mayapan, Landa (Tozzer 1941:39) noted that all the sons of the royal house of Cocom were slain save for one who was on a trading expedition to Honduras. The regal nature of contact between the Maya and Teotihuacan has profound implications regarding the extent and intensity of cultural exchange. It is at the utmost elite level that the transmission of complex information is most developed, and surely such communication would have involved bilingual individuals, translators, and scribes versed in several systems of writing.

That Maya-style ceramics and the eclectic Realistic Paintings both appear at Tetitla is of special interest. Such pottery, however, is by no means unique to that compound. Rather, the Maya serpent in profile is one of the most popular repetitive motifs appearing on Teotihuacan plano-relief vessels. In this study, three distinct styles of the motif have been discussed: (1) that seen in the tall vessels from Xolalpan; (2) that found on vases with vertical, architectonic borders; and, finally, (3) the version that occurs with three registers of crossed bands and other motifs. Although it is conceivable that differences in style reflect several contemporaneous workshops within the city, it is more likely that these styles are temporally distinct. Given the resemblance of the serpent head to El Zapote Stela 5, the Xolalpan vessels appear to be the earliest, and the vases with ornamented vertical borders date somewhat later in time. The vessels with the three horizontal bands, which actually are the least Maya in style, are the last in the sequence. Indeed, the vessel from Tetitla Burial 2 is identified as dating to the Metepec phase (Sempowski 1992:Figure 10), or shortly before the demise of the Teotihuacan state. In addition to the Mayoid plano-relief vessels, coarseware censers bearing mold-made images of the Maya Bearded Dragon have been discovered in many sectors of the city. Although Teotihuacan generally has been viewed as a monolithic culture that did not borrow from contemporary Mesoamerican cultures, it is clear that the situation was far more dynamic. The Realistic Paintings and Net Jaguar murals from the Room 11 Complex at Tetitla display a true synthesis of Teotihuacan and foreign styles, a fusion that is as subtle as the eclectic styles that developed later at Cacaxtla and Xochicalco.

The study of the Maya presence at Teotihuacan has important implica-

tions regarding our understanding of the ancient city. First, close attention to Classic Maya stylistic change—as in the brilliant work of Tatiana Proskouriakoff (1950)—can serve as a powerful tool for cross-dating material at Teotihuacan, because Maya-style motifs can be correlated with specific Long Count dates. Second, locally fashioned Maya-style art at Teotihuacan gives us a unique glimpse of what the inhabitants of the city found important and fascinating about the Early Classic Maya. For example, the Maya area clearly was regarded as a place of great wealth: the source of cacao, jade, and quetzal plumes. A plano-relief vessel published by Linné (1942:Figure 175) depicts a youth hunting quetzals with a blowgun in a mountainous environment forested with fruit-laden cacao trees. This is an idealized portrayal of the piedmont of southern Chiapas and Guatemala. At Teotihuacan, there also was a deep interest and understanding of the accouterments and symbolism of Maya kingship, with the ceramic *almena* being a condensed diagram of Maya royal costume (Figure 11.1a). In addition, the inhabitants of Teotihuacan were aware of the symbolism and rituals of Maya royal ancestor veneration, including aspects of the funerary costume and the importance of the Bearded Dragon in conjuring ancestors. This serpent being was an especially popular motif at Teotihuacan and seems to have served almost as a condensed symbol of "Mayaness" at the site. At Teotihuacan, the Bearded Dragon was identified with the quetzal-plumed serpent Quetzalcoatl. Teotihuacanos, like later Mesoamerican peoples, identified Quetzalcoatl with the east, the realm of the Maya, riches, and rain-bringing wind. The wind god Ehecatl Quetzalcoatl of the Late Postclassic Aztecs wore the costume of Huastec Maya, inhabitants of the eastern realm of the Gulf Coast. Clearly, the Maya region had a great deal to do with how Early Classic Teotihuacanos saw themselves and their surrounding world.

Acknowledgments

Much of this study derives from a series of letters I composed to George Cowgill, Stephen Houston, and David Stuart in 1997 and 1998, and I am indebted to these scholars for their thoughtful comments and encouragement. I also benefited from comments and suggestions by Geoffrey Braswell, John Douglass, and Leonardo López Luján. In addition, I wish to thank Evelyn Rattray for her comments and for generously sharing her published and unpublished work, as well as for showing me some of the material from the Merchants' Barrio excavations. I am grateful to Virginia Fields for calling my attention to a vessel in the Los Angeles County Museum of Art. Earlier versions of this study were presented in 1998 at the Fifteenth Symposium of the Maya Meetings at the University of Texas, and in 1999 at the Depart-

ment of Anthropology of Arizona State University. My research at Teotihuacan was partly supported by a grant from the Academic Senate of the University of California, Riverside.

Notes

1. At Cacaxtla, an elaborate but fragmentary ceramic *almena* plaque portraying a standing figure with a split Tlaloc mask was placed atop an offering of four human skulls (Jiménez 1988).

2. According to the ceramic chronology used in this volume (Figure 1.2; Cowgill 1997:Figure 1), the Early Xolalpan phase dates to c. A.D. 350–450, and the Late Xolalpan phase to c. A.D. 450–530. This earlier chronology is more consistent with evidence for Teotihuacan-Maya interaction found in southeastern Mesoamerica.

3. At Teotihuacan, the interlace scroll design appears well before the Late Classic florescence of El Tajín (de la Fuente 1996:21). Nonetheless, it is clear that this stylistic motif originated in the Gulf Coast region. In concept, it is very similar to the earlier scroll designs of both Late Preclassic Tres Zapotes and the contemporary "Izapan" style of the Maya region. The basal portion of the Protoclassic Matisse Stela displays scrolls outlined with parallel lines, a common trait of the Classic interlace scroll design (see Easby and Scott 1970:61). In addition, Lustrous ware, a fine Veracruz trade ware appearing in large amounts at Early Classic Teotihuacan, commonly displays elaborate forms of the interlace scroll motif, making it likely that at the great city this motif was strongly identified with the Gulf Coast.

4. In Arthur Miller's major catalog of Teotihuacan murals, the illustrations for Murals 1 and 8 of Tetitla Corridor 12 are reversed from the numbers designated by the accompanying map (see Miller 1973:Plan XIII, Figures 322 and 323). In other words, the figures place the murals on opposite sides from their designation on the map. For this study, I use the number designations that appear on the map.

5. The structure appearing in the Net Jaguar scenes displays jaguar-pelt markings as well as the tasseled jade-mat elements, all of which appear in Classic Maya portrayals of thrones. Given its strongly elite quality, this building may represent a royal lineage shrine.

6. In the Cacaxtla mural, the avian figure is accompanied by a date composed of a large feather with a coefficient of thirteen. With its blackened tip, this feather can be identified as that of an eagle, providing the date 13 Eagle. The dancing avian figure has similarly marked feathers, along with prominent talons, a sharply curved beak, and a feather crest. Although it has received little attention in recent studies, the eagle is widely portrayed with warriors in Teotihuacan art (e.g., Berrin and Pasztory 1993:134).

7. This sign seems to have almost a toponymic function and frequently occurs as the basal element on Maya-style Teotihuacan vessels (Figures 11.18d, 11.19a–b, 11.20a–b). This also is true for one of the Xolalpan vessel lids, where the sign surrounds the quetzal handle (Figure 11.20b). It is conceivable that the motif is based on the knotted-bundle toponym serving as the main sign of the Tikal emblem glyph.

Teotihuacan and Early Classic Interaction: A Perspective from Outside the Maya Region

George L. Cowgill

Relations between Teotihuacan and societies in the Maya area have long been a controversial topic. The effect of this book is less to resolve disputes than to assemble recent information and to frame the issues more clearly. This is very useful, since it points to strategic directions for further research. Opinions about the role of Teotihuacan, Teotihuacanos, and persons claiming some sort of affiliation with Teotihuacan in the Maya area continue to vary greatly, even within this volume. Some contributors prefer interpretations that minimize Teotihuacan's impact on the Maya. This is shown especially in their proclivities toward speculations that tend in an internalist direction. Moreover, the significance of minor departures from real or supposed uniformities at Teotihuacan is sometimes exaggerated. An externalist-internalist dichotomy is too simple, but the terms do capture broad differences in outlooks. Nevertheless, the overall thrust of this volume is toward a nuanced balance, avoiding simplistic internalist and externalist extremes and advocating more awareness of ancient people as knowledgeable actors making choices in the light of their perceived interests and contexts. This is an approach I welcome (Cowgill 2000b).

My perception of the 1970s and 1980s is that strong externalist views were limited largely to William Sanders and others closely associated with or strongly influenced by him. Many others involved in Teotihuacan research, such as René and Clara Millon and myself, are conspicuously absent from criticisms in this volume. The Millons have differed with some of the internalist views of Linda Schele and others, but they have not been dogmatic externalists (see especially C. Millon 1973 and R. Millon 1988). In the 1980s and 1990s, I was put off by exaggerated claims about a Teotihuacan trade empire that rested on a very flimsy basis of data. I largely agreed with John Clark's (1986) criticisms of Robert Santley's (1983) work, although Clark greatly underestimated the volume of obsidian debris at Teotihuacan and,

regrettably, tended to lump the more judicious interpretations of Michael Spence with Santley's problematic views. This, as well as conflicting interpretations of inscriptions and iconography at Tikal and Uaxactun and what then seemed like weak evidence for a Teotihuacan presence in coastal Guatemala, made me tend to side with those such as Arthur Demarest and Antonia Foias (1993) who minimized the impact of Teotihuacan on the Maya (e.g., Cowgill 1997, 2000a). Now, however, my perspective has shifted. New information about a Teotihuacan-related foreigner at Copán (Chapter 5; Fash and Fash 2000), new interpretations of Tikal and Copán inscriptions (Stuart 2000a), my own review of neglected information about Teotihuacan influence and presence in Chiapas, and new evidence of Teotihuacan-related phenomena in Pacific Guatemala (Chapter 2) all lead me to question strongly internalist opinions. At present it looks as if, after many centuries of relatively equal interactions between multiple regions of Mesoamerica, there was a brief period when Teotihuacanos, or at least people somehow related to Teotihuacan, made substantial interventions backed by force in Maya affairs. These people may or may not have been acting as agents of the Teotihuacan state. It even is possible that there was a wide-reaching but short-lived Teotihuacan empire. It will be interesting to see whether future research strengthens or undermines this picture.

Maya States as Secondary Developments and the "Horizon" Issue

Two issues can be dismissed quickly, although I am not sure they will be. One is the old notion that tropical forest environments are intrinsically unfavorable to the autonomous development of statelike societies, so that any lowland states must necessarily be secondary states, developed in response to stimuli from the semi-arid and irrigation-prone highlands. This owes less to the New Archaeology than to the influence of scholars such as Karl Wittfogel and Julian Steward (although Steward acknowledged that the Maya did not fit his hydraulic model and that other explanations for their development should be sought). Alas, those unschooled Maya fecklessly developed statelike institutions anyhow, before there was much interaction with Teotihuacan. For better or worse, there was no one around who could tell them that they were supposed to remain on a "chiefdom level" and should dismantle their pyramids and simplify their sociopolitical institutions.

A second topic that should no longer be an issue is the concept of a Teotihuacan "horizon." There has been an unfortunate tendency to conflate two concepts with quite different origins; the "Middle Classic" subdivision of

the Classic period proposed by Lee Parsons (1967–1969) and others, and the concept of a "Middle Horizon," intended to replace the use of terms like "Classic" altogether. René Millon (1976) pointed out that the terms "Formative," "Classic," and "Postclassic" are used in ways that conflate chronology and developmental stages, and this leads to confusion and muddled thought. He proposed (following practice in the Central Andes, which in turn was derived from the usage of Egyptologists) to introduce a developmentally neutral and purely chronological series of "horizons" and "intermediate" periods, which were supposed to help clarify thinking. His hope was in vain, for Mesoamericanists at once (if they did not simply splutter indignantly and cling to the old terms) began to use the new terms in ways that also mingled chronology and culture-historical or developmental notions. Geoffrey Braswell (Chapter 1) argues that others rejected the "horizon" because it is neither a neutral nor a purely chronological concept, and because of its core-periphery connotations derived from culture history.

For chronological purposes, the term "Middle Horizon" is no longer useful because it covers too long a time span. In both the Basin of Mexico and the Maya area, we can and must distinguish much shorter periods. I prefer to use approximate absolute dates in the widely shared Gregorian calendar. That, I hope, is immune to being interpreted in anything but a chronological sense. As a culture-historical or developmental concept, a Teotihuacan "horizon" no longer does justice to the complexity and variety of interactions that we can discern, as several volume contributors note.

New Data and Interpretations from Teotihuacan

The Early to Late Tlamimilolpa Transition and Cross-Dating

The ceramic transition between the Early and Late Tlamimilolpa phases (c. A.D. 250–300) is not the minor subphase change that the terminology suggests. Instead, it is one of the most pronounced changes in the whole Teotihuacan ceramic sequence. Domestic and utilitarian ceramics, such as *ollas*, basins, *cajetes, cazuelas,* craters, flat-bottomed bowls with out-curving sides and nubbin supports, and other bowl forms changed gradually during this interval. This strongly suggests continuity of the local population. Some more special forms, such as "Tlaloc" jars, *floreros,* and unslipped, very shallow bowls or lids with loop handles that double as supports when the vessels are upturned (*tapaplatos*), also changed gradually. Thin Orange ware from southern Puebla was imported to Teotihuacan even before the Early Tlamimilolpa phase, although the volume of imports apparently increased

in later periods. Composite censers became more elaborate, and mold-made ornaments on them replaced handmade ones.

Nevertheless, several ceramic categories that have no Early Tlamimilolpa antecedents appeared during the Late Tlamimilolpa phase. Especially notable are direct-rim cylinder tripod vases with a variety of support forms, only some of which are slab shaped. It is probable that Lustrous ware cylindrical vases were already being imported (presumably from somewhere in Veracruz) in Early Tlamimilolpa times, but there is no evidence for the *manufacture* of this type of vase at Teotihuacan before the Late Tlamimilolpa phase. The small and simple incense burners called *candeleros* are another Late Tlamimilolpa innovation. These were scarce and mostly single-chambered in Late Tlamimilolpa times. They became more abundant and generally twin-chambered in the Xolalpan phase and continued through the Metepec phase, but probably did not outlive the collapse of the Teotihuacan state. Yet another Late Tlamimilolpa innovation are small cups that taper toward the base and have low pedestal supports (called *copas*), sometimes with loop handles or spouts (also called "cream pitchers"). These innovations—the tripod cylinder, the *candelero,* the "cream pitcher," and the *copa*—are among the ceramic forms most commonly thought to be evidence of a Teotihuacan connection when they are found outside the Basin of Mexico. It is significant that they are absent from the Altun Ha offering (Chapter 9), consistent with its dating before A.D. 250. But for much of the Maya region, the period during which Teotihuacan had its greatest impact was no earlier than the Late Tlamimilolpa phase, and more likely the Early Xolalpan phase.

The time of the Early to Late Tlamimilolpa transition, therefore, is crucial for cross-dating. Based on radiocarbon dates and other evidence, I have accepted a date of around A.D. 300 (Cowgill 1997, 2000a). Evelyn Rattray (personal communication 2000) suggests a slightly earlier time, c. A.D. 250, for this transition. Thus, somewhere in the range of A.D. 250–300 now seems likely. Rattray's most recent chronological estimates for Teotihuacan ceramics put the Late Tlamimilolpa phase at A.D. 250–350, the Early Xolalpan phase at A.D. 350–450, the Late Xolalpan phase at A.D. 450–550, and the Metepec phase continuing perhaps to A.D. 650. These dates are in reasonable accord with my own estimates (see Figure 1.2) and represent a significant realignment of previous Teotihuacan ceramic chronologies. Of course, these are only current best guesses, with uncertainties on the order of fifty years and up to one hundred years in some cases.

It seems most likely that the Esperanza phase of Kaminaljuyu began no earlier than A.D. 350 and no later than A.D. 450 (Chapter 3). Its inception,

therefore, probably was contemporary with the Early Xolalpan phase. The Esperanza phase also overlaps with Late Xolalpan times, and perhaps with the Metepec phase. Although evidence for a Teotihuacan impact in central Escuintla is found in a variety of contexts dating to both the Colojate and San Jerónimo phases, influence seems to have been strongest at a time contemporary with the Early Xolalpan phase (Chapter 2). At both Copán (Chapter 5) and Tikal (Chapter 6), interaction with Teotihuacan seems to be limited to phases contemporary with Early Xolalpan times. Rattray (1989:111) has already noted that the strongest evidence for foreign interaction in the Merchants' Barrio dates to the Early Xolalpan phase. At Teotihuacan, therefore, we should look most closely in Early Xolalpan contexts for evidence of interaction with the Maya. Moreover, the closest analogies between Teotihuacan and Maya cultural patterns might be found in Early Xolalpan contexts. As Braswell (Chapter 1) points out, this chronological clarification is a major accomplishment of this volume.

Recent Excavations in the Ciudadela and the Moon Pyramid: The Problem of Comparison with Kaminaljuyu

Saburo Sugiyama (2000) and I (Cowgill 1997) have noted similarities between some of the burials in the Feathered Serpent Pyramid at Teotihuacan (especially the looted pits) and the tombs in Mounds A and B at Kaminaljuyu. Nevertheless, the Feathered Serpent burials date to the Early Tlamimilolpa phase, and the earliest of the tombs of Mounds A and B are contemporary with the Early Xolalpan phase. Thus, those at Kaminaljuyu are at least a century later. It is interesting that they resemble those at Teotihuacan as much as they do, and not too surprising that there also are differences. This is especially so because all the unlooted burials so far discovered at the Feathered Serpent Pyramid contain only sacrificial victims, while those at Kaminaljuyu contain principal occupants as well as victims. Furthermore, the overall pattern of the Feathered Serpent Pyramid burials is unlike anything else found so far at Teotihuacan, or indeed in all of Mesoamerica.[1]

Burials being found in ongoing excavations within the Moon Pyramid are adding more information about variations in Teotihuacan mortuary practices associated with major pyramids and are showing patterns rather different from those at the Feathered Serpent Pyramid (Cabrera and Sugiyama 1999). It is unlikely, however, that any burials so far reported from the Moon Pyramid postdate the Early Tlamimilolpa phase or contain individuals other than sacrificial victims, so these, too, are of limited relevance for comparison with the tombs of Kaminaljuyu.

It would be best to compare the elite burials at Kaminaljuyu with high-level elite burials more likely to be contemporary at Teotihuacan. This brings to light the curious fact that there still are no data on high-level elite burials postdating the Early Tlamimilolpa phase. Studies such as those of Martha Sempowski and Michael Spence (1994), Evelyn Rattray (1992), and the contributors to Linda Manzanilla and Carlos Serrano's (1999) volume have provided a wealth of information about Teotihuacan burials of all periods. Sempowski, especially, adduces evidence for considerable variation in the richness of mortuary offerings. But even the richest of these do not seem to represent more than the lower ranks of the elite; none look like those of persons as important as the principal occupants of the tombs in Kaminaljuyu Mounds A and B. We have no information about burials at Teotihuacan that can be compared properly with contemporary elite tombs in the Maya region.

If there was a shift in Late Tlamimilolpa times to more collective political institutions with less exalted rulers (as some evidence suggests), it is possible that such burials never existed. Other possible explanations for our lack of evidence for high-level elite burials postdating the Early Tlamimilolpa phase are that other methods—such as cremation—may have been used, as was the case with Aztec kings (Headrick 1999); that they have all been looted; or that some are still there to be discovered.

Incidentally, "Tlaloc" jars are not common household items found frequently in burials at Teotihuacan (cf. Pasztory 1993:297). They occur occasionally in burials under the floors of apartment compounds throughout the city, but they are absent from most burials, even those that contain other ceramics. They are relatively abundant at the Feathered Serpent Pyramid and even more abundant in Burial 2 at the Moon Pyramid (Cabrera and Sugiyama 1999). The "Tlaloc" vessel from Kaminaljuyu illustrated by Alfred Kidder et al. (1946:Figure 200q, r) differs considerably from those of all periods at Teotihuacan and almost certainly was not made there.

Teotihuacan Burial Patterns and the Principal Individuals in Kaminaljuyu Mounds A and B

So far as I know, there are indeed no burials at Teotihuacan in the "tailor" (or "lotus") position, which is found in Teotihuacan-related burials at Mirador in Chiapas as well as at Kaminaljuyu (Agrinier 1970, 1975). Many Teotihuacanos were buried with their legs bent at the knees and drawn up toward the chin, but the feet tend to be fairly close together rather than near the knee or thigh of the opposite leg. To me, however, the "tailor" position seems only

a minor regional innovation of Chiapas and Kaminaljuyu. Braswell (Chapter 4) points out that the use of wooden coffins or boxes, which is described by Kidder et al. (1946:88–89), indeed seems unique for Early Classic Mesoamerica. Wrapping per se is not.

Oxygen isotope ratios in teeth of persons in Kaminaljuyu Mounds A and B give only an ambiguous indication that one individual probably spent some time either at Teotihuacan or at any of the other places (presumably quite numerous) where a similar ratio prevailed (White et al. 2000). Nevertheless, several persons in the Kaminaljuyu burials seem to be of nonlocal origin. All of these foreigners are individuals interpreted by Kidder et al. (1946) as sacrifices or trophy skulls. At present, central Escuintla is an unexplored possibility for their origin. Such a possibility, however, suggests to Braswell (Chapter 4) that an unequal or unfriendly relationship existed between Kaminaljuyu and the Montana region. Nevertheless, we should remember that stable isotope studies have been performed on only sixteen individuals buried in Mounds A and B, and there may be additional foreigners not yet identified.

Whoever the principal individuals in the burials in Kaminaljuyu Mounds A and B were, it seems unlikely that their primary identities were as merchants. Braswell agrees, and stresses the military and religious nature of some of the burial furnishings (Chapter 4). This is not to say that they may not have been deeply engaged in commercial activities, but I think it is quite uncommon for merchants to receive the most lavish burials in a community. Very likely they held the highest local politico-religious offices, probably including military aspects. I agree with those who argue that they were rulers of Kaminaljuyu, whatever their origins. It is regrettable that we still know so little about the meanings of specific signs and symbols at Teotihuacan itself. If we could read them better, we might use those on objects in Kaminaljuyu graves to tell us more about the roles, statuses, offices, and affiliations of those buried there.

The *Talud-Tablero* at Teotihuacan and in the Maya Area

A central aspect of most discussions of *talud-tablero* architecture at different sites is their proportions (Chapters 4, 5, 7, and 10; see also Demarest and Foias 1993; Santley 1987, 1989). I am not sure that such comparisons of *talud-tablero* ratios are very meaningful. Moreover, the uniformity of architecture at Teotihuacan has been overstated.

Santley (1987) states that the ratio of *talud* to *tablero* height at Teotihuacan ranges from about 1:1.6 to 1:2.5, while the relative proportions at Kami-

naljuyu are approximately 1:1. That is, at Teotihuacan, *tableros* tend to be higher relative to *taludes* than they are at Kaminaljuyu. In considering short *taludes* at Teotihuacan, it is important to note that it was quite common practice to add a new floor abutting a *talud* without raising the associated *tablero*, which has the effect of leaving the *talud* much shorter than it was originally. This, incidentally, suggests that Teotihuacanos had a somewhat casual attitude about *talud-tablero* ratios and did not attach great meaning to them. But the main point is that, unless information about the original height of the *talud* is available, comparisons should be limited to pyramids with multiple stacked sets of *taludes* and *tableros*, where the problem of raised floors is less likely to arise. Even so, Noel Morelos García (1993:Plans B.2 and D.1) shows some pyramid profiles in the West Plaza Group of the Avenue of the Dead Complex where *talud-tablero* ratios are as low as 1:1.3. Thus, the differences in these ratios between Teotihuacan and Kaminaljuyu or Matacapan are not always as great as Santley (1987) says. I do not think much significance can be attached to these rather small differences, especially since the evidence about exact proportions at Kaminaljuyu seems rather limited.

Architecture built in the *talud-tablero* style appeared in Puebla and Tlaxcala by the second century A.D. (García Cook 1981; Plunket and Uruñuela 1998b), and perhaps much earlier (Giddens 1995). Early examples in the Maya area may not have been derived directly from Teotihuacan. At Teotihuacan, pyramids with *tableros* on all four sides began to appear no later than the third century, and pyramids lacking *tableros* on the rear may also be that early. Published examples are those atop the north, east, and south platforms of the Ciudadela. Unpublished excavations directed by Eduardo Matos Moctezuma at Group 5-prime, a three-pyramid complex west of the Moon Pyramid, show that these pyramids also lacked *tableros* on their rears. Moreover, there are examples of structures with *taludes* but no *tableros*, such as the earlier stages of Structure 1B-prime:N1E1 in the Great Plaza of the Ciudadela (Cabrera 1982:80). Stairs lacking balustrades were revealed in one of the La Ventilla compounds excavated by Rubén Cabrera Castro in 1992–1994.[2] *Tableros* without bottom moldings, reminiscent of examples from Oaxaca (Cabrera 1996:30–31, figuras 7 and 8), were also discovered and are believed to date to the Late Tlamimilolpa or Early Xolalpan phase (Cabrera 1996:39).

Thus, the *talud-tablero* style of Teotihuacan varies nearly as much as that of Tikal, as described by Juan Pedro Laporte (Chapter 7), with many of the same variants appearing at both sites. There was less of a rigid canonical style

at Teotihuacan than has sometimes been thought. At Teotihuacan there also are courts enclosed by platforms that, to my eye, are not unlike those in the Acropolis-Palangana area of Kaminaljuyu, such as the one just south of the "House of the Priests" near the Sun Pyramid (R. Millon 1973:Map 1, number 41, map square N3E1).

Maya at Teotihuacan

There is abundant evidence of Maya connections and influences at Teotihuacan. Imported ceramics of Early Classic lowland Maya origin have long been known, especially from the so-called Merchants' Barrio, but they are also widely dispersed in small quantities throughout the city. Karl Taube (Chapter 11) greatly enriches our understanding of the iconographic and hieroglyphic evidence for this connection at Teotihuacan previously identified by Clara Millon (1973) and others.

It is possible that the Feathered Serpent Pyramid, Structure 1C:N1E1, and the structures on the East Platform of the Ciudadela form a Maya E-group—as argued by Laporte (Chapter 7), Vilma Fialko Coxemans (1988b), Rubén Cabrera Castro (2000), and Rubén Morante López (1996)—but I am not yet convinced. Seeing a resemblance requires one to ignore the North and South Platforms and everything else in the Ciudadela. If the Ciudadela had been intended as a place to enact the practices connected with Maya astronomical groups, I would expect it to have looked far more like Maya examples. Nevertheless, it is very clear that influences, and almost surely people, went both ways, and for several centuries. But nothing suggests that Maya, however much some of them may have been honored outsiders, ever intervened significantly in Teotihuacan's internal affairs.

Taube (Chapter 11) mentions that Late Preclassic Maya ceramics occur at Teotihuacan. Robert Smith (1987:29, 67, 279, Figure 3) discusses and illustrates two Waxy ware sherds found in a layer underneath the Sun Pyramid in a context not later than the Early Tzacualli phase (i.e., the first century A.D.), although some of the material in this layer is earlier. He considers one bowl or dish with a red slip to be very much in the Chicanel tradition. The other is a bowl with a dark gray to black slip, which also may belong to the "Chicanel horizon" but has "more of a Mamomlike appearance" (Smith 1987:29, 67). He thinks these two sherds may date to the first century B.C. In addition, a few dozen foreign sherds found in the surface collections of the Teotihuacan Mapping Project from various parts of the city tentatively have been identified as Sierra Red and Flor Cream. These types have a wide distri-

bution in the Maya area (David Cheetham, personal communication 2002). Instrumental neutron activation analysis (INAA), which will determine the sources of those at Teotihuacan, is in progress (Chapter 13).

What Was Going on in Regions between Teotihuacan and the Maya Area?

The focus of this volume is Teotihuacan and the Maya area. For this reason, little attention is paid here to regions between central Mexico and south-eastern Mesoamerica. This may leave readers with the inaccurate impression that little evidence for Teotihuacan-related presences has been found in the vast region that separates the highland city from the Maya area. We need a book as large as this one on the general theme of "Teotihuacan abroad." At present, more has been published about Teotihuacan-related phenomena in the Maya area than about sites within a few days' journey of the city of Teotihuacan.

Nevertheless, even what we know now shows that Teotihuacan "presences" of various kinds were widespread in Mesoamerica. Seen from a Mesoamerican perspective, Teotihuacan-related phenomena in the Maya area are simply the farthest southeastern expressions of strong Teotihuacan influences. To be sure, it seems that the spatial distribution of these presences was quite patchy, even more patchy than those of the Aztec empire, and very little is known about their nature. We must not assume that Teotihuacan's expansion was simply an early version of the Aztec empire. There surely were important differences as well as some similarities.

René Millon (1988) provides a recent review of Teotihuacan's varied presences outside its central Mexican domain. His review still is very useful, but it needs to be extended and brought up to date. In particular, by omitting evidence from Chiapas, it lends itself to the assumption that Teotihuacan presences were sparse in the region between Matacapan and Monte Albán and the Maya area.

In western coastal Oaxaca, Arthur Joyce (2000) reports a high proportion of central Mexican green obsidian from the lower Río Verde Valley in the Early Classic, as well as some *candeleros* and Teotihuacan-like ceramics, including a few possible imports from Teotihuacan. It may be that Teotihuacanos bypassed the Monte Albán state farther to the east in order to obtain Pacific marine shells directly from this region, among others. Monuments at Monte Albán refer to Teotihuacan, and some probably depict Teotihuacanos (Marcus and Flannery 1996), but here, especially on the Bazán slab (Taube 2000c:Figure 30b), what appear to be emissaries from Teotihuacan inter-

act with local dignitaries. The "special relationship" between Teotihuacan and Monte Albán has been much discussed. It seems that the two powers coexisted without either conquering the other.

At present it looks as if Teotihuacan's relations with the various regions within the Gulf lowlands were quite variable and concentrated in specific sites. One of the most common foreign wares found at Teotihuacan is Lustrous ware, often constituting one percent or more of excavated sherd lots. The source of Lustrous ware still is unknown, but INAA and other considerations suggest that it may have been produced somewhere in northern Veracruz, possibly not far from El Tajín, although that site itself seems too late to have been a likely source (Cowgill and Neff 2001). But other possible sources, perhaps in some unexpected region, should not be ruled out.

In the Mixtequilla region of south-central Veracruz, Stela 15 at Cerro de las Mesas has strong Teotihuacan connections (Miller 1991:32, Figure 2.10d; Taube 2000c:Figure 34b), and some ceramics there and at Tres Zapotes have some similarities to those at Teotihuacan, but in general the impact of Teotihuacan seems limited. Foreign sherds at Teotihuacan identifiable as from the Mixtequilla or nearby regions of central Veracruz appear to be scarce (Barbara Stark and Annick Daneels, personal communications 2000).

At Matacapan, in the Tuxtlas region of southern Veracruz, there seems to be no good evidence for an "enclave" of Teotihuacanos. This possibility was exaggerated in early reports by Santley and others. Nonetheless, some sort of connection is clear, manifested by the presence of locally manufactured twin-chambered *candeleros* of Teotihuacan style. Also, a few of the cylinder tripod vase supports illustrated by Ortiz and Santley (1998:391) have quite close Teotihuacan counterparts. Most Matacapan cylinder vases are less similar to those from Teotihuacan, but perhaps we should not expect local artisans to make closer copies. At Teotihuacan, INAA studies indicate that some imported ceramics resembling Proto-Tiquisate ware, beginning as early as A.D. 200, were likely from somewhere in the Tuxtlas–San Lorenzo region (Cowgill and Neff 2001). Other foreign sherds at Teotihuacan have been identified as good Matacapan types by Christopher Pool and Philip Arnold (personal communications 2000).

In his study of Teotihuacan writing, Karl Taube (2000c) concentrates on sites where Teotihuacan standardized signs occur. These are quite comparable to those of the Aztecs as a form of real writing, although only some of the signs are similar. In concentrating on writing, he does not discuss several other important kinds of evidence bearing on Teotihuacan connections. He has much to say about Teotihuacan-style carved stelae, less about ceram-

ics, and nothing about obsidian, other materials from central Mexico, and occurrences of Teotihuacan-like architecture. Even so, the picture is impressive. Taube calls attention to several monuments of Teotihuacan style from the states of Guerrero and Michoacán. This region is not far from the Teotihuacan core area, and may even be an extension of it.

Stela 1 at Piedra Labrada, not far east of Matacapan, has a string of Teotihuacan symbols and glyphs, including the flaming-bundle torch, the reptile-eye glyph (with a bar-and-dot seven), a rattlesnake-tail sign, and three "tilled-earth" glyphs (Taube 2000c:Figure 35f). The "tilled-earth sign" is perhaps the only Teotihuacan sign that occurs on *candeleros* as well as in other media (e.g., Séjourné 1966a:Figures 17 [lower left] and 19 [top and second from bottom of leftmost column]). Also attributed to the southern Gulf lowlands is the Soyoltepec monument, in a strong Teotihuacan style, with flaming-bundle torches and a feathered-serpent headdress (Taube 2000c:Figure 35g). Barbara Stark (personal communication 2001) notes that the scroll style on this monument suggests an origin in the south-central or the western part of southern Veracruz. She adds that Soyoltepec is in the Tuxtla mountains.

Other monuments in Teotihuacan style occur in the Cerro Bernal area of western coastal Chiapas, at the sites of Los Horcones and Fracción Mujular. Especially striking is Los Horcones Stela 3 (Taube 2000c:Figure 33e), which shows the Teotihuacan rain god in a strongly Teotihuacan style.

Except possibly for those made of *tecalli* (travertine), these stone monuments must have been locally carved, and were not sent from Teotihuacan as gifts to local dignitaries. They are stylistically far more like monuments found at Teotihuacan (e.g., the fragment of a *tecalli* stela found in the Quetzalpapalotl Palace [Acosta 1964:figura 60; Taube 2000c:Figure 30a]) than monuments known from the Maya region, except for the Tikal marker (Figure 7.6). They suggest the presence of persons very closely related to Teotihuacan in positions of considerable local authority. These individuals may have been representatives of the Teotihuacan state, but this is not certain.

Pierre Agrinier (1970, 1975) describes and discusses Teotihuacan-like materials found at the site of Mirador in western Chiapas (not to be confused with El Mirador, Petén, Guatemala). Bowls with flat bottoms and out-curving sides, direct-rim cylinder tripod vases, scarce "cream pitchers," and infrequent one-chambered *candeleros* bear rather general resemblances to Teotihuacan materials but seem more similar to Teotihuacanoid ceram-

ics from highland Guatemala and perhaps southern Veracruz. A few hemispherical bowls from Mirador almost surely are Thin Orange ware, which was made in Puebla but whose distribution may have been controlled by Teotihuacan. But, to my eye, none of the other Mirador ceramics are at all likely to have come directly from Teotihuacan (cf. Bernal 1966:104). As Agrinier points out, the absence of Teotihuacan-like figurines may be due to a general aversion to figurines in this region during the Early Classic, but the absence also of Teotihuacan-derived composite censers contrasts with their abundance in Pacific Guatemala. Agrinier reports no evidence of *talud-tablero* architecture at Mirador. On the other hand, green obsidian spear points from a cache resemble Teotihuacan types so closely that I think they probably were made by Teotihuacan artisans. This, together with evidence of destruction and burning of earlier structures, suggests (to me as well as to Agrinier) an abrupt and probably violent takeover by a small group of newcomers who had some Teotihuacan connections, but who may not have come directly from Teotihuacan. There certainly is no suggestion that Teotihuacanos in any numbers settled at Mirador.

Agrinier reports a (presumably uncalibrated) radiocarbon date for this phase at Mirador: A.D. 450 ±110 years. The one-sigma calibrated range is A.D. 428–629 (Stuiver and Kra 1986), corresponding to the end of the Early Xolalpan phase and the Late Xolalpan to Metepec phases. Stylistic resemblances to Teotihuacan are too vague to suggest more than a general Late Tlamimilolpa to Metepec interval, although some of the fine-line incised ceramics from the apparently early Cache 13 of Mound 20 are somewhat reminiscent of pottery dating to the Miccaotli and Early Tlamimilolpa phases. Teotihuacan-like cylinder vases also are found at Izapa (Lowe et al. 1982:Figure 7.21).

The strongly Teotihuacan features of Los Horcones Stela 3 contrast with the much remoter resemblances of locally made Teotihuacanoid ceramics at sites such as Mirador and Kaminaljuyu. This could mean that the occupants of Mirador and Kaminaljuyu had less-direct ties with Teotihuacan, but it might instead be that elites considered stelae too important to be left to unsupervised local artisans and either directed their work very closely or actually imported sculptors from Teotihuacan. It is likely that they cared less about ceramics and that they were quite satisfied with rather loose approximations made by local potters, except in the few cases where the importance of a dignitary merited actual importation of vessels from Teotihuacan.

A Proposed Scenario

Before A.D. 200

Interaction between Teotihuacan and the Maya began at least as early as the first century A.D., and more likely by the first century B.C. People in diverse regions of Mesoamerica had already been interacting for millennia— very likely since the first humans arrived. Late Preclassic Maya sherds found at Teotihuacan should be studied more closely and their dates and sources determined as exactly as possible. These ceramics could have reached Teotihuacan through intermediaries, and there is no evidence that people from Teotihuacan or the Maya lowlands were intervening in one another's affairs. Nevertheless, Teotihuacanos already had at least indirect contact with the Maya. I wonder if any evidence of contact with Teotihuacan will be found at immense Late Preclassic Maya sites such as El Mirador. Teotihuacan was also immense by this time, and if such data are found, I suspect that they will indicate exchanges between relatively equal partners.

A.D. 200 to 350

Frederick Bove and Sonia Medrano Busto (Chapter 2) report that, in the third century, objects from central Mexico appear at and near Balberta, in Pacific Guatemala. These include 174 pieces of Pachuca green obsidian and some Thin Orange ware. Proto-Tiquisate ware, certainly foreign to Teotihuacan and probably from somewhere in the Tuxtlas–San Lorenzo region of the southern Veracruz lowlands (Cowgill and Neff 2001), shows up during this period at the nearby Bonanza site. Small quantities of ceramics similar in style and identical in composition begin to appear in Early Tlamimilolpa (or possibly earlier) contexts at the Feathered Serpent Pyramid of Teotihuacan, a time that aligns well chronologically with the Guatemalan data. The isolated Altun Ha offering (Chapter 9) appears at about the same time. All these occurrences seem to be continuations and perhaps intensifications of kinds of interactions already under way a century or two earlier. They do not suggest any active intervention of Teotihuacanos in Maya affairs. Instead, they suggest that Teotihuacanos were sufficiently interested in obtaining materials from the Maya region that they found it worthwhile to cultivate Maya potentates as trading partners. It may be that some of these connections were indirect, mediated by mutual partners from the Gulf lowlands. This could explain the presence of Proto-Tiquisate ware both at Teotihuacan and in southern Guatemala.

The fact that ceramics from some still unknown source in the southern Gulf lowlands were arriving both at Teotihuacan and in coastal Guatemala is intriguing and calls for more investigation. The Teotihuacan presence at Matacapan is thought to be later, and the source of Proto-Tiquisate ware probably is elsewhere in the southern Gulf lowlands.

A.D. 350 to 450/500

Then, during a period of perhaps no more than a century, I see interventions by Teotihuacan-related people at Matacapan (where the relationship may have lasted longer), in the Cerro Bernal district and Mirador in Chiapas; at Montana/Los Chatos in coastal Guatemala; at Tikal, Copán, Kaminaljuyu, Río Azul, and several other places in the southern Maya lowlands; and possibly as far north as Becan. There was a change in kind as well as intensity of relationships, because in many cases there are strong indications that these interventions were backed by armed force, as summarized below. This period corresponds roughly with the Early Xolalpan phase at Teotihuacan according to current chronological estimates.

In the Montana district, no objects imported from Teotihuacan have been reported, but locally made materials with close counterparts at Teotihuacan include twin-chambered *candeleros,* composite censers, and distinctive "portrait" figurines whose bodies are in twisted poses and that are thought to represent soldiers. Perhaps less directly related to Teotihuacan are small vessels apparently rather similar to Teotihuacan *copas* (or "cream pitchers") and direct-rim cylinder vases. Bove and Medrano (Chapter 2) interpret this as evidence of a Teotihuacan colony. But it seems to me that a significant settlement of whole Teotihuacano households would have been accompanied by locally produced utility wares in Teotihuacan styles, as was the case at Tlailotlacan, the Oaxaca Barrio of Teotihuacan, where some Oaxacan-style utility wares were locally produced. The warrior "portrait" figurines found at Montana may have had a role in the socialization of children, but they may have been significant in adult rituals as well. Thus it seems likely to me that the Montana data represent an incursion of soldiers, and possibly merchants, with direct or at least very close ties to Teotihuacan. If they were indeed soldiers, one might expect obsidian spear points of Pachuca or Otumba obsidian, but in some of the other sites where such points have been found—such as Mirador, Balberta, and Kaminaljuyu—they have been limited to a few burials and caches. It may be that exotic obsidian points exist but have not been discovered yet in the Montana district.

Based on present evidence, the Teotihuacan-related occupation at Montana may have begun as early as A.D. 350, in which case it could have been the source for arrivals of foreigners at Tikal and Copán, although the stable isotope data from the Hunal Tomb at Copán suggests otherwise to Jane Buikstra (1997), Buikstra et al. (2000), and Robert Sharer (Chapter 5). Braswell (Chapter 4) notes that stable isotope data *may* indicate that some of the sacrificed individuals and trophy skulls from the Kaminaljuyu tombs came from this region, but adds that there is no indication that the principal occupants of the tombs were from the south coast. A clear priority is conducting such assays on dental and skeletal materials from central Escuintla.

The role of the city of Teotihuacan in these interventions remains unclear. One possibility is that they were carried out by agents of the Teotihuacan state, or at least on behalf of powerful Teotihuacanos with interests in the Maya area. This could mean the extension of "imperial" control, but not necessarily. The objective might have been, for example, to overthrow local dynasties and replace them with new leaders inclined to offer more favorable terms of trade to Teotihuacanos. Such interventions certainly have occurred in Guatemala in recent times.

A less likely possibility is that interventions were carried out by dissident factions or even independent "adventurers." This term, used by Kidder et al. (1946:255), continues to reverberate. Indeed, if Teotihuacan was the first Tollan, or Tula, it may not be too speculative to wonder if the story of the Tezcatlipoca-Quetzalcoatl conflict might distantly echo some factional strife within Teotihuacan. If there was a shift in Late Tlamimilolpa times to more collective political institutions, adherents of more individualizing strategies may have left voluntarily or been expelled and sought their fortunes in the Maya area. But this possibility makes it difficult to explain why fine objects made at Teotihuacan appear in elite burials at Maya sites. Such goods do not suggest hostile relations between the newcomers and Teotihuacan.

It is widely recognized that war is a prominent theme in Teotihuacan-related concepts and symbols in the Maya area, especially during the Late Classic when Teotihuacan was no longer a great power. Clearly a great deal of this had to do with religious and other ideational aspects. Nonetheless, we should not neglect highly material aspects. Why would a foreign cult make such a strong impression on the Maya? I am extremely skeptical of the idea that Teotihuacanos had any strong incentive to act as proselytizing missionaries, as is Braswell (Chapter 4). But I also doubt that Teotihuacan concepts and ritual practices related to war were adopted by the Maya because they filled some perceived need that could not be satisfied easily by adaptations of

their own traditions. Maya visitors to Teotihuacan surely would have been impressed by the size and dense population of the city and also by its immense pyramids and the spacious layout of its civic-ceremonial core. Yet, since they already had civic-ceremonial complexes of their own the size of those at El Mirador, we cannot assign too much weight to this factor.

I suspect that what was most impressive about central Mexican concepts related to war is that Teotihuacan armies, which must have played an important role in the early consolidation of the city's power within the Basin of Mexico, thereafter won a stunning series of victories farther afield. Interventions in Maya politics by foreigners with strong Teotihuacan associations, beginning in the fourth century, may be the farthest southeastern extent of military successes that already had a long history behind them.

I see such successes as results of new tactics and more disciplined units, possibly new weapons such as atlatls, probably the demographic strength to put more men in the field (at least for short campaigns where soldiers could live mostly off the land), a few exceptionally skilled leaders, and a certain amount of plain luck. Contemporaries would have been well aware of all these elements, but they also may well have attached great importance to the ability to call on the aid of an exceptionally efficacious set of war gods, including the War Serpent and the storm god in his military aspect. If this indeed was the case, the Maya and other Mesoamericans would have been eager to learn how to invoke the aid of these Teotihuacan-associated deities.

I do not propose this as the whole explanation for the prevalence of Teotihuacan-derived war symbolism among the Maya, especially during the Late Classic period, but I think it probably was an important factor. Furthermore, the concrete impact of a series of Teotihuacan victories, whatever the role attributed to supernatural assistance, would itself have left powerful memories. It is likely that economic considerations were important in these conquests, but I doubt if they were the only strong incentives. Sheer hunger for power, lust for victory, and the desire to quash worrisome potential rivals probably also were important.

It is doubtful whether Teotihuacan had the institutional resources, or Mesoamerica the infrastructure, needed to sustain an empire, even a "hegemonic" one, so if there ever was a Teotihuacan empire it probably began to fall apart as soon as it was created.

It is interesting that at Copán, inscriptions and stable isotope analysis suggest that it was a foreign-born Maya *man* who married a local Maya *woman*. Although we do not know yet where Yaax Nu'n Ahyiin of Tikal was born, it also seems probable that he was a foreigner. We may venture that he, too,

married a woman of the previous dynastic line. If the rulers of Teotihuacan intended to establish direct rule over Maya polities rather than hegemonic domination, it is likely that they would have sent out viceroys together with their Teotihuacano wives, thus maintaining their ties to the homeland and distancing themselves from their foreign subjects, much as the British did in India in the 1800s. When rulers want to cement alliances with other rulers of lesser or approximately equal power, a common strategy—at least in societies where men hold most political power—is to offer daughters in marriage. This also is a popular strategy when the intent is to rule provinces indirectly through preexisting local rulers. One example is the marriage of an Aztec princess to the heir apparent of a Zapotec kingdom. Another example is the marriage of the "Lady of Dos Pilas" to a king of Naranjo. Clearly such a policy of indirect rule bolstered by marital alliance was not what lay behind the foreign interventions at Tikal and Copán. The intent instead was to set up new dynastic lines, adding to their legitimacy by having outside men marry into established local (and presumably elite) families. This marital pattern, apparently seen at Copán and perhaps at Tikal, is another suggestion that the Teotihuacan-related foreigners were not under the close control of Teotihuacan rulers, although they may have been on excellent terms with those rulers.

After A.D. 450/500

What was the long-term significance of these foreign interventions in the Maya area? Except for putting new persons in power, perhaps not much. Certainly the most hierarchically organized Maya polities already were states. The subsequent history of Maya politics seems to consist of even greater deviations from central Mexican practices than before, with an intensification of what Richard Blanton et al. (1996) call "individualizing" or "networking" strategies. Exchanges between Teotihuacan and the Maya probably continued after A.D. 500 and perhaps until the collapse of the Teotihuacan state. Subsequent Epiclassic sites in central Mexico, such as Cacaxtla and Xochicalco, show even stronger Maya influences (at least in iconography), but these are of a different nature than what we see before A.D. 500. The decline of Teotihuacan by the end of the Early Classic may not have been a calamity for the Maya, but it may have opened new possibilities for prosperity during the Late Classic period. It is during this period that we see Maya elites making the most references to Teotihuacan. Partly these proclaim connection with an already distant past, but they also may reflect some lasting religious practices and beliefs, mainly related to war.

Future Directions

Needless to say, more excavations are highly desirable, especially in regions where some kind of evidence demonstrating central Mexican connections has already been found. At present, the nature of Teotihuacan-related "presences" at different sites, even within the A.D. 350–450 interval, is both varied and perplexing. Some of this may be the result of sampling accidents in places where little work has been done or even of incomplete reporting. Much, however, seems real. For example, *candeleros* are well represented at Matacapan and in the Montana district, but rare elsewhere. Composite censers quite similar to those at Teotihuacan are abundant in Pacific and piedmont Guatemala, but scarce or absent elsewhere. Stone monuments in a strongly Teotihuacan style occur in Guerrero, southern and central Veracruz, and the Cerro Bernal district of Chiapas, but Bove and Medrano (Chapter 2) report a distinct hiatus at this time in the long tradition of monumental sculpture in Pacific Guatemala. In the Maya lowlands, the Tikal marker from Group 6C-XVI is strongly related to Teotihuacan, but on other monuments, central Mexican elements appear in contexts that basically are Maya in style and content. Warrior "portrait" figurines have been reported only for central Escuintla. Green obsidian from the Pachuca source is found at many sites—sometimes as the sole evidence of a central Mexican connection and sometimes together with other Teotihuacan-related materials—but green obsidian has *not* been found at all Teotihuacan-related sites. *Talud-tablero* architecture, whether or not directly derived from Teotihuacan, has been found at only a few sites, but many have not been very extensively explored. We need to find out more about which of these differences are real and what they mean.

Stable isotope analyses of teeth should be actively pursued, using not only oxygen and strontium, but also any other compositional evidence bearing on place of origin. INAA and other compositional studies of ceramics and obsidian routinely use twenty or more elements, and multivariate analyses prove far more informative than those using only two elements. Using two elements for teeth would be more informative than using just one, but adding several more elements would be even better. Many more reference collections of teeth from all over Mesoamerica should be studied. Some nonmetric dental and skeletal traits may also prove useful, even if their genetic bases are unclear and their expression can be greatly modified by life history factors.

INAA and other compositional studies of Teotihuacan-like ceramics found outside the city are another obvious line of investigation, although it seems to have been neglected until recently. There is an extensive body

of INAA data on ceramics and clays from Teotihuacan and other parts of the Basin of Mexico at the University of Missouri, as well as earlier data obtained by the Brookhaven National Laboratory, so it should be possible to unambiguously identify actual imports from Teotihuacan. With more reference collections of ceramics and clays from other parts of Mesoamerica, it should become increasingly possible to identify sources of other Teotihuacan-like ceramics made elsewhere, including those in the Altun Ha offering (Chapter 9).

Investigations of Teotihuacan-related manifestations have been hampered by the limited published data on the typology and chronology of ceramics at Teotihuacan itself. For lack of anything better, we often turn to Séjourné (1966a), but that volume has many shortcomings. Smith (1987) is far more systematic, but he covers only earlier periods and makes a number of dubious chronological assignments. Rattray (2001) should greatly aid comparative studies.

As Carmen Varela Torrecilla and Braswell (Chapter 10) also stress, we need a comprehensive study of the time-space distribution of subtypes of direct-rim tripod-supported cylinder vases in Mesoamerica. It is a truism that only certain subtypes were made at Teotihuacan. We should know more about the distribution of cylinder vases that are close copies of Teotihuacan subtypes and also about the time-space distribution of less similar subtypes. Which of these different subtypes appear to have developed independently of Teotihuacan? Which may have derived (perhaps through intermediate subtypes) from Teotihuacan models?

Given the number of stelae and other monuments scattered throughout Mesoamerica that are carved in a strongly Teotihuacan style or that bear motifs closely associated with Teotihuacan, we should learn more about the chronology of sculptural styles at Teotihuacan itself. Teotihuacan sculpture shares a great deal with other media, including mural art and ceramics, so this would be a part of the larger project of improving our chronology of Teotihuacan styles, motifs, signs, and symbols in all media.

As Taube (2000c) convincingly argues, Teotihuacan standardized signs are a form of writing comparable to that of the Aztecs. We need to become better at reading this writing, not only for what it can tell us about Teotihuacan at home but also for the light it can shed on Teotihuacan abroad. Could we, for example, confirm that some signs or insignia are diagnostic of agents of the Teotihuacan state, as has been proposed by Clara Millon (1973) and others? Might some indicate other offices or occupations? Further research on Teotihuacan writing, together with studies of Maya glyphs that

may represent words of Teotihuacan origin, may settle the debate about the dominant language of Teotihuacan. Some scholars favor a Nahua language, but some evidence suggests that Nahua speakers did not arrive in numbers in central Mexico before the decline of Teotihuacan (e.g., Justeson et al. 1985). Other possibilities such as Otomí and Totonac remain open. Studies of loan words of Teotihuacan origin that are found in Maya texts may help resolve questions about Teotihuacan-Maya interactions.

Finally, we need a really thorough review of "Teotihuacan abroad" throughout Mesoamerica, which could provide a broader perspective for the proper assessment of the special case of Teotihuacan-related phenomena in the Maya area. This volume carries us great distances in right directions and suggests priorities for further work.

Acknowledgments

I thank Gerardo Aldana and, especially, David Cheetham for helpful comments on an earlier draft of this chapter.

Notes

1. A drawing of construction methods at the Feathered Serpent Pyramid published by Manuel Gamio (1979, 2:151, figura 35) is confusing. It is apparently a conflation of evidence from the actual Feathered Serpent Pyramid and the later "Plataforma Adosada" built over its west face. Only the Feathered Serpent Pyramid has cellular interior construction consisting of north-south and east-west walls of uncut stones laid in mud mortar. The later platform has much looser fill, using large wooden posts but lacking interior cells (Millon 1973:Figure 33). Cellular construction is rare in Teotihuacan pyramids.

2. "La Ventilla" refers to a whole district rather than to a single apartment compound. Those designated "A" (itself composed of three compounds), "B," and "C" (R. Millon 1973:30 and Map 1, numbers 19, 20, and 21, in map grid square S1W2) are several hundred meters from each other and from the several compounds excavated by Cabrera Castro and his group in the 1990s (Cabrera 2000). The composite stela similar to the Tikal marker was found in La Ventilla A (R. Millon 1973:33).

The Maya and Teotihuacan

Joyce Marcus

Thanks to all the new data being gathered in Mesoamerica, we are now in a better position to develop models for the interaction between Teotihuacan and the Maya. In preparing this chapter, I reviewed the evidence for "foreign ties" at each of the seven sites discussed in this volume and realized that one could create at least seven different models. After noting numerous similarities in them, however, I was able to reduce the number to four. I hasten to add that even after this reduction, no two cases were identical and such case-to-case variability is very significant when trying to build accurate models.

In this chapter I will cover four general themes: (1) how archaeologists have viewed Teotihuacan-Maya interaction during the last seventy years; (2) how alternate generations of Mayanists have often returned to the same position; (3) why it was an error to link Maya state formation to Teotihuacan; and (4) how we might improve our "interaction" models.

The Past

During the first half of the twentieth century, the ancient Maya were often regarded as an isolated people whose "unique civilization" developed "practically without influence from the outside" (Morley 1946:14; see also Pendergast 1971:455). This view was destined to change when Alfred V. Kidder, Oliver G. Ricketson, and Robert Wauchope began to excavate Mound A at Kaminaljuyu, a major site on the outskirts of modern Guatemala City (Kidder et al. 1946). At that time, Kaminaljuyu had more than two hundred earthen mounds and covered at least 5 km². During the excavation of Mounds A and B, the Carnegie investigators found several superimposed buildings with *talud-tablero* architecture, then considered a hallmark of Teotihuacan. Today we know that the *talud-tablero* style was used at still earlier sites in the highland Mexican states of Puebla and Tlaxcala (García Cook 1981; Gendrop 1984; Giddens 1995; Plunket and Uruñuela 1998a, 1998b).

In addition to the *talud-tablero* architecture in Mounds A and B, Kidder et al. (1946) found tombs filled with hundreds of ceramic vessels as well as abundant shell, bone, and stone artifacts. As described by George Brainerd: "The graves of notables contain handsomely decorated objects from central Veracruz, from Teotihuacan, and from the Maya lowlands, and the building techniques used for the tombs are such as to suggest that foremen from Teotihuacan may have directed their construction" (1954:23). Brainerd (1954:23) makes two important observations: (1) that the styles of the tomb objects reflect contact with multiple regions (Veracruz, Teotihuacan, and the Maya lowlands); and (2) that such a "cosmopolitan exchange of goods and ideas" was more marked among elites than among commoners. What we do not know is how many of the "foreign-looking" vessels were imported and how many were local imitations of foreign styles. So far, few of the tombs' artifacts have proven to be actual imports from the Mexican highlands. Most attention is now concentrated on sixteen Thin Orange vessels, believed to have been imported from Puebla (Demarest and Foias 1993:156–157; Rattray 1977, 1990). Future paste analyses might demonstrate, however, that more vessels were imported from lowland regions (e.g., Veracruz, Tabasco, or northern Guatemala) than from the Mexican highlands. Even the cylindrical tripod, once considered a hallmark of Teotihuacan, now is thought to have originated in the lowlands of Veracruz (Rattray 1977, 1983).

Recent analyses in which tooth enamel phosphate and carbonate were used to determine oxygen isotope ratios have revealed that the principal skeletons in the Mounds A and B tombs were not from Teotihuacan, as earlier scholars had assumed. A few of the retainers accompanying the principal tomb occupants, however, might be nonlocal people from either the Maya lowlands, the Pacific Coast of Guatemala, or the Mexican highlands (White et al. 2000; Wright 2000).

The evidence from the 1930s excavations in Mounds A and B at Kaminaljuyu forced archaeologists to think seriously about the impact of Teotihuacan on the Maya. For a time, however, archaeologists assumed that this impact might be restricted to the Maya highlands, perhaps because there are obsidian sources in that region and it was thought that one of Teotihuacan's interests was to control production and distribution of obsidian in Mesoamerica (Cheek 1977b; Sanders 1974, 1977; Sanders and Michels 1977; Sanders and Santley 1983; Santley 1989). Eventually, the Maya lowlands also began to reveal non-Maya elements, and those finds forced archaeologists to change their notion that Teotihuacan's impact was confined to the Guatemalan highlands.

Archaeologists began to recover "foreign" elements at lowland sites such as Tikal and Uaxactun from excavations that yielded Early Classic vessels as well as new texts and iconography (Coe 1967, 1990; Coggins 1975; Greene and Moholy-Nagy 1966; Harrison 1970, 1999; Shook 1958; A. L. Smith 1950; R. E. Smith 1955). Based on her work with the Tikal stelae in 1970, Tatiana Proskouriakoff was the first to argue that "foreigners" arrived at Tikal on January 16, A.D. 378 (the 11 Eb' 15 Mak date in the inscriptions corresponds to 8.17.1.4.12 in the Long Count calendar). Because they carried "highland" weapons (Figure 8.3b), she suggested that they were warriors from the Mexican highlands (Proskouriakoff 1993:7–8). And, because the arrival of these warriors coincided with the death of the Tikal ruler Chak Tok Ich'aak ("Great Paw"), she argued that Uaxactun, "either in league with foreigners or using the foreigners as mercenaries, was responsible for the incident that led to the demise of Great Paw" (Proskouriakoff 1993:8). If true, the violent death of a Maya ruler at the hands of an outsider (i.e., Siyaj K'ahk') would illustrate four points: (1) how important warfare was during this era; (2) how warfare disrupted the Tikal line of succession; (3) how that death paved the way for an outsider to take the throne; and (4) why the usurper adopted foreign motifs to legitimize his right to rule. There is no description of the precise circumstances surrounding the death, nor does any text assert that Siyaj K'ahk' occupied the Tikal throne. Instead, Siyaj K'ahk' helped install Yaax Nu'n Ahyiin, a usurper, in office (Schele and Freidel 1990:157). His accession took place on September 13, A.D. 379, more than a year and a half after the death of Chak Tok Ich'aak. Yaax Nu'n Ahyiin (Figures 8.3a, 8.4a, c) did not link himself to any of Tikal's nine former rulers; instead, he claimed to be the son of a foreigner with the name or title of "Spear-Thrower Owl." So far we lack portraits of Siyaj K'ahk' and "Spear-Thrower Owl," the key "foreigners." Proskouriakoff's pioneering study of the arrival of "foreigners" at Tikal has been the basis of later work that emphasized either the impact of Teotihuacan on Tikal (e.g., Fahsen 1988; Fialko 1987, 1988a; Jones and Satterthwaite 1982; Schele and Freidel 1990; Valdés and Fahsen 1995) or, alternatively, the impact of Kaminaljuyu on Tikal (e.g., Coggins 1975, 1979; cf. Chapter 8 and Demarest and Foias 1993).

The arrival of foreigners also is the theme of a vessel found in Problematical Deposit 50, located to the west of the North Acropolis at Tikal. On the vessel, figures are shown walking from a *talud-tablero* building (Structure 3 in Figure 13.1) to a place with both a *talud-tablero* platform supporting a Maya-style temple (Structure 2) and a Maya-style pyramid and temple (Structure 1). Structure 3 may represent Teotihuacan, while Structures 1 and 2

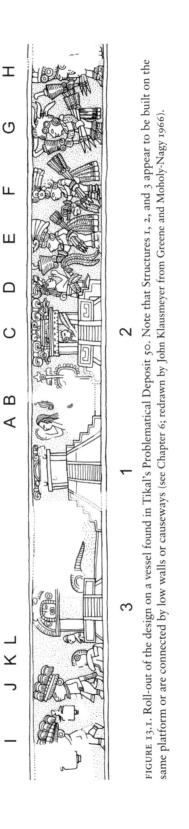

I J K L 　 A B 　 C D E F G H

3 　 1 　 2

FIGURE 13.1. Roll-out of the design on a vessel found in Tikal's Problematical Deposit 50. Note that Structures 1, 2, and 3 appear to be built on the same platform or are connected by low walls or causeways (see Chapter 6; redrawn by John Klausmeyer from Greene and Moholy-Nagy 1966).

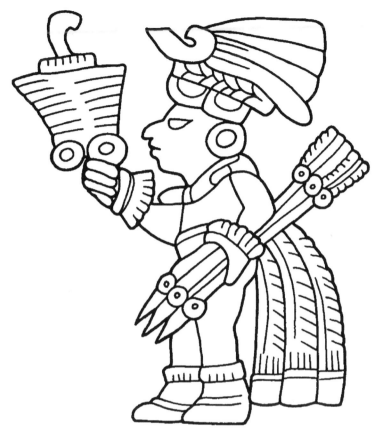

FIGURE 13.2. Enlarged view of figure on a vessel from Tikal's Problematical Deposit 50. He carries a spear-thrower (atlatl) in his right hand and darts in his left. Although the spear-thrower is often regarded as a "highland Mexican" weapon, it had great time depth in the Maya lowlands (drawn by John Klausmeyer from Figure 13.1, Individual E).

are assumed to be either two styles of buildings that coexisted at Tikal, or Structure 2 represents Kaminaljuyu and Structure 1 represents Tikal (Coggins 1975; Schele and Freidel 1990). Individuals I and J are two men wearing tassel headdresses, who are shown with lidded vessels; the contents of the vessels are not indicated. In front of these two traders are four men not wearing tassel headdresses. Individuals E, G, and H carry spear-throwers in their right hands, and all four carry spears or darts in their left and wear padded shirts and long feathers (Figure 13.2). One attribute that differentiates traders from warriors is the presence of the tassel headdress. Years ago, Clara Millon (1973, 1988) suggested that those who wore tassel headdresses were peaceful emissaries and long-distance traders who traveled from Teotihuacan to

distant places (Figure 13.3a). Depictions of such emissaries are known from Kaminaljuyu (Figure 13.3b) and Monte Albán (Marcus 1983b:Figures 6.5–6.7). Although the Tikal vessel in Figure 13.1 has been interpreted in many ways—the arrival of visitors, the reception of a trading expedition, the arrival of a military escort, the conquest of Tikal by Teotihuacan, and a procession of individuals between three structures built on the *same* platform at the *same* site (see Chapter 6; Conides 2000)—we cannot interpret it fully until we identify the specific people and places.

Complementing the iconographic and hieroglyphic information are important excavation data from Tikal. Juan Pedro Laporte's (1987, 1989, 1998) excavations in Mundo Perdido have exposed buildings in *talud-tablero* style, with the first examples appearing 100–200 years before Proskouriakoff's "foreigners" arrived in A.D. 378. During the next three centuries at Tikal, many more structures were built that displayed architectural variants of the *talud-tablero*. Laporte (Chapter 7) notes that additional Petén and Campeche sites—none yet extensively excavated—have *talud-tablero* buildings. He concludes that the architectural designs are so varied, and occur over such a long time, that the sources for these styles are multiple—that is, some or all may have been inspired by sites other than Teotihuacan. The argument that the architecture at Tikal reflects *many* sources of inspiration is not only gaining momentum but is also suggested by several lines of evidence at sites such as Copán.

Ongoing work at Copán by Robert Sharer, Loa Traxler, David Sedat, William Fash, Barbara Fash, and Ricardo Agurcia suggests that Copán had *multiple* Early Classic ties with foreign powers, with Tikal and Kaminaljuyu figuring most prominently among these. The Copán data suggest that Tikal (or other Petén sites) and Kaminaljuyu (or other highland Guatemala sites) were as important as Teotihuacan in shaping the style of some Early Classic royal structures and the contents of associated royal tombs at Copán. Tikal and Kaminaljuyu (or some intervening sites) may have been mediators in a multisite network that ultimately linked Copán with the central Mexican highlands (Chapter 5).

In contrast to the Tikal and Copán situation, with their links to multiple highland and lowland regions, David Pendergast's (1971) excavations in Belize reveal only one brief interaction between Altun Ha and Teotihuacan. This lack of sustained foreign contact is not too surprising, since Altun Ha is 1,150 km from Teotihuacan and it was not nearly as large or politically prominent as Tikal. Pendergast suggests that a few Teotihuacanos

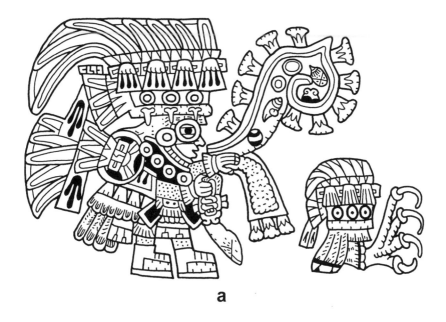

a

b

FIGURE 13.3. Teotihuacan emissaries. (a) This figure, wearing the tassel headdress, was painted on a mural at Techinantitla c. A.D. 450–550. His name combines the ambassadorial title "tassel headdress" with his personal name "Eagle Claw." He carries no weapons; instead, he is associated with footprints indicating a journey (not shown here), an incense bag, and a speech or song scroll (drawn by John Klausmeyer from C. Millon 1988:116). (b) Painted scene of bearers carrying bowls containing a haunch of venison (at left) and a fish (at right). They wear tassel headdresses and utter speech scrolls. The other bowls may contain corn, tamales, or copal balls. This scene was painted on a bowl placed in Tomb A-III at Kaminaljuyu. Kidder et al. (1946:236) concluded that the vessel "without question emanated from some Maya pottery center" and "yet the painting of its stuccoed outer surface is unmistakably Mexican" (drawn by John Klausmeyer from Kidder et al. 1946:Figure 207a).

might have made it all the way to Altun Ha, their arrival coinciding with the post-interment rites for an Altun Ha lord. Although Pendergast views the cache as evidence of a visit by Teotihuacanos, other archaeologists might interpret the same cache as the contents of a trade bundle passed down the line through intermediaries (see Chapter 9).

Pendergast asks if the attendance of Teotihuacanos at this ritual made any significant long-term difference at Altun Ha; his answer is "no." Thus this posited trip by highland peoples to Altun Ha may be analogous to a visit by Teotihuacan ambassadors to Monte Albán, Oaxaca, which coincided with the inauguration of a new Zapotec ruler and the dedication of a temple platform at the southern end of the Main Plaza (Marcus 1992b:325–329). Both appear to be events whose impact was short-lived, however politically and diplomatically important they may have seemed at the time.

How Alternate Generations of Mayanists Return to the Same Position

In evaluating the impact of Teotihuacan, Mayanists have oscillated between assigning that city a truly major role and no role at all. Given our current evidence, neither position seems tenable. The truth seems to lie somewhere along the continuum between these extremes, and what is even more significant, our *interpretations* of the impact of the Mexican highlands vary from site to site and from decade to decade.

During the 1920s and 1930s, most Mayanists regarded central Mexico's role as minimal. From the 1940s through the 1970s, Teotihuacan was viewed as having had a major impact on Kaminaljuyu. In the 1980s, Mayanists returned to the notion that central Mexico's direct role was minimal and argued that the Maya were simply selecting highland Mexican weapons and motifs to create a new warfare iconography. By the late 1990s, some scholars were saying that Teotihuacan had had a major impact on Maya cities, and a few suggested that the son of a Teotihuacano king had ruled Tikal.

Such pendulum swings are characteristic of Maya archaeology (Marcus 1983a:454), because scholars tend to overreact to current positions and tend to overemphasize a single piece of information from one site in their efforts to characterize the Maya region as a whole. Perhaps in the future we can avoid this cyclic return to previous positions by using multiple lines of evidence, by continuing to create a finer-grained chronology for all of Mesoamerica, and by developing processual models that combine both the specific decisions made by human agents and the general trends seen in various regional traditions and political trajectories. We often have assumed that the arrival

of "foreigners" or the inclusion of a "foreign" artifact in a cache was more causally significant than long-term local processes.

Another problem affecting our interaction models is that of precise contemporaneity. We still have problems linking Teotihuacan and Maya ceramic sequences, and even linking ceramic sequences from one Maya site to another (see Chapter 10). Without more precise chronological control, it is difficult to distinguish simultaneous events (e.g., visits to several sites in the same year) from nonsimultaneous events (e.g., multiple visits scattered over ten to twenty years). I return to this theme below.

Why It Was an Error to Link Maya State Formation to Teotihuacan

Maya state formation is still poorly understood because: (1) evidence for the transition from chiefdom to state often lies deeply buried; (2) complex chiefdoms may cycle into incipient states and then back to complex chiefdoms during time spans too short for an archaeologist to distinguish (Anderson 1994; Flannery and Marcus 2000; Wright 1984); and (3) too few archaeologists have spelled out the specific archaeological criteria they use to establish statehood (see Marcus 1993, 1998).

Current evidence suggests that from 800 to 400 B.C. the Maya region was characterized by both simple and complex chiefdoms, often cycling from one to the other. For the period 400 B.C. to A.D. 100, there is growing evidence for paramount chiefdoms that utilized large labor forces to create truly monumental pyramids at sites like Calakmul, El Mirador, Nakbe, Lamanai, and Cerros (Folan et al. 1995; Freidel 1977, 1986; Hansen 1991, 1998; Matheny 1980, 1986, 1987; Pendergast 1979, 1981, 1982, 1990; Pincemin et al. 1998; Robertson and Freidel 1986). There is significant evidence for raiding, captive taking, and the mass burial of sacrificed victims during this period (Fowler 1984; Laporte 1989; Marcus 1995; Robin and Hammond 1991; Sharer and Sedat 1987). Between A.D. 100 and 400 a few major Maya states emerged, with their capitals at Calakmul, Tikal, and Copán (Fash 1991; Folan et al. 1995; Laporte 1987; Laporte and Fialko 1995; Marcus 1983a, 1995, 1998; Pincemin et al. 1998; Sharer 1983).

This era of early Maya state formation *preceded* any significant arrival of "foreigners," since the dates for such events, as recorded on stone monuments, are A.D. 378 (El Perú), A.D. 378 (Tikal), and A.D. 426 (Copán) (Proskouriakoff 1993; Schele and Freidel 1990; Sharer 1983:254; Valdés and Fahsen 1995). The "arrival" of Teotihuacanos at Tikal in A.D. 378 occurs long after the formation of the Tikal state and long after the reign of Tikal's

first king; in fact, the Teotihuacanos arrived during the reign of the ninth Tikal ruler (Coggins 1975; Harrison 1999; Jones and Satterthwaite 1982; Proskouriakoff 1993; Schele and Freidel 1990). In much the same way, the arrival of Teotihuacanos at Copán took place long after the reign of its earliest-known rulers in A.D. 159 (Chapter 5; Morley 1920; Schele and Freidel 1990). In other words, our key examples of visits by Teotihuacanos occurred when the Maya were on a political par with Teotihuacan, long after the initial Maya state had emerged.

Attempts to explain the origins of the Maya state by invoking "Teotihua-can influence" misled Maya archaeologists for years. Such a notion may have pleased scholars working in central Mexico, but it did little to advance our understanding of state formation, primarily because it left local processes underemphasized. Admittedly, of course, we still know less about the *in situ* processes that led to Maya state formation than we would like. Until very recently we could not even answer the question as to when the first true palace made its appearance in the Maya region. At Tikal there are stone palaces, such as Structure 5D-46, dating to A.D. 350, but preceding them were still earlier palaces (Coe 1990). Nevertheless, the precise date of Tikal's first palace still is not known.

Thanks to new work at Copán, we now realize that, in some parts of the Maya area, the first palaces may have been built of adobe—a material that does not survive well in the tropical lowlands. Excavations at Copán by Loa Traxler (1998) have pushed back the date of the earliest palace to before A.D. 400. Copán's reliance on earthen architecture well into the Early Classic has revealed how late the introduction of stone masonry occurred there. Earthen architecture has a long tradition in the highlands of Guatemala, particularly at Kaminaljuyu. In arid highland Mexico, recovering mud and adobe architecture is less of a problem. If we did not have the unique situation at Copán—unusual preservation combined with the opportunity to excavate tunnels—Traxler might never have recovered any elite residences antedating the advent of stone masonry (Sharer, Traxler et al. 1999). Now we must ask: When work is conducted at Late Preclassic and Early Classic sites elsewhere in the Copán Valley, will we be able to recognize mud platforms and their perishable superstructures for what they really are? Will we be able to tell the earliest palaces from still earlier chiefly residences, perhaps built of the same materials between A.D. 1 and 400?

Now that we know that Maya states emerged well before Teotihuaca-nos arrived at such places as Tikal and Copán, we can try to explain why Teotihuacanos visited the Maya. Knowing their motives will facilitate build-

ing more appropriate models to describe central Mexican–Maya interaction. Fash and Fash (2000) and Karl Taube (Chapter 11) have made a good case that the Maya also visited Teotihuacan; such visits would have enabled the Maya to bring foreign goods and ideas back to their homeland.

Building Models

It is clear from a sample of the literature that there can be no "one-size-fits-all" model for contacts with Teotihuacan. In some cases, there is evidence for a single short-term contact; in other cases, there seems to have been repeated contact over many centuries. For example, Pendergast (1971:456) considers his Altun Ha "Teotihuacan cache" to represent a single event that occurred c. A.D. 150–200. At Tikal, the earliest *talud-tablero* buildings appear c. A.D. 250, while others at that site were built centuries later; in contrast, Tikal texts suggest a short-lived interaction between A.D. 378 and 445. At Copán, the texts suggest that Teotihuacan interaction began in A.D. 426 and, judging from tombs and architecture, lasted less than a decade.

For Kaminaljuyu, where we lack Classic-period texts with dates, the duration of interaction is hard to pin down; it may have lasted from A.D. 350 to 550, but this estimate could be shortened or lengthened with more data (Chapter 3). William Sanders, Joseph Michels, and others have argued that the impact of Teotihuacan on Kaminaljuyu not only was of long duration but also had profound effects, among them the alteration of Kaminaljuyu's political, religious, and economic organization (Michels 1979; Sanders 1974, 1977; Sanders and Michels 1977). Geoffrey Braswell (Chapter 4), however, argues that Teotihuacan's impact on Kaminaljuyu has been overstated. Ties between the two sites are more likely to have involved inter-elite gift giving, status reinforcement, and emulation (Demarest and Foias 1993:162; Sharer 1983:254), as well as reciprocal visits (Chapter 11; Fash and Fash 2000) and participation in shared religious practices.

Pendergast's (Chapter 9) evidence for Teotihuacan contact comes from a single cache. The cache was placed above the wooden roof of Tomb F-8/1 (Pendergast 1971). In the offering were at least 85 greenstone beads, 23 ceramic vessels, 248 green obsidian "eccentrics" (including human figures), and 13 bifacially chipped green obsidian points. Pendergast (1971:456) calls this "a complete cache of the type characteristic of Miccaotli phase times at Teotihuacan," and dates it to A.D. 150–200. If this early date of the Altun Ha cache holds up, Teotihuacan contact would be earlier here, at a moderate-sized town like Altun Ha, than at capital cities like Tikal, Calakmul, and Copán.

Because the impact of Teotihuacan at Altun Ha seems to be confined to a single cache, Pendergast concludes that some Mayanists have overemphasized Teotihuacan's role in the region. The same can probably be said for Cache 69-2 at Becan, which also constitutes a single event. Included in the cache at Becan was a cylindrical tripod vase of probable highland Guatemalan origin; in it was a two-piece hollow figure of Teotihuacan style containing ten smaller figurines (Figure 13.4; Ball 1974). Joseph Ball (1983:134–135) interprets this cache as a "victory offering" and links it iconographically to Teotihuacan's owl and jaguar military orders. Ball (1977b:170) noted that the vessel and its contents occurred "in a disturbed mortuary—redeposited cache context together with several pieces of Petén Gloss ware and could well owe their presence to trade or to the gift giving that accompanied funerary visitation."

Thus, while objects from highland Mexico and highland Guatemala certainly made their way to lowland Maya sites, a number of Mayanists, including Joseph Ball (1977, 1983), Geoffrey Braswell (Chapter 4), Arthur Demarest and Antonia Foias (1993), and David Pendergast (Chapter 9), suspect that Teotihuacan's impact on Altun Ha, Becan, and Kaminaljuyu has been overstated.

Let us now look at four models that incorporate some of this variability.

Model 1: Single-Event Interaction

Sites such as Altun Ha and Becan (as well as Monte Albán in Oaxaca) suggest a single-event model for interaction with a distant foreign power. The event may be *violent,* such as the burning of a building during a raid, or *amicable,* such as elite gift giving or attendance at a building dedication.

Model 2: Multistage Interaction

Contrasting with the single-event model is one in which foreign contact is multistage. Such multistage interaction could begin as a symmetrical relationship between two cities through military or marital alliance; later it might become asymmetrical, with one city gaining the upper hand. Certainly, there is no clear-cut evidence for a Teotihuacan takeover at any Maya site, despite efforts to interpret the hieroglyphic data to suggest that the son of a Basin of Mexico ruler was on the throne of Tikal (Stuart 2000a; cf. Coggins 1975, 1979; Mathews 1985; Proskouriakoff 1993; Schele and Freidel 1990; Valdés and Fahsen 1995). Fortunately, such scenarios can be tested by the use of oxygen-isotope ratios of tooth enamel phosphate, by strontium assay, and by analysis of DNA from the skeletons of the "foreign"

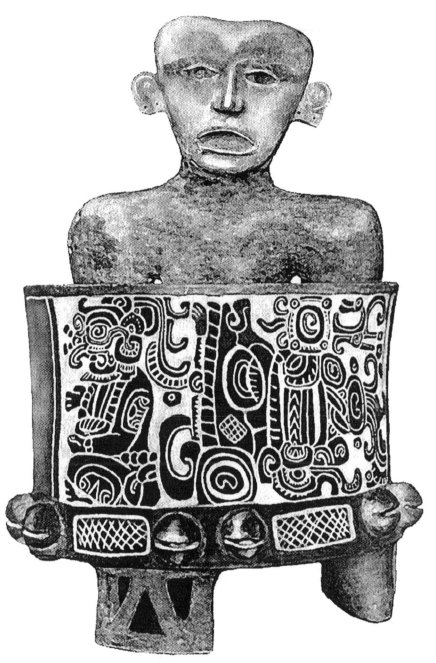

FIGURE 13.4. A Teotihuacan-style "host" figurine was found, as shown, inside a highland Maya-style vessel from Room 3, Structure XIV, at Becan. It dates to c. A.D. 450–500. Height of figurine is 22 cm; height of vessel is 16 cm (drawn by Kay Clahassey from the photograph that appeared on the cover of *Archaeology* magazine; see Ball 1974).

protagonists mentioned in the texts of sites like Copán and Tikal.[1] Royal usurpers often claim to be descended from some glamorous foreign lineage, using exotic "foreign" elements in their commissioned monuments, architecture, and craft items to support that claim (Chapter 8; Marcus 1974, 1992b; Pasztory 1993; Schele and Freidel 1990:163; Stone 1989). Such a situation makes it imperative to test such assertions with biological evidence of foreign ancestry.

An example of such a "foreigner" is the fifth-century-A.D. ruler at Copán named K'inich Yaax K'uk' Mo'. He is presented as the founder of a new dynasty and depicted in warrior gear, including a War Serpent shield on his right forearm and Teotihuacan-style "storm god" goggles over his eyes. Texts state that K'inich Yaax K'uk' Mo' arrived at Copán and took office in A.D. 426/427 (Chapter 5). Isotope analyses of the probable skeleton of K'inich Yaax K'uk' Mo' show that he did come from outside the Copán Valley, but not from one of the three sites considered most likely—Teotihuacan, Kaminaljuyu, and Tikal. Instead, K'inich Yaax K'uk' Mo' appears to have been from a lowland Maya site, probably located somewhere between Tikal and Copán (Jane Buikstra, Robert Sharer, and Loa Traxler, personal communications 2000). Two possibilities that should be considered are Quiriguá and Pusilha, sites that were closely linked to Copán. A monument at Pusilha, in fact, contains a retrospective reference to a predynastic ruler of Copán called "Leaf Ajaw" (Geoffrey E. Braswell, personal communication 2000).

The rulers who succeeded K'inich Yaax K'uk' Mo' asserted that he was Copán's *first* ruler, but two lines of evidence indicate that such was not the case. One source is a set of retrospective texts that mention the names of still earlier rulers (including "Leaf Ajaw"). Other evidence found deeply buried at Copán includes the remnants of structures that formed a royal center before K'inich Yaax K'uk' Mo' arrived (Sharer, Fash et al. 1999; Sharer, Traxler et al. 1999). During K'inich Yaax K'uk' Mo's reign, Copán continued to build earthen structures (similar to those at Kaminaljuyu), but also erected its first masonry constructions and created at least one *talud-tablero* platform. During the reign of K'inich Yaax K'uk' Mo's son, two funerary temples were built, both displaying lowland Maya–style apron moldings on their façades (similar to those at Tikal). Based on architectural as well as ceramic data, Sharer (Chapter 5) persuasively argues that it is just as easy to show Copán's ties to Kaminaljuyu and Tikal as to Teotihuacan.

The Copán situation may have started out as an asymmetrical interregional relationship, becoming more symmetrical at a later time. Military conquest may have allowed a usurper like K'inich Yaax K'uk' Mo' to seize

the Copán throne, and marrying a local noblewoman may have allowed him to retain control. Such a scenario seems to fit current evidence, because strontium isotope results indicate that the presumed wife of K'inich Yaax K'uk' Mo' was a local woman (Chapter 5). After their marriage and the birth of an heir (Copán's Ruler 2), relations between K'inich Yaax K'uk' Mo's place of origin and his new realm may have become more symmetrical.

Such a scenario may fit not only Copán but also Tikal and a few other Maya cities where there is evidence for an outsider who arrives to found a new dynasty (Coggins 1975; Marcus 1992b; Proskouriakoff 1993; Schele and Freidel 1990; Sharer, Fash et al. 1999; Sharer, Traxler et al. 1999). As we have seen, even though an outsider may be portrayed as a "Teotihuacan warrior," he actually may have come from another Maya site. Clemency Coggins (1975) argues that this situation fits Tikal, where the usurper Yaax Nu'n Ahyiin and others were outsiders, perhaps from Kaminaljuyu.

It is worth noting that at Copán, the usurper who took the throne did not assert his "foreignness." Instead, it was his descendants who did most of the proclaiming. Both Tikal's Siyaj Chan K'awiil and Copán's Ruler 2 expounded on their fathers' exotic pasts, emphasizing that they were warriors. As Sharer states in Chapter 5, Copán's Ruler 2 "sponsored a vast building program and the carving of texts on stone monuments in honor of his father." Still, all depictions of K'inich Yaax K'uk' Mo' in central Mexican military garb date to the Late Classic, long after the events of the early fifth century. The only clear contemporary (or near-contemporary) portrait is on the Motmot marker, where K'inich Yaax K'uk' Mo' is shown in full Maya regalia. Stela 35 may also be an early portrait of K'inich Yaax K'uk' Mo', and, again, he is shown in Maya garb.

In contrast, Stela 4 of Tikal is a contemporary and eclectic depiction of Yaax Nu'n Ahyiin (Figure 8.3a). It shows him in central Mexican garb, but he holds the God III effigy head and is looked down upon by an ancestor/deity that invokes comparison with the Maya highlands and Pacific piedmont (Chapter 8). His son Siyaj Chan K'awiil, like later descendants of the dynastic founder of Copán, continued to depict Yaax Nu'n Ahyiin as a warrior dressed in Teotihuacan garb (Figure 8.4a,c). In speaking of Tikal Stela 31, Esther Pasztory writes: "This is not a situation in which a Tikal artist was 'influenced,' but a situation in which a conscious choice was made to represent a Teotihuacan-style shield with a Teotihuacan deity on it for a specific purpose by a Maya artist and patron" (1993:118). That purpose evidently was to assert that his father was a warrior.

In sum, although several Maya cities show evidence for multistage con-

tacts with more distant centers over the centuries, we should remain skeptical about various usurpers' actual places of origin. Whenever their tombs can be found, isotopic and DNA tests should be used to evaluate their claims of remote or exotic hometowns. Moreover, it may be simplistic to view foreign interaction at these sites only in terms of Teotihuacan. Just as the "Middle Classic Hiatus" once was attributed to the withdrawal of the great highland city rather than to local or regional processes, it may be that other Maya sites played a greater causal role in the events of late-fourth-century Tikal and early-fifth-century Copán. This certainly was the case at Copán, where analysis of the usurper's presumed remains suggests he came from the Maya lowlands.

Model 3: Simple Dyadic Interaction

Most models used by Mayanists imply a simple dyadic relationship, in which Teotihuacan is the *sole* foreign power affecting a Maya city. Growing evidence suggests that ascribing one (and only one) source of contact is less plausible than formerly thought.

Model 4: Multiple Partners or Interactions Mediated through Multiple Sites

A model showing a better fit with our growing body of data would be one in which each major Maya city had ties to several other Maya cities, as well as to several non-Maya cities elsewhere in Mesoamerica. Some of these ties might have been *direct,* while others were *indirect.* A few major Maya sites might have been linked to Teotihuacan by direct visits, while many others had indirect relationships with intermediaries like Kaminaljuyu.

We should not lose sight of the fact that although some Early Classic Maya sites display signs of contact with Teotihuacan, other nearby sites do not. For example, two sites in the Valley of Guatemala—Kaminaljuyu and Solano—have buildings in Teotihuacan style, while nearby El Frutal does not. This raises the possibility that Teotihuacan contacts may have been royal family to royal family, rather than region to region. Such noble-to-noble interaction was common in the ancient world.

The Argument for Multiple Models

The evidence for "foreign" contact at Maya centers is too varied to support a single model. Some of the variation may be due to size differences in our databases and the historical accidents of where excavations were conducted, but the rest is likely due to different kinds of interaction. Why do some sites show

single-event relationships with Teotihuacan, while others seem to have inter-mittent interactions with foreigners over longer periods? One possibility is that such differences have something to do with the sociopolitical complexity of each site *prior* to its initial contact with Teotihuacan. Single-event contacts may amount to no more than one ambassadorial visit at the time of a build-ing or tomb dedication; prolonged multiple contacts may suggest repeated attempts to establish political alliance or a long-term trade relationship.

Teotihuacan's motives may also have something to do with a given Maya city's political clout. For example, Copán and Tikal appear to have been the centers of strong early states, which were not as vulnerable to an asymmet-rical relationship as a weaker center on the Gulf Coast. The powerful site of Calakmul has so far revealed little contact with Teotihuacan, not even a single-event cache.[2]

As for the timing of contacts, we should consider the possibility that some interaction with the highlands occurred during gaps in the succession of rulers. Especially in the case of the most powerful Maya states, any "out-side intervention" might only have been possible during such moments of weakness.

The excitement of some Mesoamerican scholars over evidence for foreign interaction—specifically Teotihuacan contacts—may have caused them to at-tribute to the central Mexican city more power in the Maya lowlands than it really had. It seems unlikely that Teotihuacan could hold on to a Maya state for a substantial period of time. The distances involved average more than 1,000 km, and even the Aztec had problems holding on to colonies that distant from the Basin of Mexico. María Josefa Iglesias Ponce de León (Chapter 6) suspects that even if Teotihuacan *did* succeed in putting one of its rulers on the throne of Tikal, the long-term effect was minor. Similarly, Ball (1977b:170) notes that "foreign elements therefore appear neither suddenly nor *en masse* at Becan; nor are they accompanied by any radical disruption of the local developmental chain."

The ethnohistorical record of Mesoamerica tells us that powerful states could move against their close neighbors if the latter were organized at a less complex sociopolitical level, but their relationship with powerful dis-tant neighbors usually was more circumspect. They might bring gifts to the funerals of rulers residing in other polities. They might bring items to be in-cluded in caches below important structures being dedicated. They might send royal women to marry into the ruling houses of strong states with whom they wanted closer relations; those royal brides might even bring retinues with them. So far, it seems that we will have to look beyond these processes

to account for most of the evidence for foreign contact that we see in the lowland Maya region.

What would greater political contact look like? We know that once a rival state had affinal ties to the royal house of a distant polity, that rival might bide its time. If there came a break in succession—as when a foreign ruler died without an heir, or there was a dispute among royal siblings over succession—the opportunity existed for meddling or a military coup. A rival state might throw its support behind one of the competing siblings, expecting to be rewarded, or it might send one of its own princes as a usurper. All these alternatives might produce more archaeological evidence for "foreign contact" than that described in the previous paragraph. Most scholars, however, believe that we lack clear-cut evidence for long-term political control.

Prospects for the Future

Earlier generations of archaeologists were limited in their interpretations by the much smaller sample of Mesoamerican cities that had been excavated. When they found what appeared to be caches of "foreign" artifacts, they tended to attribute them to one of a handful of "foreign" cities, forgetting that thousands of as-yet-unexcavated sites were alternative possible sources. They also placed too heavy an explanatory burden on a small number of imperishable materials, like ceramics and obsidian. Even today, we ask obsidian to explain much more than it can, simply because it is preserved and can be assigned to a geological source.

María Josefa Iglesias Ponce de León persuasively argues that when we overemphasize the handfuls of artifacts that might be foreign (or imitations of foreign items), we underplay the hundreds of thousands of local artifacts. By so doing, we run the risks of downplaying local *in situ* political evolution and of making foreign contact into a prime mover. Now that Mayanists have demonstrated that the state had emerged in the Maya lowlands before there is any evidence for significant highland Mexican visits, we should not overplay the role of foreign contact and downplay *in situ* processes.

A corollary of this change in attitude would be a healthier skepticism about "foreign" artifacts. We should source the clays of many more foreign-looking pottery vessels to determine whether they are actual imports or local imitations. We also should recognize that materials like obsidian might have passed through many hands, at many intervening sites, before they reached the Petén.

The sourcing of artifacts should be accompanied whenever possible by the sourcing of skeletons. Jane Buikstra's isotopic analyses show that Copán's

dynastic founder K'inich Yaax K'uk' Mo' was indeed from "elsewhere"—but not from Teotihuacan, Kaminaljuyu, or Tikal. And his wife turns out to be a local Copán woman, which suggests that his strategy may have been to marry the daughter, sister, or widow of a previous Copán ruler. One day we may know from which lowland Maya city K'inich Yaax K'uk' Mo' came.

In the future, we will recognize that the lowland Maya had many more foreign partners than the "usual suspects" named by earlier generations of archaeologists. Until Clemency Coggins (1975) emphasized the role of Kaminaljuyu in Tikal's affairs, most Mayanists had been thinking of Teotihuacan as the main source of "foreignness." From all the new data presented in this volume, we now know that Kaminaljuyu was only one of many possible intermediaries between Teotihuacan and the Petén; areas such as the Pacific Coast of Guatemala, the Gulf Coast of Mexico, western Chiapas, the Campeche lowlands, as well as the states of Puebla, Tlaxcala, and Morelos must also be considered. Instead of a simple dyadic relationship with Teotihuacan, the Maya had a much wider network of direct and indirect contacts.

It is also becoming clear that throughout their history, Maya cities were more heavily influenced by other Maya cities than they were by Teotihuacan or any other non-Maya center. The Maya area comprises hundreds of thousands of square kilometers, and many key political processes likely involved highland-lowland Maya interaction, royal Maya usurpers, intersite Maya warfare, and other *local* processes. We should not underplay *in situ* processes, nor overplay the impact of highland Mexico, as we seek to understand the evolution of the Early Classic Maya. After all, the Valley of Oaxaca—an area much smaller than the Maya lowlands, and much closer to the Basin of Mexico—did not experience Teotihuacan visits until well after the Zapotec state had formed. And when that contact occurred, it appears to have involved peaceful visits by Teotihuacanos bearing copal pouches and perhaps *Spondylus* shells (Marcus 1983b). Even the few Teotihuacan-style vessels on Monte Albán's North Platform largely appear to be local imitations rather than imports.

The expanding Zapotec state did have an impact on its neighbors, especially those not yet organized at a state level. Significantly, however, the Zapotec impact seems to have been restricted to one relatively brief period—100 B.C. to A.D. 100—that immediately followed state formation (Balkansky 1998a, 1998b; Marcus 1992a, 1998; Spencer 1998). In contrast, alleged Teotihuacan contact in the lowland Maya region took the form of varied and isolated events that occurred intermittently over a longer period of time. For example, "foreign contact" occurred around A.D. 150–200 at Altun Ha

(Chapter 9), A.D. 378–426 at Tikal (Chapters 6–8), A.D. 426–437 at Copán (Chapter 5), A.D. 400–550 at Kaminaljuyu (Chapter 3), and A.D. 500–600 at Oxkintok in northern Yucatán (Chapter 10). Such sporadic contact looks more like diplomacy or trade rather than the kind of coordinated aggressive expansion that could affect political evolution. The Zapotec (or Oaxaca) barrio at Teotihuacan (c. A.D. 200–300),[3] in contrast, provides an example of peaceful contact that may have affected local processes driving the Teotihuacan state.

In the future, when we have a better grasp of the local processes leading to Maya state formation, we will be in a better position to provide plausible explanations for the occasional "foreign influence" we see at some Maya cities. It is simplistic, indeed anachronistic, to ignore local processes and events and make foreign contacts into a kind of *deus ex machina*. Yes, the Maya were visited by diplomats and traders from distant cities, but we should not assume that the course of Maya history changed every time it happened.

Notes

1. Such analyses have been or soon will be conducted on the remains thought to be K'inich Yaax K'uk' Mo' of Copán and Yaax Nu'n Ahyiin (who is not specifically described as a "foreigner"). Other unidentified bodies at Copán and Kaminaljuyu that were associated with foreign or foreign-inspired goods have also been subject to such analyses (see Chapters 4 and 5). Unfortunately, the bodies of Siyaj K'ahk' and the posited individual known as "Spear-Thrower Owl" have not been identified.

2. Editor's note: Obsidian from the Zaragoza, Puebla, source has been found at Calakmul in a variety of contexts (including a cache) dating to the Early to Late Classic transition. As at other sites, this more likely suggests interaction with important sites in the Gulf Coast region than connections with Teotihuacan.

3. Michael Spence (1998:294–295) argues that Tlailotlacan was founded c. A.D. 220 and occupied until A.D. 450 or later. Nonetheless, ceramic cross-dating with the Valley of Oaxaca makes it more likely that the Zapotec barrio was abandoned at the end of the third century A.D.

Bibliography

ACOSTA, JORGE R.

1964 *El Palacio del Quetzalpapalotl*. Memorias del Instituto Nacional de
 Antropología e Historia No. 10. Mexico City: Instituto Nacional de
 Antropología e Historia.

ADAMS, RICHARD E. W.

1986 Archaeologists Explore Guatemala's Lost City of the Maya: Río Azul.
 National Geographic Magazine 169(4):420–451.

1991 Archaeological Research at the Lowland Maya City of Rio Azul. *Latin
 American Antiquity* 1:23–41.

1999 *Río Azul: An Ancient Maya City*. Norman: University of
 Oklahoma Press.

ADAMS, RICHARD E. W., ED.

1987 *Rio Azul Reports, Number 3: The 1985 Season*. San Antonio: Center for
 Archaeological Research, University of Texas, San Antonio.

ADAMS, WILLIAM Y.

1968 Invasion, Diffusion, Evolution? *Antiquity* 42:194–215.

ADAMS, WILLIAM Y., DENNIS P. VAN GERVEN, AND RICHARD S. LEVY

1978 The Retreat from Migrationism. *Annual Review of Archaeology*
 7:483–532.

AGRINIER, PIERRE

1970 *Mound 20, Mirador, Chiapas, Mexico*. Papers of the New World
 Archaeological Foundation 28. Provo, Utah: Brigham Young University.

1975 *Mounds 9 and 10 at Mirador, Chiapas, Mexico*. Papers of the New World
 Archaeological Foundation 28. Provo, Utah: Brigham Young University.

AGURCIA FASQUELLE, RICARDO

1996 Rosalila, el corazón de la Acrópolis: El templo del Rey-sol. *Yaxkin*
 14:5–18.

1997 Il tempio del Re Sole e la sua evoluzione nell'acropoli di Copán. In
 I Maya di Copán: l'Atene del Centroamerica, edited by Giuseppe Orefici,
 pp. 99–108. Milan: Skira editore.

AGURCIA FASQUELLE, RICARDO, AND DONNA K. STONE

1991 Dirt, Sherds, Stones, Stratigraphy and Sculpture: The Excavation of
 Structure 10L-16 at Copán, Honduras. Paper presented at the
 Forty-seventh International Congress of Americanists, New Orleans.

ANDERSON, DAVID G.

1994 *The Savannah River Chiefdoms*. Tuscaloosa: University of
 Alabama Press.

ANDREWS, E. WYLLYS, IV

1965 Archaeology and Prehistory in the Northern Maya Lowlands: An
 Introduction. In *Archaeology of Southern Mesoamerica, Part 1*, edited by
 Gordon R. Willey, pp. 288–330. *Handbook of Middle American Indians*,
 Vol. 2, Robert Wauchope, general editor. Austin: University of
 Texas Press.

ANDREWS, E. WYLLYS, IV, AND E. WYLLYS ANDREWS V

1980 *Excavations at Dzibilchaltun, Yucatan, Mexico*. Middle American
 Research Institute Publication 48. New Orleans: Tulane University.

ANDREWS, E. WYLLYS, V

1979 Early Central Mexican Architectural Traits at Dzibilchaltun, Yucatan. In *Actes du XLIIᵉ Congrès international des américanistes*, Vol. 8, pp. 237-249. Paris: Congrès international des américanistes.

1981 Dzibilchaltun. In *Archaeology*, edited by Jeremy A. Sabloff, pp. 313-341. *Handbook of Middle American Indians*, Supplement 1, Victoria R. Bricker, general editor. Austin: University of Texas Press.

ANDREWS, E. WYLLYS, V, AND NORMAN HAMMOND

1990 Redefinition of the Swasey Phase at Cuello, Belize. *American Antiquity* 55:570-584.

ANDREWS, E. WYLLYS, V, WILLIAM M. RINGLE, P. J. BARNES, ALFREDO BARRERA RUBIO, AND TOMÁS GALLARETA NEGRÓN

1984 Komchen, an Early Maya Community in Northwest Yucatan. In *Investigaciones recientes en el área maya: XVII Mesa Redonda*, Tomo 1, pp. 73-92. Mexico City: Sociedad Mexicana de Antropología.

ANDREWS, GEORGE

1986 *Los estilos arquitectónicos del Puuc: Una nueva apreciación*. Mexico City: Instituto Nacional de Antropología e Historia.

ANGULO, JORGE

1987 Nuevas consideraciones sobre los llamados conjuntos departamentales, especialmente Tetitla. In *Teotihuacan: Nuevos datos, nuevas síntesis, nuevos problemas*, edited by Emily McClung de Tapia and Evelyn Rattray, pp. 275-316. Mexico City: Instituto de Investigaciones Antropológicas, Universidad Nacional Autónoma de México.

ANTHONY, DAVID W.

1990 Migration in Archeology: The Baby and the Bathwater. *American Anthropologist* 92:895-914.

1997 Prehistoric Migration as Social Process. In *Migrations and Invasions in Archaeological Explanation*, edited by John Chapman and Helena Hamerow, pp. 21-32. BAR International Series 664. Oxford: British Archaeological Reports.

2000 Comments. *Current Anthropology* 41:554-555.

ARMILLAS, PEDRO

1944 Exploraciones recientes en Teotihuacán, México. *Cuadernos americanos* (Mexico City) 16:121-136.

1950 Teotihuacán, Tula, y los toltecas: Las culturas post-arcaicas y pre-aztecas del centro de México. Excavaciones y estudios, 1922-1950. *Runa: Archivo para las ciencias del hombre* (Buenos Aires) 3:37-70.

ARROYO, BÁRBARA

1990 *Entierramientos de Balberta, un sitio en la costa sur de Guatemala*. BAR International Series 559. Oxford: British Archaeological Reports.

ARROYO, BÁRBARA, OSWALDO CHINCHILLA MAZARIEGOS, AND EDUARDO MORALES SÁNCHEZ

1993 Burials at Balberta: Mortuary Ritual and Bone Chemical Analysis/Los entierros de Balberta: Patrón funerario y análisis químico de los restos óseos. In *The Balberta Project: The Terminal Formative-Early Classic Transition on the Pacific Coast of Guatemala/El Proyecto Balberta. La transición entre el Formativo Terminal y el Clásico Temprano en la Costa Pacífica de Guatemala*, edited by Frederick Bove, Sonia Medrano,

Brenda Lou, and Bárbara Arroyo, pp. 107-135. Memoirs in Latin
American Archaeology No. 6. Pittsburgh: University of Pittsburgh and
Asociación Tikal.

AVELEYRA ARROYO DE ANDA, LUIS
1963 La estela seccional de La Ventilla, Teotihuacán. *Boletín* (Instituto de
 Antropología e Historia, Mexico City) 11:11-12.

AVENI, ANTHONY F., AND HORST HARTUNG
1989 Uaxactun, Guatemala, Group E and Similar Assemblages:
 Archaeoastronomical Reconsideration. In *World Archaeoastronomy*,
 edited by Anthony F. Aveni, pp. 441-461. Cambridge: Cambridge
 University Press.

BALKANSKY, ANDREW K.
1998a The Origin and Collapse of Complex Societies in Oaxaca (Mexico):
 Evaluating the Era from 1965 to the Present. *Journal of World Prehistory*
 12:451-493.
1998b Urbanism and Early State Formation in the Huamelulpan Valley of
 Southeastern Mexico. *Latin American Antiquity* 9:37-67.

BALL, JOSEPH W.
1974 A Teotihuacan-style Cache from the Maya Lowlands. *Archaeology*
 27(1):2-9.
1976 Ceramic Sphere Affiliations of the Barton Ramie Ceramic Complexes.
 In *Prehistoric Pottery Analysis and the Ceramics of Barton Ramie in the
 Belize Valley*, by James C. Gifford, pp. 323-330. Memoirs of the
 Peabody Museum of Archaeology and Ethnology, Vol. 18. Cambridge:
 Harvard University.
1977a *The Archaeological Ceramics of Becan, Campeche, Mexico*. Middle
 American Research Institute Publication 43. New Orleans: Tulane
 University.
1977b An Hypothetical Outline of Coastal Maya Prehistory: 300 B.C.-
 A.D. 1200. In *Social Process in Maya Prehistory*, edited by Norman
 Hammond, pp. 167-196. London: Academic Press.
1978 Archaeological Pottery of the Yucatan-Campeche Coast. In *Studies in
 the Archaeology of Coastal Yucatan and Campeche, Mexico*, pp. 69-146.
 Middle American Research Institute Publication 46. New Orleans:
 Tulane University.
1979 Southeastern Campeche and the Mexican Plateau: Early Classic
 Contact Situation. In *Actes du XLII^e Congrès international des
 américanistes*, Vol. 8, pp. 271-280. Paris: Congrès international des
 américanistes.
1983 Teotihuacan, the Maya, and Ceramic Interchange: A Contextual
 Perspective. In *Highland-Lowland Interaction in Mesoamerica:
 Interdisciplinary Approaches*, edited by Arthur G. Miller, pp. 125-145.
 Washington, D.C.: Dumbarton Oaks Research Library and Collection.

BANCO INDUSTRIAL
1998 *Colección de arte prehispánico*. Guatemala City: Corporación Banco
 Industrial.

BARBOUR, WARREN D.
1976 *The Figurines and Figurine Chronology of Ancient Teotihuacan, Mexico*.

Ph.D. diss., Department of Anthropology, University of Rochester. Ann Arbor: University Microfilms.

1998　The Figurine Chronology of Teotihuacan, Mexico. In *Los ritmos de cambio en Teotihuacán: Reflexiones y discusiones de su cronología*, edited by Rosa M. Brambila Paz and Rubén Cabrera Castro, pp. 243–253. Mexico City: Instituto Nacional de Antropología e Historia.

BARRERA RUBIO, ALFREDO, AND KARL A. TAUBE

1987　Los relieves de San Diego: Una nueva perspectiva. *Boletín de la Escuela de Ciencias Antropológicas de la Universidad de Yucatán* 83: 3–18.

BARTHEL, THOMAS S.

1963　Die Stele 31 von Tikal. *Tribus* 12:159–214.

BECKER, MARSHALL J.

1983　Kings and Classicism: Political Change in the Maya Lowlands during the Classic Period. In *Highland-Lowland Interaction in Mesoamerica: Interdisciplinary Approaches*, edited by Arthur G. Miller, pp. 159–200. Washington, D.C.: Dumbarton Oaks Research Library and Collection.

BECQUELIN, PIERRE

1969　*Archéologie de la region de Nebaj (Guatemala)*. Memoires de l'Institut d'ethnologie, No. 2. Paris: L'Institut d'ethnologie.

BECQUELIN, PIERRE, AND CLAUDE-FRANÇOIS BAUDEZ

1982　*Tonina: Une cité Maya du Chiapas (Mexique)*. Vol. 2. Paris: Mission archéologique et ethnologique française au Mexique.

BELL, ELLEN E., AND DORIE REENTS-BUDET

2000　Early Classic Ceramic Offerings at Copán: A Comparison of the Hunal and Margarita Tombs. Paper presented at the Sixty-fifth Annual Meeting of the Society for American Archaeology, Philadelphia.

BERLIN, HEINRICH

1952　Excavaciones en Kaminaljuyú: Montículo D-III-13. *Antropología e historia de Guatemala* 4(1):3–18.

BERLO, JANET C.

1983　The Warrior and the Butterfly: Central Mexican Ideologies of Sacred Warfare and Teotihuacan Iconography. In *Text and Image in Pre-Columbian Art: Essays on the Interrelationship of the Verbal and Visual Arts*, edited by Janet C. Berlo, pp. 78–117. BAR International Series 180. Oxford: British Archaeological Reports.

1984　*Teotihuacan Art Abroad: A Study of Metropolitan Style and Provincial Transformation in Incensario Workshops*. BAR International Series 199. Oxford: British Archaeological Reports.

1989　Art Historical Approaches to the Study of Teotihuacan-Related Ceramics from Escuintla, Guatemala. In *New Frontiers in the Archaeology of the Pacific Coast of Southern Mesoamerica*, edited by Frederick J. Bove and Lynette Heller, pp. 147–165. Anthropological Research Paper Number 39. Tempe: Arizona State University.

1992　Icons and Ideologies at Teotihuacan: The Great Goddess Reconsidered. In *Art, Ideology, and the City of Teotihuacan*, edited by Janet C. Berlo, pp. 129–168. Washington, D.C.: Dumbarton Oaks Research Library and Collection.

BERNAL, IGNACIO

1966 Teotihuacan ¿Capital de imperio? *Revista mexicana de estudios antropológicos* (Mexico City) 20:95–110.

1969 *The Olmec World*. Translated by Doris Heyden and Fernando Horcasitas. Berkeley and Los Angeles: University of California Press.

BERNAL, IGNACIO, ED.

1963 *Teotihuacán: Descubrimientos, reconstrucciones*. Mexico: Instituto Nacional de Antropología e Historia.

BERRIN, KATHLEEN, AND ESTHER PASZTORY, EDS.

1993 *Teotihuacan: Art from the City of the Gods*. London and New York: Thames and Hudson.

BLANTON, RICHARD E.

1972 Prehispanic Adaptation in the Ixtapalapa Region, Mexico. *Science* 175:1317–1326.

1978 *Monte Albán: Settlement Patterns at the Ancient Zapotec Capital*. New York: Academic Press.

BLANTON, RICHARD E., GARY M. FEINMAN, STEPHEN A. KOWALEWSKI, AND PETER N. PEREGRINE

1996 A Dual-Processual Theory for the Evolution of Mesoamerican Civilization. *Current Anthropology* 37:1–14.

BORHEGYI, STEPHAN F. DE

1951 Further Notes on Three-Pronged Incense Burners and Rim-Head Vessels in Guatemala. *Notes on Middle American Archaeology and Ethnohistory* 4(101):162–176. Washington, D.C.: Carnegie Institution of Washington.

1956 The Development of Folk and Complex Cultures in the Southern Maya Area. *American Antiquity* 21:343–356.

1965 Archaeological Synthesis of the Guatemalan Highlands. In *Archaeology of Southern Mesoamerica, Part 1*, edited by Gordon R. Willey, pp. 3–58. *Handbook of Middle American Indians*, Vol. 2, Robert Wauchope, general editor. Austin: University of Texas Press.

1971 Pre-Columbian Contacts B—The Dryland Approach: The Impact and Influence of Teotihuacan Culture on the Pre-Columbian Civilizations of Mesoamerica. In *Man across the Sea: Problems of Pre-Columbian Contacts*, edited by Carroll L. Riley, J. Charles Kelley, Campbell W. Pennington, and Robert L. Rands, pp. 79–105. Austin: University of Texas Press.

BOVE, FREDERICK J.

1989a *Formative Settlement Patterns on the Pacific Coast of Guatemala: A Spatial Analysis of Complex Societal Evolution*. BAR International Series 493. Oxford: British Archaeological Reports.

1989b Reporte preliminar de las investigaciones en las regiones Tiquisate y La Gomera/Sipacate, costa sur de Guatemala. In *Investigaciones arqueológicas de la costa sur de Guatemala*, edited by David S. Whitley and Marilyn P. Beaudry, pp. 38–81. Institute of Archaeology Monograph 31. Los Angeles: Institute of Archaeology, University of California.

1990 The Teotihuacan-Kaminaljuyu-Tikal Connection: A View from the South Coast of Guatemala. In *The Sixth Palenque Round Table 1986*,

edited by Merle G. Robertson and Virginia M. Fields, pp. 135–142. Norman: University of Oklahoma Press.

2000 Commentary on Travel Letter from Puerto Mexico. In *Early Scholars' Visits to Central America*, edited by Marilyn Beaudry-Corbett and Ellen T. Hardy; translated by Theodore E. Gutman, pp. 104–111. Occasional Paper 18. Los Angeles: The Cotsen Institute of Archaeology, University of California.

BOVE, FREDERICK J., SONIA MEDRANO, BRENDA LOU, AND BARBARA ARROYO, EDS.

1993 *The Balberta Project: The Terminal Formative–Early Classic Transition on the Pacific Coast of Guatemala/El Proyecto Balberta: La transición entre el Formativo Terminal y el Clásico Temprano en la Costa Pacífica de Guatemala*. Memoirs in Latin American Archaeology No. 6. Pittsburgh: University of Pittsburgh and Asociación Tikal.

BOVE, FREDERICK J., AND HECTOR NEFF

2000 Economic Interaction and Political History: A Chemical Compositional Approach. In *Proceedings of the Inter-Congress Meeting of Commission 4: Data Management and Mathematical Methods in Archaeology*, edited by Keith Kintigh. Archaeological Research Papers. Tempe: Arizona State University. In press.

BOVE, FREDERICK J., HECTOR NEFF, BÁRBARA ARROYO, SONIA MEDRANO BUSTO, AND JOSÉ GENOVEZ

2000 *The Archaeological Ceramics and Chronology of Pacific Coastal Guatemala: Formative to Postclassic*. Manuscript in preparation.

BRAINERD, GEORGE W.

1954 *The Maya Civilization*. Los Angeles: Southwest Museum.

1958 *The Archaeological Ceramics of Yucatan*. Anthropological Records No. 19. Berkeley: University of California.

BRASWELL, GEOFFREY E.

1996 *A Maya Obsidian Source: The Geoarchaeology, Settlement History, and Ancient Economy of San Martín Jilotepeque, Guatemala*. Ph.D. diss., Department of Anthropology, Tulane University. Ann Arbor: University Microfilms.

2001a Cultural Emulation, Ethnogenesis, and Survival: The "Nahuaization" of the Highland Maya in the Fifteenth and Sixteenth Centuries. In *Maya Survivalism*, edited by Ueli Hostettler and Matthew Restall, pp. 51–58. Acta Mesoamericana 12. Markt Schwaben, Germany: Verlag Anton Sauerwein.

2001b Postclassic Maya Courts of the Guatemalan Highlands: Archaeological and Ethnohistorical Approaches. In *Royal Courts of the Ancient Maya*, Vol. 2, edited by Takeshi Inomata and Stephen D. Houston, pp. 308–331. Boulder, Colo.: Westview Press.

2002a K'iche'an Origins, Symbolic Emulation, and Ethnogenesis in the Maya Highlands: A.D. 1400–1524. In *The Postclassic Mesoamerican World*, edited by Michael E. Smith and Frances F. Berdan. Salt Lake City: University of Utah Press. In press.

2002b Obsidian Exchange Spheres of Postclassic Mesoamerica. In *The Postclassic Mesoamerican World*, edited by Michael E. Smith and Frances F. Berdan. Salt Lake City: University of Utah Press. In press.

BRASWELL, GEOFFREY E., AND FABIO E. AMADOR BERDUGO
1999 Intercambio y producción durante el Preclásico: La obsidiana de
 Kaminaljuyú-Miraflores II y Urías, Sacatepéquez. In *XII simposio de
 investigaciones arqueológicas en Guatemala, 1998*, edited by Juan Pedro
 Laporte, Héctor L. Escobedo, and Ana Claudia Monzón de Suasnávar,
 Tomo 2, pp. 905–910. Guatemala City: Museo Nacional de
 Arqueología y Etnología.

BROWN, KENNETH L.
1977a Toward a Systematic Explanation of Culture Change within the Middle
 Classic Period of the Valley of Guatemala. In *Teotihuacan and
 Kaminaljuyu*, edited by William T. Sanders and Joseph W. Michels, pp.
 411–439. College Park: Pennsylvania State University Press.
1977b The Valley of Guatemala: A Highland Port of Trade. In *Teotihuacan and
 Kaminaljuyu*, edited by William T. Sanders and Joseph W. Michels, pp.
 205–395. College Park: Pennsylvania State University Press.

BRUEGGEMANN, JUERGEN K., SARA LADRÓN DE GUEVARA, AND JUAN SÁNCHEZ BONILLA
1992 *Tajín*. Mexico City: Citibank.

BUIKSTRA, JANE E.
1997 The Bones Speak: High-Tech Approaches to the Study of Our
 Ancestors. Paper presented for the Loren Eiseley Associates, University
 of Pennsylvania Museum, Philadelphia.

BUIKSTRA, JANE E., SUSAN R. FRANKENBERG, AND LYLE W. KONIGSBERG
1990 Skeletal Biological Distance Studies in American Physical
 Anthropology: Recent Trends. *American Journal of Physical
 Anthropology* 82:1–7.

BUIKSTRA, JANE E., DOUGLAS PRICE, JAMES BURTON, AND LORI E. WRIGHT
2000 The Early Classic Royal Burials at Copan: A Bioarchaeological
 Perspective. Paper presented at the Sixty-fifth Annual Meeting of the
 Society for American Archaeology, Philadelphia.

BURMEISTER, STEFAN
2000 Archaeology and Migration: Approaches to an Archaeological Proof of
 Migration. *Current Anthropology* 41:539–567.

CABRERA CASTRO, RUBÉN
1982 La excavación de la Estructura 1B' en el interior de la Ciudadela. In
 Memoria del Proyecto Arqueológico Teotihuacan 80–82, edited by Rubén
 Cabrera Castro, Ignacio Rodríguez García, and Noel Morelos G., pp.
 75–87. Mexico City: Instituto Nacional de Antropología e Historia.
1995 Atetelco. In *La pintura mural prehispánica en México, Teotihuacan*,
 edited by Beatriz de la Fuente, 1(1):202–256. Mexico City: Universidad
 Nacional Autónoma de México.
1996 Figuras glíficas de La Ventilla, Teotihuacan. *Arqueología* 15:27–40.
1998a La cronología de la Ciudadela en su secuencia arquitectónica. In *Los
 ritmos de cambio en Teotihuacán: Reflexiones y discusiones de su
 cronología*, edited by Rosa M. Brambila Paz and Rubén Cabrera Castro,
 pp. 143–166. Mexico City: Instituto Nacional de Antropología e
 Historia.
1998b Teotihuacan: Nuevos datos para el estudio de las rutas de
 comunicación. In *Rutas de intercambio en Mesoamerica*, edited by

Evelyn C. Rattray, pp. 57–100. Mexico City: Universidad Nacional Autónoma de México.

2000 Teotihuacan Cultural Traditions Transmitted into the Postclassic according to Recent Excavations. In *Mesoamerica's Classic Heritage: From Teotihuacan to the Aztecs*, edited by Davíd Carrasco, Lindsay Jones, and Scott Sessions, pp. 195–218. Niwot: Colorado University Press.

CABRERA CASTRO, RUBÉN, AND SABURO SUGIYAMA

1999 El Proyecto Arqueológico de la Pirámide de la Luna. *Arqueología* 21:19–33.

CABRERA CASTRO, RUBÉN, SABURO SUGIYAMA, AND GEORGE L. COWGILL

1991 The Templo de Quetzalcoatl Project at Teotihuacan: A Preliminary Report. *Ancient Mesoamerica* 2:77–92.

CAMERON, CATHERINE M., ED.

1995 Migration and the Movement of Southwestern Peoples. *Journal of Anthropological Archaeology* 14(2). Special edition.

CARLSON, JOHN B.

1993 Venus-regulated Warfare and Ritual Sacrifice in Mesoamerica. In *Astronomies and Cultures*, edited by Clive L. N. Ruggles and Nicholas J. Saunders, pp. 202–252. Niwot: University Press of Colorado.

CARPIO, EDGAR H.

1989 Las herramientas de obsidiana en Balberta: Tecnología y función. Tesis de Licenciatura, Escuela de Historia, Universidad de San Carlos de Guatemala, Guatemala.

CARR, ROBERT E., AND JAMES E. HAZARD

1961 *Map of the Ruins of Tikal, El Petén, Guatemala.* Tikal Report 11. Philadelphia: University Museum, University of Pennsylvania.

CASO, ALFONSO, AND IGNACIO BERNAL

1952 *Urnas de Oaxaca.* Mexico City: Instituto Nacional de Antropología e Historia.

CHASE, ARLEN F., AND DIANE Z. CHASE

1995 External Impetus, Internal Synthesis, and Standardization: E-Group Assemblages and the Crystallization of Classic Maya Society in the Southern Lowlands. In *The Emergence of Lowland Maya Civilization: The Transition from the Preclassic to the Early Classic*, edited by Nikolai Grube, pp. 87–101. Acta Mesoamericana 8. Möckmühl, Germany: Verlag Anton Saurwein.

CHEEK, CHARLES D.

1976 Teotihuacan Influence at Kaminaljuyu. In *XIV Mesa Redonda, Sociedad Mexicana de Antropología, Tegucigalpa (1975)*, Tomo 2, pp. 55–71. Mexico City: Sociedad Mexicana de Antropología.

1977a Excavations at the Palangana and the Acropolis, Kaminaljuyu, Guatemala. In *Teotihuacan and Kaminaljuyu*, edited by William T. Sanders and Joseph W. Michels, pp. 1–204. College Park: Pennsylvania State University Press.

1977b Teotihuacan Influence at Kaminaljuyu. In *Teotihuacan and Kaminaljuyu*, edited by William T. Sanders and Joseph W. Michels, pp. 441–452. College Park: Pennsylvania State University Press.

CHINCHILLA MAZARIEGOS, OSWALDO F.

1990a Estudio nutricional de los restos óseos prehispánicos de Balberta, Escuintla, por medio del análisis de estroncio. Tesis de Licenciatura, Facultad de Ciencias Químicas y Farmacia, Universidad de San Carlos de Guatemala, Guatemala.

1990b Observaciones sobre los nombres personales en las inscripciones mayas del período Clásico Temprano, con especial referencia a Tikal. Tesis de Licenciatura, Area de Arqueología, Escuela de Historia, Universidad de San Carlos, Guatemala.

1996a *Settlement Patterns and Monumental Art at a Major Pre-Columbian Polity: Cotzumalguapa, Guatemala.* Ph.D. diss., Department of Anthropology, Vanderbilt University. Ann Arbor: University Microfilms.

1996b "Peor-es-Nada": El origen de las esculturas de Cotzumalguapa en el Museum für Völkerkunde, Berlin. *Baesller-Archiv* 44:295–357.

CLANCY, FLORA S.

1979 A Reconsideration of the Mexican Artistic Traits Found at Tikal, Guatemala. Paper presented at the Forty-third International Congress of Americanists, Vancouver.

1980 *A Formal Analysis of the Relief Carved Monuments at Tikal, Guatemala.* Ph.D. diss., Department of Art History, Yale University. Ann Arbor: University Microfilms.

1999 *Sculpture in the Ancient Maya Plaza.* Albuquerque: University of New Mexico Press.

CLARK, JOHN E.

1986 From Mountains to Molehills: A Critical Review of Teotihuacan's Obsidian Industry. In *Economic Aspects of Prehispanic Highland Mexico,* edited by Barry L. Isaac, pp. 23–74. Research in Economic Anthropology, Supplement No. 2. Greenwich, Conn.: JAI Press.

1997 The Arts of Government in Early Mesoamerica. *Annual Reviews in Anthropology* 26:211–234.

COBOS PALMA, RAFAEL

2001 *Puertos marítimos en tierras bajas mayas: Estudio del patrón de distribución-abastecimiento de caracoles y conchas entre 700 y 1050 dC.* Mexico City: Instituto Nacional de Antropología e Historia-CONACULTA. In press.

COE, MICHAEL D.

1978 *Lords of the Underworld: Masterpieces of Classic Maya Ceramics.* Princeton, N.J.: Princeton University Press.

COE, WILLIAM R.

1959 *Piedras Negras Archaeology: Artifacts, Caches, and Burials.* University Museum Monograph 18. Philadelphia: University of Pennsylvania.

1967 *Tikal: A Handbook of the Ancient Maya Ruins.* Philadelphia: University Museum, University of Pennsylvania.

1972 Cultural Contact between the Lowland Maya and Teotihuacan as Seen from Tikal, Peten, Guatemala. In *Teotihuacan: XI Mesa Redonda,* edited by Alberto Ruz Lhuillier, Tomo 2, pp. 257–271. Mexico City: Sociedad Mexicana de Antropología.

1990 *Excavations in the Great Plaza, North Terrace, and Acropolis of Tikal.*

6 vols. Tikal Report 14, University Museum Monograph 61. Philadelphia: University of Pennsylvania.

COGGINS, CLEMENCY C.

1975 *Painting and Drawing Styles at Tikal: An Historical and Iconographic Reconstruction.* Ph.D. diss., Department of Fine Arts, Harvard University. Ann Arbor: University Microfilms.

1979 Teotihuacan at Tikal in the Early Classic Period. In *Actes du XLII^e Congrès international des américanistes,* Vol. 8, pp. 251–269. Paris: Congrès international des américanistes.

1983 An Instrument of Expansion: Monte Alban, Teotihuacan, and Tikal. In *Highland-Lowland Interaction in Mesoamerica: Interdisciplinary Approaches,* edited by Arthur G. Miller, pp. 49–68. Washington, D.C.: Dumbarton Oaks Research Library and Collection.

COHEN, RONALD

1978 Introduction. In *Origins of the State: The Anthropology of Political Evolution,* edited by Ronald Cohen and Elman R. Service, pp. 1–20. Philadelphia: Institute for the Study of Human Issues.

COHODAS, MARVIN

1985 Public Architecture of the Maya Lowlands. *Cuadernos de arquitectura mesoamericana* 6:51–68.

CONIDES, CYNTHIA

2000 The Stuccoed and Painted Ceramics from Teotihuacan, Mexico: A Study of Authorship and Function of Works of Art in an Ancient Mesoamerican City. Ph.D. diss., Department of Art History, Columbia University, New York.

COOK DE LEONARD, CARMEN

1985 Las almenas de Cinteopa. *Cuadernos de arquitectura mesoamericana* 4:51–56.

COVARRUBIAS, MIGUEL

1946 El arte "olmeca" o de La Venta. *Cuadernos americanos* 28(4):153–179.

COWGILL, GEORGE L.

1974 Quantitative Studies of Urbanization at Teotihuacan. In *Mesoamerican Archaeology: New Approaches,* edited by Norman Hammond, pp. 363–396. Austin: University of Texas Press.

1979 Teotihuacan, Internal Militaristic Competition, and the Fall of the Classic Maya. In *Maya Archaeology and Ethnohistory,* edited by Norman Hammond and Gordon R. Willey, pp. 51–62. Austin: University of Texas Press.

1983 Rulership and the Ciudadela: Political Inferences from Teotihuacan Architecture. In *Civilizations in the Ancient Americas: Essays in Honor of Gordon R. Willey,* edited by Richard M. Leventhal and Alan L. Kolata, pp. 313–343. Albuquerque: University of New Mexico Press.

1992 Toward a Political History of Teotihuacan. In *Ideology and Pre-Columbian Civilizations,* edited by Arthur A. Demarest and Geoffrey W. Conrad, pp. 87–114. Santa Fe, N.Mex.: School of American Research Press.

1993 Distinguished Lecture in Archeology: Beyond Criticizing New Archeology. *American Anthropologist* 95:551–573.

1996 Discussion. *Ancient Mesoamerica* 7:325–331.

1997 State and Society at Teotihuacan, Mexico. *Annual Review of Anthropology* 26:129–161.

1998 Nuevos datos del Proyecto Templo de Quetzalcoatl acerca de la cerámica Miccaotli-Tlamimilolpa. In *Los ritmos de cambio en Teotihuacán: Reflexiones y discusiones de su cronología*, edited by Rosa M. Brambila Paz and Rubén Cabrera Castro, pp. 185–199. Mexico City: Instituto Nacional de Antropología e Historia.

1999a Discussion. Paper presented at the Sixty-fourth Annual Meeting of the Society for American Archaeology, Chicago.

1999b Rituales domésticos e intereses del estado en Teotihuacan. Paper presented at the Primera Mesa Redonda de Teotihuacan, Instituto Nacional de Antropología e Historia, Centro de Estudios Teotihuacanos, San Juan Teotihuacán, Mexico. In press.

2000a The Central Mexican Highlands from the Rise of Teotihuacan to the Decline of Tula. In *The Cambridge History of the Native Peoples of the Americas*, Vol. 2, *Mesoamerica, Part 1*, edited by Richard E. W. Adams and Martha J. MacLeod, pp. 250–317. Cambridge: Cambridge University Press.

2000b "Rationality" and Context in Agency Theory. In *Agency in Archaeology*, edited by Marcia-Anne Dobres and John Robb, pp. 51–60. London and New York: Routledge.

COWGILL, GEORGE L., AND HECTOR NEFF

2001 Algunos resultados del análisis por activación neutrónica de cerámica foránea en Teotihuacan. Paper presented at the Segunda Mesa Redonda de Teotihuacan, Instituto Nacional de Antropología e Historia, Centro de Estudios Teotihuacanos, San Juan Teotihuacán, Mexico. In press.

CRUZ ANTILLÓN, RAFAEL

1994 *Análisis arqueológico del yacimiento de obsidiana de Sierra de Las Navajas, Hidalgo.* Mexico City: Instituto Nacional de Antropología e Historia.

CRUZ ANTILLÓN, RAFAEL, AND ALEJANDRO PASTRANA

1994 Sierra de Las Navajas, Hidalgo: Nuevas investigaciones sobre la explotación prehispánica de obsidiana. In *Simposium sobre arqueología en el estado de Hidalgo*, edited by Enrique Fernández Dávila, pp. 31–45. Mexico City: Instituto Nacional de Antropología e Historia.

CULBERT, T. PATRICK

1979 The Ceramics of Tikal: Eb, Tzec, Chuen, and Manik Complexes. Ms. on file, University of Arizona, Tucson.

1991 Polities in the Northeast Peten, Guatemala. In *Classic Maya Political History: Hieroglyphic and Archaeological Evidence*, edited by T. Patrick Culbert, pp. 128–145. Cambridge: Cambridge University Press.

1993 *The Ceramics of Tikal: Vessels from the Burials, Caches, and Problematical Deposits.* Tikal Report 25, Part A, University Museum Monograph 81. Philadelphia: University of Pennsylvania.

1994 Los cambios sociopolíticos en las Tierras Bajas Mayas durante los siglos IV y V DC. In *VII simposio de investigaciones arqueológicas en Guatemala, 1993*, edited by Juan Pedro Laporte and Héctor L. Escobedo, pp. 391–396. Guatemala City: Museo Nacional de Arqueología y Etnología.

DAHLIN, BRUCE H.
1976 *An Anthropologist Looks at the Pyramids: A Late Classic Revitalization Movement at Tikal, Guatemala.* Ph.D. diss., Department of Anthropology, Temple University. Ann Arbor: University Microfilms.
1984 A Colossus in Guatemala: The Preclassic City of El Mirador. *Archaeology* 37(5):18–25.

DANEELS, ANNICK
1997 Settlement History in the Lower Cotaxtla Basin. In *Olmec to Aztec,* edited by Barbara L. Stark and Philip J. Arnold III, pp. 206–252. Tucson: University of Arizona Press.

DE LA FUENTE, BEATRIZ
1995 Tetitla. In *La pintura mural prehispánica en México, Teotihuacan,* edited by Beatriz de la Fuente, 1(1):258–311. Mexico City: Universidad Nacional Autónoma de México.
1996 El estilo teotihuacano en la pintura mural. In *La pintura mural prehispánica en México, Teotihuacan,* edited by Beatriz de la Fuente, 1(2):3–64. Mexico City: Universidad Nacional Autónoma de México.

DE LA FUENTE, BEATRIZ, SILVIA TREJO, AND NELLY GUTIÉRREZ SOLANA
1988 *Escultura en piedra de Tula.* Mexico City: Universidad Nacional Autónoma de México.

DEMAREST, ARTHUR A.
1997 The Vanderbilt Petexbatun Regional Archaeological Project 1989–1994. *Ancient Mesoamerica* 8:209–227.

DEMAREST, ARTHUR A., AND ANTONIA E. FOIAS
1993 Mesoamerican Horizons and the Cultural Transformations of Maya Civilization. In *Latin American Horizons,* edited by Don S. Rice, pp. 147–191. Washington, D.C.: Dumbarton Oaks Research Library and Collection.

DEMAREST, ARTHUR A., AND WILLIAM R. FOWLER, EDS.
1984 Proyecto El Mirador de la Harvard University, 1982–1983. *Mesoamérica* 7:1–160.

DE SMET, PETER A. G. M.
1985 *Ritual Enemas and Snuffs in the Americas.* Centrum voor Studie en Documentatie van Latijns Amerika, Amsterdam.

DIGBY, ADRIAN
1972 *Maya Jades.* London: The British Museum.

DREWITT, BRUCE
1966 Planeación en la antigua ciudad de Teotihuacán. In *Teotihuacan: XI Mesa Redonda,* Tomo 1, pp. 79–94. Mexico City: Sociedad Mexicana de Antropología.

EASBY, ELIZABETH KENNEDY, AND JOHN F. SCOTT
1970 *Before Cortés: Sculpture of Middle America.* New York: The Metropolitan Museum of Art.

EKHOLM, GORDON F.
1961 Some Collar-Shaped Shell Pendants from Mesoamerica. In *Homenaje a Pablo Martínez del Río en el vigésimoquinto aniversario de la primera edición de los orígenes americanos,* pp. 287–293. Mexico City: Instituto Nacional de Antropología e Historia.

EMERY, KATHERINE F.
1997 Artefactos óseos de Mundo Perdido: Descripción y análisis
 osteométrico. Ms. on file, Proyecto Nacional Tikal, Instituto de
 Antropología e Historia, Guatemala City.

ERICASTILLA GODOY, SERGIO, AND SHIONE SHIBATA
1991 Historia de las investigaciones arqueológicas en los sitios de
 Kaminaljuyú y el montículo de la Culebra. In *Informe, Vol. 1: Primer
 informe de exploraciones arqueológicas,* edited by Kuniaki Ohi, pp.
 33–47. Tokyo: Museum of Tobacco and Salt.

FAHSEN, FEDERICO
1988 A New Early Classic Text from Tikal. Research Reports on Ancient
 Maya Writing 17. Washington, D.C.: Center for Maya Research.
2000 Kaminaljuyú y sus vecinos. In *XIII simposio de investigaciones
 arqueológicas en Guatemala, 1998,* edited by Juan Pedro Laporte, Héctor
 L. Escobedo, Ana Claudia Monzón de Suasnávar, and Bárbara Arroyo,
 Tomo 1, pp. 57–83. Guatemala City: Museo Nacional de Arqueología y
 Etnología.

FAHSEN, FEDERICO, LINDA SCHELE, AND NIKOLAI GRUBE
1995 The Tikal-Copán Connection: Shared Features. Copán Note 123.
 Austin: Instituto Hondureño de Antropología e Historia and the Copán
 Acropolis Archaeological Project.

FASH, BARBARA W.
1992 Late Classic Architectural Sculpture Themes at Copan. *Ancient
 Mesoamerica* 3:89–102.

FASH, WILLIAM L., JR.
1991 *Scribes, Warriors, and Kings: The City of Copan and the Ancient Maya.*
 New York: Thames and Hudson.
1995 Classic Copán and the Theater State. In *Copán: The Rise and Fall of a
 Classic Maya Kingdom,* edited by E. Wyllys Andrews V and William L.
 Fash, Jr. Santa Fe, N.Mex.: SAR Press. In preparation, ms. date 1995.
1997 Official Histories and Archaeological Data in the Interpretation of the
 Teotihuacan-Copan Relationship. Paper presented at the symposium
 "A Tale of Two Cities: Copan and Teotihuacan," Harvard University,
 Cambridge, Massachusetts.
1998 Dynastic Architectural Programs: Intention and Design in Classic Maya
 Buildings at Copan and Other Sites. In *Function and Meaning in Classic
 Maya Architecture,* edited by Stephen D. Houston, pp. 223–270.
 Washington, D.C.: Dumbarton Oaks Research Library and Collection.

FASH, WILLIAM L., JR., AND BARBARA W. FASH
1996 Building a World View: Visual Communication in Classic Maya
 Architecture. *RES* 29/30:127–148.
2000 Teotihuacan and the Maya: A Classic Heritage. In *Mesoamerica's
 Classic Heritage: From Teotihuacan to the Aztecs,* edited by Davíd
 Carrasco, Lindsay Jones, and Scott Sessions, pp. 433–463. Niwot:
 University Press of Colorado.

FASH, WILLIAM L., JR., AND ROBERT J. SHARER
1991 Sociopolitical Developments and Methodological Issues at Copán,
 Honduras: A Conjunctive Perspective. *Latin American Antiquity*
 2:166–187.

FASH, WILLIAM L., JR., RICHARD V. WILLIAMSON, CARLOS RUDY LARIOS, AND JOEL PALKA
1992 The Hieroglyphic Stairway and Its Ancestors. *Ancient Mesoamerica*
3:105-115.

FERRIZ, HORACIO
1985 Caltonac, a Prehispanic Obsidian-Mining Center in Eastern Mexico?:
A Preliminary Report. *Journal of Field Archaeology* 12:363-370.

FIALKO COXEMANS, VILMA
1987 El Marcador de Juego de Pelota de Tikal: Nuevas referencias epigráficas
para el Clásico Temprano. In *Primer simposio mundial sobre epigrafía
maya*, pp. 61-80. Guatemala City: Asociación Tikal.
1988a El Marcador de Juego de Pelota de Tikal: Nuevas referencias epigráficas
para el Clásico Temprano. *Mesoamérica* 15:117-135.
1988b Mundo Perdido, Tikal: Un ejemplo de complejos de conmemoración
astronómica. *Mayab* 4:13-21.

FLANNERY, KENT V., AND JOYCE MARCUS
2000 Formative Mexican Chiefdoms and the Myth of the "Mother Culture."
Journal of Anthropological Archaeology 19:1-37.

FLANNERY, KENT V., AND JOYCE MARCUS, EDS.
1983 *The Cloud People: Divergent Evolution of Zapotec and Mixtec
Civilizations.* New York: Academic Press.

FOIAS, ANTONIA E.
1987 The Influence of Teotihuacan in the Maya Culture during the Middle
Classic: A Reconsideration of the Ceramic Evidence from Kaminaljuyu,
Uaxactun, and Copan. B.A. honors thesis, Department of
Anthropology, Harvard University, Cambridge, Massachusetts.

FOLAN, WILLIAM J., JOYCE MARCUS, SOPHIA PINCEMIN, MARÍA DEL ROSARIO
DOMÍNGUEZ CARRASCO, LARAINE FLETCHER, AND ABEL MORALES LÓPEZ
1995 Calakmul: New Data from an Ancient Maya Capital in Campeche,
Mexico. *Latin American Antiquity* 6:310-334.

FONCERRADA DE MOLINA, MARTA
1980 Mural Painting in Cacaxtla and Teotihuacan Cosmopolitanism. In *Third
Palenque Round Table, 1978, Part 2,* edited by Merle Greene Robertson,
pp. 172-183. Austin: University of Texas Press.

FOWLER, WILLIAM R.
1984 Late Preclassic Mortuary Patterns and Evidence for Human Sacrifice at
Chalchuapa, El Salvador. *American Antiquity* 49:603-618.

FREIDEL, DAVID A.
1977 A Late Preclassic Monumental Mayan Mask at Cerros, Northern
Belize. *Journal of Field Archaeology* 4:488-491.
1978 Maritime Adaptation and the Rise of Maya Civilization: A View from
Cerros, Belize. In *Prehistoric Coastal Adaptations: The Economy and
Ecology of Maritime Middle America,* edited by Barbara L. Stark and
Barbara Voorhies, pp. 239-265. New York: Academic Press.
1979 Culture Areas and Interaction Spheres: Contrasting Approaches to the
Emergence of Civilization in the Maya Lowlands. *American Antiquity*
44:36-54.
1986 The Monumental Architecture. In *Archaeology at Cerros, Belize, Central
America,* Vol. 1, *An Interim Report,* edited by Robin A. Robertson and

David A. Freidel, pp. 1-22. Dallas: Southern Methodist
University Press.

1990 The Jester God: The Beginning and End of a Maya Royal Symbol. In
Vision and Revision in Maya Studies, edited by Flora S. Clancy and Peter
Harrison, pp. 67-78. Albuquerque: University of New Mexico Press.

FREIDEL, DAVID A., AND LINDA SCHELE

1988a Kingship in the Late Preclassic Maya Lowlands: The Instruments and
Places of Ritual Power. *American Anthropologist* 90:547-565.

1988b Symbol and Power: A History of the Lowland Maya Cosmogram. In
Maya Iconography, edited by Elizabeth Benson and Gillett Griffin, pp.
44-93. Princeton, N.J.: Princeton University Press.

GAMIO, MANUEL

1926 Cultural Evolution in Guatemala and Its Geographic and Historic
Handicaps. *Art and Archaeology* 22:202-222.

1927a Cultural Evolution in Guatemala and Its Geographic and Historic
Handicaps. *Art and Archaeology* 23:16-32.

1927b Cultural Evolution in Guatemala and Its Geographic and Historic
Handicaps. *Art and Archaeology* 23:71-78.

1927c Cultural Evolution in Guatemala and Its Geographic and Historic
Handicaps. *Art and Archaeology* 23:129-133.

GAMIO, MANUEL, ED.

1922 *La población del Valle de Teotihuacán.* 3 vols. Mexico City: Secretaria de
Agricultura y Fomento.

1979 *La población del Valle de Teotihuacán.* 5 vols. Mexico City: Instituto
Nacional Indigenista.

GARCÍA CAMPILLO, JOSÉ MIGUEL

1994 Comentario general sobre la epigrafía en Oxkintok. In *VII simposio de
investigaciones arqueológicas en Guatemala, 1993,* edited by Juan Pedro
Laporte and Héctor L. Escobedo, pp. 711-725. Guatemala City: Museo
Nacional de Arqueología y Etnología.

GARCÍA CAMPILLO, JOSÉ MIGUEL, MARÍA JOSEFA IGLESIAS PONCE DE LEÓN, ALFONSO
LACADENA, AND LUIS T. SANZ CASTRO

1990 Estudio de fragmentos cerámicos con inscripciones glíficas del Clásico
Temprano de Tikal. *Mayab* 6:38-44.

GARCÍA COOK, ANGEL

1981 The Historical Importance of Tlaxcala in the Cultural Development of
the Central Highlands. In *Archaeology,* edited by Jeremy A. Sabloff, pp.
244-276. *Handbook of Middle American Indians,* Supplement 1,
Victoria R. Bricker, general editor. Austin: University of Texas Press.

GARCÍA COOK, ANGEL, AND BEATRIZ LEONOR MERINO CARRIÓN

1998 Cantona: Urbe prehispánica en el altiplano central de México. *Latin
American Antiquity* 9:191-216.

GENDROP, PAUL

1984 El tablero-talud en la arquitectura mesoamericana. *Cuadernos de
arquitectura mesoamericana* 2:5-27.

1985 Los remates o coronamientos de techo en la arquitectura
mesoamericana. *Cuadernos de arquitectura mesoamericana* 4:47-50.

GIDDENS, WENDY LOUISE

1995 Talud-Tablero Architecture as a Symbol of Mesoamerican Affiliation

and Power. M.A. thesis, Department of Anthropology, University of California, Los Angeles.

GÓMEZ, OSWALDO

1998 Nuevas excavaciones en el Templo V, Tikal. In *XI simposio de investigaciones arqueológicas en Guatemala, 1997,* edited by Juan Pedro Laporte and Héctor L. Escobedo, Tomo 1, pp. 55-70. Guatemala City: Museo Nacional de Arqueología y Etnología.

1999 Excavaciones en el interior del Templo V, Tikal. In *XII simposio de investigaciones arqueológicas en Guatemala, 1998,* edited by Juan Pedro Laporte, Héctor L. Escobedo, and Ana Claudia Monzón de Suasnávar, Tomo 1, pp. 187-194. Guatemala City: Museo Nacional de Arqueología y Etnología.

GÓMEZ CHAVEZ, SERGIO

1999 Nuevos datos sobre relación entre Teotihuacan y el Occidente de México. Paper presented at the Primera Mesa Redonda de Teotihuacan. Instituto Nacional de Antropología e Historia, Centro de Estudios Teotihuacanos, San Juan Teotihuacán, Mexico.

GONZÁLEZ LICÓN, ERNESTO

1990 *Los zapotecos y mixtecos: Tres mil años de civilización precolombina.* Milan and Mexico: Editorial Jaca Book and the Consejo Nacional para la Cultura y las Artes.

GRAHAM, ELIZABETH

1987 Resource Diversity in Belize and Its Implications for Models of Lowland Trade. *American Antiquity* 54:753-767.

GRAHAM, ELIZABETH, AND DAVID M. PENDERGAST

1993 New Data from Ambergris Caye on Coastal Maya Production and Exchange. Paper presented at the Fifty-eighth Annual Meeting of the Society for American Archaeology, St. Louis.

GRAHAM, IAN

1982 *Corpus of Maya Hieroglyphic Inscriptions 3(3), Yaxchilan.* Cambridge: Peabody Museum of Archaeology and Ethnology, Harvard University.

GRAHAM, IAN, AND ERIC VON EUW

1975 *Corpus of Maya Hieroglyphic Inscriptions 2(1), Naranjo.* Cambridge: Peabody Museum of Archaeology and Ethnology, Harvard University.

1977 *Corpus of Maya Hieroglyphic Inscriptions 3(1), Yaxchilan.* Cambridge: Peabody Museum of Archaeology and Ethnology, Harvard University.

GREENE, VIRGINIA, AND HATTULA MOHOLY-NAGY

1966 A Teotihuacan-Style Vessel from Tikal. *American Antiquity* 31:432-434.

GROVE, DAVID C.

1993 "Olmec" Horizons in Formative Period Mesoamerica: Diffusion or Social Evolution? In *Latin American Horizons,* edited by Don S. Rice, pp. 83-111. Washington, D.C.: Dumbarton Oaks Research Library and Collection.

1997 Olmec Archaeology: A Half Century of Research and Its Accomplishments. *Journal of World Prehistory* 11(1):51-101.

GRUBE, NIKOLAI, AND LINDA SCHELE

1994 Kuy, the Owl of Omen and War. *Mexicon* 16:10-17.

GRUBE, NIKOLAI, LINDA SCHELE, AND FEDERICO FAHSEN

1995 The Tikal-Copán Connection: Evidence from External Relations.

Copán Note 121. Austin: Instituto Hondureño de Antropología e
Historia and the Copán Acropolis Archaeological Project.

GRUBE, NIKOLAI, AND DAVID STUART
1987 Observations on T110 as the Syllable *ko*. Research Reports on Ancient
Maya Writing 8: 1-14. Washington, D.C.: Center for Maya Research.

HALL, CLARA (SEE ALSO MILLON, CLARA)
1962 A Chronological Study of the Mural Art of Teotihuacan. Ph.D. diss.,
Department of Anthropology, University of California at Berkeley.

HAMMOND, NORMAN
1977 The Earliest Maya. *Scientific American* 236(3):116-133.
1985 The Emergence of Maya Civilization. *Scientific American*
255(2):106-115.
1989 Cultura Hermana. *Quarterly Review of Archaeology* 9(4):1-4.

HAMMOND, NORMAN, CATHERINE CLARK, MARK HORTON, MARK HODGES, LOGAN
MCNATT, LAURA J. KOSAKOWSKY, AND ANNE PYBURN
1985 Excavations and Survey at Nohmul, Belize, 1983. *Journal of Field
Archaeology* 12:177-200.

HAMMOND, NORMAN, SARA DONAGHEY, COLLEEN GLEASON, J. C. STANEKO,
DIRK VAN TUERENHOUT, AND LAURA J. KOSAKOWSKY
1987 Excavations at Nohmul, Belize, 1985. *Journal of Field Archaeology*
14:257-281.

HAMMOND, NORMAN, JOHN J. ROSE, J. C. STANEKO, DEBORAH MUYSKENS, THOMAS
ADDYMAN, AND COLLEEN GLEASON
1987 Archaeological Investigations at Nohmul, Belize, 1986. *Mexicon*
9:104-109.

HANSEN, RICHARD D.
1984 Excavation on Structure 34 and the Tigre Area, El Mirador, Petén,
Guatemala: A New Look at the Preclassic Lowland Maya. M.A. thesis,
Department of Anthropology, Brigham Young University, Provo, Utah.
1991 The Maya Rediscovered: The Road to Nakbe. *Natural History*
91(5):8-14.
1993 Investigaciones arqueológicas en el sitio Nakbe: Los estudios recientes.
In *VI simposio de investigaciones arqueológicas en Guatemala, 1992*, edited
by Juan Pedro Laporte, Héctor L. Escobedo, and Sandra Villagrán de
Brady, pp. 115-122. Guatemala City: Museo Nacional de Arqueología y
Etnología.
1994 Las dinámicas culturales y ambientales de los orígenes mayas: Estudios
recientes del sitio arqueológico Nakbe. In *VII simposio de investigaciones
arqueológicas en Guatemala, 1993*, edited by Juan Pedro Laporte and
Héctor L. Escobedo, pp. 369-387. Guatemala City: Museo Nacional de
Arqueología y Etnología.
1998 Continuity and Disjunction: The Pre-Classic Antecedents of Classic
Maya Architecture. In *Function and Meaning in Classic Maya
Architecture*, edited by Stephen Houston, pp. 49-122. Washington,
D.C.: Dumbarton Oaks Research Library and Collection.

HÄRKE, HEINRICH
2000 Comments. *Current Anthropology* 41:558-559.

HARLOW, GEORGE E.
1993 Middle American Jade: Geologic and Petrologic Perspectives on

Variability and Source. In *Precolumbian Jade: New Geological and Cultural Interpretations,* edited by Frederick W. Lange, pp. 9–29. Salt Lake City: University of Utah Press.

HARRISON, PETER D.

1970 The Central Acropolis, Tikal, Guatemala: A Preliminary Study of the Functions of Its Structural Components during the Late Classic Period. Ph.D. diss., Department of Anthropology, University of Pennsylvania, Philadelphia.

1999 *The Lords of Tikal: Rulers of an Ancient Maya City.* London: Thames and Hudson.

HASSIG, ROSS

1992 *War and Society in Ancient Mesoamerica.* Berkeley: University of California Press.

HAVILAND, WILLIAM A., JR.

1962 A "Miniature Stela" from Tikal. *Expedition* 4:2–3.

1985 *Excavations in Small Residential Groups of Tikal: Groups 4F-1 and 4F-2.* Tikal Report 19, University Museum Monograph 58. Philadelphia: University of Pennsylvania.

1992 Status and Power in Classic Maya Society: The View from Tikal. *American Anthropologist* 94:937–940.

HAY, CONRAN A.

1978 *Kaminaljuyu Obsidian: Lithic Analysis and Economic Organization of a Prehistoric Mayan Chiefdom.* Ph.D. diss., Department of Anthropology, Pennsylvania State University. Ann Arbor: University Microfilms.

HEADRICK, ANNABETH

1999 The Street of the Dead . . . It Really Was: Mortuary Bundles at Teotihuacan. *Ancient Mesoamerica* 10:69–85.

HEALAN, DAN M.

1997 Pre-Hispanic Quarrying in the Ucareo-Zinapecuaro Obsidian Source Area. *Ancient Mesoamerica* 8:77–100.

HELLMUTH, NICHOLAS

1972 Report on First Season of Explorations and Excavations at Yaxhá, El Petén, Guatemala. *Katunob* 7(4):24–49; 92–97.

1975 The Escuintla Hordes: Teotihuacan Art in Guatemala. *Progress Report 1 (Number 2).* Cocoa, Fla.: Foundation for Latin American Anthropological Research.

1978 Teotihuacan Art in the Escuintla, Guatemala, Region. In *Middle Classic America: A.D. 400–700,* edited by Esther Pasztory, pp. 71–85. New York: Columbia University Press.

1986 Yaxhá. *Mexicon* 8:36–37.

1987 *Monster und Menschen in der Maya-Kunst.* Graz, Austria: Akademische Druck und Verlagsanstalt.

1993a *Discussions Leading to Conclusions Relative to Dating the Art of Tiquisate.* Cocoa, Fla.: Foundation for Latin American Anthropological Research.

1993b *Middle Classic Pottery from the Tiquisate Area, Escuintla, Guatemala, Part I.* Cocoa, Fla.: Foundation for Latin American Anthropological Research.

HENDON, JULIA A.
1991 Status and Power in Classic Maya Society: An Anthropological Study.
 American Anthropologist 91:894–918.
HERMES CIFUENTES, BERNARD
1983 Tipología de artefactos cerámicos. Ms. on file, Proyecto Nacional Tikal,
 Instituto de Antropología e Historia, Guatemala City.
1984 La secuencia cerámica de Mundo Perdido, Tikal: Una visión preliminar.
 Paper presented at the symposium "La Plaza de la Gran Pirámide o
 Mundo Perdido," Instituto Nacional de Antropología e Historia,
 Guatemala City.
1985 Informe sobre fechamiento de lotes cerámicos de las exploraciones de
 Mundo Perdido y Zonas de Habitación, Tikal. Ms. on file, Proyecto
 Nacional Tikal, Instituto de Antropología e Historia, Guatemala City.
1991 Propuesta para la clasificación de artefactos cerámicos en contexto
 arqueológico. *Mayab* 7:5–9.
1993 La secuencia cerámica de Topoxté: Un informe preliminar. *Beiträge zur
 Allgemeinen und Vergleichenden Archäologie* 13:221–251.
HODDER, IAN
1990 Style as Historical Quality. In *The Uses of Style in Archaeology*, edited by
 Margaret W. Conkey and Christine A. Hastorf, pp. 44–51. Cambridge:
 Cambridge University Press.
HOPKINS, MARY R.
1987 An Explication of the Plans of Some Teotihuacan Apartment
 Compounds. In *Teotihuacan: Nuevos datos, nuevas síntesis, nuevos
 problemas*, edited by Emily McClung de Tapia and Evelyn Rattray, pp.
 369–388. Mexico City: Instituto de Investigaciones Antropológicas,
 Universidad Nacional Autónoma de México.
HOUSTON, STEPHEN D.
1984 An Example of Homophony in Maya Script. *American Antiquity*
 49:790–805.
1993 *Hieroglyphs and History at Dos Pilas: Dynastic Politics of the Classic
 Maya.* Austin: University of Texas Press.
1994 Literacy among the Pre-Columbian Maya: A Comparative Perspective.
 In *Writing without Words: Alternative Literacies in Mesoamerica and the
 Andes*, edited by Elizabeth Boone and Walter D. Mignolo, pp. 27–49.
 Durham, N.C.: Duke University Press.
1998 Classic Maya Depictions of the Built Environment. In *Function and
 Meaning in Classic Maya Architecture*, edited by Stephen D. Houston,
 pp. 333–372. Washington, D.C.: Dumbarton Oaks Research Library and
 Collection.
HOUSTON, STEPHEN D., HÉCTOR L. ESCOBEDO, AND MARK CHILD
1999 Al filo de la navaja: Resultados de la segunda temporada del Proyecto
 Arqueológico Piedras Negras. In *XII simposio de investigaciones
 arqueológicas en Guatemala, 1998*, edited by Juan Pedro Laporte, Héctor
 L. Escobedo, and Ana Claudia Monzón de Suasnávar, Tomo 1, pp.
 373–392. Guatemala City: Museo Nacional de Arqueología y Etnología.
HOUSTON, STEPHEN D., AND DAVID STUART
1996 Of Gods, Glyphs, and Kings: Divinity and Rulership among the Classic
 Maya. *Antiquity* 70:289–312.

1998 The Ancient Maya Self: Personhood and Portraiture in the Classic
 Period. *Res: Anthropology and Aesthetics* 33:73–101.

HOUSTON, STEPHEN D., DAVID STUART, AND KARL A. TAUBE
1989 Folk Classification of Classic Maya Pottery. *American Anthropologist*
 91:722–726.

IGLESIAS PONCE DE LEÓN, MARÍA JOSEFA
1987 Excavaciones en el Grupo Habitacional 6D-V, Tikal, Guatemala. Ph.D.
 diss., Departamento de Historia de América II (Antropología de
 América), Universidad Complutense, Madrid.
1988 Análisis de un depósito problemático de Tikal, Guatemala. *Journal de la
 Société des américanistes* 74:25–48.
1989 Los depósitos problemáticos de Tikal. In *Memorias del II° Coloquio
 Internacional de Mayistas,* Tomo 1, pp. 555–568. Mexico City: Centro de
 Estudios Mayas, Universidad Nacional Autónoma de México.
1996 El hombre depone y la arqueología dispone: Formas de deposición en la
 cultura maya, el caso de Tikal. *Los Investigadores de la Cultura Maya* 4,
 pp. 187–217. Universidad Autónoma de Campeche, Campeche.
2000 Buscando nuevos caminos en la interpretación arqueológica: El
 proyecto "Los mayas prehispánicos ante el siglo XXI: Aplicación de
 análisis de ADN mitocondrial al estudio de las clases sociales de la
 ciudad arqueológica de Tikal, Guatemala." *Revista española de
 antropología americana* 30:337–339.

IGLESIAS PONCE DE LEÓN, MARÍA JOSEFA, ANDRÉS CIUDAD RUIZ, EDUARDO ARROYO,
JESÚS ADÁNEZ, AND SARA ÁLVAREZ
2000 Aplicaciones de la antropología molecular a la arqueología maya: El
 caso de Tikal. Paper presented at the XIV Simposio de Investigaciones
 Arqueológicas en Guatemala, Guatemala City.

IGLESIAS PONCE DE LEÓN, MARÍA JOSEFA, AND LUIS T. SANZ CASTRO
1999 Patrones de replicación iconográfica en materiales del Clásico
 Temprano de Tikal. In *XII simposio de investigaciones arqueológicas en
 Guatemala, 1998,* edited by Juan Pedro Laporte, Héctor L. Escobedo,
 and Ana Claudia Monzón de Suasnávar, Tomo 1, pp. 169–186.
 Guatemala City: Museo Nacional de Arqueología y Etnología.

JARQUÍN, ANA MARÍA
1987 Arquitectura y sistemas constructivos de la fachada de la Ciudadela. In
 Teotihuacán: Nuevos datos, nuevas síntesis, nuevos problemas, edited by
 Emily McClung de Tapia and Evelyn Rattray, pp. 512–515. Mexico
 City: Instituto de Investigaciones Antropológicas, Universidad Nacional
 Autónoma de México.

JARQUÍN, ANA MARÍA, AND ENRIQUE MARTÍNEZ VARGAS
1982 Exploración en el lado Este de la Ciudadela (Estructuras 1G, 1R, 1Q y
 1P). In *Memoria del Proyecto Arqueológico Teotihuacán 80-82: Primeros
 resultados,* edited by Rubén Cabrera Castro, Ignacio Rodríguez, and
 Noel Morelos, pp. 19–47. Mexico City: Instituto Nacional de
 Antropología e Historia.

JIMÉNEZ OVANDO, ROBERTO
1988 Entierros humanos prehispánicos de la zona arqueológica de Cacaxtla,
 Tlaxcala. *Antropológicas* 2: 57–72.

JONES, CHRISTOPHER
1991 Cycles of Growth at Tikal. In *Classic Maya Political History:*
 Hieroglyphic and Archaeological Evidence, ed. T. Patrick Culbert, pp.
 102–127. Cambridge: Cambridge University Press.

JONES, CHRISTOPHER, AND LINTON SATTERTHWAITE
1982 *The Monuments and Inscriptions of Tikal: The Carved Monuments.* Tikal
 Report 33A, University Museum Monograph 44. Philadelphia:
 University of Pennsylvania.

JOYCE, ARTHUR A.
2000 Imperialism in Pre-Aztec Mesoamerica: Monte Albán, Teotihuacan, and
 the Lower Río Verde Valley. Ms. on file, Department of Anthropology,
 University of Colorado, Boulder.

JOYCE, ARTHUR A., AND MARCUS WINTER
1996 Ideology, Power, and Urban Society in Pre-Hispanic Oaxaca. *Current*
 Anthropology 37:33–79.

JOYCE, THOMAS ATHOL, J. COOPER CLARK, AND J. ERIC S. THOMPSON
1927 Report on the British Museum Expedition to British Honduras. *Journal*
 of the Royal Anthropological Institute 59:439–459.

JUSTESON, JOHN S., WILLIAM M. NORMAN, LYLE CAMPBELL, AND TERRENCE KAUFMAN
1985 *The Foreign Impact on Lowland Mayan Language and Script.* Middle
 American Research Institute Publication 53. New Orleans: Tulane
 University.

KAPLAN, JONATHAN
1995 The Incienso Throne and Other Thrones from Kaminaljuyu,
 Guatemala: Late Preclassic Examples of a Mesoamerican Throne
 Tradition. *Ancient Mesoamerica* 6:185–196.

KERR, JUSTIN
1997 *The Maya Vase Book*, Vol. 5. New York: Kerr Associates.

KIDDER, ALFRED V.
1947 *Artifacts of Uaxactun, Guatemala.* Carnegie Institution of Washington
 Publication 576. Washington, D.C.: Carnegie Institution of Washington.
1961 Archaeological Investigations at Kaminaljuyu, Guatemala. *Proceedings*
 of the American Philosophical Society 105(6):559–570.

KIDDER, ALFRED V., JESSE D. JENNINGS, AND EDWIN M. SHOOK
1946 *Excavations at Kaminaljuyu, Guatemala.* Carnegie Institution of
 Washington Publication 561. Washington D.C.: Carnegie Institution of
 Washington.

KIRSCH, RICHARD W.
1973 An Annotated Bibliography of the Archaeology of Kaminaljuyu. In *The*
 Pennsylvania State University Kaminaljuyu Project—1969, 1970 Seasons:
 Part I—Mound Excavations, edited by Joseph W. Michels and
 William T. Sanders, pp. 483–524. Occasional Papers in Anthropology,
 No. 9. College Park: Department of Anthropology, Pennsylvania State
 University.

KOLB, CHARLES C.
1987 *Marine Shell Trade and Classic Teotihuacan, Mexico.* BAR International
 Series 364. Oxford: British Archaeological Reports.
1988 Classic Teotihuacan Candeleros: A Preliminary Analysis. In *Ceramic*
 Ecology Revisited 1987: The Technology and Socioeconomics of Pottery,

edited by Charles C. Kolb, pp. 449–646. BAR International Series 436. Oxford: British Archaeological Reports.

KOWALEWSKI, STEPHEN A., GARY M. FEINMAN, LAURA FINSTEN, AND RICHARD E. BLANTON

1991 Pre-Hispanic Ballcourts from the Valley of Oaxaca, Mexico. In *The Mesoamerican Ballgame*, edited by Vernon Scarborough and David Wilcox, pp. 25–44. Tucson: University of Arizona Press.

KREJCI, ESTELLA, AND T. PATRICK CULBERT

1995 Preclassic and Classic Burials and Caches in the Maya Lowlands. In *The Emergence of Lowland Maya Civilization: The Transition from the Preclassic to the Early Classic*, edited by Nikolai Grube, pp. 103–116. Acta Mesoamericana 8. Möckmühl, Germany: Verlag Anton Saurwein.

KRICKEBERG, WALTER

1937 Bericht über neuere Forschungen zur Geschichte der alten Kulturen Mittelamerikas. *Die Welt als Geschichte* (Berlin) 3:194–230.

KUBLER, GEORGE

1967 *The Iconography of the Art of Teotihuacan.* Washington, D.C.: Dumbarton Oaks Research Library and Collection.

1973 Iconographic Aspects of Architectural Profiles at Teotihuacan and in Mesoamerica. In *The Iconography of Middle American Sculpture*, pp. 24–39. New York: Metropolitan Museum of Art.

1984 "Renascence" y disyunción en el arte mesoamericano. *Cuadernos de arquitectura mesoamericana* 2:75–87.

LANGLEY, JAMES C.

1992 Teotihuacan Sign Clusters: Emblem or Articulation? In *Art, Ideology, and the City of Teotihuacan*, edited by Janet C. Berlo, pp. 247–280. Washington, D.C.: Dumbarton Oaks Research Library and Collection.

LAPORTE, JUAN PEDRO

1987 El "talud-tablero" en Tikal, Petén: Nuevos datos. In *Homenaje a Román Piña Chan*, edited by Barbro Dahlgren, Carlos Navarrete, Lorenzo Ochoa, Mari Carmen Serra Puche, and Yoko Sugiura, pp. 265–316. Mexico City: Instituto de Investigaciones Antropológicas, Universidad Nacional Autónoma de México.

1988 El Complejo Manik: Dos depósitos sellados, Grupo 6C-XVI, Tikal. In *Ensayos de alfarería prehispánica e histórica de Mesoamérica, homenaje a Eduardo Noguera*, edited by Mari Carmen Serra Puche and Carlos Navarrete, pp. 97–185. Mexico City: Instituto de Investigaciones Antropológicas, Universidad Nacional Autónoma de México.

1989 Alternativas del Clásico Temprano en la relación Tikal-Teotihuacan: El Grupo 6C-XVI, Tikal, Petén. Ph.D. diss., Universidad Nacional Autónoma de México, Mexico City.

1995 Preclásico a Clásico en Tikal: Proceso de transformación en Mundo Perdido. In *The Emergence of Lowland Maya Civilization: The Transition from the Preclassic to the Early Classic*, edited by Nikolai Grube, pp. 17–33. Acta Mesoamericana 8. Möckmühl, Germany: Verlag Anton Saurwein.

1996 Organización territorial y política prehispánica en el sureste de Petén. Atlas Arqueológico de Guatemala 4. Instituto de Antropología e Historia and Universidad de San Carlos, Guatemala.

1998 Exploración y restauración en el Templo del Talud-Tablero, Mundo
 Perdido, Tikal (Estructura 5C-49). In *XI simposio de investigaciones
 arqueológicas en Guatemala, 1997*, edited by Juan Pedro Laporte and
 Héctor L. Escobedo, Tomo 1, pp. 21-42. Guatemala City: Museo
 Nacional de Arqueología y Etnología.

1999a Contexto y función de los artefactos de hueso en Tikal, Guatemala.
 Revista española de antropología americana 29:31-64.

1999b Exploración y restauración en el conjunto de palacios de Mundo
 Perdido, Tikal (Estructuras 5C-45/47). In *XII simposio de investigaciones
 arqueológicas en Guatemala, 1998*, edited by Juan Pedro Laporte, Héctor
 L. Escobedo, and Ana Claudia Monzón de Suasnávar, Tomo 1, pp.
 195-234. Guatemala City: Museo Nacional de Arqueología y Etnología.

2000 Trabajos no divulgados del Proyecto Nacional Tikal, parte 2: Hallazgos
 en las exploraciones de la Zona Norte. Paper presented at the XIV
 Simposio de Investigaciones Arqueológicas en Guatemala,
 Guatemala City.

LAPORTE, JUAN PEDRO, AND VILMA FIALKO
1987 La cerámica del Clásico Temprano desde Mundo Perdido, Tikal: Una
 reevaluación. In *Maya Ceramics: Papers from the 1985 Maya Ceramic
 Conference*, edited by Prudence M. Rice and Robert J. Sharer, Vol. 1,
 pp. 123-181. BAR International Series 345 (i). Oxford: British
 Archaeological Reports.

1990 New Perspectives on Old Problems: Dynastic References for the Early
 Classic at Tikal. In *Vision and Revision in Maya Studies*, edited by Flora
 Clancy and Peter Harrison, pp. 33-66. Albuquerque: University of New
 Mexico Press.

1993 Análisis cerámico de tres depósitos problemáticos de fase Eb, Mundo
 Perdido, Tikal. In *Tikal y Uaxactun en el Preclásico*, edited by Juan
 Pedro Laporte and Juan Antonio Valdés, pp. 53-69. Mexico City:
 Instituto de Investigaciones Antropológicas, Universidad Nacional
 Autónoma de México.

1995 Un reencuentro con Mundo Perdido, Tikal. *Ancient Mesoamerica*
 6:41-94.

LAPORTE, JUAN PEDRO, AND OSWALDO GÓMEZ
1998 Depósitos de material como actividad ritual en Tikal: Nueva evidencia
 del inicio del Clásico Tardío. Paper presented at the IV° Congreso
 Internacional de Mayistas, La Antigua Guatemala, Guatemala.

LAPORTE, JUAN PEDRO, BERNARD HERMES CIFUENTES, LILIÁN VEGA DE ZEA, AND MARÍA
JOSEFA IGLESIAS PONCE DE LEÓN
1992 Nuevos entierros y escondites de Tikal, subfases Manik 3a y 3b.
 Cerámica de cultura maya 16:30-68.

LAPORTE, JUAN PEDRO, AND MARÍA JOSEFA IGLESIAS PONCE DE LEÓN
1992 Unidades cerámicas de la fase Manik 3, Tikal, Guatemala. *Cerámica de
 cultura maya* 16:69-101.

1999 Más allá de Mundo Perdido: Investigación en Grupos Residenciales de
 Tikal. *Mayab* 12:32-57.

LEE, EVERETT S.
1966 A Theory of Migration. *Demography* 3:47-57.

LIGHTFOOT, KENT G., AND ANTOINETTE MARTINEZ
1995 Frontiers and Boundaries in Archaeological Perspective. *Annual Review of Anthropology* 24:471–492.

LINNÉ, SIGVALD
1934 *Archaeological Researches at Teotihuacan, Mexico.* Ethnographic Museum of Sweden, new series, Publication 1. Stockholm: Ethnographic Museum of Sweden.
1942 *Mexican Highland Cultures.* Ethnographic Museum of Sweden, new series, Publication 7. Stockholm: Ethnographic Museum of Sweden.

LOTHROP, SAMUEL K.
1926 Stone Sculptures from Finca Arevalo, Guatemala. *Indian Notes, Museum of the American Indian* 3:147–171.
1927 *Pottery Types and Their Sequence in Salvador.* Indian Notes and Monographs 1, pp. 164–220. New York: Museum of the American Indian, Heye Foundation.

LOTHROP, SAMUEL K., W. F. FOSHAG, AND JOY MAHLER
1957 *Pre-Columbian Art.* New York: Phaidon Publishers.

LOU, BRENDA
1991 Un análisis del patrón de asentamiento de Balberta, Escuintla, Guatemala: Perspectivas para un estudio regional. Tesis de Licenciatura, Escuela de Historia, Universidad de San Carlos de Guatemala, Guatemala City.
1994 Antiguas rutas de comunicación e intercambio entre las Tierras Altas y Costa Sur de Guatemala: Evidencia mineralógica en sitios de Escuintla Central. In *VII simposio de investigaciones arqueológicas en Guatemala, 1993,* edited by Juan Pedro Laporte and Héctor L. Escobedo, pp. 113–130. Guatemala City: Museo Nacional de Arqueología y Etnología.

LOWE, GARETH W., PIERRE AGRINIER, J. ALDEN MASON, FREDERIC HICKS, AND CHARLES E. ROZAIRE, EDS.
1960 *Excavations at Chiapa de Corzo, Chiapas, Mexico.* Papers of the New World Archaeological Foundation 8–11. Provo, Utah: Brigham Young University.

LOWE, GARETH W., THOMAS A. LEE, JR., AND EDUARDO MARTÍNEZ ESPINOSA
1982 *Izapa: An Introduction to the Ruins and Monuments.* Papers of the New World Archaeological Foundation 31. Provo, Utah: Brigham Young University.

MANRIQUE, LEONARDO
1982 La cerámica del Altiplano. In *Historia del Arte Mexicano,* Vol. 28, pp. 121–133. Mexico City: Salvat Mexicana de Ediciones.

MANZANILLA, LINDA, ED.
1993 *Anatomía de un conjunto residencial teotihuacano en Oztoyahualco.* 2 vols. Mexico City: Universidad Nacional Autónoma de México.

MANZANILLA, LINDA, AND CARLOS SERRANO, EDS.
1999 *Prácticas funerarias en la ciudad de los dioses: Los enterramientos humanos de la antigua Teotihuacan.* Mexico City: Instituto de Investigaciones Antropológicas, Universidad Nacional Autónoma de México.

MARCUS, JOYCE
1974 The Iconography of Power among the Classic Maya. *World Archaeology* 6:83–94.

1983a Lowland Maya Archaeology at the Crossroads. *American Antiquity* 48:454–488.

1983b Teotihuacán Visitors on Monte Albán Monuments and Murals. In *The Cloud People: Divergent Evolution of the Zapotec and Mixtec Civilizations*, edited by Kent V. Flannery and Joyce Marcus, pp. 175–181. New York: Academic Press.

1989 Preface. In *New Frontiers in the Archaeology of the Pacific Coast of Southern Mesoamerica*, edited by Frederick J. Bove and Lynette Heller, pp. xv–xvii. Anthropological Research Papers No. 39. Tempe: Arizona State University.

1992a Dynamic Cycles of Mesoamerican States. *National Geographic Research and Exploration* 8:392–411.

1992b *Mesoamerican Writing Systems: Propaganda, Myth, and History in Four Ancient Civilizations*. Princeton, N.J.: Princeton University Press.

1993 Ancient Maya Political Organization. In *Lowland Maya Civilization in the Eighth Century A.D.*, edited by Jeremy A. Sabloff and John S. Henderson, pp. 111–183. Washington, D.C.: Dumbarton Oaks Research Library and Collection.

1995 Where Is Lowland Maya Archaeology Headed? *Journal of Archaeological Research* 3:3–53.

1998 The Peaks and Valleys of Ancient States: An Extension of the Dynamic Model. In *Archaic States*, edited by Gary Feinman and Joyce Marcus, pp. 59–94. Santa Fe, N.Mex.: SAR Press.

MARCUS, JOYCE, AND KENT V. FLANNERY

1996 *Zapotec Civilization: How Urban Society Evolved in Mexico's Oaxaca Valley*. London: Thames and Hudson.

MARQUINA, IGNACIO

1964 *Arquitectura prehispánica*. 2d ed. Mexico City: Instituto Nacional de Antropología e Historia.

MARTIN, SIMON

1998 At the Periphery: Early Monuments in the Environs of Tikal. Paper presented at the Third European Maya Conference, Hamburg.

MARTIN, SIMON, AND NIKOLAI GRUBE

2000 *Chronicle of Maya Kings and Queens: Deciphering the Dynasties of the Ancient Maya*. London: Thames and Hudson.

MARTÍNEZ HIDALGO, GUSTAVO, TANNIA CABRERA, AND NANCY MONTERROSO

1996 Excavaciones en el Sector 2 del Proyecto Arqueológico Miraflores II. Report on file, Instituto de Antropología e Historia, Guatemala City.

MARTÍNEZ LÓPEZ, CIRA

1994 La cerámica de estilo teotihuacano en Monte Albán. In *Monte Albán: Estudios recientes*, edited by Marcus Winter, pp. 25–54. Oaxaca: Proyecto Especial Monte Albán 1992–1994.

MATA AMADO, GUILLERMO

1964 Apuntes arqueológicos sobre el Lago de Amatitlán. *Revista del Instituto de Antropología e Historia de Guatemala* 16(1):63–77.

MATA AMADO, GUILLERMO, AND ROLANDO RUBIO

1987 Incensarios talud-tablero del Lago de Amatitlán (Guatemala). *Mesoamérica* 13:185–203.

MATHENY, RAYMOND T.

1986 Investigations at El Mirador, Peten, Guatemala. *National Geographic and Exploration* 2:332–353.

1987 El Mirador: An Early Maya Metropolis Uncovered. *National Geographic* 172(3):317–339.

MATHENY, RAYMOND T., ED.

1980 *El Mirador, Peten, Guatemala, an Interim Report.* Papers of the New World Archaeological Foundation 45. Provo, Utah: Brigham Young University.

MATHEWS, PETER

1985 Maya Early Classic Monuments and Inscriptions. In *A Consideration of the Early Classic Period in the Maya Lowlands,* edited by Gordon R. Willey and Peter Mathews. Institute for MesoAmerican Studies Publication 10. Albany: State University of New York.

MAUDSLAY, ALFRED P.

1889–1902 *Biologia Centrali-Americana: Archaeology,* 5 vols. London: R. H. Porter and Dulau and Company.

MAXWELL, JUDITH M., AND CRAIG A. HANSON

1992 *Of the Manners of Speaking That the Old Ones Had: The Metaphors of Andrés de Olmos in the TULAL Manuscript* Arte para Aprender la Lengua Mexicana *1547.* Salt Lake City: University of Utah Press.

MCANANY, PATRICIA A.

1995 *Living with the Ancestors.* Austin: University of Texas Press.

MCBRIDE, HAROLD W.

1969 Teotihuacan-Style Pottery and Figurines from Colima. *Katunob* 7:86–91.

MCKILLOP, HEATHER I., AND PAUL F. HEALY, EDS.

1989 *Coastal Maya Trade.* Trent University Occasional Papers in Anthropology Number 8. Peterborough, Ontario.

MEDRANO BUSTO, SONIA

1988 Arquitectura de Balberta, Escuintla. Tesis de Licenciatura, Escuela de Historia, Universidad de San Carlos de Guatemala, Guatemala.

MEJÍA, HÉCTOR E., AND EDGAR SUYUC LEY

1999 Prospección geológica-arqueológica en Llano Largo, San Antonio La Paz, El Progreso. In *XII simposio de investigaciones arqueológicas en Guatemala, 1998,* edited by Juan Pedro Laporte, Héctor L. Escobedo, and Ana Claudia Monzón de Suasnávar, Tomo 2, pp. 525–536. Guatemala City: Museo Nacional de Arqueología y Etnología.

MERWIN, RAYMOND E., AND GEORGE C. VAILLANT

1932 *The Ruins of Holmul, Guatemala.* Memoirs of the Peabody Museum of Archaeology and Ethnology, Vol. 2, No. 2. Cambridge: Harvard University.

MICHELS, JOSEPH W.

1973 Radiocarbon and Obsidian Dating: A Chronometric Framework for Kaminaljuyu. In *The Pennsylvania State University Kaminaljuyu Project—1969, 1970 Seasons: Part I—Mound Excavations,* edited by Joseph W. Michels and William T. Sanders, pp. 21–65. Occasional Papers in Anthropology, No. 9. College Park: Department of Anthropology, Pennsylvania State University.

1977 Political Organization at Kaminaljuyu: Its Implications for Interpreting
 Teotihuacan Influence. In *Teotihuacan and Kaminaljuyu,* edited by
 William T. Sanders and Joseph W. Michels, pp. 453–467. College Park:
 Pennsylvania State University Press.

1979 *The Kaminaljuyu Chiefdom.* College Park: Pennsylvania State
 University Press.

MILES, SUZANNA W.

1963 Informe sobre Kaminal-Juyú, rendido al Instituto de Antropología e
 Historia, por la arqueóloga Susan [*sic*] Miles. *Antropología e historia de
 Guatemala* 15(1):35–38.

1965 Sculpture of the Guatemala-Chiapas Highlands and Pacific Slopes, and
 Associated Hieroglyphs. In *Archaeology of Southern Mesoamerica, Part 1,*
 edited by Gordon R. Willey, pp. 237–275. *Handbook of Middle American
 Indians,* Vol. 2, Robert Wauchope, general editor. Austin: University of
 Texas Press.

MILLER, ARTHUR G.

1973 *The Mural Painting of Teotihuacan.* Washington, D.C.: Dumbarton Oaks
 Research Library and Collection.

1978 A Brief Outline of the Artistic Evidence from Classic Period Cultural
 Contact between Maya Lowlands and Central Mexican Highlands. In
 Middle Classic Mesoamerica: A.D. 400–700, edited by Esther Pasztory,
 pp. 63–70. New York: Columbia University Press.

1995 *The Painted Tombs of Oaxaca, Mexico.* Cambridge: Cambridge
 University Press.

MILLER, ARTHUR G., ED.

1983 *Highland-Lowland Interaction in Mesoamerica: Interdisciplinary
 Approaches.* Washington, D.C.: Dumbarton Oaks Research Library and
 Collection.

MILLER, MARY E.

1988 The Boys in the Bonampak Band. In *Maya Iconography,* edited by
 Elizabeth P. Benson and Gillett G. Griffin, pp. 318–330. Princeton, N.J.:
 Princeton University Press.

1991 Rethinking the Classic Sculptures of Cerro de las Mesas, Veracruz. In
 Settlement Archaeology of Cerro de las Mesas, Veracruz, Mexico, edited
 by Barbara L. Stark, pp. 26–38. Institute of Archaeology Monograph
 34. Los Angeles: University of California.

MILLON, CLARA H. (SEE ALSO HALL, CLARA)

1972 The History of Mural Art at Teotihuacan. In *Teotihuacan: XI Mesa
 Redonda,* edited by Alberto Ruz Lhuillier, Tomo 2, pp. 1–16. Mexico
 City: Sociedad Mexicana de Antropología.

1973 Painting, Writing, and Polity in Teotihuacan, Mexico. *American
 Antiquity* 38:294–314.

1988 A Reexamination of the Teotihuacan Tassel Headdress. In *Feathered
 Serpents and Flowering Trees,* edited by Kathleen Berrin, pp. 114–134.
 San Francisco: The Fine Arts Museum of San Francisco.

MILLON, RENÉ

1964 The Teotihuacán Mapping Project. *American Antiquity* 29:345–352.

1966 Extensión y población de la ciudad de Teotihuacán en sus diferentes

períodos: Un cálculo provisional. In *Teotihuacan: XI Mesa Redonda,* Tomo 1, pp. 57–78. Mexico City: Sociedad Mexicana de Antropología.

1967 Teotihuacán. *Scientific American* 216(6):38–48.

1968 Urbanization at Teotihuacan: The Teotihuacan Mapping Project. In *Actas y memorias del XXXVII congreso internacional de americanistas,* Vol. 1, pp. 105–120. Buenos Aires: Congreso Internacional de Americanistas.

1970 Teotihuacán: Completion of Map of Giant Ancient City in the Valley of Mexico. *Science* 170:1077–1082.

1973 *Urbanization at Teotihuacan, Mexico,* Vol. 1, Part 1, *The Teotihuacan Map.* Austin: University of Texas Press.

1976 Chronological Development and Terminology: Why They Must Be Divorced. In *The Valley of Mexico: Studies in Pre-Hispanic Ecology and Society,* edited by Eric R. Wolf, pp. 23–27. Albuquerque: University of New Mexico Press.

1981 Teotihuacan: City, State, and Civilization. In *Archaeology,* edited by Jeremy A. Sabloff, pp. 198–243. *Handbook of Middle American Indians,* Supplement 1, Victoria R. Bricker, general editor. Austin: University of Texas Press.

1988 The Last Years of Teotihuacan Dominance. In *The Collapse of Ancient States and Civilizations,* edited by Norman Yoffee and George Cowgill, pp. 102–164. Tucson: University of Arizona Press.

MOHOLY-NAGY, HATTULA

1963 Shell and Other Marine Material from Tikal. *Estudios de cultura maya* 3:65–83.

1986 Variability in Early Classic Burials at Tikal, Guatemala. Ms. in possession of the author.

1989 Formed Shell Beads from Tikal, Guatemala. In *Proceedings of the 1986 Shell Bead Conference: Selected Papers,* edited by Charles Hayes III and Lynn Ceci, pp. 139–156, Rochester Museum and Science Center Research Records 20. Rochester, N.Y.: Rochester Museum and Science Center.

1991 The Flaked Chert Industry of Tikal, Guatemala. In *Maya Stone Tools: Selected Papers from the Second Maya Lithic Conference,* edited by Thomas Hester and Harry Shafer, pp. 189–202. Madison, Wis.: Prehistory Press.

1994 *Tikal Material Culture: Artifacts and Social Structure at a Classic Lowland Maya City.* Ph.D. diss., Department of Anthropology, University of Michigan. Ann Arbor: University Microfilms.

1998 A Preliminary Report on the Use of Vertebrate Animals at Tikal, Guatemala. In *Anatomía de una civilización: Aproximaciones interdisciplinarias a la cultura maya,* edited by Andrés Ciudad Ruiz, Yolanda Fernández Marquínez, José Miguel García Campillo, María Josefa Iglesias Ponce de León, Alfonso Lacadena García-Gallo, and Luis T. Sanz Castro, pp. 115–130. Publicación 4. Madrid: Sociedad Española de Estudios Mayas.

1999a Mexican Obsidian at Tikal, Guatemala. *Latin American Antiquity* 10(3):300–313.

1999b Vertebrate Fauna in Tikal Caches and Burials. Paper presented at the

Sixty-fourth Annual Meeting of the Society for American Archaeology, Chicago.

MOHOLY-NAGY, HATTULA, FRANK ASARO, AND FRED H. STROSS

1984 Tikal Obsidians: Sources and Typology. *American Antiquity* 49:104-117.

MOHOLY-NAGY, HATTULA, AND FRED NELSON

1990 New Data and Sources of Obsidian Artifacts from Tikal, Guatemala. *Ancient Mesoamerica* 1:71-80.

MOORE, FRANK

1966 An Excavation at Tetitla, Teotihuacan. *Mesoamerican Notes* 7-8. Puebla: University of the Americas.

MORANTE LÓPEZ, RUBÉN B.

1996 Los observatorios astronómicos subterráneos: ¿Un invento teotihuacano? *Revista mexicana de estudios antropológicos* 42:159-172.

MORELOS GARCÍA, NOEL

1993 *Proceso de producción de espacios y estructuras en Teotihuacán: Conjunto Plaza Oeste y Complejo Calle de los Muertos.* Mexico City: Instituto Nacional de Antropología e Historia.

MORLEY, SYLVANUS G.

1920 *The Inscriptions at Copan.* Carnegie Institution of Washington Publication 219. Washington, D.C.: Carnegie Institution of Washington.

1946 *The Ancient Maya.* Stanford: Stanford University Press.

MORRIS, EARL H., JEAN CHARLOT, AND ANN AXTEL MORRIS

1931 *The Temple of the Warriors at Chichen Itza, Yucatan.* Carnegie Institution of Washington Publication 406. Washington, D.C.: Carnegie Institution of Washington.

MÜLLER, FLORENCIA

1978 *La cerámica del centro ceremonial de Teotihuacan.* Mexico City: Instituto Nacional de Antropología e Historia.

MUÑOZ COSME, ALFONSO

1990 Laberintos, pirámides y palacios: Las fases arquitectónicas de la ciudad de Oxkintok. In *Oxkintok 3*, edited by Miguel Rivera Dorado, pp. 99-111. Madrid: Misión Arqueológica de España en México.

MURCIA, VICTOR MANUEL

1994 Un método natural para la conservación de estructuras arquitectónicas hechas de tierra: El uso de una planta silvestre llamada escobilla. In *Kaminaljuyú (1991-94)*, edited by Kuniaki Ohi, Tomo 2, pp. 565-574. Tokyo: Museum of Tobacco and Salt.

NAGAO, DEBRA

1989 Public Proclamation in the Art of Cacaxtla and Xochicalco. In *Mesoamerica after the Decline of Teotihuacan, A.D. 700-900*, edited by Richard Diehl and Janet C. Berlo, pp. 83-103. Washington, D.C.: Dumbarton Oaks Research Library and Collection.

NAVARRETE, CARLOS, AND LUIS LUJÁN MUÑOZ

1986 *El gran montículo de la Culebra en el Valle de Guatemala.* Mexico City: Universidad Nacional Autónoma de México.

NEFF, HECTOR

1995 A Role for "Sourcing" in Evolutionary Archaeology. In *Evolutionary*

Archaeology: Methodological Issues, edited by Patrice A. Teltser, pp. 69–112. Tucson: University of Arizona Press.

NEFF, HECTOR, AND FREDERICK J. BOVE

1999 Mapping Ceramic Compositional Variation and Prehistoric Interaction in Pacific Coastal Guatemala. *Journal of Archaeological Science* 26:1037–1051.

NEFF, HECTOR, FREDERICK J. BOVE, EUGENIA J. ROBINSON, AND BÁRBARA ARROYO

1994 A Ceramic Compositional Perspective on the Formative to Classic Transition in Southern Mesoamerica. *Latin American Antiquity* 5:333–358.

NICHOLSON, H. B.

1987 The "Feathered Serpents" of Copan. In *The Periphery of the Southeastern Classic Maya Realm,* edited by Gary W. Pahl, pp. 171–188. Los Angeles: UCLA Latin American Center Publications, University of California.

NOGUERA, EDUARDO

1944 Excavaciones en Jiquilpan. *Anales del Museo Michoacano,* 2d ser., 3:37–52.

1962 Nueva clasificación de figurillas del Horizonte Clásico. *Cuadernos americanos* 124(5):127–136.

NORMAN, V. GARTH

1973 *Izapa Sculpture, Part 1.* Papers of the New World Archaeological Foundation 20. Provo, Utah: Brigham Young University.

OHI, KUNIAKI

1994a En busca de la técnica para la conservación de las estructuras arquitectónicas de tierra. In *Kaminaljuyú (1991–94),* edited by Kuniaki Ohi, Tomo 2, pp. 533–536. Tokyo: Museum of Tobacco and Salt.

1994b Historia y cultura de Kaminaljuyú. In *Kaminaljuyú (1991–94),* edited by Kuniaki Ohi, Tomo 2, pp. 747–753. Tokyo: Museum of Tobacco and Salt.

OHI, KUNIAKI, ED.

1991 *Informe, Vol. 1: Primer informe de exploraciones arqueológicas.* Tokyo: Museum of Tobacco and Salt.

1994c *Kaminaljuyú (1991–94).* Tokyo: Museum of Tobacco and Salt.

OHI, KUNIAKI, HIROSHI MINAMI, NOBUYUKI ITO, SHIONE SHIBATA, AND SHO NAKAMORI

1994 La cerámica de Kaminaljuyú. In *Kaminaljuyú (1991–94),* edited by Kuniaki Ohi, Tomo 2, pp. 505–508. Tokyo: Museum of Tobacco and Salt.

ORTIZ, AGUSTÍN, AND LUIS BARBA

1992 Estudio químico de los pisos del Satunsat, en Oxkintok, Yucatán. In *Oxkintok 4,* edited by Miguel Rivera Dorado, pp. 119–126. Madrid: Misión Arqueológica de España en México.

ORTIZ, PONCIANO, AND ROBERT SANTLEY

1998 Matacapan: Un ejemplo de enclave teotihuacano en la costa del Golfo. In *Los ritmos de cambio en Teotihuacán: Reflexiones y discusiones de su cronología,* edited by Rosa Brambila Paz and Rubén Cabrera Castro, pp. 360–377. Mexico City: Instituto Nacional de Antropología e Historia.

O'SHEA, JOHN M.

1981 Social Configurations and the Archaeological Study of Mortuary Patterns: A Case Study. In *The Archaeology of Death,* edited by Robert

Chapman, Ian Kinnes, and Klaus Randsborg, pp. 39-52. Cambridge: Cambridge University Press.

PADDOCK, JOHN

1972 Distribución de rasgos teotihuacanos en Mesoamérica. In *Teotihuacan: XI Mesa Redonda*, edited by Alberto Ruz Lhuillier, Tomo 2, pp. 223-243. Mexico City: Sociedad Mexicana de Antropología.

PARSONS, JEFFREY R.

1971 *Pre-Hispanic Settlement Patterns in the Texcoco Region, Mexico.* Memoirs of the Museum of Anthropology Number 3. Ann Arbor: Museum of Anthropology, University of Michigan.

1974 The Development of a Prehistoric Complex Society: A Regional Perspective from the Valley of Mexico. *Journal of Field Archaeology* 1:81-108.

PARSONS, JEFFREY R., ELIZABETH BRUMFIEL, AND MARY HODGE

1996 Developmental Implications of Earlier Dates for Early Aztec in the Basin of Mexico. *Ancient Mesoamerica* 7:217-230.

PARSONS, LEE A.

1964 The Middle American Co-Tradition. Ph.D. diss., Department of Anthropology, Harvard University.

1967-1969 Bilbao, Guatemala: An Archaeological Study of the Pacific Coast Cotzumalhuapa Region. 2 vols. Milwaukee Public Museum Publications in Anthropology, Nos. 11-12. Milwaukee, Wis.: Milwaukee Public Museum.

1978 The Peripheral Coastal Lowlands and the Middle Classic Period. In *Middle Classic Mesoamerica: A.D. 400-700*, edited by Esther Pasztory, pp. 25-34. New York: Columbia University Press.

1986 *The Origins of Maya Art: Monumental Stone Sculpture of Kaminaljuyu, Guatemala, and the Southern Pacific Coast.* Studies in Pre-Columbian Art and Archaeology, No. 28. Washington, D.C.: Dumbarton Oaks Research Library and Collection.

1991 The Ballgame in the Southern Pacific Coast Cotzumalhuapa Region and Its Impact on Kaminaljuyu during the Middle Classic. In *The Mesoamerican Ballgame*, edited by Vernon Scarborough and David Wilcox, pp. 195-212. Tucson: University of Arizona Press.

PASZTORY, ESTHER

1974 *The Iconography of the Teotihuacan Tlaloc.* Studies in Pre-Columbian Art and Archaeology No. 15. Washington, D.C.: Dumbarton Oaks Research Library and Collection.

1976 *Murals of Tepantitla, Teotihuacan.* New York: Garland Publishing.

1978a Artistic Traditions of the Middle Classic Period. In *Middle Classic Mesoamerica: A.D. 400-700*, edited by Esther Pasztory, pp. 108-142. New York: Columbia University Press.

1983 *Aztec Art.* New York: Harry N. Abrams.

1988a Feathered Serpents and Flowering Trees with Glyphs. In *Feathered Serpents and Flowering Trees: Reconstructing the Murals of Teotihuacan*, edited by Kathleen Berrin, pp. 136-161. San Francisco: The Fine Arts Museums of San Francisco.

1988b A Reinterpretation of Teotihuacan and Its Mural Painting Tradition. In *Feathered Serpents and Flowering Trees: Reconstructing the Murals of*

Teotihuacan, edited by Kathleen Berrin, pp. 45–77. San Francisco: The Fine Arts Museums of San Francisco.

1988c Small Birds with Shields and Spears and Other Fragments. In *Feathered Serpents and Flowering Trees: Reconstructing the Murals of Teotihuacan,* edited by Kathleen Berrin, pp. 169–183. San Francisco: The Fine Arts Museums of San Francisco.

1992 Abstraction and the Rise of a Utopian State at Teotihuacan. In *Art, Ideology, and the City of Teotihuacan,* edited by Janet C. Berlo, pp. 281–320. Washington, D.C.: Dumbarton Oaks Research Library and Collection.

1993 An Image Is Worth a Thousand Words: Teotihuacan and the Meanings of Style in Classic Mesoamerica. In *Latin American Horizons,* edited by Don S. Rice, pp. 113–145. Washington, D.C.: Dumbarton Oaks Research Library and Collection.

1997 *Teotihuacan: An Experiment in Living.* Norman: University of Oklahoma Press.

PASZTORY, ESTHER, ED.

1978b *Middle Classic Mesoamerica: A.D. 400–700.* New York: Columbia University Press.

PAULINYI, ZOLTÁN

2001 Los señores con tocado de borlas. *Ancient Mesoamerica* 12:1–30.

PENDERGAST, DAVID M.

1970 Tumbaga Object from the Early Classic Period, Found at Altun Ha, British Honduras (Belize). *Science* 168:116–118.

1971 Evidence of Early Teotihuacan–Lowland Maya Contact at Altun Ha. *American Antiquity* 36:455–460.

1979 *Excavations at Altun Ha, Belize, 1964–1970,* Vol. 1. Toronto: Royal Ontario Museum.

1981 Lamanai, Belize: Summary of Excavation Results, 1974–1980. *Journal of Field Archaeology* 8:29–53.

1982 *Excavations at Altun Ha, Belize, 1964–1970,* Vol. 2. Toronto: Royal Ontario Museum.

1990 *Excavations at Altun Ha, Belize, 1964–1970,* Vol. 3. Toronto: Royal Ontario Museum.

PINCEMIN, SOPHIA, JOYCE MARCUS, LYNDA FLOREY FOLAN, WILLIAM J. FOLAN, MARÍA DEL ROSARIO DOMÍNGUEZ CARRASCO, AND ABEL MORALES LÓPEZ

1998 Extending the Calakmul Dynasty Back in Time: A New Stela from a Maya Capital in Campeche, Mexico. *Latin American Antiquity* 9:310–327.

PLUNKET, PATRICIA, AND GABRIELA URUÑUELA

1998a Bajo El Volcán: Riesgo y catástrofe en el Preclásico Superior. *Antropología e interdisciplina: XXIII Mesa Redonda,* edited by Julieta Arechiga, Mario Humberto Ruz, Ana Bella Pérez, Judith Zurita, and Leopoldo Valinas, pp. 15–27. Mexico City: Sociedad Mexicana de Antropología.

1998b Preclassic Household Patterns Preserved under Volcanic Ash at Tetimpa, Puebla, Mexico. *Latin American Antiquity* 9:287–309.

POHL, MARY E., AND JOHN M. POHL

1994 Cycles of Conflict: Political Factionalism in the Maya Lowlands. In

Factional Competition and Political Development in the New World, edited by Elizabeth Brumfiel and John W. Fox, pp. 138–157. Cambridge: Cambridge University Press.

POLLOCK, HARRY E. D.

1965 Architecture of the Maya Lowlands. In *Archaeology of Southern Mesoamerica, Part 1*, edited by G. R. Willey, pp. 378–440. *Handbook of Middle American Indians*, Vol. 2, Robert Wauchope, general editor. Austin: University of Texas Press.

1980 *The Puuc: An Architectural Survey of the Hill Country of Yucatan and Northern Campeche, Mexico*. Memoirs of the Peabody Museum of Archaeology and Ethnology, Vol. 19. Cambridge: Harvard University.

POPENOE DE HATCH, MARION

1989 An Analysis of the Santa Lucía Cotzumalguapa Sculptures. In *New Frontiers in the Archaeology of the Pacific Coast of Southern Mesoamerica*, edited by Frederick J. Bove and Lynette Heller, pp. 167–194. Anthropological Research Papers No. 39. Tempe: Arizona State University.

1991 Kaminaljuyú: Un resumen general hasta 1991. *U Tz'ib* (Asociación Tikal, Guatemala) 1(1):2–6.

1995 Correcciones sugeridas para el reporte cerámico de Bilbao, publicado por L. A. Parsons en 1967. In *VIII simposio de investigaciones arqueológicas en Guatemala, 1994*, edited by Juan Pedro Laporte and Héctor L. Escobedo, pp. 101–105. Guatemala City: Museo Nacional de Arqueología y Etnología.

1997 *Kaminaljuyú/San Jorge: Evidencia arqueológica de la actividad económica en el Valle de Guatemala 300 a.C. a 300 d.C.* Guatemala City: Universidad del Valle de Guatemala.

1998 Los k'iche's-kaqchikeles en el altiplano central de Guatemala: Evidencia arqueológica del período clásico. *Mesoamérica* 35:93–115.

POPENOE DE HATCH, MARION, ALFREDO ROMÁN, TOMÁS BARRIENTOS, AND NANCY MONTERROSO

1996 Excavaciones en el Sector 3 del Proyecto Arqueológico Miraflores II. Report on file, Instituto de Antropología e Historia, Guatemala City.

PRING, DUNCAN C.

1977 The Dating of Teotihuacán Contact at Altun Ha: The New Evidence. *American Antiquity* 42:626–628.

PROSKOURIAKOFF, TATIANA

1950 *A Study of Classic Maya Sculpture*. Carnegie Institution of Washington Publication 593. Washington, D.C.: Carnegie Institution of Washington.

1993 *Maya History*. Austin: University of Texas Press.

PULESTON, DENNIS

1979 The Discovery of Talud-Tablero Architecture at Tikal. In *XV Mesa Redonda, Sociedad Mexicana de Antropología*, Tomo 2, pp. 377–384. Guanajuato: Universidad de Guanajuato.

QUIRARTE, JACINTO

1973 Izapan and Mayan Traits in Teotihuacan III Pottery. In *Studies in Ancient Mesoamerica*, edited by John Graham, pp. 11–29. Contributions of the University of California Archaeological Research Facility 18. Berkeley: University of California.

RATHJE, WILLIAM L.

1971 The Origin and Development of Lowland Maya Classic Civilization.
 American Antiquity 36:275-285.

1972 Praise the Gods and Pass the Metates: A Hypothesis of the
 Development of Lowland Rainforest Civilizations in Mesoamerica. In
 Contemporary Archaeology: A Guide to Theory and Contributions, edited
 by Mark P. Leone, pp. 359-392. Carbondale: Southern Illinois
 University Press.

1973 Classic Maya Development and Denouement: A Research Design. In
 The Classic Maya Collapse, edited by T. Patrick Culbert, pp. 405-454.
 Albuquerque: University of New Mexico Press.

RATHJE, WILLIAM L., DAVID A. GREGORY, AND FREDERICK M. WISEMAN

1978 Trade Models and Archaeological Problems: Classic Maya Examples. In
 Mesoamerican Communication Routes and Cultural Contacts, edited by
 Thomas A. Lee, Jr., and Carlos Navarrete, pp. 147-175. Papers of the
 New World Archaeological Foundation No. 40. Provo, Utah: Brigham
 Young University.

RATTRAY, EVELYN C.

1977 Los contactos entre Teotihuacan y Veracruz. In *XV Mesa Redonda,
 Sociedad Mexicana de Antropología*, Tomo 2, pp. 301-311. Guanajuato:
 Universidad de Guanajuato.

1983 Gulf Coast Influences at Teotihuacan. Paper presented at the
 symposium "Art and the Rise of the Teotihuacan State," University of
 California, Los Angeles.

1987a Los barrios foráneos de Teotihuacan. In *Teotihuacan: Nuevos datos,
 nuevas síntesis, nuevos problemas*, edited by Emily McClung de Tapia
 and Evelyn C. Rattray, pp. 243-273. Mexico City: Universidad
 Nacional Autónoma de México.

1987b Introducción. In *Teotihuacan: Nuevos datos, nuevas síntesis, nuevos
 problemas*, edited by Emily McClung de Tapia and Evelyn Rattray, pp.
 9-56. Mexico City: Instituto de Investigaciones Antropológicas,
 Universidad Nacional Autónoma de México.

1989 El barrio de los comerciantes y el conjunto Tlamimilolpa: Un estudio
 comparativo. *Arqueología* 5:105-129.

1990 New Findings on the Origins of Thin Orange Ceramics. *Ancient
 Mesoamerica* 1:181-195.

1992 *The Teotihuacan Burials and Offerings: A Commentary and Inventory.*
 Vanderbilt University Publications in Anthropology 42. Nashville,
 Tenn.: Vanderbilt University.

1997 *Entierros y ofrendas en Teotihuacan: Excavaciones, inventario, patrones
 mortuarios.* Mexico City: Instituto de Investigaciones Antropológicas,
 Universidad Nacional Autónoma de México.

2001 *Teotihuacan: Ceramics, Chronology, and Cultural Trends.* Mexico City
 and Pittsburgh: Instituto Nacional de Antropología e Historia and the
 University of Pittsburgh.

RATTRAY, EVELYN C., AND GARMAN HARBOTTLE

1992 Neutron Activation Analysis and Numerical Taxonomy of Thin Orange
 Ceramics from the Manufacturing Sites of Río Carnero, Puebla,

Mexico. In *Chemical Characterization of Ceramic Pastes in Archaeology,* edited by Hector Neff, pp. 221–231. Madison, Wis.: Prehistory Press.

REENTS-BUDET, DORIE
1994 *Painting the Maya Universe: Royal Ceramics of the Classic Period.* Durham, N.C.: Duke University Press.

RENFREW, COLIN
1986 Introduction. In *Peer Polity Interaction and Socio-Political Change,* edited by Colin Renfrew and John F. Cherry, pp. 109–116. Cambridge: Cambridge University Press.

RICE, DON S.
1993 The Status of Latin American Horizons. In *Latin American Horizons,* edited by Don S. Rice, pp. 357–364. Washington, D.C.: Dumbarton Oaks Research Library and Collection.

RICE, DON S., ED.
1993 *Latin American Horizons.* Washington, D.C.: Dumbarton Oaks Research Library and Collection.

RINGLE, WILLIAM M., TOMÁS GALLARETA NEGRÓN, AND GEORGE J. BEY III
1998 The Return of Quetzalcoatl: Evidence for the Spread of a World Religion during the Epiclassic Period. *Ancient Mesoamerica* 9:183–232.

RIVERA DORADO, MIGUEL, ED.
1988 *Oxkintok 1.* Madrid: Misión Arqueológica de España en México.
1989 *Oxkintok 2.* Madrid: Misión Arqueológica de España en México.
1990 *Oxkintok 3.* Madrid: Misión Arqueológica de España en México.
1992 *Oxkintok 4.* Madrid: Misión Arqueológica de España en México.

RIVERA GRIJALBA, VÍCTOR
1984 Tepeapulco. *Cuadernos de arquitectura mesoamericana* 2:41–46.

RIVERA GRIJALBA, VÍCTOR, AND DANIEL SCHÁVELZON
1984 Los tableros de Kaminaljuyú. *Cuadernos de arquitectura mesoamericana* 2:51–56.

ROBERTSON, ROBIN A., AND DAVID A. FREIDEL, EDS.
1986 *Archaeology at Cerros, Belize, Central America, Vol. 1: An Interim Report.* Dallas: Southern Methodist University Press.

ROBIN, CYNTHIA, AND NORMAN HAMMOND
1991 Burial Practices. In *Cuello,* edited by Norman Hammond, pp. 204–225. Cambridge: Cambridge University Press.

ROBICSEK, FRANCIS
1975 *A Study in Maya Art and History: The Mat Symbol.* New York: The Museum of the American Indian, Heye Foundation.

RODAS MANRIQUE, SERGIO
1993 Catálogo de barrigones de Guatemala. *U Tz'ib* (Asociación Tikal, Guatemala) 1(5):1–36.

RODRÍGUEZ GIRÓN, ZOILA, AND MARCO ANTONIO ROSAL
1987 La Plataforma 5C-53, Mundo Perdido, Tikal: Un caso de interpretación. In *Memorias del Primer Coloquio Internacional de Mayistas,* pp. 319–330. Mexico City: Centro de Estudios Mayas, Universidad Nacional Autónoma de México.

RUIZ AGUILAR, MARÍA ELENA
1986 Análisis preliminar de la lítica de Mundo Perdido, Tikal. *Mesoamérica* 11:113–133.

1989 Instrumentos líticos procedentes de un basurero, Tikal, Petén. In
 Memorias del II° Coloquio Internacional de Mayistas, Tomo 1, pp. 569–
 602. Mexico City: Centro de Estudios Mayas, Universidad Nacional
 Autónoma de México.
1990 Comparación de instrumentos líticos en diferentes áreas de actividad:
 Mundo Perdido, Tikal. In *Etnoarqueología: Primer Coloquio Bosch-
 Gimpera,* edited by Yoko Sugiura and Mari Carmen Serra Puche, pp.
 527–554. Mexico City: Instituto de Investigaciones Antropológicas,
 Universidad Nacional Autónoma de México.

RUIZ GALLUT, MARÍA ELENA
1999 Imágenes en Tetitla: De disfraces y vecinos. Paper presented at the
 Primera Mesa Redonda de Teotihuacán Instituto Nacional de
 Antropología e Historia, Centro de Estudios Teotihuacanos San Juan
 Teotihuacán, Mexico.

RUPPERT, KARL J.
1940 Special Assemblage of Maya Structures. *The Maya and Their Neighbors:
 Essays on Middle American Anthropology and Archaeology,* edited by
 Clarence Hay, Ralph L. Linton, Samuel K. Lothrop, Harry L. Shapiro,
 and George C. Vaillant, pp. 222–231. New York: Appleton Century.

SAHAGÚN, FRAY BERNARDINO DE
1950–1982 *Florentine Codex: General History of the Things of New Spain.* Translated
 by Arthur J. O. Anderson and Charles E. Dibble. Santa Fe, N.Mex.:
 School of American Research.
1997 *Primeros Memoriales.* Translated by Thelma Sullivan. Norman:
 University of Oklahoma Press.

SAKAI, HIDEO, YASUSHI TANAKA, AND TOSHIO NAKAMURA
1994 Investigación de arqueomagnetismo y fechamiento de carbono 14 en
 Mongoy, Kaminaljuyú (resumen). In *Kaminaljuyú (1991–94),* edited by
 Kuniaki Ohi, Tomo 2, pp. 709–711. Tokyo: Museum of Tobacco and Salt.

SANDERS, WILLIAM T.
1965 *The Cultural Ecology of the Teotihuacán Valley: A Preliminary Report of
 the Results of the Teotihuacán Valley Project.* College Park: Department
 of Anthropology, Pennsylvania State University.
1973 The Cultural Ecology of the Lowland Maya: A Reevaluation. In *The
 Classic Maya Collapse,* edited by T. Patrick Culbert, pp. 325–365.
 Albuquerque: University of New Mexico Press.
1974 From Chiefdom to State: Political Evolution at Kaminaljuyu,
 Guatemala. In *Reconstructing Complex Societies: An Archaeological
 Colloquium,* edited by Charlotte B. Moore, pp. 97–116. Supplement to
 the Bulletin of the American Schools of Oriental Research 20.
 Cambridge, Mass.: American Schools of Oriental Research.
1977 Ethnographic Analogy and the Teotihuacan Horizon Style. In
 Teotihuacan and Kaminaljuyu, edited by William T. Sanders and
 Joseph W. Michels, pp. 397–410. College Park: Pennsylvania State
 University Press.
1981 Ecological Adaptation in the Basin of Mexico: 23,000 B.C. to the
 Present. In *Archaeology,* edited by Jeremy A. Sabloff, pp. 147–197.
 Handbook of Middle American Indians, Supplement 1, Victoria R.
 Bricker, general editor. Austin: University of Texas Press.

SANDERS, WILLIAM T., ED.
1970 The Teotihuacán Valley Project Final Report, Vol. 1. Occasional Papers in
 Anthropology Number 3. College Park: Pennsylvania State University.
SANDERS, WILLIAM T., AND JOSEPH MICHELS, EDS.
1977 Teotihuacan and Kaminaljuyu: A Study in Prehistoric Culture Contact.
 College Park: Pennsylvania State University Press.
SANDERS, WILLIAM T., JEFFREY R. PARSONS, AND ROBERT S. SANTLEY
1979 The Basin of Mexico: Ecological Processes in the Evolution of a
 Civilization. New York: Academic Press.
SANDERS, WILLIAM T., AND BARBARA J. PRICE
1968 Mesoamerica: The Evolution of a Civilization. New York:
 Random House.
SANDERS, WILLIAM T., AND ROBERT S. SANTLEY
1983 A Tale of Three Cities: Energetics and Urbanization in Pre-Hispanic
 Central Mexico. In Prehistoric Settlement Patterns: Essays in Honor of
 Gordon R. Willey, edited by Evon Z. Vogt and Richard M. Leventhal,
 pp. 243–291. Albuquerque: University of New Mexico Press.
SANTLEY, ROBERT S.
1983 Obsidian Trade and Teotihuacan Influence in Mesoamerica. In
 Highland-Lowland Interaction in Mesoamerica: Interdisciplinary
 Approaches, edited by Arthur G. Miller, pp. 69–124. Washington, D.C.:
 Dumbarton Oaks Research Library and Collection.
1987 Teotihuacan Influence at Matacapan: Testing the Goodness of Fit of the
 Enclave Model. Paper presented at the 52nd Annual Meeting of the
 Society for American Archaeology, Toronto.
1989 Obsidian Working, Long-Distance Exchange, and the Teotihuacan
 Presence on the South Gulf Coast. In Mesoamerica after the Decline of
 Teotihuacan, A.D. 700–900, edited by Richard Diehl and Janet C. Berlo,
 pp. 131–151. Washington, D.C.: Dumbarton Oaks Research Library and
 Collection.
SANZ CASTRO, LUIS T.
1998 Iconografía, significado, ideología: Problemas y cuestiones en la
 interpretación actual del arte maya. In Anatomía de una civilización:
 Aproximaciones interdisciplinarias a la cultura maya, edited by Andrés
 Ciudad Ruiz, Yolanda Fernández Marquínez, José Miguel García
 Campillo, María Josefa Iglesias Ponce de León, Alfonso Lacadena
 García-Gallo, and Luis T. Sanz Castro, pp. 65–85. Publicación 4.
 Madrid: Sociedad Española de Estudios Mayas.
SCHELE, LINDA
1986 The Tlaloc Complex in the Classic Period: War and the Interaction
 between the Lowland Maya and Teotihuacan. Paper presented at the
 Symposium on the New Dynamics, Kimbell Art Museum, Fort Worth.
1987 Stela I and the Founding of the City of Copán. Copán Note 30. Austin:
 Instituto Hondureño de Antropología e Historia and the Copán
 Acropolis Archaeological Project.
1989 A Brief Commentary on the Top of Altar Q. Copán Note 66. Austin:
 Instituto Hondureño de Antropología e Historia and the Copán
 Acropolis Archaeological Project.

1992 The Founders of Lineages at Copán and Other Maya Sites. *Ancient Mesoamerica* 3:134–144.

SCHELE, LINDA, FEDERICO FAHSEN, AND NIKOLAI GRUBE

1994 The Floor Marker from Motmot. Copán Note 117. Austin: Instituto Hondureño de Antropología e Historia and the Copán Acropolis Archaeological Project.

SCHELE, LINDA, AND DAVID A. FREIDEL

1990 *A Forest of Kings: Untold Stories of the Ancient Maya.* New York: William Morrow.

SCHELE, LINDA, AND NIKOLAI GRUBE

1992 The Founding Events at Copán. Copán Note 107. Austin: Instituto Hondureño de Antropología e Historia and the Copán Acropolis Archaeological Project.

1994a *Notebook for the Eighteenth Maya Hieroglyphic Workshop at Texas.* Austin: Department of Art and Art History and the Institute of Latin American Studies, University of Texas.

1994b Who Was Popol-K'inich? Copán Note 116. Austin: Instituto Hondureño de Antropología e Historia and the Copán Acropolis Archaeological Project.

SCHELE, LINDA, NIKOLAI GRUBE, AND FEDERICO FAHSEN

1993 The Tikal-Copán Connection: The Copán Evidence. Copán Note 112. Austin: Instituto Hondureño de Antropología e Historia and the Copán Acropolis Archaeological Project.

1994 The Xukpi Stone: A Newly Discovered Early Classic Inscription from the Copán Acropolis (Part II, Commentary on the Text). Copán Note 114. Austin: Instituto Hondureño de Antropología e Historia and the Copán Acropolis Archaeological Project.

SCHELE, LINDA, AND PETER MATHEWS

1998 *The Code of Kings: The Language of Seven Sacred Maya Temples and Tombs.* New York: Scribner.

SCHELE, LINDA, AND MARY E. MILLER

1986 *The Blood of Kings: Dynasty and Ritual in Maya Art.* New York: George Braziller.

SEDAT, DAVID W.

1996 Etapas tempranas en la evolución de la Acrópolis de Copán. *Yaxkin* 14:19–27.

1997a The Founding Stage of the Copán Acropolis. ECAP Papers No. 2. Philadelphia: Instituto Hondureño de Antropología e Historia and the Early Copán Acropolis Program.

1997b The Earliest Ancestor to Copán Str. 10L-16. ECAP Papers No. 3. Philadelphia: Instituto Hondureño de Antropología e Historia and the Early Copán Acropolis Program.

1997c Vessel 1 from the Margarita Tomb. ECAP Papers No. 7. Philadelphia: Instituto Hondureño de Antropología e Historia and the Early Copán Acropolis Program.

SEDAT, DAVID W., AND FERNANDO LÓPEZ

1999 Tunneling into the Heart of the Copán Acropolis. *Expedition* 41(2):16–21.

SEDAT, DAVID W., AND ROBERT J. SHARER
1994 The Xukpi Stone: A Newly Discovered Early Classic Inscription from
 the Copán Acropolis (Part I, The Archaeology). Copán Note 113.
 Austin: Instituto Hondureño de Antropología e Historia and the Copán
 Acropolis Archaeological Project.
1997 Evolución de la Acrópolis de Copán durante el Clásico Temprano. *Los
 Investigadores de la Cultura Maya* 5, pp. 383–389. Campeche:
 Universidad Autónoma de Campeche.

SÉJOURNÉ, LAURETTE
1959 *Un palacio en la ciudad de los dioses.* Mexico City: Instituto Nacional de
 Antropología e Historia.
1966a *Arqueología de Teotihuacán: La cerámica.* Mexico City: Fondo de
 Cultura Económica.
1966b *Arquitectura y pintura en Teotihuacán.* Mexico City: Siglo Veintiuno
 Editores.

SELER, EDUARD E.
1976 [1915]*Observations and Studies in the Ruins of Palenque.* Translated by Gisela
 Morgner. Pebble Beach, Fla.: Robert Louis Stevenson School.
1990–1998 *Collected Works in Mesoamerican Linguistics and Archaeology,* 6 vols.
 Edited by Frank E. Comparato. Culver City, Calif.: Labyrinthos.

SEMPOWSKI, MARTHA L.
1992 Economic and Social Implications of Variations in Mortuary Practices
 at Teotihuacan. In *Art, Ideology, and the City of Teotihuacan,* edited by
 Janet C. Berlo, pp. 27–58. Washington, D.C.: Dumbarton Oaks
 Research Library and Collection.
1994 Mortuary Practices at Teotihuacan. In *Mortuary Practices and Skeletal
 Remains at Teotihuacan,* edited by Martha L. Sempowski and Michael
 Spence, pp. 1–314. Salt Lake City: University of Utah Press.

SEMPOWSKI, MARTHA L., AND MICHAEL W. SPENCE, EDS.
1994 *Mortuary Practices and Skeletal Remains at Teotihuacan.* Salt Lake City:
 University of Utah Press.

SHARER, ROBERT J.
1978 Summary of Architecture and Constructional Activity. In *The Prehistory
 of Chalchuapa, El Salvador,* Vol. 1, edited by Robert J. Sharer, pp.
 121–132. Philadelphia: University of Pennsylvania Press.
1983 Interdisciplinary Approaches to the Study of Mesoamerican Highland-
 Lowland Interaction: A Summary View. In *Highland-Lowland
 Interaction in Mesoamerica: Interdisciplinary Approaches,* edited by
 Arthur G. Miller, pp. 241–263. Washington, D.C.: Dumbarton Oaks
 Research Library and Collection.
1996 Los patrones del desarrollo arquitectónico en la Acrópolis de Copán del
 Clásico Temprano. *Yaxkin* 14:28–34.
1997a Formation of Sacred Space by the First Kings of Copán. ECAP Papers
 No. 10. Philadelphia: Instituto Hondureño de Antropología e Historia
 and the Early Copán Acropolis Program.
1997b Initial Research and Preliminary Findings from the Hunal Tomb. ECAP
 Papers No. 5. Philadelphia: Instituto Hondureño de Antropología e
 Historia and the Early Copán Acropolis Program.

1997c K'inich Yax K'uk' Mo' and the Genesis of the Copan Acropolis. Paper
 presented at the symposium "A Tale of Two Cities: Copan and
 Teotihuacan," Harvard University.
1999a Archaeology and History in the Royal Acropolis, Copán, Honduras.
 Expedition 41(2):8-15.
1999b Tikal and the Copan Dynastic Founding. A paper prepared for the
 School of American Research Advanced Seminar "Changing
 Perspectives on Tikal and the Development of Ancient Maya
 Civilization," Santa Fe, New Mexico.

SHARER, ROBERT J., WILLIAM L. FASH, JR., DAVID W. SEDAT, LOA P. TRAXLER, AND
RICHARD V. WILLIAMSON
1999 Continuities and Contrasts in Early Classic Architecture of Central
 Copan. In *Mesoamerican Architecture as a Cultural Symbol*, edited by
 Jeff K. Kowalski, pp. 220-249. New York: Oxford University Press.

SHARER, ROBERT J., JULIA M. MILLER, AND LOA P. TRAXLER
1992 Evolution of Classic Period Architecture in the Eastern Acropolis,
 Copan, Honduras. *Ancient Mesoamerica* 3:145-159.

SHARER, ROBERT J., AND DAVID W. SEDAT
1987 *Archaeological Investigations in the Northern Maya Highlands,
 Guatemala: Interaction and the Development of Maya Civilization.*
 University Museum Monographs, No. 59. Philadelphia: University
 Museum, University of Pennsylvania.

SHARER, ROBERT J., LOA P. TRAXLER, DAVID W. SEDAT, ELLEN E. BELL, MARCELLO A.
CANUTO, AND CHRISTOPHER POWELL
1999 Early Classic Architecture beneath the Copan Acropolis: A Research
 Update. *Ancient Mesoamerica* 10:3-23.

SHIBATA, SHIONE
1994a Investigación arqueológica en el Edificio Chay (D-III-1), Kaminaljuyú.
 In *Kaminaljuyú (1991-94)*, edited by Kuniaki Ohi, Tomo 2, pp. 415-436.
 Tokyo: Museum of Tobacco and Salt.
1994b Recopilación de la historia de los estudios cronológicos de
 Kaminaljuyú. In *Kaminaljuyú (1991-94)*, edited by Kuniaki Ohi, Tomo
 1, pp. 73-89. Tokyo: Museum of Tobacco and Salt.
1994c Restauración y conservación del Edificio Chay, Kaminaljuyú. In
 Kaminaljuyú (1991-94), edited by Kuniaki Ohi, Tomo 2, pp. 553-559.
 Tokyo: Museum of Tobacco and Salt.

SHOOK, EDWIN M.
1940 Explorations in the Ruins of Oxkintok, Yucatán. *Revista mexicana de
 estudios antropológicos* 4(3):165-171.
1952 Lugares arqueológicos del altiplano meridional central de Guatemala.
 Antropología e historia de Guatemala 4(2):3-40.
1958 The Temple of the Red Stela. *Expedition* 1(1):26-33.
1965 Archaeological Survey of the Pacific Coast of Guatemala. In *Archaeology
 of Southern Mesoamerica, Part 1*, edited by Gordon R. Willey, pp. 180-
 194. *Handbook of Middle American Indians*, Vol. 2, Robert Wauchope,
 general editor. Austin: University of Texas Press.
1971 Inventory of Some Pre-Classic Traits in the Highlands and Pacific
 Guatemala and Adjacent Areas. In *Observations on the Emergence of
 Civilization in Mesoamerica*, edited by Robert F. Heizer and John A.

Graham, pp. 70–77. Contributions of the University of California Archaeological Research Facility 18. Berkeley: University of California.

SHOOK, EDWIN M., AND ALFRED V. KIDDER

1952 *Mound E-III-3, Kaminaljuyu, Guatemala.* Carnegie Institution of Washington Publication No. 596, Contribution 53. Washington, D.C.: Carnegie Institution of Washington.

SHOOK, EDWIN M., AND ALFRED V. KIDDER II

1961 The Painted Tomb at Tikal. *Expedition* 4(1):2–7.

SHOOK, EDWIN M., AND A. LEDYARD SMITH

1942 Guatemala: Kaminaljuyu. In *Carnegie Institution of Washington Yearbook 1941*, pp. 263–267. Washington, D.C.: Carnegie Institution of Washington.

SMITH, AUGUSTUS LEDYARD

1950 *Uaxactun, Guatemala: Excavations of 1931–1937.* Carnegie Institution of Washington Publication 588. Washington, D.C.: Carnegie Institution of Washington.

1961 Types of Ball Courts in the Highlands of Guatemala. In *Essays in Pre-Columbian Art and Archaeology*, edited by Samuel K. Lothrop et al., pp. 100–125. Cambridge: Harvard University Press.

1965 Architecture of the Maya Highlands. In *Archaeology of Southern Mesoamerica, Part 1*, edited by G. R. Willey, pp. 76–94. *Handbook of Middle American Indians*, Vol. 2, Robert Wauchope, general editor. Austin: University of Texas Press.

1982 Major Architecture and Caches. In *Excavations at Seibal*, edited by Gordon R. Willey. Memoirs of the Peabody Museum of Archaeology and Ethnology, Vol. 15, No. 1. Cambridge: Harvard University.

SMITH, AUGUSTUS LEDYARD, AND ALFRED V. KIDDER

1951 *Excavations at Nebaj, Guatemala.* Carnegie Institution of Washington Publication 594. Washington, D.C.: Carnegie Institution of Washington.

SMITH, MICHAEL E., AND CYNTHIA HEATH-SMITH

1980 Waves of Influence in Postclassic Mesoamerica? A Critique of the Mixteca-Puebla Concept. *Anthropology* 4(2):15–50.

SMITH, ROBERT E.

1955 *Ceramic Sequence at Uaxactun, Guatemala*, 2 vols. Middle American Research Institute Publication 20. New Orleans: Tulane University.

1971 *The Pottery of Mayapan Including Studies of Ceramic Material from Uxmal, Kabah, and Chichen Itza.* 2 vols. Papers of the Peabody Museum of Archaeology and Ethnology 66. Cambridge: Harvard University.

1987 *A Ceramic Sequence from the Pyramid of the Sun, Teotihuacan, Mexico.* Papers of the Peabody Museum of Archaeology and Ethnology 75. Cambridge: Harvard University.

SMITH, VIRGINIA

2000 The Iconography of Power at Xochicalco: The Pyramid of the Plumed Serpents. In *The Xochicalco Mapping Project*, edited by Kenneth Hirth, Vol. 2, pp. 57–82. Salt Lake City: University of Utah Press.

SMYTH, MICHAEL

2000 They Came from the West: Teotihuacan in the Yucatan during the Early Classic Period. Paper presented at the Sixty-fifth Annual Meeting of the Society for American Archaeology, Philadelphia.

SNOW, DEAN R.

1995 Migration in Prehistory: The Northern Iroquoian Case. *American Antiquity* 60:59–79.

1996 More on Migration in Prehistory: Accommodating New Evidence in the Northern Iroquoian Case. *American Antiquity* 61:791–796.

SOCIEDAD MEXICANA DE ANTROPOLOGÍA

1966 *Teotihuacan: XI Mesa Redonda,* Tomo 1. Mexico City: Sociedad Mexicana de Antropología.

SOUSTELLE, JACQUES, AND IGNACIO BERNAL

1958 *Mexico: Pre-Hispanic Paintings.* Paris: United Nations Educational Scientific and Cultural Organization.

SPENCE, MICHAEL W.

1992 Tlailotlacan, a Zapotec Enclave in Teotihuacan. In *Art, Ideology, and the City of Teotihuacan,* edited by Janet C. Berlo, pp. 59–88. Washington, D.C.: Dumbarton Oaks Research Library and Collection.

1993 La identificación de los barrios étnicos de Teotihuacán. Paper presented at the Thirteenth International Congress of Anthropological and Ethnological Sciences, Mexico City.

1994 Human Skeletal Material from Teotihuacan. In *Mortuary Practices and Skeletal Remains at Teotihuacan,* edited by Martha L. Sempowski and Michael Spence, pp. 315–411. Salt Lake City: University of Utah Press.

1996a Commodity or Gift: Teotihuacan Obsidian in the Maya Region. *Latin American Antiquity* 7:21–39.

1996b A Comparative Analysis of Ethnic Enclaves. In *Arqueología mesoamericana: Homenaje a William T. Sanders,* edited by Alba Guadalupe Mastache, Jeffrey R. Parsons, Robert S. Santley, and Mari Carmen Serra Puche, Tomo 1, pp. 333–353. Mexico City: Instituto Nacional de Antropología e Historia and Arqueología Mexicana.

1998 La cronología de radiocarbono de Tlailotlacan. In *Los ritmos de cambio en Teotihuacán: Reflexiones y discusiones de su cronología,* edited by Rosa M. Brambila Paz and Rubén Cabrera Castro, pp. 283–297. Mexico City: Instituto Nacional de Antropología e Historia.

SPENCER, CHARLES S.

1998 A Mathematical Model of Primary State Formation. *Cultural Dynamics* 10:5–20.

SPINDEN, HERBERT J.

1917 The Origin and Distribution of Agriculture in America. *Acts and Proceedings of the Nineteenth International Congress of Americanists,* pp. 269–276. Washington, D.C.: International Congress of Americanists.

STARK, BARBARA L.

1989 *Patarata Pottery: Classic Period Ceramics of the South-Central Gulf Coast, Veracruz, Mexico.* Anthropological Papers, Vol. 51. Tucson: Department of Anthropology, University of Arizona.

1990 The Gulf Coast and the Central Highlands of Mexico: Alternative Models for Interaction. *Research in Economic Anthropology* (Greenwich, Conn.: JAI Press) 12:243–285.

STIRLING, MATTHEW W.

1943 *Stone Monuments of Southern Mexico.* Bureau of American Ethnology Bulletin 138. Washington, D.C.: Smithsonian Institution.

STONE, ANDREA

1989 Disconnection, Foreign Insignia, and Political Expansion: Teotihuacan and the Warrior Stelae of Piedras Negras. In *Mesoamerica after the Decline of Teotihuacan, A.D. 700–900,* edited by Richard Diehl and Janet C. Berlo, pp. 153–172. Washington, D.C.: Dumbarton Oaks Research Library and Collection.

STUART, DAVID

1986 The Chronology of Stela 4 at Copán. Copán Note 12. Austin: Instituto Hondureño de Antropología e Historia and the Copán Acropolis Archaeological Project.

1989 The "First Ruler" on Stela 24. Copán Note 7. Austin: Instituto Hondureño de Antropología e Historia and the Copán Acropolis Archaeological Project.

1992 Hieroglyphs and Archaeology at Copan. *Ancient Mesoamerica* 3:169–184.

1997 Smoking Frog, K'inich Yax K'uk' Mo', and the Epigraphic Evidence for Ties between Teotihuacan and the Classic Maya. Paper presented at the symposium "A Tale of Two Cities: Copan and Teotihuacan," Harvard University.

1998 The Arrival of Strangers. *Pre-Columbian Art Research Institute Newsletter* 25:10–12.

1999 Epigraphic Evidence for Early Classic Interaction between Teotihuacan and Tikal: The "War" with Uaxactun. Paper presented at the Sixty-fourth Annual Meeting of the Society for American Archaeology, Chicago.

2000a "The Arrival of Strangers": Teotihuacan and Tollan in Classic Maya History. In *Mesoamerica's Classic Heritage: From Teotihuacan to the Aztecs,* edited by Davíd Carrasco, Lindsay Jones, and Scott Sessions, pp. 465–513. Niwot: Colorado University Press.

2000b K'inich Yax K'uk' Mo' and the Early History of Copán. Paper presented at the Sixty-fifth Annual Meeting of the Society for American Archaeology, Philadelphia.

STUART, DAVID, NIKOLAI GRUBE, LINDA SCHELE, AND FLOYD LOUNSBURY

1989 Stela 63, a New Monument from Copán. Copán Note 56. Austin: Instituto Hondureño de Antropología e Historia and the Copán Acropolis Archaeological Project.

STUART, DAVID, AND STEPHEN D. HOUSTON

1994 *Classic Maya Place Names.* Studies in Pre-Columbian Art and Archaeology 33. Washington, D.C.: Dumbarton Oaks Research Library and Collection.

STUART, DAVID, AND LINDA SCHELE

1986 Yax-K'uk'-Mo', the Founder of the Lineage of Copán. Copán Note 6. Austin: Instituto Hondureño de Antropología e Historia and the Copán Acropolis Archaeological Project.

STUIVER, MINZE, AND RENEE S. KRA

1986 Calibration Issue, Proceedings of the Twelfth International [14]C Conference. *Radiocarbon* 28(2B):805–1030.

SUGIYAMA, SABURO

1989 Burials Dedicated to the Old Temple of Quetzalcoatl at Teotihuacan,
 Mexico. *American Antiquity* 54:85–106.

1992 Rulership, Warfare, and Human Sacrifice at the Ciudadela, Teotihuacan:
 An Iconographic Study of Feathered Serpent Representations. In *Art,
 Ideology, and the City of Teotihuacan*, edited by Janet C. Berlo, pp. 205–
 230. Washington, D.C.: Dumbarton Oaks Research Library and
 Collection.

1993 Worldview Materialized in Teotihuacan, Mexico. *Latin American
 Antiquity* 4:103–129.

1996 *Mass Human Sacrifice and Symbolism of the Feathered Serpent Pyramid in
 Teotihuacan, Mexico*. Ph.D. diss., Department of Anthropology, Arizona
 State University. Ann Arbor: University Microfilms.

1998a Cronología de sucesos ocurridos en el Templo de Quetzalcoatl,
 Teotihuacán. In *Los ritmos de cambio en Teotihuacán: Reflexiones y
 discusiones de su cronología*, edited by Rosa M. Brambila Paz and Rubén
 Cabrera Castro, pp. 167–184. Mexico City: Instituto Nacional de
 Antropología e Historia.

1998b Teotihuacan Militarism and Its Implications in Maya Social Histories.
 Paper presented at the Sixty-third Annual Meeting of the Society for
 American Archaeology, Seattle.

1998c Teotihuacan Notes: Internet Journal for Teotihuacan Archaeology and
 Iconography. http:archaeology.la.asu.edu/vm/mesoam/teo.notes.

2000 Teotihuacan as an Origin for Postclassic Feathered Serpent Symbolism.
 In *Mesoamerica's Classic Heritage: From Teotihuacan to the Aztecs*, edited
 by Davíd Carrasco, Lindsay Jones, and Scott Sessions, pp. 117–143.
 Niwot: Colorado University Press.

TAUBE, KARL A.

1985 The Classic Maya Maize God: A Reappraisal. In *Fifth Palenque
 Roundtable*, edited by Merle G. Robertson and Virginia Fields, pp.
 171–181. San Francisco: Pre-Columbian Art Research Institute.

1986 The Teotihuacan Cave of Origin. *RES: Anthropology and Aesthetics*
 12:51–82.

1992a The Iconography of Mirrors at Teotihuacan. In *Art, Ideology, and the
 City of Teotihuacan*, edited by Janet C. Berlo, pp. 169–204. Washington,
 D.C.: Dumbarton Oaks Research Library and Collection.

1992b *The Major Gods of Ancient Yucatan*. Studies in Pre-Columbian Art and
 Archaeology, No. 32. Washington, D.C.: Dumbarton Oaks Research
 Library and Collection.

1992c The Temple of Quetzalcoatl and the Cult of Sacred Warfare at
 Teotihuacan. *Res: Anthropology and Aesthetics* 21:53–87.

1994a The Birth Vase: Natal Imagery in Ancient Maya Myth and Ritual. In
 The Maya Vase Book, Vol. 4, edited by Justin Kerr, pp. 650–685. New
 York: Kerr Associates.

1994b The Iconography of Toltec Period Chichen Itza. In *Hidden in the Hills:
 Maya Archaeology of the Northwestern Yucatan Peninsula*, edited by
 Hanns J. Prem, pp. 212–246. Acta Mesoamericana 7. Möckmühl,
 Germany: Verlag von Flemming.

1996 The Olmec Maize God: The Face of Corn in Formative Mesoamerica, *Res: Anthropology and Aesthetics* 29/30:39–81.

1998a Enemas rituales en Mesoamérica. *Arqueología mexicana* 6(34):38–45.

1998b The Jade Hearth: Centrality, Rulership, and the Classic Maya Temple. In *Function and Meaning in Classic Maya Architecture*, edited by Stephen D. Houston, pp. 427–78. Washington, D.C.: Dumbarton Oaks Research Library and Collection.

2000a The Stairway Block Sculptures of Structure 10L-16, Copán, Honduras: Fire and the Evocation and Resurrection of K'inich Yax K'uk' Mo'. Paper presented at the Sixty-fifth Annual Meeting of the Society for American Archaeology, Philadelphia.

2000b The Turquoise Hearth: Fire, Self Sacrifice, and the Central Mexican Cult of War. In *Mesoamerica's Classic Heritage: From Teotihuacan to the Aztecs,* edited by Davíd Carrasco, Lindsay Jones, and Scott Sessions, pp. 269–340. Niwot: Colorado University Press.

2000c The Writing System of Ancient Teotihuacan. *Ancient America* (Barnardsville, N.C.: Center for Ancient American Studies) 1.

THOMPSON, J. ERIC S.

1939 *Excavations at San Jose, British Honduras.* Carnegie Institution of Washington Publication 506. Washington, D.C.: Carnegie Institution of Washington.

TORRENCE, ROBIN, AND SANDER E. VAN DER LEEUW, EDS.

1989 Introduction: What's New about Innovation? In *What's New? A Closer Look at the Process of Innovation,* edited by Sander E. van der Leeuw and Robin Torrence, pp. 1–15. London: Unwin Hyman.

TOZZER, ALFRED M.

1941 *Landa's Relación de las Cosas de Yucatán.* Papers of the Peabody Museum of American Archaeology and Ethnology 18. Cambridge: Harvard University.

TRAXLER, LOA P.

1996 Los grupos de patios tempranos de la Acrópolis de Copán. *Yaxkin* 14:35–54.

1998 At Court in Copan: Palace Groups of the Early Classic. Paper presented at the Sixty-third Annual Meeting of the Society for American Archaeology, Seattle.

2001 The Royal Courts of Early Classic Copán. In *Royal Courts of the Ancient Maya, Vol. 2: Case Studies,* edited by Takeshi Inomata and Stephen D. Houston. Boulder, Colo.: Westview Press. In press.

VAILLANT, GEORGE C.

1930a The Archaic Cultures of Mexico. *Palacio* (Santa Fe, N.M.) 28:17–19.

1930b Notes on the Middle Cultures of Middle America. *Proceedings of the Twenty-third International Congress of Americanists,* pp. 74–81. New York: International Congress of Americanists.

1932 Stratigraphical Research in Central Mexico. *Proceedings of the National Academy of Science* 18:487–490.

1935 *Excavations at El Arbolillo.* American Museum of Natural History Anthropological Papers, Vol. 35, Part 2. New York: American Museum of Natural History.

1938 A Correlation of Archeological and Historical Sequences in the Valley
 of Mexico. *American Anthropologist* 40:535-573.
1940 Patterns in Middle American Archaeology. In *The Maya and Their
 Neighbors*, edited by Clarence L. Hay, Ralph L. Linton, Samuel K.
 Lothrop, Harry L. Shapiro, and George C. Vaillant, pp. 295-305. New
 York: Appleton-Century.

VALDÉS, JUAN ANTONIO, AND FEDERICO FAHSEN
1995 The Reigning Dynasty of Uaxactun during the Early Classic: The Rulers
 and the Ruled. *Ancient Mesoamerica* 6(2):197-219.

VALDÉS, JUAN ANTONIO, FEDERICO FAHSEN, AND GASPAR MUÑOZ COSME
1997 *Estela 40 de Tikal: Hallazgo y Lectura.* Guatemala City: Instituto de
 Antropología e Historia de Guatemala and Agencia Española de
 Cooperación Internacional.

VALDÉS, JUAN ANTONIO, MÓNICA URQUIZÚ, AND JEANETTE CASTELLANOS
1996 Excavaciones en el Sector 6 del Proyecto Arqueológico Miraflores II.
 Report on file, Instituto de Antropología e Historia, Guatemala City.

VALDÉS, JUAN ANTONIO, MARIO VÁSQUEZ, MARÍA CANO, PATRICIA HERNÁNDEZ, AND
ISABEL AGUIRRE
1996 Excavaciones en el Sector 5 del Proyecto Arqueológico Miraflores II.
 Report on file, Instituto de Antropología e Historia, Guatemala City.

VALENZUELA, JUAN
1945 Las exploraciones efectuadas en Los Tuxtlas, Veracruz. *Anales del
 Museo de Arqueología, Historia y Etnografía* (Mexico City) 3:83-105.

VARELA TORRECILLA, CARMEN
1998 *El clásico medio en el noroccidente de Yucatán: La fase Oxkintok Regional
 en Oxkintok (Yucatán) como paradigma.* Paris Monographs in American
 Archaeology 2, Eric Taladoire, series editor. BAR International Series
 739. Oxford: British Archaeological Reports.

VARELA TORRECILLA, CARMEN, AND IGNACIO MONTERO
1994 La secuencia cerámica de Oxkintok: Rasgos generales y análisis
 cuantitativo. In *VII simposio de investigaciones arqueológicas en
 Guatemala, 1993,* edited by Juan Pedro Laporte and Héctor
 L. Escobedo, pp. 691-709. Guatemala City: Museo Nacional de
 Arqueología y Etnología.

VIEL, RENÉ
1999 El período formativo de Copán, Honduras. In *XII simposio de
 investigaciones arqueológicas en Guatemala, 1998,* edited by Juan Pedro
 Laporte, Héctor L. Escobedo, and Ana Claudia Monzón de Suasnávar,
 Tomo 1, pp. 99-104. Guatemala City: Museo Nacional de Arqueología
 y Etnología.

VIEL, RENÉ, AND CHARLES D. CHEEK
1983 Sepulturas. In *Introducción a la arqueología de Copán,* Tomo 1, edited by
 Claude-François Baudez, pp. 551-609. Tegucigalpa, Honduras:
 Secretaría de Estado en el Despacho de Cultura y Turismo and Instituto
 Hondureño de Antropología e Historia.

VILLAGRA CALETI, AGUSTÍN
1954 Trabajos realizados en Teotihuacán: 1952. *Anales* (Mexico City:
 Instituto Nacional de Antropología e Historia) 4, Part 1(34):69-78.
1971 Mural Painting in Central Mexico. In *Archaeology of Northern*

Mesoamerica, Part 1, edited by Gordon F. Ekholm and Ignacio Bernal, pp. 135–156. *Handbook of Middle American Indians,* Vol. 10, Robert Wauchope, general editor. Austin: University of Texas Press.

VIVÓ ESCOTO, JORGE

1964 Weather and Climate of Mexico and Central America. In *Natural Environment and Early Cultures,* edited by Robert C. West and Robert Wauchope, pp. 187–215. *Handbook of Middle American Indians,* Vol. 1, Robert Wauchope, general editor. Austin: University of Texas Press.

VON WINNING, HASSO

1987 *La iconografía de Teotihuacán: Los dioses y los signos.* 2 vols. Mexico City: Universidad Nacional Autónoma de México.

VON WINNING, HASSO, AND NELLY GUTIÉRREZ SOLANA

1996 *La iconografía de la cerámica de Río Blanco, Veracruz.* Mexico City: Universidad Nacional Autónoma de México.

WEBSTER, DAVID L.

1973 The B-V-11 Mound Group: A Middle Classic Elite Residence Compund. In *The Pennsylvania State University Kaminaljuyu Project—1969, 1970 Seasons: Part I—Mound Excavations,* edited by Joseph W. Michels and William T. Sanders, pp. 253–295. Occasional Papers in Anthropology, No. 9. College Park: Department of Anthropology, Pennsylvania State University.

1977 Warfare and the Evolution of Maya Civilization. In *The Origins of Maya Civilization,* edited by Richard E. W. Adams, pp. 335–371. Albuquerque: University of New Mexico Press.

WETHERINGTON, RONALD K.

1978a The Ceramic Chronology of Kaminaljuyu. In *The Ceramics of Kaminaljuyu, Guatemala,* edited by Ronald K. Wetherington, pp. 115–149. College Park: Pennsylvania State University Press.

WETHERINGTON, RONALD K., ED.

1978b *The Ceramics of Kaminaljuyu, Guatemala.* College Park: Pennsylvania State University Press.

WHITE, CHRISTINE D., AND FRED J. LONGSTAFFE

2000 Stable Isotope Analysis of Human Skeletal Remains from Río Azul. Ms. on file at the Department of Anthropology, University of Western Ontario, London, Ontario.

WHITE, CHRISTINE D., FRED J. LONGSTAFFE, AND KIMBERLEY R. LAW

2001 Revisiting the Teotihuacan Connection at Altun Ha: Oxygen-Isotope Analysis of Tomb F-8/1. *Ancient Mesoamerica* 12:65–72.

WHITE, CHRISTINE D., FRED J. LONGSTAFFE, MICHAEL W. SPENCE, AND KIMBERLEY R. LAW

2000 Testing the Nature of Teotihuacan Imperialism at Kaminaljuyú Using Phosphate Oxygen-Isotope Ratios. *Journal of Anthropological Research.* 56(4):535–558.

WHITE, CHRISTINE D., MICHAEL W. SPENCE, HILARY LE-Q. STUART-WILLIAMS, AND HENRY P. SCHWARCZ

1998 Oxygen Isotopes and the Identification of Geographical Origins: The Valley of Oaxaca versus the Valley of Mexico. *Journal of Archaeological Science* 25:643–655.

WIDMER, RANDOLPH J., AND REBECCA STOREY

1993 Social Organization and Household Structure of a Teotihuacan
 Apartment Compound: S3W1:33 of Tlajinga Barrio. In *Prehispanic
 Domestic Units in Western Mesoamerica*, edited by Robert S. Santley and
 Kenneth G. Hirth, pp. 87–104. Boca Raton, Fla.: CRC Press.

WILKERSON, S. JEFFREY K.

1991 And Then They Were Sacrificed: The Ritual Ballgame of Northeastern
 Mesoamerica through Time and Space. In *The Mesoamerican Ballgame*,
 edited by Vernon Scarborough and David Wilcox, pp. 45–72. Tucson:
 University of Arizona Press.

WILLEY, GORDON R.

1974 The Classic Maya Hiatus: A Rehearsal for the Collapse? In
 Mesoamerican Archaeology: New Approaches, edited by Norman
 Hammond, pp. 417–444. Austin: University of Texas Press.

WILLEY, GORDON R., AND PHILIP PHILLIPS

1958 *Method and Theory in American Archaeology*. Chicago: University of
 Chicago Press.

WILLIAMSON, RICHARD V.

1996 Excavations, Interpretations, and Implications of the Earliest Structures
 beneath Structure 10L-26 at Copan, Honduras. In *Eighth Palenque
 Round Table, 1993*, edited by Martha J. Macri and Jan McHargue, pp.
 169–175. San Francisco: Pre-Columbian Art Research Institute.

WINTER, MARCUS

1974 Residential Patterns at Monte Albán, Oaxaca, Mexico. *Science*
 186(4168):981–987.

1998 Monte Albán and Teotihuacan. In *Rutas de intercambio en Mesoamerica*,
 edited by Evelyn C. Rattray, pp. 153–184. Mexico City: Universidad
 Nacional Autónoma de México.

WOLF, ERIC R., ED.

1976 *The Valley of Mexico: Studies in Pre-Hispanic Ecology and Society*.
 Albuquerque: University of New Mexico Press.

WOLFMAN, DANIEL

1973 *A Re-evaluation of Mesoamerican Chronology: A.D. 1–1200*. Ph.D. diss.,
 Department of Anthropology, University of Colorado. Ann Arbor:
 University Microfilms.

1990 Mesoamerican Chronology and Archaeomagnetic Dating, A.D. 1–1200.
 In *Archaeomagnetic Dating*, edited by Jeffery L. Eighmy and Robert S.
 Sternberg, pp. 261–308. Tucson: University of Arizona Press.

WRIGHT, HENRY T.

1984 Prestate Political Formations. In *On the Evolution of Complex Societies:
 Essays in Honor of Harry Hoijer*, edited by Timothy Earle, pp. 41–77.
 Malibu, Calif.: Undena Press.

WRIGHT, LORI E.

1996 The Inhabitants of Tikal: A Bioarchaeological Pilot Project. Final
 Report to the Foundation for the Advancement of Mesoamerican
 Studies, on file at the Department of Anthropology, Texas A & M
 University, College Station.

1999 Los niños de Kaminaljuyú: Isótopos, dieta y etnicidad en el altiplano
 guatemalteco. In *XII simposio de investigaciones arqueológicas en*

Guatemala, 1998, edited by Juan Pedro Laporte, Héctor L. Escobedo, and Ana Claudia Monzón de Suasnávar, Tomo 1, pp. 485–491. Guatemala City: Museo Nacional de Arqueología y Etnología.

2000 Teeth from the Tombs: Diet and Identity at Kaminaljuyu. Paper presented at the University Museum Maya Weekend, University of Pennsylvania, Philadelphia.

WRIGHT, LORI E., AND HENRY P. SCHWARCZ

1998 Stable Carbon and Oxygen Isotopes in Human Tooth Enamel: Identifying Breastfeeding and Weaning in Prehistory. *American Journal of Physical Anthropology* 106:1–18.

1999 Correspondence between Stable Carbon, Oxygen, and Nitrogen Isotopes in Human Tooth Enamel and Dentine: Infant Diets and Weaning at Kaminaljuyú. *Journal of Archaeological Science* 26:1159–1170.

WRIGHT, LORI E., MARIO VÁSQUEZ, MIGUEL ANGEL MORALES, AND W. MARIANA VALDIZÓN

2000 La bioarqueología en Tikal: Resultados del primer año del Proyecto Osteológico Tikal. In *XIII simposio de investigaciones arqueológicas en Guatemala, 1999,* edited by Juan Pedro Laporte, Héctor L. Escobedo, Ana Claudia Monzón de Suasnávar, and Bárbara Arroyo, Tomo 1, pp. 515–522. Guatemala City: Museo Nacional de Arqueología y Etnología.

YURTSEVER, YUECEL, AND JOEL R. GAT

1981 Atmospheric Waters. In *Stable Isotope Hydrology: Deuterium and Oxygen-18 in the Water Cycle,* Technical Report Series, No. 210, edited by Joel R. Gat and R. Gonfiantini, pp. 103–142. Vienna: International Atomic Energy Agency.

Index

Page numbers in italics refer to maps and other illustrations.